Magnificent BUILDINGS, *Splendid* GARDENS

Magnificent BUILDINGS, *Splendid* GARDENS

David R. Coffin

Edited by **Vanessa Bezemer Sellers**

| Department of Art and Archaeology | Princeton University | In Association with Princeton University Press |

Copyright © 2008 by the Trustees of Princeton University
In the Nation's Service and in the Service of All Nations

Published by the Department of Art and Archaeology
Princeton University, Princeton, New Jersey 08544-1018

Distributed by Princeton University Press
41 William Street, Princeton, New Jersey 08540-5237
press.princeton.edu

Library of Congress Cataloging-in-Publication Data

Coffin, David R.
Magnificent buildings, splendid gardens / David R. Coffin ;
edited by Vanessa Bezemer Sellers.
p. cm.
Includes bibliographical references and index.
ISBN-13: 978-0-691-13664-6 (hardcover : alk. paper)
ISBN-13: 978-0-691-13677-6 (paperback : alk. paper)
1. Architecture, Renaissance—Italy. 2. Architecture—
Italy—16th century. 3. Art, Italian—16th century.
4. Gardens, Italian. 5. Gardens, English.
I. Sellers, Vanessa Bezemer. II. Princeton University.
Dept. of Art and Archaeology. III. Title.
NA1115.C64 2008
720.945'09024—dc22

2007032325

British Library Cataloging-in-Publication Data is available

Books published by the Department of Art and Archaeology,
Princeton University, are printed on acid-free paper and meet
the guidelines for permanence and durability of the Committee
on Production Guidelines for Book Longevity of the Council on
Library Resources.

This book has been composed in ITC New Baskerville and Interstate

Printed in Italy

Managing Editor: Christopher Moss
Designer: Isabella D. Palowitch, Artisa LLC
Indexer: Barbara E. Cohen

10 9 8 7 6 5 4 3 2 1

Contents

List of Illustrations

5. The Self-Image of the Roman Villa during the Renaissance, pp. 90–117

6. Some Architectural Drawings of Giovan Battista Aleotti, pp. 118-137

Foreword

The twenty essays and articles collected in this volume constitute but a small fraction of David R. Coffin's contributions to scholarship over the course of half a century. In conception, the book is a variation on the theme of the scholarly festschrift, and in keeping with that genre, it celebrates a lifetime of teaching and scholarship. However, Professor Coffin's former students wisely decided that the best way to show their esteem for their mentor would be to make his own scattered studies available in a single volume. For this alone we owe them a debt of gratitude. But they have done much more: to the sturdy stock of each of Professor Coffin's original essays, one of his students has grafted a commentary assessing its contributions and situating it within their beloved teacher's broad scholarly interests.

David Coffin's contributions to advancing the study of art history in this country and his particular role in shaping the field of garden and landscape history are well known. His influence was in no way limited to his distinguished series of scholarly publications, however, and is equally evident in the number and quality of students he trained. In many cases their own scholarship has pursued pathways first identified as promising in one of Professor Coffin's seminars or books, and their own outstanding series of publications demands to be seen as an important part of his intellectual legacy.

One of the essays included in this volume, on the *Lex Hortorum*, includes a discussion of Cardinal Andrea della Valle's sculpture court, in which he displayed his extensive collection of ancient statuary. The cardinal posted eight inscriptions there stating his intentions, one of which read as follows: *Maiorum memoriae nepotumque imitationi* (In memory of our ancestors and for the emulation of their descendants). These same words apply equally well to the collection of David Coffin's essays, presented in these pages with such care and affection by his students.

John Pinto
Howard Crosby Butler Memorial Professor of the History of Architecture
Princeton University

Acknowledgments

The creation of a scholarly compendium requires teamwork, and there are numerous persons, both within and outside of the Department of Art and Archaeology at Princeton University, whom I would like to thank for their assistance in bringing this work to completion. In the beginning stages, John Pinto, Howard Crosby Butler Memorial Professor of the History of Architecture at Princeton, was most helpful in discussing the form this volume should take. I am grateful for his encouragement throughout the process and also for his gracious foreword. Patricia Fortini Brown, who was then chair of the Department of Art and Archaeology, provided a positive assessment of the main proposals for this project that was of vital importance. Susan Lehre, manager of the department, gave us indispensable logistical assistance during many phases of our work. Christopher Moss, the department's editor of publications, deserves a medal for his dedication to this project; his expert, painstaking labors created a unified book out of a body of work that was written by David Coffin over many years and published with widely varying conventions and styles; he also located and updated much of the photographic material. Isabella Palowitch created the handsome design and clear layout of the book, while John Blazejewski, photographer in Princeton's Index of Christian Art, enhanced a number of the illustrations. I am also grateful to Nancy Coffin for kindly offering her favorite portraits of David to illustrate this compilation of her late husband's work. Finally, I extend my sincere thanks to the Publications Committee of the Department of Art and Archaeology for its generous financial support.

Outside Princeton, I would like to thank Andrea Bayer (Metropolitan Museum of Art, New York), who gave crucial advice, particularly on the content of the introduction. I am also indebted to Mirka Beneš (University of Texas at Austin) for reading a preliminary version of the text and giving valuable suggestions for its improvement. I am especially grateful to Sabine Eiche (independent scholar, Florence, Italy), who carefully combed through the introduction and commentaries, correcting various mistakes and inconsistencies.

Last and most importantly, I offer sincere thanks to my colleagues and fellow contributors—all former students of David Coffin—whose assessments of their professor's articles make this work complete: Richard Betts, Pierre de la Ruffinière du Prey, Tracy Ehrlich, Meredith Gill, David Gobel, Edward Harwood, Franklin Hamilton Hazlehurst, Claudia Lazzaro, Graham Smith, Lydia Soo, and David Wright.

Vanessa Bezemer Sellers

Magnificent BUILDINGS, *Splendid* GARDENS

Introduction

The title of this book, *Magnificent Buildings, Splendid Gardens*, is derived from the name of two treatises— one on magnificence, the other on splendor—written in the late fifteenth century by the Neapolitan humanist and statesman Giovanni Pontano. Both works discuss the essential role of architecture and gardens for the humanist owner's image and personal prestige. In Pontano's treatises, as David Coffin noted in his 1987 article "The 'Lex Hortorum' and Access to Gardens of Latium during the Renaissance,"[1] true "magnificence" refers to architectural structures, including richly decorated villas and palaces, while "splendor" is associated with more ephemeral objects, such as gardens planted with exotic flowers. Pontano contradicts Alberti's famous dictum, namely, that villas and gardens exist primarily for the nourishment of the family, asserting that the truly "splendid man" should enjoy his estate and should also invite to his table many fellow citizens and strangers to delight in his villa and garden. Like Pontano, Coffin was fascinated by humanist ideals of living and learning, qualities that he, too, cultivated during his remarkable long career of teaching and research at Princeton University. Following the humanist tradition, then, the reader is invited to enjoy the fruits of Coffin's own studies on villas and gardens of the Renaissance and the Baroque Age.

David Coffin made an enduring contribution to the study of the history of art and architecture, leaving us six books as well as an impressive body of essays on gardens,

art, and architecture; most of his articles are included in this volume. While his work focused on the study of architecture and gardens in Italy and in England from the sixteenth through the eighteenth century, Coffin also published on other topics, including drawings and antiquarian studies. These latter fields are represented here by articles dating from the early part of his career—studies on drawings by Tintoretto and Pietro da Cortona, as well as on the architect-archaeologist Pirro Ligorio, who was one of Coffin's life-long interests. The complete bibliography of Coffin's publications (pp. 8–13 below), including his book reviews, provides a comprehensive overview of his scholarly interests and accomplishments.

The essays gathered here, written between 1951 and 2001, originally appeared as articles in a variety of international journals and festschrifts.[2] They are now brought together in book form to make them more easily accessible to a wider audience. This collection serves a two-fold purpose: firstly, as a compendium of research put together by an internationally distinguished scholar who opened up entirely new areas of research, it is an academic source for future students of architecture, landscape and garden design, and related disciplines. Secondly, because it is a richly illustrated survey of European gardens and buildings, we hope that it will be a useful visual resource.

The essays are followed by commentaries (pp. 278–288 below) that consist of brief reviews of Coffin's essays by

a number of his former students, all of whom are specialists in those particular areas. These commentaries serve to highlight the essential points Coffin makes in his original texts. They also place the articles within the larger framework of Coffin's oeuvre and the latest scholarship, pointing out the significance of his contributions to the field.

David Coffin's Contribution to the Study of the History of Art, Architecture, and Gardens

The influence of David Coffin's work in the academic sphere was considerable. While he devoted his career to the study of architectural history in a broader sense, he is known primarily as one of the founders of garden and landscape studies and for developing it into a distinct academic discipline. In doing so, he inspired and influenced a generation of scholars who now work in this flourishing field. The significance of Coffin's work and his contribution to this academic field, as well as the methodology used in his studies, have recently been examined in two articles by Mirka Beneš. In "A Tribute to Two Historians of Landscape Architecture: David R. Coffin (1918–2003) and Elisabeth B. MacDougall (1925–2003)," published in the *Journal of the Society of Architectural Historians*,[3] Beneš focuses on the innovative approaches to the study of garden history developed by Coffin and his colleague Elisabeth Blair MacDougall. Beneš's other article, "Recent Developments and Perspectives in the Historiography of Italian Gardens," in *Perspectives on Garden Histories*,[4] which follows the essay on garden history by Coffin himself, takes a broader view of the development of the field. Some of the points raised in these articles will appear throughout this introduction.

Coffin, like Elisabeth MacDougall, belonged to the first generation of landscape and garden historians, and both brought to the new field analytical approaches and methodologies carried over from their backgrounds in the history of art or architecture. In American scholarly circles it was the architectural historian James Ackerman in the mid-1950s who first included gardens in his research and publications on villas, but it was Coffin in the early 1960s, followed a decade later by Elisabeth MacDougall, who began to focus on the garden as a work of art in its own right. Their pioneering research, initially Eurocentric and limited to design issues, made it possible

David R. Coffin

for garden history to grow into the interdisciplinary field of studies that it is today.

Of crucial importance for the future development of the new discipline was the method that Coffin applied in his analysis of gardens, namely, iconography. This method of analyzing works of art as part of a broader philosophical, intellectual, and cultural pattern was originally developed by Coffin's mentor at Princeton, Erwin Panofsky. Coffin transferred the methodology of iconography from the art of painting to the realm of garden design, examining the garden as a three-dimensional landscape painting, as it were, and analyzing its design and decorative features (including fountains and statues) in order to assess the deeper meaning of both the layout of the garden and its ornamentation. Coffin's award-winning book *The Villa d'Este in Tivoli*, published in 1960, was the first monograph to incorporate such an innovative iconographical analysis of a garden, demonstrating that the d'Este garden symbolized the mythical Garden of the Hesperides. Ten years later, Elisabeth MacDougall would use the same approach in her dissertation on the Villa Mattei.[5] The application of an iconographical method to garden history was crucial not only for the further development of this new discipline, but also for its growing appreciation by a larger academic audience. Just as allegorical programs in the visual arts had been analyzed, the symbolic programs of Italian and English gardens of the sixteenth and seven-

teenth centuries, for example, could now be similarly studied and evaluated systematically. Through his iconographical interpretations, Coffin was also able to draw larger comparisons among various villa and garden designs, recognizing patterns of form and meaning. His discoveries gave an important impulse to further research, bringing garden and landscape studies into the mainstream of art history.

David Coffin's publications are considered standard works and are invariably referred to in the academic literature. In addition to *The Villa d'Este at Tivoli*, his other award-winning book was *The Villa in the Life of Renaissance Rome* (1979), which focuses on the development of the country estates and social activities of the Roman popes and their courtiers during the Renaissance. In 1991, he published *Gardens and Gardening in Papal Rome*, which also examines the *villeggiatura* around Rome but extends the scope to the late eighteenth century when the English garden style became fashionable. This work describes, among other topics, the intellectual and cultural life of the ruling classes, the collecting of antiquities, the restoration of ancient waterworks, the development of urban gardens and garden parks and their function as places for lavish entertainment. In *The English Garden: Meditation and Memorial* (1994), Coffin explores the English garden and aspects of transience, focusing on the garden as a place for contemplation and commemoration from the sixteenth through the eighteenth century. In his final monograph, *Pirro Ligorio: The Renaissance Artist, Architect, and Antiquarian* (2004), Coffin presents a comprehensive account of the life and work of this erudite architect-archaeologist, with a complete annotated checklist of his drawings. This book traces Ligorio's career from his early years in Naples, through his work at the papal court in Rome, and his appointment as court antiquarian in Ferrara.

Coffin's monographs and articles have never lost their relevance in spite of many changes in writing and publishing styles, as well as in teaching methods and techniques, since the 1940s, when he began his career. His writings stretch from a time when there were only a handful of academic publications on architecture and gardens to the present day, with its profusion of scholarly literature on those topics. Similarly, his teaching career traced a course from the world of slide projectors with 3 × 6 inch glass slides to the days of early PowerPoint presentations. Coffin's work remains up-to-date in part because of his empirical and synthetic manner of writing, which is founded on archival information and other primary sources. Coffin's typical working method, as is clearly shown in the articles republished in this volume, was grounded in painstakingly thorough research, the discovery and analysis of disparate written and visual documentary evidence, which, placed within a framework of rigorous argumentation, lead the reader step by step to a transparent conclusion. Thus Coffin's documentary emphasis—his scrupulous examination of both visual data and written sources as the basis for determining historical fact and cultural meaning—stands as the significant feature of his academic legacy.

What led David Coffin to the study of gardens, for which he would become so well-known? As early as his senior year in college (1939–40), when he wrote a 179-page thesis entitled "The Greeks' Attitude Toward Nature," he was interested in the relationship of art, humanism, and the physical world, themes that would reappear in his later writings. From the outset of his career Coffin greatly admired parks and gardens, starting with those he observed in England during his military service in World War II, and in Italy in the 1940s and early 1950s. His scholarly interest in gardens, however, grew out of his involvement with architecture and architects. Only gradually, and at the outset only from the standpoint of the architectural historian, did he incorporate landscape, as he came to understand and appreciate more and more the crucial relationship between buildings and gardens. By the time he retired from teaching at Princeton, his work had been recognized as ground-breaking, and as a significant advancement of our understanding of the interaction between architecture and landscape.

A very fitting description of Coffin's work and his particular writing style, which is characterized by a fact-based clarity and simplicity, comes from one of his former students, Graham Smith. Commenting on one of Coffin's early publications, Smith remarks how typical it was of the author: "It says no more than needs to be said, while including everything that is worthwhile to say." Other reviewers have made similar comments about Coffin's concise, well-modulated narratives. David Cast, for example, in his review of Coffin's landmark book *The Villa in the Life of Renaissance Rome*, described the 369 pages of text in as being "without a wasted or superfluous sentence."[6] Overall, an examination of the reception of Coffin's publications shows that the majority of reviewers especially appreciated the clarity with which Coffin arranged and presented newly found source material.

Some scholars, however, have expressed concerns about Coffin's sober writing style, wishing for a more passionate response to the topic of villas and gardens. Another perceived limitation of Coffin's scholarship was mentioned by James Ackerman in his review of *The Villa in the Life of Renaissance Rome*.[7] While Ackerman admired the "imposing amount of information," he regretted the presentation of the material "in the most clinically factual way," without in-depth evaluation or clear opinion to guide the reader, as in the exhaustive German scholarly publications, such as Christoph Frommel's *Der römische Palastbau der Hochrenaissance* (Tübingen, 1973). In retrospect, however, some of the criticism regarding the lack of deep analysis or lively discussion proved to be unfounded: in subsequent articles Coffin presented certain aspects of his research on Roman villa life in profoundly evocative and colorful detail, a good example being his essay on the "Lex Hortorum," republished below.

While Coffin's somewhat dry methodology and restrained writing style may be perceived as limitations, they can also be viewed as an asset, particularly from today's perspective. His transparent, clearly framed studies distinguish themselves from a parade of more recent publications that present haphazard research and almost random assemblages of ideas. Unlike the current and at times confusing scholarly directions in landscape history, Coffin's work is refreshingly traditional: it does not come with sweeping theories or provocative revisions. As David Gobel, one of his former students, points out in the commentaries below, Coffin's theses, though often profound, were understated, and he kept his conjectures and predictions to himself. It is up to the readers to draw their own conclusions, appropriate to their personal interests and viewpoints.

Coffin was the model of the disciplined, scrupulous scholar and researcher. In her comments on the manuscript of this volume, Sabine Eiche applauds his scholarly principles and character, observing that he never gave in to fashionable trends in art history, never resorted to jargon, and never forgot the purpose of his work, namely, the compilation, coherent arrangement, synthesis, and interpretation of historical facts on architecture and gardens. She predicts that his articles and books will provide material for many future studies, not only in garden art and architecture, but in various fields. Time will tell, of course, whether David Coffin's work remains essential to these future studies, but his legacy as an innovative scholar will surely live on.

David Coffin's Academic Career at Princeton University

David Robbins Coffin (1918–2003) spent most of his academic career and professional life at Princeton University. Arriving in Princeton in 1936 as a freshman in the Department of Art and Archaeology, he received his bachelor's degree in 1940. After a year of graduate study at Yale University, he returned to Princeton to begin work on his master's degree, which was interrupted by several years of military service during World War II. In 1945 he returned to Princeton's campus and completed his Master of Fine Arts in 1947, subsequently writing a dissertation on Pirro Ligorio and the Villa d'Este, earning his Ph.D. in 1954. After teaching at the University of Michigan in 1947–49, Coffin officially joined the Princeton faculty in 1949 as a lecturer, becoming assistant professor in 1954, associate professor in 1956, and full professor in 1960.

While Princeton was his home base, Coffin, accompanied by his family, spent a number of years abroad studying art, architecture, and gardens and gathering source material in archives and libraries. The years of research in Italy and England were among the most important for his career. Thus he spent the academic year 1951–52 as a Fulbright scholar in Italy, returning for one semester in 1956, and again in 1963–64 and 1972–73 with fellowships from the American Council of Learned Societies and from the John Simon Guggenheim Memorial Foundation, respectively. In the 1970s and 1980s he also traveled extensively through parts of England to study its houses and gardens, which he had first observed when he was stationed there during World War II, in the early 1940s.

After a long and fruitful career, Coffin retired from Princeton's Department of Art and Archaeology in 1988. Subsequently, as emeritus professor and with characteristic steadiness of purpose, Coffin continued to write, publishing four more books, several important articles, and a number of book reviews. His last publication, the monograph *Pirro Ligorio: The Renaissance Artist, Architect, and Antiquarian*, was released a few months after his death, which occurred on October 14, 2003, at the age of 85. Bringing his own world of ideas and interests to a full circle, in this last book Coffin returned to the topic that had fascinated him since his early years at Princeton: the life and work of the humanist-archaeologist Pirro Ligorio, whom he particularly admired both as a scholar of antiquity and as architect of the Villa d'Este.

To describe Coffin's academic career at Princeton is to

describe to some extent the unfolding of the entire discipline of garden history itself, since his signal contribution was the creation of a new, separate field of study, namely, the history of gardens and landscapes. Coffin, who said he came to the study of gardens, ironically, through his wartime experience in England, oversaw the gradual evolution of garden and landscape history from a topic that formed part of the larger study of humanities to a specialized field of learning. He was a key figure in establishing the Landscape History Program at Dumbarton Oaks, Washington, D.C. in the early 1970s, organizing and editing the proceedings of its first symposium on the Italian garden. At the time of his death he was advisor to the development of a similar landscape history program at the Bard Graduate Center for Studies in the Decorative Arts, Design, and Culture in New York City. In the intervening decades Coffin organized and, through his influence and example, directly stimulated the development of specialized lecture series and university courses throughout America and abroad.

During his tenure at Princeton University, David Coffin held two endowed chairs: from 1966 to 1970 he was Marquand Professor of Art and Archaeology, and in 1970 he was named the Howard Crosby Butler Memorial Professor of the History of Architecture. Among the many distinguished awards, fellowships, and titles bestowed on him are the Alice Davis Hitchcock Book Award of the Society of Architectural Historians (1961), an American Council of Learned Societies Fellowship (1963–64), the John Simon Guggenheim Memorial Foundation Fellowship (1972–73), and Princeton University's Howard T. Behrman Award for distinguished achievement in the humanities (1982). In addition to his many academic responsibilities, Coffin was able to hold important administrative positions both at Princeton University and other institutions. During his tenure as chair of the Department of Art and Archaeology (1964–70), Coffin served the faculty well, generously giving of his time and overseeing the renovation of McCormick Hall and the building of the new Marquand Library.

Coffin also served as the director of the College Art Association (1957–61) and the Society of Architectural Historians (1967–70), of which he was also treasurer (1969–70), and he was an active member of the Renaissance Society, the American Catholic Historical Association, and the Garden History Society. He also chaired the Princeton Group, made up of faculty members from the Department of Art and Archaeology and the Institute for Advanced Study, in addition to local supporters, which aided the work of the Committee to Rescue Italian Art, formed after the catastrophic 1966 flooding of regions in northern and central Italy. Coffin's other professional activities included serving as editor of the College Art Association's monograph series (1955–58), editor-in-chief of *The Art Bulletin* (1959–62), serving on the editorial board of *The Journal of Garden History* (1981–91), and acting as the Kress Professor in the Center for Advanced Studies in the Visual Arts in Washington, D.C. (1995–96). Every year Coffin was present at the Colloquium on the History of Gardens at Dumbarton Oaks, which, first organized by him more than thirty years before, continues to have an impact on the development of garden history and landscape studies today.

David Coffin was widely known as one of Princeton's best and most popular teachers. His renowned lectures, which carried the audience, seemingly without effort, through the realms of Renaissance architecture and landscape, were frequented as much by students in other departments as by those majoring in art and architecture. It was evident that Coffin taught by example, and his courses, like his writings, were exercises in lucidity and succinctness. In addition to being admired for his academic achievements, Coffin is remembered by the wider student body and the Princeton faculty for his kindness and unassuming demeanor. Furthermore, he was a born mentor who always had his students in mind. His office in McCormick Hall, its walls lined with uniform gray-blue binders containing a lifetime's collection of notes, was always open to graduate students and undergraduates alike. None would leave without inspiring thoughts and an encouraging word. All were generously provided with access to his meticulously organized files, which were filled with painstakingly assembled archival data and photographs. Continuing his typically measured, punctual ways and precise working habits, even as emeritus Coffin could be found in the Marquand Library at set hours and could be seen walking at equally regular intervals across campus from the Firestone Library carrying books for his latest research. His life and scholarly discipline remain an inspiring example to all.

In the spring of 2003, Coffin was honored and his outstanding career was celebrated at Prospect House on Princeton's campus, almost seventy years after he first entered its gates. As his former students and colleagues gathered from around the world to pay tribute to their friend and mentor, it was clear that his legacy would live on. This compendium of Coffin's articles, promised as a forthcoming gift during that reunion, is now published in his memory.

The Selection and Organization of the Essays

David Coffin himself selected the articles for republication in this volume and approved their thematic arrangement within four different sections. The collection begins with his articles dealing with *Architecture and Architects*, followed by essays on *Gardens and Landscape Designers*, which comprise the bulk of his work. For the sake of completeness, and because they reflect Coffin's interest in fresco cycles, particularly those depicting villa landscapes, articles about drawings have also been included under the heading *Drawings*. What has *not* been included, as the attentive reader will notice, is one of Coffin's articles on villas, namely, his article on the plans of the Villa Madama published in the *Art Bulletin* in 1967. According to the commentary written by Sabine Eiche for this volume, this was a ground-breaking essay at the time. Coffin, however, did not want it republished because of important discoveries made subsequently, which he duly incorporated into his later writings on the Villa Madama in *The Villa in the Life of Renaissance Rome* (Princeton, 1979). Finally, the collection of Coffin's articles ends most appropriately with a section on scholars. It comprises two short pieces commemorating two giants of twentieth-century art history: Erwin Panofsky and Earl Baldwin Smith, both of whom Coffin was proud to count among his advisors during his formative years at Princeton University. In Coffin's eyes, Panofsky and Smith had achieved the ideal standard of humanist living and learning, a standard Coffin always strove for and in fact attained in his later years.

An admiration for classical humanism and learning stimulated Coffin's intellectual pursuits from the beginning of his academic career, when he focused on the architect-archaeologist Pirro Ligorio, who was the subject of his Princeton dissertation, "Pirro Ligorio and the Villa d'Este," completed in 1954. Coffin saw in Ligorio the embodiment of classical and antiquarian knowledge, and his fascination with Ligorio ultimately resulted in the biography *Pirro Ligoro: The Renaissance Artist, Architect, and Antiquarian*, published posthumously in 2004, but it had started much earlier, when he wrote several shorter studies on the subject. Indeed, within the span of a decade, between 1954 and 1964, Coffin published two major articles on Ligorio and his wide-ranging activities, first focusing on Ligorio's fresco decorations, and subsequently on Ligorio's general artistic theory. It is with these two studies that the present collection begins.

Vanessa Bezemer Sellers

Notes

1. "The 'Lex Hortorum' and Access to Gardens of Latium during the Renaissance," *Journal of Garden History* 2 (1982), 201–232, reprinted on pp. 164–189 below.

2. The original places of publication are cited in the commentaries that follow the essays.

3. M. Beneš, "A Tribute to Two Historians of Landscape Architecture: David R. Coffin (1918–2003), and Elisabeth B. MacDougall (1925–2003)," *Journal of the Society of Architectural Historians* 63 (2004), 248–254.

4. M. Beneš, "Recent Developments and Perspectives in the Historiography of Italian Gardens," in *Perspectives on Garden Histories*, edited by Michel Conan (Washington, D.C., 1999), 37–76.

5. E. B. MacDougall, "The Villa Mattei and the Development of the Roman Garden Style" (Ph.D. diss., Harvard University, 1970).

6. D. Cast, review of *The Villa in the Life of Renaissance Rome*, in *Architectura* 11 (1981), 190–192.

7. J. S. Ackerman, review of *The Villa in the Life of Renaissance Rome*, in *Journal of the Society of Architectural Historians* 39 (1980), 242–243.

Editorial Note

The articles that appear in this volume have been reprinted with minor corrections and with the citations brought into a consistent style. At the request of the owning institutions, information on some objects has been updated, particularly in the captions. With the permission of the publishers, the spelling and punctuation in articles that appeared in British journals have been changed to American forms.

Publications of David R. Coffin

1950

Review of Joan Evans, *Art in Mediaeval France, 987–1498* (London and New York, 1948). *College Art Journal* 9 (1950), 442–446.

1951

"Tintoretto and the Medici Tombs." *Art Bulletin* 33 (1951), 119–125.

1954

"A Drawing by Pietro da Cortona for His Fresco of the *Age of Iron.*" *Record of the Princeton Art Museum* 13 (1954), 33–37.

1955

"Pirro Ligorio and Decoration of the Late Sixteenth Century at Ferrara." *Art Bulletin* 37 (1955), 167–185.

Review of James S. Ackerman, *The Cortile del Belvedere* (Vatican City, 1954). *Journal of the Society of Architectural Historians* 14, no. 4 (December, 1955), 30–31.

1956

"John Evelyn at Tivoli." *Journal of the Warburg and Courtauld Institutes* 29 (1956), 157–158.

"Padre Guarino Guarini in Paris." *Journal of the Society of Architectural Historians* 15, no. 2 (May, 1956), 3–11.

Review of Leon Battista Alberti, *Ten Books on Architecture,* edited by Joseph Rykwert (London, 1955). *Art Bulletin* 38 (1956), 57–58.

1957

"Theater Drawings." *Princeton University Library Chronicle* 18 (1957), 194–201.

1959

Review of Nino Carboneri, *L'architetto Francesco Gallo, 1672–1750* (Turin, 1954). *Art Bulletin* 41 (1959), 346–348.

Review of Rudolf Wittkower, *Art and Architecture in Italy, 1600 to 1750* (Harmondsworth and Baltimore, 1958). *Journal of the Society of Architectural Historians* 18 (1959), 164–165.

1960

The Villa d'Este at Tivoli. Princeton: Princeton University Press, 1960.

"A Drawing by Taddeo Zuccaro." *Record of the Art Museum, Princeton University* 19 (1960), 5–10.

"Renaissance Architecture." In *The Encyclopædia Britannica,* 14th edition, vol. 19, 135–144. Chicago, London, and Toronto: Encyclopædia Britannica, 1960. Numerous reprintings with various titles, including "Renaissance Architecture," in the revised 14th edition, 1971, vol. 19, 129–138D; "Visual Arts, Western: Renaissance Visual Arts, Architecture," in *The New Encyclopædia Britannica,* 15th edition, 1974, vol. 29, 380–397; and "Architecture, the History of Western: The Renaissance," in the revised 15th edition, 1990, vol. 13, 994–1011.

Review of Nicolas Powell, *From Baroque to Rococo: An Introduction to Austrian and German Architecture from 1580 to 1790* (London and New York, 1959). *Journal of Modern History* 32 (1960), 276–277.

1962

"Some Architectural Drawings of Giovan Battista Aleotti." *Journal of the Society of Architectural Historians* 21 (1962), 116–128.

Review of James S. Ackerman, *The Architecture of Michelangelo* (New York, 1961). *Journal of the Society of Architectural Historians* 21 (1962), 103–104.

1963

Review of Howard Hibbard, *The Architecture of the Palazzo Borghese* (Rome, 1962). *Renaissance News* 16 (1963), 117–118.

1964

"Pirro Ligorio on the Nobility of the Arts." *Journal of the Warburg and Courtauld Institutes* 27 (1964), 191–210.

1966

"Some Aspects of the Villa Lante at Bagnaia." In *Arte in Europa: Scritti di storia dell'arte in onore di Edoardo Arslan*, vol. 1, 569–575. Milan: Tip. Artipo, 1966.

1967

"The Plans of the Villa Madama." *Art Bulletin* 59 (1967), 111–122.

Review of Mario Passanti, *Nel mondo magico di Guarino Guarini* (Turin, 1963), and Giuseppe M. Crepaldi, *La real chiesa di San Lorenzo in Torino* (Turin, 1963). *Journal of the Society of Architectural Historians* 26 (1967), 222–223.

1968

"The Art Museum and the Teaching of the History of Art." *Record of the Art Museum, Princeton University* 27 (1968), 51–54.

"In Memoriam." In *A Commemorative Gathering for Erwin Panofsky at the Institute of Fine Arts, New York University, in Association with the Institute for Advanced Study*, 14–15. N.p., 1968.

1971

"Mirabilia Romae." *Princeton University Library Chronicle* 32 (1971), 173–175.

1972

Editor and preface, *The Italian Garden*. First Dumbarton Oaks Colloquium on the History of Landscape Architecture. Washington, D.C.: Dumbarton Oaks, 1972.

Review of George L. Hersey, *Alfonso II and the Artistic Renewal of Naples, 1485–1495* (New Haven, 1969). *Journal of the Society of Architectural Historians* 31 (1972), 64–67.

1973

"Alberti," "Bramante," "Brunelleschi," "Michelozzo," "Palladio," "Sangallo Family," and "Sanmicheli." In *McGraw-Hill Encyclopedia of World Biography*, vol. 1, 92–95; vol. 2, 144–146, 209–211; vol. 7, 396–397; vol. 8, 265–268; vol. 9, 387–389, 391–392. New York: McGraw-Hill, 1973.

1974

Review of Paolo Portoghesi, *Rome of the Renaissance* (London, 1972). *Journal of the Society of Architectural Historians* 33 (1974), 148–149.

1976

Review of Stefano Ray, *Raffaello architetto: Linguaggio artistico e ideologia nel Rinascimento romano* (Rome and Bari, 1974). *Art Bulletin* 58 (1976), 292–293.

Review of *Studi Bramanteschi: Atti del congresso internazionale, Milano, Urbino, Roma, 1970* (n.p., 1974). *Architectura: Zeitschrift für Geschichte der Baukunst* 6 (1976), 70–73.

1978

"Pope Innocent VIII and the Villa Belvedere." In *Studies in Late Medieval and Renaissance Painting in Honor of Millard Meiss*, edited by Irving Lavin and John Plummer, 88–97. New York: New York University Press, 1978.

1979

The Villa in the Life of Renaissance Rome. Princeton Monographs in Art and Archaeology 43. Princeton: Princeton University Press, 1979; paperback edition, 1988.

"Pope Marcellus II and Architecture." *Architectura: Zeitschrift für Geschichte der Baukunst* 9 (1979), 11–29.

1980

Review of William H. Adams, *The French Garden, 1500–1800* (New York, 1979). *Journal of the Society of Architectural Historians* 39 (1980), 172–173.

Review of Philip E. Foster, *A Study of Lorenzo de'Medici's Villa at Poggio a Caiano* (New York, 1978). *Burlington Magazine* 122, no. 926 (May, 1980), 350–351.

Review of *Sebastiano Serlio on Domestic Architecture: Different Dwellings from the Meanest Hovel to the Most Ornate Palace. The Sixteenth-Century Manuscript of Book VI in the Avery Library of Columbia University*, edited by Myra N. Rosenfeld (New York, 1978). *Renaissance Quarterly* 33 (1980), 102–106.

1981

Review of Luigi Zangheri, *Pratolino: Il giardino delle meraviglie* (Florence, 1979). *Journal of Garden History* 1 (1981), 279–282.

1982

"The 'Lex Hortorum' and Access to Gardens of Latium during the Renaissance." *Journal of Garden History* 2 (1982), 201–232.

"Pirro Ligorio." In *MacMillan Encyclopedia of Architects*, vol. 3, 9–11. New York: MacMillan, 1982.

Review of Joseph Connors, *Borromini and the Roman Oratory: Style and Society* (New York and Cambridge, Mass., 1980). *Catholic Historical Review* 68 (1982), 528–529.

Review of Cecil Gould, *Bernini in France: An Episode in Seventeenth-Century History* (Princeton, 1982). *Renaissance Quarterly* 36 (1983), 117–119.

1984

Review of George L. Hersey, *Architecture, Poetry, and Number in the Royal Palace at Caserta* (Cambridge, Mass., 1983). *Renaissance Quarterly* 37 (1984), 264–267.

1986

"The Elysian Fields of Rousham." *Proceedings of the American Philosophical Society* 130 (1986), 406–423.

"Repton's 'Red Book' for Beaudesert." *Princeton University Library Chronicle* 47 (1986), 121–146.

"An Interview with David Coffin." *The Princeton Journal* 2 (1986), 221–230.

1987

Review of John D. Hunt, *Garden and Grove: The Italian Renaissance Garden in the English Imagination, 1600–1750* (Princeton, 1986). *Renaissance Quarterly* 40 (1987), 543–546.

Review of Richard Krautheimer, *The Rome of Alexander VII, 1655–1667* (Princeton, 1985). *Catholic Historical Review* 73 (1987), 628–629.

Review of Kenneth Woodbridge, *Princely Gardens: The Origins and Development of the French Formal Style* (London and New York, 1986). *Burlington Magazine* 129, no. 1006 (January, 1987), 37.

1988

"From Art to Nature." In *Landscape and Architecture: Sharing Common Ground, Defining Turf, Charting New Paths. Proceedings of the Annual Conference, Council of Educators in Landscape Architecture,* edited by Margaret McAvin, 3–13. Providence, R.I.: Department of Landscape Architecture, Rhode Island School of Design, 1988.

Review of Charles R. Mack, *Pienza: The Creation of a Renaissance City* (Ithaca, N.Y., 1987). *Catholic Historical Review* 74 (1988), 477–478.

1989

Review of Janet Southorn, *Power and Display in the Seventeenth Century: The Arts and Their Patrons in Modena and Ferrara* (Cambridge, 1988). *Catholic Historical Review* 75 (1989), 711–712.

1990

Review of John Onians, *Bearers of Meaning: The Classical Orders in Antiquity, the Middle Ages, and the Renaissance* (Princeton, 1988). *Renaissance Quarterly* 43 (1990), 179–181.

1991

Gardens and Gardening in Papal Rome. Princeton: Princeton University Press, 1991.

Review of Richard J. Goy, *Venetian Vernacular Architecture: Traditional Housing in the Venetian Lagoon* (Cambridge, 1989). *American Historical Review* 96 (1991), 200–201.

1992

Review of Andrea Palladio, *The Churches of Rome,* translated by Eunice D. Howe (Binghamton, N.Y., 1991). *Catholic Historical Review* 78 (1992), 112–113.

Review of Charles Burroughs, *From Signs to Design: Environmental Process and Reform in Early Renaissance Rome* (Cambridge, Mass., 1990). *Renaissance Quarterly* 45 (1992), 157–160.

1993

Review of *Roma e lo studium urbis: Spazio urbano e cultura dal Quattro al Seicento, Atti del convegno, 7–10 giugno 1989*, edited by Paolo Cherubini (Rome, 1992). *Catholic Historical Review* 79 (1993), 742–743.

Review of Geoffrey James and Robert Harbison, *The Italian Garden* (New York, 1991). *Journal of Garden History* 13 (1993), 124.

Review of Claudia Lazzaro, *The Italian Renaissance Garden: From the Conventions of Planting, Design, and Ornament to the Grand Gardens of Sixteenth-Century Central Italy* (New Haven, 1990). *Annali di architettura* 4–5 (1992–93), 234–236.

Review of Clare Robertson, *Il Gran Cardinale: Alessandro Farnese, Patron of the Arts* (New Haven, 1992). *Catholic Historical Review* 79 (1993), 108–109.

Review of Christine Smith, *Architecture in the Culture of Early Humanism: Ethics, Aesthetics, and Eloquence, 1400–1470* (Oxford and New York, 1990). *American Historical Review* 98 (1993), 1280–1281.

1994

The English Garden: Meditation and Memorial. Princeton: Princeton University Press, 1994.

1996

"Frascati," "Ligorio, Pirro," and "Tivoli, Villa d'Este." In *The Dictionary of Art*, edited by Jane Turner, vol. 11, 740–742; vol. 19, 370–373; and vol. 31, 63–64. New York and London: Grove's Dictionaries and Macmillan, 1996.

"Earl Baldwin Smith." In *Luminaries: Princeton Faculty Remembered*, edited by Patricia H. Marks, 264–272. Princeton: Association of Princeton Graduate Alumni, 1996.

1998

"The Self-Image of the Roman Villa during the Renaissance." *Architectura: Zeitschrift für Geschichte der Baukunst* 28 (1998), 181–203.

1999

"The Study of the History of the Italian Garden until the First Dumbarton Oaks Colloquium." In *Perspectives on Garden Histories.* Dumbarton Oaks Colloquium on the History of Landscape Architecture 21, edited by Michel Conan, 27–35. Washington, D.C.: Dumbarton Oaks, 1999.

Review of *John Evelyn's "Elysium Britannicum" and European Gardening*, edited by Therese O'Malley and Joachim Wolschke-Bulmahn (Washington, D.C., 1998). *Journal of the New England Garden History Society* 7 (1999), 62–63.

2000

Princeton University's Graduate College. Princeton: Princeton University, 2000.

"Venus in the Eighteenth-Century English Garden." *Garden History* 28 (2000), 173–193.

2001

"The Gardens of Venice." *Source: Notes in the History of Art* 21, no. 1 (fall, 2001), 4–9.

"Venus in the Garden of Wilton House." *Source: Notes in the History of Art* 20, no. 2 (winter, 2001), 25–31.

2002

Review of James S. Ackerman, *The Villa: Form and Ideology of Country Houses* (Princeton, 1990). In *The A. W. Mellon Lectures in the Fine Arts: Fifty Years*, 148–151. Washington, D.C.: National Gallery of Art, Center for Advanced Study in the Visual Arts, 2002.

Review of Mirka Beneš and Dianne Harris, *Villas and Gardens in Early Modern Italy and France* (Cambridge, Mass., 2001). *Journal of the New England Garden History Society* 10 (2002), 54–55.

Review of Mario Carpo, *Architecture in the Age of Printing: Orality, Writing, Typography, and Printed Images in the History of Architectural Theory* (Cambridge, Mass., 2001). *Renaissance Quarterly* 55 (2002), 1094–1095.

2004

Pirro Ligorio: The Renaissance Artist, Architect, and Antiquarian. University Park, Penn.: The Pennsylvania State University Press, 2004.

1

Pirro Ligorio and Decoration of the
Late Sixteenth Century at Ferrara

In July 1577 the Ferrarese painter Bartolomeo Faccini was killed by falling from a temporary scaffolding set up in the court of the Este Castle at Ferrara.[1] Faccini and his brother Girolamo had just completed decorating the four walls of the courtyard with frescoes depicting two hundred of the most notable members of the Este family, which then ruled Ferrara. According to Cesare Cittadella, the Faccini had included a portrait of the contemporary duke, Alfonso II, with those of his ancestors. Since Alfonso II objected to the inclusion of his portrait, the artist had to erase it. It was only after all the scaffolding was removed that Bartolomeo Faccini discovered that he had forgotten to destroy the name and arms of the duke which had been below this portrait. It was this which caused the erection of a temporary scaffolding from which Faccini plunged to his death.

Of these frescoes in the courtyard of the castle there are preserved now only the faintest remains of three frescoes[2] showing six noble Estes (Fig. 1). Cittadella in the eighteenth century, although lamenting the condition of the frescoes at that time, does give a more complete description of the painting than can be made from the present remains: "Here as in chiaroscuro were painted various compartments divided by colonnades and frames, forming, as it were, many niches in which were painted standing portraits of these illustrious personages much greater than life size, done in a bright bronze color and highlighted with the greatest skill as if gilded statues,

arranging two images in each division, and on the pedestals, painted beneath, are depicted their noble arms with the names of the Princes."[3]

In 1641 the engraver Catarino Doino created in honor of the Duke of Modena a series of prints depicting the Este rulers of Ferrara. According to his preface, Doino requested Antonio Cariola to contribute brief lives of the Estes to accompany the thirteen engravings.[4] Each print is composed of a pair of portraits derived from the frescoes by the Faccini on the castle at Ferrara. That these engravings are related to the frescoes at Ferrara is proven by the fact that the first print (Fig. 2), portraying Almerico and Tedaldo, the first and second marquises of Ferrara, resembles very closely the faded remains of the lower right panel still extant on the castle (Fig. 1).

Five years later, when a new edition of Gasparo Sardi's history of Ferrara was brought out, the frescoes again served as a source for another set of engraved portraits of the Este marquises and dukes which faced each chapter in the book (Fig. 3).[5] There are eleven of these illustrations containing twenty-two portraits. With some notable exceptions, Sardi's illustrations are almost identical with the prints by Doino. In fact, the first plate in Sardi's book, containing portraits of Almerico and Tedaldo, is closer to the original fresco than the Doino print is (Fig. 2), since in the latter the figure of Tedaldo has been reversed so that his head is turned to the right and his left arm is brought across his body.

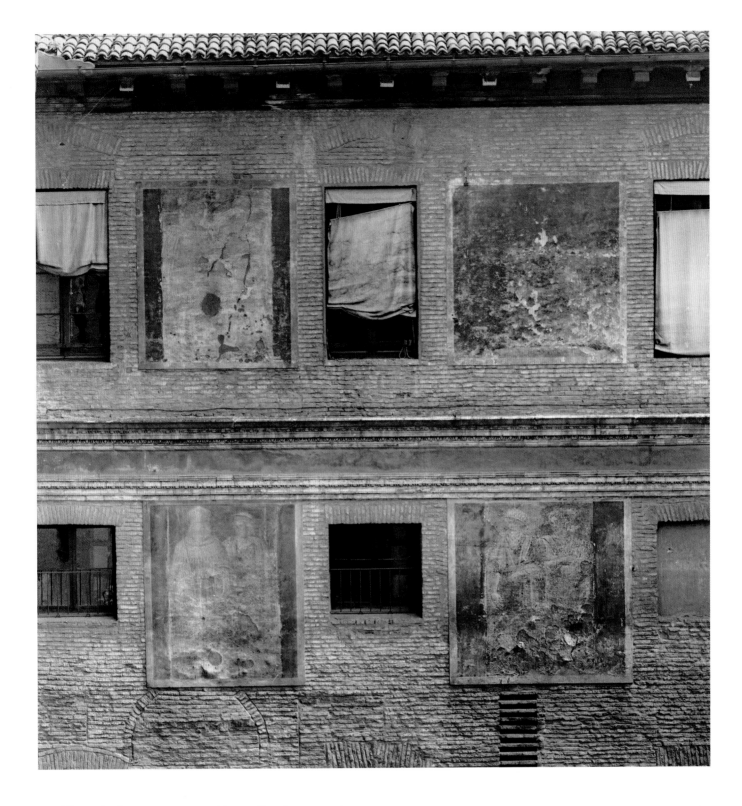

Fig. 1. Ferrara, Este Castle, court (photo: Ministero beni e attività culturali, Soprintendenza PSAE, Bologna)

There is, however, more evidence for the reconstruction of these genealogical frescoes than just the seventeenth-century engravings. In the Ashmolean Museum at Oxford are twenty-four drawings, each showing a pair of members of the Este family.[6] They are full-length figures standing before an architectural setting which generally includes columns, doors, and niches (Fig. 5). In the niches are often depicted small statues of allegorical figures in classic guise. In addition to the Oxford drawings there are four drawings in the British Museum at London, which belong to the same series (Fig. 4),[7] and two privately owned in England.[8] At Florence, in the Gabinetto Disegni e Stampe of

| Pirro Ligorio at Ferrara

the Uffizi, there is a drawing of the same nature, but its height probably precludes its belonging to the same series as the English drawings.[9] However, it is certainly a drawing by the same hand and belongs to this project of a series of genealogical portraits of the Este family.

There is no question that these drawings were executed by the sixteenth-century Neapolitan artist and archaeologist Pirro Ligorio. Ligorio was not a distinguished draftsman, and the drawings of the Este family reveal all the faults as well as the characteristics that are to be seen in the drawings by Ligorio in the large collections of his manuscripts at Naples and Turin,[10] or in the fresco, *Dance of Salome*, by him in the Oratorio of S. Giovanni Decollato at Rome.[11] Characteristic of Ligorio are the heavy, rather doughy figures with large, flabby, almost boneless hands. The great interest in the archaeological detail of the architectural setting decorated with small classic statues is very apparent in the S. Giovanni Decollato fresco as well as in the manuscript drawings. The drawings at Oxford present

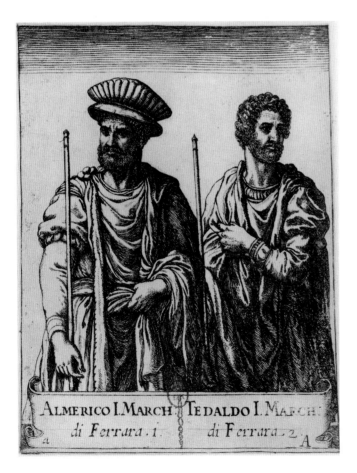

Fig. 2. Catarino Doino, engraving of Almerico I and Tedaldo I d'Este. Paris, Bibliothèque Nationale de France (photo: Bibliothèque Nationale de France)

an archaeologist's interest in ancient costume; there are even fragments, on the edge of some of the drawings, of Ligorio's notes as to the type of costume.[12] Thus, on drawing H at Oxford he labels the apparel of Johannes II, Grand Master of Prussia, as "habito Greca" (Fig. 5).

Pirro Ligorio, who was born at Naples in 1513 or 1514, entered the service of Alfonso II d'Este, Duke of Ferrara, on December 1, 1568, as the ducal antiquarian to succeed Enea Vico.[13] Ligorio was not solely an antiquarian, since, after his arrival at Rome from Naples about 1534,[14] he acquired his first fame as a painter primarily of house facades in the tradition of Polidoro da Caravaggio. Baglione in his seventeenth-century *Vite* describes many of these paintings, which, of course, no longer exist. The decoration consisted of friezes of figures, trophies, floral rinceaux, and occasionally scenes from Roman history executed in chiaroscuro with frequent mention of the use of yellow.[15] During this time Ligorio was also gathering together a wealth of archaeological and classical knowledge, most of which is still preserved in his manuscripts at Naples, Turin, and the Bodleian Library at Oxford. His first contact with the Este family occurred when he was hired by Ippolito II d'Este, the cardinal of Ferrara and uncle of Duke Alfonso II, as an antiquarian, in 1549.[16] When the cardinal of Ferrara had to retire to North Italy in 1555 in disfavor with Pope Paul IV, Ligorio soon turned up, in 1557, in the papal service as Architect of the Vatican, a position which he held also under Pope Pius IV and during which time he was extremely active in the numerous architectural projects of Pius IV.[17] The succession of Pope Pius V in 1566 was not favorable to the artistic plans and acquisition of classical sculpture which Ligorio promoted under Pius IV, so that Pirro returned to work for the cardinal of Ferrara. It was at this time that Ligorio carried almost to completion the planning and decoration of the lovely gardens for the cardinal's villa at Tivoli.[18]

Among the drawings by Ligorio of the Este nobles, two in the British Museum (nos. 1947-3-5-1 and 1947-3-5-2) correspond to the fragments of fresco preserved on the Este Castle at Ferrara. On the other hand, several of the Oxford and British Museum drawings have also been the source for the engravings by Doino and the illustrations in Sardi's history of Ferrara. For example, the British Museum drawing (no. 1947-3-5-2) with portraits of Fulco III and Bonifacio IV (Fig. 4) was used for the Sardi engraving of the Marquises Almerico and Tedaldo (Fig. 3). Since Ligorio did not limit himself to the Este rulers of Ferrara, the engravers have selected the ruling nobles from the drawings

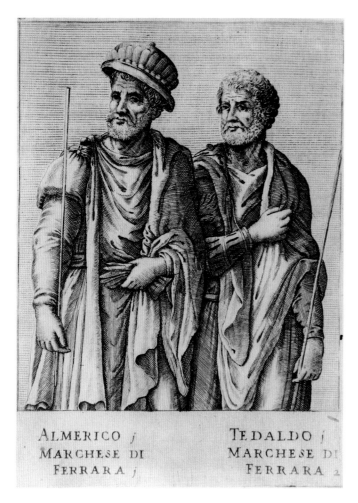

Fig. 3. Engraving of Almerico and Tedaldo I d'Este from Gasparo Sardi, *Libro delle historie ferraresi* (Ferrara, 1646)

of the family first published at Ferrara in 1570 by the ducal secretary G. B. Pigna[20] is proven by the fact that Ligorio specifies a date in relation to an Este noble and notes it in his inscription below the picture only when Pigna does.[21]

Originally there must have been one hundred drawings by Ligorio for the frescoes, since the inscription which formerly stood in the court below the painting specifies that two hundred nobles of the Este family were depicted.[22]

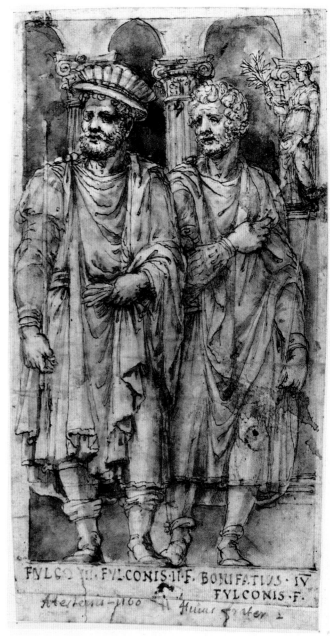

Fig. 4. Pirro Ligorio, Fulco III and Bonifacio IV d'Este. London, British Museum, acc. no. 1947-3-5-2 (photo: © Copyright The Trustees of The British Museum)

and reassembled them in new pairs. In doing so many of the figures have been reversed, and at times changes have been made in costume, gestures, and even identification of the nobles. The engravings also cut off the figures below the knee and omit architectural settings.

Ligorio, of course, did not execute the frescoes on the Ferrarese castle depicting the members of the Este family. The painting itself, as we have seen, was carried out by the Faccini brothers. However, Ligorio must have planned and arranged this series of portraits, and the drawings probably represent the remains of a manuscript, or possibly a scroll,[19] which was presented to the duke for his approval. It would require a learned man, such as the duke's antiquarian, to select from Pigna's history of the Estes the personages who were to be depicted and to arrange them, as Ligorio has, in pairs, usually of brothers or father and son. That the historical source for these genealogical portraits of the Estes was the genealogical tree in the history

| *Pirro Ligorio at Ferrara*

Fig. 5. Pirro Ligorio, Este nobles. Oxford, Ashmolean Museum, inv. 262, 263, and 264 (photo: Ashmolean Museum, University of Oxford)

There are preserved, therefore, thirty-one of the original drawings, including the Florentine example, but an idea of some of the other portraits is furnished by the engravings. The two sets of engravings, the illustrations in Sardi and Doino's prints, are difficult to analyze as to their accuracy because of the changes made in gestures and costumes. The engravers of both must have gone back in each case to Ligorio's drawings, since in different prints they vary as to which is more accurate, although in general the illustrations in Sardi's history are closer to the drawings.[23] These engravings, however, furnish an approximate idea then of twelve of the portraits which are no longer known in drawings or painting. This means that with the extant fragments of painting there are preserved at least seventy-two out of the original two hundred portraits.[24]

The Este family of Ferrara had long been interested in the genealogy of their house, and legendary accounts of the origin of the family date back to the Middle Ages. In the thirteenth century Paolo Marro claimed that the Estes were descended from a Trojan prince Martus who attacked Milan.[25] A century later, a more unfavorable legend, spread by their Paduan enemies, singled out as the progenitor of the Estes Ganelon of Mainz, the infamous traitor to Charlemagne at Roncevaux.[26] The latter legend lived long enough to haunt Ercole I d'Este, when, after the battle of Fornovo in 1495, he visited Venice to be greeted by the taunts of the street urchins:

Marquis of Ferrara, of the House of Mainz,
You will lose your state in spite of the King
of France.[27]

In the late Quattrocento the nobility of Ferrara was so interested in French romances, such as *Tristan* and *Palamedes*, that they not only named their children after the heroes and heroines of these romances[28] but desired their own versions of such tales. This is the source of inspiration of the great Ferrarese poems of Boiardo, Ariosto, and Tasso. In all these poems the authors introduce references to the genealogy of the Estes and their most notable deeds. So Boiardo in *Orlando Innamorato* (book II, canto XXI) specifies his hero Ruggiero as the ancestor of the Estes, and Ruggiero, in his turn, was descended from Hector of Troy. Later (book II, canto XXV) Boiardo describes a loggia decorated with the exploits of four of the Este rulers.[29] Ariosto continues the story begun by Boiardo and in *Orlando Furioso* (canto III) has the magician Merlino summon up for Bradamante the shades of the future nobles of the Este family as Vergil reveals in the *Aeneid* the descent of Augustus from Aeneas. Finally, Tasso has the wizard in *Gerusalemme Liberata* (canto XVII) point out to Rinaldo his Este ancestry back to the Roman Caius Atius as it was depicted on a wondrous shield.

In the mid-sixteenth century the ducal secretary of Ercole II d'Este, Cinzio Giraldi, out of deference to his master, expanded the legendary genealogy of the Estes to include the ancient hero Hercules as ancestor of the family. Giraldi, in his commentary on Ferrara and the Estes, recounts the older legends of descent from the Trojan Antenor and even the biblical Noah, but then he adds:

I can scarcely be persuaded that it [the Este race] had its origin from the ordinary beginnings of mortals. . . . Wherefore I come generally to the conclusion that I believe that the Este race (which we

have developed more fully in Lydian meter in our *Hercule*) is descended from ancient Hercules. . . . Hence I have always considered those who taught that the Este princes received their origin from the most noble family of Gauls much more correct than others thought, for I know that the ancient Hercules whom we believe to be the author of this race, having conquered Geryon and overcome the Pyrenees, proceeded into Gaul. There he married Galata, daughter of the king of the Celts. . . . By her, Hercules had a son, Galatis, who, when he suceeded his grandfather in the kingdom (for Hercules went

Fig. 6. Ferrara, Este Castle, Sala del Consiglio (photo: Vecchi & Graziani)

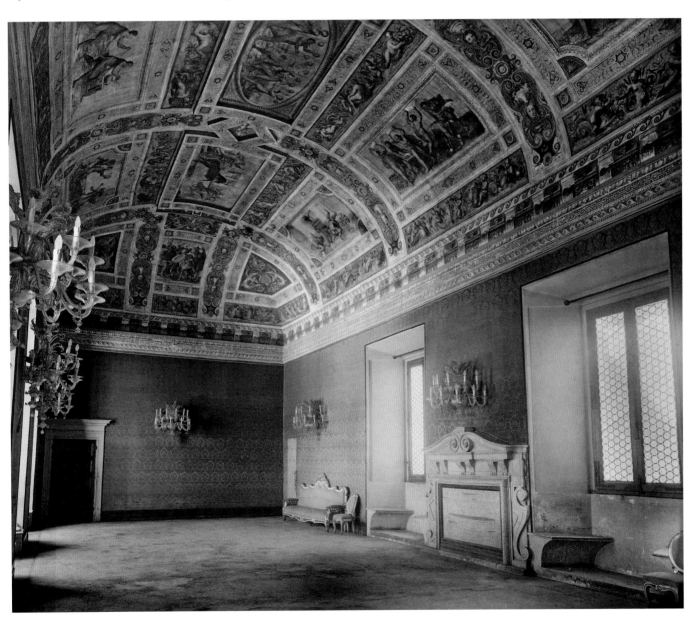

| *Pirro Ligorio at Ferrara*

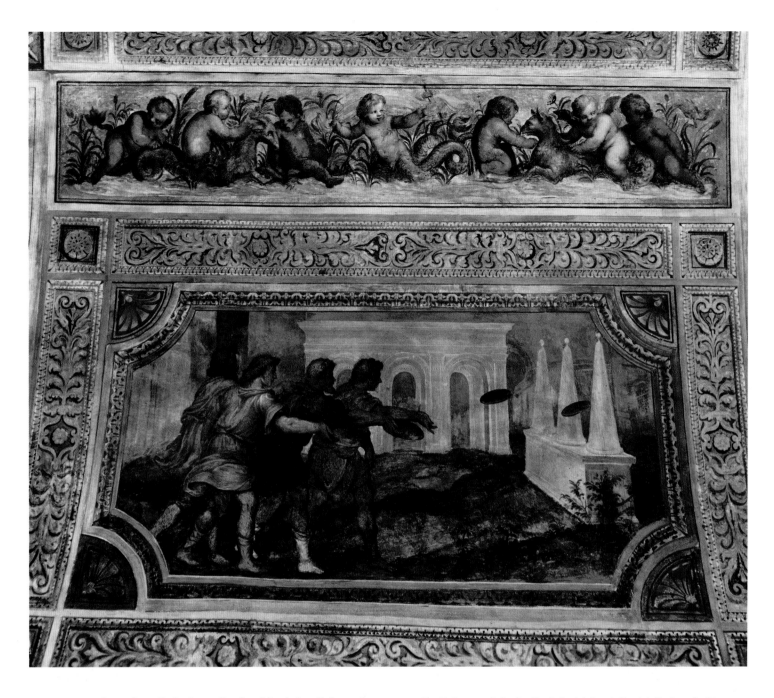

down into Italy from Gaul) wished the Celts to be called Gauls [*Gallos*] by the addition of the letter L to his name. I would believe that the royal families of Gaul come from his progeny. Thence, I cannot deny, just as water comes together in a stream from a spring, comes this very noble Este family, which now among the others of Italy, however illustrious, occupies a princely rank, and I must agree with those who testify that this outstanding family has arisen from the most illustrious nobility of the Gauls. But if this which is repeated above should seem much too much to some, I ask that this indulgence be given me, and I ask them to be no less fair to me, because I carry the origin of this famous family back to Hercules, than Roman antiquity was to Livy, since he testified that Mars was the progenitor of the family of Romulus, founder of the Roman Empire.[30]

The ducal secretary of Alfonso II d'Este, G. B. Pigna, then published in 1570 his history of the Estes, in which he mentions only briefly that the Estes were descended from the Trojans.[31] Pigna, however, by means of a genealogical tree added to his book, as well as by the text, works out in an historical manner the continuous descent of

the Estes from the Roman Caius Atius. This desire to prove their Roman ancestry provokes the Estes' great desire to collect and own all ancient Roman inscriptions, and some forgeries, which mention the family of Atius, since it was common belief that the name Este was derived from Atius.[32]

As has been noted, Pigna's history is the source for Ligorio's genealogical drawings, but these drawings and the frescoes derived from them are not the only example in the pictorial arts of the Este interest in their genealogy. Cinzio Giraldi relates that the painter Girolamo da Carpi painted for Ercole II a series of portraits of the Este rulers of Ferrara, commencing with Azzo IV, on the royal palace at Copparo.[33] These paintings, which were destroyed in 1808, were probably executed sometime between 1542 and about 1547.[34] The dates of these two sets of genealogical portraits, one in the forties, the other in the seventies, correspond to one of the most troublesome

Fig. 8. Ferrara, Este Castle, Sala del Consiglio, detail of vault, *Pancratium* (photo: Vecchi & Graziani)

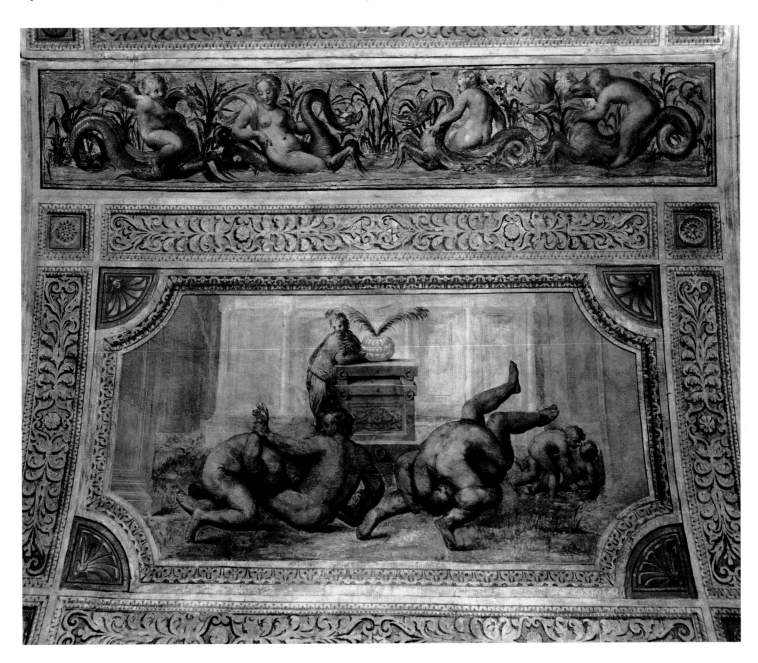

| *Pirro Ligorio at Ferrara*

Fig. 9. Ferrara, Este Castle, Saletta dei Giuochi, detail of vault, *Telesias* (photo: Vecchi & Graziani)

political problems—although they had many—which bothered the Ferrarese rulers during the sixteenth century. This was the question of order of precedence, particularly with the Medici rulers of Florence at the papal, imperial, and various royal courts of Europe.[35]

In September 1541, when the Emperor Charles V came to Lucca to meet Pope Paul III, the former upset the usual order of precedence by permitting Ercole II d'Este, Duke of Ferrara, to ride at his right side, while Cosimo I de' Medici, Duke of Florence, had to be content with the inferior left-hand position. Later, at the banquet at Lucca, this favoring of the Estes continued when the Duke of Ferrara was granted the honor of handing the napkin to the emperor. At Christmas of the same year the Ferrarese ambassador, on the precedent of the imperial courtesy at Lucca, claimed and received a more honorific position in the papal chapel at Rome than the Florentine ambassador, despite the complaints and anger of the latter. Early in 1542, however, the pope reversed his decision, which simply increased the fervor of the controversy. The quarrel soon spread to the

various courts of Europe, with the Medici usually in favor, but fortunes of favor often changed rapidly depending upon the relations between the two contestants and each court.

The marriage in 1558 of Lucrezia de' Medici, daughter of Cosimo I, to Alfonso II d'Este, who became Duke of Ferrara in 1559, brought only a temporary respite to the controversy, which became intensified after the death of the Medici Duchess of Ferrara in 1561. At this time the Ferrarese began to gain the advantage, at least at the imperial court and in Venice, but the most serious blow was inflicted when Pope Pius V granted Cosimo I the title of Grand Duke of Tuscany late in 1569. Immediately the Este agents protested to the Emperor Maximilian II regarding the Medici promotion. The emperor, irritated by the idea of the pope encroaching upon what he considered his prerogatives in respect to imperial fiefs, annulled in 1570 the title and honors accorded to the Medici by the pope

and ordered a presentation of both sides of the controversy at the imperial court. However, Pope Pius V and his successor, Gregory XIII, persisted in their support of the Medici.

Both the Medici and the Estes had attempted earlier to strengthen their position at the imperial court by marriage. In 1565 Duke Alfonso II married Barbara, Archduchess of Austria and sister of the emperor, while her sister Johanna became the wife of Francesco de' Medici, son of Cosimo I. Again the fortunes of the Estes were adverse, for Barbara of Austria, Duchess of Ferrara, died in 1572. It was inevitable that by 1576 an imperial decree was published with papal approval authorizing the Medici to carry the title of Grand Duke. The quarrel between the two families lingered on to the middle of the eighties when, aided by the marriage in 1583 of Cesare d'Este, son of Don Alfonso, to Virginia de' Medici, daughter of Cosimo I, the two cardinals of the families, Ferdinando de' Medici and Luigi d'Este, brought about amicable relationships.

In the controversy regarding precedence the principal argument used by the Estes and feared by the Medici was the continuous lineage of the Estes as rulers of Ferrara and their earlier attainment than the Medici to the rank of duke. It was on "the antiquity of family, the antiquity of the rank of Duke, the antiquity of the city of Ferrara, the nobility of the many great German houses related with that of the Este, and the antiquity of the states dependent and subject"[36] to Alfonso II that the Estes rested their case. Venceslao Santi has already shown how this quarrel regarding precedence was the motivating force for the numerous histories of Ferrara and of the Estes which appeared in the sixteenth century, and that it was particularly Pigna's history, published in 1570, which was the official Ferrarese instrument of propaganda for their cause. Actually, Pigna's book was based upon the preliminary work of Girolamo Faletti, the Ferrarese ambassador at Venice, who died in 1564. Faletti had also begun a genealogical tree of the Estes which was completed by Pigna and published in 1565 in an engraving by Enea Vico. Pigna also relates that there was as decoration in the ducal museum at Ferrara a large genealogical tree based upon the investigations of the earlier Ferrarese historian Alessandro Sardi on which were listed "those families of German princes, and the other nobles which there have been from the Roman republic until now."[37]

Not only were the diplomats, lawyers, and historians involved in the dispute, but, as Santi notes, "as Pigna is the historian of the controversy, Tasso is the poet."[38] Tasso's genealogical shield in the *Gerusalemme Liberata* is based upon

the research of historians such as Alessandro and Gasparo Sardi, Cinzio Giraldi, and Faletti. In fact, after Pigna's death in 1575 Tasso attempted to succeed him as historian of the Estes. Although unsuccessful in this, the poet later wrote a dialogue, unpublished until the nineteenth century, entitled *Della precedenza*.[39] Tasso's epic *Gerusalemme* is not his only poetry concerned with praise of the antiquity and nobility of the Estes, for the poet wrote two sonnets upon the genealogical paintings by the Faccini in the courtyard at Ferrara,[40] and on December 10, 1581, Tasso wrote from his confinement in the Ospedale di Sant'Anna: "I am thinking of making a small poem about each of the princes of the House of Este, who is depicted in the courtyard; I should like it, therefore, if you could send me the tree of the House and the History of Pigna which is among my other books. . . ."[41]

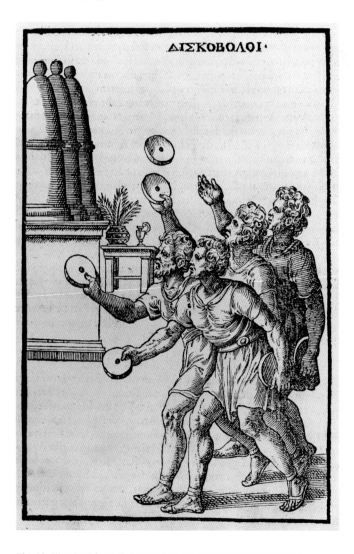

Fig. 10. Woodcut from G. Mercuriale, *De arte gymnastica libri sex* (Venice, 1573), Discus Throwing

| *Pirro Ligorio at Ferrara*

Fig. 11. Woodcut from G. Mercuriale, *De arte gymnastica libri sex* (Venice, 1573), *Pancratium*

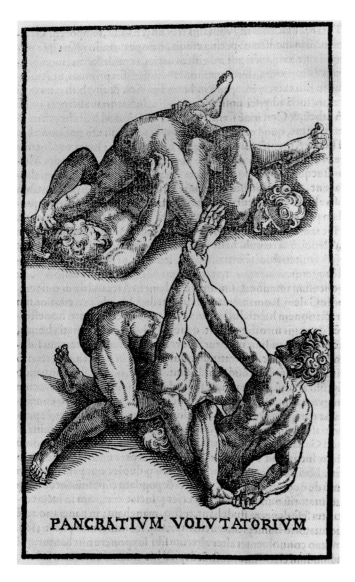

PANCRATIVM VOLVTATORIVM

There can be no doubt, therefore, that the ruler portraits by Girolamo da Carpi at Copparo and the genealogical portraits painted on the castle by the Faccini after Ligorio's design were meant to be pictorial propaganda in this controversy regarding precedence. The dates of the two series of paintings tie in closely with the most critical phases of the argument, its beginning in 1541 and the five years, 1570 to 1575, when the quarrel came to a climax at the imperial court.[42] The elegant palace at Copparo, which was often used for hunting parties of notable guests, and the imposing castle at Ferrara, which was the ancient stronghold of the family, were natural locations for billboards proclaiming to all visitors the Este claim to prece-

dence on the basis of the antiquity of the family and its long unbroken dominion.

The inclusion in the drawings by Ligorio, following the history of Pigna, of the numerous German relatives of the Estes, especially in the regions of Brunswick and Lüneburg, is inspired naturally by the circumstance that in the 1570s the argument about precedence was to be arbitrated at the imperial court, where it was hoped that the family relationships of the Estes with the German nobility would influence the decision. This orientation toward Germany is also indicated by the fact that Latin and German translations of Pigna's history were published but not French or Spanish. Copies of the book were sent not only to Rome but also to the emperor, his ministers, and the electors and nobles of Germany to inform the Germans of "the relationship of blood between the most illustrious families of Germany and that" of the Estes.[43]

The argument between the Medici and the Estes, although it ended in a rejection of the Ferrarese claims, influenced greatly, as Santi explains, the history of Europe during the late sixteenth century, the writing of history, and the study of genealogy. Actually the defeat of the Estes was simply one of several severe blows to them during the late sixteenth century. In 1570 Ferrara suffered an extreme catastrophe when an earthquake destroyed or damaged a large part of the city. Meanwhile the branch of the Po River which flowed past the city and which furnished the principal means of transportation for commerce was becoming more and more sluggish each year until eventually navigation on the Po past Ferrara became almost nonexistent, and the entire economic life of the city was endangered. The final disaster came in 1597 when Duke Alfonso II died without direct heirs. The Duchy of Ferrara, which was a papal fief, was seized by Pope Clement VIII, and Alfonso's successor, his cousin Cesare d'Este, had to retire to the imperial fiefs of Modena and Reggio.

Duke Alfonso II had attempted to revive the fame of the court at Ferrara as a notable center for the arts, as it had been in the late fifteenth century and early sixteenth century when Ariosto, Boiardo, and Bembo dominated literature, and painting had flourished with Cosimo Tura, Lorenzo Costa, Dosso Dossi, Giovanni Bellini, and Titian. The revival under Alfonso II was primarily a literary one, represented by Tasso, G. B. Guarini, and Pigna, which was strengthened by intensive collecting of ancient manuscripts. But there was also important antiquarian activity under Enea Vico and Ligorio; outstanding music, especially the renowned Concerte delle Dame; and some

Fig. 12. Pirro Ligorio, frieze with symbols of the constellations. Turin, Archivio di Stato, Ms. Ja.II.17, vol. xxx, fol. 31v (photo: Archivio di Stato, Turin)

Fig. 13. Pirro Ligorio, *askoliasmos*. Turin, Archivio di Stato, Ms. Ja.II.17, vol. xxx, fol. 51r (photo: Archivio di Stato, Turin)

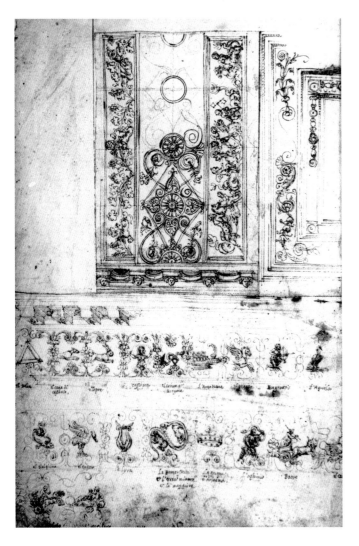

Fig. 12. Pirro Ligorio, frieze with symbols of the constellations. Turin, Archivio di Stato, Ms. Ja.II.17, vol. xxx, fol. 31v (photo: Archivio di Stato, Turin)

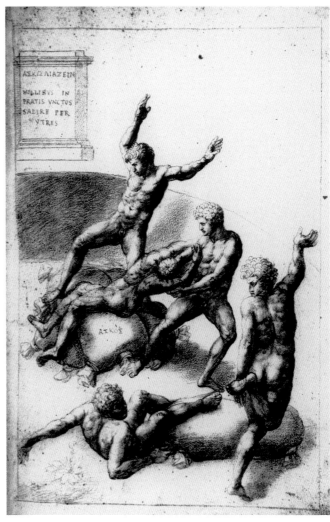

Fig. 13. Pirro Ligorio, *askoliasmos*. Turin, Archivio di Stato, Ms. Ja.II.17, vol. xxx, fol. 51r (photo: Archivio di Stato, Turin)

notable architecture by Alberto Schiatti, Alessandro Balbi, and G. B. Aleotti. Much of the architecture was a necessary result of the damage caused by the earthquake of 1570 and later shocks, since Ferrara experienced earthquakes almost annually for at least the next six years. Most of this artistic and humanistic activity at Ferrara, except the architecture, ceased when the papacy occupied the city.

In addition to the painted decoration by the Faccini of the courtyard of the Este Castle, there was also executed during the reign of Alfonso II some interior decoration at the castle. There are still preserved three rooms with sixteenth-century decoration: the Sala dell'Aurora, the Sala del Consiglio (or Sala dei Giuochi), and between them the Saletta dei Giuochi. The attribution of this decoration has varied considerably owing to a lack of documen-

tation. In the eighteenth and nineteenth centuries the local historians were inclined to attribute the Sala dell'Aurora to the leading Ferrarese painter of the first half of the sixteenth century, Dosso Dossi, and the other two rooms, with some hesitancy, to Dosso or to his pupils.[44] The more recent monographs on Dosso Dossi have omitted all this decoration.[45] Adolfo Venturi introduced two other artists as the painters of the Sala dell'Aurora on the basis of a document of 1548 which notes that Girolamo da Carpi and one Camillo, probably Camillo Filippi, painted "the ceiling and frieze of the room of the Signor, our Very Illustrious [Duke], where he sleeps in the Castle."[46]

Even if Venturi is correct about the date and artists of the Sala dell'Aurora, the decoration of the other two rooms is later and during the reign of Alfonso II. Un-

Fig. 14. Pirro Ligorio, athletes holding *halteres*. Turin, Archivio di Stato, Ms. Ja.II.17, vol. xxx, fol. 18r (photo: Archivio di Stato, Turin)

earthquake of 1570. The inscription which accompanied the frescoes completed by the Faccini in 1577 on the walls of the courtyard specifies that the paintings are "in this courtyard of the castle restored by him" (i.e., Alfonso II).[48] Ligorio in his unpublished treatise on earthquakes, which contains a diary of the earthquake at Ferrara in 1570, relates that the

> fine building of the old castle, although built with thickness of walls and solidity of brickwork, shook greatly. It received its greatest damage on the interior of one of the apartments, which suffered some harm from another earthquake nine years ago. Not being taken care of, some of the fabric was so disturbed that the weight during this earthquake has allowed one part of the wall inside to fall and dragged some rooms to the ground. The rest of the damage is light and repairable. . . . The room and lodging of the German guard in the old court fell entirely.[49]

The frescoes in the Sala del Consiglio (Fig. 6) and the nearby Saletta dei Giuochi are extremely archaeological in spirit. The vaults of both rooms are decorated with scenes of ancient gymnastic and athletic exercises such as discus throwing (Fig. 7), chariot racing, wrestling (Fig. 8), armed dances (the *telesias* [Fig. 9] and *pyrrichae saltationes*), swimming, various ball games (the *trigon* and the *pilae ludus*), and the dance on leather bottles (*askoliasmos*). This subject matter is undoubtedly a reflection of Duke Alfonso's great love of athletic exercise, especially wrestling and tennis, as well as the tourney and hunting. Solerti repeats several accounts indicating the ducal predilection for athletics,[50] and Frizzi in his history of Ferrara claims that in 1592 the duke "because gymnastics, hunting, fishing, swimming, and riding were no longer expedient at his age, was limited, master of these that he was, to teach the exercise of them to youth, and to be a spectator and judge."[51] Obviously some authority on antiquity must have worked out this program and described the various erudite games to the painter. L. N. Cittadella, when he ascribed these paintings to the Dossi brothers and their pupils, suggested that the antiquarian might be one of the Giraldi or Celio Calcagnini.[52]

Earlier, however, the editor of Baruffaldi, when he claimed that the Sala del Consiglio and Saletta dei Giuochi were probably by the later artist Sebastiano Filippi, called Bastianino, had correctly put his finger on the archaeologist behind the program, that is, Pirro Ligorio, the

noticed by art historians, Pirro Ligorio in a letter of July 31, 1574, describing the triumphal arches which he designed for the entry into Ferrara of Henry III, king of France, mentions that the king "was lodged in the rooms of the *Specchio* where there are recently painted all the ancient arts accompanied by the exercises of every gymnastic type including those which are the custom of the human race from childhood."[47] This decoration was probably a consequence of the restoration made necessary in the castle as a result of damage incurred during the

Fig. 15. Pirro Ligorio, plan of library and museum, Este Castle, Ferrara. Turin, Archivio di Stato, Ms. Ja.II.17, vol. xxx, fol. 90r (photo: Archivio di Stato, Turin)

antiquarian of Duke Alfonso II.[53] The editor noted the close relationship of these frescoes with the second edition, published in 1573, of the book by the Paduan doctor Girolamo Mercuriale entitled *De arte gymnastica libri sex.* The first edition of Mercuriale, published in 1569, had no illustrations except the plan of a palestra. The edition of 1573, on the other hand, is lavishly illustrated with the various types of ancient gymnastic exercises. Even the appearance of these prints (Figs. 10 and 11) with heavy Latin and Greek labels in Roman type and the heavy, rotund nudes with emphasized musculature suggests their source in drawings by Ligorio, as Métral noted also for some of the illustrations to the French archaeologist Vigenère's *Annotations de Tite-Live.*[54] But the proof that Ligorio is behind most of the illustrations in Mercuriale is not just visual, since the author indicates repeatedly throughout the text that he has received information and even

drawings from Ligorio.[55] Regarding the illustration of a men's bath, Mercuriale notes: "Here, however, we give only one sketch imparted to us by Pirro Ligorio from his very famous writings on ancient subjects."[56] For the illustration of the jumpers with weights, the author writes: "And so that one can have a more certain knowledge of this form of exercise we have taken care to furnish images of the *halteristarii* which Pirro Ligorio sent to us taken from ancient carved gems."[57] That the information and drawings were sent to Mercuriale after Ligorio's transfer to Ferrara is indicated not only by the date, since they are not in the 1569 edition, but also by the reference to information found by Ligorio in the collection of antiquities of the Duke of Ferrara.[58]

The editor of Baruffaldi presents further proof, which is now lost, of the connection between Ligorio and Mercuriale, for he claims to have seen in Ferrara a manuscript

Fig. 16. Pirro Ligorio, elevation of museum, Este Castle, Ferrara. Turin, Archivio di Stato, Ms. Ja.II.17, vol. xxx, fol. 89r (photo: Archivio di Stato, Turin)

now unknown but owned then by one Giuseppe Boschini. This manuscript by Ligorio was directed to Mercuriale with a note by Ligorio: "I send to you, sir, the two drawings for your work, the Gymnastica, one of the types of gladiatorial exercise of the *Mirmillo* and of the *Secutor.*"[59] It is noted in Baruffaldi that this drawing was not used by Mercuriale, but rather one of the pyrrhic dance which was to be found also in the lost manuscript of Ligorio and whose subject is among the frescoes of the Sala del Consiglio.

Nine of the different types of exercise illustrated in Mercuriale are to be found in the two rooms of the castle of Ferrara (Fig. 6). This does not mean that the frescoes are taken from the drawings used as illustration in Mercuriale; only one, the so-called *petaurum* (rope-dancers, which in this case shows a girl being raised in a swing by two other girls), is closely similar. There is a difference in format because the book illustrations are vertical, with the figures crowded together, while the frescoes tend to be horizontal, with the scenes spaced out. However, there are

many similarities in details: for example, most of the paintings and many of the illustrations have architectural backgrounds to denote the palestra; in the background of several of the frescoes and illustrations alike, behind the figures, is depicted a vase holding the palms of award on a table or altar (Figs. 8 and 10); and in both the representations of the discus throwing contest (Figs. 7 and 10) are to be found the three *metae* indicating a Roman circus.[60] The woodcut of the *pancratium* in Mercuriale (Fig. 11), although without any background, has the wrestlers depicted in positions very close to those of the fresco at Ferrara (Fig. 8). These resemblances substantiate the view of the editor of Baruffaldi in suggesting that, as in the

frescoes of the courtyard, Ligorio is the author, but not the executant, of these two programs of ancient gymnastics.

There is likewise some slight evidence of this relationship in drawings by Ligorio himself. Among Ligorio's drawings in Turin (Fig. 12) is one page of sketches for pictorial decoration[61] which will also be discussed later, but we should notice now that it contains one strip of decoration showing putti disporting themselves among and on the backs of sea horses and sea monsters like the bands of decoration used between the gymnastic scenes in the Sala del Consiglio (Figs. 6, 7, and 8). Also among the Turin drawings are depictions of the *askoliasmos* (Fig. 13) and of athletes holding *halteres* (Fig. 14).[62] There is, however, no pictorial relationship between these latter two drawings and the frescoes of these types of gymnastics at Ferrara, but a base in the background of the *askoliasmos* (Fig. 13) is inscribed with the quotation from Vergil's *Georgics* (II, 384): *Mollibus in pratis vnctos salire per vtres*, which Mercuriale also quotes when he discusses the *askoliasmos*.[63]

Mercuriale furnishes some indication of the ancient sources from which Ligorio acquired a pictorial knowledge of gymnastic exercises. The most frequently cited sources are ancient gems which have young boys wrestling[64] or indulging in various types of exercises.[65] These gems are certainly the inspiration for the small panels of decoration in the Saletta dei Giuochi[66] where putti are represented playing tennis, dancing, fishing, and enjoying some of the gymnastic games which occur in the larger frescoes of the two rooms. Details of gymnastic equipment, such as the *caestus* of the boxer, are based upon coins, as, for example, those of Smyrna,[67] but Mercuriale's claim that scenes of wrestling exist on Syracusan coins "as Ligorio has disclosed to us"[68] is unfounded, unless Ligorio had in mind the scene of Hercules wrestling with the Nemean lion.

The Estes had formed a large collection of ancient manuscripts, coins, gems, and other antiquities, which had been greatly increased by the interest of Duke Alfonso II.[69] As a result of these collections, Pirro Ligorio was commissioned to undertake the organization and decoration of another part of the castle. In 1571, again probably as an aftermath of the earthquake, Ligorio was ordered to prepare a library and museum to house the ducal collections. Several letters dated during this year furnish the evidence for this project. On July 20, 1571, Alessandro de' Grandi, the ducal archaeological agent at Rome, wrote to the Duke of Ferrara about a commission which he had been given to obtain ancient busts of philosophers.[70] According to this letter Ligorio must have requested eighteen such statues

for the duke. Of this number De' Grandi had just received three heads from the duke's uncle, the cardinal of Ferrara, together with the promise of one more to be sent from Tivoli; eight had already been acquired which were then in the process of restoration, and two more were awaiting restoration. De' Grandi was thus left with the necessity of locating four more antique busts. This letter helps to clarify a note from the ducal representative in Rome, Evangelista Baroni, which accompanied the letter of De' Grandi. The note commences with a list of eight ancient portraits of philosophers and literati which are probably the eight busts mentioned by De' Grandi as in the process of restoration and soon to be sent to the duke. At the end of Baroni's note is added a recommendation signed by Ligorio that these busts should be bought and used to decorate the study or library of the duke.

The reason for Ligorio's seeking the antique portraits on behalf of the duke is further explained by a letter of Fulvio Orsini to his master, the Cardinal Farnese, dated September 11, 1571, which relates that "the Duke of Ferrara, after the design of Pirro, is putting together his library of manuscripts, made up of books of Manutius, Statius, and of others; and above the pilasters which separate the bookcases he puts the ancient heads of philosophers and literary men."[71] Such a collection of ancient portraits is very like the one Ligorio had earlier assembled to decorate the Belvedere Court of the Vatican in Rome, even going to the effort of forging inscribed names on some portraits in order to have a complete collection of literati.[72] Finally, on September 15 a letter of De' Grandi to the duke states that the fourteen heads of ancient philosophers have been sent to Ferrara about ten days previously.[73]

In Ligorio's notebooks at Turin there is a sketch plan (Fig. 15) of a section of the Este Castle at Ferrara showing four rooms and a staircase.[74] One of the smaller rooms is labelled "Per la libraria," and the largest room "Per Antichario," so that this must be a plan of the library and museum arranged by Ligorio. As a result of the many changes which the castle at Ferrara has suffered this work no longer survives,[75] and one cannot be sure that the sketch resembles the finished work or that it is only a project. The drawing shows several corrections, so that it is preliminary to the actual work. The largest room, which is the museum, is almost seventy feet long and about twenty-five feet wide.[76] It is entered from the stair-hall by a door toward the end of the long central wall of the apartment. Seven windows light the outer wall, while the three inner walls are lined with cupboards (*armarii*). A door in the long inner wall leads

Fig. 17. Pirro Ligorio, ceiling design with canopy of heaven. Turin, Archivio di Stato, Ms. Ja.II.17, vol. xxx, fol. 21v (photo: Archivio di Stato, Turin)

The lower section has pairs of herms flanking the cupboards, while the upper section has Ionic pilasters flanking a rectangular niche which, from the sketchy indications of the drawing, was intended to hold a statue. In the small interval between the coupled pilasters were to be set two busts, above one another, and a bust was to be placed in the break of the pediment over the rectangular niche.[82]

There is some evidence that the two sketches by Ligorio, which are preserved in Turin, for the library and museum of the castle must date from the first half of 1571, soon after the first severe earthquake shocks beginning November 1570. On the right side of the drawing with details of the elevation of the museum (Fig. 16) are two lists of the names of Greek historians and philosophers. These names very possibly form a list of the Greek writers whose portraits Ligorio desired to have as decoration for the rooms. This would correspond to the fact that in his letter of July 1571 De' Grandi noted that Ligorio had requested eighteen such portraits to be obtained at Rome and Tivoli. Ligorio's ideal list of writers does not agree at all with the philosophers whose busts De' Grandi obtained and therefore suggests that Ligorio's sketches must date sometime before July 1571. There is not preserved any exact information when the decoration of these rooms was completed, but they were certainly finished by the end of 1574. Pighius, in his description of the visit of Prince Charles of Cleves to Italy, remarks that at Ferrara the prince admired "the excellent equipment of the new library" and that "Pirro Ligorio, the very ingenious architect, learned antiquarian, and skilled man, had collected for the decoration of the library" many ancient statues, coins, and gems.[83] Therefore, the visit of Prince of Cleves to Ferrara, which took place from November 19 to 24, 1574,[84] gives us a date *ante quem* for the completion of this work.

Among Ligorio's drawings at Turin are many sketches for the pictorial decoration presumably of various rooms at Ferrara.[85] Naturally this decoration is not necessarily for rooms in the castle, since other programs of decoration were being carried out at Ferrara at this time.[86] Two drawings contain the designs for ceilings. In one (Fig. 17)[87] a great oval canopy of heaven is stretched out over the room in a classic manner, and in the oval center is depicted an allegorical figure. Being a combination of classic elements, this allegory would be difficult to interpret except that Ligorio himself has left us a description of an alleged ancient painting of Time which contains sufficient points of similarity to Ligorio's own drawing to give some

into another large room, and another door in the center of the farther end wall goes into the library. Flanking each cupboard, window, or door is a pair of projections indicating pilasters or, as we shall see, herms. The library is the same width as the museum and about thirty-four feet long.[77] From the museum is a door into another large room which has its entrance also from the stair-hall. This large room is about sixty-four by twenty-nine and one-half feet[78] with four large windows. Beyond this room is another small room, about nineteen and one-half feet long,[79] which is also entered from the library and which has an outer door into a corridor or another room.

On another page of the Turin manuscript is a rough sketch of the elevation (Fig. 16) of one of the walls, probably of the museum.[80] The elevation is in two stories, each story about nine and one-half feet high,[81] with a vault above.

aid in interpretation. Ligorio claims that he had seen in the Capuan countryside an ancient room in which:

> . . . time [was] painted, who had four wings on his shoulders and four on his feet. Two of those on his shoulders were closed for the time which sleeps, and the two others were open as if flying, for the time which truly never ceases its flight nor pauses. In one hand he held a wheel with numbers signifying the long centuries and was surrounded by a snake, which is the year. [He had] an eye upon his breast above the heart and a girdle of the signs of the zodiac. . . . He was shown dropping his excrement behind him from his buttocks, and it fell upon a large human eye. From this [excrement] every wild beast, quadruped or winged, takes plunder or nourishment. By this is portrayed that the things of time with the eye of the sun bring nourishment, which is always being converted in consumption and is dissolved corruptly into the earthly nature. Time flying represents here the new things of the renewal of all things. Being shown as going forward to the future, he flies from east to west, covering and dimming with his mists the things past and putting them into oblivion.[88]

This allegorical figure of Time seems to be in general a conflation of the classic personification of Kairos, or Opportunity, and the Orphic figure Phanes.[89] The attribute of four wings at the shoulder, two flying and two at rest, is found in Cartari's description of Saturn as Time.[90] In Ligorio's drawing the identification of his personification of Time with the Sun, which is merely implied in the written description, is made explicit by the sun rays about the head of the personification. Perhaps by analogy with Felicitas, who is represented on some Roman coins as a female personification with right foot on a globe,[91] Ligorio's Time holds the caduceus, symbolizing Peace, in his right hand, and the cornucopia of Plenty in his left.

In the upper right corner of one of the pages from a manuscript of Ligorio's drawings at Turin (Fig. 18) is the other sketch for a ceiling.[92] This ceiling, perhaps of carved wood, was to contain twelve octagons, in each of which was to be a single putto. If this ceiling was to be wood and not stucco, it would have resembled to some extent those ceilings which were created a short time later for Luigi Cardinal d'Este in the Palazzo dei Diamanti at Ferrara.[93] Beside the drawing Ligorio has listed the months of the

Fig. 18. Pirro Ligorio, ceiling design with octagonal panels. Turin, Archivio di Stato, Ms. Ja.II.17, vol. xxx, fol. 25v (photo: Archivio di Stato, Turin)

year, omitting March by error. Therefore, the putti in the twelve octagons must be either personifications of the months or, more likely, are representative of the Labors of the Months. The representation is very sketchy, but it may be possible to identify the first putto of January as carrying a shovelful of warm coals, while the putto for May is in a position suggesting the act of mowing.

On the bottom of a page which has been discussed previously (Fig. 12) is a drawing of a frieze, composed of symbols of the constellations, which was meant to be painted on the walls of a room just beneath the ceiling, as shown by the indication of the modillion blocks of the ceiling. It is even possible that this frieze was intended to accompany one of the two ceiling projects which have just been discussed, since the subjects of both the ceilings are devoted to the representation of Time. There are preserved in the drawing

symbols of nineteen of the constellations but, it should be noted, none of them is a zodiacal symbol.

Among these drawings by Ligorio at Turin are numerous sketches for panels, details, or large expanses of decoration in the so-called grotesque manner.[94] One drawing contains two long vertical panels of decoration. The decoration of the wider panel (Fig. 19) is centered about a standing figure of Helios, the Sun, who is flanked by tripods on which are posed probably the horses of the Sun. On the attenuated architecture are placed busts of the Sun and Moon and two Phrygian-hatted torchbearers. These secondary figures are undoubtedly derived from some Mithraic relief in which they are accustomed to be represented flanking Mithras killing the bull, except that on Mithraic reliefs the torchbearers are shown each holding only a single torch, one elevated, the other lowered, while in Ligorio's drawing each figure holds two torches in alternating positions.[95] The decoration then climbs upward with a bust of the Moon flanked by two cupids. The right side of the drawing is more finished than the left so that one can notice above the right-hand cupid a row of elements from the sea: a shell, Neptune's trident, and a crab. Perched above the central bust of the Moon is a single winged female figure, perhaps Psyche, at whom a cupid is shooting. Toward the top the decoration consists of vines, flowers, palmettes, birds, and the like.

Another drawing (Fig. 20) has a loggia in the attenuated style condemned by Vitruvius, with a hint of distant landscape. In the center above the loggia is a crowned figure of Isis holding two *sistra*. At the top a Victory lights a beacon with her torch. At the right of the drawing the murder of Agamemnon by Clytemnestra takes place within a tent as if it were Judith and Holofernes but is labeled by Ligorio as the Greek tragedy. The peak of the tent serves as the base for a statue of Mars set within a niche. Up the stairs leading from the loggia to this statue climbs a Victory holding a trophy of armor.

The representational details of these drawings have been mentioned because the grotesque style of decoration was not merely decoration to Ligorio.[96] In his manuscript encyclopedia on antiquity, now preserved at Turin, Ligorio devotes an extended passage to a discussion of grotesque painting in which he claims that this style of decoration contained a rich system of meaning.

So that in whatever way such paintings are discovered as we have observed, although to the common people they may offer fantastic subjects,

Fig. 19. Pirro Ligorio, decorative panel with grotesques. Turin, Archivio di Stato, Ms. Ja.II.17, vol. xxx, fol. 11v (photo: Archivio di Stato, Turin)

Fig. 20. Pirro Ligorio, decorative panel with loggia and grotesques. Turin, Archivio di Stato, Ms. Ja.II.17, vol. xxx, fol. 13v (photo: Archivio di Stato, Turin)

| *Pirro Ligorio at Ferrara*

all were symbols and appropriate subjects, not made without secrets, although moderns imitating such antiquities create them without significance and without meaning. There are fantastic forms as of dreams, but there are mingled both the moral and fabulous actions of the gods. There are subjects which in part imitate the elements of nature, in foliage, in animals . . . hence one must believe that they were represented in order to infer human passions from their nature. All [were] placed amid lovely festoons and bonds of a delicate and varied nature so as to present in this form moral aims, positive actions, the false, the true, the uncertainty, and the foreseeable, the phantasies of future things. . . .[97]

Ligorio goes on then to give a hint of his source for the idea that all antique decoration should be meaningful in relation to the building or room which it decorates. He points out that Vitruvius (I.ii.5) discussed the appropriateness of the various orders to the personality of the various gods in whose temples the orders were to be used.[98]

In two other passages from Ligorio's discourse on the grotesque style he relates:

There have been some moderns, who, not knowing the truth about such painting and its origin, have called them grotesque, fanciful, and whimsical pictures, even monstrous. [This is] because they have not seen that the pictures were found there [i.e., in grottoes] by chance, not for any fantastic aim nor to represent wicked and foolish subjects, but to make the rooms attractive with their variety and to enhance them. Also they are created to bring amazement and marvel, as one might say, to wretched mortals; to signify as much as may be possible the pregnancy and fullness of the intellect and its fancies which the man erudite and learned in sciences has. Also to give satisfaction and to represent misfortunes, to put in order the insatiability of the various unusual concepts drawn from such variety as there is among created things. . . . It is not to be doubted, as some doubt, that everywhere are found painted meaningful subjects. In every building, both illuminated and dark, this type of painting was used in ancient times, both in grottoes and outside them.[99] The works of pagans were painted with *grotteschi*, and

those of Christians [such as the catacombs, which Ligorio also briefly discusses] were blank or with some Christian painting. Therefore, we must believe that the grotesque pictures of the pagans are not without meaning and are contrived with some fine philosophical skill and depicted poetically, because, as we have been able to see, in these same ancient paintings are subjects of consonance and conformity. They parallel one another like a palinode of answers and harmonies. . . . Wherefore, hieroglyphic letters have been used to signify in small principles various events such as mundane governments, those of the greatest powers, and imperial deeds and commands. . . .[100]

The mention of the use of hieroglyphs in grotesque painting, of course, reveals another source for this approach of Ligorio. On the basis of the writings of Horapollo, the Renaissance had become very intrigued with the idea of using hieroglyphs as a means of communication which at the same time would remain obscure to the uninitiated. In 1556 Giovanni Piero Valeriano had published his commentary on hieroglyphs which served as a textbook for these studies. So in his discourse on grotesque painting Ligorio specifies that to signify "pride of feminine beauty [one paints] the crane, for piety, the stork, for purity, the dove, the swan [indicates] the century, as also the raven, the stag, and the elephant."[101] All of these symbolic meanings can then be found, exactly or implied, in Valeriano's book.[102]

In this discussion of grotesque painting Ligorio goes through almost the entire range of ancient mythology and subject matter, often attempting to reveal the moral or philosophical meaning which he believed was expressed by the different stories or subjects. For example, one subject, which had been used earlier to decorate the vestibule to the Casino of Pius IV designed by Ligorio himself in the Vatican,[103] is that of "the chariots of cupids drawn by animals: by lions, by tigers, by elephants, by dragons, by camels, by ostriches, by bears, by hedgehogs, by tortoises, and by every type of bird. All show that a cupid is conqueror of each, and, as each animal runs to his delegated goal and all live under the yoke of love, they are extended. At the end they are led under the palm and victory of Cupid, who carries away the crown of all."[104]

Another quotation, which may help to explain the torchbearers in the drawing by Ligorio (Fig. 19), which was previously discussed, specifies that "burning torches signify

the light of understanding and the soul, the heat, the fires; and the torch doused and extinguished to earth demonstrates the coldness of the deceased and the dead body."[105]

Ligorio praises or mentions the painting of Raphael and his followers, Giovanni da Udine and Giulio Romano, several times. He notes that he has seen "cupids, who have despoiled the gods of their arms and carried them through the air, painted in a room on the Esquiline, which was destroyed by villainous painters. From this Raphael took the same idea in the marriage of Hebe with Hercules painted in the loggia of Agostino Chigi in the Trastevere [i.e., the Villa Farnesina] opposite Rome and made of it a noble painting."[106] In fact, in all the writings of Ligorio there are only a few references to sixteenth-century painters, and the only favorable references are in general to Raphael and his school. This is understandable when one realizes that Ligorio's own painting is derived from Raphael, perhaps by way of Baldassare Peruzzi.[107]

Some of Ligorio's drawings show a great resemblance to the style of Raphael's pupil and assistant, Giulio Romano. This is indicated by the fact that some of Ligorio's drawings have been, and still are, attributed to Giulio Romano, for example, the drawing of *Leda and Her Children* in the Gabinetto Disegni e Stampe of the Uffizi Gallery at Florence.[108] This is true also of the *Rape of Proserpina*(?) which was attributed to Giulio Romano when it was in the Fenwick Collection[109] but which now, in the British Museum, London (no. 1946-7-13-359), is correctly given to Ligorio. However, that there should be any influence directly on Ligorio from Giulio Romano seems impossible since Giulio left Rome for Mantua in 1524, when Ligorio was only about ten years old and had not yet come to Rome from Naples.

Ligorio's insistence that grotesque decoration should be infused with meaning and symbolism raises the question as to whether this is merely his own individual opinion or, if this was a prevalent attitude during the sixteenth century, as to when such an idea arose. The idea that the subject matter of ancient art and its Renaissance revival should convey philosophical and moral principles seems very natural for the art of the last half of the sixteenth century as Seznec has presented it in his excellent work *The Survival of the Pagan Gods*.[110] For example, Lomazzo in his chapter on grotesque painting in his *Trattato*, published the year after Ligorio's death, reveals a similar attitude toward this painting. Lomazzo claims: "In these *grottesche* the painter expresses subjects and concepts, not with their own forms, but with others: so that if one wishes to represent a

person of good reputation (*fama*), he will make the *fama* in the grotesque painting gay and bright; but for another person of ill repute he will make the *fama* dark and black; . . ."[111] What is in doubt is whether such an attitude occurred earlier in the century. The grotesque decoration executed in the famous loggia of the Vatican Palace by Giovanni da Udine under the direction of Raphael perhaps should be investigated in this light at some time.

The various programs of decoration at Ferrara organized by Ligorio reveal another instance of the extreme pedantry prevalent in so many of the Italian decorative programs of the last half of the sixteenth century.[112] On the basis of his one certain painting and many drawings Pirro Ligorio does not appear as an outstanding artist; that is, of course, not true of his architecture or work at the Villa d'Este. But it must be remembered that Ligorio, at least during his last fifteen years at Ferrara, considered himself first an archaeologist or antiquarian and was so employed by the Duke of Ferrara. However, being trained as an artist, Ligorio was able to wed in himself the two needs of his age: artistic expression and erudition. In fact, his career, insofar as the evidence is available now, seems to present him as shifting from the role of a painter in his early life, to that of the scholar in his later career, but this is undoubtedly too much of a simplification of what must have been an intermingling of these talents in his personality.[113]

Notes

1. [C. Cittadella], *Catalogo istorico de' pittori e scultori ferraresi*, vol. 2 (Ferrara, 1782), 69–72.

2. There are actually four panels of fresco surface preserved on the wall of the castle courtyard, but only three of these panels have any visible remains of fresco painting.

3. [C. Cittadella], *Catalogo istorico* (note 1 above), 69–70.

4. A. Cariola, *Ritratti de ser.^{mi} principi d'Este sig.^{ri} di Ferrara* (Ferrara, 1641).
Doino's engravings also exist as a series of independent prints. The only difference that I can note between the engravings used as illustrations in the book written by Cariola preserved in the British Museum and the independent prints in the Bibliothèque Nationale de France is that each of the book illustrations is identified in the left-hand corner of the title of the print merely by a lower-case letter of the alphabet from "a" to "n," while the French engravings add the same letter in capitals at the right side of the title.
Despite the preface in Cariola's book signed by Catarino Doino, in which he refers to the illustrations as "miei intagli," these prints have been attributed to the Ferrarese painter and engraver Giuseppe Caletti,

following A. Bartsch, *Le peintre graveur*, vol. 20 (Vienna, 1820), 135–136, nos. 11–23 (see also C. le Blanc, *Manuel de l'amateur d'estampes* [Paris, 1854–1888], vol. 1, 563, nos. 8–20; and J. Seznec, "Dessins à la gloire des princes d'Este à l'Ashmolean Museum," *La Revue des arts* 4 [1954], 25).

5. G. Sardi, *Libro delle historie ferraresi*, revised by A. Faustini (Ferrara, 1646).

6. The Ashmolean drawings, which were purchased in 1947, are executed in pen and brown ink with a brownish-yellow wash on white paper. There are traces of black pencil beneath the ink. Each of the drawings has been marked later in faint pencil on its lower edge with a letter of the alphabet from A to X. These drawings vary slightly in size: height 22.4 cm to 24.8 cm; width 11.3 cm to 13.5 cm.

While this study was in preparation there appeared the article by J. Seznec ("Dessins" [note 4 above], 21–26) which published three of the Ashmolean drawings and noted the existence of the other drawings. This article, however, did not go very closely into the relationship between the drawings, frescoes, and engravings and did not discuss their historical significance.

7. Acquisition nos. 1947-3-5-1, 1947-3-5-2, 1947-3-5-3, and 1947-3-5-4.

8. Seznec, "Dessins" (note 4 above), 24.

9. No. 1375 Figura; height 25 cm; width at top 12.7 cm, at bottom 12 cm. These dimensions agree, of course, very well with those of the English drawings, but it must be noted that the height of the latter, at a maximum of 24.8 cm, also includes a large lower margin which contains the name of each of the figures. The Uffizi drawing, on the other hand, does not have this lower margin or inscription. The Uffizi drawing, done in the same technique as the English ones, is attributed in Florence to Polidoro da Caravaggio but bears a note that Mr. Philip Pouncey has attributed it to Pirro Ligorio.

10. Naples, Biblioteca Nazionale, Mss. XIII.B.1–10; and Turin, Archivio di Stato, Mss. Ja.III.3–16 and Ja.II.1–16.

11. H. Voss, *Die Malerei der Spätrenaissance in Rom und Florenz* (Berlin, 1920), vol. 1, 254–256, and vol. 2, 570; A. Modigliani, "Due affreschi di Pirro Ligorio nell'Oratorio dell'Arciconfraternità di San Giovanni Decollato," *Rivista del R. Istituto d'archeologia e storia dell'arte* 3 (1931), 184–188; and A. Venturi, *Storia dell'arte italiana*, vol. 9, pt. 5 (Milan, 1932), 777–781.

12. Perhaps the best comparative example to show Ligorio's interest in and knowledge of classic apparel is volume two of his notebooks at Naples (Biblioteca Nazionale, Ms. XIII.B.2) which has drawings and text devoted solely to classic costume as evidenced by classic sculpture.

13. Modena, Archivio di Stato, Camera Ducale, Bolletta Salariati: Vol. del 1569, Provisionati, fol. 141:

Al nome d'Iddio MDLXVIIII
m/ Pirro Ligorio Antiquario con prouisione de sc.^ti venticinque d.° in°: il mese: principiando il suo seruire adi p.^mo Xmbre dllo anno 1568 pss.° passato, di com'iss.^e dlli m.^i ss.^ri Duc^li Fattori gnti et anco appare m.^to Ducale. (Contraction indications have been omitted from this passage.)

However, Ligorio probably did not move to Ferrara until the late spring or summer of 1569. There is a very important letter, published in part by V. Pacifici (*Ippolito II d'Este: Cardinale di Ferrara* [Tivoli, 1920], 399), dated April 10, 1569, which seems to be a letter of presentation regarding Ligorio to the duke from his ambassador. If this is a letter of presentation, Ligorio could only have reached Ferrara by the spring of 1569, and his stipend beginning December 1568 would probably be earned by his activity on the duke's behalf while still in Rome. There are also records of payment to Ligorio as "Antiquarian of the Very Excellent Signor Duke" from the cardinal of Ferrara at Rome in February, April, and July 1569 (Modena, Archivio di Stato, Camera Ducale, Casa Amministrazione: Registri del Cardinale Ippolito II, Pacco 119: Registro del 1569, fol. 20, February 5, 1569, and April 4, 1569; and fol. 48, July 23, 1569).

14. Ligorio reports in the Turin manuscript, vol. 1, fol. 3r, that he lived thirty-five years in Rome, and, as he left Rome for Ferrara in 1569, this would suggest that he arrived in Rome about 1534. For the Turin statement, see H. Dessau, in *Sitzungsberichte der königlich preussischen Akademie der Wissenschaften zu Berlin* (1883), 1077 n. 1.

15. G. Baglione, *Le vite de' pittori, scultori et architetti* (Rome, 1642), 9–10. See also W. Hirschfeld, *Quellenstudien zur Geschichte der Fassadenmalerei in Rom im XVI. und XVII. Jahrhundert* (diss., Halle, 1911), 10–12; and R. Lanciani, "Ricordi inediti di artisti del secolo XVI, II: Pirro Ligorio pittore," *Ausonia* 1 (1906), 101–102. V. Moschini mentioned that there were "pale remains on the lateral facade of the house at Via Campomarzio 30" (V. Moschini, *S. Giovanni Decollato*, Le chiese di Roma illustrate 26 [Rome, n.d.], 49), but in 1952 these remains were unidentifiable.

16. A. Serafini, *Girolamo da Carpi, pittore e architetto ferrarese (1501–1556)* (Rome, 1915), 344 n. 2.

17. Ligorio's first appearance as architect in the papal accounts is on January 11, 1558, when he is paid twenty-five golden *scudi* as his monthly salary for January (R. Ancel, "Le Vatican sous Paul IV: Contribution à l'histoire du palais pontifical," *Revue bénédictine* 25 [1908], 55). However, this payment says that the "provision of the present month has been granted to him again [*di nuouo*] by Our Lord," implying that he has been paid similarly before, although there is no record of it. Walter Friedländer (*Das Kasino Pius des Vierten* [Leipzig, 1912], 123 n. 8) believed that Ligorio was involved in work for the pope from May 1555, soon after the election of Pope Paul IV, and in support of this argument referred to a mandate of August 1558 in which Ligorio was ordered to receive a large sum of money for the period from May 1555 through February 1558. However, this mandate says that the money should be paid to "Master Pirro Ligorio, Architect of the Palace, or Master Baldassare Opizio, Treasurer of the Reverend Bishop of Forli, Secret Treasurer of His Holiness, who should disburse this money," for work done from May 1555 through February 1558 (Rome, Archivio di Stato, Mandati Camerali 904, fols. 131v–132r). The money, therefore, is not being paid to Ligorio for work executed by him in that period, but rather he is simply to act as the disbursing agent of money due for work accomplished during the period.

More evidence that Ligorio entered the papal employ only late in 1557 is furnished in one of the many letters written by Ligorio's friend Antonio Agustín, then bishop of Alife, to Onofrio Panvinio. Agustín's

letter of November 27, 1557, relates that "Messer Pirro the painter is in the favor of His Holiness." Since this letter is in the midst of a series in which Ligorio's activities are noted, it suggests that Ligorio's employment by the pope is a new matter in November 1557, and this in turn agrees with the documents which we have noted (see A. Agustín, *Antonii Augustini Archiepiscopi Tarraconensis Epistolae Latinae et Italicae*, ed. J. Andresio [Parma, 1804], 302).

18. I hope soon to present a detailed study of the gardens and pictorial decoration of the Villa d'Este at Tivoli, on which I have been working now several years. I have also gathered a great deal of information on Pirro Ligorio himself, but it will still require a long time before this material can be presented as a biography of Ligorio.

19. Seznec, "Dessins" (note 4 above), 24, seems to propose that the drawings were part of a continuous scroll, "une longue bande continue."

20. G. B. Pigna, *Historia de principi di Este* (Ferrara, 1570). I have used the second edition, published at Venice in 1572.

21. The only two discrepancies between Ligorio and Pigna are undoubtedly the result of errors. Once Ligorio by mistake denotes Heinrich XVII, Duke of Groningen, as number XVI of the name (Oxford, Ashmolean Museum, drawing labeled T), and the other time Ligorio corrects Pigna, who calls Otto XII, Duke of Brunswick, the eleventh of that name, although Pigna has previously listed another Otto XI.

22. M. A. Guarini, *Compendio historico dell'origine, accrescimento, e prerogatiue delle chiese, e luoghi pij della città, e diocesi di Ferrara* (Ferrara, 1621), 188:

> Atiae gentis Principum a C. Atio Pob. genus ducentium, gentilium, & Agnatorum suorum, quorum perpetua serie, in Italia supra MCC. Annos & in Germania, ex Vuelphorum haereditate, nouo; imperio late dominantium res gestae Historia ad memoriam sempiternam explicari fecerat, has etiam Imagines, vna cum insignibus, quibus illi vtebantur, in hoc Arcio a se instauratae Atrio suscipiendas proposuit Serenissimus Alfonsus II. Ferrariae Dux. Anno Domini MDLXXVII.

The reference in the inscription to an unbroken series of Estes in Italy for twelve hundred years is to be found paralleled in Pigna's history (*Historia de principi* [note 20 above], 3), which is another proof of the relationship between the book and the paintings.

23. An analysis of the relationship between Ligorio's drawings and the engravings is as follows:

Oxford drawing F = Sardi (*Libro delle historie* [note 5 above]), p. 64, except that Azzo X is numbered Azzo VIII in the engraving. Doino's print D shows many changes in costume and gesture.

Oxford drawing G = Sardi, p. 130, in reverse with minor deviations in gestures. Sardi changes the names of the nobles from Obizio VII to Rinaldo III and from Nicolo to Azzo XI. Doino G in this case is slightly closer to the drawing in gestures, but not costume, and labels the figures as in Sardi.

The left figure in the Oxford drawing I = the right figure of Sardi, p. 158, in reverse. Doino H is very similar to Sardi, but the costume and gestures show minor changes.

The left figure in Oxford J = the left figure of Sardi, p. 172. Doino I has the same figure but with slight variations in the costume.

The left figure in Oxford N = the right figure of Sardi, p. 172, in reverse. Doino I is similar to Sardi but shows alterations in costume and gesture.

The right figure in Oxford N = the left figure of Sardi, p. 190, in reverse with changes in costume and gesture. The left figure of Doino K is similar but with more extensive changes in costume and gesture than Sardi.

The right figure in Oxford O = the right figure of Sardi, p. 190, with major deviations in gesture and hat. The right figure of Doino K is similar to Sardi, but the hat is taken from the Ligorio drawing.

British Museum drawing 1947-3-5-2 = Sardi, p. 20, except that the figures in Sardi are renamed Almerico and Tedaldo. Doino's print A reverses the figure of Tedaldo.

It has been noted already that the Sardi illustration on p. 20, showing Almerico and Tedaldo, is closer to the extant fresco at Ferrara than Doino's print A. On the other hand, Doino B, with portraits of Bonifacio III and Matilda, is certainly more in the style of Ligorio's drawings than Sardi's illustration on p. 38, which has no resemblance to the Doino print and is drawn in an older, less Renaissance style.

The portrait of Cesare I d'Este in Doino's engraving N may not be derived from a drawing by Ligorio, but his counterpart, Alfonso II, may be, since, as we have seen, the eighteenth-century historians relate that the Faccini had painted a likeness of Alfonso II on the castle, which was only removed after the objections of the duke.

Three of the drawings at Oxford have some of the outlines of the figures traced upon the back of the drawing presumably by one of the engravers (drawing G both figures, drawing J left figure, drawing O both figures). In two of these drawings (G and J) the Sardi engraving is closer to the drawing, while in drawing O neither print is identical with the drawing, suggesting that it was more likely the engraver of the Sardi portraits who traced the drawings.

24. The number seventy-two does not include the two drawings in a private collection in England, the subject matter of which I have no knowledge. It is very possible that those two drawings may contain the image of four more lost portraits, if they do not correspond to any of the engravings.

25. L. A. Muratori, *Delle antichità Estensi ed italiane*, pt. 1 (Modena, 1717), 67–68.

26. P. Rajna, *Le fonti dell'Orlando Furioso*, 2nd ed. (Florence, 1900), 136–137; and P. Rajna, "Le origini delle famiglie padovane," *Romania* 4 (1875), 161–183.

27. E. G. Gardner, *Dukes and Poets in Ferrara* (New York, n.d.), 319.

28. G. Bertoni, *La Biblioteca Estense e la coltura ferrarese ai tempi del Duca Ercole I (1471–1505)* (Turin, 1903), 72.

29. See Rajna, *Le fonti dell'Orlando Furioso* (note 26 above), 133–134; and Gardner, *Dukes and Poets* (note 27 above), 286 and 292.

30. G. B. Giraldi Cintio, "De Ferraria et Atestinis Principibus Commentariolum," in J. G. Graevius and P. Burmann, *Thesaurus Antiquitatum et Historiarum Italiae*, vol. 7, pt. 1 (Leiden, 1722), cols. 4–5. Giraldi's history of Ferrara was apparently written in 1544 and first published at Ferrara in 1556.

Ultimately Giraldi's source of the story of Hercules' son as ruler of Gaul is Diodorus Siculus (V.ii).

Giraldi also wrote a poem (*Dell'Hercole* [Modena, 1557]), dedicated to Duke Ercole II, in which he relates the descent of the Estes from Hercules (cantos IX and XIII).

Actually Hercules had been associated with the Estes earlier, as is indicated by a letter describing the festivities at Rome in 1502 in honor of the marriage of Lucrezia Borgia to Alfonso I d'Este (F. Gregorovius, *Lucrezia Borgia* [New York, 1948], 142–143). In this case Hercules is apparently not to be considered an ancestor of the Estes but merely an honorific reference to Ercole I, then Duke of Ferrara and father of the bridegroom. However, by the time of Ercole II, when Cinzio Giraldi was writing his several works on Hercules, the labors of Hercules became a quite frequent subject for representation in Ferrarese court art (see F. Antal, "Observations on Girolamo da Carpi," *Art Bulletin* 30 [1948], 88–89); in fact, the court of the Este Palace at Ferrara was decorated at this time by the Dossi brothers with the deeds of Hercules executed in grisaille (G. Vasari, *Le vite de' più eccellenti pittori, scultori ed architettori*, ed. G. Milanesi, vol. 5 [Florence, 1880], 98; and G. Baruffaldi, *Vite de' pittori e scultori ferraresi* [Ferrara, 1846], vol. 1, 254–258).

Hercules, therefore, became the legendary hero and ancestor of the Este family and appears in such decoration as that of the Villa d'Este at Tivoli, which I shall discuss in my study of the villa. Even today a statue of Hercules is the main decoration in a niche on the facade of the seventeenth-century Este Palace at Modena.

31. I have used the second edition: G. B. Pigna, *Historia de principi di Este* (Venice, 1572), 2.

32. D. Fava, "Alfonso II d'Este raccoglitore di codici greci," *Rendiconti: Reale Istituto Lombardo di Scienze e Lettere*, ser. 2, 51 (1918), 484–485 and 496.

33. Giraldi Cintio, "De Ferraria et Atestinis Principibus Commentariolum" (note 30 above), cols. 12–13 and 54.

34. Baruffaldi, *Vite* (note 30 above), vol. 1, 388 n. 1, gives the date of the destruction of the paintings.

Baruffaldi (p. 388) also prints an inscription which he claims belonged to these portraits by Girolamo da Carpi, relating that the painting was done on the order of Ercole II in 1534. As all later historians have pointed out, this date is impossible, since Ercole II, who built the palace at Copparo, only succeeded to the dukedom in November 1534 which would never leave enough time in 1534 for the building and then decoration of the palace. Perhaps the date in Baruffaldi should read 1544, since there is documentation for painting at Copparo by the Dossi in 1542 and 1543 (Serafini, *Girolamo da Carpi* [note 16 above], 213). A. Frizzi (*Memorie per la storia di Ferrara*, 2nd ed. [Ferrara, 1848], vol. 4, 337) wrote in the late eighteenth century that Ercole II "se ne costrusse un nuovo [luogo di delizia] in quest'anno [1540] nella villa di Coparo ad uso di caccia, e poi 7 anni dopo vi alzò il vasto palagio che tuttavia sussiste, il che distintamente si ricorda dalle due iscrizioni in marmo che vi si leggono." See also L. N. Cittadella, *Notizie amministrative, storiche, artistiche relative a Ferrara* (Ferrara, 1868), 544–545; and G. Gruyer, *L'Art ferrarais à l'époque des princes d'Este* (Paris, 1897), vol. 1, 486–487.

35. See P. Capei, "Saggio di atti e documenti nella controversia di precedenza tra il Duca di Firenze e quello di Ferrara negli anni 1562–1573," *Archivio storico italiano*, n.s., 7, pt. 2 (1858), 93–116; V. Santi, "La precedenza tra gli Estensi e i Medici e la historia de' principi d'Este di G. Battista Pigna," *Atti della deputazione ferrarese di storia patria* 9 (1897), 37–122; P. Gribaudi, "Questioni di precedenza fra le corti italiane nel secolo XVI," *Rivista di scienze storiche* 1 (1904), 166–177, 278–285, and 347–356; and E. Palandri, *Les négociations politiques et religieuses entre la Toscane et la France à l'époque de Cosme 1er et de Catherine de Médicis (1544–1580)* (Paris, 1908), 37–52. Santi's study in 1897 is by far the most detailed and most relevant to this study; the other works simply present additional documents and evidence regarding the quarrel. Therefore, the major source for my discussion of the argument is Santi.

36. Santi, "La precedenza" (note 35 above), 85. The fear of the Medici in respect to this argument of the Estes is to be seen in the instructions quoted by Gribaudi ("Questioni di precedenza" [note 35 above], 285) that Cosimo I gave to the Florentine ambassador to France that in any discussion with the queen he was not to talk about Florence as a duchy but only to speak of it as a republic or state "poiche il Duca di Ferrara vuol combattere contro questo titolo di Duca con la pretenzione di essere più antico duca."

37. Pigna, *Historia de principi* (note 31 above), 91. As late as 1584 this genealogical tree was apparently in the Este museum; see the inventory of the "guardaroba del Duca Alfonso II" of that year published in *Documenti inediti per servire alla storia dei musei d'Italia*, vol. 3 (Florence and Rome, 1880), 13.

38. Santi, "La precedenza" (note 35 above), 116.

39. T. Tasso, *Appendice alle opere in prosa di Torquato Tasso*, ed. A. Solerti (Florence, 1892), 107–157. A letter of Tasso in 1579 to Duke Alfonso II also mentions some of the reasons favoring the Ferrarese claims to precedence (T. Tasso, *Le lettere di Torquato Tasso*, ed. C. Guasti, vol. 2 [Florence, 1854], 62–67, no. 125).

40. T. Tasso, *Le rime di Torquato Tasso*, ed. A. Solerti, vol. 3 (Bologna, 1900), 86 and 87, nos. 66 and 67.

It has not previously been noted by art historians regarding Pirro Ligorio, the designer of the castle paintings, that he must have been a friend of Tasso as well as merely a contemporary courtier in the large entourage of the duke. This is indicated by three sonnets written by Tasso in honor of Ligorio, two of them in remembrance of his death in October 1583 (ibid., pp. 471–473, nos. 422–424). There is also a sonnet by Tasso to Cesare Ligorio, the very young son of Ligorio (ibid., p. 474, no. 425); Solerti (idem) suggests that Cesare may be a grandson of Pirro Ligorio, but Baruffaldi (*Vite* [note 30 above], vol. 2, 393 n. 1) has published the baptismal record dated April 2, 1579, of a son of Pirro Ligorio named Cesare Gabriele, who was born during Pirro's old age.

Tasso also refers to Ligorio in his letter of 1580 written to the Neapolitans pleading for their help in his troubles at Ferrara (Tasso, *Le lettere di Torquato Tasso*, ed. Guasti [note 39 above], vol. 2, 78). In this case Tasso's reference was natural, as Ligorio was a famous son of Naples.

A. Solerti in his life of Tasso (*Vita di Torquato Tasso* [Turin, 1895], vol. 1, 179–180, and vol. 2, pt. 2, 102, doc. LVII) publishes documents showing that Ligorio went along with Tasso, the doctor Brasavola, and the historian Sardi in the small advance party which left late in 1572 for Rome where they were joined later by the duke. According to Solerti, this ducal trip to honor the new pope, Gregory XIII, was concerned with the future succession to the Ferrarese duchy, since Alfonso II had no sons, but Santi ("La precedenza" [note 35 above], 81 n. 1) is more probably correct when he claims that the visit was concerned with the controversy regarding precedence.

41. Tasso, *Le lettere di Torquato Tasso*, ed. Guasti (note 39 above), vol. 2, 168.

42. Baruffaldi (*Vite* [note 30 above], vol. 1, 413) claims that it was the idea of Ercole II to have the court of the castle decorated with such portraits, but that his death prevented it.

43. Santi, "La precedenza" (note 35 above), 72. The German translation was only published at Mainz in 1580, but a manuscript translation had been sent to Germany in the autumn of 1570 (ibid., pp. 86–87).

44. [C. Cittadella], *Catalogo istorico* (note 1 above), vol. 1, 141–142; Baruffaldi, *Vite* (note 30 above), vol. 1, p. 261 n. 2 on pp. 262–263; L. N. Cittadella, *Il castello di Ferrara* (Ferrara, 1875), 41–46; and following the above, Gruyer, *L'Art ferrarais* (note 34 above), vol. 2, 283, where he mentions only the Sala dell'Aurora; and E. G. Gardner, *The Painters of the School of Ferrara* (London and New York, 1911), 230, where the Sala dell'Aurora is said to be designed by Dosso and executed by pupils.

45. W. C. Zwanziger, *Dosso Dossi* (Leipzig, 1911); and H. Mendelsohn, *Das Werk der Dossi* (Munich, 1914).

46. A. Venturi in his early publication, *La R. Galleria Estense in Modena* (Modena, 1882), 25, gave only the document without relating it to the Sala dell'Aurora, which was then done by A. Serafini, *Girolamo da Carpi* (note 16 above), 242–253, and A. Venturi, *Storia dell'arte italiana*, vol. 9, pt. 6 (Milan, 1933), 655 and 666 n. 1, and apparently followed by Antal, "Observations on Girolamo da Carpi" (note 30 above), 94 n. 82.

I have some doubts regarding the attribution of this work to Girolamo da Carpi, since there is some evidence, both iconographical and stylistic, to connect the painting of the Sala dell'Aurora with the work of Pirro Ligorio and Sebastianino Filippi. However, the evidence at this time is so slight and controversial that I do not feel that it is worth bringing into this discussion.

47. P. de Nolhac and A. Solerti, *Il viaggio in Italia di Enrico III re di Francia e le feste a Venezia, Ferrara, Mantova e Torino* (Turin, 1890), 333.

That the Specchio or Sala del Consiglio (now usually called the Sala dei Giuochi) was used regularly as the bedroom for visiting nobles is perhaps further indicated by a sonnet of Tasso in praise of the Duke de Joyeuse, which in old manuscripts claims that the duke "fu allogiato . . .

ne le stanze de gli specchi" (Tasso, *Le rime di Torquato Tasso*, ed. Solerti [note 40 above], vol. 3, 441, no. 394).

48. See above note 22.

49. Turin, Archivio di Stato, Ms. Ja.II.15, vol. XXVIII, fol. 75r. The entire passage regarding the castle under the date Friday, November 17, 1570, reads as follows:

> Bolleuano l'acque del po fiume, bolleuano quelle del castello Tialdo, et quel del castello uecchio, et strepitauano, et esso bello edificio del castello uecchio quantunque sia fabrica per grossezza di muri et per saldezza dell'opera lateritia tremò grandemente, riceue grandissimo danno dalla parte di dentro di uno degli appartamenti, la quale parte per l'altro terremoto già noue anni sono fete alcuni resentimenti, ma non sendo curato, anzi fu perturbato da qualche fabrica che lo incarco in questo Terremoto ha lasciato da una parte il muro didentro cadere, et tirato atterra alcune stanze: nel resto delli danni riceuuti, sono facili et rimediabili; perche il moto lha scosso per tre lati, et da quello appartamento che cadde solo duoi ragazzi ui morirono mentre stauano a fare colatione, non hauendo seguitati gli altri ch'erano saltati fuori et questi erano duoi seruidori del conte Scipione Sacrato. Sendo partiti lo principe et la principessa con tutta la corte gia, questo luogo pati come patirono tutte le parti della Magnificentissima casa d'Este; tutti gli appartamenti sacrasso. Cadde affatto la stanza et alloggiamento della guardia de Thedesci nella corte vecchia.

In this diary Ligorio reports quite extensively on the damage incurred by buildings in Ferrara, and I hope soon to use this as a starting point for a study of late Cinquecento architecture in Ferrara.

A. Solerti (*Ferrara e la corte estense nella seconda metà del secolo decimosesto* [Città di Castello, 1891], xciii and xcvi) quotes several letters regarding damage to the castle. The ambassador from Urbino reports: "Il castello è tutto fracassato. . . ." The ducal secretary Pigna claims that ". . . il castello di dentro ha qualche lesione," while the duke himself relates: ". . . il nostro castello ha patito alquanto in una muraglia che camminava da una torre all' altra, per essere caduta una parte nuova fabbricata dal signor Duca nostro padre, sopra un pezzo di marmo che si tiro dietro quella parte di dentro, ma che nel resto non vi è cosa che importi."

50. Solerti, *Ferrara e la corte estense* (note 49 above), xxiii and lii–liii.

51. Frizzi, *Memorie per la storia di Ferrara* (note 34 above), vol. 4, 441.

52. Cittadella, *Il castello di Ferrara* (note 44 above), 42.

53. Baruffaldi, *Vite* (note 30 above), vol. 1, 464 and n. 1 on pp. 465–466.

54. D. Métral, *Blaise de Vigenère, archéologue et critique d'art (1523–1596)* (Paris, 1939), 198. What Métral did not discover was that the two illustrations in Vigenère's book of 1583 showing a men's bath and a funerary repast (ibid., pp. 196–198), which Métral recognized as by Ligorio but for which he could not find a source, are indirectly from Ligorio by way of Mercuriale.

55. G. Mercuriale, *De arte gymnastica libri sex* (Venice, 1573), fols. 18r, 25r, 44r, 54r, 61r, 63r, 103r, 111r, 119r, 123r, 126r, 154r, and 166r. The first edition of Mercuriale was entitled *Artis gymnasticae apud antiquos celeberrimae, nostris temporibus ignoratae, libri sex* (Venice, 1569). In the preface dedicated to Andreas Frisius of the later edition of Mercuriale, published at Amsterdam in 1672, the illustrations are said specifically to be woodcuts made by Cristoforo Coriolano after Pirro Ligorio.

56. G. Mercuriale, *De arte gymnastica*, 1573 ed. (note 55 above), fol. 44r.

57. Ibid., fol. 126r. Other references which seem to refer to Ligorio drawings are on fols. 111r, 119r, and 154r.

58. Ibid., fol. 154r. Ligorio undoubtedly became acquainted with Mercuriale first in Rome, since Mercuriale was called there in 1562 by Pope Pius IV and remained there in the entourage of Cardinal Farnese for eight years studying antiquities before he went to Padua as a professor of medicine (see the *Enciclopedia italiana*, vol. 22 [Rome, 1934], 891, s.v. "Mercuriale, Girolamo"). It was, of course, precisely during that interval that Ligorio was active in Rome as papal architect and, as several letters to and from the Cardinal Farnese and his secretary Fulvio Orsini indicate, Ligorio was on intimate terms with members of the Farnese household.

59. Baruffaldi, *Vite* (note 30 above), vol. 1, 464, n. 1 on p. 465.

60. It may be objected that the form of the *metae* differs between the book illustration, which has rather squat, round *metae*, and the fresco with taller, thinner *metae*, but both these types of *metae* are to be found in the engravings after Ligorio of Roman circuses, where the Circus Flaminius has *metae* like the book of Mercuriale and the Circus Maximus like those of the fresco (copies of these engravings, for example, can be found in the version of Lafreri's *Speculum Romanae magnificentiae* owned by the Metropolitan Museum of Art, New York, volume I, nos. 65 and 68). What is important is that the *metae* occur in the discus throwing scene of both Mercuriale and the fresco to indicate the setting of the circus, while the other exercises have colonnades to represent the palestra.

61. Turin, Archivio di Stato, Ms. Ja.II.17, vol. XXX, fol. 31v.

62. Ibid., fol. 51r and fol. 18r.

63. Mercuriale, *De arte gymnastica* (note 55 above), 121.

64. A. F. Gori, *Gemmae antiquae ex thesauro Mediceo*, vol. 2 (Florence, 1732), 131, pl. LXXXIII, nos. 2 and 4.

65. L. Agostino, *Gemmae et sculpturae antiquae depictae* (Franeker, 1694), pt. 2, 40–42, no. 21, illus. pl. 21.

66. See G. Agnelli, *Ferrara e Pomposa*, Italia artistica 2 (Bergamo, 1904), 72 and 74

67. L. Anson, *Numismata Graeca: Greek Coin-types Classified for Immediate Identification*, pt. 2 (London, 1911), 33, nos. 346–350.

68. Mercuriale, *De arte gymnastica* (note 55 above), 103.

69. Especially during the first two years of his reign (from October 3, 1559) Alfonso II had exerted great effort to gather an outstanding collection of Greek manuscripts, including those of Alberto Pio, brother of Ridolfo Cardinal Pio, while the Ferrarese ambassador at Venice bought up all the manuscripts he could obtain from the East (see D. Fava, "Alfonso II d'Este raccoglitore di codici greci," *Rendiconti: Reale Istituto Lombardo di Scienze e Lettere*, ser. 2, 51 [1918], 418–500; and D. Fava, *La biblioteca estense nel suo sviluppo storico* [Modena, 1925], 130–162). For Enea Vico's activity in creating the Este collection of medallions, see G. Campori, "Enea Vico e l'antico museo estense delle medaglie," *Atti e memorie delle R. R. deputazioni modenesi e parmensi di storia patria* 7 (1874), 37–45.

70. *Documenti inediti per servire alla storia dei musei d'Italia*, vol. 4 (Florence, 1880), 456.

71. A. Ronchini, "Fulvio Orsini e sue lettere ai Farnesi," *Atti e memorie delle R. R. deputazioni di storia patria per le provincie dell'Emilia*, n.s., 4, pt. 2 (1880), 50.

Ligorio is, of course, trying to emulate the ancients in their arrangement of a library, since he remarks in his Neapolitan manuscript. "Soleuano gli antichi d'animo nobile, porre nelle loro Bibliotheche le effigie di tutti quegli, che haueuano scritto, ò fatte opere egregie, come li ritratti, di Poeti, di Philosophi, d'Oratori, dei grammatici, capitani et historici, ò d'altre professioni degni di memoria, . . ." (Naples, Biblioteca Nazionale, Ms. XIII.B.2, p. 395, actually unpaginated: page headed "Di Homero Poeta").

72. A. Michaelis, "Geschichte des Statuenhofes im vaticanischen Belvedere," *Jahrbuch des kaiserlich deutschen archäologischen Instituts* 5 (1890), 5–72; and C. Huelsen, "Die Hermeninschriften berühmter Griechen und die ikonographischen Sammlungen des XVI. Jahrhunderts," *Mitteilungen des kaiserlich deutschen archäologischen Instituts: Römische Abteilung* 16 (1901), 123–208.

73. Ronchini, "Fulvio Orsinio" (note 71 above), 50 n. 1. The license to export these fourteen heads, dated August 27, 1571, is published by A. Bertolotti, "Esportazione di oggetti di belle arti da Roma nei secoli XVI, XVII, XVIII e XIX," *Archivio storico artistico archeologico e letterario della città e provincia di Roma* 1 (1875), 177.

74. Turin, Archivio di Stato, Ms. Ja.II.7, vol. XX, fol. 90r: 403 × 285 mm (at top) or 277 mm (at bottom); pen and brown ink on white paper.

75. The museum and library designed by Ligorio were located on the southeastern side of the castle, probably on the top floor. The dimensions of Ligorio's plan agree with the dimensions of the southeastern side of the castle as published in the second-floor plan in B. Ebhardt, *Die Burgen Italiens*, vol. 1 (Berlin, 1909), 33, fig. 114. This location is also indicated by the existence of the oval stair in the corner of Ligorio's plan which matches the oval stair in the northern corner of the southeastern side of the castle.

76. Dimensions are 52 *piedi* long (21.216 m, if Ferrarese *piedi*) and 18 *piedi* 7 *oncie* wide (7.582 m). According to the measure in the Este Castle itself, one Ferrarese *piede* equals 40.8 cm.

77. 25½ *piedi* long (10.404 m).

78. 47 *piedi* 9 *oncie* long (19.482 m) and 22 *piedi* 4 *oncie* wide (9.112 m).

79. 14½ *piedi* long (5.916 m).

80. Turin, Archivio di Stato, Ms. Ja.II.7, vol. XX, fol. 89r.

81. 7 *piedi* high (2.856 m).

82. The inventory of 1584 (*Documenti inediti* [note 37 above], vol. 3, 6–22), entitled "Inventario delle statue vase ed altre cose di guardaroba del Duca Alfonso II," has brief indications of the location of objects in the *guardaroba*, but these references are too meager to insure that the *guardaroba* is the same as Ligorio's *antichario*.

83. S. V. Pighius, *Hercules Prodicius* (Antwerp, 1587), 350–351.

84. Solerti, *Ferrara e la corte estense* (note 49 above), cviii–cx.

85. Ms. Ja.III.16 in the collection of Ligorio manuscripts in the Archivio di Stato at Turin states that the last four volumes of the collection of thirty (Mss. Ja.II.14–17) were purchased ca. 1696 at Rome. Volume XXVIII (Ms. Ja.II.15) is Ligorio's treatise on earthquakes which was written while he was at Ferrara, and therefore one can assume that these other volumes were produced at Ferrara.

86. For example, there were executed at this time decorative programs at the destroyed pleasure houses of the Belvedere (A. F. Trotti, "Le delizie di Belvedere illustrate," *Atti della deputazione ferrarese di storia patria* 2 [1889], 15) and of Copparo (Baruffaldi, *Vite* [note 30 above], vol. 1, 461–462).

87. Turin, Archivio di Stato, Ms. Ja.II.17, vol. XXX, fol. 21v.

88. Turin, Archivio di Stato, Ms. Ja.III.10, vol. VIII, fols. 154v–155r. The complete description by Ligorio is as follows: "Onde di più addurremo, quel che uitali Grottesche era dipinto nel paese capuano in una stanza trouata con la statua di Venere. Nella cui pittura si scorgeua il Tempo dipinto, che hauea quattro ali sugli homeri e quattro nelli piedi, due di quelle delle spalle erano chiuse poste per lo tempo che si dorme, et due altre erano aperte et come uolatili, per lo Tempo che già non mai lascia il suo uolato, ne si ferma, et in mano teniua la rota conli numeri disegnati delli longhi secoli et circundato dal serpente ch'è l'anno. Et uno occhio nel petto sopra della parte del core, et cinto del segno del Zodiaco. Il serpe ci mostra la Loxia, cio è facile et lubrica et aggile sua consuetudine di sempre andare posato sopra una uolubile Rota. Poscio demostraua di lassare dal suo tergo dalle natiche il suo scremento, et lo fa cadere sopra un grande occhio humano, et di quello ogni animale feroce quadrupede, et uolatile facendone rapina sene nodriscono. Donde si ritrahe che le cose del tempo, con l'occhio del sole aduce gli nodrimenti che sempre si uanno conuertendo, nella consuntione et corrottamente si risoluono in la natura terrena et il tempo uolando ci rappresenta cose nuoue della rinouatione di tutte le cose, presento per andare innanzi alle future scorre dall'oriente all'occidente, et ua cuoprendo et abagliando con le sue nebie le cose passate et le mette in oblio. Erano in questa stanza rouinata altre cose, ch'erano state guaste, per la terra di che era stata ripiena, et feccandosi la humidita, i colori erano smarriti et stinti. Laquale stanza fu

ueduta presso all'Amphitheatro detto i Verlasci di Capoa et per cauare delle pietre fu sfondata, et guasta, mentre hanno del detto edificio murate le mura di capoa citta noua."

89. For Kairos, Phanes, and Chronos, see especially E. Curtius, "Die Darstellungen des Kairos," *Archäologische Zeitung* 33 (1876), 1–8; R. Eisler, *Weltenmantel und Himmelzelt* (Munich, 1910), vol. 2, 382–417; and E. Panofsky, *Studies in Iconology* (New York, 1939), 71–73.

Ligorio, in a manuscript at Rome (Biblioteca Apostolica Vaticana, Ms. Barb. Lat. 5083), uses the more traditional form of Kairos in association with the zodiac and a head of Serapis presumably to denote Time in his forgery of a supposed ancient coin (see A. Greifenhagen, "Zum Saturnglauben der Renaissance," *Die Antike* 11 [1935], 83–84).

90. V. Cartari, *Imagini delli dei de gl'antichi* (Venice, 1674), 18.

91. H. Mattingly, *Coins of the Roman Empire in the British Museum*, vol. 3 (London, 1916), 375, no. 1036, illus. pl. 69, no. 16. It is possible, also, that the attribute of the caduceus, which this figure of Time holds, may be due to Macrobius, *Saturnalia*, I.xix.16, in which Mercury is claimed to be the same divinity as the Sun.

92. Turin, Archivio di Stato, Ms. Ja.II.17, vol. XXX, fol. 25v.

93. Baruffaldi, *Vite* (note 30 above), vol. 1, 101–102; and Venturi, *Storia dell'arte italiana*, vol. 9, pt. 7 (Milan, 1934), 800, 806–808.

94. Turin, Archivio di Stato, Ms. Ja.II.17, vol. XXX, fols. 11v, 13v, 14v, 17v, 23v, 27v, 28v, 31v, and 58r.

95. For Mithraic reliefs, see F. Cumont, *Textes et monuments figurés relatifs aux mystères de Mithra* (Brussels, 1896), vol. 2, especially 194, fig. 19; 198, figs. 23 and 24; 252, fig. 87; and 265, fig. 105.

96. J. Seznec (*The Survival of the Pagan Gods* [New York, 1953], 267) in his analysis of the effect of the Council of Trent on mythological painting points out that Cardinal Paleotti's discourse on painting "condemned even *grotteschi* 'in the name of reason' (book II, chaps. xxvii–xlii). He thus includes in his attack against mythology its most innocent derivatives, and would deprive artists even of motifs of pure decoration." However, Ligorio's statements regarding grotesque decoration, as we shall see, show that this type of painting was not considered mere decoration by at least some of the Italian erudites of the sixteenth century.

97. Turin, Archivio di Stato, Ms. Ja.III.10, vol. VIII, fol. 151v: "Hor dunque inqual unque modo si scorgono pitture tali, secondo hauemo osseruato, se bene al uulgo pareno materie fantastiche, tutte erano simboli et cose industriose, non fatte senza misteris, se bene, è moderni imitando tali antichità, le fanno senza significato è senza historia. Vi sono forme fantastiche et come de insogni, vi furono mesticati le cose morali et fauolose degli Iddij. Vi sono cose che in parte imitano le cose della natura, nelle frondi, nell'animali . . . onde è da credere che fussero rappresentare, per ragionare della natura di quelli, nelle humani afferti, tutte poste in tra uaghi lauori di festoni et di legamenti di cose deboli et uariate: come per mostrare nel' figurato, le cose morali, le cose certe, le false, le uere, la incertitudine, et le anteuedute le imaginatione del le cose future."

Pirro Ligorio at Ferrara

98. Ibid., fol. 152r: "Per questa uarietà delli deboli legamenti, solamente Vitruuio le ributta dalla sua seuera legge dell' Architettura, et non per altro, per cio the egli il significato, dell'animali. Voleua che si mettessero nelli Freggi ò Zophori dell'ordini, dei quali ueniuano, significati per simboli delli iddij à quali erano fatti Tempij: et in ogni uno secondo l'animale che al Dio si dedicaua ò sacrificaua, di quella sorte se ornaua l'edificio: per cio che il Tempio di Ioue, era ornato di Fulmini, di tauri bianchi et di Aquile; . . ."

99. Ibid., fol. 152v: "Sono stati alcuni moderni, chi non sapendo la uerita di tale pittura et la sua origine, lhà chiamate Grottesche et insogni et strauaganti pitture anzi mostruose. Imperoche essi non si sono ha ueduti che ui sono state ritrouate accaso, ne à fantastico fine, ne per mostrare cose uitiose et pazze, per accommodare con la loro uarieta et inuaghire gli alloggiamenti. Anzi loro sono fatte per recare stupore, et marauiglia per dire cosi ai miseri mortali, per significare quanto sia possibile, la grauidanza, et pienezza dell'intelletto, et le sue imaginationi, che fu lhuomo erudito et dotto nelle scienze, et per sadisfare, et per mostrare l'accidenti, per accommodare la insatiabilita, delli uarij et strani concetti cauati da tante uarieta che sono nelle cose create. . . . Non è da dubbitare, di quel che alcuni dubbitano, che in ogni loco non ui si trouino dipinte cose significatiue, et in ogni edificio, et luminoso et oscuro, è anticamente, usata essa pittura, et nelle Grotte et fuori di esse."

100. Ibid., fol. 153v: "Et sendo opere de gentili erano dipinte di Grottesche, et quelli di christiani erano bianche, ò con qualche christiana pittura. La onde hauemo da credere, chele pitture grottesche de gentili non siano senza significatione, et ritrouate da qualche bello ingegno, philosophico, et poeticamente rappresentate imperoche secondo, hauemo potuto uedere nelle istesse antiche pitture, sono di soggetto di consonantia, et conformemente; sono paralelle à guisa d'una palinodia per replicate et correspondenti . . . onde ad uso di lettere Hieroglifiche fatte, come per significare inciô uarij auuenimenti negli piccioli principij, che hanno le cose delli gouerni terreni quelle delle grandissime potenti, et nelli fatti et nelli comandamenti imperatorij. . . ."

101. Ibid., fol. 155v: ". . . per la superbia della bellezza donnile la Grua, per la pieta la cycogna, per la colomba la purita, il cygno per lo secolo, come il coruo, il ceruo et l'Elephante; . . ."

102. G. P. Valeriano Bolzani, *Hieroglyphica sive de sacris aegyptiorum literis commentarii* (Basel, 1556). I presume that the idea of the crane symbolizing women's pride in beauty is to be inferred from the section headed *Perseverentissimi Mores* (fol. 129r), in which a handsome man who does not wish with age to change his fashions is symbolized by crane's feathers, since they are supposedly the only type of bird's feathers which preserve their color with age.

103. Friedländer, *Das Kasino Pius des Vierten* (note 17 above), pls. XI and XII. This same subject is used in the frieze of the Sala dell'Aurora in the Este Castle at Ferrara.

104. Turin, Archivio di Stato, Ms. Ja.III.10, vol. VIII, fol. 156r: "Li carri dell'amori tirati dalli animali dalli Leoni, dalli tigri, dalli Elephanti, dalli Draconi, dalli cambeli, dalli struzzi, dall'oursi, dalli spinosi, delle Testugini, et da ogni Augello. Che tutti fanno il figurato che d'ogni uno Amore è uincitore et come ogni animale corre alla sua deputata meta, et tutte sotto il giogo amoroso uiuono, si propagano, et alfine si conducono sotto la palma et uittoria d'Amore, che di tutti ne porta la corona."

105. Ibid., fol. 155v: "Le Facelle ardenti ci significano il lume dell'animo et l'Anima, il calore, li incendij, et la facella premuta et stinta interra mostra la freddezza del cadauere stinta et il corpo morto."

106. Ibid., fol. 155r: "In altre simili pitture hauemo uiste l'opere di Volcano, l'Amori che hauemo spogliate l'arme à gli Dei, et le portauano per l'aria, ch'erano dipinte in una stanza nelle Esquilie, la quale da scelerati pittori furono guastati. Onde Raphaele prese la istessa inuenzione, nelle nozze di Hebe con Hercule dipinti nella loggia di Augustin Ghisi in Transtibore incontra à Roma; et ne fece una nobile pittura."

Raphael is also mentioned again in ibid., fol. 152r: "Per tale cagione, simile grottesche erano uenute, ad una somma eccellenza, et da esse l'Eccellente Raphaele d'Vrbino et Ioan' da Vdina, pittori degni d'immortale nome, imitando l'antichità con molta arte ornarono la loggia del sacro palazzo Apostolico, et con tal sorte di pittura molto uagamente et con stucchi legarono le Historie del Vecchio et nuouo Testamento, i quali ornamenti recano molta uaghezza, doue i pesci, l'Augelli, leuerdure et le figurette, pareno cose uiue con uitale spirito. La onde gli antichi per simili modi, che hà fatto Raphaele, a loro imitatione, cosi haueano ligati di figure grottesce. Le cose delli Heroi et delle Muse, di colori uaghi, di belli ornamenti: percio dunque se alcuni pareno cose false et uane, dalli dotti furono sempre stimate come figure di cose morali, et di cose imitate dalla natura."

The paintings by Giulio Romano *alla grottesca* at Mantua are noted in ibid., fol. 152v: "Neanco è da dubitare che le Grotte non fussero luminose come alla cui similitudine dell'antichi fece in Mantua Iulio Romano pittore, nella grotte delli Giganti Fulminati, et ingrottesca dipinse la loggia in questo luogo chiamato Iltè, et la loggia in Marmiruolo fuori di Mantua ambiduoi essi luoghi. . . ."

107. Ligorio's artistic training can only be surmised upon the basis of his drawings and one fresco, the *Dance of Salome* in the Oratorio of S. Giovanni Decollato at Rome. Architecturally, Ligorio came out of a similar milieu in terms of the school of Bramante and, in particular, Baldassare Peruzzi, whose work influences Ligorio's architecture, and whose son, Sallustio, was frequently a colleague of Ligorio.

Ligorio's writings, as has been noted, support this artistic connection with the school of Raphael. So in his Oxford manuscript (Bodleian Library, Ms. Canonici Ital. 138, fol. 27r) when discussing the cornice of the Temple of Hercules at Rome he adds: "Certamente io no' la hò uista ma l'hebbi dalli disegni di Baldassarre eccellentissimo Architetto, le lode del quale si seruarranno nel XXV libro. doue difusamente trattaremo dele regole dela pittura, et d'alcune del'Architettura, parlando degli antichi, et moderni Maestri." Later in the same manuscript (fol. 131r) he mentions the Villa Farnesina, where there are ". . . delle pitture che ancho ui sono di man di Rafaello, et d'altri suoi creati, et di man di Baldassaro Architetto, le riserbo nel XXXVII libro doue gli artifici si dichiarano antichi et moderni."

The archaeological tendency in sixteenth-century painting from Peruzzi to Ligorio has been discussed, although only briefly, by Antal, "Observations on Girolamo da Carpi" (note 30 above), especially pp. 85–86 and pp. 94–99, where Antal considers Girolamo da Carpi "as a link between Peruzzi and Ligorio in this chain of erudite, archaeologizing mannerism" (p. 99).

108. P. N. Ferri, *Catalogo riassuntivo della raccolta di disegni antichi e moderni posseduta dalla R. Galleria degli Uffizi di Firenze* (Rome, 1890), 189, no. 577, and illustrated in *I disegni della R. Galleria degli Uffizi*, ser. 5, fasc. 1, no. 1. Morelli, however, considered the drawing a copy after Giulio Romano; see E. Habich, "Handzeichnungen italienischer Meister," *Kunstchronik*, n.s., 4 (1893), 159.

109. A. E. Popham, *Catalogue of Drawings . . . of . . . T. Fitzroy Phillipps Fenwick of . . . Cheltenham* (n.p., 1935), 60, no. 7.

110. J. Seznec, *The Survival of the Pagan Gods* (New York, 1953), first published as *La survivance des dieux antiques*, Warburg Institute Studies 2 (London, 1940).

111. G. P. Lomazzo, *Trattato dell'arte della pittura, scoltura, et architettura* (Milan, 1584), 422. Lomazzo also speaks about the use of hieroglyphs (p. 423) in such painting. This same attitude toward *grottesche* is again shown by Lomazzo in his book of poetry (*Rime di Gio. Paolo Lomazzi* [Milan, 1587]) which carries the subtitle: *Nelle quali ad imitatione de i Grotteschi vsati da pittori, ha cantata le lode di Dio, & de le cose sacre, di Prencipi, di Signori, & huomini letterati, di pittori, scoltori, & architetti.*

112. This atmosphere of erudition and pedantry is revealed, of course, in the book of Seznec to which I have previously referred (see note 110), but it is also brilliantly outlined in the study by F. Baumgart ("La Caprarola di Ameto Orti," *Studj romanzi* 25 [1935], 77–179) of the very intricate iconographical program at Caprarola.

113. One of the rare autobiographical notes in Ligorio's manuscripts at Turin seems to deny, in fact, this development from painter to archaeologist, for he asserts that he turned to mathematics and drawing ". . . non per farme nell'arte della pittura profetteuole, ma per possere esprimere le cose antiche, o' d'edificij in prospettiua, et in proffilo" (Turin, Archivio di Stato, Ms. Ja.III.3, vol. I, fol. 6r). However, at the present we know nothing about Ligorio's life and artistic training before the record on May 15, 1542, of his contract to decorate the loggia of the palace of the Archbishop of Beneventum at Rome, when the artist was presumably about twenty-eight years old (for the contract, see Lanciani, "Ricordi inediti" [note 15 above], 101–102).

2

Pirro Ligorio on the Nobility of the Arts

Late in the year 1568 the Neapolitan artist and archaeologist Pirro Ligorio abandoned Rome, where he had acquired momentary fame as papal architect for Popes Paul IV and Pius IV, to enter the service of Duke Alfonso II d'Este as court archaeologist at Ferrara. During his thirty-five years of residence in Rome Ligorio had prepared an encyclopedic study of the antiquities of Rome which, he had announced in the preface of his preliminary book on antiquities (1553), would consist of forty books.[1] This encyclopedia is now preserved in the Biblioteca Nazionale at Naples (Mss. XIII.B.1–10) in ten manuscript volumes organized by subject matter into fifty books, although the numbering from one to fifty is sporadic, with many missing books.[2] Each book is devoted to one subject, such as Greek or Roman medallions, ancient costume, weights and measures, inscriptions, burial customs, etc. The organization and coverage recall the plan of the Vitruvian Academy as related in Claudio Tolomei's letter of 14 November 1542,[3] and it is very possible that Ligorio's Neapolitan manuscripts were inspired by the Vitruvian Academy. In fact, much of the material preserved in his manuscripts was first gathered in the 1540s, when the Academy was active. Early in 1567 Ligorio sold his manuscript encyclopedia and his collection of medallions to Cardinal Alessandro Farnese, probably as a result of straitened financial conditions after the cessation of his service as papal architect.[4]

With his removal to Ferrara, Ligorio began another version of his encyclopedia of antiquities, now in the Archivio di Stato at Turin (Mss. Ja.III.3–16 and Ja.II.1–16). This encyclopedia, which is dedicated to his new patron, Duke Alfonso, is in eighteen volumes containing twenty-four books, each book devoted to a letter of the alphabet. The change in format from an organization by subject matter to an organization by the alphabet marks a break from the ancient and medieval systems of subject matter to the new pedantic and more usable system of the alphabet popular in the seventeenth century. In addition to these eighteen volumes which comprise the new encyclopedia on antiquity, there are twelve other manuscripts at Turin. Eleven of them deal with antiquity by subject matter, e.g., famous Roman families, famous cities, the meaning of the dragon, the cock, and the basilisk. The twelfth volume is not really a manuscript but a collection of fifty-seven drawings by Ligorio.

Buried among the eleven odd manuscripts is one entitled "Treatise of Pirro Ligorio, Neapolitan Patrician, Roman Citizen, on Some Things Pertaining to the Nobility of the Ancient Arts."[5] As this manuscript was never published, it apparently had no influence, but it is interesting as revealing the personal reaction of a sixteenth-century artist to the art produced about him, for the treatise is not solely concerned with ancient art. The treatise is, however, undated, and it is difficult to date its creation very accurately. I believe that it was written during the decade 1570 to 1580,

when Ligorio was in Ferrara. The date 1580 is suggested as a *terminus ante quem* by the fact that in the title of the treatise Ligorio does not mention his Ferrarese citizenship granted in that year, as he does in some of his other manuscripts at Turin. One doubtful note regarding this suggested date for the manuscript is that he speaks of an ancient marble relief "among the delights of the Lord Ranuccio Cardinal of Sant'Angelo, among his other things; this Lord . . . preserves it most worthily in memory of Timanthes its first inventor."[6] As Cardinal Ranuccio Farnese died 29 October 1565, this passage would suggest that the manuscript dates from before his death. However, an examination of Ligorio's other manuscripts in Naples and Turin reveals that he often retains out-of-date information regarding the ownership of objects.[7] More important, the aggrieved and bitter spirit of this treatise, as discussed later, intimates that it must have been written at least after 1566, when Ligorio suffered his loss of favor at the papal court, and there is even a hint that some of his comments on architecture may have been inspired by Palladio's *I quattro libri dell'architettura*, which was published in 1570. Certainly Ligorio had planned this treatise earlier and probably had made drafts of it in the 1560s or 1550s. This is indicated in his manuscript in the Bodleian Library at Oxford (Ms. Canonici Ital. 138, fols. 27r and 131r), where he writes of "Baldassare [Peruzzi], the very excellent architect, whose praises will be attended to in book XXV, where we will treat extensively regarding the rules of painting, and of some of those of architecture, speaking of ancient and modern masters" (fol. 27r) and then mentions later the Villa Farnesina at Rome, where there are "paintings which are also from the hand of Raphael and other of his followers, and from the hand of Baldassare the architect which I will reserve for book XXVII, where the arts, ancient and modern, will be discussed" (fol. 131r). This Oxford manuscript may be the first one begun by Ligorio that is preserved today, since in it he always refers to himself merely as "pittore Napoletano" with no indication of his Roman citizenship of 1560.[8] Hence, at this earlier date he planned to write a treatise on the arts, such as the one in Turin, as a book of his encyclopedia on antiquities.

The entire treatise is tinged with bitterness and despair. It is an outcry against the wickedness and evil that Ligorio feels dominate the arts, and this reaction even colors his conception of his century, which he refers to as "this century of lost hope" or "this corrupt century." He inveighs against pretence and dissimulation, and constantly suggests that patrons are deceived and good artists defeated by the pretensions of the stupid or the wily.

Every mason and every surveyor wishes to be an architect; it is enough to make one sick that so much ignorance should befall now to men of our day. So as to appear as excellent as was Michelangelo Buonarrotti they put on a hat and short boots with shoes over them and have bushy eyebrows under the shaggy hat to imitate his knowledge, as if that were in the hat or boots, and as associating with a doctor one learns to go dressed as one without having the knowledge or method to be able to study as they do in order to go about so dressed, they wish to appear doctors or Michelangelos.[9]

Michelangelo himself is ostensibly treated with respect throughout the treatise, but there are repeated hidden attacks against his art. The followers of Michelangelo, however, are obviously the principal source of Ligorio's venom and bitterness, and the treatise is the personal reaction of Ligorio's resentment for the ill treatment that he felt that he had experienced at the papal court in Rome, particularly under Pius V.

The first evidence of trouble came at the very end of the reign of Pius IV when Ligorio was at the height of his career; as papal architect he had completed the Casino of Pius IV, was finishing the Belvedere Court in the Vatican Palace, and was beginning to modernize the Sapienza or University of Rome; as architect of St. Peter's he had just succeeded the deceased Michelangelo and had in hand completing the great dome of the church. Then on 1 August 1565 it was reported that Ligorio had been secretly imprisoned a few days previously under suspicion of defrauding the pope in the building of the Belvedere Court and the new doors for the Pantheon and in the purchase of antiques to decorate other works, such as the Casino of Pius IV.[10] A week later nothing further had developed except to seize Ligorio's collection of ancient medals, which were rumored to be worth six thousand *scudi* but on inspection proved to be of little value. Cardinal Amulio then attempted to clear Ligorio's name with the pope without success.[11] Finally on 4 September 1565 Ligorio wrote to Cardinal Alessandro Farnese thanking him profusely for his aid during the recent trouble.[12] In the letter, which is subscribed "outside of the prisons of Rome," Ligorio makes no mention of the nature of the charge against him except to note that the accusation was made by Fra Guglielmo della Porta, whom Ligorio in his anger characterizes as "falsatore del piombo, scultoretto da cocozze."

Although Ligorio's name turns up occasionally in later papal accounts, by June 1567 he was no longer palace architect,

and Nanni di Baccio Bigio began to receive the twenty-five golden *scudi* which constituted the usual salary for the chief palace architect.[13] The last account in which Ligorio was paid as palace architect is the record of work for the coronation of Pius V on 17 January 1566.[14] The cause of this change was undoubtedly the accession of the new pope, who was antipathetic to most of the interests of his predecessor, under whom Ligorio flourished. The man who replaced Ligorio as artistic adviser to the pope was the Florentine Giorgio Vasari, one of Ligorio's most bitter enemies. Vasari came to Rome in February 1566, soon after the coronation of Pius V, to find favor with the new pope.[15] He was also there in April and again from February through most of March 1567,[16] at which times he was in high honor at the papal court and probably influential in ousting Ligorio as palace architect and papal adviser.

By October 1566 Fulvio Orsini was aware that Ligorio was considering removal from Rome, as in a letter of that date he lamented that the study of archaeology at Rome would be finished if Ligorio should leave, for the old Farnese coterie of antiquarians was destroyed by death, dispersal, and inactivity.[17] In 1568 Ligorio was suggested as a candidate for the position of court antiquarian at Ferrara to replace Enea Vico, who died in 1567. Duke Alfonso II d'Este had authorized his agent for antiquities in Rome, Alessandro de' Grandi, to find an antiquarian for him, and in some of Grandi's letters to the duke the details of this negotiation are related. On 31 March 1568 Grandi wrote that he has looked for both medals and an antiquarian, and that Ligorio would be very pleased to serve as antiquarian when he had completed some of the business with which he was engaged in Rome or its neighborhood,[18] the incomplete business undoubtedly being the fountains of the Villa d'Este at Tivoli, since the contracts for some of these fountains were only agreed upon in July and August 1568. Grandi repeated the notice of Ligorio's willingness to serve the duke in his letter of 14 April.[19] The negotiations, however, were protracted because, according to Grandi, writing on 1 May, Ligorio would not specify a salary desired but would only reply: "I do not wish to sell myself to the Lord Duke but desire to make as the price only that I may serve him. I will accept whatever will be given me and I will agree to his wish."[20] In June the negotiations were approaching an agreement, as indicated in a letter dated 12 June of the Cavaliere Francesco Priorato to the ducal secretary. The Cavaliere mentioned that Ligorio "complains of the many travails and misfortunes that he has had in this court at Rome, and of his bad fortune, and that truly this court is so much changed and in such a way, that it is with the greatest desire that he should like to serve His Excellency the Lord Duke." Ligorio claimed that anyone could recognize

> from the little profit which he had made in the time of Pius IV, although he possessed, as one knows, his [the pope's] favor, the little hope that remained now for him to ever do anything better because of the nature of the Pope [Pius V] and of the period. Now only those are esteemed and honored who under a pretext of continence and humility increase the greater part of their income without spending anything and also without entertaining persons of worth and intellect as he, and with the exception of our Cardinal [the cardinal of Ferrara] and the Farnese [cardinal], one could see well that there was no one who had the means, much less the desire, to spend money, so that this court [the papal court] has been reduced to such extremity that men of his kind must find their living and fortune elsewhere.[21]

Ligorio then proposed as his terms thirty *scudi* a month, with food, two servants, and a house, but finally the negotiators agreed upon twenty-five *scudi* if authorized by the duke, and by 1 December 1568 Pirro Ligorio was at Ferrara in the service of the duke.[22]

It is against this personal background of Ligorio's downfall at Rome that one must consider the tone of his treatise on the arts, but it must also be remembered that the change in atmosphere from the papal court of Pius IV to that of Pius V was commented on by many in addition to Ligorio. Several ambassadors compared the papal court of Pius V to the deathly silence of a monastery.[23]

Ligorio's treatise on the arts is not a systematic one. Its organization is rather rambling, and only toward the end does it assume any orderly form, which he identifies by introducing subject headings in the margins. The treatise is principally concerned with the problem of good and bad art, presented for the most part in terms of examples. For Ligorio naturalness and appropriateness are the two basic principles for the judgment of art, and in particular appropriateness in relation to a knowledge of antiquity. Ligorio's treatise is then very derivative, being based to a large extent upon the recent dialogue on decorum by Giovanni Andrea Gilio da Fabriano, entitled *Dialogo secondo . . . de gli errori, e de gli abusi de' pittori circa l'historie* (1564), and to a lesser

extent upon Lodovico Dolce's dialogue *L'Aretino* (1557). So, influenced by Gilio da Fabriano's warning (fol. 91) to represent a running horse after nature, Ligorio describes how some artists incorrectly depict the gait of a walking horse (fol. 91v). This accusation is also found in volume eight of his Neapolitan manuscripts, where he illustrates an epitaph accompanying an ancient relief of a horseman and writes in the margin: "Notice the error of him who carved this horse, since he has not studied the gait of animals; it moves both legs on one side which is contrary to nature."[24] In the Turin manuscript he then contrasts the poses of a running and of a jumping horse. Other errors against nature that he notes are to paint "small rivers navigated by large boats like those of the sea which are not fit for rivers" (fol. 16v) or "trees so large that their height in proportion to the size of the city is more than ten times larger than the city" (fol. 20v).

There are likewise errors which are historical in origin.

> St. Paul, when he was converted by the great God our Savior a short distance from the gate of Joppa, was rather young, but painters, who have not studied as they should, have painted him at that conversion as old and taxed with years. So also happens to St. John the Apostle. Painting the miracle which he did under the rule of Domitian, they depict him at the age which he had when he lived as a young man under Tiberius, with chalice in his hand full of poison which by the divine will became serpents; therefore, in the age when he was given the poison by the cruel Emperor Domitian he was about ninety years old, or a little less (fol. 17v).

The complaint against the age of St. Paul in paintings of his conversion is undoubtedly derived from Gilio da Fabriano's objection to Michelangelo's Pauline Chapel fresco,[25] and is one of the many instances when Ligorio attacks the work of Michelangelo without identifying him.

Ligorio then goes on to discuss tradition as a background for sacred images and again follows Gilio's argument that artists should follow ancient custom and not be arbitrary in their depiction of sacred subjects.[26] He points out that there is an agreed manner of depicting only the Holy Trinity.

> But for his other faithful saints they do not observe any method; they use no guide for the images, since each painter imagines them in his own way. Certainly it should be done, as the gentiles were accustomed, that is, to preserve a mode of images accepted by the early church, when, having a fresher knowledge of the semblance of the saints of God, they depicted them according to their ability So we Christians should not abandon the early principles according to which our saints were first depicted, improving and bringing them to perfection when we represent them and their garments. We have seen the images of the apostles, columns of the Holy Church, made long ago in ivory and cameo, where, in truth, with the highest excellence of those times, they are represented in the same manner of face and garments as still we see them carved by these ancients on the sepulchral slabs of the blessed pontiffs found in the old church of St. Peter's, in which, although there is seen there little art and little excellence, one notices that all the sculptors of that period imitated the same things in garments and images; so likewise are they seen in ancient works of mosaic painting. To this end we should make one image from another, having already before our eyes the examples which we should assimilate and bring to perfection. The license of the painters and sculptors of our times has been so great that we do not recognize our saints evoked by their images, but we recognize them by the symbols and instruments that they put in their hands, or by the name which they subscribed to them.[27]

Some of the errors dealing with antiquity have to do with the unusual forms of sirens, giants, or dragons. He claims that some artists depict sirens as a wingless combination of woman and fish, while ancient writers and sculptors know of them as winged virgins in the upper half and birds below (fol. 9r).[28] Giants likewise should not be entirely human but should have serpent lower halves, since they are the children of heaven and earth (fol. 9r). Dragons, he adds, are often depicted as fantastic creatures with fat bodies, claws, and bat wings, whereas they should merely be large serpents, the male having a small horn on the nose and a small pointed beard "as Nicander writes" (fol. 14v).[29] The dragon of Medea and that of Mercury's caduceus are exceptions in having bird's wings.

He laments that some artists depict Circe going to the boats to bring her potion to the sailors, when they should drink it at the table in her palace surrounded by the other sailors already transformed into beasts by the potion. Nor

should the Laestrygonians attack strangers in the sea but kill them during the night in the lodgings offered their visitors (fol. 17r).

Ligorio is particularly upset by anachronism, such as the Argo painted as a contemporary boat (fol. 16v) or the use of modern armor or costume for ancient stories and vice versa (fols. 19r and 21r), so that "we see Caesar or Alexander of Macedonia dressed in German costume." The complaint regarding costume is made by both Dolce and Gilio da Fabriano,[30] but Ligorio's mention of Caesar and Alexander indicates that Dolce was his chief inspiration.

For Ligorio appropriateness or decorum is the main principle of good art. Following Gilio's complaint that some sacred scenes are no more decorous than paintings in baths or taverns, Ligorio claims that lascivious subjects are painted in churches which would be scandalous in baths.[31] He then goes on at great length to discuss the appropriateness of ancient decoration for the types of building it served, so the Temple of Diana is decorated with bows and arrows and the heads of animals or that of Mars with armor and palms of victory (fols. 10r–11r). Another example that Ligorio relates may be based upon a demonstrable example. He complains that "if they [some artists] make a city gate, they place a mask in the middle as though it were a Temple of Bacchus or a theater,"[32] which immediately brings to mind Michelangelo's Porta Pia created at Rome during Ligorio's architectural activity at the papal court. For Ligorio such a gate should be decorated with figures of Justice and Equity, a remembrance of the founder of the city, the image of the creator, "or some other thing worthy of divine glory."

The largest part of the treatise (fols. 4v–8v) considers sixteen designs for a fountain, some proposed by "a painter who designed many *capricii* but without any foundation in history or allegory," and the objections against these proposals, usually in terms of appropriateness. Although Ligorio does not identify the purpose or the proposed location of this fountain, his account of one of the designs describes elements which suggest that the fountain was for a member of the Este family. This fountain depicted Hercules killing the Lernean Hydra with two eagles below spitting water into a basin, and the eagle was the heraldic symbol of the Este, as Hercules was their legendary ancestor. In addition, several of the designs, which Ligorio notes were more acceptable to the judges, had subjects similar to fountains proposed for the Villa d'Este at Tivoli built for Cardinal Ippolito II d'Este, who is presumably the "principe" for whom, as Ligorio mentions (fols. 5v and 6r), the fountain designs were prepared.

One of the more acceptable designs portrayed the Rape of Europa (fol. 7r). In another

> were some marine monsters who accompanied Thetis with the shield of Achilles, a work of Vulcan, on her arm. . . . Having chosen this one also, but not surfeited so as to look no further, there was shown another drawing where within the first basin lay a woman from whose breasts poured forth water, and above her flew the horse Pegasus to signify the Helicon fountain, . . . [where] was born the fountain of the Muses from which issue two rivers as the poets relate, thus wishing to signify that it is the Fountain of Virtue and of Memory.[33]

There was also a Meta Sudans which seemed to be composed completely of rippling and undulating water. He then quotes at length the designer's philosophical interpretation of his creation which equates the movement of water with human life. As a result, one of the judges, while admitting that "the design was beautiful," complained that "it was too philosophical."

That these designs may have been for fountains in the Villa d'Este at Tivoli is suggested by the fact that similar, although not identical, fountains were created or planned for those gardens. There was a Fountain of Thetis listed in sixteenth-century descriptions, although the seventeenth-century historian Antonio del Re objected to its name, claiming that it depicted Europa and the Bull.[34] Also at Tivoli above the Oval Fountain, or Fountain of Tivoli, still springs the horse of Pegasus in whose hoofmarks appeared the Fountain of Helicon.[35] Finally, in the original plan for the gardens at Tivoli as depicted in Dupérac's engraving of 1573 there was to stand in the center of each of the two great fishpools at the foot of the slope a large Meta Sudans reminiscent of the description of the last fountain in Ligorio's treatise.[36] As all the Tiburtine fountains date after the autumn of 1565, and principally in 1567 and 1568, this also suggests a date for Ligorio's treatise after 1565.

The major cause for rejecting several of the designs was morality. The first design with a nude Venus "was ridiculed by some monks who said that for it to be a nude Venus was a dirty and obscene thing" (fol. 4v), while the two designs with Galatea were "too lascivious" (fol. 6r) or amorous (fol. 6v). Finally, a design of Leda embraced by the swan was likewise considered "a dirty thing" and was "contrary to the examples which should be worthy of decorum in public judgment, and lascivious things should be used or placed in

locations which were not always seen, since they are not worthy of being permitted in every location."[37] This judgment in terms of public versus private morality may have been inspired by Lodovico Dolce's dialogue, where Aretino excuses Giulio Romano's pornographic engravings as not wanting in decorum since they were not intended for public squares or churches.[38]

Although the majority of Ligorio's objections to his contemporaries' art is based upon meaning, on a few occasions he discusses elements of style as errors, most of these elements being of the type generally associated with Mannerism. He complains of the constant distortion of figures, which are forced into meaningless poses, or of groups of figures so confused and discordant that one cannot interpret the meaning of the scene.[39] He claims that some painters "are not ashamed to show bodies from in front and in back at the same time," and thereby seems to be echoing Alberti's treatise on painting.[40] Like Dolce, and probably inspired by him, Ligorio laments the over-use of foreshortening in contemporary painting.

> It does not seem to them a beautiful thing, nor worthy of being seen, unless they make some peculiar foreshortening in every figure. . . . They make supple figures appear to lie askew without any harmony, and it seems to them either great or admirable when they depict foreshortened figures in every picture.[41]

In the same way Ligorio inveighs against Mannerist architectural details.

> To them it still appears worthy of praise when in architecture they have made many pediments within one another, some broken, some whole, and they put such broken things on the temples of God, on private houses, and on great palaces, which the ancients used on tombs, straining everything to produce such stupidities, and besides this they have altered even the members of the cornices, of the coronas, of the architraves of those buildings of which they have charge. They have made frames out of plumb and fall out of perpendicular, which is against the nature of the frames, and of the state of things which are made strong and stable.[42]

The condemnation of broken pediments, pediments within pediments, and frames out of perpendicular suggests that Ligorio had in mind some of the architectural detail of Michelangelo and his followers, and, in fact, Ligorio states this explicitly in volume eight of his encyclopedia of antiquities in Turin.

> There have been such broken orders from the fine ingenuity of Messer Michelangelo Buonarroti of Florence without another thought of any reason. He has filled his architecture with these broken things, and that which was given by the pagans to the gods of death, he has given and introduced on to the temples of the eternal and immortal God to whom they have always dedicated, as they should dedicate, whole things with whole pediments. . . . Other followers of Michelangelo imitate him in architecture; everything has broken members, with fittings of gloomy and ugly effect, and the fireplaces, the picture frames, the windows, the doors, the mirror decorations of private houses are filled with them.[43]

Ligorio is particularly disturbed by the use of broken pediments, which he mentions at least three times in the treatise. This he shares, of course, with Palladio who, in the chapter on architectural abuses in his *Quattro libri* (bk. I, chap. XX) of 1570, enumerates as abuses particularly the idea of broken pediments and the use of cartouches. Interestingly, Ligorio also speaks at least twice against the use of cartouches, pointing out that there are some poor artists who "praise masks, cartouches in broken pediments, interrupted ornaments; as one sees on every palace and every church, in every place, and they do not know why such are the friends of him who has despoiled architecture, and they have thereby corrupted all the youth."[44] It is possible then that Ligorio's discussion of architectural errors was inspired by Palladio's book, which would tend to support the hypothesis that Ligorio's treatise dates from the decade 1570 to 1580. However, Ligorio's reasons for discrediting broken pediments differ from Palladio's. For Palladio, pediments should not be broken since they are derived from the gables of roofs, and he points out that it is absurd to break the center of a roof which is meant to keep out inclement weather. Ligorio's objections are more symbolic in origin and dependent upon the tradition of antiquity.

> They have wished, moreover, not only to disparage the things of nature but have destroyed and abused all that the ancients with marvelous art have erected with the greatest consideration to morality,

some to life, some to death, admonishing men to make worthy and immortal things. They have applied the things of death to the temple of God, since these, being broken things, are appropriate to the limited life of mortals. To God they should give perfect things, ours give him broken things, and in the meantime hear me, he who can, and suffer that I speak the truth; I speak of broken pediments which are only suitable for tombs.[45]

In accordance with the Renaissance theory of decorum or appropriateness, the use of the classic pediment had often been the subject of discussion. Alberti in the middle of the fifteenth century associated the pediment particularly with the temple and warned that a private house should not bear a large pediment, which might rival that of a temple, but that the vestibule of the house if raised above the rest of the structure might have a small pediment (bk. IX, chap. IV). Vasari likewise reports that, when Baccio d'Agnolo decorated the facade of his Palazzo Bartolini in Florence with rectangular, pedimented windows and a columnar portal, the Florentines scorned the design as "more like the facade of a church than a palace."[46] It was Palladio in his treatise of 1570 who insisted on the appropriateness of the pediment as a feature of private houses, since it was his theory that the ancient temple was derivative from the ancient house.[47]

Although Ligorio never identifies any of the artists who in his eyes have corrupted art, he does drop a few hints. In addition to his hidden attacks on Michelangelo, he speaks of a "stupid foreigner" and "his comrade who has come to Rome from beyond the seas." One of these, according to Ligorio, considers himself the finest connoisseur of drawing, although he cannot draw a line.[48] One wonders whether the unusual combination of an artist at Rome "from beyond the seas" and a foreigner might not be a reference to the youthful El Greco and Giulio Clovio. It was in November 1570 that Giulio Clovio wrote to Cardinal Farnese recommending very highly to his support the young El Greco who had just arrived in Rome.[49] Much later Mancini claims that El Greco, when he was in Rome under Pius V, and therefore presumably before May 1572, had offered to replace Michelangelo's fresco of the *Last Judgment* with one more appropriate to the location and equal in aesthetic value. As a result of this presumption, Greco had to flee the wrath of the painters in Rome.[50] However distorted this later report may be, it suggests that there was an Italian tradition attributing a presumptuous attitude to El Greco which is anal-

ogous to Ligorio's complaints regarding the two foreigners. If the hypothesis of this identification is correct, there would be more evidence to date Ligorio's treatise to the decade of the 1570s. In fact, it would have to date after 1573. When El Greco arrived in Rome in 1570, Ligorio was already in Ferrara, but he returned to Rome for a visit at the beginning of 1573[51] and at that time undoubtedly visited his old friends in the Farnese entourage, such as Fulvio Orsini. The aged, infirm Giulio Clovio, whom Ligorio had known for years, was still in the employ of the Farnese cardinal, and the same is probably true for El Greco, whose paintings Ligorio may have seen during this visit.

Ligorio also notes that there were "three very deceitful men at this time" in Rome who praise mediocre art and criticize good art; who "as soon as anyone has the impulse to praise the works of some master they interpose some wicked contrary opinion."[52] To them Ligorio attributes most of the errors in architectural decoration and distortions in figure painting noted above. One immediately suspects that of these three men one must be the sculptor Fra Guglielmo della Porta, whose accusation of Ligorio in 1565 had brought him so much trouble, and a second may be the painter and architect Giorgio Vasari, who replaced Ligorio as papal art entrepreneur under Pius V and who reveals his dislike of Ligorio in his letters. It is true that Vasari resided in Florence, but he spent the first half of each of the three years 1571 through 1573 in Rome painting for Pius V and so was there during Ligorio's return in 1573. In fact, Ligorio's treatise on the arts suggests that it may have been written in reply to Vasari's *Lives*, published in 1568. The painters with whom Ligorio had particularly worked in Rome were the Zuccaro brothers, who, together or separately, had decorated the Casino of Pius IV, the Sala Regia, and the Villa d'Este at Tivoli. Federico Zuccaro's antipathy toward Vasari, caused by the latter's preference for the work of Francesco Salviati over that of Taddeo Zuccaro, is known from Federico's notes in his copy of Vasari's *Lives* and his letter to Antonio Chigi.[53] In the latter Federico remarks that Vasari knows how to praise only Tuscan artists, whether good or bad, and Zuccaro's attitude toward Vasari resembles very much Ligorio's dislike of his contemporaries, whom he considers speak evil of good artists and praise the mediocre.

Like Gilio da Fabriano, Ligorio finds that most of the errors that have ravaged contemporary art are due to ignorance. For him the artist must be a learned man.

So that the spiteful and stupid are those who think that they are far above it, since they hold that the

architect may be a plebeian artist and that his name is acquired by chance, and that he may be a mason. They do not know that he is one who orders and maintains everything that lies within the arts. It is proper that he should learn philosophy, musical method, symmetry, arithmetic, mathematics, astronomy, history, morality, medicine, geography, cosmography, topography, proportion, perspective, sculpture and painting; and demonstrate various inventions all in proportion. It is necessary then that the architect be a wise and experienced man.[54]

Ligorio's plea that the architect be trained in the liberal arts is, of course, based closely on the architectural training recommended by Vitruvius (bk. I, chap. i), but it is also a note of self-adulation, since Ligorio himself practiced painting, architecture, and cartography, and was well versed in archaeology, history, and philosophy. The artist must seek knowledge either from men learned in their disciplines or from books.

> If we should desire to know about painting matters, we should have recourse to the most excellent painter. If we wish to know about matters of war, we should take counsel of the deeds of illustrious captains, we should have recourse to the books where are treated the deeds of war or the things that Polyxenos of Macedonia and Marcus Fronto and Polybius treat (fol. 25r).[55]

The artist can avoid errors and produce beautiful works by carefully studying antique works of art and a few sixteenth-century artists.

> We should look at the good, at those things most excellent in manners and in works, in architecture, ancient things, and the precepts of Vitruvius. In painting the pleasing Raphael of Urbino, the drawing and sculpture of Michelangelo, always holding the ancients before our eyes and in our memory as works most worthy and most like the beauty and quality of generative nature.[56]

Or another passage:

> In painting imitate nature and Raphael in style, in drawing Michelangelo and Polydoro, who in our time have been the most excellent men above all others of this century; these are our Apelles and the true eyes of painters.[57]

However, in an earlier passage condemning his colleagues, Ligorio praises a few other painters.

> They are not ashamed to say that he who follows in architecture the method of Vitruvius is a trivial man, and he who follows the style of Raphael of Urbino in painting, Parmigianino, Correggio, Giorgione, is a person without judgment and displeasing, and those who imitate the ancients are without intellect, so foolish are their reproofs, that it appears to them that it should be an ordinary thing to imitate the style of those who have been the best.[58]

Again Ligorio is apparently attacking Vasari, who seems to speak with approval of Michelangelo's deviations from the classic principles of architecture based upon "Vitruvius and antiquities."[59] In any case, it is Raphael whom Ligorio favors most, and in one part he praises Raphael alone, both as man and painter.

> He does not have the kindness or charity that Raphael of Urbino had, who was most noble in spirit, a very fertile inventor, most joyful in style, showing himself a man of good will to his people, very generous in negotiation, in painting above every other painter, more lofty and more excellent.[60]

In his other writings Ligorio praises other members of Raphael's circle. There has been quoted previously his two references in the Bodleian manuscript to Baldassare Peruzzi, whom he promised to extol in the treatise on the arts.[61] In volume eight of Ligorio's Turin encyclopedia under the heading "grotesque painting" he speaks favorably of the work of Raphael and Giovanni da Udine in the Vatican, the painting of Giulio Romano in the Grotto of the Giants and his "grotesque" style in the loggia of the Palazzo del Te at Mantua and in the loggia at Marmirolo outside of Mantua,[62] but in the treatise itself these artists are put aside, and only Raphael receives the accolade of being the finest painter to imitate.

The first two-thirds of Ligorio's treatise is mainly concerned with the errors he finds in contemporary and ancient art, while the last third is more positive in nature, discussing artistic principles of imitation, expression, and

symmetry. These subjects are then often identified by subtitles in the margins, although they are not developed very systematically. He starts with the question of imitation or similitude. "And we should understand as imitation, that it is to represent variety in beauty, and not do as those painters or sculptors who know how to make only one image, and all the heads that they make, both masculine and feminine, seem sons and daughters of one father."[63] He points out that beautiful women when seen separately show a resemblance one to another but when seen beside one another are both beautiful and yet different.[64] Hence the goal of the artist is to imitate nature but to choose from nature the beautiful. Ligorio does not explicitly explain the artist's source of knowledge of the beautiful but hints at an idealist theory with inspiration from God. He points out that God as the creator has furnished a variety of fine examples.

> Imitating God there is created such a felicity of work as obtains merit, so that you will make things resembling the divine. The more we shall choose the most beautiful and the most varied, the more will the style be grounded on the beautiful mode of angelic creatures, and they will not seem to be painted human thoughts, but celestial beauties conceived by the mind which perceives the splendid part and which takes into account the divine splendor; so will be made a beautiful mode of drawing and coloring.[65]

He does not quote the usual Renaissance example of Zeuxis choosing his ideal as a composite of the fairest details from a group of individuals, but gives as ancient analogies Polygnotos using Elpinice, sister of Cimon, as his model for Helen, or Phidias selecting Lais or Phryne as model for his several statues of Venus.[66] He interprets the ancient myth of the birth of Athena sprung full-grown from Jove's head by the blow of Vulcan's hammer as the creative process of the artist. "For this Jove is understood to be the idea and intellect of all the immortal things of the arts and the wisdom of creatures; Vulcan the excellent master who brings forth with art things of fine and beautiful invention."[67]

As do all Renaissance theorists, Ligorio compares painting to literature, since both arts must be concerned with human "expressions" (*effetti*) and "passions" (*passioni*). Poetry, however, has the advantage, for "in truth, evil or good or joy or pain are shown more easily in the words of the poet than they are shown with the brush" (fol. 29v). The painter, like the doctor or the philosopher, has to see the internal meaning (*le cose intrinsiche*) through the external expression (*il strinsico*). Then, as does almost every Renaissance book on art theory (Alberti, Dolce, Gilio da Fabriane), he quotes the account of Timanthes' painting of the sacrifice of Iphigenia, "as related by many authors, and particularly Valerius Maximus and Pliny" as an outstanding example of the use of expressions in painting. The description of Timanthes' painting is very long and carefully records the costume and poses of all the figures.[68] At the end Ligorio explains that the painting is preserved in an ancient, fragmentary, Parian marble relief among the possessions of Cardinal Ranuccio Farnese. There is, however, apparently no evidence now of the preservation of this relief.

For Ligorio one of the essentials of good art is what he calls "symmetry" (*semitria*). "The virtue of sculpture and of painting consists in the elements of symmetrical design [*disegno semitriato*] and in invention" (fol. 27r). He points out that one of the worse things is for an artist to consider himself a master when "he has neither symmetry, nor history, nor method, nor style, nor invention, nor composition" (fol. 4r), thus equating "symmetry" with the other traditional Renaissance art factors. The sixteenth-century theorists on painting do not seem to use the term in their analysis of painting, but architectural and sculptural theorists with the authority of Vitruvius (bk. I, chap. ii) and Pliny (*N.H.*, XXXIV.65) had incorporated the term into their theory.[69] Ligorio never defines his meaning of this word, but by implication it seems to suggest proportional harmony and consonance, as it does for the earlier theorists—harmony among elements in a total composition or harmony among parts of a single figure. He speaks of artists as creating "against nature and against correct symmetry [when] they create unseemly things, [when] they seek poses purposely unusual in order to extract the bizarre, and they scorn every order and every pleasing and fine style, in such a manner that all their figures put together form an asymphony, a discord."[70]

Painting and sculpture are "sisters of one flesh, since both are born of virtue," but painting is superior in their goal of imitation, for it gains its semblance of vivacity not only by depicting actions but through its use of color. It is also the first of the arts, as "it demonstrates the mode of creating relief" which is for Ligorio the essence of sculpture (fol. 28r). In fact, painting is "universal to everything" and acts "as the first mover, the first intelligence, the first counsellor" (fol. 28v: *come primo mobile, prima intelligentia, prima consigliera*). As a result painting is the most honored of all

the arts. It is "the art of the Lord, since it should be pursued not for reward but for glory."

> Hence it is of necessity that one should paint for love and not for the necessity of acquiring a living, because, when a man sets himself to do something excellent, it is requisite to think of this project at ease and to lay aside anxiety (fol. 30r).[71]

In the wake of all the Renaissance theorists, Ligorio confirms the nobility of painting among the Greeks and Romans by reciting at great length (fols. 28v–29r) the interest in painting of ancient philosophers, such as Plato, Aristotle, and Pythagoras, or the patronage and artistic endeavors of ancient emperors, such as Julius Caesar, Augustus, Nero, Hadrian, Titus, and Marcus Aurelius. Some of the ancient references were given previously by Alberti and Dolce, but Ligorio has filled out these accounts from his own vast knowledge of antique sources and added further stories.

As has been noted, much of Ligorio's treatise is very closely dependent upon the previous treatises of Lodovico Dolce and Gilio da Fabriano. This is understandable, as they are the two writers who are most outspoken against Michelangelo and therefore opposed to the position of Vasari. Dolce's dialogue also has the added advantage for Ligorio of its great praise of Raphael. The treatise of Ligorio is in a sense the last gasp of the rivalry and enmity that commenced in the early sixteenth century between the circle of Bramante and Raphael and that of Michelangelo. Ligorio and Vasari represent the last phase of this conflict. Vasari, of course, knew Michelangelo personally; Ligorio did not so know Raphael, but undoubtedly considered himself in the artistic lineage of Raphael.

The controversy that broke out at the beginning of the reign of Pope Pius IV over the decoration of the Sala Regia in the Vatican Palace was another aspect of this conflict. We know the story only from the side of Vasari, but one can read further between the lines.[72] Vasari relates that Pius IV ordered that Daniele da Volterra should finish the decoration of the Sala Regia, which he had already begun. Cardinal Alessandro Farnese, however, made every effort to have half the commission given to Francesco Salviati. The Tuscan artistic circle was soon rent by internal discord. Michelangelo, out of friendship to Daniele, insisted that the latter be allowed to complete the entire commission, while Vasari urged that Salviati receive half the project, since he feared the irresolution that Daniele showed in artistic endeavors. To the displeasure of the pope the work was de-layed. Ligorio at that moment interjected himself into the controversy by suggesting that the commission be dispersed and one fresco assigned to each of the many young painters who were active at Rome. As Ligorio was in favor with Pius IV the idea was carried out and commissions given to Taddeo Zuccaro, Livio Agresti, Orazio Samacchini, Girolamo da Sermoneta, Giuseppe Salviati, Giambattista Fiorini, and Zoppelli da Cremona. Francesco Salviati, angry and ill, then abandoned Rome for Florence. As Vasari notes, Salviati considered that Ligorio had betrayed him, since they had been friends until this moment and, in fact, had previously worked together in the Oratorio of San Giovanni Decollato at Rome. Most of the younger artists working in the Sala Regia after Ligorio's suggestion belong more to the lineage of Raphael than of Michelangelo, which may likewise be due to the influence of Ligorio.

Vasari also tells during his account of the Sala Regia of the fate of one of his own paintings. Pope Julius III had ordered from him a painting of the Calling of Peter for which he had never been paid. When he requested Pius IV either to pay him for it or to return it, he claimed that the pope sent for it and viewing it "in a poor light" ordered that it be returned to the artist. Since this incident is related by Vasari soon after his notice that Ligorio was in favor with the pope as his architect, one wonders whether the rejection of the painting may not have been instigated in part by Ligorio.

In the end, of course, Vasari had the victory. The publication of his *Lives* gave a Tuscan flavor for a long time to the history of Italian art, and under Pope Pius V Vasari returned to favor in Rome and himself completed the Sala Regia. At the same time Ligorio found refuge in Ferrara. He probably considered this almost an exile. At least, at the death of Vignola in 1573, Cardinal Farnese was approached by friends of Ligorio with the hope that the latter be chosen to continue St. Peter's and the Farnese Palace at Caprarola[73] and therefore to return to Rome, but the cardinal replied that he had already made other arrangements. Ligorio then lived out the remainder of his life in Ferrara, active principally as the ducal archaeologist, writing his second encyclopedia of antiquities now in Turin and his treatise on the nobility of the arts.

Notes

1. P. Ligorio, *Libro di M. Pyrrho Ligori Napoletano, delle antichità di Roma, nel quale si tratta de' circi, theatri, & anfitheatri* (Venice, 1553).

2. E. Mandowsky and C. Mitchell, *Pirro Ligorio's Roman Antiquities*, Studies of the Warburg Institute 28 (London, 1963).

3. G. Bottari and S. Ticozzi, *Raccolta di lettere sulla pittura, scultura ed architettura* (Milan, 1822), vol. 2, 1–17, letter no. I.

4. J. P. Wickersham Crawford, "Inedited Letters of Fulvio Orsini to Antonio Agustín," *Publications of the Modern Language Association of America* 28 (1913), 585; letter of 17 January 1567.

5. Turin, Archivio di Stato, Ms. Ja.II.15, vol. XXIX, 191 folios. The treatise is on the first thirty-three folios; fols. 34–141 are blank; and fols. 142–191 are a later copy of the first thirty-three folios. The full title of the treatise is: Trattato di Pyrrho Ligorio patritio napolitano cittadino romano, di alcvne cose appartenente alla nobiltà delle antiche arti, et massimamente dela pittvra, dela scoltvra, et dell'architettura, et del bene et del male, che s'acqvistano coloro i' quali errano nell'arti, et diqvelli, che non sono dela professione, che parlano troppo per parere dotti diqvel che non sanno, et detrattando altrvi se istessi detvrpano.

6. See below, note 68.

7. For example, in volume five of the Neapolitan manuscripts Ligorio refers to objects owned by Uberto Strozzi (p. 362), who died in 1553, and by Gentile Delfini (p. 281), who died in 1559, but the title of this book XXV of his encyclopedia describes Ligorio as a Roman citizen, which honor was granted him only in 1560.

8. As the Oxford manuscript has bound in it at the beginning a letter of Ligorio to Ercole Basso dated May 14, 1581, Ligorio must have brought it with him to Ferrara.

9. Fol. 21v: "Vogliano essere ogni muratore architetto et ogni misuratore di terreni, cosa da uomitare, che tanta ignorantia sia caduta ora gli huomini adi nostri. Essi per parere eccellenti come è stato Michelagnelo Bonarroti si mettano il capello et li stiualetti in gamba con le scarpe di sopra et tengono le ciglia sotto il capello peloso per imitare la scienza di quello, come quella stesse nel capello et nelli stiuali; et come pratticando con uno dottore se impari nell'andar uestito senza hauere lingua ò metodo da potere studiare a cosi costoro perandare cosi uestiti, uogliono parere dottori et Michelagnoli." I have translated the word "capello" as hat rather than hair, since Ligorio in his equation of "capello" with boots and his mention of a doctor's apparel seems to be concerned with elements of dress.

10. Rome, Biblioteca Apostolica Vaticana, Ms. Vat. Lat. 6436, fols. 35v–36r, *avviso* of 1 August 1565: "M Pirro Ligori sousastante alla fabrica di San Pietro fù posto prigione in secreta hieri l'altro, et leuatoli tutte le scritture: si dice ch'e per hauer' rubato assai nella fabrica di beluedere: nelle porte della Roto'do et in hauer nel resto del'altre fabriche fatto pagar' molti pili, et statue antiche al grosso prezzo essendo co' li padroni accordato, per meno, assai." The *avvisi* in Ms. Vat. Lat. 6436 are very difficult to read as the ink has spread and the folios of the manuscript have been covered with protective paper; hence the transcriptions here may not be absolutely accurate.

11. Ibid., fol. 48r, *avviso* of 8 August 1565: "Doppo la captura di Pirro Ligori no' si è proceduto, ad altro, ch'a leuar' le sue medaglie ch si stimauano, di prezzo di $\frac{m}{6}$ scudi: ma poi l'hanno ritrouate di metallo et di pocchis.ª ualuta. Il Car.le Amulio, per purgarsi del oppinione ch'ha, la corte, ch riso li habbi causato ogni danno ha fatto off.to per lui con S.S.ta publicam.ta senza però ottenir' risp.ª bona."

12. A. Ronchini, "Una lettera inedita di Pirro Ligorio," *Atti e memorie delle R.R. deputazioni di storia patria per le provincie modenesi e parmensi* 3 (1865), 109–114.

13. Rome, Archivio di Stato, Mandati Camerali 920, fol. 83v.

14. Rome, Archivio di Stato, Mandati Camerali 918, fol. 21v. Later references in the papal records are for work performed before the election of Pius V.

15. G. Vasari, *Il libro delle ricordanze di Giorgio Vasari*, ed. A. del Vita (Rome, 1938), 93.

16. W. Kallab, *Vasaristudien*, Quellenschriften für Kunstgeschichte, n.s., 25 (Vienna, 1908), 123–124 and 128–129.

17. Wickersham Crawford "Inedited Letters" (note 4 above), 583.

18. *Documenti inediti per servire alla storia dei musei d'Italia*, vol. 4 (Florence, 1880), 455. R. Lanciani, *Storia degli scavi di Roma*, vol. 3 (Rome, 1907), 261, quotes a section of this letter under the date 31 May as if it were the letter of conclusion in the negotiations.

19. *Documenti inediti* (note 18 above), 455–456.

20. Modena, Archivio di Stato, Cancelleria Ducale, Estero, Ambasciatori, agenti e corrispondenti Estensi, Italia, Roma, busta 45: ". . . non mi uoglio io medesimo uendere al S.r Duca, et fare il prezzo solo desidero, seruirlo et accettaro quello che mi sara dato, et m'accomodaro al uoler suo, . . ."

21. Ibid., letter from Cavaliere Francesco Priorato to G. B. Pigna, dated 12 June 1568: ". . . egli se dolse de molti i trauagli, et accidentj ch'ha hauuto in questa corte di Roma, et de la mala sua fortuna, et ch'in effetto e tanto, et talmente questa corta mutata, che de bonissima uoglia uerebbe à seruire l'Eccza del Sig'Duca . . . dal poco frutto ch'hauaua fatto al tempo de Pio IIII, se ben egli possedeua, come si sa, la gratia sua, la poca speranza che le restaua di far horane mai più cosa bona, rispetto à la natura del Papa, et al tempo, essendo quelli solo estimati et honoratj hora quali sotto ombra, de continenza, et humiltà, auanzano la magg.r parte de le loro entrate, senza non solo spender' in cosa alcuna ma ne anco con intertener' le persone ualorose, et d'intelletto come lui, et che leuato il Car.le n'ro et di Farnese, poteua lui molto ben conoscere che no' e era alcuno ch'hauesse modo, ne meno uolesse spendere, di modo che questa corte era ridotta in tale estremità, che l'huomini pari suoi, doueuan procacciar' altr'onde il uitto, et la fortuna loro, . . ."

22. Modena, Archivio di Stato, Camera Ducale, Bolletta salariati, vol. del 1569, Provisionati, fol. 141.

23. L. von Pastor, *The History of the Popes*, vol. 17 (London, 1929), especially 140–144.

24. Naples, Biblioteca Nazionale, Ms. XIII.B.8, p. 301: "Notate l'errore di cui sculpi questo cavallo che non hauea studiato il caminar degli animali; il quale muoue le gambe tutte due da un lato cosa contra natura."

25. G. A. Gilio da Fabriano, *Dialogo secondo*, in *Trattati d'arte del cinquecento*, ed. P. Barocchi, vol. 2 (Bari, 1961), 45. The discussion of St. John's age is likewise from Gilio, in ibid., 32.

26. Ibid., 110–111.

27. Fols. 17v and 18r: "Errano anchora nel dipignere molte cose simili delle quali ab astera hauerne detti di alcuni. Per cio che solamente in due cose rappresentano ordinatamente, il Dio padre et il figliuolo et spirito santo. Ma nell'altri suoi fideli santi non ui osseruano metodo alcuno, niuna regola usano nelle effigie, per che ogni pittore si imagina à suo modo. Certamente si doueria fare come usauano i gentili, tenere un' metodo dell'effigie accette dalla primitiua chiesa quando più frescamente s'haueua la contezza della sembianza di santi di iddio li dipigneuano secondo il loro douere. . . . Cosi doueriamo noi cristiani non uscire degli ordini primi secondo erano incominciati à mostrarsi i nostri santi ammegliorando, et reducendogli à perfettione, rappresentare essi et li loro habbiti. Noi hauemo uiste le effigie degli Apostoli colonne di santa chiesa fatti anticamente et di auorio et in cameo, oue nel uero con somma eccellenza di quei tempi rappresentati della medesimo guisa delle faccie et palliati, come anchora li ueggiamo da essi antichi scolpiti nelli pili sepulchri di Beati pontefici trouati nell'antica chiesa di san pietro, ne quali quantunque uisi ueda poca arte, et poca eccellenza si considera che tutti i scultori di quel tempo imitauano le cose istesse degli habiti et dell'effigie; cosi parimente si ueggono nell'antichi opere di pittura musaica. A' che affetto noi douemo fare una effigie per un altra hauendo gia gli essempli innanzi gli occhi à cui douemo farli assimigliare, et ridurle alla perfettione. La licenza di nostri tempi di pittori et di scultori, ha fatto tanto che per le effigie non conosciamo i nostri sancti euocati, ma li conosciamo per li segni e istrumenti che le mettono nelle mani, ò del nome che sescriuono sotto."

28. Dolce quotes Horace in respect to the error of depicting a combination of beautiful maid and fish (*Dialogo della pittura intitolato L'Aretino* [Venice, 1557]; see *Trattati d'arte del cinquecento*, ed. P. Barocchi, vol. 1 [Bari, 1960], 168), but Dolce is objecting to all monstrous combinations, while Ligorio's judgment is solely dependent upon truth to antiquity.

29. Nicander of Colophon, *The Poems and Poetical Fragments*, ed. and trans. A. S. F. Gow and A. F. Scholfield (Cambridge, 1953), 56–59: *Theriaca*, lines 438–444.

30. Dolce, in *Trattati d'arte* (note 28 above), vol. 1, 165; and Gilio da Fabriano, in ibid., vol. 2, 50–52.

31. Fol. 10r: ". . . nelle cose lasciue che pensa di fare, et nelle sacre et profane, et nei sacri tempij si uedono, certe dishonesta, che nelle stufe darrebbono scandalo; . . ." Cf. Gilio da Fabriano, in ibid., 111; this accusation, of course, goes back to Aretino's condemnation of Michelangelo's *Last Judgment;* see *Lettere sull'arte di Pietro Aretino*, vol. 2, *1543–1555*, ed. E. Camesasca (Milan, 1957), 175–177, no. CCCLXIV.

32. Fol. 11r: "Se eglino fanno una porta alla città, ui piantano una maschera per mezzo, come fusse un' Tempio di Baccho ò un Theatro."

33. Fols. 7r–7v: "Nel cui mezzo erano alcuni mostri marini, che accompagnauano Thetide col scudo di Achille in braccio opera di Volcano, . . .

Cosi hauendo eletto questo ancora: ma non satij di uedere più oltre fù mostrato, un altro disegno, quiui dentro il primo vaso giaceua dentro una donna, che per le mammelle uersaua acqua, et sopra di essa uolaua il cauallo pegaseo, come che significasse il fonte Helicone, . . . nacque il fonte delle Muse donde nascono duoi fiumi secondo fauulano i poeti. Siche uolendo significare esser il fonte della uirtù, et della Memoria, . . . Fu resoluto di acettare li duoi suddetti, . . . fu ueduto un altro disegno, molto bello, alqual non si poteua opporre cosa alcuna con retta ragione, onde essendo diuenuti tutti muti i circonstanti, alfine essendo considerato, come il disegno in tutte le parti correspondeua attissimamente, perche surgendo in'alto faceua una Meta rotonda, ma fatta à gradi, et incima della Meta era una palla di Nube la quale pioueua tutta da zampilli, et gocciole d'acqua, inundaua la Meta talmente che mostraua esser'un corpo tutto di acqua, che undeggiante da grado à grado saltauano le onde et s'increspauano come ridenti, tal che con alcuni bollori che accompagnauano tutta la forma pareua ueramente ch'ogni cosa fremesse per qualche occulto secreto."

34. D. R. Coffin, *The Villa d'Este at Tivoli* (Princeton, 1960), 36.

35. Ibid., 33 and 87.

36. Ibid., 20 and 112.

37. Fols. 6v–7r: ". . . fuor' dell'essempij che deuono esser degni di honesta in cause publiche, et deono le cose lasciue essere usate ò poste ne luoghi, che non sempre si ueggono: benche sono degne di non essere in niun luogo permesse."

38. Dolce, in *Trattati d'arte* (note 28 above), vol. 1, 189.

39. Fol. 12v: "Cosi donque per lo amore di costoro cosi braui entriamo à parlare di quel che chiamano snocciolamento, ò uogliamo dire delli sforzamenti degli atti, del corpo delle mani et delle braccia et coscie dell'huomo, tutte fatte senza proposito, et con ogni sorte di storcitura poste in opera, che per fignere le figure pronte nell'atto lhanno fatte furiose, con attitudine pazzescha et dispiaceuole, più tosto menaccianti, che sua dente ò dimostrante quel che la natura porge nell'occasioni dell'historie. . . . Hauendo solamente pensato far certi groppi di figure confuse insieme et tanto discordi, che non sene puote retrarre il significato, . . ."

40. Fol. 18r: "Non si uergognano di farle mostrare i corpi dauante et le schiene a' uno medesimo tempo." Cf. L. B. Alberti, *Della pittura*, ed. L. Mallé (Florence, 1950), 96.

41. Fol. 13r: ". . . et non pare loro cosa bella ne degna di esser ueduta, se non ui fanno qualche strana scorciatura in ogni figura. . . . Fanno parere le figure snodate gittate attrauerso senza consonantia, et quello pare loro sia grande è mirabile, quando fingono le imagini scorciate in ogni historia, . . ." Cf. Dolce, in *Trattati d'arte* (note 29 above), vol. 1, 180–181.

42. Fol. 13r: "A quelli anchora pare cosa degna di laude quando nell'architettura hanno fatti molti frontispitij l'uno dentro dell'altro, chi rotto et chi intero, et mettono tali interrompimenti nelli tempij di iddio, nelle case priuate, et ne gran palazzi, le qual cose gli antichi usarono nelli sepulchri, sforzansi tutti à produrre tale sciocchezze, et hanno oltre à questo per

uariare insino ai membri delle cornici delle corone, degli epistylij di quegli edificij che hanno curati. Li contorni li hanno fatti traspiombare et cadere fuor del perpennicolare infuori, cosa contra la natura delle quadrature, et della dicissione delle cose che si fanno ferme et stabili."

43. Turin, Archivio di Stato, Ms. Ja.III.10, vol. VIII, fols. 159v–160r: ". . . sendo state uedute dallo bello ingegno di M. Michelagnolo Buonarrati Fiorentino senza altro pensamento, d'alcuna ragiona, questi tali ordini rotti, ha piena la sua architettura in esse interrompimenti, et quello che si daua da gentili alli Dij della Morte, lha dati et introdutti nelli Templi d'iddio aeterno et immortale acui si dedicarono sempre come si deeno dedicare le cose integre, con li integri fastiggij. . . . Altri Michelagnolastri seguitando il medesimo nell'architettura, ogni cosa è con membri rotti, con masiaracce di mesto et bruto affetto, et ne sono pieni li cammini delli focolari, i quadri di pittura, le fenestre, le porte gli ornamenti delli specchi delle case priuate."

44. Fol. 11v: "Laudano costore le maschere, le cartocci nelli frontispitij rotti gli ornamenti interrotti; come si uede in ogni palazzo et in ogni chiesa, in ogni luogo et non sanno perche talche sono amici di chi ha storpiata l'architettura, et hanno incio corrotta tutta la giouentù di poueri giouani, . . ."

45. Fol. 12r: "Hanno pure uoluto; non solo dispreggiare le cose di natura, ma hanno guaste et abbusate tutte quelle che gli antichi con mirabil arte hanno drizzate con somma consideratione alla moralita; che hanno mostrate, altre per le cose sagre, altre per la uita, altre per la morte applicate ammomendo gli huomini à far cose degne et immortali. Le cose della morte lhanno applicate al tempio di Iddio, per che queste essendo cose interrotte si sono accomodate alla uita impedita di mortali. A iddio diadono le cose intere, li nostri glele danno rotte, et inquesto intendami chi può, et prendaselo apacienza poi ch'io dico il uero, dico di frontispitij rotti, che ne sepulchri solo conuengono."

46. G. Vasari, Le vite de' più eccellenti pittori, scultori ed architettori, ed. G. Milanesi, vol. 5 (Florence, 1880), 351.

47. R. Wittkower, Architectural Principles in the Age of Humanism (London, 1949), 66–68.

48. The passage in the treatise reads, on fol. 9v: "Questo accordatosi con un' goffo forestiero, usa infinite isolenze con quello, et fanno tanti intoppi quanto possano, per far morir gli huomini dabene di disascio; talche per loro desiderio farebbe da fosse ogni huomo distrutto più tosto, che hauessi lume di far bene senza esso e senza il suo compagno uenuto a Roma oltramarino. L'uno di essi uuole, con esser' detrattore d'ogni gentilezza tenuto e stimato il primo sapiente, et lo meglior' conoscitore di disegno, e si prosume tanto dise istesso, che non conosce, ch'egli non seppe mai tirare una linea, non che la sappi dare ad'intendere per regola di ammaestrare, l'altro con la fede che ha à costui; et per ambittione di parere di far qualche cosa, et per li uezzi suoi, per la magnificenza per la riputatione che si reca, di signore si fa curioso delle goffagini delli piu sciocchi meccanici che si trouano; et certo hauemo ueduto se è scoperto ignorante et alieno d'ogni cosa eccellente."

49. J. F. Willumsen, La jeunesse du peintre El Greco (Paris, 1927), vol. 1, 421.

50. Ibid., 423–424.

51. A. Solerti, Vita di Torquato Tasso (Turin, 1895), vol. 1, 179–180, and vol. 2, pt. 2, 102, doc. LVII. Ligorio was apparently also in Rome in 1570; see Mandowsky and Mitchell, Pirro Ligorio's Roman Antiquities (note 2 above), 5–6.

52. Fol. 11v: "In questa Roma conoscemo tre falsissimi huomini à questo tempo che corromperiano il porfido durissimo se con essi si strecolasse li quali somersi nelle inuentioni del cauillare, mettono le cose sciocche per buone, le mediocre le inalzano al cielo, le eccellenti le biasimano, . . . che tosto che si faccia un motiuo di laudare l'opere di qualche uirtuoso ui poneno qualche scelerata oppenione incontrario."

53. G. Vasari, Le vite de' più eccellenti pittori, scultori ed architettori, ed. G. Milanesi, vol. 7 (Florence, 1881), 73–134, notes; and Bottari and Ticozzi, Raccolta di lettere (note 3 above), vol. 7, 509–513, letter no. XXXV.

54. Fols. 13v–14r: "Tal che i maligni et i goffi sono quelli, che pensano distare di sopra, per che tengono chel Architetto sia uno artista plebeo, et chel nome suo s'acquisti accaso, et che sia uno Muratore, et non sanno, che esso, è uno che ordina et diffende tutto quel che giace dentro l'arti. Et le conuiene imparare philosophia, metodo di musica, semetria, eremetrica, matamatica, astronomia, historia, moralità, medicina, geografia, cosmographia, topographica, analogia, prospettiua, sculpire et dipignere; et dimostrare uarie inuentioni tutte proportonabile. Hauendo dimestiero dunque che l'architetto habbi da essere huomo sciente et prattico; . . ."

55. Ligorio presumably mistakes the Roman orator Marcus Fronto for Sextus Julius Frontinus, who wrote on military affairs as well as on the aqueducts.

56. Fol. 22r: ". . . douemo riguardare ai buoni, alle cose più eccellenti nelli costumi et nell'opere, nell'architettura le cose antiche et li precetti di Vitruuio. Nella pittura il piaceuole Raphaele da Vrbino, di Michelagnolo il disegno il sculpire, tenendo sempre gli antichi denanzi gli occhi et nella memoria come à opere più degne, et piu simile alla bellezza et qualità de la natura generante."

57. Fols. 26v–27r: "Nel dipignere contrafate la natura et Raphaele, nel stile, nel disegno Michelagnelo, et Polydoro, i quali al tempo nostro sono stati i più eccellenti huomini sopra attutti gli altri di questo secolo, questi sono i nostri Apelli e gli occhi ueri de pittori."

58. Fol. 12v: ". . . non uergognandosi di dire che colui il quale seguita nell'architettura il metodo di Vitruuio sia huomo triuiale, et quel che seguita il stile di Raphael da Vrbino nel dipignere il parmigiano, il Coreggio, Giorgione sia persona senza giuditio et dispiaceuole et quelli che imitano gli antichi siano senza intelletto, tanto le costoro riprensione sono insensate, che gli pare sia cosa ordinaria imitare il stile de'quelli che sono stati i megliori."

59. Vasari, Vite (note 53 above), vol. 7, 193; and also in his 1550 edition of the Lives, 975.

60. Fol. 15r: ". . . non hà gentilezza ò charità, come hebbe Raphael da Vrbino, che fu gintilissimo dell'animo, ricchissimo inuentore, giocondissimo nel stile, nel mostrare huom' dabene ai suoi, nel contrattare generosissimo, nel dipignere sopra d'ogni altro pittore, più alto et più eccellente, . . ."

61. See above, p. 45.

62. D. R. Coffin, "Pirro Ligorio and Decoration of the Late Sixteenth Century at Ferrara," *Art Bulletin* 37 (1955), 184 n. 106 [reprinted on page 42 of this volume].

63. Fol. 23r: "Et questo douemo intendere per la imitatione, rappresentare uarietà nella bellezza, et non fare come fanno quei pittori ò scultori che non sanno fare se non una effige, et tutte le teste che eglino fanno maschi et femine parono figliuoli et figliuole di uno padre." Cf. Dolce, in *Trattati d'arte* (note 28 above), vol. 1, 193, where he makes a similar observation regarding Michelangelo.

64. Fols. 22v–23r: "Et da presso fanno assai differenza tra loro, cosi ancho, ne costumi, se bene un' padre ò uno maestro gli habbi educati: in modo, che sono uarij di grandezza et di costume come d'altra similitudine, et il medesimo auuiene nelle effigie et membra dele Donne, lequali se bene quelle, che sono più eccellenti di bellezza, s'assimigliano inqualche cosa, l'una all'altra: uedute separatamente: ma uedute da presso, sono belle et diuerse ancora: et nella diuersita non fa che siano brutte: ma belle di uaria bellezza ciascuna singolarmente."

65. Fols. 23r and 23v: ". . . cercare di fare come usa la natura, che è tutta uaria maestra delli buoni essempij, fatta dall'eterno et innato Creatore, opefice di tutte le cose celesti, et de tutte le terrene. Imitando iddio ne nasce una felicita tale dell'opera sene caua il merito, per che farai cose simiglieuole alle diuine quanto più s'ellegeremo le più belle, è le più uarie, tanto più il stile si fondera nella maniera bella dell'angeliche creature: et non pareranno pensieri humani dipinti, ma celesti bellezze immaginate dall'animo che sente di parte splendida et tiene presso se conto del diuino splendore; cosi si farà una bella maniera nel disegnare et nel collerire."

66. Fols. 23v–24r. R. W. Lee ("*Ut Pictura Poesis:* The Humanistic Theory of Painting," *Art Bulletin* 22 [1940], 205) points out that Dolce in his dialogue suggests that there are two ways by which an artist can achieve beauty from nature. One is the usual Renaissance composite ideal seen in the story of Zeuxis painting Helen; the other is to use a perfect model as Apelles and Praxiteles do when they depict Aphrodite after Phryne. It is this latter approach that Ligorio selects.

67. Fol. 27v: ". . . per esso Ioue ci da ad'intendere la iddea et intelletto di tutte le cose immortali dell'arti et delle creature la prudenza, Volcano la eccellente maestro che attrahe fuora con l'arte le cose delle buone et belle inuenzioni. . . ."

68. Fols. 30v–31r: "Timante pittore, fù si eccellente nell'arte sua, che quasi oscuro le cose naturali tanta Energia hauea nelle sue dimostrationi di non so che più di uiuace formosità che usaua, tanto fu marauiglioso nelle imitationi nelle cose che egli dipigneua; onde i suoi marauigliosi effetti si raccontano in molti auttori, et particolarmente presso di Valerio Maximo et di Plinio. Si troua come dipinse effettuosamente la historia di Iphigenia offerta al sacrificio in Aulyde, oue presentata al nume a pie dell'altare di Diana, piena di mesto pianto et di dolor' graue, ò uogliamo dire di timore di religione strinta la dimostro tutta languida et inchinata. Fece d'intorno all'altare di Diana Calcante uestito da sacerdote con barba longha et capelli ligati nella collottola a guisa di uergine di quella Dea

uestito di stola et di casbula; il quale era maninconuso et mesto facendo l'officio dell'arte Aruspicina. Vlysse dall'altro lato vestito con una veste corta et succinta militare colla spalla destra et braccio gnudato colla sinistra mano una hasta, di eta di piu di quanta anni barbato di pelo folto et capelli a guisa quasi che si dipigne Ioue, con li calciamenti Militari et la clamide gitata et raccolta sula spalla et sul braccio sinistro. Appresso à questo Aiace, esclamante armato alla greca. Et Minelao parimente lamentantesi, et Agamemnone dipinse assiso col capo coperto, per dimostrare una certa arte, per celare di non possere dimostrare et esprimere in lui quell'ultimo effetto di mestitia d'uno intrinsico dolore, ma cosi fatto dipinse marauigliosamente le lacrime nella sua pittura di Calcante Aruspice uersante un uaso sull'altare, et quel del fratello di essa Iphigenia. Ma qual fosse il pianto del padre Agamemnone copertamente lascio nella estimatiua, è nel giuditio di chi lo remiraua col uolto ascosto sotto al manto. Questa pittura dunque essendo tanto degnamente espressa da Timante che piacque molto, tanto che fù nel medesimo senso scolpita di rilieuo, la quale era si bene inuenta et dimostratiua, ben ritrouata, che merito di esser degna di farla uedere in scoltura. La quale di mezzo rilieuo di marauiglioso stile dunque la ueggiamo in parte in una tauola di marmo Pario antica et fragmentata nelle dilitie del signor Ranuccio cardinale Sant'Angelo, tra le altre sue cose, il qual signore specchio à uero lucidissimo occhio della casa Farnesa la conserua degnissimamente à memoria di Timante suo primo inuentore. In cotale fragmento si uede dunque, Calcante, che si piega a sacrificare e ministra attorno dell'altare le sacre cerimonie. Agamemnone col capo coperto, tutto doloroso si dimostra, con una testa di montone appiedi, la qual testa rappresenta quel animale che egli uccise nella selua sacrata à Diana in Aulyde, per la cui morte è successo, secondo la oppenione, che haueuano credettero che uenisse quella crudele pestilenza à greci."

69. See A. Chastel, *Art et humanisme à Florence au temps de Laurent le Magnifique* (Paris, 1959), 100–101; and Wittkower, *Architectural Principles* (note 47 above), especially 13–16, 89, 121–122, and 136–137. Among the sixteenth-century theorists on painting, Michelangelo Biondo alludes in passing to ancient writers on symmetry and color (*Della nobilissima pittura* [Venice, 1549], fol. 9).

70. Fols. 12v–13r: "Al dispetto della natura et di quel che uuole l'arte, usano contra natura et contra la dritta semitria, fanno cose innoheste, cercano gli atti apposta strani per cauarsi la bizzaria, et scherniscono ogni metodo et ogni diletteuole et ottimo stile: di maniera che tutte le loro figure messe insieme fanno una assimphonia, una discordia, . . ."

71. Fol. 29r: "Come anchora si può dire che la pittura sia arte da signore: per che si dee essercitare non per premio: ma per gloria." Cf. Alberti, *Della pittura* (note 40 above), 81.

Fol. 30r: "Onde è di necessità, che per amore si dipinga, et non per necessità di acquistare il uitto: per che quando si mette lhuomo à far cosa eccellente; le conuiene con quietudine pensare à quella cosa, et porre da parte il trauaglio della mente."

72. G. Vasari, *Le vite de più eccellenti pittori, scultori ed architettori*, ed. G. Milanesi, vol. 8 (Florence, 1881), 35–40.

73. A. Ronchini, "Fulvio Orsini e sue lettere ai Farnesi," *Atti e memorie delle R.R. deputazioni di storia patria per le provincie dell'Emilia*, n.s., 4, pt. 2 (1880), 54, n. 3.

3

Pope Innocent VIII and the Villa Belvedere

The Roman chronicler Infessura records that Pope Innocent VIII (1484–1492) "built in the vineyard, beside the papal palace, a palace which is called from its view the Belvedere, and it is well known to have cost 60,000 ducats for its construction."[1] Built to the north of St. Peter's and the Vatican Palace on the summit of a hill called Monte Sant'Egidio in medieval documents, the Villa Belvedere faced Monte Mario and the Milvian bridge with Monte Soratte on the horizon (Fig. 1). Below were the Prati or meadows that ran to the edge of the Tiber, beyond which was the northern sector of the city of Rome. Most of the trudging pilgrims or splendid ambassadorial corteges coming to Rome from the north would pass beneath the Belvedere to enter the Vatican by one of the gates in the Leonine wall. For lighter diversion the Prati offered one of the most favorite sites sought by the Romans, where they could escape from the dingy, crowded streets of the city on a summer afternoon.

The few documents concerned with the building of the Villa Belvedere are so ambiguous that its exact history is doubtful. It must have been begun, however, in 1485, since the first certain document, dated April 13, 1486, records a mandate of March 3 to pay for 5,000 paving tiles and 2,000 roofing tiles "for the palace in the vineyard of our Very Holy Lord."[2] The purchase of such material suggests that the construction of the villa was then well advanced. A payment of September 22, 1487, "for the com-

pletion of the building of walls in the vineyard of the palace" may also refer to the new villa, although the description of the work is vague. Finally, the vault of the loggia of the villa bears an inscription asserting that Pope Innocent VIII founded (*fundavit*) the villa in 1487. This inscription is usually interpreted as recording the completion of the structure and the commencement of the decorative program. There are several other documents regarding the work of the decorative painter Piermatteo d'Amelia that are difficult to interpret, although according to a very late document of 1492 he worked in part "in the location which is called Belvedere" as well as elsewhere in the Vatican.[3] Those payments to him in 1486 and 1487 for decorative painting "in the secret garden" (*in orto secreto*) or "in the loggia near the well" (*in logia prope puteum*) must refer to the pope's private garden to the west of the Vatican Palace in the area of the present Court of San Damaso. A payment of February 20, 1486 "for the painting of a round table with the arms of our Very Holy Lord at the pavilion (*pampilionem*) in the vineyard" presumably refers to the pavilion built in 1461 for Pope Pius II. There is, therefore, no exact information as to when Piermatteo painted in the Belvedere or what he did.

The identification of the designer or architect of the villa is more confusing than the dates of its creation. Vasari in the mid-sixteenth century hesitantly reports that "it is said" that the designer was the Florentine sculptor

N

9

TERRACE

8

7

2

3

4

5

6

I

Diagrammatic plan of the Villa Belvedere in the fifteenth century
1. Chapel
2. Sacristy
3. Main loggia
4. Papal apartments: Room of the Prophets
5. Papal apartments: Room of the Liberal Arts
6. Papal apartments: anteroom
7. Papal apartments: pope's bedroom?
8. Loggetta
9. Loggia

Antonio Pollaiuolo and then qualifies the attribution by adding that the execution of the building was carried out by others, since Pollaiuolo was inexperienced in architecture. On the other hand, a document of 1495 notes that the late Jacopo da Pietrasanta was owed money "for building the house in the vineyard of the Apostolic Palace called the Belvedere" during the lifetime of Innocent VIII.[4] There is not, however, enough comparable material to decide whether Jacopo was also the designer of the villa or merely the executor of the design of Pollaiuolo or some other artist.

The Villa Belvedere stood on Monte Sant'Egidio at the head of the vineyard or park, called the *pomerium* in contemporary documents, which Pope Nicholas III in 1278–1279 enclosed on the northern side of the Vatican Palace just outside the Leonine wall. Originally the villa was roughly U-shaped in plan (see Diagrammatic Plan), facing north with a secondary wing on the eastern end projecting down into the vineyard. When Bramante and Pope Julius II added the Statue Court on the southern side of the villa, much of that exterior elevation was changed,

and with the creation of the Museo Clementino in the late eighteenth century most of the interior of the villa was drastically revised, including destruction of the chapel frescoed by Mantegna. Early-eighteenth-century drawings now in the Library of the British Museum, however, and the descriptions of the Vatican by Taja (written 1712, published 1750) and Chattard (1762–1767) permit a reconstruction of the fifteenth-century villa.[5]

During the recent restoration of the structure of the original villa, it was discovered that there were two building campaigns under Pope Innocent VIII.[6] The secondary wing

Innocent VIII and the Villa Belvedere

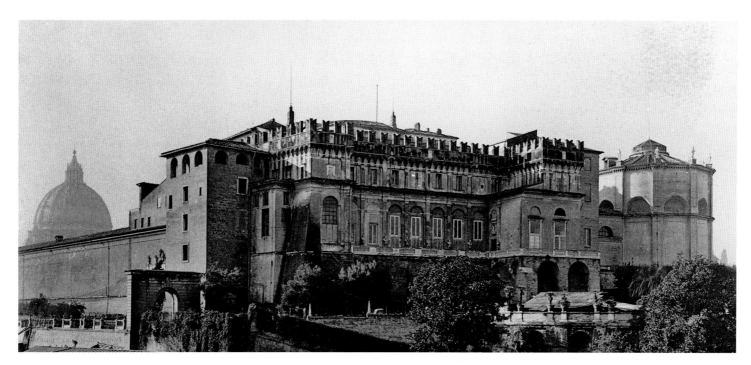

Fig. 1. Vatican, Villa Belvedere, northern facade (photo: Archivio Fotografico, Musei Vaticani)

at the east was found to have been added to the main block later during the pontificate of Innocent VIII, and presumably at the same time were added the interior walls that form the small papal apartment and chapel within the main block. The first structure, therefore, was essentially a loggia-pavilion for afternoon or early evening repasts and seclusion during the summer. Soon after its completion the pavilion was converted into a villa by the addition of the service wing at the southeast, the incorporation of a small papal apartment in the eastern end, and a chapel and sacristy in the western end of the original building. There is no sure documentation for the date of this change, but the inscription painted in the gallery recording that Innocent VIII "founded" it in 1487 probably refers to this alteration rather than to the commencement of the decoration.[7]

The villa is set with its main block running east to west and with two small wings projecting to the north. These wings are not symmetrical in size, for the one at the western end projects more than twice the length of the eastern one. The reason for this lack of symmetry is generally attributed to an effort to make the building conform to the irregularity of the site. As the northern terrace and flanking wings are partially built out over the escarpment, however, this explanation does not consider the fact that symmetry might have been gained by building out the eastern end of the escarpment as was done at the western end. Since the principal value of the villa, as its name indicates, was its magnificent view, the explanation of its asymmetry may be

related to this. The end wings are to help protect the main loggia from winds, but if the eastern wing had projected as far as its companion, much of the breathtaking view out over the Prati would have been cut off. The view to the west toward Monte Mario was limited in comparison to the panorama to the north and east over the Prati to the distant Sabine hills focused on Monte Soratte.

Innocent VIII soon converted his loggia-pavilion into a suburban villa. In the southwestern corner a small chapel and an adjacent sacristy were created in the bay of conjunction of the main loggia and the northern wing, leaving the northern wing as an independent loggia. A portal led from the main loggia into the sacristy and then into the chapel. The eastern wall of the chapel had a window into the main loggia so that Mass being said in the tiny chapel could be heard in the loggia. The altar stood against the western wall opposite this window with a tondo window in the lunette above it.

The papal apartment of five rooms was fashioned in the eastern end of the pavilion by closing, except for windows, the two eastern arches of the principal loggia and introducing interior walls and fireplaces. A secondary service wing was then added at the southeastern corner, but later alterations to this wing prevent any knowledge of its original disposition.

Soon the decorative program of the villa was underway. In a letter of April 24, 1488, to the Marquis of Mantua, the painter Andrea Mantegna indicated a desire to be

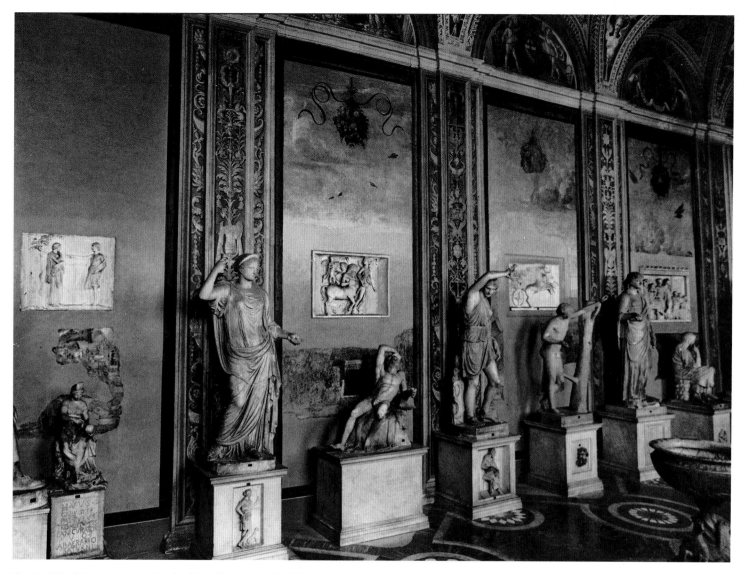

Fig. 2. Villa Belvedere, main loggia (3 on Diagrammatic Plan, p. 59) (photo: Archivio Fotografico, Musei Vaticani)

released for duty, undoubtedly in Rome, and on June 10, 1488, the marquis sent Mantegna to Pope Innocent VIII accompanied by a letter of introduction.[8] It was probably on the recommendation of Cardinal Giuliano della Rovere, the future Pope Julius II, that Mantegna was invited to Rome, since, as early as February 1484, the cardinal had endeavored to lure Mantegna there, and during the papacy of Innocent VIII the cardinal was the most influential individual at the papal court.[9] From June 1488 until September 1490 Mantegna was active in Rome in the employ of the pope. Another artist who worked in the Belvedere, according to Vasari's much later account, was the younger Umbrian painter Pinturicchio, who decorated "some rooms and loggias in the palace of the Belvedere, where, among other things, as the pope desired, he painted a loggia full of landscapes and portrayed there Rome, Milan, Genoa, Florence, Venice, and Naples in the

manner of the Flemings."[10] It has generally been assumed that Pinturicchio began the landscape paintings of the loggia in 1487, with the minor decorative painter Piermatteo d'Amelia and other artists executing the lunettes of the loggia, and that Andrea Mantegna came independently in the middle of 1488 to fresco the small chapel and sacristy at the western end of the villa. Since the work of Piermatteo d'Amelia cannot be precisely dated, however, and the 1487 inscription probably refers to the architectural renovation of the villa, it is very possible that Mantegna was selected early in 1488, as one of the most famous Italian painters of the period, to be the master in charge of the decoration, and that Pinturicchio, Piermatteo, and other unknown artists joined him to help carry out the program. In fact, in a letter of June 15, 1489, Mantegna complained that the work was too much for one man alone, and, as has been pointed out, such a complaint

| Innocent VIII and the Villa Belvedere

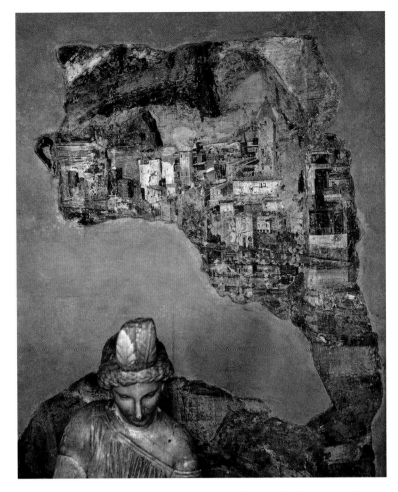

Fig. 3. Villa Belvedere, main loggia, fragment of landscape (photo: Archivio Fotografico, Musei Vaticani)

seems very unlikely to be caused by a commission involving only the decoration of the very tiny chapel and sacristy.[11] It may also be significant that Raffaele Maffei in 1506 in the earliest reference to the decoration of the villa mentions only Mantegna and does not limit his contribution to the chapel.[12]

Illusionism is the most striking characteristic of most of the decoration of the Villa Belvedere, thus strengthening the suggestion that Mantegna was the master in charge of the entire decorative program.[13] The chapel and sacristy (Diagrammatic Plan, p. 59, 1 and 2) decorated by Mantegna himself were destroyed in the eighteenth century, so that our knowledge of them is based only on the literary descriptions of that time. In the sacristy a ceiling coffered with various geometric forms was decorated in the grotesque style, while the walls were treated illusionistically, with pilasters feigned in paint dividing the walls into compartments in which were depicted open cupboards with the various liturgical paraphernalia found in a sacristy, such as chalices, censers, pyxes, and miters. The adjacent chapel, entered from the sacristy, was dedicated to St. John the Baptist, as

indicated by the paintings and also by a dedicatory inscription dated 1490 on the east wall, which also recorded that the chapel was painted by Andrea Mantegna.

The decorative program of the chapel is not unusual but does understandably contain references to its owner, the pope. The dedication to the Baptist reflects this, since St. John was his name-saint. The bust depictions of the martyrs St. Stephen and St. Lawrence and the hermit saints Anthony Abbot and Paul on the entrance wall are probably also personal references. Of Stephen and Lawrence, who are often paired as the first notable Christian martyrs, the latter was dear to Innocent VIII, because as cardinal his titular church had been San Lorenzo in Lucina. In the same way, of the pair of hermit saints, Innocent held St. Anthony Abbot in special reverence. For the papal coronation in 1484, the artist Antoniazzo Romano painted twenty-five images of St. Anthony for the new pope's room at the Vatican, and in 1486 Piermatteo d'Amelia was paid for painting two figures of St. Anthony in the "secret garden" and one painting of St. Anthony in the "loggia near the well." It has been further suggested that these eremitical saints were chosen in reference to the Belvedere as a contemplative retreat beyond the activity of the Vatican Palace.[14] Even later stories, perhaps legendary only in part, connect several of the figures of the Virtues in the lunettes below the vault to the personality of the pope.[15]

The main loggia of the villa (Diagrammatic Plan, 3), originally about 18.75 meters long by 6.5 meters wide, had its closed rear or southern wall and end walls compartmented by pilasters feigned in paint to match the open arcade on the northern side (Fig. 2). Before the eighteenth-century alterations, there were six bays on each of the long walls and two on each of the end walls. The areas between the pilasters on the southern wall were painted with a continuous landscape illusionistically suggesting that the wall was open to match the northern side. The end walls are now lost, and only fragments (drastically repainted and restored) of five compartments on the back wall are preserved. These landscapes presumably are the remains of those attributed to the painter Pinturicchio by Vasari, who states that the cities of Rome, Milan, Genoa, Florence, Venice, and Naples were depicted in them. Vasari, therefore, expanded on the earlier notice of Albertini, written by 1509 and published in 1515, that "the most famous cities of Italy" were represented.[16] The present fragments, however, seem rather to be landscapes of fantasy with no identifiable references to specific sites (Fig. 3), except for a small fragment

in the third bay from the east end, which depicts the northern elevation of the Villa Belvedere itself (Fig. 4).[17]

Above each wall compartment of the loggia was a lunette, again decorated illusionistically as if open, with a glimpse from below of thick arches under which sport pairs of winged putti as supporters of various attributes. Only seven of these lunettes are now preserved with some approximation of their fifteenth-century decoration, that is, the two lunettes above the eastern end of the loggia and the five on the rear, southern wall commencing at the eastern end. Three different sets of attributes are presented by the putti in the lunettes: two lunettes have the papal arms, two more have the *impresa* of Innocent VIII of a peacock exposing the multicolored fan of his tail with the motto "Leauté passe tout," and the other three lunettes have putti joyously making music on lute, pipe, drum, harp, trumpet, and bagpipe (Fig. 5). The other lunettes, which are destroyed or completely repainted, continued the same pattern except for the two lunettes at the western end of the loggia above the wall of the chapel and sacristy, which contained half-length figures of St. John the Baptist and St. John the Evangelist appropriate to the dedication and function of these rooms, but our knowledge of these lunettes is solely literary, as they were destroyed with the chapel in the late eighteenth century. Over the loggia is a very decorative, repainted vault with arabesques painted to imitate stucco (Fig. 6). The four vaults toward the east of the loggia remaining from the original decoration have in their centers large tondi with flaming suns on which are superimposed the arms of Innocent VIII within a laurel wreath. Between these large tondi are smaller ones with mythological depictions in grisaille, four of which seem to represent Ganymede with the eagle, Leda with the swan, Europa with the bull, and Daedalus and Icarus.

The first room of the papal apartment (Diagrammatic Plan, p. 59, 4), adjacent to the eastern side of the loggia, had its walls compartmented by columns feigned in paint, between which were again open cupboards, as in the sacristy. These cupboards were painted to contain the objects of a study, including books, vases, and a cage with a parrot. The depiction of a parrot was probably not mere whimsy, as there was a tradition since the Middle Ages that one room of the papal apartment was entitled the *Camera del Papagallo*, in which presumably the papal parrot was kept. There was such a room in the Vatican Palace, a similar one was provided by Pope Paul II in his Palazzo Venezia, and there was one in the Apostolic Palace at Bologna.[18] The rooms "of the parrot" in the Vatican Palace and the Palazzo

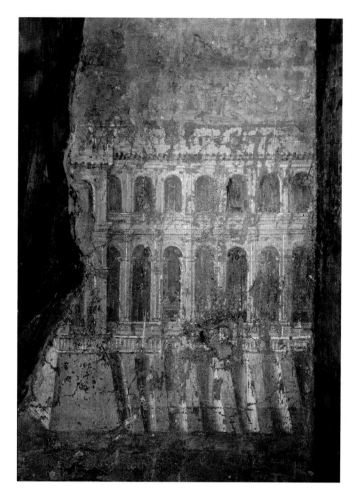

Fig. 4. Villa Belvedere, main loggia, fragment of landscape showing northern elevation of the villa (photo: Archivio Fotografico, Musei Vaticani)

Venezia seem to have served the same function, as semiprivate rooms between the inner, private apartment of the pope and the public, ceremonial rooms. Unfortunately the wall decoration of this room in the Belvedere was destroyed in the eighteenth century. Slightly later, Pinturicchio painted the walls of the Sala dei Misteri of the Borgia Apartment in the Vatican Palace with similar open cupboards containing a few objects, including the papal tiara of Alexander VI, but probably a closer approximation to the appearance of the Belvedere decoration is offered by the much later Sala della Gloria in the Villa d'Este at Tivoli, where also the small chapel has a window opening into a large adjacent room like the arrangement in the Belvedere.

Of the lunettes above the walls in the first room of the papal apartment of the Belvedere, those on the longer eastern and western walls have been destroyed or revised, presenting now only the arms of Innocent VIII supported by angels, but the pairs of lunettes on the northern and southern walls, although repainted, preserve an idea of the original decoration. Each of these four lunettes contains a pair of half-length figures, presumably of prophets,

| *Innocent VIII and the Villa Belvedere*

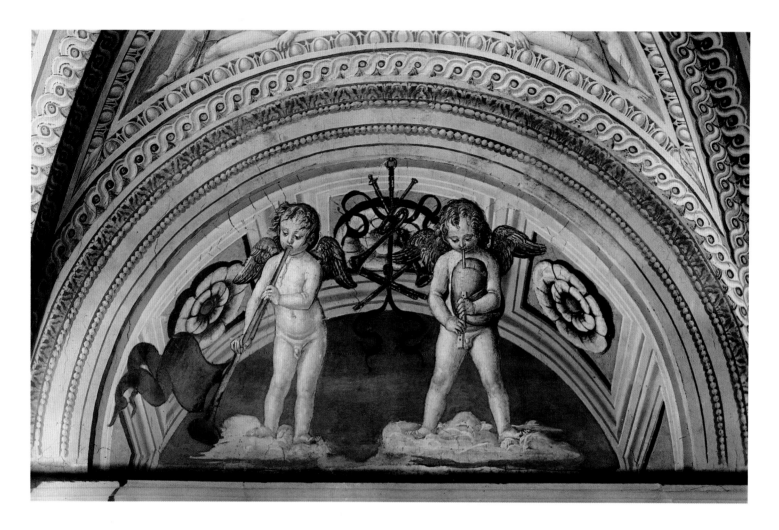

as two of them wear foreign headdresses and they all have long banderoles, which now lack any inscription, but they have no haloes (Fig. 7). The remaining four prophets, who are now missing, must have been in the central lunettes of the long walls. The vault is an elegantly coffered one centered around the arms of Innocent VIII against a rayed sun, as in the loggia (Fig. 8). Around the coat-of-arms are two coffers with Innocent's *impresa* of the peacock and four coffers with female figures playing or holding musical instruments.

The adjacent room to the east (Diagrammatic Plan, p. 59, 5), although slightly narrower than the Room of the Prophets, was similarly organized for decoration. The walls, now lost, were compartmented by illusionistically painted, freestanding columns. Of the original ten lunettes above, only eight are now preserved, and several of these have been extensively repainted. Two on the western side have the papal arms; the remaining six have half-length

male figures. As the figure on the northern end of the eastern wall points to a tablet with geometric figures that he holds with his left hand (Fig. 9), he must be a noted geometer, such as Euclid, and the figures therefore probably represent the Seven Liberal Arts, although their identifying symbols are now so scant or repainted as to prevent sure identification. The figure who examines a globe (Fig. 10) may be an astronomer, however, such as Ptolemy, although he now does not have the crown that the Renaissance generally attributed to him, or Gionitus, son of Noah, as depicted on the Campanile at Florence. Among the figures preserved there is none who would seem to be associated with music, but, as we shall see, this omission is explained by the decoration of an adjacent room. The barrel vault above the lunettes bears the papal arms in the center surrounded by six panels in the shape of Greek crosses, all the fields filled with delicate arabesque decoration in gold against blue.

Beyond the Room of the Liberal Arts was a smaller room (Diagrammatic Plan, 6) which communicated on the south to the service wing and on the north opened into an even smaller room. Each of these small rooms had

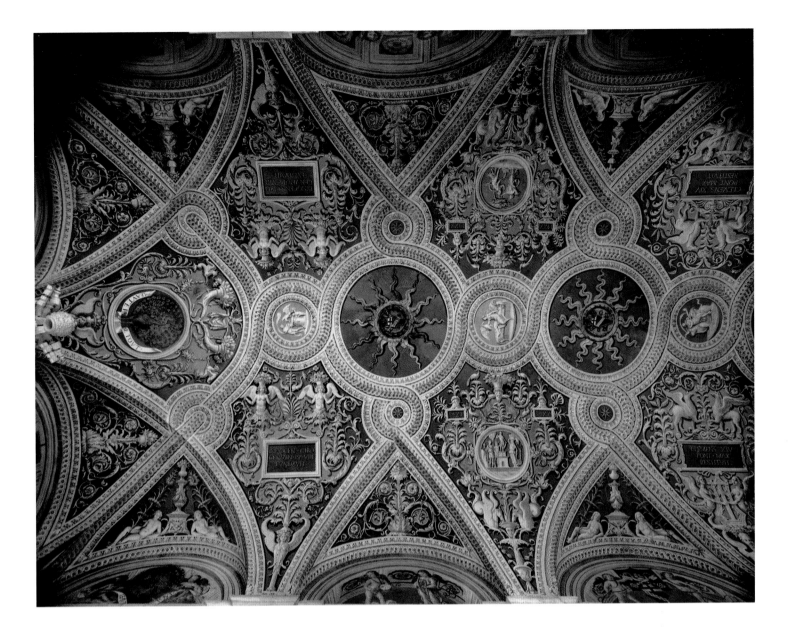

Fig. 6. Villa Belvedere, main loggia, vault with arabesques (photo: Archivio Fotografico, Musei Vaticani)

a single window in its eastern wall, but eighteenth-century accounts of their decoration are very modest. It has been suggested that the smaller, inner room (Diagrammatic Plan, 7) might have served as the pope's bedroom.[19]

On the north a small loggetta (Diagrammatic Plan, 8) also opened from the Room of the Liberal Arts by a portal and a window that introduced indirect light into the latter room. Although the walls of the loggetta were broken by doors and windows, there were pilasters feigned in paint, between which were small landscapes with buildings and hunting scenes. The decoration of the four lunettes with papal arms or fruit festoons was not unusual except for the lunette over the portal and window into the Room of the Liberal Arts, which still depicts a choir of half-length, singing male figures (Fig. 11). The group of eight young and old choristers centers around an elderly monk holding a

large choirbook, while a youth at the right presents a scroll covered with musical notation. This lunette probably represents the art of music, which is missing in the adjacent Room of the Liberal Arts.

The loggetta at the northeastern corner of the villa opened upon the terrace that ran along the northern side of the building. At the northwestern end of the terrace was a larger, open loggia (Diagrammatic Plan, 9) compartmented on the interior by Doric pilasters with marble capitals and bases, between which were again depicted landscapes.

The decorative program of the Villa Belvedere had at least two notable features. Vasari noted much later that the

Innocent VIII and the Villa Belvedere

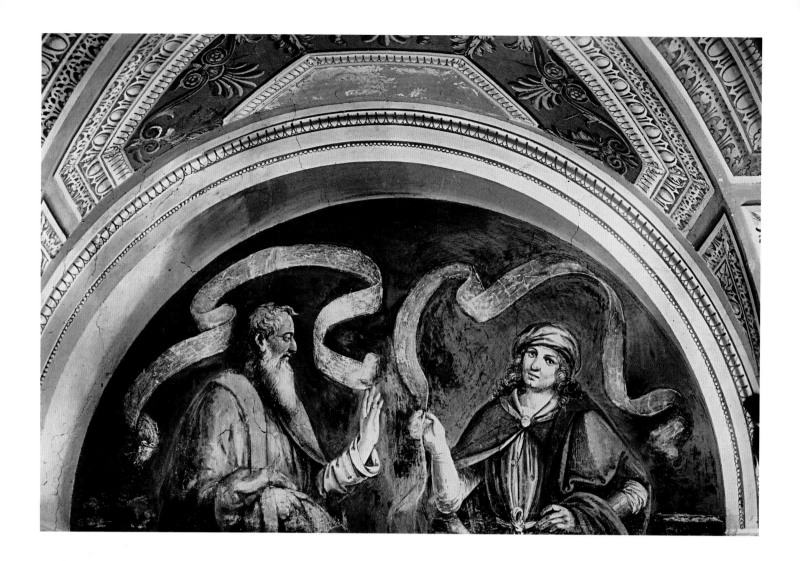

Fig. 7. Villa Belvedere, Room of the Prophets (4 on Diagrammatic Plan, p. 59), lunette with prophets (photo: Archivio Fotografico, Musei Vaticani)

landscapes painted in the principal loggia were unusual for the late fifteenth century in Rome and credited them to the pope's own desire. In fact, not only was the main loggia decorated with landscapes, but so were the smaller loggias. This is not surprising, however, since the two books that were most concerned with architecture and its decoration, published shortly before the creation of the Villa Belvedere, advocated such decoration. The ancient treatise on architecture by the Roman Vitruvius, which first appeared in print at Rome probably in 1486, mentions that in antiquity covered promenades like the large loggia of the Belvedere, because of the length of their walls, were decorated with landscapes depicting "harbors, promontories, shores, rivers, springs, straits, temples, groves, mountains, cattle, shepherds" (VII.v.2), rather like the pathetic fragments of landscape revealed recently in the restoration of the Belvedere. In a similar fashion Alberti, in his *De archi-*

tectura, published at Florence in 1485, says—probably echoing Vitruvius—that for villa decoration he finds delight in landscapes of "pleasant regions, harbors, fishing, hunting, swimming, country sports, flowery and shady fields" (IX, iv). The eighteenth-century descriptions of the landscapes in the smallest loggia particularly mention hunting scenes. In another passage on decoration in the same section of Alberti's treatise, he admires the depiction of architectural columns on walls, suggestive of the illusionistic decoration found in many rooms of the Villa Belvedere. There are also other remarks by Alberti on the villa that seem fitting to this first Roman Renaissance villa, for he wishes a villa to stand on the summit of an easy ascent that suddenly opens up at the site to a wide prospect (IX, ii), and within the villa he recommends that the first room to be reached after the entrance should be the chapel (V, xvii), which is also true in the Belvedere. In terms of the physical orientation of architecture, Alberti tends to be very pragmatic and to adapt the orientation to the particular geographical situation. Vitruvius, however, is more dogmatic on this point, and it may have been his

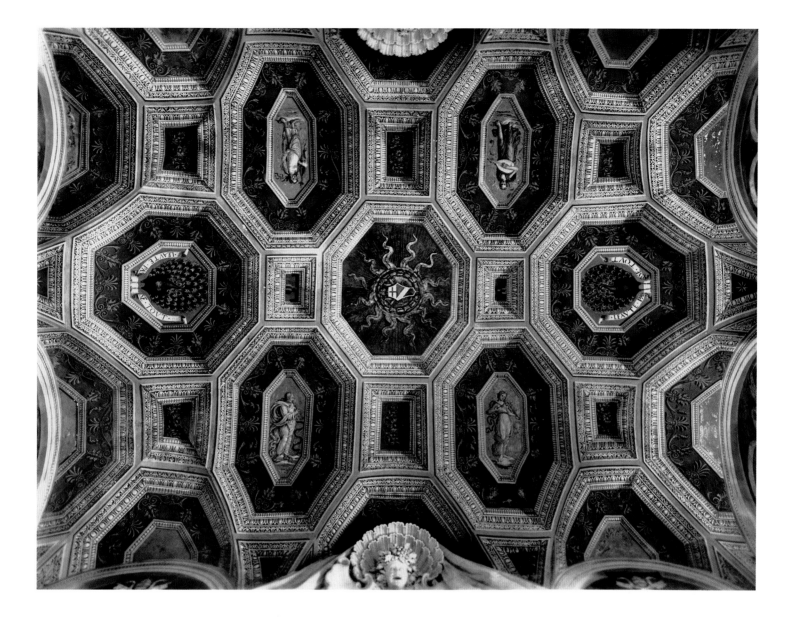

Fig. 8. Villa Belvedere, Room of the Prophets, ceiling (photo: Archivio Fotografico, Musei Vaticani)

dicta that guided the siting of the Belvedere. Vitruvius insisted that in southern regions oppressed by heat a building should be opened toward the north and northeast (VI.i.2). It may be accidental, but it is interesting in this regard that, while in general the Villa Belvedere faces northward, it is also turned slightly off the northern axis to the east. Vitruvius also suggested that private rooms and libraries should be on the east to receive the morning light (VI.iv.1), and in the Belvedere the papal apartment was added to the eastern end of the loggia-pavilion.

The other unusual feature of the decoration of the Belvedere is the frequent reference to music. In the principal loggia, while two-thirds of the lunettes contain personal references to the pope either in terms of his papal arms or his *impresa* of the peacock, the remaining lunettes have music-making putti. Similarly, in the neighboring Room of the Prophets, the vault contains four music-making figures complementing the arms and *impresa* of the pope. Then in

the small, private loggia off the pope's apartment is the large lunette decorated with a singing choir. This emphasis on music in the decoration may be explained, as indeed may the creation of the villa, by the state of the pope's health.[20]

During his entire pontificate Innocent VIII experienced precarious health. He was elected pope on August 29, 1484; the first record of illness was early in October 1484, but the diary of Burchard, the papal master of ceremonies, and the Roman chroniclers constantly note attacks of fever thereafter. At least three times—in March 1485, January 1486, and again in August and September 1490—the severity of the pope's illness was so grave that rumors of his death spread in Rome.[21] Because of war or ill health Innocent VIII was never able to fulfill his vow to visit the sanctuary of the Santa Casa at Loreto or other cities of the

| *Innocent VIII and the Villa Belvedere*

Fig. 9. Villa Belvedere, Room of the Liberal Arts (5 on Diagrammatic Plan, p. 59), lunette with geometer (photo: Archivio Fotografico, Musei Vaticani)

Fig. 9. Villa Belvedere, Room of the Liberal Arts (5 on Diagrammatic Plan, p. 59), lunette with geometer (photo: Archivio Fotografico, Musei Vaticani)

Fig. 10. Villa Belvedere, Room of the Liberal Arts (5 on Diagrammatic Plan, p. 59), lunette with astronomer(?) (photo: Archivio Fotografico, Musei Vaticani)

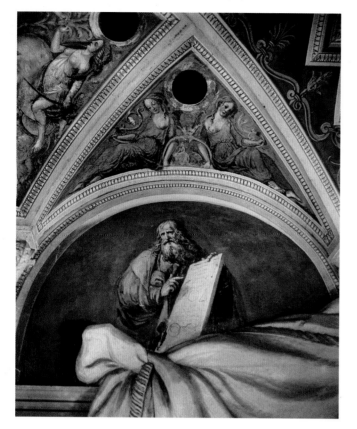

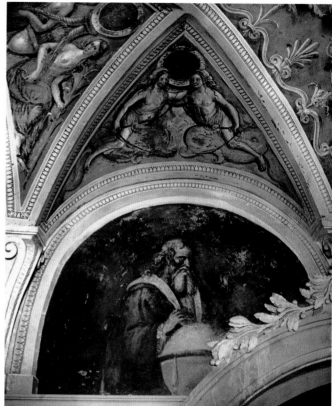

Papal States, and his only visits outside of Rome were to Ostia or La Magliana. The solution for Innocent VIII was offered by Alberti in his treatise on architecture when he wrote: "Doctors advise that we should enjoy the freest and purest air that we can; and, it cannot be denied, a villa situated high in seclusion will offer this" (IX, ii).

Since at least late antiquity music was considered to have therapeutic powers. Avicenna's *Canon of Medicine*, which was the standard medical handbook for the late Middle Ages and Renaissance and which was first printed in 1473, listed "sweet song" as one of the sedatives for pain (bk. I, fen. IV, chap. 30). The Renaissance Neoplatonic renewal of interest in the theory of macrocosm-microcosm strengthened this belief.[22] In fact, when Pico della Mirandola was at Rome from at least November 1486 to August 1487 to present his controversial theses, the role of sympathetic magic in terms of music and words was involved in the argument. For Pico, "as medicine cures the spirit by means of the body, so music does the body by means of the spirit."[23] Bishop Pedro García, who was a member of the papal commission

that examined the theses and condemned thirteen of them, admitted that the musical harmony of sounds might cure bodily infirmities but denied such powers to words as Pico had held.[24] Similarly, Marsilio Ficino wrote in his *De vita triplici*, published in 1489, that music and song affected the human spirit and brought it into conformity with the celestial harmony, referring to David's curing the insanity of Saul by his music.[25] In his book Ficino also considered astrology and how one might attract the benign influences of the planets. Even Pope Innocent VIII was interested in astrology, according to a letter of the Milanese court astrologer to Ludovico il Moro, which indicates that the pope had requested the duke to find out from his astrologer the future health of the pope. The answer in the letter dated July 20, 1492, forecasts the imminent death of the pope, which did occur on July 25.[26]

Two contemporary events reveal that the concept of the therapeutic power of music and its ability to relieve pain prevailed at the court of Innocent VIII. In 1489 Gabriele Zerbi of Verona, a professor of medicine at the

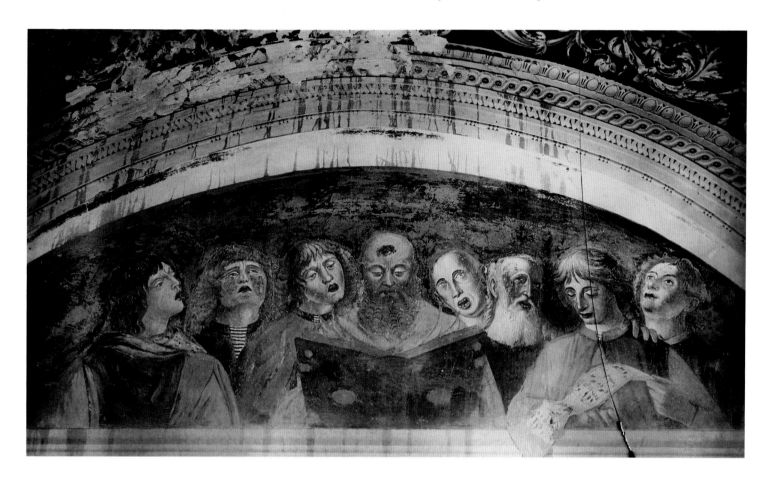

University of Rome, published a treatise on old age, entitled *Gerontocomia*, and dedicated it to the pope.[27] In the treatise Zerbi discusses all the living conditions beneficial to old age, including a detailed consideration of the effects of every possible food and drink. Toward the end of the book, in chapter 42, Zerbi claims that "music is the most powerful of the arts, and harmony has the admirable virtue of lessening the pains of human souls and of making them pleasant? *(Potentissima artiū musica est et mirificam habet virtutem armonia ad mitigandos dolores animarum humanorum et ad letifacandas ipsas).* He then develops the theme with references to Plato, Aristotle, Galen, Avicenna, Aesculapius, and the account of David and Saul.

So a year later, in a letter of August 17, 1490, a Florentine living in Rome records that he was called the previous day to the bedchamber of Pope Innocent VIII, who was rumored to be on his deathbed, and requested to play his viol just outside the entrance to the room until he was summoned by the pope himself to enter, where he remained an hour and a half. As this happened during the summer month of August, it is possible that this event occurred in the Villa Belvedere, although there is no proof. In fact, a few days previously, the same Florentine noted that he had been chatting at a table "in a shady loggia," suggestive of the Belvedere, with the Princess of Bisignano and the pope's daughter, Teodorina, whom he also saw later in the papal bedchamber nursing her father.[28]

It is probable, therefore, that Innocent VIII began the Villa Belvedere as a recuperative retreat after his long and serious illness commencing in March 1485.[29] At first this retreat was merely a pavilion for the enjoyment in the afternoon or early evening of the cool, northern exposure; but, as his health was continually threatened, Innocent transformed the pavilion into a private villa where he might dwell accompanied by only a small, intimate entourage. The decoration of the villa, undertaken probably under the direction of the painter Mantegna, then included frequent references to music as the art of harmony, bringing relief to the human soul and body—appropriate to a setting for physical recuperation.

Notes

1. *Diario della città di Roma di Stefano Infessura scribasenato,* ed. O. Tommasini (Rome, 1890), 279.

2. E. Müntz, "L'architettura a Roma durante il pontificato d'Innocenzo VIII," *Archivio storico dell'arte* 4 (1891), 459. Müntz, in *Les Arts à la cour des papes Innocent VIII, Alexandre VI, Pie III* (Paris, 1898), 77–78, claimed that a document of April 6, 1485, for the purchase of a vineyard "located behind the tribune of the Prince of the Apostles" marks the acquisition of land for building the villa, but, as later scholars have noted, the location of the land behind St. Peter's does not correspond to that of the villa.

3. E. Müntz, "Nuovi documenti: le arti in Roma sotto il pontificato d'Innocenzo VIII (1484–1492)," *Archivio storico dell'arte* 2 (1889), 480–481.

4. Müntz, "L'architettura a Roma" (note 2 above), 460. Recently the mysterious architect Baccio Pontelli has been suggested as the possible designer on the basis of a resemblance of the Villa Belvedere to the cloister of Santa Chiara at Urbino designed by Pontelli's master, Francesco di Giorgio; see C. L. Frommel, *Die Farnesina und Peruzzis architektonisches Frühwerk* (Berlin, 1961), 100–101. This resemblance, however, does not seem close enough to clarify the problem of the attribution.

5. For the drawings, see C. Pietrangeli, "Il Museo Clementino Vaticano," *Rendiconti della Pontificia Accademia Romana di Archeologia,* ser. 3, 27 (1951–52), 93–97. The descriptions are A. Taja, *Descrizione del Palazzo Apostolico Vaticano* (Rome, 1750), and G. P. Chattard, *Nuova descrizione del Vaticano,* 3 vols. (Rome, 1762–67).

6. D. Redig de Campos, "Il Belvedere d'Innocenzo VIII in Vaticano," in *Triplice omaggio a Sua Santità Pio XII* (Vatican City, 1958), vol. 2, 296–304.

7. The document of payment on Sept. 22, 1487 (see above, p. 58) for the completion of masonry walls in the vineyard might possibly belong to this work, but the lack of mention of "palace" or "house" in the document makes this unlikely.

8. W. Braghirolli, "Alcuni documenti inediti relativi ad Andrea Mantegna," *Giornale di erudizione artistica* 1 (1872), 201; the other letters regarding Mantegna are best published in C. D'Arco, *Delle arti e degli artefici di Mantova* (Mantua, 1857), vol. 2, 19–24.

9. G. Vasari *Le vite de' più eccellenti pittori, scultori ed architettori,* ed. G. Milanesi, vol. 3 (Florence, 1878), 396 and 398, n. 2. Regarding the position of Cardinal della Rovere, see L. von Pastor, *The History of the Popes,* vol. 5, 2nd ed. (St. Louis, 1912), 242.

10. Vasari, *Le vite* (note 9 above), 498.

11. S. Sandström, "Mantegna and the Belvedere of Innocent VIII," *Konsthistorisk Tidskrift* 32 (1963), 122; the letter is published in D'Arco, *Delle arti* (note 8 above), 21, no. 24.

12. *Commentariorum Urbanorum* (Rome, 1506), vol. 2, fol. CCCr: "Andreas Mantegna Mantuanus edes quas Beluedere cognominant in Vaticano ab Innocentio VIII adibitus ornauit miro tenuitatis opere."

13. The most recent discussions of the artists and decorative program of the Belvedere are: S. Sandström, "The Programme for the Decoration of the Belvedere of Innocent VIII," *Konsthistorisk Tidskrift* 29 (1960), 35–75; C. Pietrangeli, "Mantegna in Vaticano," *L'Urbe* 24 (1961), 95–103; J. Schulz, "Pinturicchio and the Revival of Antiquity," *Journal of the Warburg and Courtauld Institutes* 25 (1962), 35–55; and Sandström, "Mantegna and the Belvedere" (note 11 above), 121–122.

14. Sandström, "Programme for the Decoration of the Belvedere" (note 13 above), 54. For the depictions of St. Anthony, see Müntz, "Nuovi Documenti" (note 3 above), 478 and 480.

15. A dialogue published in 1513 by Mantegna's friend Battista Fiera, entitled *De iusticia pingenda,* reveals Mantegna's concern, presumably during his activity in Rome, regarding how the personification of Justice must be depicted. When his interlocutor questions why Justice should be depicted at all, Mantegna replies that "he who can order anything, commanded it"; see B. Fiera, *De iusticia pingenda,* ed. and trans. J. Wardrop (London, 1957), 11–12. There is also the story, first published by Paolo Cortese, *De cardinalatu* (Rome, 1510), fol. 87, and later in Vasari, of Mantegna's painting in the Belvedere Chapel a personification of *Discrezione* as a hint to the pope of his expectation of reward, which was countered by the pope's injunction to paint a complementary personification of *Pazienza.* The latter story especially seems legendary, although Mantegna's letters at the time of his work likewise indicate his concern for reward, but in any case these early stories suggest a tradition of personal involvement by the pope.

16. *Opusculum de mirabilibus nouae et veteris urbis Romae* (Rome, 1515), fol. 91v. The suggestion (Sandström, "Programme for the Decoration of the Belvedere" [note 13 above], 39) that the landscapes with views as defined by Vasari were to honor the attempt by Innocent VIII in late 1486 and early 1487 to reconcile the other five city states with the papacy rests on very tenuous grounds. The peace treaty of August 1486 did not involve Venice and, as von Pastor indicates (*History of the Popes* [note 9 above], vol. 5, 264–265), the agreement was broken by Naples before the end of September, although not formally repudiated until May 1487.

17. For accounts of the restoration of the landscapes, see B. Biagetti, "II. Relazione: Pitture murali," *Rendiconti della Pontificia Accademia Romana di Archeologia,* ser. 3, 15 (1939), 248–252; and B. Nogara and F. Magi, "I. Relazione," in ibid., ser. 3, 23–24 (1947–49), 363–369. For the fragment depicting the Belvedere, see D. Redig de Campos, *I Palazzi vaticani* (Bologna, 1967), 77.

18. F. Ehrle and E. Stevenson, *Gli affreschi del Pinturicchio nell'Appartamento Borgia* (Rome, 1897), 14–16; and H. Diener, "Die 'Camera Papagalli' im Palast des Papstes," *Archiv für Kulturgeschichte* 49 (1967), 43–97.

19. Sandström, "Programme for the Decoration of the Belvedere" (note 13 above), 70.

20. The emphasis on music was noted in [L. Raffaele], *Un pittore ignoto di cantori nel palazzetto privato di Innocenzo VIII in Belvedere: per le nozze della Signorina Ildina Berghi con Guido Raffaele* (Rome, 1926), but not explained. It

was William Rhoads, now of the State University of New York at New Paltz, who in a graduate report in 1967 first suggested a possible relationship between the emphasis on music and the health of the pope.

21. Von Pastor, *History of the Popes* (note 9 above), vol. 5, 247–248, 259, 280–282, and 317–318.

22. For some general accounts, see L. Thorndike, *A History of Magic and Experimental Science*, vol. 4 (New York, 1934); D. P. Walker, *Spiritual and Demonic Magic from Ficino to Campanella* (London, 1958); and G. Bandmann, *Melancholie und Musik* (Cologne-Opladen, 1960).

23. G. Semprini, *La filosofia di Pico della Mirandola* (Milan, 1936), 115.

24. L. Dorez and L. Thuasne, *Pic de la Mirandola en France (1485–1488)* (Paris, 1897); and Thorndike, *History of Magic* (note 22 above), 497–505.

25. *Opera Omnia* (Turin, 1959), vol. 1, 502; likewise the letters of Ficino to Musano (ibid., 609) and to Canigiani (ibid., 650–651); see also P. O. Kristeller, *Renaissance Thought*, vol. 2 (New York, 1965), 157–158.

26. F. Gabotto, "L'astrologia nel Quattrocento in rapporto colla civiltà," *Rivista di filosofia scientifica* 8 (1889), 382–383.

27. Probably as a result of his book, Zerbi's salary at the university was increased by Innocent VIII in March 1490 from 150 florins to 250 florins; see [G. L. Marini], *Degli archiatri pontifici*, vol. 2 (Rome, 1784), 238–239, doc. LXXVI.

28. C. Carnesecchi, "Il ritratto leonardesco di Genevra Benci," *Rivista d'arte* 6 (1909), 293–296.

29. Alberti also remarks in his treatise (IX, iv), under his discussion of the decoration of domestic architecture, that anyone ill with fever enjoys the depiction of springs and brooks. Unfortunately the landscapes of the smaller loggias, in which we might have particularly expected expression in line with Alberti's advice, are destroyed. In the same chapter, however, he likewise recommends mythological subjects, giving as an example the *Flight of Icarus* painted by Daedalus at Cumae, and Daedalus and Icarus are depicted on the vault of the main loggia. A minor sidelight may be offered by the record of a lost painting entitled *Melancholy*, attributed in the seventeenth century to Mantegna, which depicted sixteen boys playing music and dancing; see G. Campori, *Raccolta di cataloghi ed inventarii inediti* (Modena, 1870), 328.

4

Pope Marcellus II and Architecture

In the manuscript biography of Pope Marcellus II (1501–1555) written soon after his death by his half-brother Alessandro Cervini, the pope is described as being devoted during his youth to agriculture and the "mechanical arts": "Now drawing plans of castles and palaces; now working at the lathe; now with fire and with hammer he gave form to iron." Alessandro then adds that "in architecture and the knowledge of antique things he was second to none in his time, and there are still many living today who, like Sangallo or Buonarotti, would not disdain to listen to his counsel."[1] The correspondence of the pope indicates that this suggestion of his passionate interest in the mechanical arts, and particularly in architecture, is not merely a Renaissance encomium. In fact, his concern for architecture and the arts was to cause problems for many of the artists he encountered, and it endangered the creation of the church of St. Peter's at Rome.

Marcello Cervini was born in 1501 at Montefano in the Marches, where his father, Ricciardo Cervini of Montepulciano, was papal commissioner. Ricciardo, because of his knowledge of astronomy, astrology, and mathematics, was often consulted by the papal court at Rome. So at the bidding of Pope Leo X, he prepared a corrected calendar, which, according to his son Alessandro, was never published because of the death of Leo, and the corrected calendar would have to wait until the reign of Pope Gregory

XIII toward the end of the century.[2] Slightly later, Pope Clement VII at his accession in 1524 was very worried by the astronomers' prophecy of a great flood, and Ricciardo Cervini took this opportunity to introduce his son, Marcello, to the court, carrying his father's letter of assurance and proof that such a flood would not occur.

With this background it is understandable that Ricciardo Cervini personally oversaw the early education of Marcello, his eldest son and the only son of his first marriage, and that he followed the latter's career closely. There are still preserved numerous letters that Marcello Cervini wrote to his father from boyhood until his father's death in 1534. Most of the early ones reveal Marcello's very knowledgeable concern for horticulture and agriculture.[3] On February 16, 1534, however, just before the death of his father, Marcello wrote him that did not plan to marry, since he preferred to study without domestic hindrances. So he requested his father to leave him only one thousand ducats and to make his half-brothers, Alessandro and Romulo, sole heirs with the understanding that they should also provide him with an annual living of one hundred ducats.[4] Despite his announcement of withdrawal from domestic affairs the later correspondence with his half-brother Alessandro shows that Marcello would never cease to be interested in the family's welfare, quoting at times the price of grain at Siena or being advised about the *mezzadria* contracts for farming.[5]

Fig. 1. Antonio da Sangallo the Younger, plan of villa for Cardinal Cervini, Uffizi 1308A (photo: Gabinetto Fotografico, Soprintendenza per il Polo Museale Fiorentino, Firenze)

Among the letters to his father, however, are some concerned with Marcello's growing involvement at Rome with the circle of humanists and literary men. Already in December 1525 he asked his father at Castiglione d'Orcia to send him a copy of the Latin epigram commencing *Nymphis sacrum* recorded in one of his manuscripts from the church of San Giovanni at Bagni di Vignoni, adding that he wished to give it to the poet Lampridio.[6] A closer relationship was soon to be with the poet Angelo Colocci. On May 17, 1532, Marcello wrote that he was without any money and that he even had had to borrow money from Colocci.[7] The appointment of Colocci in September as secretary for papal briefs was noted with pleasure by Marcello, who in October pointed out to his father that Colocci's office might be helpful to them in a controversy with one Salvestro.[8] A year later Cervini was preparing a translation of the first book of Hero of Alexandria's Greek treatise *Pneumatica* from a manuscript owned by Colocci, and in September he returned the manuscript to Colocci with his partial translation.[9] Cervini, in turn, aided Colocci in 1536 by purchasing property from Colocci's son, Marc Antonio, so that the latter might keep his court office of *scriptor*.[10] Throughout their lives Colocci and Cervini remained close friends, with Cervini listed in Colocci's will of May 1, 1549, as its executor.[11]

By 1534 Marcello Cervini was busy at Rome as a secretary to Cardinal Alessandro Farnese, the future Pope Paul III, and in December Annibal Caro of the Farnese court noted that Cervini "is here everyday with us and turns out to be a splendid youth."[12] Part of the duties of Cervini was to oversee the affairs of the two youths, Alessandro Farnese and Guido Ascanio Sforza, nephews of Paul III, who were appointed cardinals in 1535 at the ages of fifteen and sixteen.[13]

| *Marcellus II and Architecture*

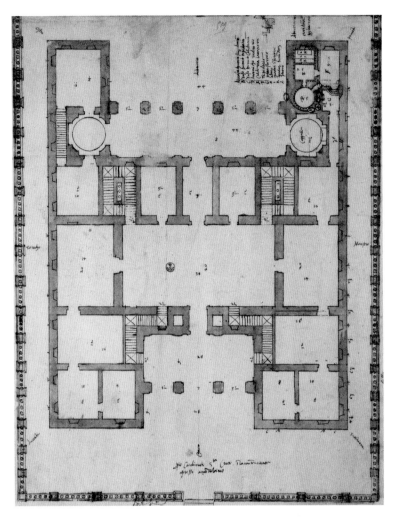

Fig. 2. Antonio da Sangallo the Younger, ground-floor plan of villa for Cardinal Cervini, Uffizi 828A (photo: Gabinetto Fotografico, Soprintendenza per il Polo Museale Fiorentino, Firenze)

It is at this time that Cervini's reputation as an authority on classical antiquity and architecture began to be remarked. The French architect Philibert Delorme, who studied in Rome from about 1533 to 1536, reports later in his treatise on architecture that Cervini approached him one day while he was measuring the ancient arch near Sta. Maria Nuova and invited Delorme to visit him to discuss architecture and antiquity.[14] It was Cervini apparently who urged Delorme to use the Roman *palmo* in his measurements rather than the French *pied du roi* and to study ancient Roman measurements, telling him of the existence of carved examples of the ancient Roman foot in the Capitoline collection and among the antiquities owned by Cardinal Galli.

On December 10, 1539, Pope Paul III appointed Cervini to be the cardinal of Santa Croce. During his absence from Rome, often on assignments from the papal court, he was kept well informed on architectural developments at Rome by his secretaries, Bernardino Maffei, who was to be elected cardinal in 1549, and Angelo Massarelli. Already in February 1540 Maffei reported that Sangallo's work on the new St. Peter's was proceeding with one hundred workmen who were refashioning the four great crossing piers, and by October 1544 Massarelli noted that the vault of the southern transept was two-thirds completed, and that he expected to see it finished within a month and a half.[15] Massarelli also sent extensive accounts of the work on the fortifications at Rome, beginning in May 1543 with the report that work had just commenced on the bastions on the far side of Santo Spirito, near the Porta Turrione.[16] By September and October 1544 the work was proceeding apace at the Castel Sant'Angelo and most of the circuit of walls protecting the Vatican Borgo.[17] On October 4, Massarelli noted that the new marble statue of the angel had been erected on the previous day atop the Castel Sant'Angelo and also reported the opening of a new street in the city from the bridge of Sant'Angelo to the Piazza of Montegiordano.[18]

In 1542 a group of scholars led by the Sienese gentleman Claudio Tolomei met informally at Rome to promote the study and publication of Roman antiquities, including an edition with commentary of the ancient treatise by Vitruvius on architecture.[19] Cardinal Cervini, because of his interest in classical antiquities and particularly in the publication of ancient texts, was undoubtedly one of the group.[20] He himself owned a manuscript of Vitruvius which Donato Giannotti promised in March 1541 to borrow to send to Pier Vettori in Florence, although it was only on June 18 that Giannotti could write Vettori that he had received that morning the cardinal's "corrected Vitruvius," which he would send as soon as he found transportation.[21]

At least by 1539 Cervini had promoted a project with the printer Antonio Blado to publish the Greek manuscripts in the Vatican Library, commencing in 1542 with the appearance of Eustatius's commentary to the first five books of Homer's *Iliad*.[22] In 1545, however, Cardinal Cervini was sent to Trent with Cardinals Pole and Del Monte as papal legates to the council entrusted with reforming the Church and attempting to reconcile it with the Protestant movement. Despite his absence from Rome he kept careful watch over the Vatican Library through his secretary Bernardino Maffei. Disturbed by the negligence of the library custodians, in 1548 he was empowered by Paul III to put the library management in order, with the cardinal's directions conveyed through Maffei, as letters of the latter in March and April indicate.[23]

With the cessation of the council and finally the election of Pope Julius III in 1550, Cardinal Cervini became more directly involved in the arts at Rome. As a familiar of the late Pope Paul III and as a member of the Congregation of Cardinals in charge of St. Peter's, Cervini was particularly entrusted with overseeing the design and location of the tomb of the former pontiff. Already on July 12, 1550, he wrote Cardinal Maffei, his former secretary, that he had received Maffei's letter enclosing designs and descriptions of the proposed tomb prepared by the sculptor Guglielmo della Porta.[24] Cervini was especially disturbed by what he considered to be the pagan rather than Christian character of some aspects of the design, suggesting that the large relief panels should depict something "less pagan." He adds that in the "new design," indicating that he has seen previous versions, he is pleased by the idea of being able to enter the tomb by three steps, but fears that with its width of nine *palmi* one would not actually be able to enter it.

Even more serious was the question of the location of the proposed tomb, which the Farnese party wished to erect as a freestanding tomb under the western dome arch at the entrance to the tribune of the new St. Peter's.[25] Even Michelangelo, as architect of the church, became involved and counseled the cardinals that the tomb should consist only of the seated bronze figure of the pontiff set in a niche. The controversy regarding the tomb persisted for almost a quarter-century, until in 1575 a reduced version with the seated figure flanked by two reclining figures of Justice and Prudence was at last to be erected in St. Peter's against the wall before the Cappella Gregoriana, following in general Michelangelo's counsel.

A month after Cervini's letter to Maffei regarding the Farnese tomb, in August 1550, Cervini also informed Maffei that he had received at Gubbio, where he had retired because of his health, a letter from the architect Vignola.[26] Cervini only mentions that he is unsure whether Vignola's letter is referring to some "first design" or to a second one, but in any case Cervini has sent the letter and drawings to his *guardarobba* to give to Maffei, since he, being in Rome, can listen to the "architects" and thereby convey Cervini's ideas better than Cervini can by letter. Vignola's letter is probably also concerned with the tomb, although it does not identify the project concerned. Cervini's question as to whether it is for the "first design" or for a second one would seem to relate the project to his earlier letter to Maffei regarding the tomb. If this is so, then the architect Vignola may have been involved in the architectural aspect of the project. Similarly, an undated letter of Michelangelo to an

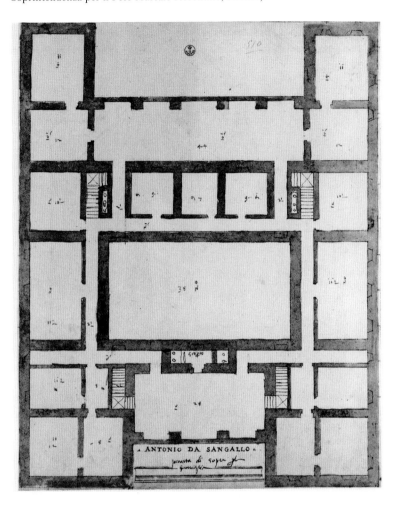

Fig. 3. Antonio da Sangallo the Younger, upper-floor plan of villa for Cardinal Cervini, Uffizi 829A (photo: Gabinetto Fotografico, Soprintendenza per il Polo Museale Fiorentino, Firenze)

unnamed cardinal regarding the principles of architecture has recently been very cogently identified as probably addressed to Cardinal Cervini at this time.[27]

Vasari claims that late in 1550 supporters of the deceased architect Antonio da Sangallo the Younger, who was Michelangelo's predecessor as architect of St. Peter's, had formed a conspiracy to denigrate Michelangelo's design. The death of Pope Paul III in November 1549 and the election of Pope Julius III was considered by them an opportune moment for one of them to replace Michelangelo in charge of the most prestigious architectural commission of the period. Among the followers of Sangallo, the leader was probably the sculptor-architect, Nanni di Baccio Bigio, who was particularly desirous of the appointment.[28] A meeting of the deputies of St. Peter's with Michelangelo was assembled by the pope late in 1550, presumably in late November or December after Cardinal Cervini's return from

| Marcellus II and Architecture

Fig. 4. Vivo d'Orcia, schematic plan of *borgo* and Villa Cervini

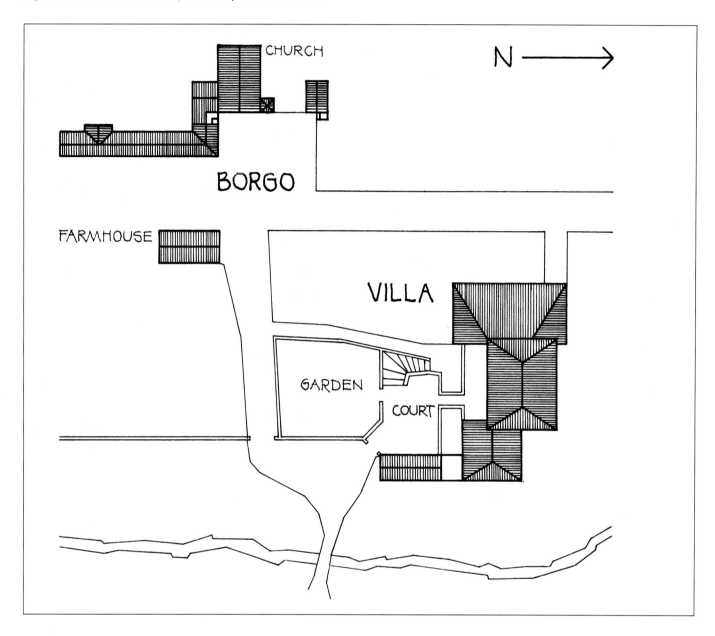

Gubbio. According to Vasari, two deputies, Cardinal Salviati the Elder and Cardinal Cervini, had complained to the pope about the lack of light in the southern transept arm of the church on the basis of misinformation from the Sangallo faction. At the meeting of the deputies with Michelangelo, Cardinal Cervini presented the accusation. When Michelangelo informed them that there were to be three more windows over the apsidal end of the transept, the cardinal replied: "You never told us that."[29] Michelangelo's answer was one that could only irritate Cervini, when he told him: "I am not nor wish to be obliged to tell you or anyone what I ought or wish to do. Your office is to obtain the money and to protect it from thieves, and as for designs of the building leave that charge to me." This reply would haunt Michelangelo five years later.

On March 23, 1555, Pope Julius III died, and Cardinal Marcello Cervini was elected his successor on April 10, 1555, as Pope Marcellus II. According to Vasari, again the Sangallo faction, and most particularly Nanni di Baccio Bigio, saw an opportunity to displace Michelangelo from the charge of completing St. Peter's.[30] Even Michelangelo, presumably recalling his contretemps five years previously with the new pope in his capacity as a deputy for St. Peter's, was apparently preparing to leave Rome and to return to

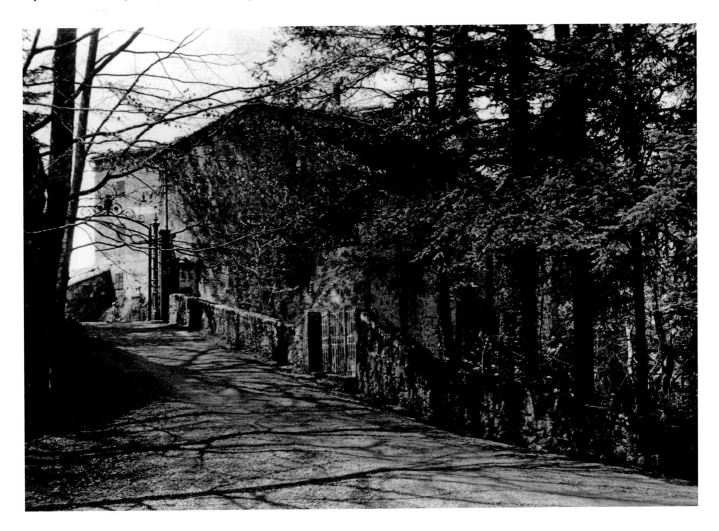

the service of Duke Cosimo I at Florence. The unexpected and sudden death of Pope Marcellus II on May 1, 1555, resolved the potential conflict over the building of St. Peter's, and on May 11, 1555, Michelangelo wrote Vasari to request the duke to allow him to continue at St. Peter's, since he was "almost ready to vault the dome."[31]

The passionate interest of Pope Marcellus II in architecture, which had in part contributed to his conflict with Michelangelo, is best illustrated in the correspondence regarding the Villa Cervini that he himself erected as a cardinal near Vivo d'Orcia. According to the Camaldolese annals, Cardinal Alessandro Farnese, who had obtained possession of the Camaldolese hermitage at Vivo d'Orcia on Monte Amiata in southern Tuscany, sold the land on March 1, 1538, to the Cervini family.[32] The sale, however, was not confirmed by the Camaldolese order until May 1541, when Cardinal Marcello Cervini took possession of

the land, which would become one of his favorite retreats, like the abbey at Gubbio. His possession of Vivo d'Orcia at this time is confirmed by his letter of August 19, 1541, to Angelo Colocci thanking the latter for an epigram he had composed honoring "mio Vivo."[33] At least by 1544, as Cervini's correspondence indicates, work was begun on a new villa for him erected just outside Vivo d'Orcia.

There are preserved at least four drawings by the architect Antonio da Sangallo the Younger of plans for a villa for Cardinal Cervini.[34] Two of the drawings (Uffizi 1308A and 1314A) present preliminary sketches. The drawing on the left side of Uffizi 1308A (Fig. 1) depicts the plan of a villa with projecting wings toward the southwest on the rear elevation. The center of the building was to have a huge, vaulted salon, as its inscription "coperto" indicates, opening onto a loggia at the rear between the projecting wings, and at the right of the salon was to be

the cardinal's apartment, labelled "Apartamento del per [sic] lo pater," with a chapel and baths in the west wing. Sangallo's major indecision was in terms of the entrance loggia toward the northeast, with three versions, ranging from a reentrant loggia to a projecting one. The sketch on the right of the drawing is principally concerned with dimensions but has introduced rooms between the rear loggia and the central void, which is now presumably to be a court, and has the entrance loggia set flush with the facade as in the facade of the fifteenth-century Medici villa at Poggio a Caiano designed by Sangallo's uncle. The incomplete drawing, Uffizi 1314A, is obviously just preliminary to the two finished drawings, Uffizi 828A and 829A, depicting the plans of the ground and upper floors.

In the ground-floor plan (Fig. 2) the villa is set on a balustraded podium surrounded by a moat over which a wooden bridge on the entrance axis offers access. Behind the entrance loggia, recessed between two slightly projecting wings, is a large, central void, presumably a central courtyard, and not a covered salon, as is suggested by the windows into it on the upper floor (Fig. 3). Symmetrically disposed in the four corners of the court are stairs to the *cantine* in the basement and to the upper floor, and at the rear a longer, six-bayed loggia opens at each end into a large, domed room, of which the one at the right was to serve as a chapel. From the cardinal's apartment at the right a long hall behind the chapel led back to the bathing

rooms in the west, rear wing on which Sangallo obviously expended particular care, inscribing each of the rooms and parts with names derived from the nomenclature of ancient Roman baths. This emphasis on classical antiquity may have been considered by Sangallo as particularly appropriate to the cardinal's interest at this time in the so-called Vitruvian Academy. The association in classical antiquity of a bathing establishment with a villa was known to the Renaissance from Pliny the Younger's letters describing his villas. Obviously inspired by Pliny, Raphael had planned a similar bathing suite in his project for the Villa Madama at Rome, where Sangallo had been his chief architectural assistant.[35]

The plan of the upper floor, labelled "pianta di sopra per la famiglia" (Fig. 3), is almost identical with that of the ground floor except for features of the latter like the baths and the chapel. Over the ground-floor loggias were to be upper loggias with piers closed by parapets. The rear stairs were to give access to a corridor encircling the central court whence windows introduce light into the corridor.

The drawings of the villa are certainly for Cardinal Cervini, as the inscription on the ground-floor plan reads: "For the Cardinal Santa Croce on Monte Amiata near Montalcino." Scholars have assumed that Sangallo's plans were created for the villa near Vivo d'Orcia, although the town of Montalcino inscribed on the drawing is some fifteen miles northwest of Vivo d'Orcia. Certainly Sangallo's plans have no resemblance to the present Cervini villa near Vivo d'Orcia, and it is very unlikely that a villa on a large podium entered from the northeast would have been at all feasible for the exact site of the present villa, which is set on the western side of a hill requiring steeply escarped buttressing on that side.

Because of Cardinal Cervini's absence from Rome from 1545 to serve as one of the papal legates to the Council of Trent, his correspondence and the diary of his secretary Angelo Massarelli offer some detailed accounts of the progress of building the cardinal's villa at Vivo d'Orcia. The earliest mention of the work is in a letter to the cardinal at Rome from his half-brother Alessandro on May 10, 1545, before the cardinal left for Trent.[36] After remarking that he has hired a couple to live at Vivo d'Orcia to provide food and to take care of

Fig. 6. Vivo d'Orcia, Cervini Borgo, farmhouse (photo: author)

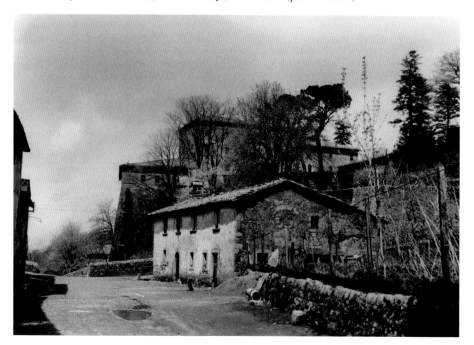

the garden, Alessandro is primarily interested in arranging to finance the work, much of the financing coming from the sale or exchange of iron ore mined in the area. He notes that the Casa del Mozella, one of the service buildings, has begun to be laid out and should be completed soon. On the preceding day eight workmen had commenced the great escarpment (*scarpa*) that was to buttress the western elevation of the villa, and the building material was prepared, the stone being cut and the lime ready. Although the basic structure was to be of brick, a preliminary estimate of the work suggested that, because of the numerous stone portals and windows on the facade, it would cost only a little more to build the facade of stone.

With the Spanish invasion of Sienese territory, Cervini, then at Trent, wrote his brother at Montepulciano on July 10 that in case of danger at Vivo he should prepare a bastion about the well where the palace was being created and send for arquebuses to protect their harvest.[37]

Massarelli's diary repeatedly notes the cardinal's concern with the design and building of his new villa.[38] On July 18 the two of them spent more than two hours discussing the site and commodity of the building. By October 12, after a day devoted to designing the villa, Massarelli prepared two clay models of the design. They met similarly on almost every successive day, until on October 16 Massarelli was requested to make "a second, last model." Nevertheless, the discussions continued almost daily, with that of October 20 lasting until four hours after sunset.

Anxious to learn about the progress of the work, on October 23 the cardinal wrote to Rome asking Ludovico Beccadello whether the weather had permitted him to visit the site.[39] In his reply of October 31 Beccadello gave an extensive report of his visit.[40] Arriving at Vivo very late on October 21, the following morning Beccadello had met Master Giovanni, presumably the builder in charge who was residing in the nearby iron foundry, to inspect the work in progress. Beccadello notes, however, that he would not furnish a detailed account of the work accomplished, since he was including with his letter "a painting and a drawing" depicting the work. Unfortunately neither painting nor drawing is preserved. Beccadello, however, was very discouraged with the slowness of work, "just like last year." He points out that the "design of the stairs toward the iron foundry, in accordance to Your Reverence's desire, appears to me too steep, since there is a great precipice and it will require much masonry and then lead with many turns not to the entrance of the house."

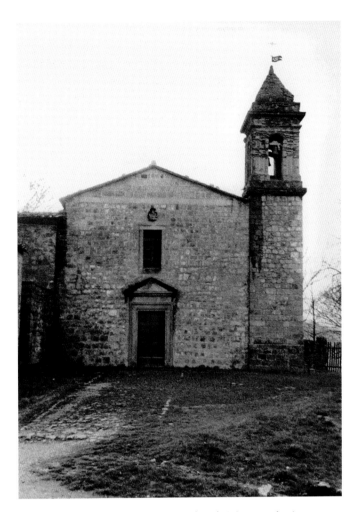

Fig. 7. Vivo d'Orcia, Cervini Borgo, church (photo: author)

Both Giovanni and Beccadello were therefore of the opinion that the stair should be on the side toward the church where the rise was more gradual and which would lead directly to the portal, but he adds that he will discuss this also with one Master Antonio.

The church, however, was proceeding well, although it was not yet covered, but beams were available so that Beccadello could urge the builders to close the church. In the house, two upper bedrooms were set, and the *sala*, presumably the salon, was finished. Beccadello concludes by reporting that Giovanni would like to speak personally to the cardinal, since that would permit the builder to control matters for better progress.

Beccadello's letter indicates that the work at Vivo began in the preceding year, 1544, but that little had been accomplished at that time. By now the architect of the design of the villa is apparently the cardinal himself, as is suggested by Massarelli's diary. In the discussion regarding

| Marcellus II and Architecture

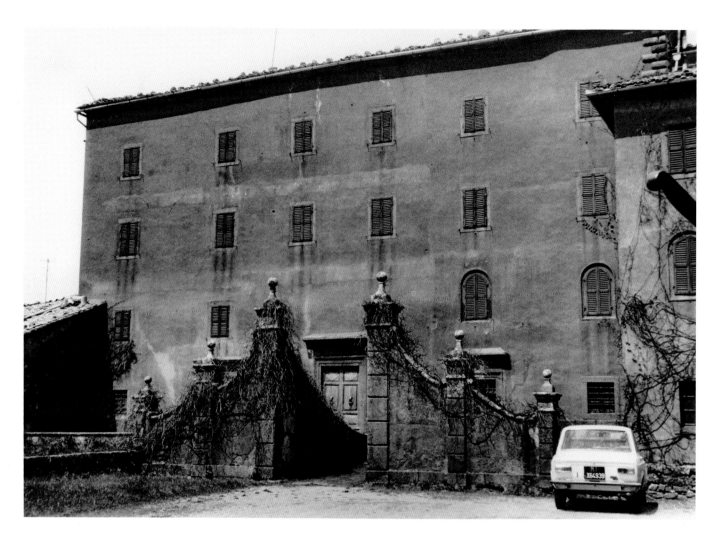

Fig. 8. Vivo d'Orcia, Villa Cervini, facade (photo: author)

the location of the stairs, Beccadello added that they would also consult Master Antonio, who may be the architect Antonio da Sangallo the Younger, since he had prepared earlier other plans for the cardinal and is also specifically identified in a later letter of October 2, 1546, just after his death.[41] The situation of an absentee patron so involved in his building as Cardinal Cervini was, attempting to convey his decisions and desires through several agents, naturally occasioned constant friction and tension with the builder. This was obviously the cause of Giovanni's request, reported by Beccadello, to speak to the cardinal. The latter, however, informed Beccadello on November 27 that Giovanni must be aware that any decision, even if "I no longer wish to use him," has come from the cardinal.[42] At the same time the cardinal was reminding his agents not to enter into any argument on their own part with Giovanni.

Beccadello's reference in his letter to forwarding a painting and drawing of the work at Vivo is further clarified in an entry on November 7 in Massarelli's diary, when he notes that "in the evening His Reverence showed me the two drawings sent him of the plan and perspective of Vivo made by Pietro Paulo Francucci," and on November 8 a letter was sent to the "painter Pietro Paulo." Francucci, however, cannot be further identified with certainty.[43] Finally, on November 24 Massarelli recorded that the cardinal showed him another drawing of Vivo just sent by Lorenzino, the cardinal's *maggiordomo* at Rome.

An undated letter of the cardinal to his half-brother Romulo "at Vivo" probably dates soon after Beccadello's letter, as in it the cardinal remarks: "The stairs please me more in accordance with the new model than the old one. Nevertheless, I await your opinion."[44]

Later surviving references to Vivo are less frequent. On January 13, 1546, Alessandro Cervini wrote the cardinal from Castiglione d'Orcia regarding the measurements

and laying out of the enclosure and garden between the escarpment of the villa and the church.[45] On October 2, Giovanni Battista Cervini informed the cardinal about difficulties with the builder Giovanni regarding measurements and evaluation of masonry at Vivo. Giovanni Battista reminds the cardinal that in respect to advice on the masonry "Master Antonio da Sangallo is dead at Terni [having died on August 3, 1546] and I am not competent."[46] This letter implies that Sangallo had been involved at least with the earlier stages of planning the villa. Giovanni Battista also notes that he will leave the matter to Alessandro Cervini, recalling the cardinal's earlier advice to Beccadello not to intrigue or to gossip about these matters.

The work at Vivo must have proceeded very slowly, but because of the cardinal's return to Rome and Tuscany his later correspondence regarding its progress is very scant. By 1553, however, the building was almost complete. On July 23, the cardinal wrote from his retreat in the abbey of Gubbio that the house of Carpia should be rebuilt in the meadow for security and that Master Giovanni "should finish the ceilings and those rooms which have to be made habitable at Vivo."[47] In character, the letter contains detailed instructions on the management of his brick kiln and the firing of the brick.

Finally on September 13, 1553, extensive directions were forwarded from Gubbio with copies to the cardinal's half-brothers, Alessandro and Captain Biagio Cervini, for preparations to be made in anticipation of a visit of the cardinal to Vivo "with as few people as possible."[48] His agents were to provide twenty-three beds, that is, "ten mattresses more than was necessary for his servants, the masons, limeworker, carpenter, and stonecutter," and instructions were included as to where to obtain the necessary mattresses and bedclothes. The cardinal was to be provided with three rooms, comprising a bedroom, a study (*studio della filosofia*), and his private dining room (*saletta*), using a large bedroom (*camera grande*). Beds for friends and courtiers were to be placed in two "old bedrooms," a "good room toward the foundry," presumably on the northern side, and in a nearby passageway. Under the roof, two "old bedrooms" and two, presumably newer ones, at the other side of the villa were to house the grooms, servants, and "all other lowly people." The letter also names as one of the cardinal's agents a certain Niccolo Francucci without any evidence as to whether he is a relative of the painter Pietro Paolo Francucci, who earlier prepared drawings of the villa for the cardinal.

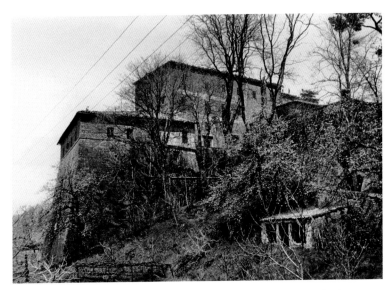

Fig. 9. Vivo d'Orcia, Villa Cervini, southern elevation (photo: author)

Finally, in a postscript to the instructions, word is conveyed to Captain Biagio Cervini, probably a half-brother of the cardinal, that, as the captain knows from letters to Alessandro Cervini, the cardinal "is resolved to finish" with the builder Master Giovanni, but warns Biagio to take care that there is no error in the measured evaluations, particularly in respect to the thickness of the walls and of the foundations "which are no longer visible."

The notice that the builder Giovanni is to be dismissed and a final reckoning of his work prepared suggests that the building of the villa is considered as basically completed by the fall of 1553, and that the cardinal's impending visit is to mark the completion. The cardinal, however, would have less than two years to enjoy his country residence, for his sudden death came on May 1, 1555, three weeks after his election as pope.

The Cervini villa stands just below the hill town of Vivo d'Orcia beside the stream called the Vivo from which the villa and town are named (Fig. 4). A bridge over the stream leads up to the gate into the forecourt of the villa at the right (Fig. 5) and on the left to a large arch opening onto the little *borgo* set in the valley below the villa. The *borgo* was to provide housing and service quarters for the farmers and retainers employed by the cardinal. A dirt road from the arch descends along the tall wall of the private garden of the villa at the right into a small piazza on axis with the church. Another unpaved road, oriented roughly south to north at right angles to the entrance road, runs through the *borgo* and along the western side of the villa. On the eastern edge of the road

Fig. 10. Vivo d'Orcia, Villa Cervini, portals (photo: author)

(Fig. 6) is a simple, two-story farm building, and on the opposite side of the road a similar, but longer and more irregular, multi-family dwelling, some of whose irregularities, such as the addition in the center of a third story, are probably the result of later changes. At the northern end of the latter building is the piazza in front of the church with its *canonica* approached by external stairs recessed in the corner adjacent to the church (Fig. 7). The church itself is a simple box of rough stone masonry whose only architectural features are the classical portal with a triangular pediment and the bell tower at the right of the facade.

Directly on axis with the entrance bridge is the gate into the forecourt of the villa (Fig. 5). Within the forecourt on the northern side another gate opens onto a small bridge crossing a dry moat to the terrace running across the front of the villa (Fig. 8). Around the central

block of the building, rising four stories above the terrace, are outlying blocks or wings of varying heights tying the central structure to the irregular slope of the site. The villa, built of rough stone with carved stone quoins on the eastern corners, has only the facade stuccoed. On the eastern side a three-story block enfolds the central section on the entrance facade, terminating its terrace. A two-story service wing projecting from the villa as far as the entrance gateway closes the forecourt on the east. At the west, where the site falls off steeply into the valley, another enclosing block rises only one story above the entrance terrace, but rests on a huge, escarped foundation mounting at least four stories high out of the valley (Fig. 9). At the rear of the entrance terrace are three portals capped by lintels (Fig. 10). On the opposite or southern side of the forecourt is a large walled garden, which, because of the steep slope, is supported on tall,

Fig. 11. Vivo d'Orcia, Villa Cervini, basement portico (photo: author)

buttressing walls toward the valley. At the western end of the forecourt a stepped ramp or *cordonata* curves down to the level of the moat, where a portico on arched piers supports the entrance terrace (Fig. 11). This is presumably the stairway mentioned in Beccadello's letter of October 31, 1545, which he and the builder, Giovanni, recommended should be on the side toward the church, as the other side toward the foundry was too precipitous and would not lead to the entrance portal. From the moat another path climbs down along the western wall of the garden toward the church and *borgo* in the valley.

At the north, the rear elevation on tall foundations looms high above the level of the river Vivo as it winds about the villa into the valley (Fig. 12). This is the side toward the foundry, whose remains are to be seen below in the valley. The irregularities in the massing of the villa may be in part the result of changes in intention and of incom-

pletion, but the building has undoubtedly been much altered and restored during the centuries, so that it is now probably only an approximation of its sixteenth-century form.[49] Architecturally the most interesting feature of the villa is its relationship to the difficult site, which required such extensive buttressing and foundations. Its aspect, as it towers above the *borgo* in the valley, is more of a fortified country residence than a pleasure villa. On the other hand, the site must have been chosen in large part for the magnificent view it offered over the valley, especially toward the north and west, and less for its protective potential.

The cardinal's correspondence does not convey a complete nor clear picture of the design and building procedures active in creating his villa, but does offer some tantalizing hints. Always of delicate health, the cardinal may have decided soon after his appointment to create for himself a country retreat. That Antonio da Sangallo the

| *Marcellus II and Architecture*

Younger was the professional architect whom the cardinal approached is understandable, since Sangallo was the architect of the Farnese family and court that had fostered the cardinal's career. This association with Sangallo explains the cardinal's position later in the controversy over St. Peter's when he was apparently sympathetic to the followers of Sangallo in their attempt to oust Michelangelo. Sangallo's plans of a villa for the cardinal unfortunately cannot be dated except for the surety that they were earlier than 1544, when the work at Vivo was begun after a different design. Also, there is no evidence that the present villa was begun after another design by Sangallo, but

there are suggestions that he was consulted at least informally as the work progressed. The cardinal himself, however, was obviously very much involved in the design of the building.

All the managerial and financial organization of the project seems to have been a family affair in which Alessandro Cervini, as the oldest, close relative, was the chief figure. Obviously the financing for the project was very limited, much of it provided by the iron ore mined nearby. On the other hand, the builder, Giovanni, was employed solely to execute the work without any professional architect, and with members of the Cervini family only, or

their employees, to oversee his work. The thread of command, therefore, was so diffuse, especially with the cardinal absent in Trent, that constant misunderstanding prevailed. Almost all the letters are tinged with distrust of the builder, and at least once, in order to prevent delay, the cardinal insisted that the builder should be reimbursed for the masonry to be executed at Cinilla on a piece-work basis and not daily, which was apparently true also at Vivo.[50] This approach, however, created the problem of evaluating the work accomplished without the expertise of professional architects or surveyors, as Giovanni Battista Cervini noted in his letter of October 2, 1546.[51]

The cardinal's letters do not, of course, reveal his actual knowledge of architecture, but merely his intense interest and involvement in the subject. He presumably had an acquaintance with the classical theory of architecture, at least as it could be interpreted from the ancient treatise of Vitruvius and probably from the fifteenth-century architectural treatise of Alberti, but it would be a humanist's knowledge with little experience of the particular problems of design. At the same time his letters offer evidence of an extraordinary command of a broad variety of practical knowledge in many fields, as exemplified in his letter of July 1553 regarding the baking of brick.[52] Such an interest and knowledge would inevitably create a climate of tension and friction in any relationship with professional artists, as happened at St. Peter's with Michelangelo. Unlike the representational arts, where the advice of the humanists could be circumscribed within the limits of their literary and theological knowledge, any advice in the field of architecture would inevitably impinge directly upon the artist's field of design.

Appendix

Selections from letters to and from Cardinal Marcello Cervini, in Florence, Archivio di Stato, Carte Cerviniane.

1. ASF, CC, Filza 19, letter of Marcello Cervini at Montepulciano to Bernardino Maffei, July 12, 1550, fol. 135r:

Ho receuta la littera di V. S. R.ma di sabbato: insieme coli disegni, et descrittioni della sepoltura della S.ta m. di Paulo iij liqualj disegni ho cominciato à considerare, et come haro finito, li rimandaro à V. S. R.ma con quel pocho che m'occorrira di dirui sopra. Fino à hora m'offende una consideratione generale. Cioe che oggi noi faciamo li sepulchri non solo le laici ma de capi della nostra religione, non da Christiani, ma da Gentili. Onde andasso pensando se fusse

(de mutare qualchuna di quelle figure, et metterui scolpire [phrase in parentheses crossed out and added above: di adattaro]) ne quadri maggiori qualche cosa che sappia meno del gentile, et sia tuttauia uaga, et conueniente. Item nel disegno nuouo: come mi piace il Tempio da poterui entrar dentro etiam salendo quelli tre gradi: cosi noue palmi soli per la sua larghezza, mi paian pochi stimando che ho il corpo habbia stare la (dentro [crossed out]) in quel bel Pilo, non si potra pure entrare: nonche andarà à torno: come per mio iuditio conuerrebbe.

2. ASF, CC, Filza 19, copy of letter of Marcello Cervini at the abbey of Gubbio to Bernardino Maffei, August 3, 1550, fol. 136v:

Il Vignola m'ha scritta l'allegata l'ra quali io non intendo bene se parla del primo Disegno, o, del 2° et in qualunche modo uedo ch'egli non ha la cosa piu per integra: ma per deliberata et resoluta. Onde ogni parte saria tardo et superfluo. Pero io hò rimandato li Disegni al mio Guardar.ba che li dia, à, V. S. R.ma insieme con questa: essendo contento per hora di quelle dui auuertenze ingenerali gia scrissi pose in nero non essendo piu informato che tanto de particolari, tutto quello ch'etui dicesse sopra, saria un parlare, a, mente et forse conturbare ogni cosa, perche mene rimetto a lei che, è, presente, et puo udir li Architetti, et respondarlo tante uolte che ui intendiate bene, cosa che non si puo far per lre.

3. ASF, CC, Filza 50, letter of Alessandro Cervini at Montepulciano to Marcello Cervini at Rome, May 10, 1545, fols. 169r–170r:

Io auuisai a V. R.mo lo stato della casa del viuo et queste che mi pareua di farci . . . (regarding grain).

Prouiddi ancho uno huomo et una donna, marito et moglie per stare, in quella casa la donna per fare pane et cucinare, et altri exercitij da donna et l'huomo per fare l'horto et altre cose. . . .

La cassa ordinai, intendo benche per anchora. Non et entrato denari. Maestro Giouanni ha cominciato a tirar su la casa del mozelle e credo che in pocho tempo sene uedra il fine.

La scarpa si comincio hiermattina con otto li opere bisogna che Giouanni battista mandi li quaranta scudi li chiesi perche n'ho permessi à (fol. 169r) maestro Giouanni à quei da Petroio che fanno la calce a Gianni Carpia, a maestro Pettarello e alle opere; da lui non ho auuiso nessuno anchorche insieme con questa laqual sara dup.ta li scriua et li chieda di nuouo li 40 scudi et di più che alla fine di maggio ueda siena qua settanta scudi per pagar li tagliatori; perche non manca il capital del' ferro che asuoi tempi, bastara à rimettere tutte queste spese; del' qual ferro nella mia parte gli mandri il conto. Di poi faci dare ad Andrea et Ottauiano sedici scudi di ferro, et perche delli ottanta scudi che li rese Biagio, ne rimando dia i quali non rihebbe piu, e otto dico il Grasso glene presso aspettar la ritornata del grasso (worn along edge). Anchorche per adesso se uenisser li (worn) per la muraglia et li 70 per la ferriera, se si tocasse mente del (worn) si potra cominciar à rimettro per la muraglia quello si fusse speso per ferriera perche per hora io non à uedo altro modo

e fa lo più, che a mezzo questo mese bisognaria mandare in Maremma a prouedar li fiene per l'anno auuenire.

Perfinche il grasso indugia avisare i denari della uena tengo Pietro a (worn) che solleciti la scarpa et la uena occorrendo e, habbia cura a tagliatu (worn) et ueda se e possibile per uia dell' Abbadia spacciare qualche quantita di ferri se e, denari non si assassinano lo speranza che le cose passaran sensa disorde (worn).

Per la muraglia di qua gia si cominciano a lauorare le pietre e ued (worn) che preso si potra cominciar a murare. La calce e cotta e fredda che sa (worn) si portara è la vena, et perche hauiamo fatto un pocho di calculo nel quale trouiamo diece scudi solo di differentia a murare di pietra et mattoni la facciata dauanti. Perche fra finestre cordoni porte et altri cosi necessarij, resto tanto poco spatio che facendo il su di pietre impousa quanto ho detto, et per questo mande quanto corsa entraua in questa a la da farsi questo anno e andare fino (fol. 169v) alla strada, come ragionamo a bocca è, in questo conto è il tutto di pietra nella facciata dauantj.

Per conto della calce ho messo in mano di Marco di Battista patrone d'essa, 1020 libre di ferro, aquel peso, a questo è riuscito 985 libre anchora non hauiamo fatto nome di prezzo, ne alla calce, ne al ferro.

Quanto a simil faccende non è cosa che piu mi prema che l'hauere li denari per li tagliatori alla fine di questo mese pero uedendo esserci il capitale del ferro pensarci fusse bene che V. R.ma S. ne sollecitasse ancho Giouanbattista perche uolendo che si lauori per questo altro anno non mi occorre per hora altro modo che questo. . . .

[Postscript] Il conto della muraglia di qua per mandarlo insieme col modello, mandaro 4 questa altra, di nuouo (fol. 170r).

4. ASF, CC, Filza 50, undated letter of Marcello Cervini to Romulo Cervini at Vivo, fol. 3r:

La muraglia desidero che si solletiti (destroyed) il resto della Muraglia et bramar il muro douara assotigliassi e farsi piu presto. Le scale mi piaccian piu sicondo il nuouo modello, che sicondo il uecchio. Non di meno ne aspetto il uostro parere.

5. ASF, CC, Filza 50, letter of Alessandro Cervini at Castiglione d'Orcia to Marcello Cervini, January 13, 1546, fols. 176r and 176v:

Ho squadrato col disegno cioe nuouamente e uenuto per uederi se si poteua cominciar hora à lauorar la chiasa e prima ho preso 20 braccia sotto alla scarpa che serue sicondo il disegno per Giardino. Di poi ho misurato X braccia piu uerso l'horto che serue per uia o uolendo dirizzarla chi ua dal canto della ferriera al canto della Chiesa, uien tagliato una punta dell'horto, uerso la Chiesa, e a questo squadro per so bisognj riquadron l'horto, e di poi la Chiesa e perche mi pare che V. S. R.ma mi commutisse che io faci se alformare la vigna, e pensamo parli in quella uien contigua (fol. 176r) al Giardino, sotto al Palazzo mi parso spettarne un altro suo auuiso. Perche non pensarej a potesti star bono ni Giardino

ni strada ni vigna per fino che quella muraglia non e finita e sgombra tutto il parse da quella banda, pensarej bene si potest riquadrare l'horto con quella proportione, e cosi la Chiusa ma non far altra strada in uigna finche non i finito di murare da quella banda solo pigliar la dirittura dalla strada lassando li 20 braccia per el Giardino e ritor in questo squadro l'horto e seguitar la Chiusa (fol. 176v).

6. ASF, CC, Filza 50, letter of Giovanni Battista Cervini from Rome to Marcello Cervini, October 2, 1546, fol. 172r:

Quanto al male di messer Alessandro ho mandatali la copia della l'ra diritta a me de 23 et pregatolo che uoglia uenire a stare qua qualche settimana e a me non porria fare il maggiore piacere.

Et quanto a maestro Gio ho medesimamente scrittoli che lui facci a' bocca quello ch' V. S. R.ma hauerebbe uoluto ch'io hauesse scritto et che se ne resolua et ne dia auiso a V. S. R.ma ne sopra cio me uoglio distendare ui altro. Se nonch'io scrissi la mente di maestro Gio et quando lei se fusse resoluta a darla à rischio se potecca uenire al prezzo ragioneuole et giusto al presexe sendo lei di questo altro parere, porra messer Alessandro essere con maestro Gio et auisare el tutto minutamente a V. S. R.ma come l'ho scritto.

Quanto al dare auiso di quelle muraglie cosi minutamente le recordo che maestro Antonio da sangallo sa morto in Ternj et per non essere io capace dicio non mi diffendaro in altro.

7. ASF, CC, Filza 49, letter of Marcello Cervini at the abbey of Gubbio, July 23, 1553, fols. 362v–363r:

Scritta questa è arriuato messer Filippo, et per lui ho hauuta la tua de 20. Si Niccolo non intende bene il Disegno, scriua la difficulta, ò, uenga à risoluerle egli proprio.

Quanto alla casa dil Carpia à me piace che si faccia tutta di nuouo piu su nel prato doui sia per esser ben sicura. Et qui si troui miglior partito, che quello che fa maestro Giouanni attaciateui al migliore, et lassate che maestro Gio: finisia li palchi, e quelle stanze chi s'hanno a far habitabili al Viuo. Onde ancor non trouate meglio per Cinilla, non si uuol cambiar maestro Giouanni per un altro dele pari.

Quanto quel che pare a Niccolo che l'opera di maestro Giouanni siencare a cinq grossi l'una, maestro et Manual senza le spese non, è (fol. 362v) cosi ogni uolta che non perdino tempo: pur il muro di Cinilla s'ha a dare à canne, e non a opera.

Ho inteso da messer Filippo a che porto sta la fornace nostra di mattoni. Per mio consiglio non aspettate piu à cuotere, poi che non si puo coprire senza tempo e spesa ne aspettate di far la cotta maggiore: ma fin che dura questo buon tempo acconciate la fornace. Informatela, et cocetela con quel lauoro che, è fatto. Et quanto à Docci per hora, non ne son necessarij molti: Et pero se m'pri che ne sien fatti tanti che possin poi coprir la fornace, e una nuoua cotta bastaranno et intratanto potrete proueder li trauicelli et correnti per coprir la detta fornace prima che si sforni accioche se possibile, è, non rouiti piu per causa del aggua.

8. ASF, CC, Filza 52, instructions written probably to Alessandro Cervini on behalf of Marcello Cervini from the abbey of Gubbio, September 13, 1553, fols. 13r–13 bis v:

> Molto Mag.co Padron mio oss.no
>
> Oltra a quanto scriue a V. S. il Cardinale, et io anche al Cap.no Biagio, mi occorre scriuere, che disegnando S. S. R.ma uenire al Viuo, con manco gente, che sia possibile, bastara tenere in ordine per la Corte fino à 23 lettj che essendo costi diece matarazi oltre al bisogna della sua famiglia, de Muratori, Calcinarolo, fa legname et scarpellino, et scriuendo io à Niccolo, che delli uinti matarazi, et due piume, che si trouano in Montep.no mandi al Viuo dodici matarazzi, saranno à suffitientia. Quanto alle coperte, Capezali, candelieri, candele di sego, pagliaricci, et lenzuola tenendo in memoria in scritto della prouisione, et di qualche di Roma, tanto a Montep.no come al Viuo, si fara prouisione di qua degni cosa di piu che sia bisognare. Onde non accade scriuere altrimente à Siena che di li si mandi pagliola per paglaricci, quali si prouedaranno dalla banda di qua; Et se pure al arriuo di questa l'ordine fusse date, et eseguito; quella prouisione non si gittara; ma in ogni caso V. S. potra darne (fol. 13r) auiso per Santino.
>
> Il Cardinale uuole alloggiare in quella medesima camara che so stato io, pero sara necessario, seruare lo studio della filosofia, che ui e uicino per quel tempo, che staremo al Viuo. Et ancora non si potra habitare per quel mezzotempo maggiore, che uiene sopra detta Camera. Ne manco nella camera grande, doue hora dorme V. S. non ci hara da stare letto alcuno, ma seruira per saletta, doue stara à magnare S. S. R.ma. In cambio di questa camera e del mezzanino su detto, che restano senza letti, mettendosi le traui di sopra doue mancano, si saranno al piano della saletta di sopra; oltra alle due Camere uecchie, una camera buona verso la ferriera, et anco in quella stantia à presso che hora serue per andito, si potra fare un letto, con serrare doue non fusse 2 porte con le store, scriuendo si a Niccolo che facci prouisioni di sei, o, otto.
>
> Messe su le traue come di sopra, et piane, et tauole, qual piane bastara che sieno piallate, o asciate, meglio (fol. 13v) che si puo come si e fatto al altre camare nuoue; quali palchi facendosi, oltra alle due camare uecchie, che sonno a canto al tetto, ue ne sara due altre, dal altra banda; Nelle quali quattro camere si disegna accomodare Palafrenieri, seruitori di Gentilhomini, Mulattieri, et tutte altre persone minute che ui si accomodaranno bene, et non potendosi mettar le traui su, almeno sopra le traui messe non si resti di fare il palco.
>
> Si mandara di qua del cacio, prosciutto; et fino à quindici castratj.
>
> Giouanni battista come li dissi a boccha faccia delle lettiere con cauallettj alla Franzese, perche le altre sono camere di cimicie: et a V. S. mi racomando et bacio le mani.
>
> Dal Abbadia fuor d'Agobio alli xiij di 7bre 1553.
>
> Mag.co Cap.no come intendarete per lettere del Cardinale a messer Aless.ro S. S. R.ma e resoluta di finirla con Maestro Giouanni. Pero m'ha commesso che io ne scusa anco à noi, accioche à insieme con Niccolo Francucci

uenendo costi à pur da noi faciate conto finale con Maestro Giouanni auertendo (fol. 13 bis r) bene à non pigliare errore nella misura; massimo delle larghezze del muro, et delli fondamenti, che hora non si uedano, hauendo rispetto à quoi lochi, doue si e trouato la pietra uiua; et fondatoui sopra, o incaualcatoui il muro, tanto principale, come delli speroni; Et perche Maestro Giouanni facilmente potrebbe uolersi riattaccare, finite la puze a fatto piacendo cosi à S. S. R.ma.

> Non partiremo di qui a cotesta uolta prima che alla fine di questo, onde uolendo fare del raspato potrete indugiare tanto piu, accioche l'una si uengha maturando.
>
> Per Santino sara bene, che auisiate doue disegnarete che stieno li caualli, non l'hauendo io saputo dire a S. S. R.ma meglio che tanto.
>
> a Aless.ro Ceruini
> al Cap.no Biagio
> Auiso del pentiero della seta del Cardinale al Vivo (fol. 13 bis v).

Notes

1. Florence, Archivio di Stato, Carte Cerviniane (later references as ASF, CC), Filza 32, fols. 128r–129r; published in part in "Documenti che illustrano la cronica di Fra Giuliano Ughi," *Archivio storico italiano: Appendice* 7 (Florence, 1849), 250 n. 2; and in part in L. von Pastor, *The History of the Popes*, vol. 14 (London, 1924), 30 n. 1.

2. For the life of Ricciardo Cervini, see especially *Archivio storico italiano: Appendice* 7, 246–256.

3. Those letters particularly concerned with horticulture are: ASF, CC, Filza 49, fol. 28r, Dec. 9, 1520; fol. 45r, Feb. 16, 1521; fol. 83r, March 14, 1524; fol. 95r, April 18, 1525; fol. 133r, Jan. 13, 1526; fol. 209, March 31, 1531; and fol. 301r, Sept. 16, 1533.

4. ASF, CC, Filza 49, fol. 312r, published in L. Cardauns, *Nuntiaturberichte aus Deutschland, 1533–1559*, vol. 5 (Berlin, 1909), xxv n. 2; the death of his father Ricciardo is mentioned in a letter of Marcello of March 3, 1534, to his brother and sister: "Non pensauo che uoi mandasta tanto tardi per me che io hauesse a trouare il nostro optime padre morto" (ASF, CC, Filza 49, fol. 316r).

5. ASF, CC, Filza 49, fol. 358r, Jan. 11, 1538, from Marcello at Rome to Alessandro; and fol. 373r, Feb. 24, 1540, from Alessandro at Castiglione d'Orcia to Marcello.

6. ASF, CC, Filza 49, fol. 127r, Dec. 18, 1525; and on April 16, 1526, Cervini acknowledged receiving the inscription (ASF, CC, Filza 49, fol. 147r). The inscription is presumably *C.I.L.* 2595; see *Corpus Inscriptionum Latinarum*, vol. 11, pt. 1 (Berlin, 1888), 410.

7. ASF, CC, Filza 49, fol. 219v.

8. ASF, CC, Filza 49, fol. 243r, Sept. 3, 1532; and fol. 251r, Oct. 4, 1532.

9. Rome, Biblioteca Apostolica Vaticana, Ms. Vat. lat. 4104, fols. 17r and 23r; P. de Nolhac, *La Bibliothèque de Fulvio Orsini* (Paris, 1887), 182; and P. L. Rose, "Humanist Culture and Renaissance Mathematics: The Italian Libraries of the Quattrocento," *Studies in the Renaissance* 20 (1973), 69–70.

10. F. Ubaldino, *Vita Angeli Colotii Episcopi Nucerini* (Rome, 1673), 61–62.

11. S. Lattès, "Studi letterari e filologici di Angelo Colocci," in *Atti del convegno di studi su Angelo Colocci* (Jesi, 1972), 254.

12. A. Caro, *Lettere familiari*, ed. A. Greco, vol. 1 (Florence, 1957), 23–24.

13. Ibid., 26.

14. P. Delorme, *Architecture de Philibert de l'Orme* (Rouen, 1648), bk. V, chap. I, fols. 131r–131v.

15. ASF, CC, Filza 20, fol. 19r (undated but bound after letter of Feb. 27, 1540); Filza 20, fol. 32v, April 22, 1540; and Filza 23, fol. 29v, Oct. 4, 1544.

16. ASF, CC, Filza 23, fol. 3, May 26, 1543.

17. ASF, CC, Filza 23, fols. 13v–14r, Sept. 18, 1544; and fol. 22r, Sept. 23, 1544.

18. ASF, CC, Filza 23, fols. 29r and 29v, Oct. 4, 1544.

19. G. Bottari and S. Ticozzi, *Raccolta di lettere sulla pittura, scultura ed architettura*, vol. 2 (Milan, 1822), 1–17, letter no. I.

20. Ignazio Danti in his prefatory biography of Vignola, when he mentions Vignola's work for the Academy, lists as other members Marcello Cervini, Bernardino Maffei (Cervini's secretary), and Alessandro Manzuoli; see J. Barozzi da Vignola, *Le due regole della prospettiva pratica* (Rome, 1583).

21. P. Paschini, "Un cardinale editore: Marcello Cervini," in *Miscellanea di scritti di bibliografia ed erudizione in memoria di Luigi Ferrari* (Florence, 1952), 388. A sixteenth-century manuscript of the preface and book I of Vitruvius owned by Cervini is now in the Vatican Library as part of Ms. Ottoboni 850; see C. H. Krinsky, "Seventy-eight Vitruvius Manuscripts," *Journal of the Warburg and Courtauld Institutes* 30 (1967), 61.

22. L. Dorez, "Le Cardinal Marcello Cervini et l'imprimerie à Rome (1539–1550)," *Mélanges d'archéologie et d'histoire* 12 (1892), 289–313.

23. ASF, CC, Filza 20, fol. 231r, March 27, 1548; and fol. 236r, April 8, 1548, from Maffei at Rome to Cardinal Cervini at Bologna.

24. Appendix 1.

25. For the history of the tomb, see H. Siebenhüner, "Umrisse zur Geschichte der Ausstattung von St. Peter in Rom von Paul III. bis Paul V. (1547–1606)," in *Festschrift für Hans Sedlmayr* (Munich, 1962), 230–245.

26. Appendix 2.

27. E. H. Ramsden, ed., *The Letters of Michelangelo* (Stanford, 1963), vol. 2, 290–293.

28. R. Wittkower, "Nanni di Baccio Bigio and Michelangelo," in *Festschrift Ulrich Middeldorf* (Berlin, 1968), 252.

29. G. Vasari, *La vita di Michelangelo nelle redazioni del 1550 e del 1568*, ed. P. Barocchi (Milan and Naples, 1962), vol. 1, 92.

30. Ibid., 96.

31. *Letters*, ed. Ramsden (note 27 above), vol. 2, 153–154.

32. J. B. Mittarelli and A. Costadoni, eds., *Annales Camaldulenses*, vol. 8 (Venice, 1764), 74–75. The annals are incorrect either as to date or buyer, since Ricciardo Cervini, father of Marcello, whom the annals claim was the buyer, had died in February 1534; for his death see above p. 72 and note 4.

33. Rome, Biblioteca Apostolica Vaticana, Ms. Vat. lat. 4104, fol. 1r. The epigram is presumably that published in G. F. Lancellotti, *Poesie italiane, e latine di Monsignor Angelo Colocci* (Jesi, 1772), 86. A year later Colocci sent Cervini a sonnet commemorating Vivo; Rome, Biblioteca Apostolica Vaticana, Ms. Vat. lat. 4104, fol. 7r, letter of Cervini to Colocci, dated Sept. 20, 1542; the sonnet is presumably that in Lancellotti, *Poesie*, 84–85.

34. G. Giovannoni, *Antonio da Sangallo il giovane* (Rome, n.d.), vol. 1, 303–304; and L. Ragghianti Collobi, *Il libro de' disegni del Vasari* (Florence, 1974), 127.

35. For Raphael's description of the plan of the Villa Madama, see P. Foster, "Raphael on the Villa Madama: The Text of a Lost Letter," *Römisches Jahrbuch für Kunstgeschichte* 11 (1967–68), 307–312.

36. Appendix 3.

37. ASF, CC, Filza 50, fol. 165r, July 10, 1545.

38. Massarelli's diary from Feb. 24 to Dec. 1, 1545, is published in S. Merkle, ed., *Concilium Tridentinum: Diariorum, actorum, epistularum, tractatuum*, vol. 1, *Diariorum*, pt. 1 (Freiburg, 1901), 152–339.

39. Rome, Biblioteca Apostolica Vaticana, Ms. Vat. lat. 4104, letter of Oct. 23, 1545, fol. 35r.

40. G. Buschbell, ed., *Concilium Tridentinum: Diariorum, actorum, epistularum, tractatuum nova collectio*, vol. 10, *Epistularum*, pt. 1 (Freiburg, 1916), 228–229.

41. Appendix 6.

42. Rome, Biblioteca Apostolica Vaticana, Ms. Vat. lat. 4104, insert accompanying letter of Nov. 27, 1545, from the cardinal at Trent to Beccadello, fol. 31r.

43. The full name of the Bolognese painter Innocenzo da Imola (ca. 1488–1545) was Innocenzo Francucci. Master of such painters as Prospero Fontana and Primaticcio, his father was the goldsmith Pietro, but there is no evidence of a sure relationship to Pietro Paolo Francucci; see R. Galli, *Innocenzo da Imola: I tempi, la vita, le opere* (Bologna, 1951). However, a minor painter, Pietro da Imola, was paid in August 1545 for the decoration of papal furniture in the villa on the Quirinal; see A. Bertolotti, "Speserie segrete e pubbliche di Papa Paolo III," *Atti e memorie delle RR. deputazioni di storia patria per le provincie dell'Emilia* 3 (1878), 195.

44. Appendix 4.

45. Appendix 5.

46. Appendix 6. See also letters of Oct. 2, 1546, and Oct. 13, 1546, published in *Concilium Tridentinum*, ed. Buschbell (note 40 above), 907–908.

47. Appendix 7.

48. Appendix 8.

49. An inscription set high on the northern, escarped buttress and difficult to decipher identifies a late-nineteenth-century restoration. It records that Count Leopoldo Alessandro Cervini began work on April 15, 1894, under the direction of the architects A. Corsi and V. Mariani, which was completed on November 30, 1896.

50. Appendix 7.

51. Appendix 6.

52. Appendix 7.

5

The Self-Image of the Roman
Villa During the Renaissance

Several of the sixteenth-century villas in and near Rome contain depictions of themselves in their interior decoration.[1] An examination of these images reveals a variety of reasons for their occurrence, although all in some form involved pride of possession, self-aggrandizement of the owner, and celebration of the pleasures and benefits of country life. The "self-image" of the Roman villa seems to begin in the late fifteenth century in the Villa Belvedere erected above the Vatican Palace. Pope Innocent VIII (1484–92), after an extended severe illness, in March 1485 began to build on the summit of Monte S. Egidio at the Vatican in Rome a pavilion with an open, ground-floor loggia where he could recuperate, removed from the noise and bustle of the Vatican Palace (Fig. 1). Identified as the Villa Belvedere because of the magnificent views it offered of nearby Monte Mario and the Milvian bridge, the casino stood overlooking the Prati or meadows just outside the walls of the city, through which pilgrims trudged coming to the holy sites from the north. The persistence of severe bouts of papal illness accompanied by rumors of his death undoubtedly induced further work at the villa. An inscription dated 1487 on the vault of the loggia describing the villa as "founded" (*fundavit*) probably marks the moment when a small papal apartment was incorporated in the east end of the structure and a chapel at the west end.[2]

Between the new apartment and the chapel remained an open loggia six bays long and two deep (Fig. 2, A).

Seventy-five years later the historian Vasari claimed that the walls of the loggia were decorated by the painter Pinturicchio at the express wish of the pope with landscapes of six Italian cities. Unfortunately the walls were painted over in the late eighteenth century when the loggia was converted into a statue gallery for the Vatican Museum. Restorations during this century have revealed fragments of the paintings identified by Vasari, although these fragments with one exception seem to depict urban landscapes of fantasy.[3] One fragment, however, contains a representation of the north facade of the Villa Belvedere itself (Fig. 3). Two famous architectural treatises published just before the cityscapes were painted may explain their existence. The ancient Roman theorist Vitruvius, whose treatise was published in 1486, claimed that long promenades like the Belvedere loggia were decorated in antiquity with landscape painting (VII.v.2). The Renaissance theorist Alberti, undoubtedly influenced by Vitruvius, recommended that landscapes were particularly appropriate for the decoration of villas (IX, iv).

The decoration of the rear and east end walls of the loggia was designed to create the illusion that one was standing in a completely open room with glimpses of cityscapes that would parallel, and perhaps contrast with, the actual landscape vistas from the open side of the loggia. Eighteenth-century descriptions of the loggia even mention painted balustrades along the base of the walls to

further the illusion of an open loggia. There were, however, other landscapes in the papal villa which are now all lost. All the wall decoration of the several rooms of the papal apartment was destroyed in the eighteenth century, leaving only some of the vault decoration. The walls of the antechamber to the apartment, according to eighteenth-century accounts, were painted illusionistically as a *studiolo* with painted bookshelves containing objects suitable to a study (Fig. 2, B).[4] Next to the papal bedchamber was a small loggia looking out to Monte Mario and the Prati (Fig. 2, C), and opposite it at the northwestern end of the villa was a slightly larger, matching loggia (Fig. 2, D). The walls of both these loggias were painted with open landscapes containing a few scattered *vigne* or farmhouses and men hunting, or as Chattard in the eighteenth century describes the private, papal loggia (Fig. 2, C) with "a very beautiful landscape, with distant hunts and some buildings masterfully rendered." Chattard only mentions "different landscapes" in the opposite loggia (Fig. 2, D) but notes that "there is revealed from this loggia a very pleasant

Fig. 2. Rome, Villa Belvedere, reconstruction plan: A. Loggia; B. Studiolo; C. Papal loggia; D. Private loggia

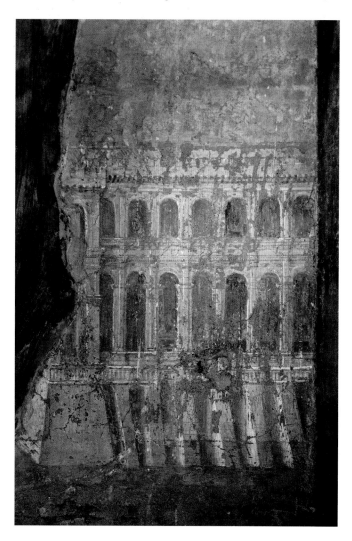

view of the surrounding gardens and delightful villas." The scenes illustrated in the smaller loggias are those the pope would see looking over the Prati, which fifteenth-century accounts record were a favorite hunting locale for Romans. In fact, an early-fourteenth-century map of Rome by Fra Paolino da Venezia depicted men hunting in the area of the Prati. These scenes in the smaller loggias would be in contrast to the city views of the major loggia (Fig. 2, A), and in the view of Rome (Fig. 3) the papal villa would turn its back to the city and face toward the country. The decoration of the loggia walls thus once illustrated the Petrarchan theme of the pleasures of country life versus the city. This may explain why in the bay seemingly associated with Rome the main feature was a view of the new papal suburban villa. So the suburban villa exists at the point of connection between city and country, as in the large loggia painted views of cities are on the walls toward the actual city of Rome in contrast with the open arcade opposite with its view over the Prati.

Another distinctive aspect of the Belvedere decoration was its emphasis on music. In the lunettes decorating the upper part of the individual bays of the principal loggia music-making putti sport in company with the papal arms or the pope's *impresa*, a peacock, thus associating music with the patron. In the neighboring Room of the Prophets are music-making figures, again with papal references, and a singing choir occupies the lunette in the small, private loggia of the papal apartment. Music was considered during the Renaissance to be a particular palliative for illness.[5] This emphasis on music in the decoration promotes the concept of the villa as a recuperative retreat.

Undoubtedly the health of Pope Innocent VIII determined the construction of his villa and the choice of its site following the advice of Alberti, who noted: "Doctors advise that we should enjoy the freest and purest air that we can; and it cannot be denied, a villa situated high in seclusion will offer this" (IX, ii). The depiction of the Belvedere among its decoration must express the pride that the pope had in it and will commence a century-long tradition among the owners of Roman villas.

In May 1505 the wealthy Sienese banker Agostino Chigi purchased land just outside the walls of the Trastevere section of Rome where he soon commissioned the architect Baldassare Peruzzi to design and to build a suburban villa now called the Farnesina.[6] In the fall of 1511 the villa was complete enough to be the subject of a Latin poem published by Egidio Gallo, *De Viridario Augustini Chigii* (Rome, 1511), a literary equivalent of the pictorial self-image. Gallo's poem, reporting how Venus, the goddess of love, left her home on Cyprus to reside in Chigi's villa at Rome, is obviously modeled on the poem by the ancient Roman Claudian entitled the *Epithalamium of Honorius and Maria*. Gallo's poem, therefore, must also be an epithalamium to celebrate the projected marriage of the widower Chigi to Margherita Gonzaga, the illegitimate daughter of the Marquis of Mantua, which was being negotiated in the fall of 1511 but was broken off late in 1512.

A few years later, probably in 1515 or 1516, the architect Peruzzi was called back to decorate the main salon on the second floor of the villa. Normally the reception rooms of a villa or country residence were on the ground floor. The fact that the main reception hall of the Farnesina is located on the second floor suggests that

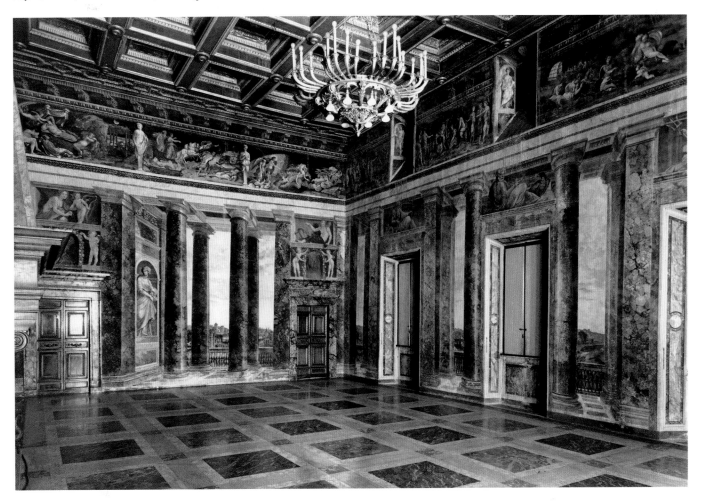

Alberti's identification of a suburban villa or "suburban *hortus*" as combining features of a city house with that of a villa is in effect here. Apparently the breadth of the illusionism that Peruzzi was to undertake in his decoration required the entire room to be lengthened at both ends, thus incorporating into the salon an adjacent hallway (Fig. 4). Vasari in his life of the Venetian painter Titian describes the amazement that the artist revealed at the remarkable illusionism that Peruzzi conveyed in his Farnesina decoration. Between the doors and windows are depicted open loggias supported by pairs of Doric columns. Pinturicchio's illusionistic landscapes in the Belvedere loggia have been more fully exploited here, as the Farnesina landscapes are clearly related to the actual surroundings of the villa. So at the east end of the salon facing the densely inhabited city the landscapes offer glimpses of the city in which actual Roman buildings, such as the Torre delle Milizie, can be identified (Fig. 5). The

west end, on the other hand, toward the open countryside features broad rustic landscapes (Fig. 6). As in the Belvedere, which was presumably the inspiration for the Farnesina decoration, there is the contrast between an urban setting and the pleasures of a rustic countryside. All these scenes are viewed as if seen from the interior of the salon, which is seemingly converted into a loggia open on all sides. There is, however, one exception to this viewpoint. A landscape between a pair of columns toward the southwestern corner of the room depicts the Porta Settimiana of the Trastevere as seen from within the walls, and over the gateway is a glimpse of the block of the Farnesina itself (Fig. 7). The visual scheme of this extraordinary illusionism has been momentarily perverted in order that Chigi's own suburban residence can be incorporated into the decoration. To a visitor fully engaged with the illusionism this sudden appearance of the villa itself in the seemingly realistic ambience of the decoration

| *The Self-Image of the Roman Villa*

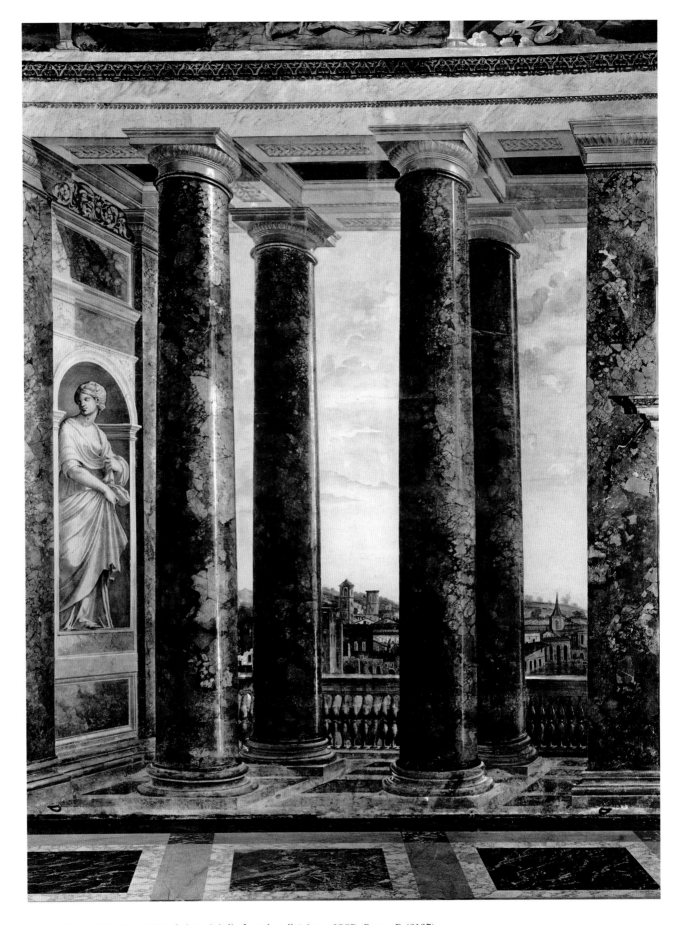

Fig. 5. Rome, Villa Farnesina, Salon, detail of east wall (photo: ICCD, Rome, E 42137)

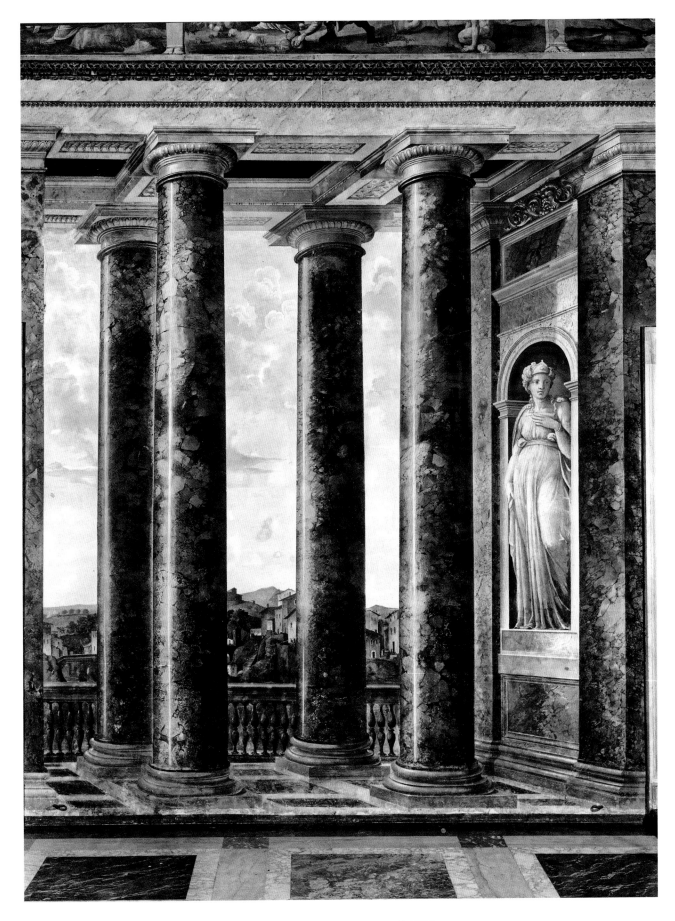

Fig. 6. Rome, Villa Farnesina, Salon, detail of west wall (photo: ICCD, Rome, E 42136)

The Self-Image of the Roman Villa

Fig. 7. Rome, Villa Farnesina, Salon, detail of fresco with Farnesina (photo: author)

must have lent a startling or at least an amusing note to the illusion.

Already in 1512 Blosio Palladio, a young poet later to be bishop of Foligno, had written a poetic description of the villa in Latin, *Suburbanum Augustini Chisii*, in which he had remarked on its site "almost standing in the midst of the city," so that "you see on that side the houses, on this side the country," which Peruzzi closely delineated in his decoration. Palladio's comment may be a reminiscence of the epigrammatic account of the villa of Julius Martialis on the Janiculum hill by the ancient Roman poet Martial (IV, 64):

> On this side may you see the seven sovereign hills
> and take the measure of all Rome. . . .
> On that side the traveller shows on the Flaminian
> or Salarian way. . . .[7]

Certainly Baldassare Turini, the datary of Pope Leo X, had Martial's epigram in mind when he built his villa on the Janiculum hill above the Farnesina (Fig. 8), since the Latin inscription, *Hinc Totam Licet Aestimare Romam*, derived

from Martial's epigram is written above the portal of the villa's loggia.[8]

Now identified as the Villa Lante, the vault of its *salone* is decorated with scenes from ancient Roman history which occurred on or near the Janiculum hill, thus related to the site of Turini's villa. One scene illustrates the account of the ancient Roman historian Livy (XL, 29) of the discovery of the tomb of Numa Pompilius and the Sibylline Books (Fig. 9). At the center rear of the fresco is a depiction of the facade of the Villa Lante itself, thus confirming its association with Martial's villa on the summit of the Janiculum hill. Presumably in order to identify the Villa Lante more readily it has been turned in the painting with its facade overlooking the slope of the hill. The owner undoubtedly took pride in reconstructing an ancient villa on what he assumed was its original site.

In the middle of the sixteenth century, Pope Julius III, who particularly enjoyed rustic life, built a lavish villa on a large estate just north of the Porta del Popolo at Rome. The main *salone* in the center of the building on the second floor was decorated with a frieze featuring views of the famous Seven Hills of Rome.[9] The scenes depict both famous monuments and ancient historical events associated with each of the hills. So the fresco of the Capitoline hill (Fig. 10) presents in the foreground the Sabine soldiers bribing the maiden Tarpeia to allow them entrance to the city as recounted by Livy (I, xi, 6). On the two heights of the hill are a fantastic round temple, perhaps meant to be the Temple of Jupiter, and the fortified Arx. The gigantic head in the center must be the head of Constantius II, then thought to be Constantine, still preserved on the Capitoline. In addition to the views of the Seven Hills, there is an eighth panel in the frieze featuring the Villa Giulia itself (Fig. 11). At the lower left is the public fountain on the Via Flaminia, while in the distance at the right is the villa proper. The association of the papal villa with the Roman hills is provoked by the family name of Pope Julius III, a Del Monte. In the prologue to a comedy performed at the time of the coronation of Julius III he was equated with the Seven Hills as their brother:

> There is born in this Roman land a hill, which
> gradually has risen and come to such height that
> it very much overwhelms all the other seven, and
> has shown itself until now so fruitful and fecund
> to these people that the Tarpeian [rock] and
> others have had reason to rejoice in the rise of
> such a brother who has now become their Lord.[10]

Fig. 8. Rome, Villa Lante, facade (photo: Alinari/Art Resource, NY)

Again the self-image of the villa has been introduced to reflect the splendor of its owner and, in this case, the benefits he has bestowed upon his people. All the decoration praises the patron and his love of the rustic country life.

At the death of Pope Julius III in March 1555 the major part of the building of the villa had been completed, but many of the decorative details, especially the installation of his collection of antique and modern sculpture, were not complete. Two months later the sculptor-architect Ammannati, who had been charged with the erection of the nymphaeum and the sculptural decoration, wrote a letter to his former patron Marco Benavides describing in detail the villa as built and as projected to be finished.[11] Ammannati's descriptive letter has been likened to the ancient rhetorical tradition of *ekphrasis*, first used by the Greek poet Homer in his description of the shield of Achilles (*Iliad*, XVIII, 418–608).[12] Later the ancient Roman writer Pliny the Younger devoted two of his letters to examples of architectural *ekphrasis*, describing his Laurentine (II, 17) and Tuscan (V, 6) villas and gardens. Pliny's letters then became a model for Renaissance patrons of villas and gardens, commencing at least with Raphael's design for a villa

| *The Self-Image of the Roman Villa*

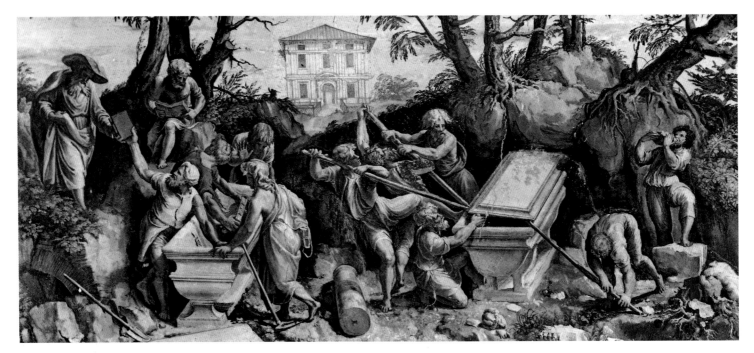

Fig. 9. Rome, Villa Lante, Salon, fresco, Finding of the Sibylline Books (photo: Fototeca di Arte Post Antica, Bibliotheca Hertziana)

at Rome, the present Villa Madama, for Cardinal Giulio de' Medici, later Pope Clement VII. Even the nymphaeum at the Villa Giulia, with four plane trees planted around the sunken fountain, was derived from Pliny's description of his Tuscan villa.[13] The visual images of the several Roman villas in their decoration are simply pictorial equivalents of the literary tradition of *ekphrasis*.

Ammannati's emphasis on the sculpture in his description of the Villa Giulia may reflect the pride that Julius III had in his collection. This explains at least in part the importance of the so-called *Lex Hortorum* inscribed on the right or south wall of the nymphaeum of the villa (Fig. 12). Commencing "Deo Et Loci Dominis Volentibus," the inscription proclaims that the estate is open for the pleasure (*honestas voluptas*) of the public and describes the delight offered by the trees and flowers, the fountains, the play of the fishes and the songs of the birds, and all the statues and paintings. The *Lex Hortorum*, which prevailed at most Roman villas and gardens throughout the sixteenth century, was to enhance the image of the patron as a man of "splendor," as the Neapolitan writer Pontano noted in the late fifteenth century.[14] The possession of treasures, such as ancient statuary, paintings, or ornamental gardens, identifies a man of splendor, but this image can occur only if the treasures are open to public access. So Julius III centered his attention on his personal villa, neglecting for the most part papal architecture.

The accession of Pius IV (1559–65) as pope on December 26, 1559, brought to the papal throne one of the most active sixteenth-century building popes. The city of Rome was said to express its reaction to the refurbishing of the city in the Latin epigram:

Marmoream me fecit, eram cum terrea, Caesar
Aurea sub quarto sum modo facta Pio.

Caesar made me of marble, when I was earthen,
Golden I have been made under the fourth Pius.[15]

Repeatedly the several Venetian ambassadors in their accounts to the Venetian senate comment in amazement on the pope's fondness for building and that there was no place in Rome which did not have his name inscribed on it.[16] For only the carved arms of Pius IV attached to his buildings and restorations there were reputed to be spent 36,000 *scudi*. During the first three years of his pontificate Pius IV is postulated to have spent a million and a half golden *scudi* for architecture and fortifications alone. His pride in his building accomplishments is revealed in the depiction twice in his decorative programs at the Vatican of his architectural achievements. The walls of the Sala dei Pontefici in the Borgia Apartment of the Vatican Palace were painted during the reign of Pius IV with landscapes which were in very poor condition already in the

eighteenth century but which depicted the building achievements or projects of Pius IV, such as Michelangelo's proposed facade for San Pietro in Vaticano, the Palazzo Venezia, the Castel Sant'Angelo, and the Porta Pia.[17]

Much more interesting from the point of view of this paper are the frescoes painted by the artist Santi di Tito illustrating the biblical Parable of the Vineyard on the vault of the stairwell of the Casino of Pius IV in the Vatican (Fig. 13). In each of the four compartments of the vault one moment of the story is pictured set against an architectural background of the pope's own architectural commissions, most designed by Pirro Ligorio, the architect of the Casino. The scene with the hiring of the first workers is viewed in the Belvedere Court with the great Nicchione at the rear. A group of a mother and several children representing the virtue of Charity sits at the left foreground to identify the theme of the paintings and the parable. The next scene has in the background the Casino of Pius IV itself viewed from the northwest (Fig. 14). The third moment has a depiction of the Via Flaminia, the main road into Rome from the north, with a glimpse in the distance of the Porta del Popolo, but at the immediate left is the public fountain before the Villa Giulia. Soon the pope will have Ligorio erect a small summer palace over the fountain for the pope's nephew, Carlo Cardinal Borromeo. The final painting, with the payment of the workers, represents Monte Cavallo or the Quirinal hill, identified by the statues of the horses, with a distant view of the Porta Pia. Pius IV, however, himself owned a small *vigna* or country residence on the west slope of the hill in the area called Magnanapoli. So on June 18, 1561, it was reported that "His Holiness, Our Lord . . . came to his garden on Monte Cavallo where he has been for some time until this morning."[18] The location of the papal *vigna* is unsure except that Ligorio mentioned in his Neapolitan

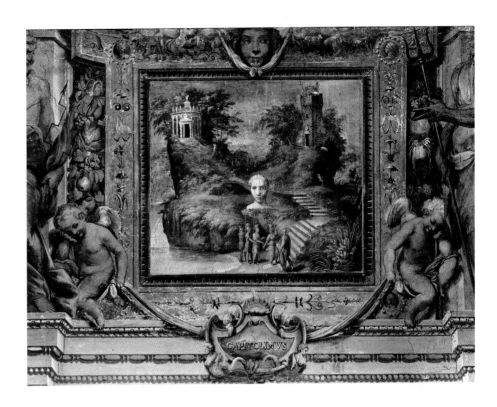

Fig. 10. Rome, Villa Giulia, Salon, fresco of Capitoline hill (photo: ICCD, Rome, E 57421)

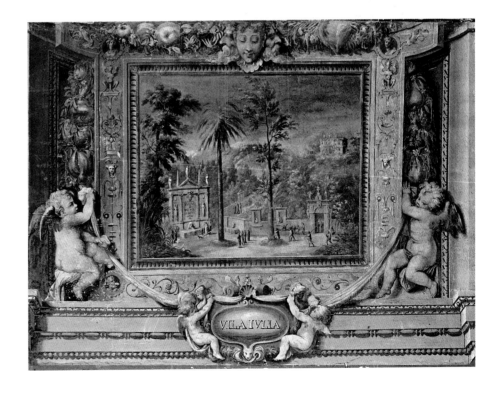

Fig. 11. Rome, Villa Giulia, Salon, fresco of Villa Giulia (photo: ICCD, Rome, E 57418)

DEO·ET·LOCI·DOMINIS
VOLENTIBVS

HOC IN SVBVRBANO·OMNIVM·SI·NON QVOT·IN·ORBIS·AT
QVOT IN VRBIS SVNT AMBITV·PVLCHERRIMO·AD HONE
STAM POTISSIME VOLVPTATEM FACTO·HONESTE VOLVPTV
ARIER·CVNCTIS FAS HONESTIS ESTO·SET NE FORTE QVIS
GRATIS INGRATVS SIET·IVSSA HAECCE·ANTE OMNIA·OMNES
CAPESSVNTO
QVOVIS QVISQ·AMBVLANTO·VBIVIS QVIESCVNTO·VERVM
HOC CITRA SOMNVM·CIRCVM SEPTA ILLVD
PASSIM QVIDLIBET LVSTRANTO·AST NEC HILVM QVIDEM
VSQVAM ATTINGVNTO
QVI SECVS FAXINT·QVIDQVAMVE CLEPSERINT·AVT RAPSE
RINT·NON IAM VT HONESTI MORIBVS SED VT FVRTIS O
NVSTI·IN CRVCEM PESSVMAM ARCENTOR
OLLIS VERO QVI FLORVM·FRONDIVM·POMORVM·OLERVM
ALIQVID PETIERINT·VILLICI·PRO ANNI TEMPORE·PRO RE
RVM COPIA ET INOPIA·PROQ·MERITO CVIVSQVE·LARGI
VNTOR
AQVAM·HANC·QVOD VIRGO EST·NE TEMERANTO·SITIMQ
FISTVLIS·NON FLVMINE·POCVLIS·NON OSCVLO·AVT VO
LIS·EXTINGVVNTO
PISCIVM LVSV OBLECTANTOR·CANTV AVIVM MVLCENTOR
AT NE QVEM INTERTVRBENT INTERIM·CAVENTO
SIGNA·STATVAS·LAPIDES·PICTVRAS·ET CAETERA TOTIVS
OPERIS MIRACVLA·QVAMDIV LVBET·OBTVENTOR·DVM
NE NIMIO STVPORE IN EA VORTANTVR
SICVI QVID·TAMEN HAVD ITA MIRVM VIDEBITVR·EORVM
CAVSSA·QVAE NEMO MIRARI SAT QVIVIT·AEQVO POTIVS
SILENTIO·QVAM SERMONIBVS INIQVIS PRAETERITO
DEHINC·PROXVMO IN TEMPLO·DEO·AC DIVO ANDREAE
GRATIAS AGVNTO·VITAMQ·ET SALVTEM·IVLIO III·PONT
MAX·BALDVINO EIVS FRATRI·ET EORVM FAMILIAE VNI
VERSAE·PLVRIMAM ET AEMITERNAM PRECANTOR
HVIC AVTEM SVBVRBANO·SPECIEM·ATQ·AMPLITVDINEM
PVLCHRIOREM·INDIES·MAIOREMQ·AC IN EO QVIDQVID
INEST·FELIX·FAVSTVM·PERPETVVM OPTANTO
HISCE ACTIS VALENTO·ET
SALVI ABEVNTO

manuscript that an ancient relief was "on the Quirinal in the garden of M. Borgogna beside that of Pope Pius." "M. Borgogna" was the French epigrapher Jean Matal or Johannes Metellus, who was in Rome from 1545 for a decade. Payments from May 1560 through December 1563, approved by Ligorio as papal architect, cover the cost of doors, windows, and woodwork at the papal residence, and a loggia and a new fishpool in the garden.

Each moment in the illustration of the Parable of the Vineyard is set, therefore, in a papal vineyard, and all the architecture was designed by Ligorio for Pius IV except the two gates—the Porta Pia by Michelangelo and the outer or northern elevation of the Porta del Popolo by Nanni di Baccio Bigio. The "self-image" of the Casino of Pius IV not only represented the pride of its owner, but contributed to the iconography of the decoration of the building.

While Julius III was building his villa and gardens just outside the walls of Rome and Ligorio was creating the Casino of Pius IV in the Vatican, one of the wealthiest

members of the College of Cardinals, Ippolito II d'Este, the cardinal of Ferrara and grandson of Pope Alexander VI, began to restore an old monastery at the hill town of Tivoli east of Rome into a country residence with magnificent gardens after the designs of the architect-archaeologist Pirro Ligorio—gardens which are still renowned for their lavish waterworks (Fig. 15). The main *salotto* in the center of the ground floor of the villa, which was used for dining according to contemporary writers, was frescoed illusionistically to suggest that one is in an open loggia supported by twisted columns somewhat like the Villa Farnesina's *salone* (Fig. 16). Between the columns are frescoed landscapes which depict the possessions of the cardinal of Ferrara, including the gardens of the Tiburtine villa itself at one end of the *salotto* and his gardens on the Quirinal hill in Rome in one of the panels of the long rear wall.[19] That the gardens are singled out for particular attention not only reflects the actuality of the rather indifferent architecture at the two sites, but the cardinal's own

| *The Self-Image of the Roman Villa*

Fig. 14. Rome, Casino of Pius IV, stairwell vault

(after W. F. Friedländer, *Das Kasino Pius des Vierten* [Leipzig, 1912], pl. XXXII)

palace (Fig. 17) up the monumental stairs and terraces in front of the building and into it. In fact, the basement excavated out of the rock was provided with a carriage entranceway leading to a circular passageway under the central round court by which visiting coaches could drive into the palace, deposit their passengers at the circular stairs at the left, continue around the passageway to exit, and withdraw to the stables at the left of the palace. The rooms at the front of the palace, such as the spiral stairs and the round chapel at each end of the central dining loggia, were rather public rooms open to all members of the court, but behind this area were two private apartments with a succession of rooms leading from the semipublic antechamber and salon to the private bedroom, dressing room, and study. The two enclosed, square gardens at the rear opening off the dressing rooms were, therefore, private gardens for the residents of each of the apartments. Thus, unlike other Roman villas and gardens, the *Lex Hortorum* did not prevail here, but, of course, there was no collection of classical antiquities to encourage public access.

Several depictions of the new palace were included, however, in its decoration. The vault of the entrance atrium on the ground floor contained two views of the palace painted by members of Federico Zuccaro's workshop. Over the entrance is a frontal view offering a glimpse of the central main street of the little town leading up to the monumental stairs and terrace before the building (Fig. 18). Opposite the picture on the rear wall over the portal into the court is a profile view of the town with the palace towering above it at the right (Fig. 19). Flanking the two depictions of Caprarola are other landscapes with mythological scenes from Ovid, such as Tereus pursuing Procne and Philomela or Apollo with Daphne, which also represent the Four Seasons. The scenes of the new palace not only assert the pride of creation and ownership of the cardinal, but emphasize the physical domination of the building over the small town below it, thus serving as an introduction to the message of the decoration of the room above the entrance atrium.

passion for gardens. His father, Duke Alfonso I d'Este of Ferrara, had earlier established several notable ornamental gardens at Ferrara, which the son emulated at Rome.

Although there was a magnificent collection of classical antiquities assembled at Tivoli, much of which is now in the Vatican Museum, no *Lex Hortorum* was inscribed at the villa, presumably because its principles were public knowledge and did not need enunciation. The villa and its gardens, however, were laid out so that there was obviously a public entrance at the base of the hillside on which the gardens were planted near the city gateway of the road from Rome (Fig. 15). A private entrance for the cardinal and his friends proceeded directly from the town into the building, and the stables for his coach and horses and those of his intimates were built in town not far from the private entrance.

About the same time, in 1556, an equally wealthy and powerful cardinal, Alessandro Farnese, grandson of Pope Paul III, commissioned the architect Vignola to complete a country residence that his grandfather had begun much earlier at the little town of Caprarola near Viterbo, north of Rome, but abandoned soon after its foundations were laid.[20] Unlike the Villa d'Este at Tivoli, where the public entrance opened onto the gardens in front of the residence, at Caprarola the gardens are private pleasaunces behind the palace. Vignola very ingeniously planned the circulation to and through the building to proceed from the public main street of the little town on axis with the

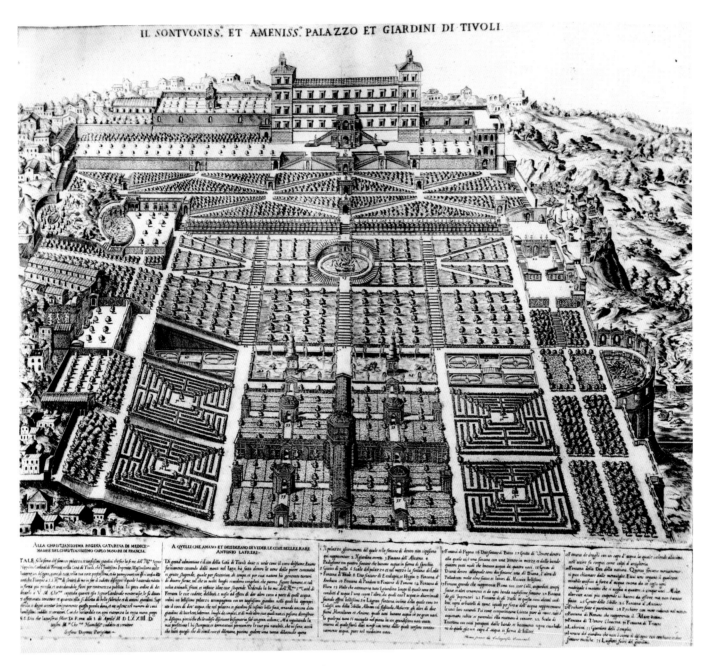

IL SONTVOSISS. ET AMENISS. PALAZZO ET GIARDINI DI TIVOLI.

Fig. 15. Tivoli, Villa d'Este, engraving, 1573 (photo: De Pretore)

In the center front of the piano nobile is a large loggia with a view upon the town on axis below (Fig. 20). Identified from the decoration of the vault as the Room of the Deeds of Hercules, it served as the principal dining hall for the court like the *salotto* at the Villa d'Este at Tivoli (Fig. 16), which obviously inspired in part the wall decoration, even to the fountain with a stuccoed landscape at one end of the room. The Caprarola decoration, with actual architectural pilasters rather than painted twisted columns, is much less illusionistic than that at Tivoli. On the back wall at Caprarola

the four bays flanking the entrance portal are painted with landscapes depicting the Four Seasons to match the great openings of the exterior wall. As the courtiers dined in the loggia, their privileged position was emphasized by the view out upon the town and surrounding lands. The wall bays over the end portals are frescoed with city views of the two major possessions of the cardinal's family, Piacenza (Fig. 21) and Parma, while the other end bays have smaller cityscapes of the lesser territories of the Farnese family such as Isola, Marta, Canino, and Caprarola itself (Fig. 22). Thus, the

| *The Self-Image of the Roman Villa*

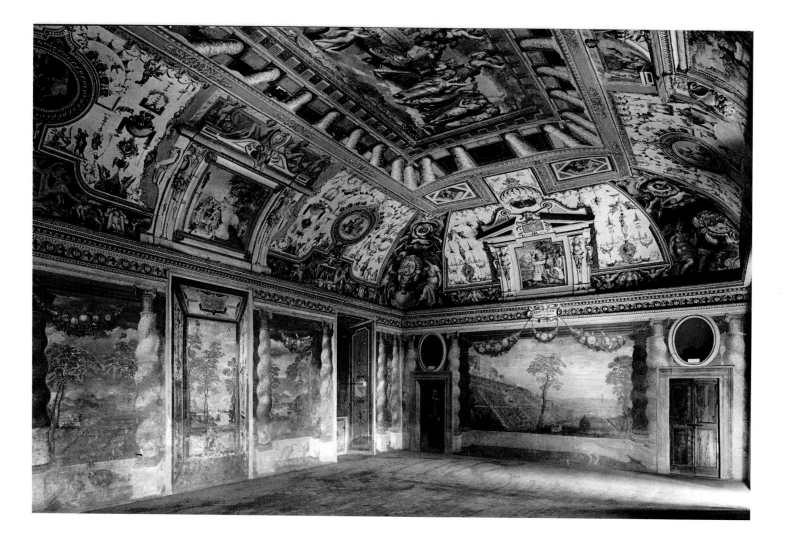

Fig. 16. Tivoli, Villa d'Este, *salotto* (photo: ICCD, Rome, E 29041)

emphasis on the Farnese domination of Caprarola was widened to include all the family's territorial possessions. The cardinal of Ferrara was content only to assert pride of ownership of his own personal land holdings at Rome and not those territories ruled by his family, the Estes of Ferrara. The Estes, however, had a long and established history as a ruling house, while the Farnese had just recently gained such a position and needed to enforce it. The design of the semifortified Farnese palace and the theme of its decoration stress the political feudalism that begins to dominate Latium at this time.

In 1584 there was published at Parma a long Latin account of Caprarola in some 240 poetic epigrams by Aurelio Orsi.[21] It is, however, not really an example of *ekphrasis*, the literary description of a visual work of art. Fragmented into the numerous epigrams, each devoted to a feature of the country residence, it gives the reader no complete image of the architecture and its ambience. It is more of an interpretative record than a descriptive one,

being concerned with the meaning associated with each painting or fountain.

While the Farnese cardinal was completing his feudal estate a distant relative and colleague, Cardinal Giovan Francesco Gambara, created a delightful villa and garden now identified as the Villa Lante at the little town of Bagnaia just north of Viterbo.[22] In 1566 the cardinal had been appointed bishop of Viterbo, but only two years later was he able to take possession of the nearby town of Bagnaia, which had long been a summer residence for the bishops of Viterbo. Earlier cardinal-bishops had enclosed a large area on the hillside of Monte Sant'Angelo adjacent to the town to serve as a hunting park and erected a hunting lodge within the park (Fig. 23). In one corner of the park on axis with the town the cardinal planted formal gardens which were to contain two small casinos as residences for himself and his friends.

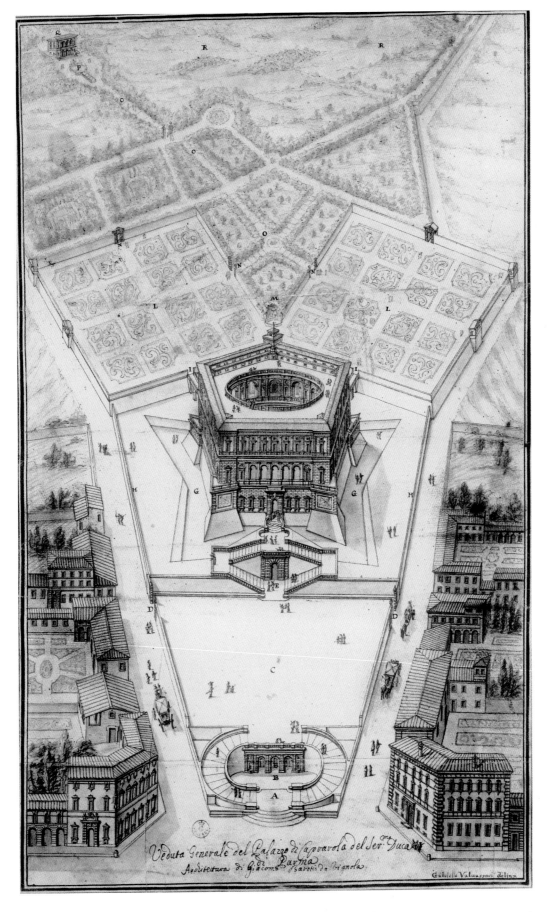

Fig. 17. Caprarola, Farnese Palace, view, drawing (photo: Gabinetto Fotografico, Soprintendenza Gallerie Firenze)

| *The Self-Image of the Roman Villa*

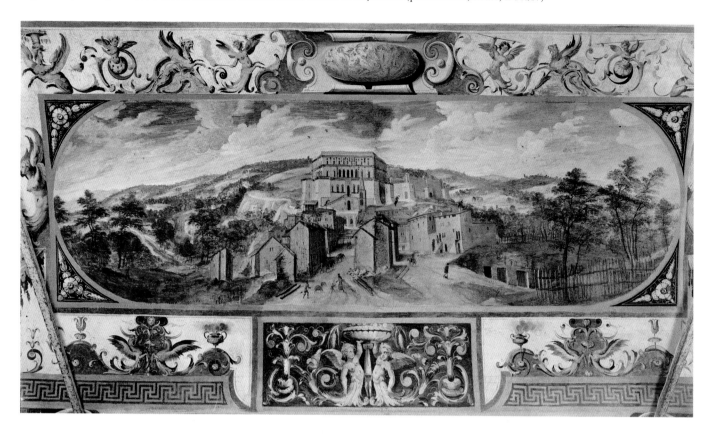

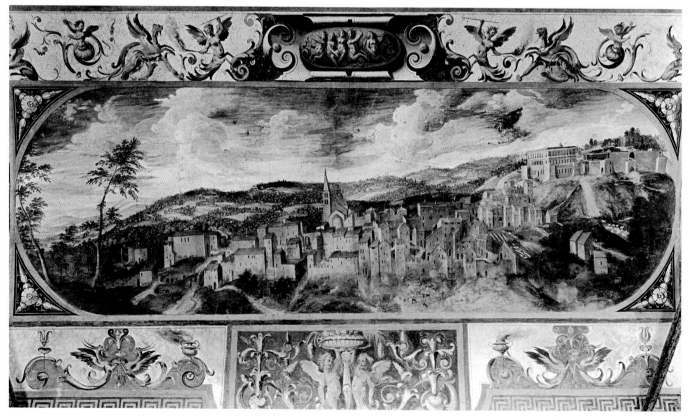

Fig. 19. Caprarola, Farnese Palace, entrance atrium, vault, fresco of Caprarola (photo: ICCD, Rome, E 56218)

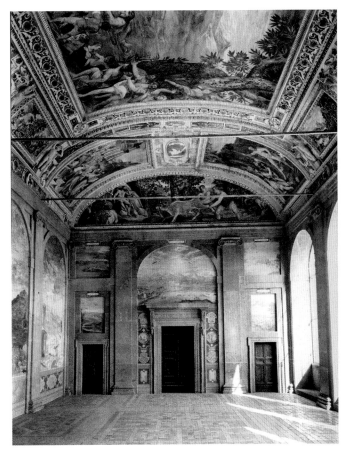

Fig. 20. Caprarola, Farnese Palace, Room of Deeds of Hercules (photo: ICCD, Rome, D 1941)

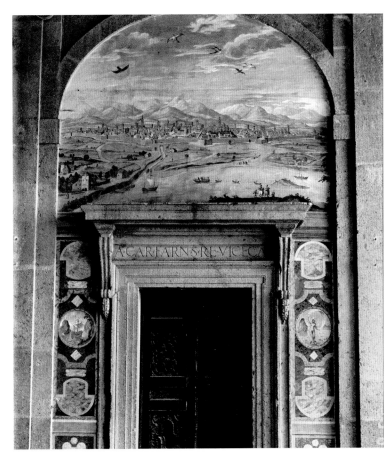

Fig. 21. Caprarola, Farnese Palace, Room of Deeds of Hercules, wall, fresco of Piacenza (photo: ICCD, Rome, E 57965)

Unlike the Este cardinal of Ferrara and the Farnese cardinal, who were members of wealthy ruling families of papal descent, Cardinal Gambara, a member of an old, noble Brescian family, had modest means. In fact, he was identified as one of the "poor cardinals" who received an annual stipend from the pope in order to project the image appropriate to a prince of the Church. In 1579, however, Pope Gregory XIII cancelled Gambara's stipend on learning of the lavish gardens the cardinal was creating. In the end Cardinal Gambara erected only the right-hand casino of the complex, identified as the Palazzina Gambara, while the twin casino at the left would be built later by Cardinal Alessandro Peretti Montalto, who also altered the principal fountain in the center of the formal garden in front of the two casinos by adding to it his arms of three mounts supported by two youths.

Gambara's casino was richly decorated with wall frescoes and friezes in the 1570s. The ground floor had a three-arched loggia opening onto the garden whose vault and walls were completely frescoed (Fig. 24). The right end

wall of the loggia depicts the gardens and casino of the Villa Lante itself (Fig. 25), based presumably on a lost drawing which was later the source of an engraving published in 1596 (Fig. 23). Since the villa and gardens at Bagnaia were the sole properties possessed by Cardinal Gambara, only one wall bay could be devoted to his lands. Interestingly, the remaining wall bays were dedicated to representations of the villas and gardens of his two wealthy colleagues, the cardinal of Ferrara and Cardinal Farnese. The other end wall of the loggia opposite the picture of the Villa Lante had a representation of the Villa d'Este at Tivoli based on the engraving of its gardens dated 1573 (Fig. 15). This fresco, however, has been severely damaged over the years, leaving only sections which can be identified with the engraving. The two large wall bays at the back of the loggia portray the Farnese cardinal's grandiose palace and gardens of Caprarola (Fig. 26) and the hunting lodge and lake he created in his *barco*, or hunting park, on the outskirts of the town of Caprarola (Fig. 27), of which there is preserved now only the roofless shell of the lodge.

The Self-Image of the Roman Villa

Fig. 22. Caprarola, Farnese Palace, Room of Deeds of Hercules, wall, fresco of Carprarola and Isola (photo: ICCD, Rome, F. 57952)

Cardinal Gambara, therefore, resorted to another rhetorical device prevalent especially in art literature, the *paragone* or comparison. Critics of painting and of sculpture had often used this device to enhance the reputation of one of the arts and its practitioners. Gambara boldly presented his country residence and garden in comparison with those of his wealthier colleagues to assert rightfully the equality, if not the superiority, of his property.

Although there was no inscribed *Lex Hortorum* at Bagnaia, the garden was designed to follow the law's principle of public access. There are actually two gates to the estate along its boundary with the town (Fig. 23). The gate leading into the formal garden in front of the two casinos was obviously the private portal for admitting the cardinal or his friends to the residences. The other large portal at one side into the park was the public entrance, permitting free access to the park and even to the upper part of the formal garden without disturbing the residents of the casinos.

Not long after the work at Bagnaia, Cardinal Farnese commissioned an additional architectural undertaking at Caprarola. In the woods above the palace he had the architect Giacomo Del Duca build a small casino or retreat with a private garden, the so-called *barchetto* or small garden park. Like the Palazzina Gambara at Bagnaia, the Farnese casino had a richly decorated, three-arched loggia opening onto the gardens. As at Bagnaia a fresco on the end wall is a "self-image," picturing the gardens and casino of the Farnese *barchetto* (Fig. 28). Here understandably there is no *paragone*, no desire to honor the properties of the other cardinals, but simply a self-aggrandizement of the cardinal as seen previously in the decoration of his great palace.

Soon in Rome another wealthy cardinal of a papal family, Cardinal Ferdinando de' Medici, would create a suburban villa to rival the earlier ones.[23] Earlier, in 1564, Cardinal Giovanni Ricci had purchased a run-down casino and grounds on the Pincian hill from the heirs of Cardinal Crescenzi. In the contract Ricci agreed to repair and to embellish the building with the understanding that the Crescenzi could repurchase the property within the next sixteen months by reimbursing Cardinal Ricci for its cost and the money he expended upon improving the property. This qualification was obviously introduced to induce the pope to permit the Crescenzi to sell the property, overriding a clause forbidding its alienation in Cardinal Crescenzi's will. This sales contract, of course, encouraged Ricci not only to repair the building, but to expand it and its grounds lavishly, thus preventing the financially strapped Crescenzi from repurchasing it.

In January 1576 the Medici cardinal bought the villa from the Ricci heirs and almost immediately summoned the elderly Florentine architect Ammannati to Rome to make revisions to the villa. While he was undertaking his work at Rome, Ammannati made a visit to Tivoli to view the gardens of the cardinal of Ferrara, which presumably the Medici cardinal considered a rival to be matched. In addition to major changes to the structure of the building, Medici acquired a notable collection of classical antiquities from the Capranica family. Ancient reliefs in the collection were installed as decoration on the garden facade of the villa, and eventually a gallery for the exhibition of

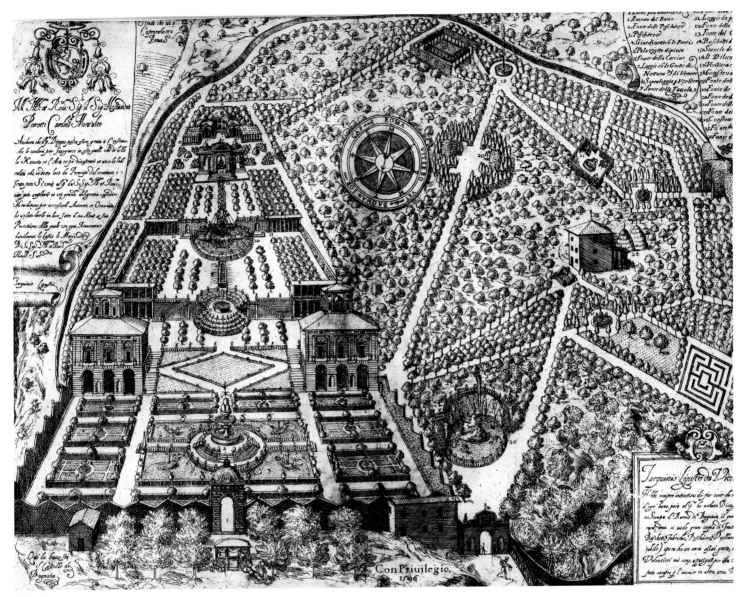

Fig. 23. Bagnaia, Villa Lante, engraving, 1596. Bibliothèque Nationale de France (photo: Bibliothèque Nationale de France)

the freestanding sculpture was erected at the rear of the villa. Much of the interior of the building was soon decorated with pictorial friezes.

An apartment on the south side of the villa, comprised of three rooms, has friezes honoring the Medici and their territorial rule.[24] The first room illustrates the numerous *imprese* or emblems that members of the Medici family have borne, combined with grotesque decoration and presumably fantastic landscapes. The second room has eight cityscapes depicting Tuscan towns controlled by Florence and, therefore, by the Medici, such as Fiesole, Prato, and Cortona. Similarly, the last room, whose decoration is severely damaged, has traces of views of at least three of the

principal Tuscan towns: Florence, Livorno, and Siena. This device of demonstrating political power by the depiction of towns under Medici control is obviously similar to the representation of the Farnese territories in the loggia at Caprarola. There is, however, no "self-image" of the Villa Medici among the cityscapes as at Caprarola; rather, the Villa Medici is located in Rome under papal control and in no way expresses the political power of the cardinal's family.

The "self-image" of the Villa Medici exists, however, in three different views hidden away in the private study of the cardinal.[25] In addition to Ammannati's revisions of the main casino, he had erected several pavilions on the

| *The Self-Image of the Roman Villa*

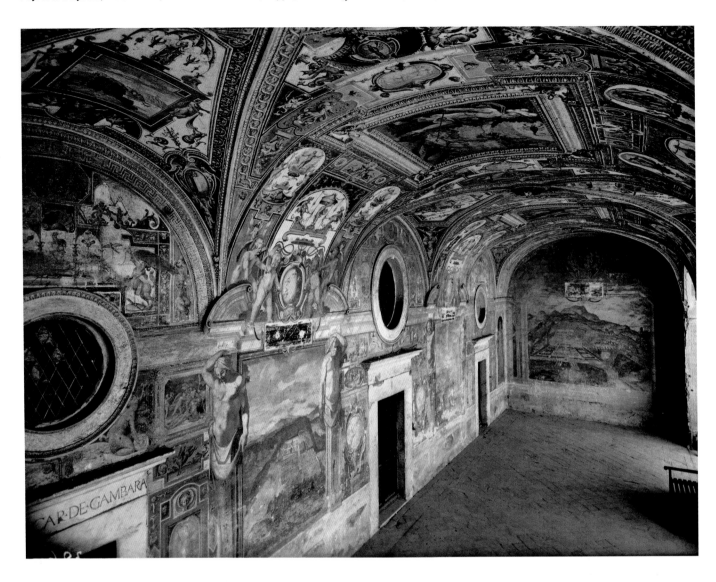

ancient Aurelian walls of the city which defined the eastern side of the gardens. One pavilion, consisting of two small rooms, was the private study of the cardinal removed from the activity of the main building. The smaller room, entitled the Stanzino dell'Aurora, leads to a terraced walkway along the city wall. Aurora is depicted in the center of the vault of the room with the Four Seasons below symbolized by four classical deities, Venus, Ceres, Bacchus, and Saturn, the latter standing above the single window of the room. Below the first three deities are three images of the Villa Medici at different stages of its existence. Under Bacchus or Fall is a presumed reconstruction of the old Crescenzi *vigna* before its restoration and expansion by Cardinals Ricci and Medici (Fig. 29). The fresco portrays a rather casual gathering of buildings and walled gardens. On the long wall under Ceres or Summer is painted the garden facade of the Villa Medici and its lavish gardens as expanded and regularized under the two cardinals (Fig. 30). The last image, under Venus or Spring, presumably presents an unrealized project to embellish the hillside approach to the villa (Fig. 31). The hillside before the city elevation of the villa was to be terraced with monumental stairways and in the center of one terrace was to be a square water basin with a fountain surmounted by a prancing Pegasus, the winged horse from whose hoofprints rose the Fountain of the Muses on Mount Parnassus. Thus the cardinal would be identified as an eminent patron of the arts. The Fountain of Pegasus was probably inspired by a similar fountain at the Villa d'Este at Tivoli visited by Ammannati in the spring of 1576.

Fig. 25. Bagnaia, Villa Lante, Palazzina Gambara, loggia, fresco of Villa Lante (photo: Soprintendenza ai Monumenti del Lazio)

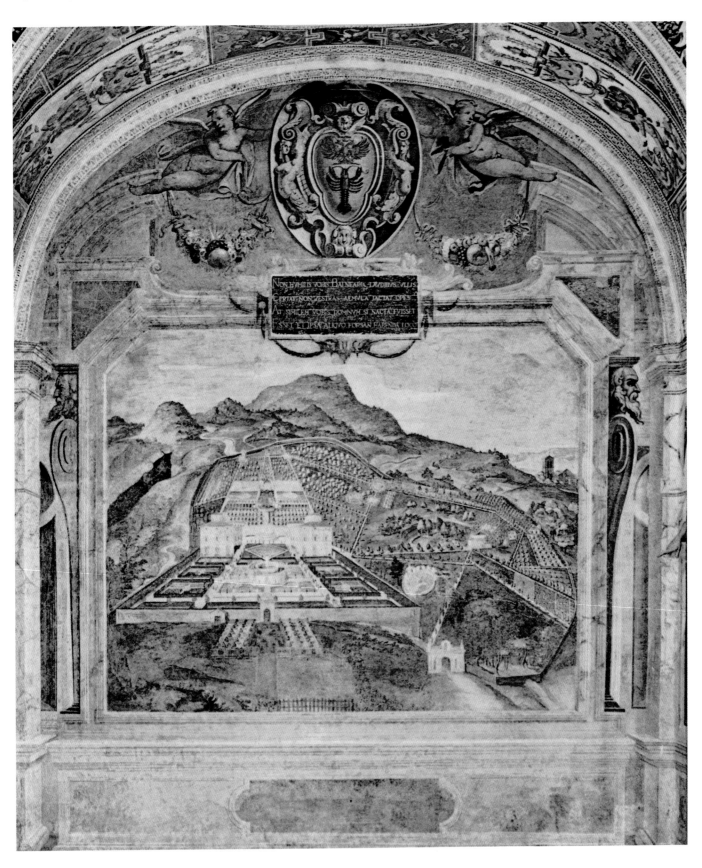

Fig. 26. Bagnaia, Villa Lante, Palazzina Gambara, loggia, fresco of the Farnese Palace, Caprarola (photo: ICCD, Rome, E 38660)

Fig. 27. Bagnaia, Villa Lante, Palazzina Gambara, loggia, fresco of *barco*, Caprarola (photo: Soprintendenza ai Monumenti del Lazio)

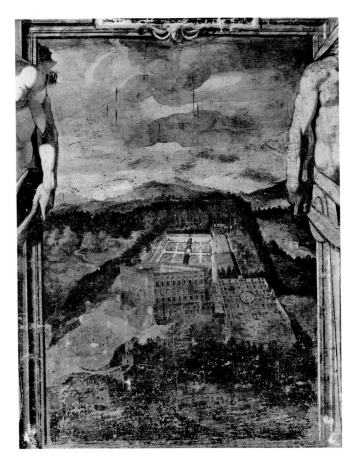

Certainly the location of the "self-image" of the Villa Medici in the private retreat of the cardinal does not correspond with previous examples where the "self-image" is an expression of public pride to enhance the reputation of the owner. It has been observed that the depictions of different stages of building at the villa resemble a visual image of the legal clause in the sales contract between the Crescenzi and Cardinal Ricci.[26] In short, the views portray the earlier condition of the *vigna* at the time of the Crescenzi, then the lavish improvements made by Ricci and Medici, and even the possibility of future improvements by the latter which would ensure his control of the hillside at the front of the villa. The paintings would confirm to the cardinal how well he and Ricci have satisfied the legal requirements to assure their retention of the property. Indeed, it is possible that he kept in the *studiolo* the very plans for his improvements which he might pore over at leisure.

In addition to the architectural improvements at the villa, Medici embellished the gardens which Ricci had laid out (Fig. 32). The long alley that proceeded from the gardens near the gallery of ancient sculpture across the Pincian hill behind the church of SS. Trinità dei Monti to the Via di Porta Pinciana was straightened and leveled. At the street at the end of the alley Ammannati designed and built a rusticated portal, which survives except for the loss of its superstructure with the Medici arms and balls or *palle* (Fig. 33). This is obviously the public entrance, as the *Lex Hortorum* inscribed on the two plaques on the gate proclaims.[27] So the general public can gain access to the gardens and to the gallery of ancient statues without inconveniencing the cardinal and his friends in the casino.[28]

By the sixteenth century the cardinals of the Church at Rome viewed their villas not only as delightful seats for the enjoyment of the pleasures of rural life, but as images of their position and wealth. The device of a villa's "self-image" and the policy of public access enunciated in the *Lex Hortorum* enhanced the position of the owners as men of "splendor," generous patrons of the arts, and men of power.

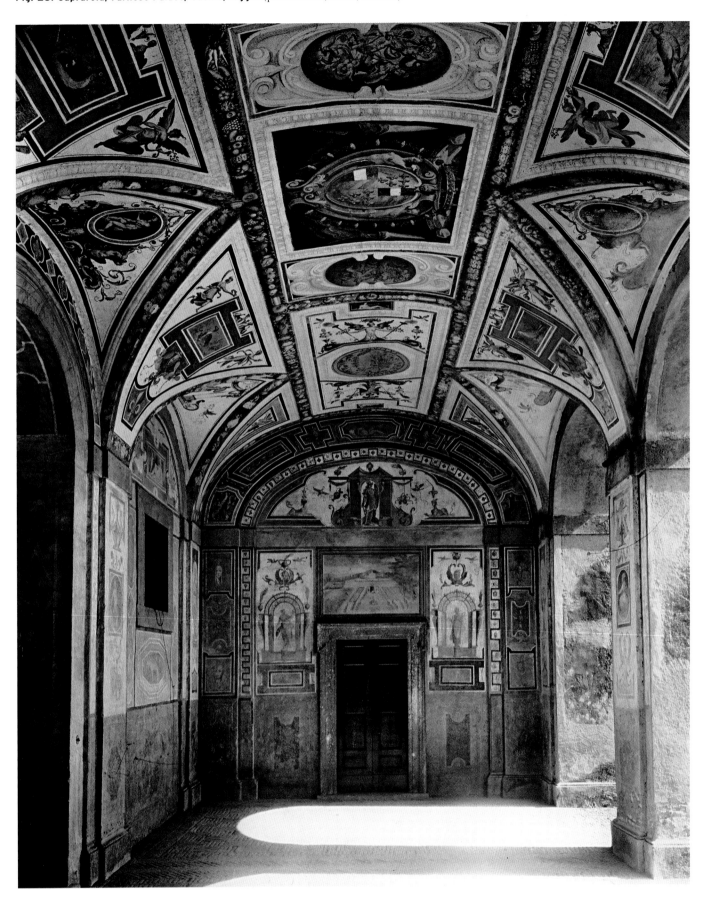

| *The Self-Image of the Roman Villa*

Fig. 29. Rome, Villa Medici, Studiolo, Room of Aurora, fresco of Crescenzi *vigna* (photo: Vasari)

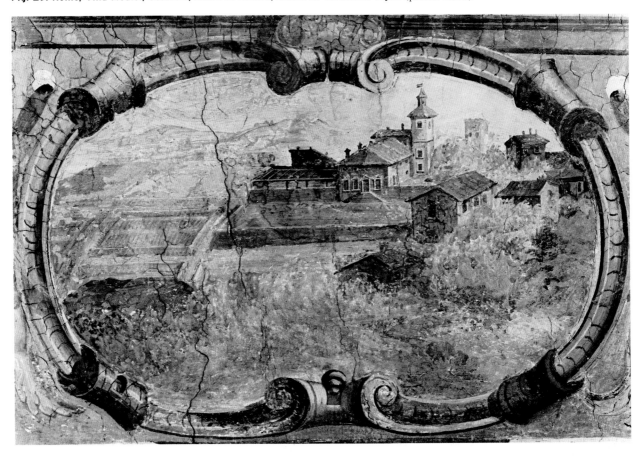

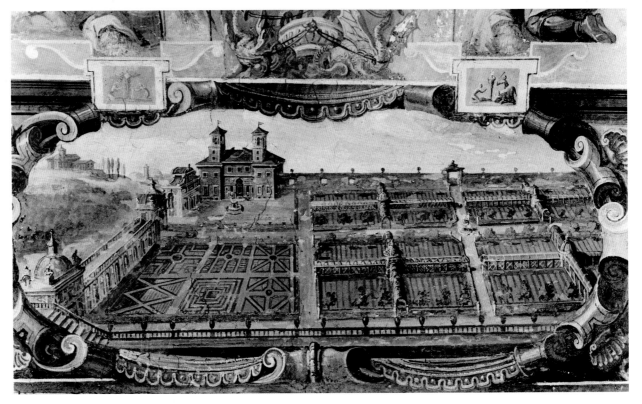

Fig. 30. Rome, Villa Medici, Studiolo, Room of Aurora, fresco of Villa Medici (photo: Vasari)

Fig. 31. Rome, Villa Medici, Studiolo, Room of Aurora, fresco of Villa Medici with terraces (photo: Vasari)

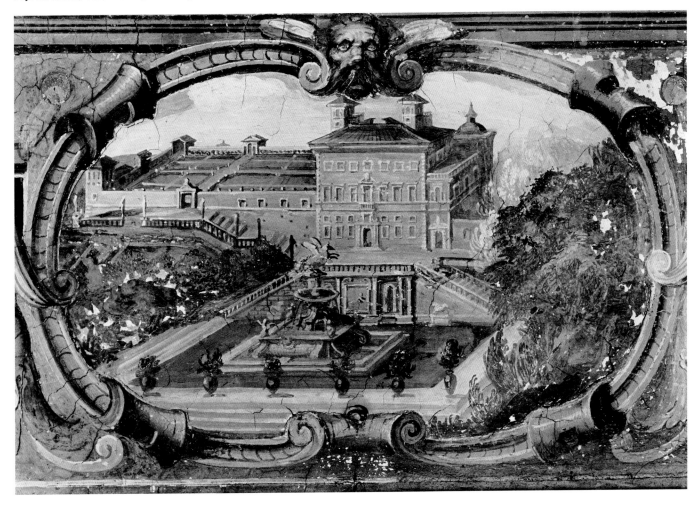

Notes

1. A version of this paper was given at a colloquium at the Center for Advanced Study in the Visual Arts at the National Gallery of Art in Washington, D.C., during the fall of 1995. I wish to thank most warmly Dean Henry Millon and other participants in the colloquium for their comments. I also wish to thank the Library Company of Philadelphia for its gracious reception of my request to study its copy of Chattard's description of the Vatican.

2. The building history is summed up in D. R. Coffin, *The Villa in the Life of Renaissance Rome* (Princeton, 1979), 69–87.

3. B. Nogara and F. Magi, "I. Relazione," *Rendiconti della Pontificia Accademia Romana di Archeologia*, ser. 3, 23–24 (1947–49), 363–368; and D. Redig de Campos, *Palazzi Vaticani* (Bologna, 1967), 77–78. Vasari's later account identifies six Italian cities as subjects of the views, although earlier Albertini in 1509 only mentioned "famous cities." The suggestion by S. Sandström, "The Programme for the Decoration of the Belvedere of Innocent VIII," *Konsthistorisk Tidskrift* 29 (1960), 54, that the frescoes were to honor an attempt by Innocent VIII in late 1486 and early 1487 to negotiate peace among the six city-states specified by Vasari seems doubtful given the lack of evidence in the fragments and the fact that the peace treaty of 1486, which was broken probably before the paintings were executed, does not seem to have involved Venice. Also the location of such paintings in the seclusion of a rather private setting does not seem particularly appropriate for what should be political propaganda.

4. Two eighteenth-century descriptions of the Vatican provide accounts of the lost decoration: A. Taja, *Descrizione del palazzo apostolico vaticano* (Rome, 1750); and G. P. Chattard, *Nuova descrizione del Vaticano*, 3 vols. (Rome, 1762–67). The quotations from Chattard are in volume 3, pp. 138 and 145–146. For the fourteenth-century map of Rome, see A. Frutaz, *Le piante di Roma* (Rome, 1962), vol. 1, 115–119, and vol. 2, pls. 143 and 145.

5. D. R. Coffin, "Pope Innocent VIII and the Villa Belvedere," in *Studies in Late Medieval and Renaissance Painting in Honor of Millard Meiss*, ed. I. Lavin and J. Plummer (New York, 1977), 96–97 [reprinted on pages 68–69 of this volume].

6. C. L. Frommel, *Die Farnesina und Peruzzis architektonisches Frühwerk* (Berlin, 1961).

7. Martial, *Epigrams* (Loeb Classical Library), trans. W. C. A. Ker (London and New York, 1919), vol. 1, p. 275.

The Self-Image of the Roman Villa

Fig. 32. Rome, Villa Medici, engraving (after G. B. Falda, *Li giardini di Roma* [Rome, n.d.], pl. 8)

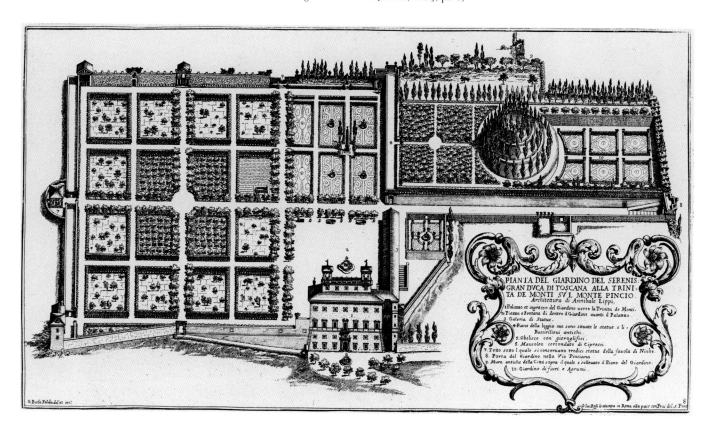

8. Coffin, *The Villa* (note 2 above), 257–265; and H. Lilius, *Villa Lante al Gianicolo* (Rome, 1981).

9. Coffin, *The Villa* (note 2 above), 150–165.

10. A. Nova, *The Artistic Patronage of Pope Julius III (1550–1555)* (New York and London, 1988), 164–165.

11. First published in *Giornale arcadico* 4 (1819), 387–398, and republished in T. Falk, "Studien zur Topographie und Geschichte der Villa Giulia in Rom," *Römisches Jahrbuch für Kunstgeschichte* 13 (1971), 171–173.

12. L. Satkowski, *Giorgio Vasari: Architect and Courtier* (Princeton, 1993), 18.

13. D. R. Coffin, *Gardens and Gardening in Papal Rome* (Princeton, 1991), 82 and fig. 62.

14. For the *Lex Hortorum* at the Villa Giulia, see Coffin, *Gardens and Gardening* (note 13 above), 246–247, and for it at Rome in general, see ibid., 249–257.

15. P. Masson, *De Episcopis Urbis* (Paris, 1586), fols. 411v–412r.

16. Account of G. Soranzo in June 1563 published in E. Alberi, ed., *Le relazioni degli ambasciatori veneti dal Senato durante il secolo decimosesto*

vol. 10 (Florence, 1857), 76–77. For the cost of the papal arms, see ibid., 174. Other remarks regarding the building activity of the pope in Venetian accounts in ibid., 76–77, 83, 131, 174, and 196. For the money spent on architecture and fortifications, see ibid., 132 and note 1 on p. 134.

17. Taja, *Descrizione del palazzo apostolico* (note 4 above), 87–88. The subjects of the landscapes are identified by F. Ehrle and E. Stevenson, *Gli affreschi del Pinturicchio nell'apartamento Borgia* (Rome, 1897), 59–61.

18. L. von Pastor, *The History of the Popes*, vol. 16 (London, 1928), 465, doc. II. See Coffin, *The Villa* (note 2 above), 192–193. For the garden of Jean Matal, see Naples, Biblioteca Nazionale, Ms. XIII.B.2, fol. 94.

19. Coffin, *The Villa* (note 2 above), 330–331.

20. G. Labrot, *Le Palais Farnèse de Caprarola: essai de lecture* (Paris, 1970); and S. Falda, *Il Palazzo Farnese di Caprarola* (Turin, 1981).

21. A. Orti, *De Caprarolae descriptione*, republished by F. Baumgart, "La Caprarola di Ameto Orti," *Studj romanzi* 25 (1935), 77–179.

22. C. Lazzaro, *The Italian Renaissance Garden* (New Haven and London, 1990), 243–269.

23. For the history of the building, see G. M. Andres, *The Villa Medici in Rome*, 2 vols. (New York and London, 1976); and A. Chastel, ed., *La Villa Médicis*, vol. 2 (Rome, 1991), especially 197–340.

Fig. 33. Rome, Villa Medici, gateway (photo: author)

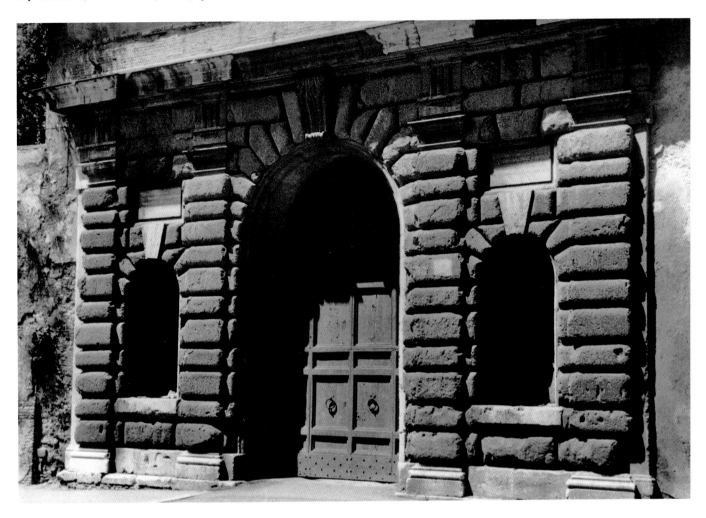

24. P. Morel, "Dynastie et territoire: le programme politique de l'appartement méridional," in *La Villa Médicis* (note 23 above), vol. 3, 232–273.

25. E. Darragon, "Le stanzino d'Aurore," in *La Villa Médicis* (note 23 above), vol. 2, 539–552.

26. S. B. Butters, "Ferdinand et le jardin du Pincio," in *La Villa Médicis* (note 23 above), vol. 2, 364.

27. Coffin, *Gardens and Gardening* (note 13 above), 231.

28. Contemporary with Cardinal Medici's embellishment of his villa, Cardinal Felice Peretti Montalto built a villa with extensive grounds in Rome near his church of Sta. Maria Maggiore. Above the portal in an upper corner room was a "self-image" of the villa, but both the building and the painting were destroyed in the mid-nineteenth century. An early-nineteenth-century engraving in Vittorio Massimo's book describing the villa preserves an image of the painting. His description, however, only singles out the "self-image" and merely notes that the room was decorated with other landscapes without identifying their nature, thus affording no context for the "self-image" and limiting any interpretation of its occurrence. After the cardinal's election as Pope Sixtus V, Aurelio Orsi, who composed the Latin epigrams on the palace at Caprarola, published in 1588 a long Latin poem, *Perettina*, describing the papal villa. See [V. Massimo], *Notizie istoriche della Villa Massimo alle Terme Diocleziane* (Rome, 1836), with the poem *Perettina* reprinted on pp. 231–238; and M. Quast, *Die Villa Montalto in Rom* (Munich, 1991).

6

Some Architectural Drawings of Giovan Battista Aleotti

The Ferrarese architect Giovan Battista Aleotti (1546–1636), called L'Argenta from his birthplace, is primarily known for one building, the Teatro Farnese at Parma, and for his activity as a hydraulic and military engineer. However, there are several rather notable works of architecture by Aleotti still preserved in Ferrara, and his architectural drawings permit us to attribute to him several more buildings or to study further his architectural style as it is revealed in some of his unexecuted designs. In addition to the large collection of Aleotti drawings preserved as a manuscript (Ms. Classe I, no. 763) in the Biblioteca Comunale Ariostea at Ferrara,[1] there are two small unexplored caches of drawings which add to our knowledge of his architecture.

In the Biblioteca at Ferrara, classified as a manuscript (Ms. Classe I, no. 217), is Aleotti's copy of Vignola's book on architecture, the *Regola delli cinque ordini d'architettura.* Interleaved within this book is a series of drawings and prints collected by Aleotti, as he notes in an inscription on the title page of the book: "Con molti fragmenti di ciascono ordine che vagavano per le stampe et altrove raccolti dal'Argenta architetto." The interleaved drawings are from three different hands, some by Aleotti himself, a few by the Neapolitan artist and archaeologist Pirro Ligorio, who died at Ferrara in 1583, and a few by the mysterious Ferrarese architect Terzo de' Terzi.[2] There is also another manuscript which has the same gathering of

three artists. It is the manuscript on antiquities by Pirro Ligorio in the Bodleian Library at Oxford (Ms. Canonici Ital. 138). Interleaved in Ligorio's bound manuscript are six drawings by Aleotti, and the last twenty folios of the manuscript comprise the beginning of a translation of Vitruvius written in an older hand resembling that of Terzo de' Terzi and dated on the first folio 8 March 1549. Directly below the date Aleotti noted: "Principio d'una tradutione d'un vitruuio. Questo lo hebbi in Munizione del Duca mentre ui fui superiore l'anno 1589." And at the bottom of this frontispiece Aleotti added: "Questa traduzzione non ho polsuto sapere dà chi uenga, mà per auiso mio deu'ella hauto Autore ò Terzo Terzi, ò Girolamo Tinti Architetti d'Hercole Secondo in quel tempo Duca di Ferrara."[3] Therefore, Aleotti must have possessed Ligorio's Oxford manuscript on antiquities after the latter's death, and there has been bound with the manuscript a few scattered drawings by Aleotti and the translation of Vitruvius, probably by Terzi, which Aleotti found in the Munizione del Duca when he was ducal architect.[4]

Bound in the front of Aleotti's copy of Vignola at Ferrara are five drawings by him for gates for the city of Ferrara to be built during the papacy of Paul V and the legateship of Cardinal Orazio Spinola. One of these designs (Fig. 1)[5] is for a gate still preserved at Ferrara, the Porta Paula, now known as the Porta Reno. The drawing resembles the present gate (Fig. 2) except for some minor

Fig. 1. Drawing for the Porta Reno, Ferrara, by Aleotti (photo: Biblioteca Comunale Ariostea, Ferrara)

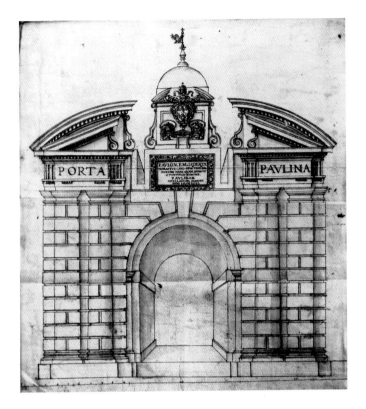

changes, such as the substitution in the gate of a smooth frieze with large mutule blocks under the cornice in place of the Doric entablature with dentil molding of the drawing, and the omission of the vertical coursing on the classic orders. The uppermost part of the central decoration between the split pediments is different from the drawing, but this change is probably the result of redoing this section when the communal arms of Ferrara were substituted for the papal arms of Paul V. The gate has heavily drafted stone coursing which runs across the paired orders, each pair consisting of a half column and pilaster. This pairing of half columns and equally projecting pilasters is reminiscent of some of the gates by Michele Sanmicheli, and Aleotti, who was a specialist in military architecture, undoubtedly knew well the military architecture of Sanmicheli. In fact, in a letter of 1598 Aleotti speaks of his return at that time from Venice, where he had been offered by the Council of Ten a position in charge of the fortresses and waterworks of the Venetian Republic analogous to the position Sanmicheli had held a half century earlier.[6] Aleotti's drawing for the Ferrarese gate bears the date 1611 in its inscription, and the extant gate has the date 1612.

Another drawing (Fig. 3) depicts a more classical gate with paired Doric half columns bearing a split segmental pediment from which rises a very simple cupola.[7] This gate, planned for the great Fortress of Ferrara begun by Pope Clement VIII and continued by Pope Paul V, was never executed, as Aleotti's own annotation on the drawing relates: "Questa porta fù di mano dell'Argenta Architetto per farla alla porta del soccorso in cittadella di Ferrara la quale non fù poi posta in opera." The inscription on the drawing carries the date of the seventh year of the pontificate of Paul V, that is, from May 1611 to May 1612, and the project is therefore contemporary with the Porta Paula, with which it reveals some affinity.

There are also three drawings (Figs. 4–6) presenting different stages in Aleotti's conception of the main portal for the Fortress of Ferrara. Unlike the other designs this gateway was to have three portals, a center one for horse and wheel traffic and side ones for pedestrians. What is presumably the first idea (Fig. 4), since it does not carry the inscription to be sent from Rome that the other two designs have, is of the Doric order with rustication, bands of rustication even covering the shafts of the pilasters.[8] Above the entablature is a simple parapet with ball ornaments, and in the upper center a very elaborate frontispiece with a split segmental pediment from the center of which rises the papal umbrella and keys. A papal coat-of-arms stands over the central entrance and cardinalate

Fig. 2. Exterior, Porta Reno, Ferrara (photo: author)

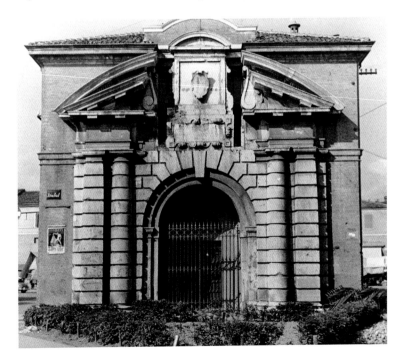

Fig. 3. Drawing for the gate to the Fortress of Ferrara, by Aleotti
(photo: Biblioteca Comunale Ariostea, Ferrara)

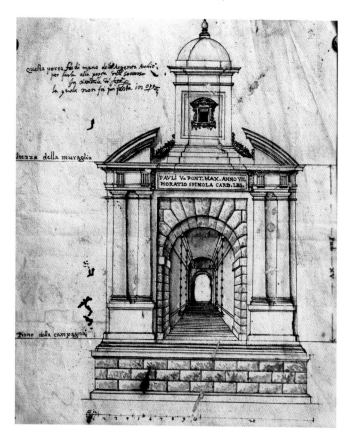

great split pediment with volute ends.[11] The centerpiece has been simplified to a panel with the papal arms of Paul V surmounted by two pediments, an inner triangular one and an outer split segmental one with the Borghese double-headed eagle in the center of it. On the right side of the gate are the arms of Cardinal Spinola, legate to Ferrara, and on the left the arms of Cardinal Scipio Borghese, nephew and secretary of state of the pope. These arms have been moved up to overlap the Doric entablature so that the latter is scarcely visible except for a triglyph above each pilaster. The design, therefore, has a slight similarity to that of the later Porta Reno (Fig. 1) which Aleotti built in 1612. In the central opening of the drawing of the gate Aleotti has written: "L'inscrizzione uenuta dà Roma è questa: Paulus V. P. M. Arcem Ferrariae à Clemente VIII pont. Max. inchoatam in opportuniorem formam redegit atq. perfecit Anno"

The final design preserved (Fig. 6) is to some extent a synthesis of his preceding two drawings. The cardinalate arms have been moved down again, allowing the Doric

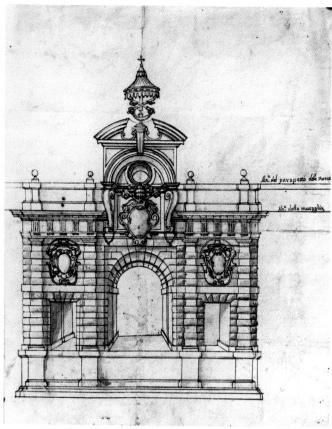

arms over the side entrances. In a letter of October 1609 Aleotti wrote to Duke Cesare d'Este of Modena, who had been ousted as Duke of Ferrara by the papacy, that he lacked marble to make the gate for the new fortress and in particular three large pieces for the arms of the pope and Cardinals Borghese and Spinola.[9] Aleotti, therefore, requested that he might use the large marble capital which was in the Porto di S. Polo, intended for the column of the Piazza Nova. He warned that, rather than executing his design for a new gate, there was a proposal to move the Porta di S. Pietro from the city walls to the fortress to serve as the main gate. In fact, this idea was later carried out, for after 1630 the old Porta di S. Pietro of the city was transferred to the fortress and the city gate was closed.[10] The letter of 1609 suggests that Aleotti's earliest drawing for the fortress gate may date from that year. Of all Aleotti's gate designs this is the most manneristic in the fantasy of the centerpiece and the incongruity between the rustication and the classicism of the Doric order.

The second project (Fig. 5) has kept the rustication of the first idea but added as its main decorative feature a

Fig. 4. First project, main gate to the Fortress of Ferrara, by
Aleotti (photo: Biblioteca Comunale Ariostea, Ferrara)

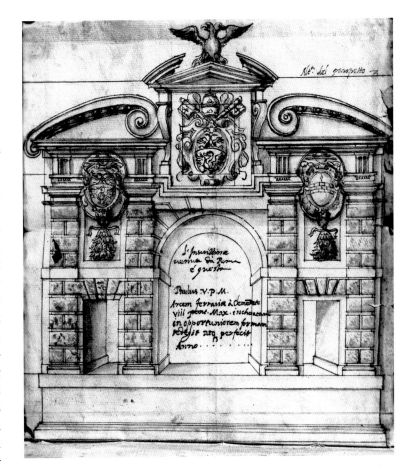

entablature to reassert itself, and the half columns are no longer lost under rustication.[12] The resultant sense of a layer of the classic order superimposed upon the rusticated wall resembles somewhat the external facade of Sanmicheli's Porta Palio at Verona. In fact, the lower part of all of Aleotti's gates uses the vocabulary of Sanmicheli. It is in the superimposition of the split pediments and decorative centerpieces that Aleotti transforms the Sanmicheli vocabulary, so that Aleotti's designs are more in the nature of portals than the fortified gateways of Sanmicheli. In this last design by Aleotti he has enlarged the mass of the split pediment with volute ends until it overwhelms the classic order beneath it. It is interesting to note that the design of this split pediment has been taken directly from the portrait title page of Vignola's book on architecture (Fig. 7), as in Aleotti's copy, where these drawings are preserved. The inscription added in script by Aleotti to his second drawing now appears inscribed on the central plaque of the third design with the date 1610. As far as I can tell, Aleotti's design for a monumental gateway to the Fortress of Ferrara was never executed, and therefore, as noted above, the old Porta di S. Pietro of the city was moved to the fortress after 1630 to serve as the main gateway. The great fortress was destroyed by the French in the late eighteenth century, rebuilt in 1815, and then totally razed in 1859. The guidebooks to Ferrara and other accounts do not seem to describe any other gates to the fortress.

The last drawing of a gateway for the Ferrarese fortress helps to clarify the attribution of a palace in Ferrara. The facade of the Palazzo Bentivoglio at Ferrara (Fig. 8), home of the Ferrarese military hero the Marchese Cornelio Bentivoglio, was refashioned from late 1583 to 1585, and recent art historians have attributed this facade on stylistic grounds to the Neapolitan artist, architect, and archaeologist Pirro Ligorio, who lived in Ferrara from 1568 until his death in 1583.[13] The facade of the Palazzo Bentivoglio has, however, very little resemblance to the style of Ligorio. The architecture of Ligorio, as seen in the Casino of Pius IV in the Vatican or the Palazzo Lancellotti on the Piazza Navona at Rome, is very decorative and delicate in its archaeologizing classicism, almost a feminine style, inspired by the art of Raphael and particularly Peruzzi. The Palazzo Bentivoglio, on the other hand, while decorative, is bold and rather masculine in its manner. The broken pediments of the *piano nobile* and the main portal, the

unusual window heads of the ground floor, and the rusticated blocks over the orders of the portal and the ground-floor windows are completely foreign to Ligorio. In fact, Ligorio himself writes very vehemently against the practice of using the split pediment.[14] Split pediments and rustication combined with the classic orders play an important role in the decorative vocabulary of Aleotti's later Ferrarese gates (Figs. 1–6), and the unusual volute split pediment over the portal of the Palazzo Bentivoglio (Fig. 9) and on the windows of the *piano nobile* (Fig. 8) are almost identical with that of one of the gate drawings (Fig. 6),[15] which we have already noted as inspired by the title page of Vignola's book. The treatment of the rustication of the portal suggests that it may be derived from Serlio's book on architecture,[16] although by this time such a portal was fairly standard in North Italian architecture. The most striking feature of the facade is the marble reliefs added to the surface of the elevation. There are clusters of trophies between the paired windows culminating in the center over the portal in the personifications of Fortitude and Virtue supporting the arms of the marchese. The sculpture is, of course, to commemorate the exploits of the

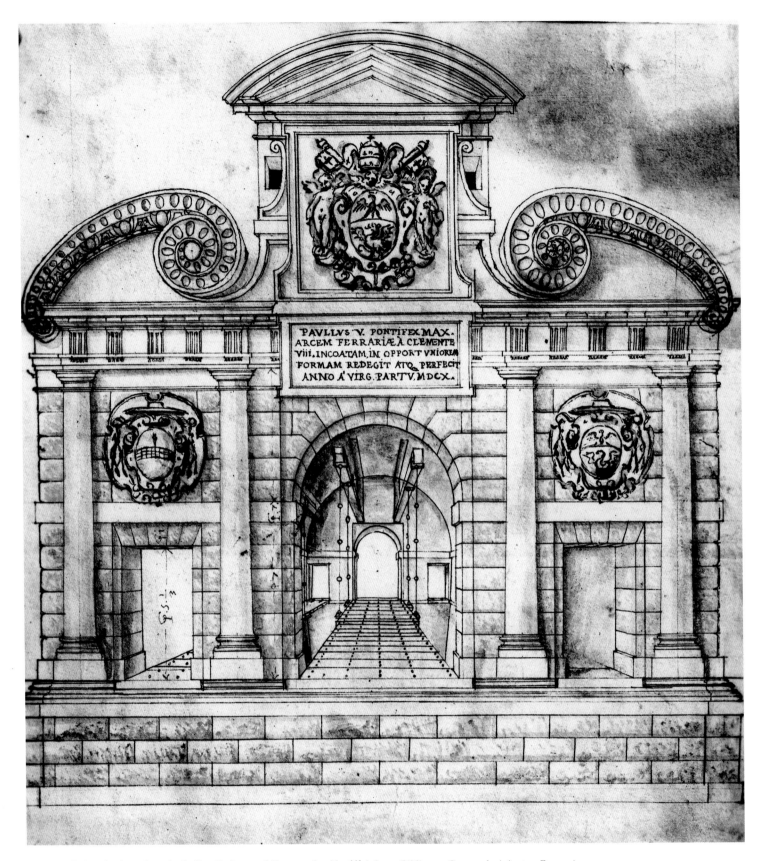

Fig. 6. Third project, main gate to the Fortress of Ferrara, by Aleotti (photo: Biblioteca Comunale Ariostea, Ferrara)

The inscription on the gate reads:

PAVLLVS V. PONTIFEX MAX.
ARCEM FERRARIÆ A CLEMENTE
VIII. INCOATAM, IN OPPORTVNIOREM
FORMAM REDEGIT ATQ. PERFECIT
ANNO A VIRG. PARTV. MDCX.

owner, who was captain-general of the Ferrarese troops. It is undoubtedly the superficial resemblance of this relief sculpture to Pirro Ligorio's stucco relief facade of the Casino of Pius IV in the Vatican that has caused art historians to attribute the Palazzo Bentivoglio to Ligorio, but there is really no similarity between the delicate overall pattern of the stucco reliefs of Ligorio and the spots of rich marble sculpture on the Ferrarese palace, while, as noted above, the architectural decorative vocabulary of the Palazzo Bentivoglio can never be paralleled in any of the works of Ligorio.

The facade of the Ferrarese palace is composed with gradual centralization created by the spacing of the windows, commencing with the loosely paired windows at the ends of the facade through a closely spaced pair to the single windows crowding up against the central portal of the ground floor and the sculpture of the coat-of-arms on the *piano nobile*. This centralization, while very successful in unifying what is a large facade, may, however, not be entirely the inspiration of the sixteenth-century architect. The structure of the palace dates from the mid-fifteenth century, and only the facade was refashioned and redecorated in the late sixteenth century. Many of the fifteenth- and early-sixteenth-century Ferrarese buildings, even down to Biagio Rossetti's own house or his Palazzo Roverella, show a syncopated spacing of the windows, usually, however, with a single window at the ends, then a pair of windows, and finally a single window close to the central portal. It may be, then, an earlier disposition of windows that the later architect has reworked so successfully.

In addition to the stylistic features that point to Aleotti as the designer of the new facade for the Palazzo Bentivoglio, there are documents that indicate contact between Aleotti and the Marchese Bentivoglio about the time of the refashioning of the facade. In fact, in Aleotti's book on the water system about Ferrara he claims that he "served for twenty-two years [namely, from about 1575], with the title of Architect, a Prince of the greatest valor of his time, Duke Alfonso, and I was honored with this title by the most Illustrious Sig. Cornelio Bentivoglio, Cavaliere of great worth, as the world knows, and with him I have founded and built many things."[17] Aleotti's early activity seems to have been of a minor sort. He notes in a manuscript that he was concerned with the hydraulic problems of the countryside of Ferrara from 1574,[18] when he was twenty-eight years old, and in his book on hydraulics he relates that he was the chief mason in 1579 for the Fontana di Montalfonso designed by Marcantonio Pasi.[19] From 1580 to 1584 Aleotti

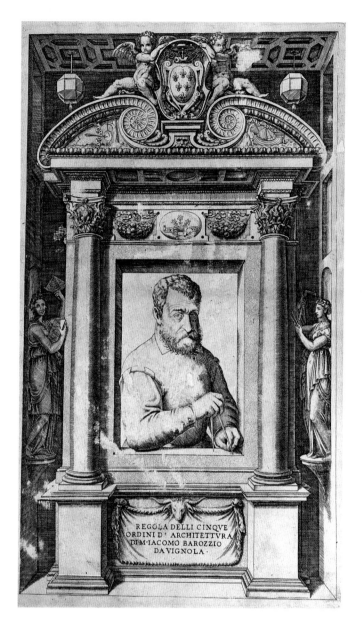

Fig. 7. Title page to Vignola, *Regola delli cinque ordini d'architettura*

tells us that he was employed destroying the old castle of Marchese Niccolò d'Este.[20] At the same time Ercole Rondinelli wrote to Cardinal Luigi d'Este at Rome in 1583, when the latter was seeking an architect: "Those architects who made the house of Messer Silvio Trotto here in the Romagna are both dead, but there is a son of one of them called Giovanni Battista Aleotti d'Argenta who is both architect and mason by profession and has built here a part of my building at Brusata. However, he is employed in the work of the bastions which are made at Ferrara, and I do not know whether he will be willing to leave here readily."[21]

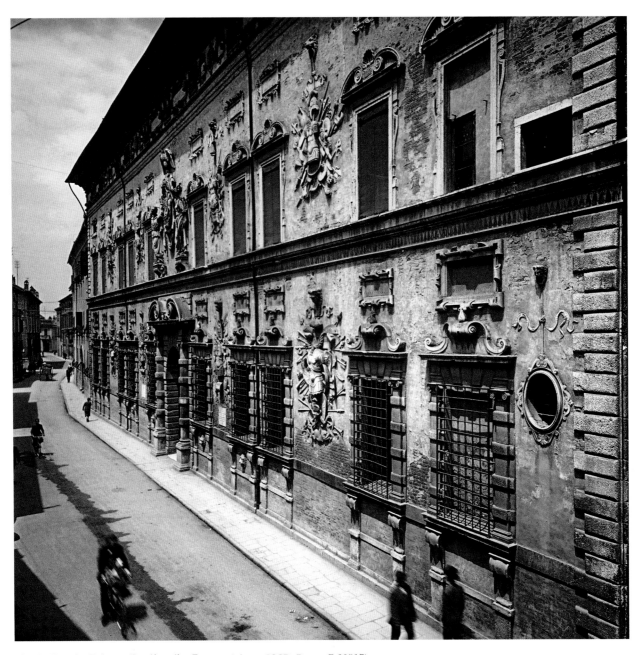

Fig. 8. Facade, Palazzo Bentivoglio, Ferrara (photo: ICCD, Rome, E 30517)

The new bastions built to replace the castle of Niccolò d'Este were erected under the direction of Cornelio Bentivoglio, and Aleotti was, therefore, in the service of the Marchese just before the latter began to redo his palace.

Finally, there is bound at the rear of Aleotti's copy of Vignola his drawing of a tomb for Cornelio Bentivoglio (Fig. 10). Since the Marchese died 26 May 1585, a few weeks after the completion of his palace,[22] it may be presumed that Aleotti's drawing for the tomb dates from 1585, although it might be a much later memorial. In any case, the split pediment of the tomb, while it has more modest volutes than the windows of the *piano nobile* and the main portal of the Palazzo Bentivoglio, has underneath its volutes the same rayonnant pattern of ornament as the pediments of the palace. Thus, it seems extremely probable that the facade of the Palazzo Bentivoglio is one of the earliest works of architecture by Aleotti still preserved.

There is also in the rear of Aleotti's Vignola a drawing (Fig. 11) for the facade of his most important church, San

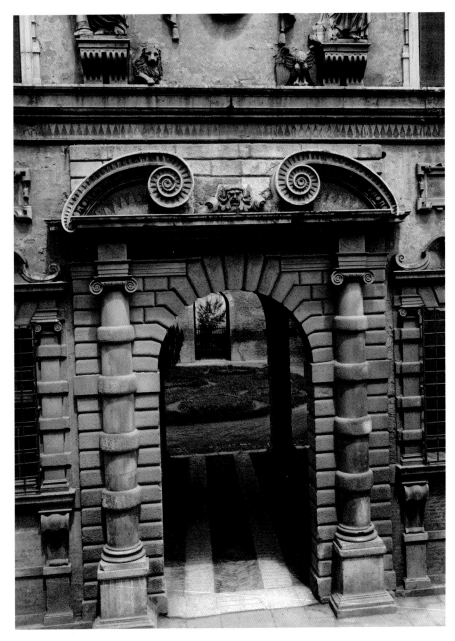

Fig. 9. Portal, Palazzo Bentivoglio, Ferrara (photo: ICCD, Rome, E 30541)

the same year the cornerstone was laid at the site of the small chapel for a church dedicated to the saint. The church of San Carlo, which required ten years for building, was erected primarily with the financial aid of the Ferrarese Cardinal Carlo Pio of Savoy the Elder.[23] The principal difference between Aleotti's design and the extant church is, of course, in the treatment of the portal, but there are minor changes, such as the substitution of dentils and modillions in the cornice of the church and the omission of the Ionic half pilasters at the ends of the facade. The portal in Aleotti's drawing is much simpler and more classic than the executed one, and the use of the oculus opening under the arch over the pediment of the portal recalls the same motif in Aleotti's first project for the Fortress of Ferrara (Fig. 4), dating about 1609.

The plan of San Carlo is an oval with the sanctuary as a separate semicircular room at the end of the main axis and two side chapels at the ends of the cross axis, as seen in Aleotti's own drawing (Fig. 13) of the interior space organization.[24] Faint pencil marks under the brown ink of the drawing demonstrate that he com-posed the oval using two tangential circles and two equilateral triangles which shared their base lines in a manner derived from one of the methods published by Serlio in the sixteenth century.[25] The apexes of the triangles served both as centers for the arcs which, in conjunction with the outer third of each circle, composed the oval and defined the location of the back wall of the two side chapels. For some accidental or intentional reason, however, Aleotti permitted the apex of the triangle on the right side of the church to be pulled in the distance equal to the thickness of the wall of the church, thus creating an oval slightly thinner than his system would normally require.

On the interior of San Carlo each quadrant of the wall has two pairs of engaged Ionic columns with a statue niche

Carlo on the Giovecca at Ferrara (Fig. 12). The drawing is quite close to the facade as it stands but shows enough differences to indicate that it is preliminary to the building. Cardinal Orazio Spinola, papal legate to Ferrara, and Archbishop Fontana of Ferrara, formerly vicar-general of San Carlo Borromeo in Milan, founded at Ferrara a confraternity in honor of San Carlo Borromeo in 1611, one year after his canonization. In January 1613 the confraternity was given the small chapel of SS. Filippo e Giacomo next to the famous Ospedale di Sant'Anna, and in September of

| Drawings of Giovan Battista Aleotti

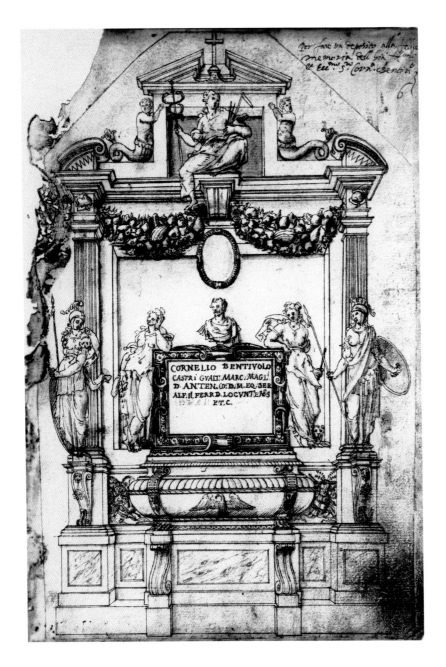

Fig. 10. Drawing for tomb of Cornelio Bentivoglio, by Aleotti (photo: Biblioteca Comunale Ariostea, Ferrara)

at Rome. The Roman church, like Michelangelo's project for St. Peter's, presents a certain Manneristic ambiguity. On the one hand, there is its lingering desire to preserve some of the Renaissance equanimity of the central plan, revealed on the exterior in the continuation of the entablature and the crowning dentilled cornice down the sides and around the church. At the same time, Sant'Andrea has a definite axis stressed by the facade engraved on the front surface of the rectangular block of the church. In San Carlo at Ferrara Aleotti has expanded his facade into a Baroque screen, above which the drum is scarcely visible and behind which the sides are totally hidden. He has then centralized his facade by reducing the pediment so as to stand only over the two inner columns, forming a tabernacle around the portal. The outer columns remain independent, marked only by the projection in the entablature above them. It seems very likely that this facade was inspired by the title page of another architectural book owned by Aleotti, just as the volutes of the Palazzo Bentivoglio came from the title page of Vignola's book. There is still preserved in Ferrara a copy of Galasso Alghisi's book on fortifications which Aleotti purchased in 1572,[26] and the title page of this book (Fig. 14) has an architectural frame very similar to the facade of San Carlo (Fig. 12). There is the same tabernacle treatment at the center flanked by statue niches on two levels and the independent half columns at the ends, and there are also five statues posed on the entablature and pediment as on San Carlo. Except for the necessary substitution of the entrance portal of San Carlo for the title of Alghisi's book, the only change that Aleotti has made is to use the Ionic order on the building in place of the Doric of Alghisi's book.

The interior of San Carlo recalls another church begun by Vignola, his Sant'Anna dei Palafrenieri in the Vatican at Rome. Presumably only the plan of Sant'Anna and the

between the pairs of columns. A continuous horizontal entablature, breaking out over the coupled columns, unifies the entire interior space, which is then capped by an oval vault. There are four major penetrations into the vault for the "thermae" windows on the cross axes and smaller penetrations between them for what are now blind oculi, presumably closed later, as can be seen on the exterior. The plan is then filled out to a rectangle by side rooms and has a planar facade, above which rises the oval drum concealing the vault (Fig. 12).

The church of San Carlo on the exterior is slightly reminiscent of Vignola's church of Sant'Andrea in Via Flaminia

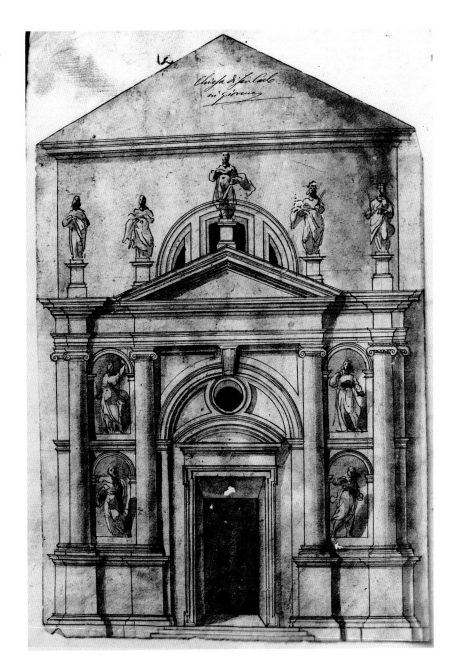

interior up to the crowning entablature represent Vignola's design, the facade and upper part of the church being much later.[27] However, it is precisely those aspects of the Roman church attributed to Vignola that the Ferrarese church resembles, although Vignola's interior has only single engaged columns, and its oval is slightly more rotund than is Aleotti's. In typical Ferrarese style, San Carlo is almost completely built of brick, even to such architectural details as the dentils, with stone limited to the portal, Ionic capitals, shell niche heads, and the plinth of the church.

Preserved in Ligorio's notebook at Oxford[28] is a drawing by Aleotti of a church facade (Fig. 15) similar enough in size (the scale indicates a width of about 32.5 Ferrarese *piedi* or about 13.25 m) and configuration to the present San Carlo to suggest that it might be an earlier project by Aleotti for the church. It depicts a one-and-a-half-story facade with coupled Doric pilasters on the main story and smaller pilasters on the attic. The principal ornament of the first story is the pedimented portal with engaged Ionic columns flanked by niches. The main element of the attic is the "thermae" window. The wall surface was then to be decorated with marble, or imitation marble, panel inlays. The most interesting feature of this drawing in comparison with San Carlo (Fig. 12) is the portal, for it shows more resemblance to the executed portal than does the portal in his drawing for San Carlo (Fig. 11), although in execution he has raised the Ionic columns up on high pedestals and split the pediment.

However, it is possible that the Oxford facade drawing may be conceived for an entirely different project. Among Aleotti's large collection of drawings in the Biblioteca at Ferrara is the plan for a church inscribed in an old hand "Spiato Santo" (Fig. 16).[29] The present church of the Spirito Santo at Ferrara dates from 1616 and has nothing to do with Aleotti's plan, which must be prior to that date. The facade in the plan, with its paired pilasters and engaged columns at the portal, reveals a slight correspondence with Aleotti's facade drawing at Oxford (Fig. 15), but they are certainly not identical, showing a difference in measurements and the relative spacing of the facade pilasters and the portal half columns. Also, the facade drawing does not suggest the skewing of the facade away from the right angle of the axis that occurs in the plan. In fact, I doubt very much that the Oxford drawing has anything to do with the Spirito Santo plan, but there is

| *Drawings of Giovan Battista Aleotti*

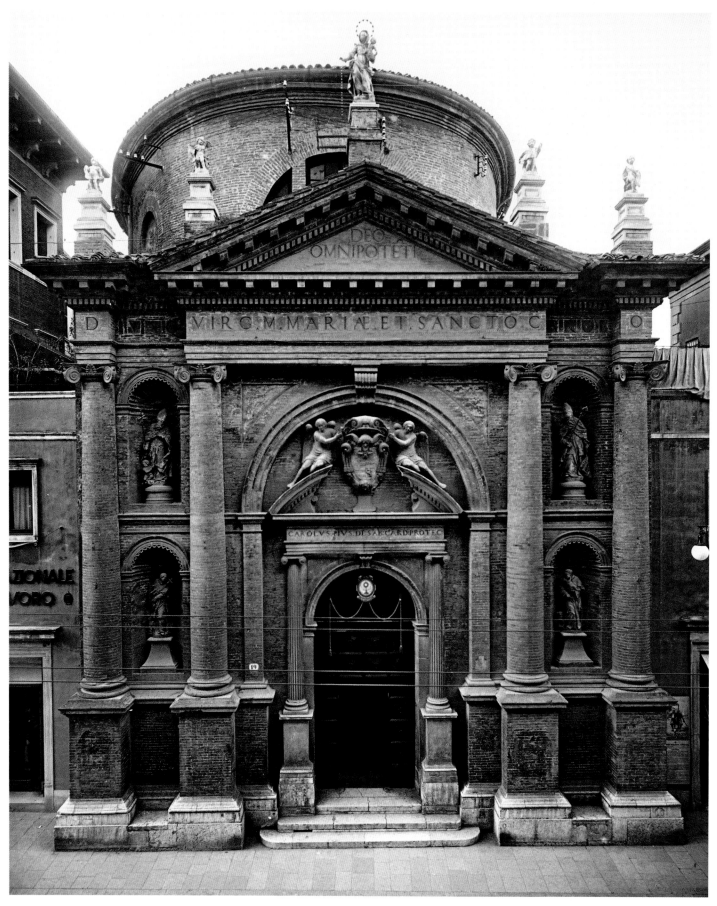

Fig. 12. Facade, San Carlo, Ferrara (photo: ICCD, Rome, E 30523)

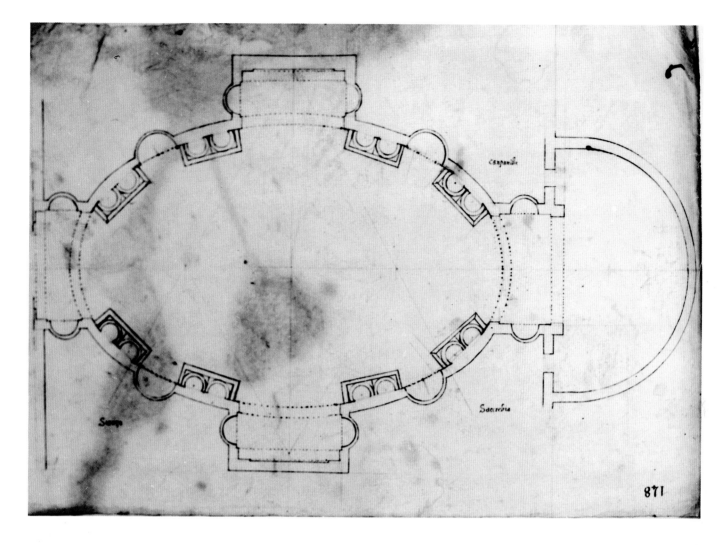

Fig. 13. Drawing of plan, San Carlo, Ferrara, by Aleotti (photo: Biblioteca Comunale Ariostea, Ferrara)

enough correspondence to make uncertain the identification of the Oxford drawing as a preliminary design for San Carlo. The most interesting aspect of the plan for the Spirito Santo (Fig. 16) is that it is almost a very primitive version of Aleotti's plan of San Carlo (Fig. 13).

The Ligorio notebook at Oxford also contains the drawing of the facade of a small palace (Fig. 17).[30] It is obviously for the Palazzo Avogli-Trotti, 10 Via Montebello, in Ferrara (Fig. 18), which has been attributed to the architect Alberto Schiatti.[31] There are some important differences between Aleotti's drawing and the executed building which are sufficient to suggest that the palace was designed by Aleotti and not Schiatti, and that some changes from the design were then made in the execution. For example, the rustication of the portal originally was meant to break through the lower part of the triangular pediment, but in the completed building the classic pediment preserves its integrity and sits above the rustication. In contrast, the ground-floor windows in

the drawing have very classic moldings identical with those of the *piano nobile*, but in the extant building, stone rustication surrounds the windows of the ground floor, and only the upper arc or angle of the pediment preserves the classic moldings. The decorative features above the cornice of the facade have also been changed in execution; the large central plaque has been omitted, and at the ends of the cornice are located smaller versions of the central plaque of the drawing in place of the obelisks. The change in the upper windows of the facade, however, is due to later alteration to the building when Aleotti's small horizontal windows were expanded downward to become vertical windows as on the other stories.

It is understandable that the Palazzo Avogli-Trotti has been attributed to Schiatti, since it resembles the Palazzo Sani (or Cicognara) on the Via Terranuova, which has also

for the infamous tax collector Cristoforo da Fiume, who was employed in this activity at Ferrara from 1569 until at least 1574,[32] it is probable that his palace was a youthful work of Aleotti, dating in the 1570s.

Also bound in Ligorio's notebook at Oxford is a drawing by Aleotti of his project to renovate and redecorate an earlier courtyard (Fig. 19).[33] The drawing corresponds very closely with the east wall of the courtyard of the great Castello Estense in the center of Ferrara, except that the castle wall has only four small arches on the ground floor between the larger end arches. Even the molding below the upper-story windows is identical with that of the castle. The two statues of Hercules, which are the only decoration depicted in the upper niches, indicate that the project must be for the Este family, who claimed Hercules as their legendary ancestor and hero. If this drawing is

Fig. 15. Facade, San Carlo(?), Ferrara, by Aleotti. Oxford, Bodleian Library, Ms. Canonici Ital. 138, fol. 98v (photo: Bodleian Library, University of Oxford)

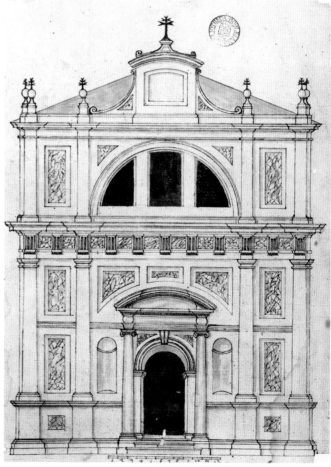

been attributed more justly to Schiatti. A comparison of the detailing of the two palaces shows, however, that the Palazzo Sani is very conservative, following more closely Girolamo da Carpi's Palazzo Naselli at Ferrara, which is the prototype for both the palaces. The architectural style of the Palazzo Sani is a very neat and precise style typical of Schiatti, as seen in his churches of San Paolo and the Madonnina. The portal is surrounded merely by a restrained panel of rustication; the ground-floor windows are capped by plain lintels; the windows of the two upper stories are all identical; and the ends of the modest palace are discreetly defined by quoins. Aleotti's Palazzo Avogli-Trotti (Fig. 17) is bolder in its use of rustication and variety, and the ends of the palace are defined more positively by the banded pseudo-pilasters, slightly reminiscent of the first of his projects for the gate to the Fortress of Ferrara (Fig. 4). Since the Palazzo Avogli-Trotti was aparently built

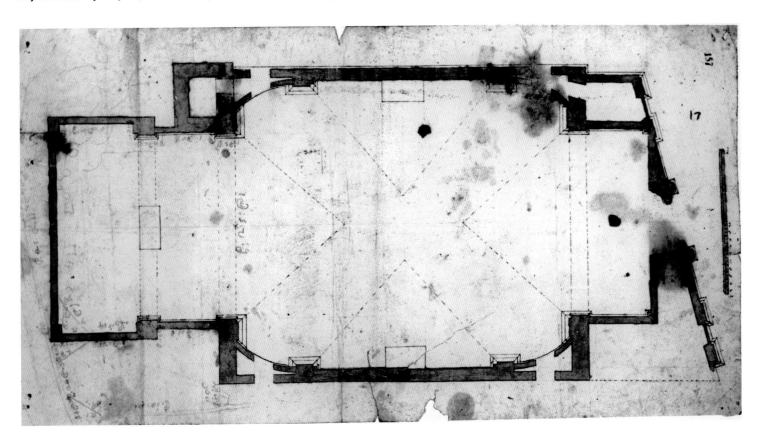

Aleotti's design to redecorate the castle courtyard, it probably dates between 1574 and 1577. The castle had been damaged in the severe earthquake of 1570, and the duke had ordered extensive rebuilding and decoration as a result of the disaster. This rebuilding and the interior decoration were only completed very hurriedly in time for the visit to Ferrara in the summer of 1574 of King Henry III of France on his way back from Poland to claim his crown in France. The walls of the courtyard of the castle at Ferrara were then frescoed with portraits of the Este family which were completed in 1577.[34] If Aleotti, therefore, had a project to decorate the courtyard it must date after the completion of the building activity in 1574 and probably not after the commencement of the frescoed portraits sometime before 1577. The drawing would be then most probably from about 1574 or 1575 when Aleotti was first serving as ducal architect.

In the drawing, which is only complete on the left half, Aleotti leaves the ground-floor arcade untouched but adds a balustrade across the *piano nobile* just below the windows. These windows have tabernacle frames with pairs of putti posed on the raking cornices of the triangular pediments.

Crowded between the windows are statue niches, two of which apparently contain the figures of angels. The second story has square mezzanine windows with heavy swags festooned between them. On the upper floor are simple classic rectangular windows set above a paneled plinth and capped by segmental pediments. Again statue niches, containing images of Hercules, are squeezed between the windows. Much of this decoration may have been intended to be of stucco set against a wall of stucco lined in imitation of blocks of stone.

The general organization of this decorative facade is reminiscent of the Palazzo Spada or Raphael's Palazzo dell'Aquila in Rome. In fact, Aleotti's design shows enough correspondence to the facade of the destroyed Palazzo dell'Aquila as depicted in Parmigianino's drawing in the Uffizi (Fig. 20) or Ferrerio's later engraving to suggest that Raphael's palace might have been a direct inspiration, although there is no known evidence of a trip to Rome by Aleotti prior to 1591.

Another drawing in the Oxford manuscript must be a record of Aleotti's personal acquaintance with sixteenth-century Roman architecture, as it depicts an inner elevation

Fig. 17. Drawing for facade, Palazzo Avogli-Trotti, Ferrara, by Aleotti. Oxford, Bodleian Library, Ms. Canonici Ital. 138, fol. 107r
(photo: Bodleian Library, University of Oxford)

of the court of the Farnese Palace.[35] Aleotti was in Rome at least twice during his lifetime. In 1591 he accompanied the Duke of Ferrara to Rome, and in the summer of 1600 he was sent there by the commune of Ferrara to present his recommendation to improve the navigation on the Po of Ferrara.[36] The drawing of the Farnese Palace at Rome may date, therefore, from one of these trips, although it is probable that Aleotti was in Rome at other times also, as suggested by the presumed drawing for the Este Castle just discussed. These trips, in any case, would have permitted Aleotti to study Vignola's architecture in Rome, such as the churches of Sant'Andrea in Via Flaminia and Sant'Anna dei Palafrenieri, which I suggested as a possible influence on his final design of San Carlo in Ferrara.

The influence of Vignola continues throughout Aleotti's life, for there is a minor echo of it in the final work that he created. In 1627 he redesigned and rebuilt at his own expense the main chapel, the Cappella del Santissimo Sacramento, in the church of Sant'Andrea at Ferrara, and in 1636 he was buried in this chapel with his first wife.[37] Unfortunately the decoration of the chapel was destroyed after the church was suppressed in 1867, and

the remains of Aleotti were transferred to the church of the Celletta near his native town of Argenta. However, there is pasted onto plate XVIIII of his copy of Vignola, now in the Biblioteca at Ferrara, a small drawing by which Aleotti has transformed the Ionic capital of Vignola into a Composite capital (Fig. 21), and on the edge of the drawing Aleotti noted: "Capitello composito nelle colone del mio Altare nella chiesa di Santo Andrea di ferrara." With Aleotti's chapel the church of Sant'Andrea became a sort

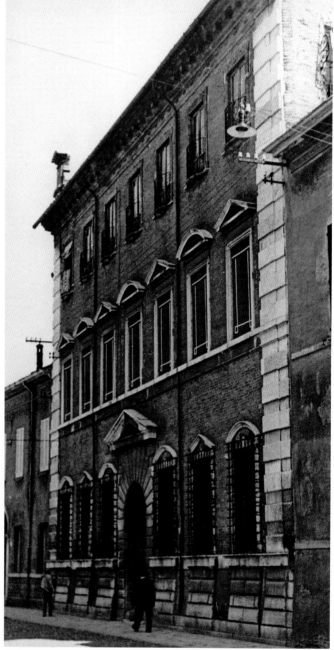

Fig. 18. Facade, Palazzo Avogli-Trotti, Ferrara (photo: author)

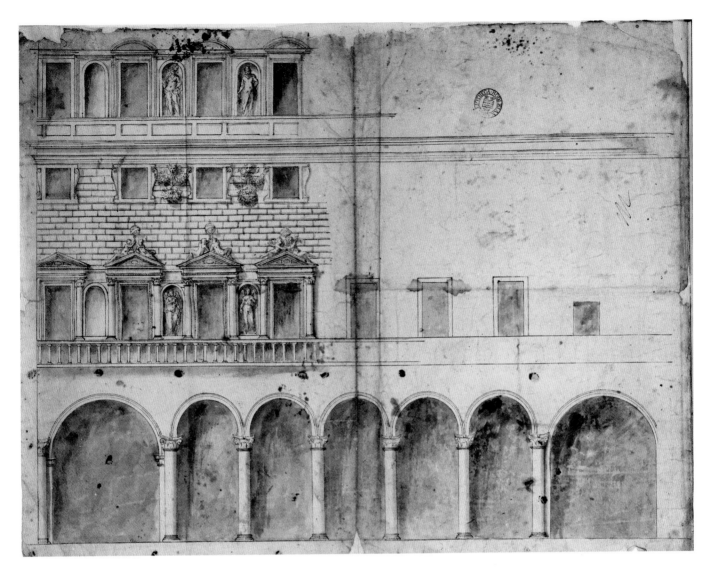

Fig. 19. Drawing for Castello Estense(?), Ferrara, by Aleotti.

Oxford, Bodleian Library, Ms. Canonici Ital. 138, fol. 103v

(photo: Bodleian Library, University of Oxford)

of Pantheon of Ferrarese architecture until its suppression, for buried in the church earlier were his great predecessor Biagio Rossetti and his older contemporary Alberto Schiatti. Unlike the work of those older men, the architecture of Aleotti marks a break with local tradition and local style. The styles of Rossetti and particularly of Schiatti in their simplicity and neatness conform harmoniously to the local tradition of brick as the basic building material. Aleotti instead looked outward to the Veneto and especially to Rome for new influences. He preferred richly modulated wall surfaces which create strong lights and darks rather than the planar surfaces of Rossetti and of Schiatti where the only color is the soft tones of the

brick itself. By the seventeenth century Aleotti was fully in the Baroque style which his earlier works suggest as more compatible to his architectural nature, but it is, of course, a provincial version of the Baroque.

Notes

1. This collection of 187 drawings, most of which are by Aleotti, is principally concerned with military and hydraulic architecture, although about fifteen drawings are of civic or religious architecture. The theatrical drawings have been very carefully studied by F. Rapp, "Ein Theater-Bauplan des Giovanni Battista Aleotti," *Neues Archiv für Theatergeschichte*, ed. M. Herrmann, Schriften des Gesellschaft für Theatergeschichte 41 (Berlin, 1930), 79–125.

2. After plate VIII there is a drawing by Aleotti with the note: "Questa cornice A, la base B, et il capitello C l'ho trovato nelle scritture de la munizione del Duca Alfonso II di Ferrara. Credo fussero di mano di quel Terzo

Fig. 20. Drawing of facade, Palazzo dell'Aquila, Rome, by Parmigianino. Gabinetto Disegni e Stampe degli Uffizi, Florence

(photo: Gabinetto Fotografico, Soprintendenza per il Polo Museale Fiorentino, Firenze)

de' Terci che fu architetto del Duca Ercole Padre di Alfonso sudetto."

3. Oxford, Bodleian Ms. Canonici Ital. 138, fol. 162.

4. G. Padovani, *Architetti ferraresi* (Rovigo, 1955), 91, denies the traditional death date of Terzi in 1557, the date when his name disappears from accounts (see L. N. Cittadella, *Notizie amministrative, storiche, artistiche relative a Ferrara* [Ferrara, 1868], vol. 1, 546), and believes that Terzi lived until at least 1563. He selects this later date only because he thought that Terzi had owned and annotated the copy of Vignola in the Biblioteca at Ferrara, but Aleotti's notes in the book and his comment in the Oxford manuscript prove that Aleotti made both of these gatherings and that he discovered the Terzi material in the Munizione del Duca.

In another manuscript by Aleotti, published in the nineteenth century, he adds that he possessed some writings by Terzo de' Terzi on the water system of Ferrara. See G. B. Aleotti, *Dell'interrimento del Po di Ferrara e divergenza delle sue acque nel ramo di Ficarolo*, ed. L. N. Cittadella (Ferrara, 1847), 68–69.

5. 438 mm × 390 mm; brown ink on white paper.

6. Modena, Archivio di Stato, Cancelleria Ducale, Ingegneri, Carteggio B^a: letter of Aleotti at Ferrara to the Marchese Bentivoglio at Modena, dated 21 and 22 January 1598.

7. 297 mm × 244 mm; brown ink on white paper.

8. 320 mm × 231 mm; brown ink on white paper.

9. Modena, Archivio di Stato, Cancelleria Ducale, Ingegneri, Carteggio B^a: letter of Aleotti at Ferrara to the Duke of Modena at Modena, dated 29 October 1609.

10. A. Frizzi, *Guida del forestiere per la città di Ferrara* (Ferrara, 1787), 101. Also bound in the front of Aleotti's copy of Vignola is a drawing for the marble statue of Pope Paul V by Giovanni Luca of Genoa which was erected in 1618 in the center of the piazza of the fortress and then

Fig. 21. Page from Vignola, *Regola delli cinque ordini d'architettura*, with added drawing by Aleotti

(photo: Biblioteca Comunale Ariostea, Ferrara)

| *Drawings of Giovan Battista Aleotti*

destroyed by the French in 1796. See A. Frizzi, *Memorie per la storia di Ferrara*, 2nd ed. (Ferrara, 1848), vol. 5, 39; and W. Hager, *Die Ehrenstatuen der Päpste* (Leipzig, 1929), 60, no. 50. Aleotti notes on the drawing that the height of the statue is 6 *piedi*, 6 *oncie*, but then indicates that the statue is not yet executed, for he adds: "La statue sera alta palmi 11 romani." In the drawing Paul V is depicted seated in a heavy chair in full papal regalia with his right arm outstretched.

11. 305 mm × 276 mm; brown ink on white paper.

12. 279 mm × 259 mm; brown ink on white paper.

13. A. Venturi, *Storia dell'arte italiana*, vol. 11, pt. 3 (Milan, 1940), 928–930; A. Lazzari, *Giornale dell'Emilia* (7 August 1950); Padovani, *Architetti ferraresi* (note 4 above), 85–86 and 122–123, although Padovani once had attributed the palace to Aleotti (see *Rivista di Ferrara* [Sept. 1933]); and G. Medri, "La scultura a Ferrara," *Atti e memorie della deputazione provinciale ferrarese di storia patria*, n.s., 17 (1957), 117–119. The manuscript diary of Giovanni Maria di Massa, now in the Vatican Library (Ms. Vat. Lat. 12597, fol. 71r), gives the exact dates for the facade: "Alli 4 del mese di maggio de lanno 1585 il signor Cornelio Bentiuolio fornite la su faciata del suo pallazzo da Santo Dominicho doue e queli trofei et ditta faciata fu prencipiata a farre del meso di decenbre lanno 1583 et la tirata in mancho de dicioto mesi tanta fatura come si uede."

14. Turin, Archivio di Stato, Ms. Ja.III, vol. XXIX, fols. 11v and 13r.

15. G. Agnelli, *Ferrara: Porte di chiese, di palazzi, di case* (Bergamo, 1909), 124, noted this resemblance but felt that the evidence was tenuous in the light of Aleotti's other architecture.

16. See particularly the plate of the rusticated Ionic order, S. Serlio, *Regole generali di architettura sopra le cinque maniere de gli edifici* (Venice, 1537), fol. XLIIIr.

17. G. B. Aleotti, *Difesa di Gio. Battista Aleotti d'Argenta, architetto, per riparare alla sommersione del Polesine di S. Giorgio, & alla rouina dello Stato di Ferrara* (Ferrara, 1601), 71.

18. Modena, Biblioteca Estense, Ms. Campori γ.B.2.8, fol. 74r.

19. Modena, Biblioteca Estense, Ms. B.1.1.1(b), notes of Campori.

20. Modena, Biblioteca Estense, Ms. Campori γ.B.2.8, fol. 53v.

21. Modena, Biblioteca Estense, Ms. B.1.1.2(d), copy by Campori of a letter of Rondinelli from Brusata, dated 1 April 1583: "Quelli che fecero qui in Romagna la casa di M. Silvio Trotto sono tutti due morti ben vi è un figlio d'uno d'essi, che si dimanda Gio: Batta Aliotto d'Argenta il qual fa professione d'Architetto et di Muratore insieme, et ha fatta qui una parte di questa mia fabrica, della Brusata. Ma egli è impiegato nell'opera de Bellovardi che si fanno a Ferrara et non so se vorra cosi facilmente partirsene."

22. Biblioteca Apostolica Vaticana, Ms. Vat. Lat. 12597, fol. 71v, diary of Giovanni Maria di Massa; and Modena, Biblioteca Estense, Ms. α.H.2.16, p. 147, diary of M. A. Guarini, 1570–1598.

23. M. A. Guarini, *Compendio historico dell'origine, accrescimento e prerogatiue delle chiese, e luoghi pij della città e diocesi di Ferrara* (Ferrara, 1621), 212–213; A. Borsetti, *Supplemento al compendio historico del Signor D. Marc'Antonio Guarini Ferrarese* (Ferrara, 1670), 36; and Frizzi, *Memorie* (note 10 above), vol. 5, 59–60.

24. Ferrara, Biblioteca Comunale Ariostea, Ms. Classe I, no. 763, drawing no. 148; 403 mm × 279 mm; brown ink on white paper.

25. S. Serlio, *Il primo libro d'architettura* (Venice, [1551]), fol. 13r, upper diagram. See also W. Lotz, "Die ovalen Kirchenräume des Cinquecento," *Römisches Jahrbuch für Kunstgeschichte* 7 (1955), 11–15.

26. Aleotti, *Dell'interrimento del Po* (note 4 above), 12. The book is Galasso Alghisi, *Delle fortificationi libri tre* ([Venice], 1570); the architectural frame of Alghisi's title page may in turn be derived from the ancient Roman Arch of the Gavi at Verona.

27. R. Wittkower, "Carlo Rainaldi and the Roman Architecture of the Full Baroque," *Art Bulletin* 19 (1937), 266–267; and Lotz, "Die ovalen Kirchenräume" (note 25 above), 50–52.

28. Oxford, Bodleian Ms. Canonici Ital. 138, fol. 98v; 441 mm × 290 mm; brown ink and gray and black wash on light brown paper.

29. Ferrara, Biblioteca Comunale Ariostea, Ms. Classe I, no. 763, drawing no. 157. In Ligorio's notebook at Oxford (Bodleian Ms. Canonici Ital. 138, fol. 100r) is a drawing by Aleotti for the frame of an altar painting, and on the verso is written "Spirtu Santo," identifying another instance of his activity for the Oratorio of the Spirito Santo. The drawing is 413 mm × 260 mm; brown ink and wash on light brown paper.

30. Oxford, Bodleian Ms. Canonici Ital. 138, fol. 107r; 373 mm × 456 mm; brown ink and wash on brown paper.

31. A. Superbi, *Apparato de' gli huomini illustri della città di Ferrara* (Ferrara, 1620), 134.

32. Ibid., 134; for the activity of Cristoforo, see G. Sardi, *Libro delle historie ferraresi* (Ferrara, 1646), in the added books of A. Faustini, pp. 52 and 59.

33. Oxford, Bodleian Ms. Canonici Ital. 138, fol. 103v; 438 mm × 572 mm; brown ink and gray-brown wash on white paper.

34. See D. R. Coffin, "Pirro Ligorio and Decoration of the Late Sixteenth Century at Ferrara," *Art Bulletin* 37 (1955), 167–180 [reprinted on pages 14–43 of this volume]. Since then I have discovered letters in the Archivio di Stato at Modena that detail the building and decorative work from September 1573 to July 1574.

35. Oxford, Bodleian Ms. Canonici Ital. 138, fol. 104v; 607 mm × 563 mm; brown ink on white paper. The remaining drawing by Aleotti in this manuscript (fol. 99r) depicts the elevation of a fantastic little building (drawing is 390 mm × 272 mm; brown ink and gray-brown wash on white paper). This building is very enigmatic, being 15 Ferrarese *piedi* wide (about 20 feet) and about 19 *piedi* high (about 25 feet). The upper part of the structure is capped by three different sizes of domes on high

drums, but it cannot be a church or chapel, since the lanterns of the domes seem to be surmounted by nude female figures, although they are depicted very sketchily. My only suggestion would be that the building may be some sort of scenery, either for the theater or for an entry.

36. Aleotti, *Dell'interrimento del Po* (note 4 above), 30 and 36. Some of the letters of Aleotti preserved in the Archivio di Stato at Modena (Cancelleria Ducale, Ingegneri, Carteggio B^a) tell us about the trip in 1600. One letter, dated 3 September 1600, was written by Aleotti from Rome to the Cardinal d'Este at Tivoli, and another, dated 22 October 1600, addressed by Aleotti from Ferrara to the Marchese Bentivoglio, relates that he returned from Rome the preceding evening.

37. A. Borsetti, *Supplemento al compendio historico del Signor D. Marc'Antonio Guarini Ferrarese* (Ferrara, 1670), 13–14, preserves the dedicatory inscription which was on the frieze of the chapel: "In Dei et D. N. Iesu Christi, ac Deiparae Virginis honorem Io. Baptista Aleotus vocatus l'Argenta dic. An. M.DC.XXVII," and the burial inscription dated 1630, which was prepared before Aleotti's death. He was buried there 10 December 1636: see L. N. C[ittadella], *Indice manuale delle cose più rimarcabili in pittura, scultura, architettura della città e borghi di Ferrara* (Ferrara, 1844), 155–156; and Aleotti, *Dell'interrimento del Po* (note 4 above), 50–51.

7

Padre Guarino Guarini in Paris

The triumphal journey to Paris in May and June 1665 of the Italian sculptor and architect, the Cavaliere Gian Lorenzo Bernini, called to France on the personal invitation of King Louis XIV to build the royal palace of the Louvre, marks the climax of the influence of Italy upon French architecture.

The renown of Bernini and the publicity of his trip to France—even though he was out-maneuvered by the French architects[1]—has helped to cast a shadow of forgetfulness over the activity at Paris at this same moment of another Italian architect, the Theatine Padre Guarino Guarini. Bernini himself, however, paid a visit soon after his arrival at Paris to the church of the Theatine order, Sainte Anne-la-Royale, begun in 1662 by Guarini. Paul de Fréart, Sieur de Chantelou, who served as guide to Bernini during his stay at Paris, relates that on June 14, 1665, Bernini "has been to see the church of the Theatines, and, when the Fathers asked him how it seemed to him, he made no reply except: 'I believe that it will turn out beautiful' [*Credo che riuscirà bella*]." The Theatine Fathers were apparently uneasy about the proportions of the dome planned for their church and remarked that the dome of the Gesù at Rome was too low, while that of Sant'Andrea della Valle, also in Rome, was higher. Bernini replied that "each had their own proportion; that one should not attempt to make the elevation only in proportion to the width, because otherwise it would be awkward to have to raise one's head so high"; and thus pointed out to them the importance of the relation of the dome to the interior space of the church. He added that "when their church would be covered, it will appear larger." There is, however, an implied criticism of the church in Bernini's later statement to them: "It would be good if they had some part on the facade which advanced, since churches which are entirely round, when one enters them, one ordinarily takes seven to eight steps, which prevents one from seeing the form well."[2] This principle is, of course, the one which Bernini himself had just been exploiting in his Italian churches at Castel Gandolfo and Ariccia.[3]

Shortly before Bernini's visit to the unfinished church of Sainte Anne-la-Royale, another Italian visitor, the young Bolognese priest Sebastiano Locatelli, had been much more lavish in his praise of the Theatine church. "It is believed without contradiction that the church of the Theatine Fathers will surpass in beauty the Val-de-Grâce and all the other churches. . . ."[4] Locatelli was undoubtedly prejudiced by the warmth of his reception in 1664 from the Theatine Fathers at Paris who invited him to say mass in their church and almost persuaded him to become a member of the Order of the Clerks Regulars or Theatines. He also notes that "the plan of this new church is so bizarre that I have never yet seen any church to resemble it, even in part."[5]

Locatelli's description of the church as "bizarre," which he does not use derogatorily, may be the first time

Fig. 1. Sainte Anne-la-Royale, Paris. Plan (G. Guarini, *Architettura civile* [Turin, 1737], pl. 9)

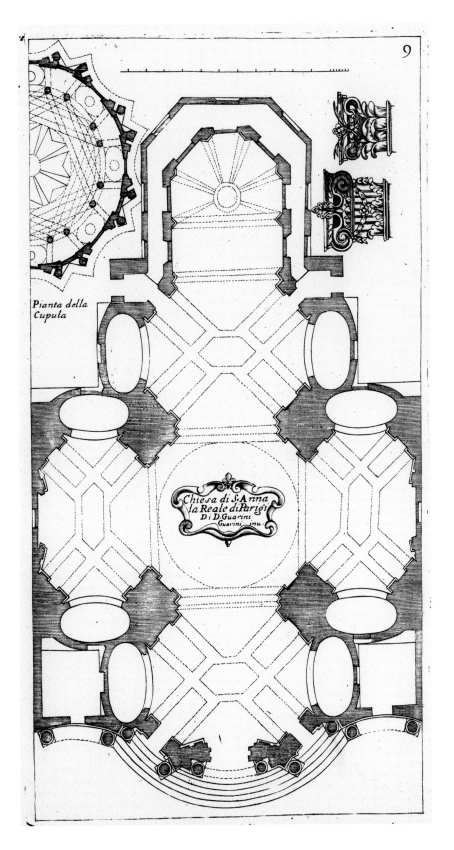

that this word was applied to Guarini's work, but it certainly was not the last time.[6] Critics, from the late seventeenth century until the late-nineteenth-century rediscovery of the power and charm of mature Baroque architecture, have repeatedly condemned Sainte Anne-la-Royale and Guarini's other buildings as "bizarre." The church at Paris, however, had to suffer not only the classic criticism of the Academy and later neoclassicism, but its religious and political associations were unfavorable to an impartial judgment by French critics and observers.

The money to commence the Theatine church at Paris came from the will of Cardinal Mazarin. It was Mazarin who introduced the Order of the Clerks Regular to France by inviting a small group of them to come to Paris from Rome in 1644. This order, whose foundation in Italy in 1524 marks one of the earliest manifestations of the later Counter Reformation, is popularly called the Theatine order from the position as Bishop of Chieti of one of its founders, Gian Pietro Carafa, the later Pope Paul IV.

Mazarin bought a house in Paris in 1647 for his favorite order at No. 23 on the Quai Malaquais, later called the Quai des Théatins (now the Quai Voltaire), on the south bank of the Seine opposite the Louvre.[7] On August 7, 1648, the Theatines occupied their new house which contained a small chapel named Sainte Anne-la-Royale at the expressed desire of young King Louis XIV, who was present at the consecration.[8] The order had the favor of the royal court even after the death of Cardinal Mazarin, but it suffered extremely in the eyes of the French because of its close association with him.

When the cardinal had to flee France in 1649, the Theatine Fathers followed him in fear of the Parisians who expressed their hatred in a series of satires which made particular fun of the Theatines' use of small figures of saints in their preaching.

| *Guarino Guarini in Paris*

Dubbing these figures "marionettes," one of the satires entitled the *Passport and Farewell of Mazarin* commences:

Farewell, then, poor Mazarin.
· · · · · · · · · · · · ·
Farewell, uncle of the Mazarinettes.
Farewell, father of the marionettes.
Farewell, author of the Theatines.[9]

The Theatines were very interested in the use of theatrical and dramatic devices in their religious observances. In fact, by December 1648, about four months after the installation of the order in its new house and chapel, all of Paris was attracted to the Theatine church "because of the representations held there in the form of a theater with a perspective at the end of which is exposed the Holy Sacrament of the altar and at one side is the Emperor Augustus with his court, on the other are the mathematicians who described the world according to the Gospel: *Edixit edictum a Caesare Augusto ut describeretur universus orbis* (Luke, II)."[10] One immediately recalls the wonderful perspective drawings of the Jesuit painter Andrea Pozzo published at the end of the seventeenth century in his book on the principles of perspective, in several of which are depicted perspective representations which were created at the end of Jesuit churches.[11] The Jesuits had been interested from an early period in the potentialities of the theater as a weapon in the Counter Reformation, but the use by the Theatines at Paris of such theatrical elements within the sacred precincts of a church seems quite early during the Counter Reformation for this growing development of the relationship between theater and religion.[12]

In 1659 the Cardinal Mazarin acquired another house on the Quai Malaquais, No. 25, contiguous to the Theatine house. Just before his death in 1661 he turned this house with some additional property at the rear over to the Theatine order. A drawing in the Archives de France at Paris (L 960, No. 30), probably dating from 1659, is a plan for the transformation of these two houses into one for the order and shows at the left the plan of the original Theatine house with the chapel of Sainte Anne-la-Royale.[13] At the death of the cardinal in 1661 his bequest of 100,000 *écus*[14] permitted the Theatines to commence their church of Sainte Anne-la-Royale, which was to replace the chapel in their house. As architect for the new church a member of the Theatine order, Padre Guarino Guarini, was sent from Italy, since it was the custom of this religious order to use its own members as designers of their buildings.

Guarini, who was born at Modena in 1624, had entered the Theatine order at the age of fifteen.[15] The young Theatine then studied theology and philosophy at Rome from 1639 to about 1647. For the history of architecture what was more important in Guarini's education was that he was in Rome when the Baroque architect Francesco Borromini was working on the churches of San Carlo alle Quattro Fontane (begun 1638) and Sant'Ivo della Sapienza (begun 1642), although both churches were completed long after Guarini's departure from Rome. Guarini must have closely observed the creation of, at least, the church of San Carlo alle Quattro Fontane, whose fabric was finished in 1641—the facade, of course, was much later—thus permitting Guarini to experience and understand the complex interior space composition of Borromini's church.

Guarini's architectural activity began on his return to Modena, where he served as overseer of the completion of the Theatine church of San Vincenzo and designed a dome for the church which was not carried out in accordance with his ideas. Encountering difficulty with the ducal court at Modena, Guarini began to travel about Italy. By 1660 he was at Messina in Sicily where he taught philosophy and mathematics and where for the first time he was able to carry out complete architectural projects. He built three churches, the Annunziata, San Filippo, and the Chiesa dei Padri Somaschi, all of them destroyed by the earthquake of 1908. During the summer of 1662 he returned briefly to Modena because of the impending death of his mother.

It must have been at this moment that Guarini was called to Paris to build the Theatine church of Sainte Anne-la-Royale, or perhaps he was already on his way north, making only a temporary stopover at Modena. The order at Paris had already purchased the land for the new church on June 2, 1661, for 72,000 *livres*,[16] thus expending for the land almost one fourth of Mazarin's bequest. This land was situated next to the house of the order. On November 28, 1662, the Prince de Conti laid the foundation stone in the name of King Louis XIV,[17] thus leaving an interval of about four months for Guarini to make his preliminary designs for the new church.

The ground plan of Sainte Anne-la-Royale is in the form of a Greek cross (Fig. 1). However, as almost all the walls, piers, and pilasters are set on a 45-degree diagonal, in plan the Greek cross seems to be composed of five overlapping or interpenetrating squares set on the diagonal. Each of the four arms of the cross is then flanked by elliptical chapels. The idea of a Greek cross plan created by

Fig. 2. Sainte Anne-la-Royale, Paris. Elevation (G. Guarini, *Architettura civile* [Turin, 1737], pl. 10)

Fig. 3. Sainte Anne-la-Royale, Paris. Section (G. Guarini, *Architettura civile* [Turin, 1737], pl. 11)

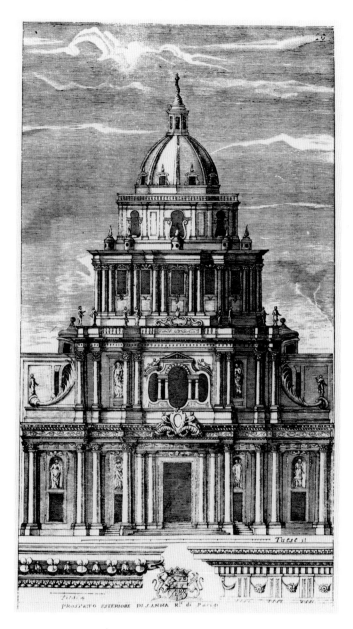

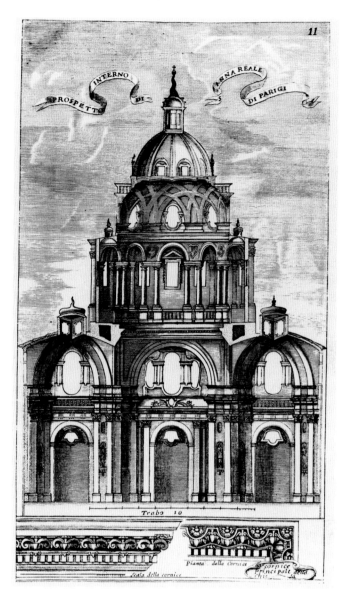

the interpenetration of five geometric forms is slightly reminiscent of the much subtler composition based on ellipses which Borromini used in San Carlo alle Quattro Fontane at Rome and which was built during Guarini's residence as a student at Rome. In Guarini's design the interpenetration of forms can only have been apparent in terms of the plan of the church, since the volumes of the various parts of the interior were kept distinctly apart through their enclosing domes, vaults, and arches. But the fact that Guarini is beginning to be aware of the possibilities of interpenetration is important when one considers his development of this spatial conception in the later works of San Lorenzo or the chapel of the SS. Sindone at Turin.[18] In comparison to Borromini's architecture what is more important is the subtlety of Borromini's spatial conception in contrast to the bolder but harsher compositions of Guarini. For example, Borromini's San Carlo depends upon the more complex and delicate form of the ellipse, while Guarini's two churches at Turin use the simpler circle or at Paris the square. Guarini does use the elliptical form in his buildings but generally in secondary or decorative elements, so at Paris, as we have noted, the flanking chapels are elliptical.[19]

| Guarino Guarini in Paris

That Borromini's church of San Carlo alle Quattro Fontane was the principal inspiration for Guarini is clearly apparent in the plan of the facade of the Parisian church. It is serpentine with two concave side bays flanking the central convex portion, just as in the earlier Roman church.[20] This means, of course, that all the columns defining the sections of the facade are set on an angle in respect to the general frontal plane of the facade. Only the two columns[21] flanking the central portal are arranged with their axes in relation to the segment of the circle on which the convex center of the church is organized. The pairs of columns which frame the outer concave bays are naturally on axes forming the radii of the segments of the circles which create the concave walls. There are, however, two other pairs of columns which are on the intermediate bays and which flank two side portals into the central vestibule which forms one of the arms of the Greek cross. These intermediate columns are set against the surface of the projecting central portion of the church facade, but their axes are not related to the segment of the circle which defines the convex central section, as are the two columns flanking the central portal. The intermediate columns, on the other hand, have their axes forming radii of the circles which define the outer concave bays, so that these columns are meant to play the full role of intermediate columns.

On the exterior the facade elevation (Fig. 2) presents a layer-cake arrangement of five superimposed parts, the upper three of which compose the dome and its drum. In physical dimensions the church was intended to be quite large,[22] but because of the several layers of stories and the rather complicated ornamental detail, the appearance of the facade of the church, at least in the print in Guarini's book, is not very monumental.

The most unusual features of the Parisian church were those of the dome and its drum, both on exterior and interior. The drum on the exterior, as is visible in its plan (Fig. 1), was an octagon but with each of the eight faces concave in form. To complicate the plan of the drum further, the eight points where the concave surfaces should have met were replaced by reëntrant angles, so that the entablature was constantly coming out to a point and breaking back. On the interior (Fig. 3) this drum was surrounded by a gallery composed of a series of Palladian motifs, so that the light from the windows in the drum would be slightly filtered before entering the crossing of the church. The dome itself was divided into two parts. On the exterior the lower part of the dome was hidden by an attic, circular in plan. Above the attic rose a small dome with eight exposed ribs, capped by a lantern which bore a fantastic helicoidal spire with globe and cross. Again there is a slight analogy in the work of Borromini at Rome, that is, the dome of Sant'Ivo della Sapienza.[23] The lower half of this dome is masked by a high attic of swelling convexities, while the lantern terminates in a spiral walk leading to the openwork metal finial with globe and cross.

The design of the interior of the dome of Sainte Anne-la-Royale is even more striking and difficult to describe. The upper part of the dome, which is visible as a dome also on the exterior, is simply a somewhat pointed single-shelled dome with eight ribs. It is the lower section, the part hidden on the exterior, which is unusual. It too is a domical form created by a series of interlacing pairs of semicircular ribs which leave an open area in the center closed by the simpler dome above. The plan of the dome (Fig. 1) perhaps explains this arrangement of ribs better than any description. It shows pairs of ribs springing some distance above the paired columns of the gallery but meant to match these columns. These ribs then vault over the next pair of supports to the succeeding pair. This alternation of pairs of supports and ribs, of course, creates an interlacement of ribs. Of equal interest are the pairs of pointed arches which result from this interlacement and which correspond at the upper level to the semicircular arches of the Palladian motifs in the gallery below. It is in the area beneath these pairs of pointed arches that are placed the viol-shaped windows which are visible on the exterior in the attic concealing this complicated domical form.

The use of the interlaced ribs and resultant pointed arches is naturally very unusual at this moment in the development of architecture which still relied upon the principles of classic architecture. Guarini, however, as his architecture indicates, felt no compulsion to consider the classic principles as rules. He observes later in his *Architettura civile* that "architecture can correct ancient rules, and invent new ones."[24] In fact, "in order to keep the proportions required by appearance, architecture ought to depart from rules, and from true proportions."[25] As a result, Guarini even expresses a sympathy for Gothic architecture, finding it "worthy of much praise,"[26] and in a chapter describing Gothic vaults he notes that "these vaults are no longer in use but they could sometime come into use."[27]

In the later church by Guarini of San Lorenzo at Turin (1668–1687) the central space is also spanned by eight pairs of ribs, but, unlike the Parisian church, at Turin the two ribs composing each of the pairs flare out from one

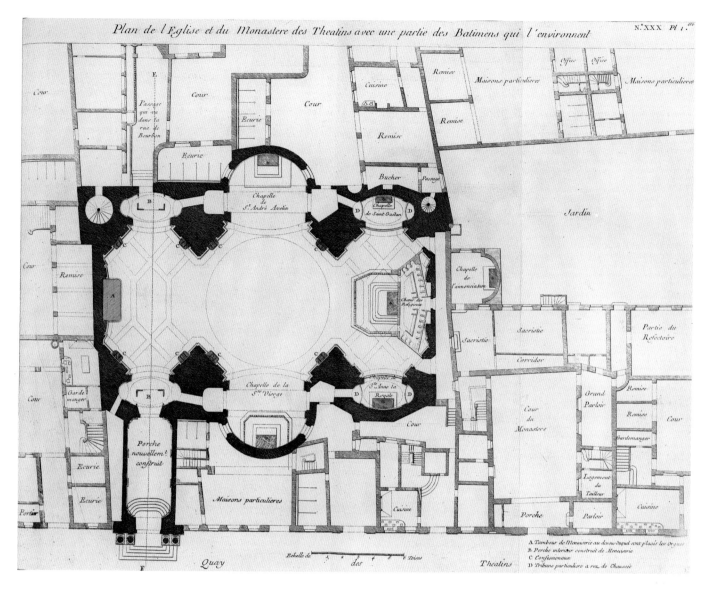

Fig. 4. Sainte Anne-la-Royale, Paris. Plan in 1752 (J.-F. Blondel, *Architecture françoise* [Paris, 1752], bk. 2, chap. 30, pl. 1)

another at the springing and intersect other ribs, all resulting in an open octagon at the center which is capped by a lantern. It has been suggested that this extraordinary dome is a result of a visit to Spain, where he could see an almost identical dome in the addition of El Hakam II to the Islamic mosque at Cordova.[28] However, it has not been noted that Guarini presumably used this same type of dome much earlier in the Chiesa dei Padri Somaschi at Messina in Sicily, where the architect was teaching from 1660 to 1662. At least in Guarini's later book the design of this church, destroyed in 1908, shows such a dome. Of course, Sicily had Islamic architecture, but I cannot find any other example of such an Islamic dome outside of

Cordova. However, since Sicily was in the possession of Spain at this time and, therefore, in close cultural contact, it is probably about this time that Guarini became aware of the Cordovan dome. Whatever and whenever the source of the Turin dome, it certainly seems to be Guarini's stay in Sicily which influenced the form of the ribs in his church of Sainte Anne-la-Royale in Paris. The use of semicircular arched forms which intersect one another so as to create a series of pointed arches is to be found as decoration on churches at Palermo, Monreale, and Cefalù in Sicily.[29]

The history of the construction and preservation of Sainte Anne-la-Royale is one of difficulties and disasters, as is true of all of Guarini's work except in the region of the

| Guarino Guarini in Paris

Piedmont in Italy. Already by 1666 the money from Cardinal Mazarin's bequest was exhausted, and Guarini was accused for the next fifty years of planning with too great ambition a church which could never have been completed on the basis of the original bequest, while the Duke de Mazarin, the cardinal's heir, was apparently unwilling to continue the interests of his benefactor.[30] Apparently no more work was done on the Theatine church until the eighteenth century, and the sixth edition of Brice's description of Paris in 1713 claims that only about a third of the original design was executed, "which appears from afar as an unformed mass, or as a ruin of some building of consequence which has been destroyed by the long course of several years."[31] Perhaps it is the unfortunate experience of Sainte Anne-la-Royale that inspires Guarini's later warning that: "The architect should proceed discreetly. Since he should aim at the convenience of whosoever builds, if he executes it at such expense that either he cannot finish the design or, completing it, may impoverish the builder and make him a beggar, that certainly will not turn out profitably but, on the contrary, will be seriously troublesome for him who should enjoy it."[32]

The church remained in this condition from 1666 to 1714, when a lottery was authorized to accumulate funds to finish it.[33] The work then progressed fairly quickly so that it could be dedicated finally on December 21, 1720,[34] but the eighteenth-century work was not a fulfillment of Guarini's original designs. The recommencement of construction was made after a new design furnished by the French architect Liévain, despite the fact that a wooden model of the section of the church designed by Guarini was still preserved in the library of the Theatine order in 1787.[35] The reason offered by the eighteenth-century writers for the change in design is that the original project was too expensive for even the new funds brought in by the lottery of 1714 and that it was too large for the site.[36] One wonders whether there was not also active the distaste of the classic eighteenth century for Guarini's project which many of the eighteenth- and early-nineteenth-century writers evince,[37] as well as the undoubted difficulty for any architect at that time to carry out the original design of the fantastic dome.

The revisions made by Liévain in completing the church are preserved, at least in plan, in J.-F. Blondel's *Architecture française*.[38] This plan (Fig. 4) reveals that the central four piers of the Greek-cross plan and the two arms of the cross on the east and west sides of the church were already constructed following Guarini's design,

likewise the elliptical chapels flanking each of these arms. Liévain, however, changed the basic design from a centralized Greek cross to a longitudinal plan by replacing the other two large arms with smaller apsidal arms. This meant that the axis of the church from entrance to altar was shifted from the north-south direction to the east-west orientation, and the chief altar was located in the west arm of the old church. The most unusual features in Guarini's design, the dome and the serpentine facade, were thus eliminated. This resulted in a building apparently much more acceptable to eighteenth-century standards of religious architecture. In fact, as Blondel's plan of 1752 reveals, there was little or no visible exterior to the church, since private houses and the house of the Theatine order surrounded the church on all four sides.

The entrance to the church was only solved later in the eighteenth century. Père François Boyer of the Theatine order was chosen Bishop of Mirepoix in 1730 and soon held important positions in the royal court as Preceptor of the Dauphin and later Almoner of Madame la Dauphine. It was he who then donated the money for the main portal of the church erected on the Quai des Théatins in 1747[39] and which was connected to the nave by a long vestibule debouching in the small elliptical chapel at the north side of what was originally the eastern arm of the church.[40] The architect was Pierre Des Maisons, who also designed a less important exit with a similar long vestibule or passageway leading to the Rue de Bourbon (now Rue de Lille).

The French Revolution led to the suppression of the Theatine order, whose only house in France was the one next to Sainte Anne-la-Royale at Paris. A drawing in the Archives de France at Paris (F[13] 849) presents a plan of 1795 to transform the church into a storehouse for military supplies by erecting two stories of wooden galleries in the interior. This plan of the church resembles in general the earlier eighteenth-century one of Blondel (Fig. 4) except that the passages from the small elliptical chapels and vestibules into the larger semicircular chapels flanking the nave are omitted, but the style of the 1795 plan is more diagrammatic and symmetrical than Blondel's and probably less accurate. About 1800 the old church was converted into a theater or playhouse, but only balls and fêtes were held there, until in October 1815 the Café des Muses was opened in the structure. Finally, from 1821 to 1823 the desecrated church was gradually demolished,[41] and private houses appeared on the site, leaving as the sole evidence of the church its eighteenth-century exit at

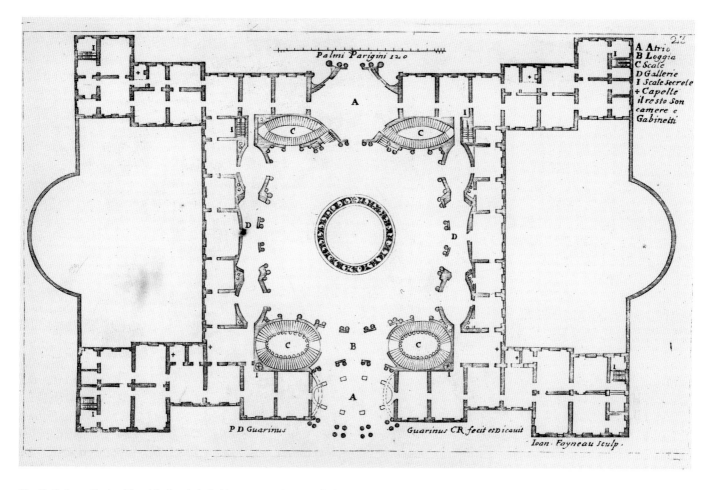

Fig. 5. Palace, Paris. Plan (G. Guarini, *Architettura civile* [Turin, 1737], pl. 23)

26 Rue de Lille.[42] Thus there disappeared from Paris apparently the only artistic product of Guarini's trip to France. At least by 1668 the Theatine architect was at Turin receiving an annual stipend as ducal engineer.[43]

There is preserved, however, one other small result presumably of Guarini's visit to Paris. In his later book *Architettura civile* (1737) there are two plates (nos. 23 and 24) presenting the plan, facade, and section, the latter entitled *Faccia interiore*, of a palace which bears no identification. That this project was produced while Guarini was in Paris is, I believe, proved by the architectural scales which are indicated on the plates. The plan (Fig. 5) has an architectural scale labelled "Palmi Parigini 120" and the elevations "Pi di Parigi 60" or "P d Parigi 60," that is, *piedi di Parigi* (Fig. 6). Since the other designs in Guarini's book are accompanied by the various local scales of measurement which were in effect in each of the cities or regions for which the buildings were created,[44] the Parisian scale on the depictions of the unidentified palace suggest immediately

that this project was made during Guarini's stay at Paris from 1662 to about 1666. Beyond this I cannot at the present suggest any further identification.[45]

The plan of the palace shows roughly a square body with wings projecting from the ends of the two principal facades, so that these two facades are almost twice the length of the central body. The central portion of the palace then surrounds a square interior court with elliptical stairs located toward the corners of the interior court. This description of an almost square palace with interior court having stairs in each of its corners suggests in a rough manner the projected plan for another great palace at Paris. That is the third design which Bernini prepared for the royal palace of the Louvre at Paris (Fig. 7). Of course, the differences between the two plans are more important than the loose similarity, but, since the Louvre plan is the one that Bernini prepared in Paris during his visit in 1665, it seems very likely that Guarini was influenced by the design. This project of Bernini was

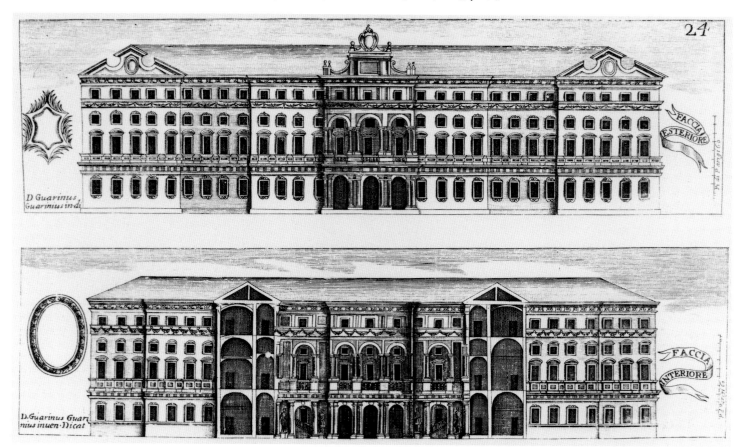

soon engraved by Marot, thus making it available to the world, but it is also possible that Guarini may have had contact with Bernini's assistant, Mattia de Rossi, who remained in Paris after Bernini's departure in order to continue the work on the palace of the Louvre.[46]

One of the principal differences between the two plans is that, while Bernini composes his design entirely in terms of rectangular forms, Guarini has managed to insert elliptical forms within a plan which is still basically rectangular in totality and elements. One of the entrance vestibules in Guarini is an ellipse cut off at each end. This elliptical atrium then results in a swelling entrance pavilion on the facade. However, the elliptical atrium is probably also derived from Bernini's work on the Louvre, since his first design for the palace, now preserved in Paris,[47] has exactly that form as the nucleus of the center of the facade. Even more important in Guarini's plan are the four elliptical stairs toward the interior court which cause the ends of two of the interior walls to swell out into the court. These stairs are then matched by elliptical sections

of the side galleries (D in the plan) which do the same for the side interior walls. The central sections of each of these interior walls, on the other hand, are concave, so that the interior court walls tend to be serpentine in plan. Actually, however, when one examines the plan and cross section in detail one realizes that the transformation from convex to concave curves is not a continuous one but a juxtaposition of the curves with a break in the cornice at the junction of the curves. This is typical of the distinction between Guarini and his mentor Borromini. Guarini always preserves more of the independence of the elements of his design, whereas Borromini more than probably any other architect in history is able to achieve the most complete fusion of all the parts or elements of his design without ever losing any of the individual elements.

If this project for a palace by Guarini was formulated during his Parisian stay, as I have suggested, it is instructive to compare this design with the plan of the Palazzo Carignano (Fig. 8), which Guarini created in Turin after his departure from Paris (begun 1679). In the later palace at

Turin the elliptical atrium is the kernel of the organization of the whole central section of the palace so that the nearby passages and stairs of honor follow the elliptical form and even carry it into the wonderfully dynamic facade of the palace. That the elliptical atrium and the stairs of honor were in Guarini's eyes the essence of the design is borne out by the series of his drawings published by Brinckmann in which Guarini struggled with the achievement of his solution. The scheme which Brinckmann designates as the earliest in the development[48] has a rectangular entrance atrium divided into three aisles by coupled columns and flanked on one side by an elliptical stair set toward the corner of the interior court and on the other side by a rectangular stair cage, the two dissimilar forms probably being alternates. Such a plan recalls the layout in Guarini's Parisian project for a palace (Fig. 5). The second design for the Palazzo Carignano[49] eliminates the corner staircases and introduces an elliptical entrance atrium with similar salon above, but this idea also existed in the presumably earlier Parisian plan. Like the Parisian prototype, the second drawing for the Palazzo Carignano has the elliptical room against the facade, with the stairs arranged toward the court, and it is only in the later drawings that the positions of the atrium and the stairs are transposed.[50]

The elevation of the Parisian palace (Fig. 6) when compared with Guarini's Piedmont elevations, as in the Palazzo Carignano and the Collegio de' Nobili (now the Accademia delle Scienze) in Turin and the Castello Reale at Racconigi,[51] betrays its earlier date in the decorative elements such as the window frames. In the former, only the minor windows of the ground floor and the small upper windows have volute pediments which resemble at all the elaborate window

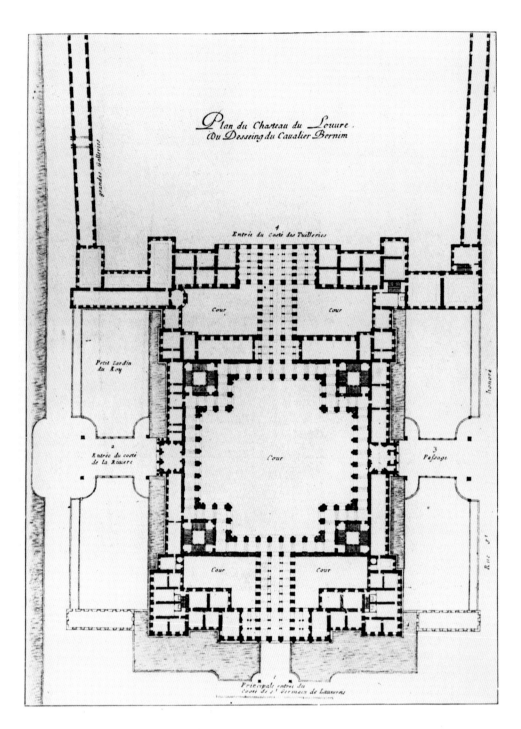

Fig. 7. The Louvre, Paris. Plan by Bernini (after J. Marot, *L'architecture françoise* [Paris, 1727])

pediments and jambs of the Piedmont architecture, while the windows of the *piano nobile* in the Parisian design have classic segmental pediments.

The two architectural products of Guarini's visit to Paris, Sainte Anne-la-Royale and the palace design preserved in

| Guarino Guarini in Paris

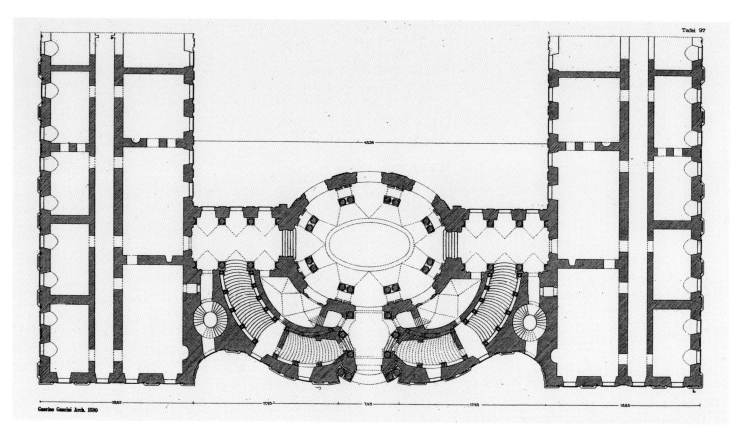

Tafel 97

Guarino Guarini Arch. 1680

Fig. 8. Palazzo Carignano, Turin. Plan (after *Palast-Architektur von Ober-Italien und Toscana vom XIII. bis XVIII. Jahrhundert*, vol. 5, *Bologna, Ferrara, Modena, Piacenza, Cremona, Pavia, Brescia, Bergamo, Mailand, Turin*, ed. A. Haupt [Berlin, 1911], pl. 97)

his *Architettura civile*, are certainly not as developed as the very bold Baroque conceptions which Guarini later executed in the Piedmont, but these earlier examples, as we have seen, do contain some of the seeds of his later projects. In addition to their importance in this respect, they represent the moment when Guarini came into contact with the second great Italian architect of the Baroque, G. L. Bernini, whose influence I believe is visible in the unexecuted palace project, but it was always Bernini's rival, Borromini, who exerted the more permanent influence. In comparison with Borromini the Theatine Guarini has little of the former's subtlety. Guarini's dictum that "architecture . . . depends upon geometry"[52] pervades his work too much. His dominating interest in the mathematical problems which later in the history of mathematics are systematized as descriptive geometry[53] causes Guarini to preserve as independent forms those geometric shapes with which he composes. At the same time, in the full Baroque tradition of Borromini, Padre Guarini is concerned with the intimate relationships between these forms without having the artistic ability to be able often to carry them out effectively. The series of drawings for the center of the Palazzo Carignano bears witness to Guarini's struggle with this artistic problem

of relationship, and, although the executed solution is most fascinating, the relationship between the central part of the palace and its wings is quite perfunctory. Guarini in his boldness in maneuvering forms is sometimes more immediately attractive than Borromini, but his art is more obvious and less rewarding to a long and detailed examination.

Notes

1. L. Mirot, "Le Bernin en France," *Memoires de la Société de l'histoire de Paris et de l'Ile-de-France* 31 (1904), 210.

2. P. de Fréart, Sieur de Chantelou, *Journal du voyage du Cavalier Bernin en France*, ed. by L. Lalanne (Paris, 1885), 33–34.

3. Chantelou's record of Bernini's comments during the visit to Sainte Anne-la-Royale is quoted in part in respect to the churches at Castel

Gandolfo and Ariccia by H. Brauer and R. Wittkower, *Die Zeichnungen des Gianlorenzo Bernini* (Berlin, 1931), 116 and 124 n. 2.

4. A. Vautier, *Voyage de France: moeurs et coutumes françaises (1664–1665), relation de Sébastien Locatelli* (Paris, 1905), 141.

5. Ibid.

6. E.g., G. Brice, *Description de la ville de Paris et de tout ce qu'elle contient de plus remarquable*, 6th ed. (Paris, 1713), vol. 3, 216.

7. M. Dumolin, *Études de topographie parisienne* (Paris, 1929), vol. 1, 296.

8. J. Bouillart, *Histoire de l'abbaye royale de Saint Germain des Prez* (Paris, 1724), 242.

9. C. Moreau, *Choix de mazarinades* (Paris, 1853), vol. 1, 50. Two other Mazarinades refer to the Theatine "marionettes" (ibid., 100 and 300).

10. M. Chéruel, *Journal d'Olivier Lefèvre d'Ormesson*, Collection de documents inédits sur l'histoire de France 9 (Paris, 1860), 598 n. 1. This reference is given in L. Hautecoeur, *Histoire de l'architecture classique en France*, vol. 2 (Paris, 1948), 245, where there is the best and most complete consideration of Sainte Anne-la-Royale.

11. A. Pozzo, *Perspectiva pictorum et architectorum* (Rome, 1693), figs. 60 and 71; the latter used in the Gesù at Rome in 1685.

12. For the Jesuit theater, see E. Boysse, *Le théatre des Jesuites* (Paris, 1880); W. Flemming, *Geschichte des Jesuitentheaters in den Landen deutscher Zunge*, Schriften der Gesellschaft für Theatergeschichte 32 (Berlin, 1923); J. Müller, *Das Jesuitendrama in den Ländern deutscher Zunge vom Anfang (1555) bis zum Hochbarock (1665)*, 2 vols. (Augsburg, 1930); and for the relationship between the theater and church decoration, see H. Tintelnot, *Barocktheater und barocke Kunst* (Berlin, 1939), 270–297.

There are some accounts of plays and scenic devices being used in churches earlier than Sainte Anne-la-Royale, for example, at Cologne in 1627 and occasionally in S. Salvator at Augsburg early in the seventeenth century (Flemming, *Geschichte des Jesuitentheaters*, 92 and 107), but the Jesuit drama was usually performed within a Jesuit college or school.

Hautecoeur, *Histoire de l'architecture classique* (note 10 above), 247, quotes accounts later in the seventeenth century to show the increasing theatrical interests at Sainte Anne-la-Royale, which by 1685 was accused by the Archbishop of Paris as "a veritable opera" with music and chairs for rent.

13. For the date of the purchase of No. 25, Quai Malaquais, see Dumolin, *Études de topographie* (note 7 above), 296–297.

14. The Comte de Brienne gives this figure in his memoirs, written by 1684 (P. Bonnefon, *Mémoires de Louis-Henri de Loménie, Comte de Brienne, dit le jeune Brienne* [Paris, 1917], vol. 2, 46–47), and it is repeated in most of the eighteenth-century guides to Paris, for example, Brice, *Description de la ville de Paris* (note 6 above), 215, although the later guides give the amount as 300,000 *livres*. The will of Mazarin, as printed in the *Oeuvres de Louis XIV* (Paris, 1806), vol. 6, 297, only notes that the cardinal "confirme

la donation aussi par lui faite aux religieux Théatins de la maison Sainte-Anne la Royale."

15. The biography of Guarini is given in T. Sandonnini, "Il padre Guarino Guarini modenese," *Atti e memorie delle RR. deputazioni di storia patria per le provincie modenesi e parmensi*, ser. 3, 5 (1888), 483–534.

16. Dumolin, *Études de topographie* (note 7 above), 269.

17. A. M. Le Fèvre, *Calendrier historique et chronologique de l'église de Paris* (Paris, 1747), 295–296. Actually, the foundation stone had already been laid and blessed earlier, on November 7, 1662, by the Bishop of Luçon; see [J. B. M.] Jaillot, *Recherches critiques, historiques et topographiques sur la ville de Paris, depuis ses commencemens connus jusqu'à présent* (Paris, 1775), vol. 5, 74.

18. See especially A. E. Brinckmann, *Theatrum novum Pedemontii* (Düsseldorf, 1931), 202 and 231.

19. Locatelli (Vautier, *Voyage de France* [note 4 above], 141–142) notes the unusual location of the altars in the center of the chapels instead of against the walls at Sainte Anne-la-Royale. The prints in Guarini's book (Figs. 1 and 3) do not show in any way this idea, but there must have been some intention since Locatelli knew the Theatines so well and must have discussed the use of the church with them.

20. The facade of San Carlo alle Quattro Fontane was executed 1665–1668.

21. The facade elevation reproduced in Guarini's book (Fig. 2) has pairs of columns on each side of the central entrance, unlike the plan (Fig. 1) which has only single columns.

22. The dimensions of the church in Guarini's book do not seem to agree with those of the building as executed, but both indicate a large church. The scale on the facade elevation in Guarini's book is in terms of "tuese," presumably the French *toise* (1.949 m). By this scale the church would be 26½ *toises* high (over 51 m) and 18 *toises*, 4 *pieds* wide (a little over 36 m). The eighteenth-century plan in J.-F. Blondel, *Architecture françoise* (Paris, 1752) (Fig. 4), and the 1795 plan, both discussed later, have the width of the actual church as 20½ *toises* (40 m).

23. Sant'Ivo was begun in 1642, while Guarini was a student at Rome (E. Hempel, *Francesco Borromini* [Vienna, 1924], 114), and was roughly completed as far as the lantern in 1650, the work of decoration and completion lasting until 1660. Thus, Guarini could either have known of the Roman church in the forties from Borromini's plans or studied the completed church, perhaps during his trip north to Modena from Sicily in 1662.

Actually, the section of Borromini's earlier dome of San Carlo alle Quattro Fontane resembles that of Sant'Ivo della Sapienza with the lower part of the dome concealed and a lantern at the top, but San Carlo does not have a spiral finial.

24. G. Guarini, *Architettura civile* (Turin, 1737), 5.

25. Ibid., 6.

26. Ibid., 7.

27. Ibid., 186. He defines and discusses all the different types of vaults on pp. 183–190.

28. S. Giedion, *Space, Time and Architecture* (Cambridge, Mass., 1941), 60. Sandonnini, "Il padre Guarino Guarini" (note 15 above), also suggests that it is in the period between 1666 and 1668, just before Guarini settled in Turin, that he may have gone to Lisbon to build his church of Santa Maria de la Divina Providencia, which might have permitted Guarini to see the mosque at Cordova. With our present limited knowledge of Guarini's life, a visit to Lisbon at this time is simply an assumption, as Sandonnini indicates, and the church at Lisbon, which was destroyed in the eighteenth century, could have been erected after Guarini's design without a visit of the architect to Portugal. For the date of the Lisbon church, see R. C. Smith, Jr., "João Frederico Ludovice: An Eighteenth Century Architect in Portugal," *Art Bulletin* 18 (1936), 275–276, where Smith suggests that the date is sometime after 1662, since the Portuguese church seems derived from the Parisian one, and that Guarini probably did not visit Lisbon but sent plans for it.

29. G. V. Arata, *L'architettura arabo-normanna e il rinascimento in Sicilia* (Milan, 1925), pls. 4–6, 35, 38–40, and 62.

30. Sandonnini, "Il padre Guarino Guarini" (note 15 above), 499, quotes a section of a letter to this effect written in 1666 by the Abbot Caprara to the Cardinal d'Este.

31. Brice, *Description de la ville de Paris* (note 6 above), 217.

32. Guarini, *Architettura civile* (note 24 above), 4. Guarini then continues by quoting as authorities for this danger Luke XIV:28, and Vitruvius, bk. IX.

33. J.-F. Blondel, *Architecture françoise* (Paris, 1752) (reimpression ed. by J. Guadet [Paris, 1904–1905]), vol. 1, bk. 2, 290.

34. Bouillart, *Histoire de l'abbaye royale* (note 8 above), 242.

35. L. V. Thiéry, *Guide des amateurs et des étrangers voyageurs à Paris* (Paris, 1787), vol. 2, 537.

36. Le Fèvre, *Calendrier historique* (note 17 above), 296; and Blondel, *Architecture françoise* (note 33 above), 290.

37. Thiéry, *Guide des amateurs* (note 35 above), 537, who reports the existence of a model of Guarini's design, is the exception when he remarks, "Ce modèle, exécuté en bois, fait regretter que cette Eglise n'ait point été terminée."

38. Blondel, *Architecture françoise* (note 33 above), vol. 1, bk. 2, no. XXX, pl. 1.

39. Le Fèvre, *Calendrier historique* (note 17 above), 296–297; and Blondel, *Architecture françoise* (note 33 above), vol. 1, bk. 2, 291.

40. The portal on the Quai des Théatins is illustrated in Blondel, *Architecture françoise* (note 33 above), vol. 1, bk. 2, no. XXX, pl. 2.

41. J. A. Dulaure, *Histoire physique, civile et morale de Paris, depuis les premiers temps historiques jusqu'à nos jours*, 4th ed. (Paris, 1829), vol. 6, 327.

42. A photograph of the extant portal is reproduced in M. Dumolin and G. Outardel, *Paris et la Seine*, Les églises de France (Paris, 1936), xviii.

43. Sandonnini, "Il padre Guarino Guarini" (note 15 above), 501. In a sense perhaps a more permanent product of Guarini's stay at Paris was his attempt at a synthesis of philosophy in his book *Placita Philosophica*, published at Paris in 1665.

44. For example, Santa Maria de la Divina Providencia at Lisbon is in *canne portoghesi;* the Annunziata of Messina uses *canne* or *palmi messinesi;* and San Lorenzo and the Palazzo Carignano of Turin and the church at Oropa have a scale of measurement labelled as *trabucchi* or *trabo*, which Guarini uses in the Piedmont. In the drawing of the facade and section of the plan of the Castello Reale at Racconigi attributed to Guarini the scale is also in *trabucchi* (Brinckmann, *Theatrum novum Pedemontii* [note 18 above], pl. 116), while the drawings of a window perhaps for the Collegio de' Nobili in Turin has *piedi di piemonte* (ibid., pl. 240b). The plate in the *Architettura civile* of the facade of Sainte Anne-la-Royale at Paris, as we have noted, specifies the scale as *tuese* and *piedi*, which are undoubtedly the Parisian *toise* and *pied*. The one exception in this correspondence between locality of building and architectural scale is explicable. The section of Sainte Anne-la-Royale has its measurements in terms of the *trabo*, but it must be recalled that these plates were prepared while Guarini was in Turin. Therefore, for some reason he had to substitute, redo, or supplement a drawing devised at Turin for the section of the Parisian church. Guarini discusses the relationships between some of the local measurements in the *Architettura civile* (note 24 above), 43–44.

45. We might note that in the plan of one floor Guarini locates six chapels, which seems somewhat excessive for a secular palace. Four of these chapels are private ones, each located in one of the apartments which makes up one of the projecting wings.

46. At least occasionally, De Rossi must have attended mass at the Theatine church in Paris; see his letter of October 1, 1665, published in Mirot, "Le Bernin en France" (note 1 above), 268 n. 1: "Io quando hebbi visto questo retratto [portrait of Louis XIV by Varin], andai a messa alli Teatini. . . ." De Rossi was probably attracted to the Theatine church because all the members of this order in Paris were still Italians, as Locatelli mentions (Vautier, *Voyage de France* [note 4 above], 141).

It might be recalled also that even the English architect Sir Christopher Wren was able to obtain a brief glimpse of Bernini's plans when Wren was in Paris in 1665 (*The Wren Society* 13 [1936], 41).

47. Brauer and Wittkower, *Die Zeichnungen des Gianlorenzo Bernini* (note 3 above), pl. 175.

48. Brinckmann, *Theatrum novum Pedemontii* (note 18 above), pl. 250. In this design the three-aisled entrance atrium, of which only the central aisle has an entrance portal, the side aisles corresponding only to windows in the facade, seems derived from the Palazzo Farnese at Rome, but the first Louvre plan of Bernini (see note 43 above) also had a secondary atrium in three aisles separated by coupled columns very like the first project for the Palazzo Carignano.

49. Ibid., pl. 251A.

50. Ibid., pls. 251B and 252A. Brinckmann (ibid., 77) suggests that this latter drawing shows French influence in its arrangement of antechambers flanking the elliptical salon and points to Guarini's stay in Paris as a source of this idea.

51. Ibid., pls. 116A, 240, 253, and 259.

52. Guarini, *Architettura civile* (note 24 above), 3.

53. M. Cantor, *Vorlesungen über Geschichte der Mathematik*, vol. 3 (Leipzig, 1898), 13, and vol. 4 (1908), 593–594.

8

John Evelyn at Tivoli

John Evelyn during his own lifetime was likened to Peiresc of France because of his erudition and manifold interests. His writings and correspondence, especially the so-called *Diary*, have been of inestimable value to historians, in particular historians of society and art. Since gardening was one of Evelyn's specialties, his descriptions in the *Diary* of French and Italian gardens have often been quoted.[1] For example, on May 6, 1645, Evelyn records in his *Diary* a visit to Tivoli in which he gives a short report of the condition of the gardens of the Villa d'Este. There are several very useful earlier and more complete accounts of the gardens at Tivoli,[2] but Evelyn in his description of the Secret Garden furnishes some details which are lacking in the earlier accounts. "In the Garden at the right hand are plac'd 16 vast Conchas of marble jetting out Waters: in the midst of these stands a *Janus* quadrifrons that cast forth 4 girandolas, calld from the resemblance [to a particular exhibition in fire-works so named] the *fontana di Speccho* [looking-glass]."[3] The other descriptions make no mention of the "sixteen vast Conchas of marble." That is, all other descriptions except one published in 1587 which has never been noted by historians of the gardens of the Villa d'Este. The 1587 account is contained in the *Hercules Prodicius* of Stephanus Vinandus Pighius which, appearing at Antwerp, is in part a record and memorial of the trip to Italy by the young Prince of Cleves in 1574–75 in company with Pighius. When one reads the Latin description of the Secret Garden by Pighius,[4] one can only conclude that John Evelyn has followed very closely the earlier account, almost to the point of translating it. In fact, all the evidence shows that the "sixteen Conchas" never existed. Pighius at his commencement of the description of the gardens of the villa frankly admits that he is working from an engraving of the gardens. There is a famous engraving depicting the villa and its gardens which was made by Etienne Dupérac in 1573. It has long been noted that this engraving is based upon the original plan for the gardens, since it depicts several elements which were projected but never executed; for example, four fish pools instead of the extant three, the Fountain of Neptune at the end of the fish pools, or the belvederes on the corners of the villa. However, the Dupérac engraving also omits the "sixteen Conchas" in the Secret Garden, having only the quadrifrons pavilion and small trees evenly spaced over the enclosed garden; but another version of Dupérac's engraving was published by Claude Duchet in 1581, which adds sixteen small fountains between the trees (Fig. 1). Presumably it is this engraving of the gardens which Pighius used to refresh his memory of the visit to Tivoli early in 1575.

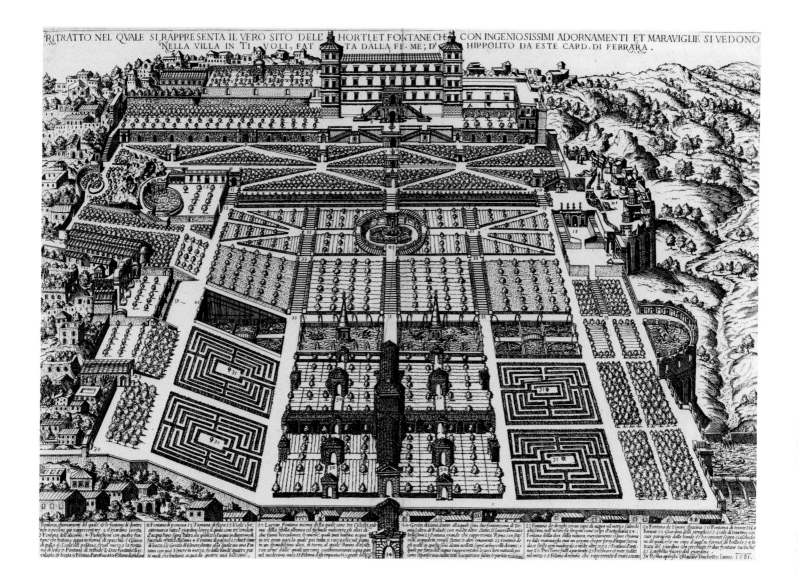

RITRATTO NEL QVALE SI RAPPRESENTA IL VERO SITO DELL' HORTI ET FONTANE CHE CON INGENIOSISSIMI ADORNAMENTI ET MARAVIGLIE SI VEDONO NELLA VILLA IN TIVOLI, FATTA DALLA FE. ME; D' HIPPOLITO DA ESTE CARD. DI FERRARA.

Fig. 1. Claude Duchet, engraving of the Villa d'Este at Tivoli, 1581

(photo: Avery Architectural and Fine Arts Library, Columbia University)

John Evelyn, however, probably did not use Pighius's sixteenth-century book as his source for the description of Tivoli. One of the most popular guidebooks to Italy, François Schott's *Itinerario d'Italia*, was derived to a great extent from the travel notices in Pighius's *Hercules Prodicius*.[5] Most of the Latin editions of Schott's guide simply copy the passages in Pighius which describe the Villa d'Este at Tivoli; the Italian editions are merely a translation of the Latin.[6] It is undoubtedly one of the editions of this guidebook which John Evelyn consulted when he wrote his notice of the trip to the Villa d'Este. Evelyn's *Diary* is actually more a book of "Memoirs" than a day-to-day narration of things that happened to him at each moment, although it is organized in diary form. Many of

the passages in it were revised by him much later, and this would seem to be true of his account of the Villa d'Este.[7]

Of course, it is possible that John Evelyn, like Pighius, had used Duchet's engraving, or a later copy, as his source for the description of Tivoli. Indeed, he probably had the engraving to aid him, since at the end of the account he claims to have seen, "lastly, a garden of simples," which is precisely one of the titles under Duchet's engraving ("32. Giardini delli semplici"). Pighius and Schott, on the other

John Evelyn at Tivoli

hand, speak of gardens with exotic plants (*piante forestieri* or *plantarum exoticarum*). Also the title of the quadrifrons pavilion in the Secret Garden, given by Evelyn as "the Fontana di Speccho," is probably derived from the engraving. Nevertheless, Duchet's engraving is not sufficient to explain the resemblance between Evelyn's description and those of Pighius and Schott. Not only is the passage in Evelyn portraying the Secret Garden very close in language to the earlier accounts, but there are some other references in Evelyn's record which suggest his use of Schott's guidebook. Although Pighius and, therefore, Schott followed the sequence of fountains as they are inscribed on Duchet's engraving, their descriptions omitted several fountains that were listed; for example, the Fountain of the Unicorn in the Secret Garden, the Fountain of the Emperors, and the Grotto of Diana. Evelyn, likewise, omits precisely these same fountains, which is too much of a coincidence to permit one to believe that he worked only from the engraving.

There is also another passage in Evelyn which is derived from Schott. After the description of the Secret Garden, Evelyn continues: "Before the Ascent of the Palace is that incomparable fountain of *Leda*, & not far from that 4 sweete & delicious Gardens." However, there never were any four such gardens near the Fountain of Leda. Evelyn's record is merely a somewhat misunderstood simplification of the much longer account reproduced in Schott of Pighius's attempt to portray the layout of the slope of the gardens below the villa as being divided up by three staircases into four rectangular wooded plots, which Pighius calls gardens.[8]

All of this is not to imply that John Evelyn did not visit the gardens at Tivoli in 1645. He records at least one feature which does not appear either in the Duchet engraving or the guide of Schott. Thus, he correctly depicts the so-called Lane of the Hundred Fountains as "a long & spacious Walk, full of Fountaines, under which is historiz'd the who<le> *Ovidian* Metamorphosis in *mezzo Relievo* rarely sculptur'd."[9] It is only the accuracy of his description which must be denied.[10] John Evelyn—like Schott, the author of the guidebook—had the misfortune to base his description of the condition of the gardens at Tivoli in the mid-seventeenth century, not on what was actually built, but on a sixteenth-century project. So Evelyn claims to have seen the Fountain of Neptune at Tivoli in "which is the statue of *Neptune* in his Chariot, on a sea-horse,"

but the Fountain of Neptune was never executed. It only existed in the engravings of Dupérac and Duchet, from which Evelyn inherited it through the *Hercules Prodicius* of Pighius via Schott's guidebook. Both Pighius and Schott acknowledged their sources, John Evelyn did not; he could not very well do so, as he was writing his diary or memoirs. Since Evelyn seems to have used both the engraving of the gardens and Schott's guide, it is probable that he wrote his description of the gardens of the Villa d'Este in his library, based upon Schott's guidebook and enhanced by a few notes of his own.[11]

Notes

1. M. L. Gothein, *A History of Garden Art* (London and Toronto, 1928), vol. 1, 257, and H. Inigo Triggs, *The Art of Garden Design in Italy* (London, 1906), 126, both quote Evelyn regarding the Villa d'Este at Tivoli.

2. For example, the account dated 1576 of Zappi (G. M. Zappi, *Annali e memorie di Tivoli di Giovanni Maria Zappi*, ed. V. Pacifici [Tivoli, 1920], 55–65) and Antonio del Re, *Dell'antichità tiburtine capitolo V* (Rome, 1611), 1–71, which is published in a Latin translation in J. G. Graevius and P. Burmann, *Thesaurus antiquitatum et historiarum Italiae*, vol. 8, pt. 4 (Leiden, 1723).

3. J. Evelyn, *The Diary of John Evelyn*, ed. E. S. de Beer (Oxford, 1955), vol. 2, 395 (see note 11 below).

4. "A dextris habet hortos seclusos, quos secretos appellant: in quibus fontium marmorei crateres sedecim eructant limpidas aquas: in quorum medio stat Ianus altior quadrifrons, quatuor item habens fontes, speculorum in modum peronornatos" (p. 529).

5. E. S. de Beer, "François Schott's *Itinerario d'Italia*," *The Library: Transactions of the Bibliographical Society*, 4th ser., 23 (1942–43), 57–83, has an analysis of the sources used by Schott and the various editions of his guidebook which, first appearing in 1600, ran through numerous printings and editions until 1761.

6. For the Latin I have consulted F. Schottus, *Itinerarium Nobiliorum Italiae Regionum* (Vicenza, 1610), and for the Italian, F. Schottus, *Itinerario overo nova descrittione de' viaggi principali d'Italia* (Padua, 1654).

7. An analysis of the form and creation of the *Diary* is contained in A. Ponsonby, *John Evelyn* (London, 1933), 176–201. For example, Ponsonby (p. 180) claims: "The travel entries are amplified and written up from full notes."

8. The passage from Schott reads: "Hinc leni descendens cliuo collis quattuor in locis in areas oblongas redactus, & exaequatus quadruplices ante praetorium peramoenos, & spatiosos hortos complectitur" (Schottus, *Itinerarium* [note 6 above], 292). As a result of Evelyn's description, Gothein, *History of Garden Art* (note 1 above), 257, thought "there may well have been four *giardini secreti*."

9. Evelyn, *Diary*, ed. de Beer (note 3 above), vol. 2, 396.

10. The quadrifrons pavilion which Evelyn describes as being in 1645 in the center of the Secret Garden is not mentioned in the very minute description of the gardens published in 1611 by Antonio del Re (note 2 above), so that it is very probable that the pavilion was removed before 1611.

11. This paper was already in proofs when Mr. de Beer's edition of Evelyn's *Diary* was published.

9

Some Aspects of the Villa Lante at Bagnaia

The identity of the architect of the villa at Bagnaia has remained tantalizingly enigmatic for more than a century. There has been general agreement that the architect must be Giacomo Barozzi da Vignola, but the absolute silence of sixteenth- and seventeenth-century sources regarding this identification has left an uneasy element of doubt. In the early nineteenth century, Percier and Fontaine, who seem to be the first historians to mention in print the name of Vignola in association with the villa at Bagnaia, record that there was a tradition for the attribution without any authority and that they considered the villa the work of "several able architects."[1] Even the recent very fine monograph on the villa admits that there is no documentary proof of Vignola's relationship with the villa,[2] and the most recent study of Vignola lists it under insufficiently documented works whose architect, if not Vignola, must belong to the circle of Vignola.[3]

The general history of the villa has been thoroughly explored in its new monograph, which proves that the right casino of the two now present at Bagnaia was built and decorated for Cardinal Giovanni Francesco Gambara. From the early sixteenth century the bishops of Viterbo had enjoyed as their summer residence the little town of Bagnaia, where Cardinal Raffaele Riario had built a small hunting lodge. As Cardinal Gambara succeeded to the Bishopric of Viterbo in 1566, it is understandable that the traditional date for the commencement of the Villa Lante

has been 1566 or soon thereafter. This date and the geographical location of the villa are undoubtedly the circumstantial evidence that has suggested the name of Vignola as its designer, for it is precisely at this time that Vignola was active completing the nearby great Farnese Palace at Caprarola. This historical probability is fully supported by the architectural style of the villa. For example, the two casinos resemble very much the Villa Vecchia at Frascati, where documents indicate that Vignola was active in 1568 and 1569.[4]

Nevertheless, the silence of sixteenth-century sources, such as Vasari or Egnatio Danti, the first biographer of Vignola, has always been disturbing. Baglione in 1642 even notes that Antonio Tempesta acquired fame for his decorations in the villa at Bagnaia, but Baglione gives no information on the architecture and gardens of the villa.[5] Therefore, there may be some importance in a document that brings Vignola in relation with the Cardinal Gambara in this period. Preserved in the Archivio di Stato at Parma is the *minuta* of a letter of Cardinal Farnese to Cardinal Gambara that reads:

Care da Gambara
Poiche il Vignola è già uenuto costà per trouare V.S. Illma et intender dallei qualo ella gli commanderà, à me non occorre dirle altro in rispta dalla sua, che' basciarle humilisste la mano, et pregarle dal S.r Dio

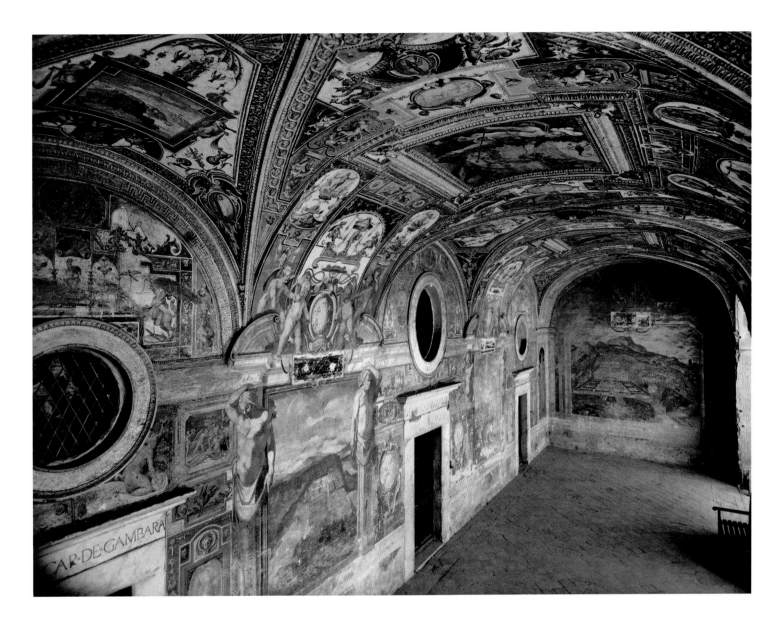

ogni [sic] contento [hole]erità
Di Capr[la] à xviij di Settem[b] [hole]8

Fig. 1. Bagnaia, Villa Lante, Casino Gambara, loggia (photo: ICCD, Rome, E 38661)

Owing to the hole in the *minuta*, the date is not completely preserved, but it is certainly September 18, 1568, for the *minuta* is recorded on the same page with another of that date to the Patriarch of Jerusalem.[6] Again the information is tantalizing as it merely notes that Vignola is with the Cardinal Gambara to receive instructions for some work. However, it seems most likely that this document must refer to Vignola's first association with the Cardinal Gambara in planning the villa at Bagnaia. The date of the *minuta* in September 1568 then explains Vasari's silence regarding Vignola at Bagnaia, for the second edition of the *Vite* was published in that year. More awkward is Egn-

atio Danti's omission in his biography published in 1583 with Vignola's treatise on perspective, but the work at Bagnaia may be buried in Danti's additional comment: "Furono fatti da lui in diuersi luoghi d'Italia molti palazzotti, molte case, molte cappelle, & altri edificij publici & priuati."[7] Baglione's life of Vignola is in turn derived for the most part from Danti.

The date 1568 for the commencement of the villa at Bagnaia is important as ordering more accurately the relative chronology of the three great cardinalate summer residences of Latium—the Palazzo Farnese at Caprarola, the Villa d'Este at Tivoli, and Cardinal Gambara's villa

157

The Villa Lante at Bagnaia

at Bagnaia—since their periods of creativity tend to overlap. Along with the Medici villa at Pratolino,[8] these three villas are frequently cited as the most notable ones of the second half of the sixteenth century, particularly for their waterworks. Montaigne in the account of his Italian trip compares the villas of Bagnaia, Tivoli, and Pratolino in a competitive spirit, and Vincenzo Scamozzi in his architectural treatise chooses these villas in company with the Farnese Palace at Caprarola for especial praise in respect to their fountains and water tricks.[9] In addition, the three villas of Latium reveal mutual influences in their gardens and decoration, but the date 1568 for Bagnaia indicates that it is the other two villas which for the most part influence Bagnaia.

That these three villas were considered as related creations is made visible in the pictorial decoration of the ground-floor loggia of the Cardinal Gambara's casino at Bagnaia (Fig. 1). The walls of the loggia are painted with landscape frescoes featuring views of the three villas as well as a view of the Borgo of Bagnaia.[10] The depiction of the Villa Lante itself presumably dates before the building by Cardinal Montalto after 1587 of the twin casino at the left and proves that the general layout of the villa was prepared by Vignola as a whole in 1568; later architects merely executed and completed his ideas. The fact that the central fountain in the fresco differs slightly from the changes made to it under Cardinal Montalto suggests that the view is based on a project for the villa, as do the dates of ca. 1574–1576 proposed by Dottoressa Brugnoli for the frescoes by Raffaellino da Reggio on the vault of the loggia.[11] The view of the Villa d'Este at Tivoli is likewise based on the Dupérac engraving of the villa issued in 1573, for it depicts from the print the belvederes at the ends of the villa which were never executed.[12]

The view of the Farnese Palace at Caprarola is very interesting in terms of the problem that has arisen regarding the two semicircular stairs at the foot of the terraces leading up to the facade of the palace (Fig. 2). It has been proposed very convincingly that these stairs date from the very end of the sixteenth century (sometime before 1617) and replace a fishpool that Vignola located there about 1568.[13] However, the recent monograph on Vignola notes that Vasari as early as the 1568 edition of his *Vite* speaks of the palace in the form of a fortress "accompagnata di fuori da una scala ovata, da fossi intorno, e da ponti levatoi," and Vasari's "scala ovata" is interpreted as being the two semicircular stairs at the foot of the approach.[14] If this were true, they would then have to date before 1568, but it is much more probable that

Vasari's "scala ovata" is merely the small oval version of Bramante's Belvedere Court stairs that was at the top of the facade terraces just before the drawbridge entering the palace. This oval stair is visible in many of the plans and views of the palace.[15] The fact that Vasari speaks of the oval stairs in conjunction with the moat and drawbridge makes it much more likely that he is referring to the upper small stairs than to the two large semicircular stairs at the foot of the terraces. On the other hand, the fresco at Bagnaia of the Farnese Palace at Caprarola very clearly depicts the two large lower stairs but does not have the later additions of the great garden and its casino made perhaps by Girolamo Rainaldi after 1578 on the western side of the palace. In this depiction no pool stands in the middle of these stairs as assumed by scholars on the basis of the text attached to Villamena's 1617 engraving of the plan of the palace: "Prima scala in mezzo della quale era una peschiera che poi, si per l'incommodo, come per l'aere nocivo, che apportaua al Palazzo, si è leuata."[16] If the fresco at Bagnaia is to be dated in the mid-1570s, and it is certainly before the later sixteenth-century additions at Caprarola, the substitution of the two semicircular stairs at the foot of Caprarola for Vignola's fishpool must be soon after his death in 1573 and may even represent his own idea, although not execution.

The decoration of villas with landscape painting has a long tradition in Italy and had been advocated by Alberti in his mid-fifteenth-century treatise on architecture (Book IX, iv). During the second half of the fifteenth century in Rome, such buildings as the so-called country house of Cardinal Bessarion and the Loggia dei Cavalieri di Rodi had rustic, pictorial decoration of trees and shrubbery in their loggias, yet these frescoes were not truly landscapes but more in the tradition of medieval tapestries. It was the Belvedere Villa of Pope Innocent VIII that introduced to Rome topographical landscapes for villa decoration. Vasari reports that Pinturicchio painted there "una loggia tutta di paesi; e vi ritrasse Roma, Milano, Genova, Fiorenza, Vinezia e Napoli, alla maniera de' Fiamminghi; come cosa insino allora non più usata, piacquero assai."[17] Unfortunately, only badly damaged, small fragments of these topographical views have recently been uncovered,[18] but it is possible that the Belvedere Villa itself was prominently displayed in the depiction of Rome. This is suggested by a series of woodcut views of Rome, dating just after Pinturicchio's frescoes, in which the Belvedere Villa dominates the upper right corner of the cityscape.[19] Sandström suggests that the choice of these six city landscapes

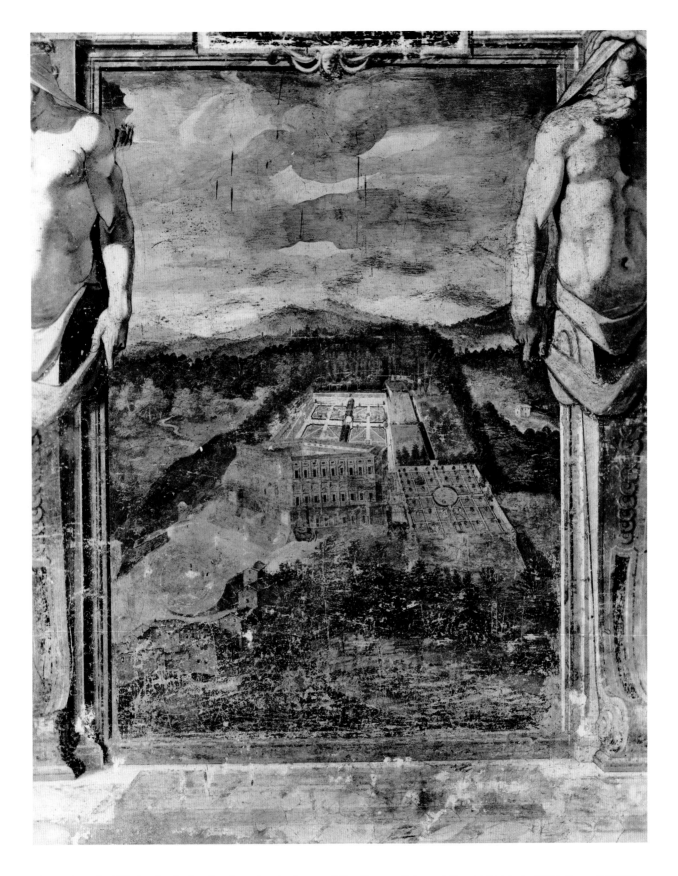

Fig. 2. Bagnaia, Villa Lante, Casino Gambara, loggia, fresco of the Farnese Palace at Caprarola (photo: ICCD, Rome, E 38660)

The Villa Lante at Bagnaia

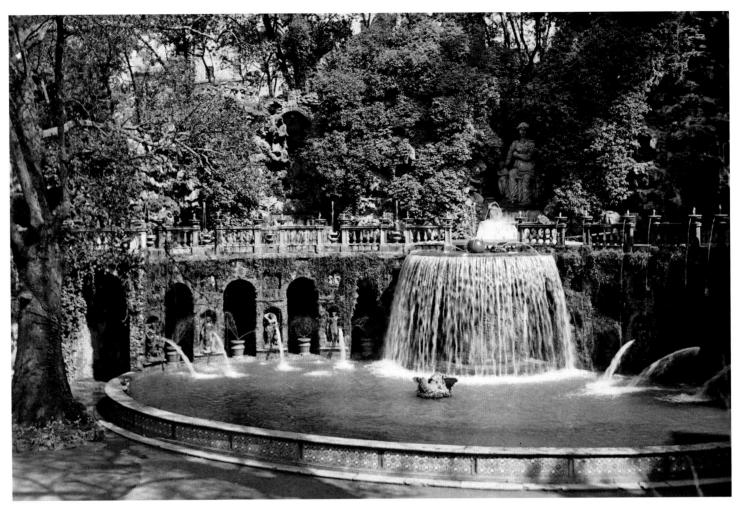

Fig. 3. Tivoli, Villa d'Este, Oval Fountain (photo: ICCD, Rome, F 3800)

was political and points out that Pope Innocent VIII had temporarily engineered a pact among these six cities, in late 1486 and 1487, at the time when these frescoes were presumably executed.[20]

About 1518 Baldassare Peruzzi decorated the walls of the Sala delle Prospettive in the Villa Farnesina at Rome, which he designed for Agostino Chigi, with illusionistic views of the city of Rome. In one slight glimpse between two painted columns is seen the Porta Settimiana of the Trastevere, beyond which is a sketchy depiction of the southern elevation of the Villa Farnesina itself.[21] The cityscapes painted on the walls of the Sala delle Prospettive are, needless to say, used to paint away the walls illusionistically and to suggest that this upper room of the Villa Farnesina is an open loggia looking out into the city of Rome. To see suddenly, as if in the distance before you, the very building in which one stood, must have amused the sixteenth-century guest, and this is presumably the reason

for the introduction of a representation of the villa on its own walls.

Soon after the decoration of the Farnesina, Polidoro da Caravaggio introduced in a similar fashion, but more prominently, a view of the Villa Lante on the Janiculum at Rome in the decoration of the salone of that villa. The sixteenth-century villa is depicted in the background of the scene of the discovery of the sarcophagi of Numa Pompilius.[22] As the sarcophagi were reputed to have been found on the Janiculum, the appearance of the Villa Lante is appropriate as a geographical symbol connecting the scene of antiquity and the Renaissance villa.

By the mid-sixteenth century the general scheme for such decoration in a villa is to cover the walls of at least one room with landscape views of the land possessions of the owner of the villa. It is as if the pages of the *Très riches heures* of the Duke de Berry were a model, and the fact that Vasari speaks of the Belvedere landscapes as "alla maniera de'

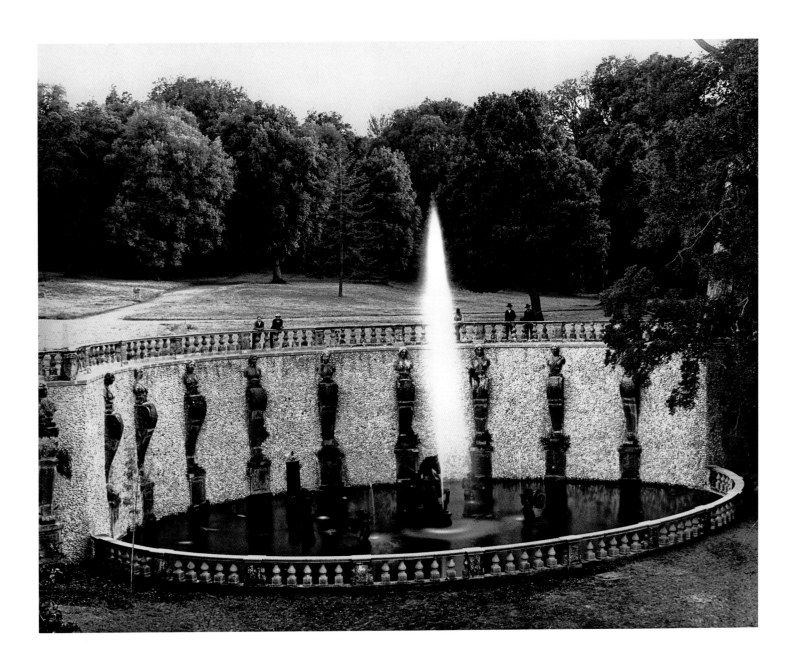

Fig. 4. Bagnaia, Villa Lante, Fountain of Pegasus (photo: ICCD, Rome, C 2698)

Fiamminghi" suggests that there may be some distant connection. In the Casino of Pius IV in the Vatican, Santi di Tito designed the vault of the staircase with four frescoes illustrating the Parable of the Vineyard, and in the background of each fresco is depicted a building constructed by Pope Pius IV, such as the Porta del Popolo, the Nicchione of the Belvedere Court, and the Casino of Pius IV itself.[23] Soon thereafter the walls of the Salotto of the Villa d'Este at Tivoli were frescoed with views of the possessions of the cardinal of Ferrara, including the Villa d'Este and his Villa of Monte Cavallo, and the Sala dell'Ercole of the Palazzo Farnese at Caprarola featured topographical views of Farnese holdings.[24] It is, therefore, unusual to find in the decoration of

the Cardinal Gambara's loggia at Bagnaia views of the two great contemporary villas at Caprarola and Tivoli, which were not owned by the Cardinal Gambara but by his two more eminent colleagues. As the Latin quatrains above the landscape frescoes suggest, the Villa Lante was built as a modest emulation of the other two villas, and this emulation can be seen in several features of the villa at Bagnaia.

The quantity of water used in fountains and waterworks in the Villa d'Este at Tivoli amazed sixteenth-century Italy and undoubtedly influenced the Villa Lante,

but in the latter there is a greater control and refinement of the use of water. It is particularly the great Oval Fountain or Fountain of Tivoli (Fig. 3) at the Villa d'Este which inspired the *fontanieri* at Bagnaia. Montaigne, in fact, notes, that the chief *fontaniere* at Bagnaia, Tommaso da Siena, had previously worked on the waterworks of Tivoli.[25] The oval shape of the Fountain of Pegasus at Bagnaia (Fig. 4) is derived from the Oval Fountain of Tivoli, but the winged horse Pegasus has been brought down from the artificial mountain above the Tiburtine fountain and stands now in the center of the basin at Bagnaia. In place of Pirro Ligorio's water nymphs at Tivoli standing in the niches of the arcade at the rear of the oval fountain, there are at Bagnaia the busts of nine maidens spitting water into the basin. These maidens are obviously the nine Muses of Mount Parnassus or Mount Helicon, where according to Greek legend a fountain spurted forth from the hoof marks of the winged Pegasus as he sprang from the mountain.

The so-called Fountain of the Giants at Bagnaia is likewise derived from the Oval Fountain at Tivoli (Fig. 3). The central cascade of the fountain of the Villa d'Este, which symbolizes the great natural cascade of the Anio at Tivoli, is broken into three smaller, successive cascades at Bagnaia issuing from between the claws of a lobster, which is the device of the Cardinal Gambara. Flanking the cascades are two statues of river gods bearing cornucopias, very like the figures of the river gods of the Anio and the Erculaneo perched above the cascade in the artificial mountain of Tivoli in the Villa d'Este.

The uppermost Fountain of the Dolphins at Bagnaia is connected to the lower Fountain of the Giants by a gently sloping, stepped ramp (*cordonata*), down the center of which gurgles a stream of water, the *catena d'acqua*, whose serpentine border and stepped bed create the variety of flow and noise of the water. This *catena d'acqua* may be inspired by the water stairs, the *scale dei bollori*, created at the Villa d'Este commencing 1567.[26] At Tivoli the water plunges down the stepped balustrades on each side of the *cordonata*, forming small jets or "flowers" of bubbling water on each step. In turn, as has been often noted before, the *catena d'acqua* at Bagnaia certainly was the model for the *catena d'acqua* that leads between rustic grottoes up to the later casino at Caprarola.[27]

The interrelationships among these three summer residences at Caprarola, Tivoli, and Bagnaia are, therefore, rather complex. Even the pictorial decoration of the buildings suggests mutual influences. For example, in all three decorative programs the figure and deeds of Hercules are depicted with, in each case, references to the personality of the cardinalate owners of these pleasure palaces. In general, the influence seems to start first with the decorative, pictorial program at Caprarola, which passed on to Tivoli. Tivoli's contribution was in terms of the great gardens and fountains. Bagnaia then blends elements from both Caprarola and Tivoli, although there is a return of influence from Bagnaia in the later additions at Caprarola. In any case, however, these shared influences mean little in comparison with the ingenuity by which their creators have evoked in each layout an artistic individuality.

Of all three, the Villa Lante at Bagnaia is perhaps the jewel in its controlled perfection and the synthesis of architecture and garden. In the progression of this development, architecture gradually gives way to the gardens and waterworks, with a culmination in Vignola's Farnese gardens on the Palatine in Rome, where only grottoes, pavilions, and aviaries remain of an architectural nature. There can be no question that the conception of the Villa Lante at Bagnaia was Vignola's, and the *minuta* in the Archivio di Stato at Parma, which indicates Vignola's contact with the Cardinal Gambara in September 1568, only confirms this.

Notes

1. C. Percier and P. Fontaine, *Choix des plus célèbres maisons de plaisance de Rome et de ses environs* (Paris, 1809).

2. A. Cantoni et al., *La Villa Lante di Bagnaia* (Milan, 1961), 43.

3. M. Walcher Casotti, *Il Vignola* (n.p., 1960), vol. 1, 239.

4. H. Hibbard, review of C. L. Franck, *Die Barockvillen in Frascati*, in *Art Bulletin* 40 (1958), 356.

5. G. Baglione, *Le vite de' pittori, scultori et architetti* (Rome, 1642), 314.

6. Parma, Archivio di Stato, Carteggio Farnesiano, Estero, Caprarola, busta 116.

7. J. Barozzi da Vignola, *Le due regole della prospettiva pratica* (Rome, 1583).

8. See W. Smith, "Pratolino," *Journal of the Society of Architectural Historians* 20 (1961), 155–168. Pratolino is absolutely contemporary with Bagnaia, since the Grand Duke of Tuscany bought the land for Pratolino in September 1568.

9. M. de Montaigne, *Journal du voyage* (Città di Castello, 1895), 527–528; and V. Scamozzi, *Dell'idea della architettura universale* (Venice, 1615), 343 and 344.

10. Cantoni et al., *Villa Lante* (note 2 above), figs. 1, 8, 9, 81, and dust-cover.

11. Ibid., 114.

12. D. R. Coffin, *The Villa d'Este at Tivoli* (Princeton, 1960), 15, note and fig. 1.

13. W. Lotz, "Vignola-Zeichnungen," *Jahrbuch der Preuszischen Kunstsammlungen* 59 (1938), 104; and W. Lotz, *Vignola-Studien* (Würzburg, 1939), 53–57.

14. Walcher Casotti, *Il Vignola* (note 3 above), vol. 1, 160 and 192–193.

15. For example, the Villamena plan and section and the anonymous plan in the Archivio di Stato, Parma (no. 22), all illustrated in ibid., vol. 1, frontispiece, and vol. 2, figs. 142 and 150.

16. Lotz's suggestion (*Vignola-Studien* [note 13 above], 55) that Montaigne's description of a "laghetto" outside of the palace may refer to Vignola's fishpool of 1568 as still extant in 1581 seems unlikely. It is more probable that Montaigne's grotto and pool was one of those in the secret gardens, such as the so-called Fontana di Tartari in the rear wall of the western secret garden.

17. G. Vasari, *Le vite de' più eccellenti pittori, scultori ed architettori*, ed. G. Milanesi, vol. 3 (Florence, 1878), 498.

18. B. Nogara and F. Magi, "Restauri alle pitture della Galleria delle Statue," *Rendiconti della Pontificia Accademia Romana di Archeologia* 23–24 (1947–49), 363–369; S. Sandström, "The Programme for the Decoration of the Belvedere of Innocent VIII," *Konsthistorisk Tidskrift* 29 (1960), 35–75; and J. Schulz, "Pinturicchio and the Revival of Antiquity," *Journal of the Warburg and Courtauld Institutes* 25 (1962), 35–55.

19. J. S. Ackerman, *The Cortile del Belvedere*, Studi e documenti per la storia del Palazzo Apostolico Vaticano 3 (Vatican City, 1954), 6 n. 2, and 7 n. 3.

20. Sandström, "Programme for the Decoration of the Belvedere" (note 18 above), 39.

21. C. L. Frommel, *Die Farnesina und Peruzzis architektonisches Frühwerk*, Neue Münchner Beiträge zur Kunstgeschichte 1 (Berlin, 1961), pl. VIe.

22. J. P. Richter, *La collezione Hertz e gli affreschi di Giulio Romano nel Palazzo Zuccari*, Römische Forschungen der Bibliotheca Hertziana 5 (n.p., 1928), 8–9, pl. VII, attributed to Giulio Romano; and A. Prandi, *Villa Lante al Gianicolo* (Rome, 1954), 15–16, Fig. 8.

23. W. F. Friedländer, *Das Kasino Pius des Vierten*, Kunstgeschichtliche Forschungen hrsg. vom Königlich Preussischen Historischen Institut in Rom 3 (Leipzig, 1912), pls. XXXII and XXXIII; and G. Arnolds, *Santi di Tito: pittore di Sansepolcro* (Arezzo, 1934), 17–19. Although not in a villa, Pius IV had decorated the walls of the Sala dei Pontefici in the Vatican Palace in a similar fashion, with landscape views of his building activities, including Michelangelo's design of St. Peter's, the Porta Pia, the Palazzo di Venezia, and the Castel Sant'Angelo, but these landscapes were in ruined condition even in the eighteenth century and are now covered up; see F. Ehrle and E. Stevenson, *Gli affreschi del Pinturicchio nell'appartamento Borgia* (Rome, 1897), 59–61.

24. Coffin, *Villa d'Este* (note 12 above), 52–54.

25. M. de Montaigne, *Journal du voyage* (note 9 above), 527.

26. Coffin, *Villa d'Este* (note 12 above), 21.

27. As M. Gothein notes (*A History of Garden Art* [London and Toronto, 1928], vol. 1, 278), the land on which this casino was erected was not owned by the Farnese until July 1587, thus indicating the priority of the *catena d'acqua* at Bagnaia.

10

The "Lex Hortorum" and Access to Gardens
of Latium During the Renaissance

On 12 May 1885, Prince Marcantonio Borghese ordered the gates of the park of his villa at Rome to be closed to the public, who had been accustomed to ride or walk freely in the grounds.[1] Rumors had already begun to circulate in Rome that Borghese was planning to sell about two-thirds of his estate for some eight million *lire* (twenty million according to other reports) to building speculators, retaining only the casino and its immediate gardens for his own use. With the establishment of Rome as the capital of the new Kingdom of Italy in 1871, the city was undergoing rapid expansion, endangering the undeveloped portions of the city. Earlier in 1885, on 6 April, the Prince of Piombino had sold the huge Ludovisi villa-park on the Pincian hill, just within the city walls outside of which lay the Borghese park; and the Ludovisi gardens were being transformed into the urban development now centered around the Via Veneto. So on 8 May 1885, Duke Leopoldo Torlonia, mayor of Rome, heeding the rumors regarding the Borghese holdings, wrote to Borghese that before he should alienate any of his property, Torlonia would like to discuss it with him on behalf of the commune of Rome, adding "independent of eventual rights that the municipality might itself point out." The latter phrase alarmed Borghese, who in his reply of 11 May announced his decision to close the park to the public, thus ensuring his legal ownership of the estate.

On 26 June the city, having appealed to the courts, won the right of public access to the property for four afternoons a week, as was the previous custom, and Prince Borghese was fined court costs. The appeal of the prince to a superior court was disallowed in February 1887 with confirmation of the previous decision. Finally, the controversy was resolved in 1901 when the state purchased the park and the casino with its works of art for 3,600,000 *lire*, and presented them in 1903 to the city of Rome as a public park and museum.

The previous decisions of the courts had been very difficult, since it was acknowledged that the Borghese family legally owned the property, but that the Roman public had right of access for public *passeggiata*. The Roman legal code provided no laws or decisions exactly relevant, but the courts could cite a few analogous examples, such as access to fountains provided for public use on private property. Also, in forming the decision, the courts took into account that some of the land had belonged to the Camera Apostolica before Pope Paul V gave it to his nephew, Cardinal Scipione Borghese, that the cardinal had been provided with water from the public aqueducts, that an old public road had been incorporated within the grounds of the villa, that some of the ancient statues used to decorate the villa had come from public locations, and that there were numerous records confirming the tradition of public access.

In the evidence cited by the courts and in all discussions on the problem reference was particularly made to a Latin inscription that once stood outside the principal portal or public entrance on the Via Pinciana, opening into the garden area in front of the casino, called the "First Enclosure" (Fig. 1). The text of the inscription, which is now presumably lost, was first printed in Manilli's mid-seventeenth-century guide to the villa:

> I, custodian of the Villa Borghese on the
> Pincio, proclaim the following:
> Whoever you are, if you are free, do not fear
> here the fetters of the law.

Go where you wish, pluck what you wish,
 leave when you wish.
These things are provided more for strangers
 than for the owner.
As in the Golden Age when freedom from the
 cares of time made everything golden, the
 owner refuses to impose iron laws on the
 well-behaved guest.
Let proper pleasure be here as the law to a
 friend, but if anyone with deceit and
 intent should transgress the golden laws
 of hospitality, beware lest the angry
 steward break his token of friendship.[2]

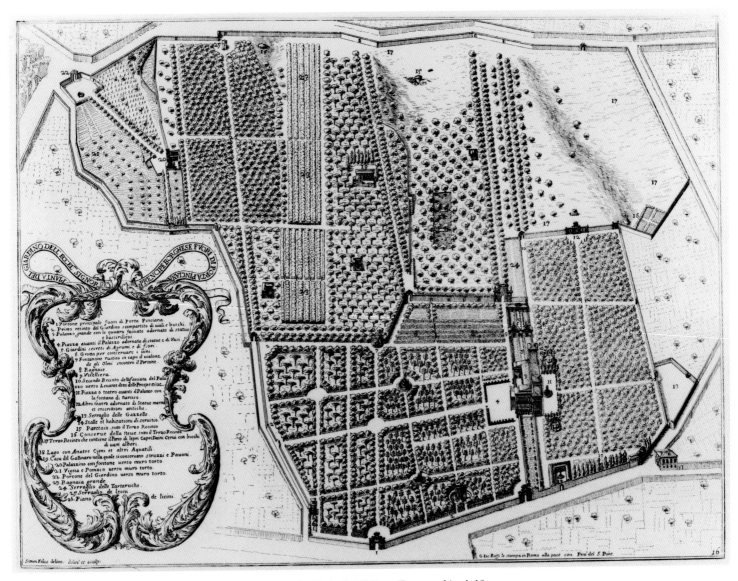

Fig. 1. Rome, Villa Borghese, engraved plan. From G. B. Falda, *Li giardini di Roma* (Rome, n.d.), pl. 16

| *The Lex Hortorum*

The Villa Borghese inscription, which has been suggested as the possible creation of Cardinal Maffeo Barberini, later Pope Urban VIII, who composed for Cardinal Borghese the distichs inscribed on the base of Bernini's group of Apollo and Daphne in the Villa Borghese,[3] still retains the association of a garden with the mythical Golden Age of classical antiquity when men were nourished by nature without labor and were free from turmoil and laws. This association, revived by fifteenth-century poets, had during the sixteenth century even inspired the iconographical planning of gardens, as at the Villa Lante at Bagnaia. At the same time the inscription was one of the finest and latest examples of what has become known as the *Lex Hortorum*, the principle that gardens are created not only for the personal enjoyment of their owners, but to afford pleasure to their friends and even to strangers and the public, diminishing the concept of private property.

Lex Hortorum

Probably the earliest example in Renaissance Rome of the *Lex Hortorum* was an inscription in the grounds of the Vigna Carafa or Vigna di Napoli, the suburban residence of Cardinal Carafa of Naples on the northwest edge of the Quirinal hill, where the present Quirinal Palace of the president of Italy stands. The cardinal's Quirinal villa may date before 1476 and certainly was in existence in 1483, when the cardinal of Aragon spent the night there.[4] The first mention of inscriptions at the villa is in Albertini's guide to Rome of 1510, where he mentions that the *vigna* and garden were decorated "with many epigrams."[5] The inscriptions in the Vigna Carafa, which presumably date from the late fifteenth century, were only published in 1592 by Schrader, who had made several trips to Italy in the mid-sixteenth century. All the pithy epigrams in Greek and Latin are derived from the classical poets and agricultural writers, including Vergil (*Georgics*, I, 338–339); Pliny the Elder (*N. H.*, XVIII, 8, 43); Cato, Varro, and Columella (all from Pliny, *N. H.*); and Hesiod (*Works and Days*, 354). A longer, contemporary inscription offers Cardinal Carafa's interpretation of the *Lex Hortorum*: "The dutiful Cardinal Oliviero Carafa, illustrious offspring of learned Naples, dedicates this villa of continuous salubrity, set on the suburban Esquiline hill, to all his friends; come, guests."[6] More than a half century later Cardinal Sadoleto, in his dialogue *Il Fedro*, which he locates in the *vigna* of Jacopo Gallo set in the Prati of Rome outside the walls of

the Castel Sant'Angelo, conveys the same sentiment: "During the floral holidays, early in the morning, I took myself to the gardens which Gallo had created for himself and for his learned friends in a field of fennel near the Hadrianic tomb."[7]

As the Roman gardens in the late fifteenth and sixteenth centuries began to amass large collections of ancient sculpture and inscriptions as their particular decorative feature, the concept of the *Lex Hortorum* began to spread, since the owners took pride in showing their treasures as evidence of their cultural heritage. Cardinal Giuliano Cesarini, at the turn of the century, possessed such a collection in the garden behind his palace on the old Via Papale in Rome. An inscription on the statuary garden house (*diaeta statuaria*) read:

> Giuliano Cesarini, Cardinal Deacon of Sant'Angelo, has dedicated this statuary garden house to his own studies and to the decorous pleasure of his countrymen on his thirty-fourth birthday, the thirteenth Kalends of June of the eighth year of Pope Alexander VI, the year 1500, and the 2,233rd year of the founding of Rome.[8]

Somewhat later, the several Cesi cardinals assembled in the garden of their palace in the Borgo near St. Peter's a large collection of Roman antiquities. Although the first collection was formed in the early 1520s, it was sold and then replaced by another collection during the fourth and fifth decades of the century. A garden portal, probably dating from the period of the later collection, bore the inscription: "The Garden of the Cesi and of Their Friends," as recorded in a drawing attributed to Ammannati.[9] Still later, the French Cardinal Jean du Bellay, who had a modest collection of antiquities in the lovely garden he arranged in part of the ruins of the Baths of Diocletian, had the entrance portal inscribed on the exterior with the name of the garden, *Horti Bellaiani*, and on the interior face of the portal a similar dedicatory inscription: "Jean, Cardinal Bishop of Ostia, founded [these gardens] for himself and his friends, 1555."[10]

The fullest exposition of the *Lex Hortorum* was in the garden statue court of Cardinal Andrea della Valle, designed by Lorenzetto probably in the 1520s as a "hanging garden" above the stables at the cardinal's palace in the center of Rome. The visual appearance of the garden is preserved in Cock's engraving of 1553, probably after a drawing by Heemskerck made during his Roman trip in

Fig. 2. Rome, Della Valle garden statue court. From Francisco d'Ollanda sketchbook, Escorial Library (after E. Tormo, ed., *Os desenhos das antigualhas que vio Francisco d'Ollanda, pintor portugués* [Madrid, 1940], fig. 54)

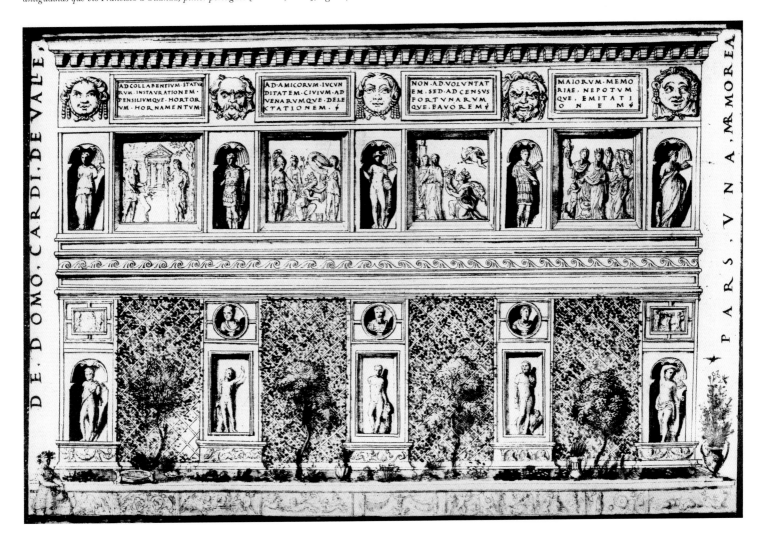

1532–1535, and in a drawing in Francisco d'Ollanda's manuscript in the Escurial of 1537 or 1538 (Fig. 2). The court, created as a setting for the cardinal's collection of ancient sculpture, has the sculpture set into the walls or in niches. Low garden beds along the walls were planted with small trees and flowers, and vines and fruit trees were espaliered against the walls. At the top level of each of the long side walls were five large antique masks alternating with four modern inscriptions in which the cardinal defined the purposes of his sculpture court:

Right Wall

 I. For the restoration of damaged statues and the decoration of the hanging gardens.

 II. For the enjoyment of friends and for the delight of citizens and strangers.

 III. Not for pleasure, but for the sake of the people and their prosperity.

 IV. For the enjoyment of life as a retreat of taste and beauty.

Left Wall

 V. For his own enjoyment and the pleasure of posterity.

 VI. For a garden of antiquities as an aid to painters and poets.

 VII. For the enjoyment of proper leisure and for the convenience of the house.

 VIII. In memory of our ancestors and for the emulation of their descendants.[11]

It was Cardinal della Valle, therefore, who expanded the concept of the *Lex Hortorum* to include not only his friends, but all Romans and visitors, as well as specifically noting the contribution of the garden collection to artists. Unfortunately the Della Valle sculpture court, later owned

| *The Lex Hortorum*

by his nephew Camillo Capranica, was dismantled toward the end of the sixteenth century, and its ancient sculpture, sold to Cardinal Ferdinando de' Medici, was used to decorate the Villa Medici at Rome.

The Villa Giulia, built from 1551 to 1555 for Pope Julius III off the Via Flaminia just north of the Porta del Popolo, still preserves in situ the inscription of its *Lex Hortorum*. The casino of the villa is set in a valley south of the Parioli hills and was originally surrounded by the extensive land holding which comprised the *vigna* (Fig. 3). On the Via Flaminia, at the corner of the new street which led into the casino, was a public fountain set in the wall enclosing the estate, and just north of the fountain on the Via Flaminia was a garden portal opening onto a path or alley proceeding to the casino. Within the *vigna* numerous paths offered access to shaded woods and the secondary buildings of the complex, including the older Villa Poggio above in the Parioli hills. The main casino was designed with a horizontal axis running from its entrance portal through the theater court behind the casino to a sunken nymphaeum or fountain court. On the interior side walls of the nymphaeum are two large inscribed plaques. The plaque on the left or north wall describes the history and ownership of the villa, forbidding alienation of the property by the pope's heirs. The opposite plaque on the south wall (Fig. 4) preserved a very lovely, extended version of the *Lex Hortorum*, noting that the garden is for seemly pleasure and establishing the laws by which it is to be enjoyed.[12] Like the *Lex Hortorum* of the Villa Borghese, it permits visitors to walk freely or rest where they wish as long as they harm nothing. It then elaborates on the pleasures of the garden—the spurts of the Acqua Vergine, the playfulness of the fish and the song of the birds, the statuary and painting.

In 1576 Cardinal Ferdinando de' Medici purchased Cardinal Ricci's villa on the Pincian hill and soon began to expand and revise his new possession, including work on the gardens behind the villa. A long, straight alley was laid down from the gardens out to the Via di Porta Pinciana, where the architect Ammannati designed an impressive, rusticated gateway (Fig. 5) to permit public entrance to the gardens without disturbing the residents of the villa. Two Latin inscriptions carved on plaques above the side niches of the public gate to the Villa Medici welcomed visitors:

> On entering, guest, into these gardens planted, as you see, on the summit of the Hill of Gardens, may it ever please you to praise them; you should

know that they are open to the master and all the master's friends.

> Having entered, guest, these gardens that Ferdinando de' Medici created at great expense, may it satisfy you seeing and enjoying them; may you wish nothing more.[13]

The Villa Mattei on the Caelian hill behind Santa Maria in Domnica had a long history of public enjoyment and is now fittingly a public park like that of the Villa Borghese. Purchased in 1553 by Giacomo Mattei, it was his son-in-law, Ciriaco Mattei, who began to transform it into a magnificent villa-park with richly decorated gardens. Given an ancient obelisk, which once stood on the Capitoline hill, Mattei erected the obelisk in the *prato* before the casino with an inscription, dated 1582, recording the gift of the "Roman people" as a monument to public good will. Four years later he inscribed on the main gate to the villa the following: "Ciriaco Mattei dedicated in 1586 to his enjoyment and that of his friends the Caelian gardens, given by Giacomo Mattei, his father-in-law, to him and his descendants, developed more magnificently with many decorations."[14] In his will, dated 26 July 1610, Mattei claimed that the "garden has been of great recreation and entertainment to me and of enjoyment of *virtuosi* and men of reputations, the house being seen often and being visited daily not only by persons of note and people of Rome but by foreigners."[15]

Public Access to Gardens

Unlike many of the other examples of the *Lex Hortorum*, which were inscribed on the public portal of the gardens, the location of the inscription at the Villa Giulia addressed to the general visitor but set within the innermost and seemingly most private area of the *vigna*, would suggest that either the concept of the *Lex Hortorum* was hypocritical or that there was a broadly observed tradition of free access to the gardens by most of the public. This was also true at Cardinal della Valle's statue court, which was set within the palace at an upper level over the stables.[16] The wealth of sixteenth-century artists' sketchbooks and drawings depicting antique sculpture in Roman gardens suggests the freedom of access offered them and confirms the intent of the Della Valle inscription that his garden was to be an aid to artists.[17]

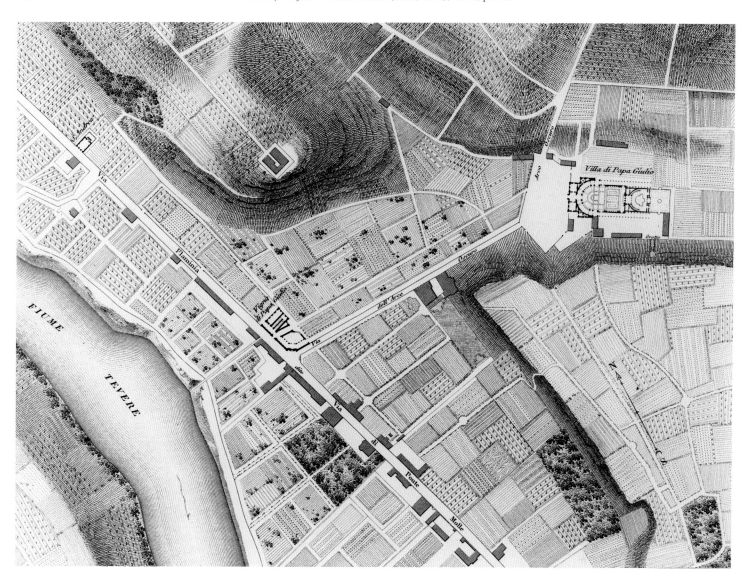

Understandably, it is foreign visitors who remark on the accessibility of the Roman gardens. So in March 1554, the German monk Matthäus Rot records in his account of his Roman trip visiting the Villa Giulia, when "Balduino del Monte, brother of the Pontifex, was driven to the *vigna* in a carriage and carried to the fountain in a litter; I was admitted with him so that I could contemplate perfectly the fountain from every part."[18] This custom of free access, however, is most clearly expressed by the Frenchman Michel de Montaigne:

> Among the most beautiful vineyards are those of the Cardinal d'Este at Monte Cavallo, Farnese on the Palatine, Orsini, Sforza, Medici; that of Pope Julius, that of Madama, the gardens of Farnese and of Cardinal Riario at Trastevere, and of Cesio

outside the Porta del Popolo. These are beauties open to anyone who wants to enjoy them, and for whatever purpose, even to sleep there, even in company if the masters are not there, and they do not like to go there much.[19]

One cannot, of course, interpret this right of access in a modern, democratic context. The Latin language of the inscriptions alone indicates the limitation of this concept. Undoubtedly the outcasts of sixteenth-century Roman society, such as the beggars or the Jews, might not be accorded that privilege, as an incident at the Villa Medici reported in an *avviso* of April 1581 notes:

> This week some Jews, having gone to see the Garden of the Cardinal de' Medici under the Trinità,

The Lex Hortorum

DEO·ET·LOCI·DOMINIS
VOLENTIBVS

HOC IN SVBVRBANO·OMNIVM·SI NON QVOT IN ORBIS·AT
QVOT IN VRBIS SVNT AMBITV·PVLCHERRIMO·AD HONE
STAM POTISSIME VOLVPTATEM FACTO·HONESTE VOLVPTV
ARIER·CVNCTIS FAS HONESTIS ESTO·SET NE FORTE QVIS
GRATIS INGRATVS SIET·IVSSA HAECCE·ANTE OMNIA·OMNES
CAPESSVNTO
QVOVIS QVISQ·AMBVLANTO·VBIVIS QVIESCVNTO·VERVM
HOC CITRA SOMNVM·CIRCVM SEPTA ILLVD
PASSIM QVIDLIBET LVSTRANTO·AST NEC HILVM QVIDEM
VSQVAM ATTINGVNTO
QVI SECVS FAXINT·QVIDQVAMVE CLEPSERINT·AVT RAPSE
RINT·NON IAM VT HONESTI MORIBVS·SED VT FVRTIS O
NVSTI·IN CRVCEM PESSVMAM ARCENTOR
OLLIS VERO QVI FLORVM·FRONDIVM·POMORVM·OLERVM
ALIQVID PETIERINT·VILLICI·PRO ANNI TEMPORE·PRO RE
RVM COPIA ET INOPIA·PROQ·MERITO CVIVSQVE·LARGI
VNTOR
AQVAM·HANC·QVOD VIRGO EST·NE TEMERANTO·SITIMQ
FISTVLIS·NON FLVMINE·POCVLIS·NON OSCVLO·AVT VO
LIS·EXTINGVVNTO
PISCIVM LVSV OBLECTANTOR·CANTV AVIVM MVLCENTOR
AT NE QVEM INTERTVRBENT INTERIM·CAVENTO
SIGNA·STATVAS LAPIDES·PICTVRAS·ET CAETERA TOTIVS
OPERIS MIRACVLA·QVAMDIV LVBET·OBTVENTOR·DVM
NE NIMIO STVPORE IN EA VORTANTVR
SICVI QVID·TAMEN HAVD ITA MIRVM VIDEBITVR·EORVM
CAVSSA·QVAE NEMO MIRARI SAT QVIVIT·AEQVO POTIVS
SILENTIO·QVAM SERMONIBVS INIQVIS·PRAETERITO
DEHINC·PROXVMO IN TEMPLO·DEO·AC DIVO ANDREAE
GRATIAS AGVNTO·VITAMQ ET SALVTEM IVLIO III·PONT
MAX·BALDVINO EIVS FRATRI·ET EORVM FAMILIAE VNI
VERSAE·PLVRIMAM ET AEVITERNAM PRECANTOR
HVIC AVTEM SVBVRBANO·SPECIEM ATQ·AMPLITVDINEM
PVLCHRIOREM·INDIES MAIOREMQ·AC IN EO QVIDQVID
INEST·FELIX·FAVSTVM·PERPETVVM OPTANTO
HISCE ACTIS VALENTO·ET
SALVI ABEVNTO

the day being last Saturday, were against their will put to work with a wheelbarrow moving earth and then given a good meal as recompense.[20]

Nevertheless, the *avviso* does indicate the ease of access into these gardens.

Elsewhere in Europe the accessibility of the public to private gardens, even to royal gardens and parks, was very uncertain. The gardens of the Tuileries in Paris were generally open to anyone provided he was "properly clothed," as the Italian Locatelli noted during his visit to Paris in 1664–1665, adding that it was easy to meet female company there.[21] This freedom was threatened, however, after Le Nôtre had completed replanting the Tuileries about 1680. At that time Colbert, the finance minister, asked Perrault, as he recounts in his *Memoires*, to go with

him to the Tuileries to close the gates there in order "to preserve this garden for the King and not to allow it to be ruined by the people."[22] As they stood in the wide, central alley of the garden, Perrault pleaded that "it will be a public misfortune no longer to be able to come here to promenade, especially as now one can no longer enter the Luxembourg [gardens] nor the Hôtel de Guise." It was only after the gardeners of the Tuileries, called into the discussion, had assured Colbert that the public did no damage, being "content to walk there and to look at the garden," that Colbert agreed to keep the Tuileries open.

In the late eighteenth century, when the gardens and park of Versailles had to be replanted, the officials complained of the negligence of the Swiss guards in controlling access so that "nurses and, above all, that mob of base footmen and scullions of which Versailles is so filled,

Fig. 5. Rome, Villa Medici, gateway (photo: author)

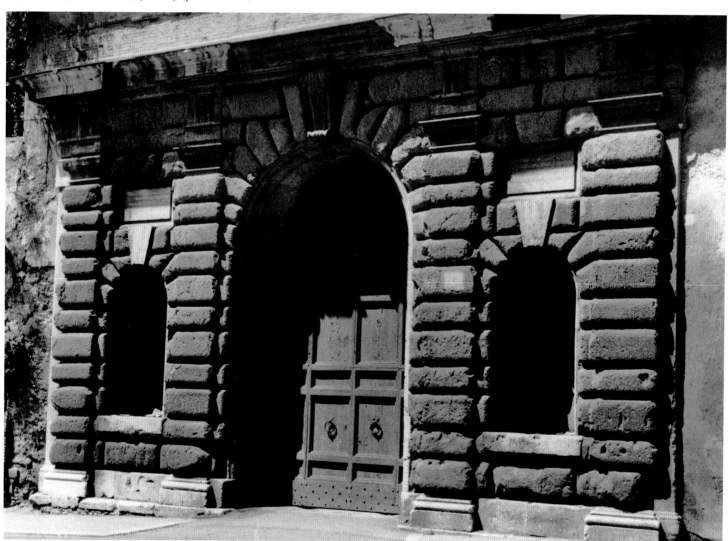

| *The Lex Hortorum*

inundate the gardens: all the children of commoners come there to play their games."[23] So, apparently in 1776, a special guard of twelve fusiliers with sergeant and corporal was re-established to curb public access. Some other Parisian private gardens, such as those of the Palais Royal, were freely open to the public, while others, including the "Disneyland of the Duc de Chartres," Parc Monceau, were accessible by tickets of admission.[24]

In England the royal parks and gardens in or near London were generally open to the public since at least the reign of James I, and the Revolution Settlement of 1689 and the Civil List Act during Queen Anne's first year limited the royal authority, preventing any alienation of the lands whose revenues were to be applied to the costs of the Civil List, thus ensuring their preservation as "public" lands.[25] This English tradition of public access to crown lands must have puzzled and disturbed the early Hanoverian rulers of England, if the remarks attributed by Horace Walpole much later to George I have any semblance of reality:

This is a strange Country! said his majesty: the first morning after my arrival at St. James's, I looked out the window, & saw a park with walks, a canal &c, which they told me were mine. The next day Lord Chetwynd, the Ranger of *my* park, sent me a fine brace of carp out of *my* Canal; & I was told I must give five guineas to Lord Chetwynds servant for bringing me *my own* carp out of *my own* canal in *my own* Park![26]

Queen Caroline, wife of George II, actually threatened the English tradition when she proposed closing to the public the gardens of Kensington Palace after their alteration and improvement by Bridgeman in the 1730s. The public outcry was only curtailed when the restriction was limited to the periods of royal residence at Kensington. At the same time it was announced in the *Universal Spectator* for 11 September 1736:

Her Majesty has been pleased to order the royal gardens at Richmond to be free to all in the same manner as those at Kensington are when the Royal Family does not reside there, so that the walks are full of company every evening to the great advantage of the town and the neighbourhood.[27]

Control over access to the royal gardens at Richmond was preserved, however, by the issuance of keys to those in favor at the court, thus adding a political aspect to the right of public access. So in 1747 Lord Lyttelton wrote to the poet Thomson:

I entirely agree with you that you have the same natural right as the Nightingales have to the Garden of Richmond, but as those iniquitous gardeners will dispute it, and might overcomes right, I doubt you will not be able to keep the key, nor can I refuse to give it up if demanded, therefore I have disposed of it to the Dutchess of Bridgwater who will be better able to maintain her possession than either you or I, at this time.[28]

Caroline's daughter, Princess Amelia, caused an even greater uproar than her mother when in 1751, after her appointment as Ranger of Richmond Park, she closed the gates of the park to the public, forbidding not only visitors to the park but public use of the old road which cut across the park as access from the town of Kingston to that of Sheen.[29] Ignoring the several memorials submitted to her by the people, her gatekeeper was finally sued by a local brewer, and in 1758 she was required by the court to provide at least ladder stiles, which would permit the old right of way across the park. Again Horace Walpole, after offering a summary of the princess's difficulty, adds: "Her mother, Queen Caroline, had formerly wished to shut up St. James's Park, and asked Sir Robert Walpole what it would cost her to do it:—he replied, 'Only a *crown,* madam.' "[30]

Much earlier, the Duke of Marlborough had become aware of the danger of issuing keys to his friends for free entry into his new gardens at Blenheim. So in 1706, while he was on the Continent on campaign, the duke took time from his military preparations to write to his clerk of the works:

I doubt not but you have observ'd as well as myself, tho' I forgot to speak of it when I was last at Woodstock, that it will occasion great disorder in the Gardens if people have a liberty of coming in when they please, and upon enquiry I find keys have been given to Severall, which will not only be an Inconvenience at ye present but a Disobligation when you come to ask them again, and therefore to prevent it in time I desire they may be all recalled in a gentle manner, and for the future no more dispos'd of to any body but to those whose business Lyes in the Gardens.[31]

Certainly the eighteenth-century *furor hortensis* in England encouraged the viewing of the "improved" gardens and parks, as evidenced in the numerous tour accounts, commencing with Celia Fiennes's *Through England on a Side Saddle in the Time of William and Mary*. In some cases admission was gained by letters of invitation or tickets specifying a convenient time, but the usual mode of entry, especially for strangers, was by gratuities to the responsible servants. So Arthur Young during his tour of northern England in 1768 noted when he arrived at Wallington, the residence of Sir Walter Blackett: "It will not here be impertinent to add, that Sir *Walter Blackett's* is the only place I have viewed, as a stranger, where no fees were taken,"[32] and Thomas Jefferson listed meticulously in his account book the tips or fees he granted servants at the famous English country houses and gardens during his tour of 1786.[33] In 1725 at the lavish and expensive gardens of the Duke of Chandos at Cannons the gratuities were divided on a *pro rata* basis among the several gardeners, but in 1728, as the duke attempted to control the cost of maintenance, the money received for viewing the gardens was impounded as a fee to be used for the purchase of garden tools.[34]

As the concept of privacy and domesticity increased in England in the early nineteenth century, the ease of access in any manner to gardens lessened. This is reflected in the account by the German Prince Pückler-Muskau of his tour of England of 1826–1828. A passionate "parkomane," as he describes himself, Pückler-Muskau, relying on his position as a foreign prince, was able to view numerous parks and gardens, but interspersed throughout his narrative are references to the "illiberality" of the English in respect to their gardens, most fully exemplified in the story of William Beckford's treatment of a lordly neighbor's visit to Fonthill Abbey. Finally, in July 1828, after describing the walls and towers surrounding a park, he sums up his frustrations by labelling the walls a "symbol of the illiberality of modern Englishmen who shut up their gardens and estates more closely than we do our sitting-rooms."[35]

During the eighteenth and early nineteenth centuries in Rome the freedom of public access seems to continue, although Volkmann in his guide to Italy of 1770–1771, based on his trip of 1757–1758, claims that only the Villa Medici was freely open and then "only to people of the middle class," while a gratuity of a couple of "Groschen" to the porter was required at other gardens.[36] Lady Miller, however, claims in 1771 that at the Corsini gardens "The public are allowed to walk in these gardens; a very great convenience, and an instance, amongst others, of the Italian

hospitality." Similarly, she notes the freedom of access to the Borghese gardens, although limited to twice a week, where the English play cricket and football watched by the Roman ladies with "their fine *Abbatis*."[37]

In the early nineteenth century James Forsyth observes the continuation of the tradition by noting when he arrived at the Villa Ludovisi, which never exhibited a welcoming inscription nor had a public gateway:

> This is the only place in Rome where a ticket of admission is required at the gates: not that Prince Piombino reserves the sacred retreat for himself; but his porters and gardeners take advantage of his absence and his order, and are only the more exacting from those strangers whom they admit without his leave.[38]

At the Villa Borghese the inscription of the *Lex Hortorum* inspired Forsyth to an amusing panegyric:

> A few cardinals created all the great villas of Rome. Their riches, their taste, their learning, their leisure, their frugality, all conspired in this single object. While the Eminent founder was squandering thousands on a statue, he would allot but one crown for his own dinner. He had no children, no stud, no dogs, to keep. He built indeed for his own pleasure, or for the admiration of others; but he embellished his country, he promoted the resort of rich foreigners, and he afforded them a high intellectual treat for a few pauls, which never entered his pocket.

In contrast, Forsyth condemns his countrymen for their materialistic egotism:

> How seldom are great fortunes spent so elegantly in England! How many are absorbed in the table, the field, or the turf; expenses which center and end in the rich egotist himself! What English villa is open, like the Borghese, as a common drive to the whole metropolis?[39]

Since the relationship of the public to European private gardens has a confusing and changing history dependent upon local laws and traditions often related to the psychology of the individual owner, it would seem particularly significant that many Roman gardens in the sixteenth

and early seventeenth centuries not only permitted free access to the public, but proclaimed that right in the *Lex Hortorum* inscribed on their walls. This custom of publicly dedicating gardens to the pleasure of friends and even strangers seems to be a local sixteenth-century Roman idea and reflects a change from the earlier attitude toward the villa and its garden.

Early in the fifteenth century the great Italian humanist and architect Leon Battista Alberti, in a little treatise on the villa, asserted: "You will buy the villa to nourish your family, not to give pleasure to others."[40] Alberti's treatise is modeled, therefore, on those of the ancient agricultural writers, the *Res Rusticae Scriptores*, such as Cato and Varro, who extol the agricultural and productive aspect of the country residence during the Roman Republic and are uneasy, as Varro certainly was, about the increasing association of luxury and idle pleasure with the Roman villa. But Alberti's dictum was as in vain as the desires of Varro.

The changes in the purpose of the Roman villa and garden came about toward the end of the fifteenth century, as a result possibly of several factors. Certainly the collecting of Roman antiquities and their exhibition in Roman courts and gardens, commencing in the late fifteenth century, encouraged access to their gardens, as evidenced by the dedicatory inscriptions in the statuary gardens of Cardinal Giuliano Cesarini in 1500 and of Cardinal della Valle. Similarly, the humanists and antiquarians must have been aware of the public nature of some of the ancient Roman gardens. So Julius Caesar bequeathed his garden on the right bank of the Tiber to the Roman people, and Agrippa left the Romans the gardens in the Campus Martius near the baths he created for the people. In fact, it is probable that he built the gardens for the public, but had not completed them before his premature death.[41] To my knowledge, however, none of the contemporary accounts of Renaissance Roman gardens makes reference to this ancient precedent, which is understandable, as the ancient examples were concerned with public ownership and not public access. Whether private gardens of ancient Rome were regularly open to the public is difficult to determine. The gardens of Sallust between the Quirinal and Pincian hills, later owned by the emperors, may have been accessible at least by the fourth century to some of the public. The first of the fourth-century pseudo-Seneca letters to St. Paul claims that Seneca and his friend Lucilius "retired to the gardens of Sallust," where they were presumably joined by several disciples of St. Paul, and an anonymous panegyric of Constantine in

the early fourth century notes the fearful reluctance of Maxentius to visit the gardens.[42] As these seem to be the only ancient references to the accessibility of the gardens of Sallust, they may have inspired the comment of Michele Mercati in the late sixteenth century that the gardens of Sallust were "filled with delights made for the amusement of the Roman people," but it is equally possible that he viewed the ancient gardens from the perspective of a sixteenth-century Roman garden.[43]

A more likely source of the concept of public access to gardens in Rome in the early sixteenth century may be offered by the writings of the Neapolitan humanist and statesman Giovanni Pontano. Two of his treatises written after 1494 and published in 1498 discuss the role of architecture and its furnishings for the image of its owner. In the treatise on Magnificence Pontano praised Cosimo de' Medici for building churches, villas, and libraries and for renewing "the custom of using private money for the public good and for the ornament of his native country."[44] The accompanying treatise on Splendor then differentiates between the two virtues:

> It is not unjustified to relate splendor closely to magnificence, since the former also involves great expense and has money in common with it as its material. Magnificence, however, assumes its name from magnitude and is involved in buildings, public shows, and gifts. Splendor, on the other hand, which is resplendent in domestic ornament, in care of the person, in furnishings, in the disposition of different things, then takes its name from being showy. So as the word magnificence is derived from making large things, then the latter virtue comes from showy things. Moreover, magnificence is more involved in public works and those things of more permanence, while splendor is concerned rather with private things and does not slight more transient or smaller things.[45]

So the last chapter of Pontano's treatise on Splendor is entitled "On gardens and villas,"[46] in which he notes that gardens are for walking in and as settings for banquets. Therefore, they should contain exotic and rare plants, "for the reason for gardens for the thrifty and profit-seeking father of a family should not be the same as for those for a splendid man." In contrast to Alberti's earlier dictum that the villa and its gardens should be a source of nourishment for the family and not for the pleasure of

others, Pontano asserts that the splendid man "should not only feed his family well and sumptuously, but will have to his table many, as they say, fellow citizens and strangers" (*cives peregrinosque*), which is echoed later in the dedicatory inscription of Cardinal della Valle's statuary garden at Rome "for the delight of citizens and foreigners" (*civium et advenarum*).

Obviously Pontano's association of splendor with pleasure gardens and villas is a reaction to the old tradition that a private garden denotes possession of natural resources which can bring material profit and sustenance, as well as pleasure, to its owner. That a garden should be open to friends and strangers as a sign of personal splendor is, therefore, merely an earlier enunciation of Thorsten Veblen's concept of "conspicuous consumption," or the idea that people may be more interested in the status conferred by their possessions than in their utilitarian value. It is understandable that this concept will be realized with the gardens at Rome in the early sixteenth century, where the social leaders and patrons of pleasure gardens were primarily cardinals of the church who lived off church benefices and family wealth—men not concerned with making money, but with promoting an image of power through the splendor of their possessions. As many of these gardens at Rome also contained great collections of antiquities, they also satisfied Pontano's belief that appropriate statues, paintings, and other rich furnishings should decorate the house of a man of splendor because "their appearance is pleasing and lends prestige to the owner, as long as many people frequent those houses so that they may see the objects."[47]

It may not be coincidental, then, that perhaps the first villa complex in Rome to exhibit an inscription dedicating the garden to the enjoyment of the friends of the owner was that created during the late fifteenth century for Oliviero Carafa, cardinal of Naples, on the Quirinal hill. Born of one of the oldest and most powerful Neapolitan families, Carafa was not only a dominant figure in the papal court, but played a leading role in Neapolitan affairs, being a particular favorite of King Ferdinando, who engineered his cardinalate in 1467. As an important patron of art and architecture in both Rome and his native city, Carafa was a living embodiment of those qualities exemplified in Pontano's image of a man of magnificence. Giovanni Pontano himself was not only one of the great fifteenth-century humanists and director of the Academy at Naples, but in the earlier fifteenth-century tradition of civic humanism served as one of the chief ministers of the

Neapolitan court and was entrusted with some of the most delicate embassies of the period, including several to the papal court at Rome. It is possible, then, that Pontano's concept of splendor may have induced the cardinal to display in his garden at Rome the dedicatory inscription to his friends. In fact, in 1498, when Pontano's treatises appeared at Naples, Cardinal Carafa made a triumphal visit to his native city, but unfortunately the exact date of the inscription in the cardinal's garden cannot be determined other than before Albertini's guide of 1510.[48]

Outside of Rome, the only garden of the early sixteenth century known to me with an inscribed *Lex Hortorum* was at Naples.[49] In the early sixteenth century Colantonio Caracciolo, Marquis of Vico, created outside the eastern walls of the city a lavish suburban villa called the Garden of Paradise, and displayed on the portal of its palace a Latin inscription dated 1543 which dedicated the house and gardens with its fountains and woods "to the pleasure of life and to the withdrawal and perpetual enjoyment of his friends."[50] Caracciolo's inscription may, of course, be inspired by the Roman gardens, but it would seem just as readily of Neapolitan origin.

Public Garden Portals

The idea that Roman gardens are open to public access will have consequences for garden design; if nothing else, the question of entrance and circulation within the garden. During the Middle Ages and early Renaissance the garden had been basically an enclosed piece of land protected by walls or thorn hedges, the *hortus conclusus* of the Song of Solomon that permeated the religious writings and iconography of the period. So when the Medici country estate at Trebbio was refurbished in the early fifteenth century, a completely walled-in garden stood at one side of the old castle with a single entrance at the corner nearest the residence (Fig. 6). Although the Utens view of the villa dates from the late sixteenth century, enough of the structure of the original garden is still extant, including the entrance pergola supported on early-fifteenth-century brick columns, to confirm the painting as a reasonably accurate depiction of the fifteenth-century garden.[51] The location of the entrance gate indicates that it is a garden meant only for the owner and his family, a private garden or outdoor living-room. The same idea was incorporated into the magnificent new palace in Florence built for Cosimo de' Medici, which had at its rear a garden enclosed by crenelated walls, a truly outdoor living-room meant

primarily for the activities of the family. It has been suggested that the garden of the Medici Palace was a reincarnation of the peristyle garden of an ancient house as "a pleasurable retreat, probably intended for family use in contrast to the public formality of the first courtyard."[52] Similarly, the Piccolomini Palace at Pienza built in the mid-fifteenth century by Pope Pius II had a garden at its rear above the stable set into the hillside on which the palace was erected. The walls enclosing the garden, however, were pierced by great windows offering vistas out of the garden to match the vistas from the loggias lining the rear elevation of the palace over the garden; but because of the topography of the site the windows were set high above the exterior ground plane, thus preserving the privacy of the garden from exterior visual intrusion.

The idea at Pienza of loggias running across the rear of the palace and looking down upon the pope's garden probably derived from the same idea at the medieval papal palace of the Vatican in Rome. Since the late thirteenth century a three-story loggia had covered the eastern facade of the papal palace, later replaced by Bramante's and Raphael's loggias, now forming one side of the Cortile di San Damaso. Presumably the loggias opened onto a small, private garden for the pope, the small garden (*viridarium parvum*) whose crenellated walls were built or repaired a century later, after the neglect induced by the Avignon papacy.[53] By its location near the papal apartments, the garden was obviously intended as the pope's private garden, although some of his activities might open it up occasionally to more public use. So Pope Pius II recounts in his memoirs, the *Commentari*, how in the summer of 1463, while he was receiving ambassadors in the garden, his pet dog fell into the water cistern, but the following day he dined privately in the same garden.[54] Throughout the fifteenth century this garden will be identified in documents as the "private garden" (*hortus secretus* or *giardino segreto*).

When Pope Paul II began in the 1460s to expand his cardinalate palace next to the church of San Marco at Rome into the huge Palazzo Venezia, he too built a completely walled-in *giardino segreto* at the southeast corner of the palace. Unlike the other fifteenth-century gardens of Rome, this one resembled a monastic cloister with a two-story portico surrounding all four sides of the garden. On the exterior there were entrances to the basement stables under the garden, like that at the Piccolomini Palace in Pienza, but the only major access to the garden was a door into the upper portico from the pope's private apartment in the southeast corner of the palace, as it too was designed

to be a private garden for the owner of the palace. So during the fifteenth century, except for the occasional incorporation of pieces of ancient sculpture or inscriptions, the Roman garden was no different from the *hortus conclusus* that prevailed throughout Northern Europe and the rest of Italy in the late Middle Ages and early Renaissance.

Soon the exhibition of ancient sculpture in garden areas at Rome provoked the concept of public access and its control. At the Vatican Palace in the early sixteenth century, Bramante added his famous spiral stairway at the eastern end of the Villa Belvedere as a public access to the new statue-garden court in which Pope Julius II exhibited his collection of antiquities, including the Apollo Belvedere and the Laocoön. This stairwell permitted the public to reach the Statue Court without penetrating the Belvedere Court or the Vatican Palace.

By the second half of the sixteenth century, when the privilege of public access to Roman gardens had become a local tradition, provision for a separate public entrance was often made. In 1564 Cardinal Giovanni Ricci purchased in the name of his nephews the old Crescenzi villa on the Pincian hill, now the Medici Villa, soon rebuilding the old residence and purchasing adjacent land until he controlled most of the summit of the hill.[55] Behind the villa, whose entrance was on the western brow of the hill, Ricci laid out expansive gardens which with his additional purchase of land toward the south would border on the Via di Porta Pinciana, allowing another access to the garden running behind the church of SS. Trinità dei Monti. With the death of the cardinal the villa and its grounds were purchased in 1576 by Cardinal Ferdinando de' Medici, who in turn made extensive changes in the building and garden. An avid collector of Roman antiquities, the Medici cardinal converted his suburban retreat into a museum of statuary, covering the garden facade of the building with the ancient bas reliefs from the dismantlement of the Della Valle statue court, erecting a long sculpture gallery above the stables attached to the south side of his villa, and scattering other pieces and groups of sculpture in niches and pavilions around the garden (Fig. 7). During the first year of work the alley to the Via di Porta Pinciana was straightened, and for the street end

Fig. 6. Trebbio, Villa Medici, Utens painting, ca. 1599 (photo: Alinari/Art Resource, NY)

Fig. 7. Rome, Villa Medici, engraved plan. From G. B. Falda, *Li giardini di Roma* (Rome, n.d.), pl. 8

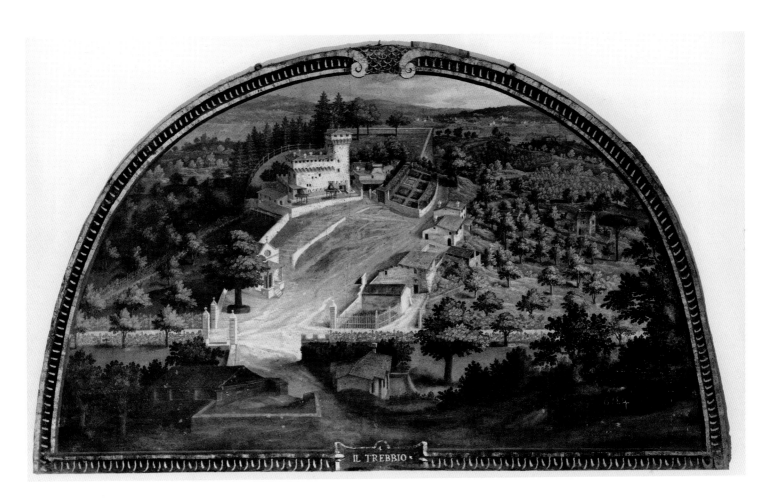

IL TREBBIO

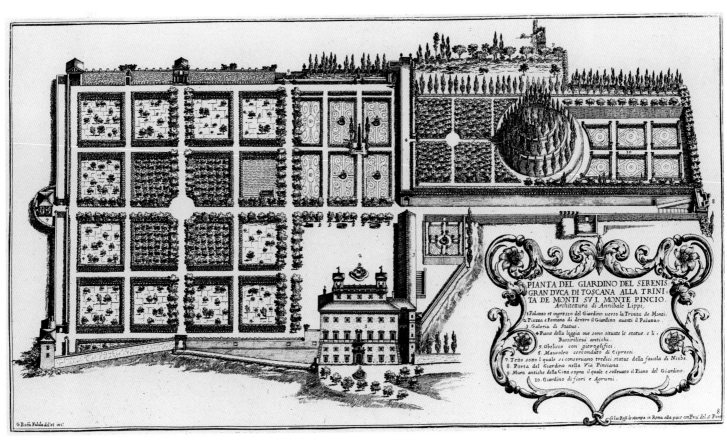

PIANTA DEL GIARDINO DEL SERENIS
GRAN DVCA DI TOSCANA ALLA TRINI
TA DE MONTI SVL MONTE PINCIO.
Architettura di Annibale Lippi.
1 Palazzo et ingresso del Giardino uerso la Trinita de Monti.
2 Piazza e Fontana di dentro il Giardino auanti il Palazzo.
3 Galeria di Statue.
4 Piano della loggia oue sono situate le statue e li
Bassirilieui antichi.
5 Obelisco con gieroglifici.
6 Mausoleo cercondato di Cipressi.
7 Tetto soto l quale si conseruano tredici statue della fauola di Niobe.
8 Porta del Giardino nella Via Pinciana.
9 Mura antiche della Cittá sopra il quale e solleuato il Piano del Giardino.
10 Giardino di fiori e Agrumi.

G.Batta.Falda del et inct. G.Iac.Rossi le stampa in Roma alla pace con Priui del S.Pont.

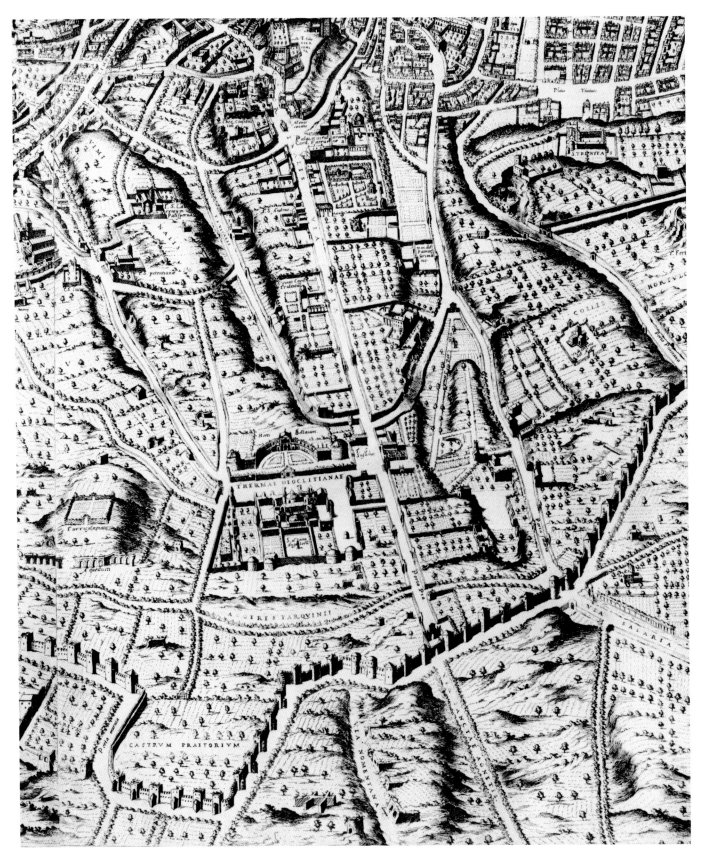

Fig. 8. Rome, area of Quirinal hill, Dupérac map, 1577 (after F. Ehrle, ed., *Roma prima di Sisto V: La pianta di Roma Du Pérac-Lafréry del 1577* [Rome, 1908])

Ammannati, the Florentine architect who was handling the redoing of the villa, designed a large, rusticated portal on which above the two side niches were plaques with the Latin inscriptions of the *Lex Hortorum* already noted (Fig. 5). While the introduction of ancient sculpture into the gardens of the Villa Medici may have caused the cardinal to emphasize so prominently the public entrance to his garden, the inscriptions make no reference to the statuary, and the topographical layout which permitted public access from the Via di Porta Pinciana had been prepared by the previous owner, Cardinal Ricci, who did not exhibit a collection of antiques in his garden. The passageway from the street debouched directly into the central alley of the garden so that there was a continuous long promenade from the street to the northern end of the garden, and the public could frequent that alley and most of the garden without disturbing the cardinal and his friends, if they were in residence at the villa. On the western side of the end of the public alley just before it entered the large garden was a small, square, walled-in garden next to the sculpture gallery, which in turn was accessible from the cardinal's private apartment in the villa. This garden, which apparently did not contain any ancient sculpture, was the *giardino segreto*, the private garden, normally reserved for the personal enjoyment of the owner.

The provision of a separate, prominent, public portal to gardens, as seen at the Villa Medici, was particularly prevalent at Rome beginning in the 1560s as a result of the urban development of the area of the Quirinal hill. The hill at the western side of the city had remained deserted throughout the Middle Ages and early Renaissance, with only vineyards and an occasional neglected or abandoned church scattered around and among the ruins of the ancient Baths of Constantine and of Diocletian. An old road, the Alta Semita, wandered along the spine of the hill from the inhabited portion of the city to the Porta Nomentana. In the late fifteenth and early sixteenth centuries suburban villas with expansive gardens lined the northern side of the street, commencing with the Vigna di Napoli of Cardinal Carafa nearest the city. In each case the residence was built on the brow of the northern edge of the hill, offering magnificent views out over the city or over the valley between the Quirinal and Pincian hills, and extensive gardens stretched back from the villa to the street. In 1561, as part of the continuing papal plan to encourage residence in the more healthy, but deserted, hill regions of the city, Pope Pius IV widened and straightened the old street of the Alta Semita, diverting it from the

Porta Nomentana, so that the street, renamed the Via Pia, would end at the new Porta Pia designed by Michelangelo (Fig. 8). By this time the old Vigna di Napoli of Cardinal Carafa at the western end of the Via Pia was leased by Ippolito II d'Este, cardinal of Ferrara, who had begun extensive building at the villa and had particularly expanded the gardens, in part as a setting for the magnificent collection of antiquities he was assembling. In February 1561 is the first of several payments to a builder for "the gate which he has to make in the garden of Montecavallo [the Quirinal garden of the cardinal of Ferrara] on the new street."[56] This must be the gate seen in the Dupérac map of 1577 (Fig. 8) entering directly into the garden on axis with a long alley that ran across the garden between the older Carafa property on the west and the new land toward the east, which had been the old Vigna Boccacci or Bertina given to the cardinal in 1560 to be incorporated into his expansive new garden. As there was already more direct access to the original Villa Carafa from the old Alta Semita at the southeast corner of the property, the new garden portal must have been meant for public access. Like the later Villa Medici, which had a small, private garden near the building, the Villa d'Este had several such walled-in *giardini segreti* clustered around the residence, two of which had loggias opening onto the gardens planted with bitter-orange trees (*merangoli*) for the relaxation of the owner.

Beyond the villa of the cardinal of Ferrara toward the east along the Via Pia were three more magnificent villa-garden complexes, those of Cardinal Grimani, Cardinal Pio da Carpi, and the cardinal of Sermoneta. Each of these had a rather similar layout to the Villa d'Este with the residence toward the northern brow of the Quirinal or, in the case of Sermoneta's, in the valley beyond so that personal access to the villa for the owner and his friends would be directly from the valley, leaving the summit of the Quirinal open for the extensive gardens that ran back to the Via Pia. The Villa Carpi, like the Villa d'Este, had several walled-in courts near the building, including the famous grotto of the sleeping nymph, and directly behind the villa was a *giardino segreto* of exotic trees carefully walled off from the more casual, larger garden. Each garden also had an elaborate, often rusticated, portal inscribed with the owner's name, opening onto the Via Pia. Engravings of these three portals, which survived longer than the one to the Villa d'Este, are preserved in later editions of Vignola's book on the orders, where they are mistakenly attributed to Michelangelo.[57] There is evidence to date all three portals at the time of the

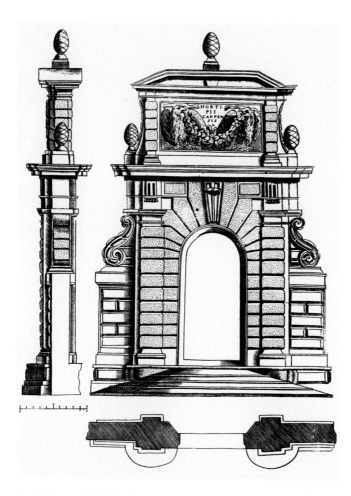

Fig. 9. Rome, Villa Carpi, gateway. From Vignola, *Li cinque ordini di architettura* (Venice, n.d.), pl. [E 6]

The tradition of a conspicuous garden portal permitting public access to the gardens without interfering with the residential life of the owner, established so prominently in the 1560s along the Via Pia, then became a regular feature at most of the later Roman gardens, as seen previously at the Villa Medici.[59] For example, Cardinal Montalto in the late 1570s had begun a very charming villa with gardens on the Esquiline hill near the Via Pia with a single major entrance at the west side of the property oriented toward his church of Sta. Maria Maggiore. After his election as Pope Sixtus V in 1585, he acquired a tremendous amount of additional, adjacent land until he possessed the largest *vigna* within the walls of Rome and expanded the gardens around his suburban residence (Fig. 10). At the same time he attempted to transform the area between the northern boundary of his newly enlarged *vigna* and the remains of the Baths of Diocletian into a new public piazza with a large palace, service buildings, and some eighteen shops along the northern edge of his estate. Adjacent to the new Palazzo di Termini was erected a large entrance portal to the gardens, the Porta Quirinale, which opened onto a long alley running completely across the garden at some distance behind the villa. This is obviously, then, a public portal entered from the public space of the new piazza, while the Porta Viminale on axis with the villa and near to his favorite church became a more private access for the pope or the visitors to his villa. Similarly, the Villa Borghese, whose *Lex Hortorum* was discussed at the beginning, was created from 1605 to 1613 on the Pincian hill just outside the Aurelian walls of the city (Fig. 1) with its public garden portal set just opposite the Porta Pinciana of the city so that the public could enter the gardens in front of the villa directly from the city gateway, while another portal further east communicated with the villa proper.

Circulation

At Rome during the sixteenth century the circulation pattern within a garden was generally determined loosely by the topography of the site and eventually, with the development of the tradition of a public portal, by the relationship among the several entrances into the garden. Within the garden the order of the paths and alleys leading away from the entrances limited, of course, the circulation path of the visitor, and the different elements composing the garden—plants, shrubs, trees, garden-seats

revision of the Via Pia in the early 1560s. The inscription on the portal of the cardinal of Carpi (Fig. 9), who died in 1564, proclaims that this is the portal of "the gardens of Pio da Carpi" (*Horti Pii Carpensis*), thus associating it with the famous ancient Roman Horti Sallustiani or Horti Luculliani, as was done about this time at other gardens in Rome, such as those in the remains of the Baths of Diocletian of Cardinal du Bellay (*Horti Bellaiani*) or of Cardinal Farnese on the Palatine hill (*Horti Palatini Farnesiorum*). Again, these portals on the Via Pia were to serve as the public entrances to the gardens. So in 1561, when Pope Pius IV laid the cornerstone of Michelangelo's Porta Pia, the Mantuan ambassador described the Via Pia as "now a most beautiful street, as almost all who dwell there have built lovely high walls with most attractive gateways, which lead into those *vigne*."[58] These lavish public garden portals then served as signs along the walled street identifying the location of the gardens.

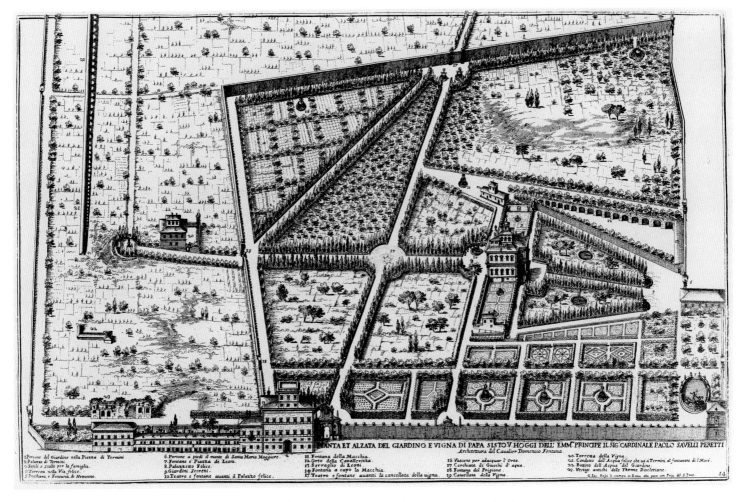

Fig. 10. Rome, Villa Montalto, engraving of *vigna.* From G. B. Falda, *Li giardini di Roma* (Rome, n.d.), pl. 14

and pergolas, fountains or statues—might determine his path relative to his personal interests. During the second half of the sixteenth century, however, several of the great gardens near Rome were created with extensive iconographical or symbolic programs, usually founded on classical mythology. It was one way by which the Renaissance could classicize gardens, analogous to the adoption of the classical orders of architecture for their building or the depiction of classical subject matter in their painting. With an iconographic program, often of a narrative mode, the circulation pattern within a garden had to be more strictly controlled in order that the program might be read correctly.

From about 1550 to 1572 the Neapolitan archaeologist and architect Pirro Ligorio laid out extensive gardens for Ippolito II d'Este, cardinal of Ferrara, in one corner of the hill town of Tivoli just within the old city walls near the Porta Romana.[60] As seen in a contemporary painting dec-

orating an end wall of the *salotto* of the villa itself (Fig. 11), the gardens were set on a steep hillside leading up to an old monastery, revised by the cardinal as his villa, perched on top of the hill. Today when visiting the Villa d'Este one first enters directly into the villa proper by a portal opening off a small piazza in front of the adjacent church of Sta. Maria Maggiore and then, after traversing the building, exits into the garden below the villa. This approach to the villa and its gardens was obviously the private entrance for the cardinal or residents of the villa. The principal and therefore public portal was at the bottom of the hill at the foot of the garden on axis with the building atop the slope and on the road from Rome that entered the town at the west through the Porta Romana. An anonymous account of the projected form of the garden, dating about 1568 and written perhaps by Ligorio himself,[61] describes the garden in accordance with its circulation pattern, which can be followed on the

| The Lex Hortorum

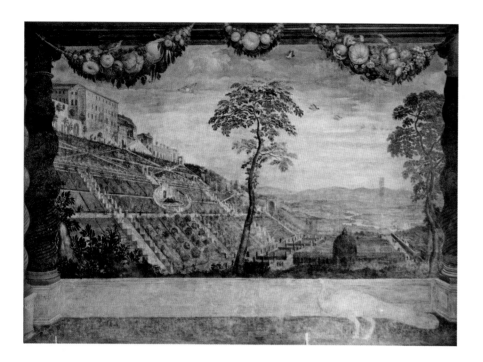

Fig. 11. Tivoli, Villa d'Este, *salotto*, fresco of Villa d'Este
(photo: ICCD, Rome, E 29043)

Dupérac engraving of 1573 of the garden (Fig. 12). The written description starts with the "principal portal" opening into a narrow "vestibule" covered by a pergola. Although the engraving cuts off both the portal and vestibule, they still exist at Tivoli. The description then continues with the identification of the central alley that runs through the garden and the cross pergola that covers the lower part of this alley. The large garden is designed in a checkerboard pattern running across the lower, flat area of the site and then continuing up the hillside beyond. In addition to the major alley corresponding to the central axis from the public portal to the villa, there are introduced into the design two major, very dominant cross axes. Finally, on the top of the hill attached to the northeast end of the villa, at the upper left in the engraving, is a smaller, completely walled-in garden isolated from the main garden and entered directly from the lower level of the building. This is, of course, another *giardino segreto* like those seen previously at the Villa Medici or the Villa Carpi in Rome.

Although there is a central axis from the entrance portal to the building, the checkerboard pattern, dramatically defined by the cross pergola immediately after the entrance, and the two powerful cross axes diminish the impact of the central alley as the path for circulation. A

visitor would undoubtedly pause under the vast dome over the center of the cross pergola, tantalized by vistas down the side tunnels. If he could resist those contradictory attractions and continue toward the villa, he would emerge from the confinement of the pergola onto the wide cross axis of the fishpools drawing his attention equally right and left. At this point of his tour of the garden, a visitor must have been sorely tried in his decision as to the direction in which to proceed.

If the visitor persisted in his desire to reach the villa above by mounting the hillside, after climbing around the central Fountain of the Dragons, he was faced with an even more frustrating choice at the next major cross axis, the Alley of the Hundred Fountains that cut across the middle of the slope. Although the Dupérac engraving depicts a slight break in the alley before being diverted right or left by the diagonal paths covering the upper part of the hillside, this momentary continuation of the central alley was omitted during the creation of the garden so that there is an unbroken wall of fountains running along the alley.

All the major features of the garden were arranged along the sides of the garden at the ends of cross axes with the one notable exception of the Fountain of the Dragons on the central alley half way up the hill just before the visitor was left with the inescapable choice of turning left or right along the Alley of the Fountains. Originally an ancient statue of Hercules, to whom the garden was dedicated, stood above the central Fountain of the Dragons, which according to the written description was meant to represent the many-headed dragon guardian of the mythical Garden of the Hesperides. At the left end of the Alley of the Hundred Fountains on Hercules's right was the Grotto of Venus or "voluptuous pleasure" in the words of the sixteenth-century description, and on his other side, but at the top of the hill, was the Grotto of Diana or "virtuous pleasure and chastity." Thus, the central motif of the garden illustrated the famous Choice of Hercules when he elected the steep, hard way of Virtue. The cross axes and the diagonal paths of the circulation path of the garden, therefore, compelled a visitor to choose between diverting interests that prepared him for the symbolism of the Choice of Hercules dominating the upper portion of the garden.

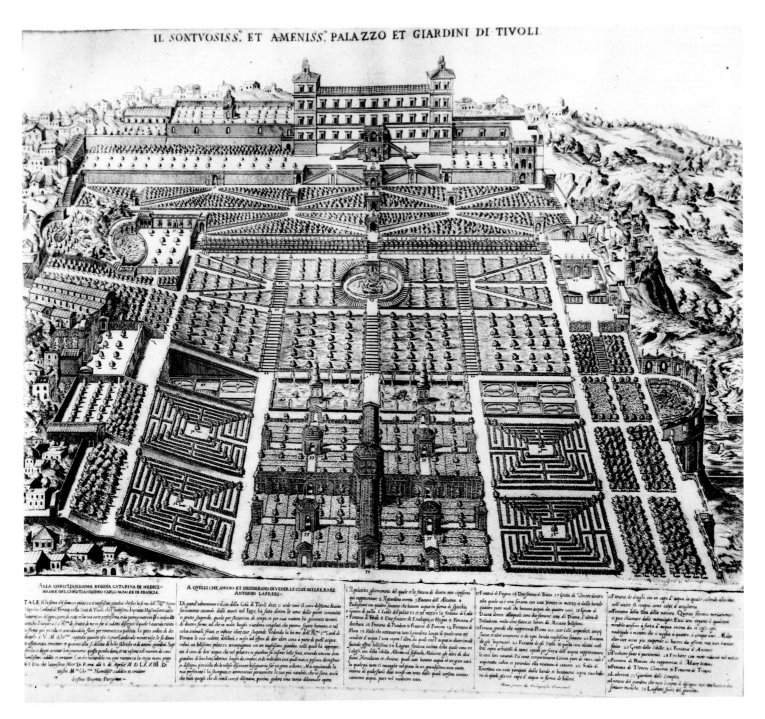

IL SONTVOSISS. ET AMENISS. PALAZZO ET GIARDINI DI TIVOLI

Fig. 12. Tivoli, Villa d'Este, engraving, 1573 (photo: De Pretore)

While the cardinal of Ferrara was completing his gardens at Tivoli, Cardinal Gambara began the gardens of his villa, the present Villa Lante, in 1568 within an old hunting park at Bagnaia north of Rome, probably after the design of the architect Vignola.[62] An engraving, dated 1596, of the Villa Lante (Fig. 13) is very helpful for the identification of many of the fountains, which are now lost, particularly in the park. At Bagnaia there are two portals into the grounds of the villa, both at the front toward the little town of Bagnaia. The left-hand portal leading directly into the formal gardens and the two casinos is the private entrance for the owner and his immediate friends coming to the casinos. The larger right-hand gateway opening into the adjacent park is, therefore, the public portal. Immediately on entrance into the park one encounters cut into the gentle hillside a large oval fountain basin in which

| The Lex Hortorum

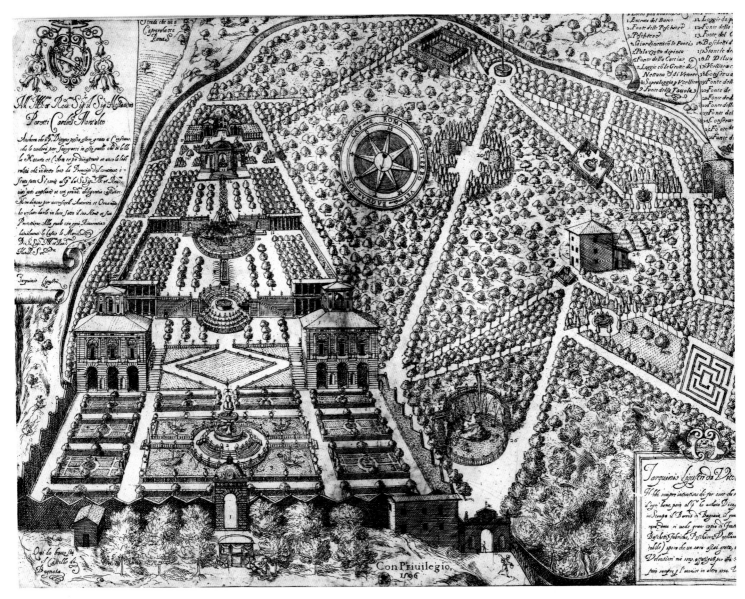

Fig. 13. Bagnaia, Villa Lante, engraving, 1596. Bibliothèque Nationale de France, Paris (photo: Bibliothèque Nationale de France)

stands a figure of the winged horse Pegasus, associating this area with the ancient Mount Parnassus.[63] The engraving then presents a very haphazard organization of alleys cut through the park. Only the diagonal alley proceeding from the public entrance directly to the old hunting lodge, erected earlier in the century in the center of the park, demonstrates a logical circulation pattern. The other fountains in the park, now lost or transformed but identified by the engraving, are associated with the world of nature, such as the Fountain of the Acorns and the Fountain of the Duck, or are symbolic of virtue, as in the Fountain of the Unicorn and the Fountain of the Dragon. This combination

of associations suggests that the naturalistic, wooded hillside of the park is meant to recall the classical myth of the Golden Age when virtuous men lived off the simple offerings of nature and did not have to labor for a living. The identification of the park with the Golden Age explains the irregular pattern of the alleys and their lack of clarity from a circulation point of view, since the inhabitants of the Golden Age lived a life of unfettered freedom, as the *Lex Hortorum* of the Villa Borghese expressed so eloquently, in an uncultivated and untouched nature. The random pattern of the alleys is, therefore, the Renaissance mode of expressing the irregularity of nature, in contrast to the

geometrically organized checkerboard pattern of the gardens of the Villa d'Este at Tivoli or those of the Villa Medici at Rome, and is really no more artificial than the serpentine windings that the eighteenth-century English landscapist used for the same expression.

The geometrical regularity of the formal garden at Bagnaia, in contrast to the adjacent park, then underscores the development of the iconographical program. A visitor, after exploring the park, would cross over into the upper part of the formal garden, as he does today, and view from the top the series of garden terraces organized along the central axis to the private portal below. On the uppermost terrace the Fountain of the Deluge gushing forth between the two little houses dedicated to the Muses recalled Ovid's account in the *Metamorphoses* (I, 89–112 and 262–323) of the destruction of the Golden Age by a great flood which covered the Earth except for the twin peaks of Mount Parnassus, where the only human survivors, Deucalion and Pyrrha, landed. The carefully manicured terraces below then represent the different stages of man's shaping of untamed nature by labor and art after he lost the free bounty of the Golden Age. The middle terrace with the large "Cardinal's Table," where the cardinal and his friends might dine, symbolizes that moment of civilization when man by his physical labor induced nature to produce food and physical sustenance. The lowest terrace before the two casinos with its topiary work and parterres presents artistic, formal horticulture in contrast to the agriculture of the level above and in combination with the nearby examples of architecture, sculpture, painting, and even the theater in the Fountain of the Lights, illustrates all the basic types of art that can be fashioned from nature. Thus, the formality of the garden and the naturalism of the park reinforce the iconographical program.

In contrast to the program of the Villa d'Este at Tivoli, that at Bagnaia is a narrative, requiring a continuous linear circulation pattern that can be read from either entrance portal. From the public portal into the park, the circulation path follows the story recounted by Ovid. That this reading was taken into account in the design of the gardens is confirmed by the vista down the terraces of the formal garden from the uppermost level (Fig. 14). From that point the semicircular recession of the Fountain of the Lights cuts into the retaining wall behind the lower terrace, permitting a clear glimpse of the circular island in the center of the lower terrace.

From the cardinal's portal into the formal garden, one moves up the terraced slope, which is the more usual

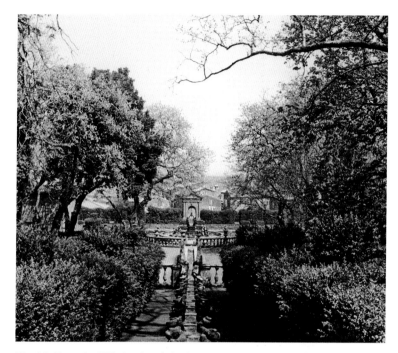

Fig. 14. Bagnaia, Villa Lante, vista down water-chain (photo: author)

approach to an Italian Renaissance garden, since one thereby is clearly aware of the wall fountains and grottoes set into the retaining walls of the terraces. This reading then expresses the favorite Renaissance theme of man's desire to return to the freedom and leisure of the Golden Age, associated so often with gardens.

The designers of Roman Renaissance gardens have, therefore, created them with different levels of comprehension and attraction. Open to a very broad and diverse public, it is understandable that the average visitor might not fully comprehend the involved, symbolic meaning conveyed by the fountains and statues, whose enjoyment might only be available to the intelligentsia or the friends of the owner. The average public, however, might enjoy the formal elements of the garden design and certainly would be attracted by the lavishness of water, statuary, and floral displays. These were to endow the owner, as Pontano noted, with the image of being a "Splendid Man." To gain the fullest benefit of this concept, however, the Roman gardens had to be open to the general public, with concatenary consequences for circulation and design.

Notes

1. Among the wealth of documentation regarding the nineteenth-century controversy, see especially P. S. Mancini, L. Meucci, and C. Rebecchini, *Il diritto del popolo romano sulla Villa Borghese in giudizio di reintegrazione in grado di appello: Memoria* (Rome, 1885); A. Gennarelli, *La Villa Pinciana fuori della Porta Flaminia ed i diritti del Popolo Romano e dello Stato sulla medesima: Memoria* (Rome, 1885); P. L. D. V. (pseudonym for Ludovico Passarini), *La questione di Villa Borghese* (Rome, 1885); L. Vicchi, *Villa Borghese nella storia e nella tradizione del popolo romano* (Rome, 1886); and G. Biroccini, *Dissertazione su Villa Borghese letta in Arcadia* (Rome, 1886).

2. I. Manilli, *Villa Borghese fuori di Porta Pinciana* (Rome, 1650), 159:

> Villae Burghesiae Pincianae
> Custos Haec Edico
> Quisquis Es Si Liber
> Legum Compedes Ne Hic Timeas
> Ito Quo Voles Carpito Quae Voles
> Abito Quando Voles
> Exteris Magis Haec Parantur Quam Hero
> In Aureo Saeculo Ubi Cuncta Aurea
> Temporum Securitas Fecit
> Bene Morato Hospiti
> Ferreas Leges Praefigere Herus Vetat
> Sit Hic Amico Pro Lege Honesta Voluptas
> Verum Si Quis Dolo Malo
> Lubens Sciens
> Aureas Urbanitatis Leges Fregerit
> Caveat Ne Sibi
> Tesseram Amicitiae Subiratus Villicus
> Advorsum Frangat.

The Manilli transcription of the inscription is obviously inaccurate in a few places, so that the version given here is taken from later, corrected versions. Passarini, *La questione di Villa Borghese* (note 1 above), 11, claims to have seen the original inscription, while Vicchi, *Villa Borghese nella storia* (note 1 above), 288, mentions that the stone was then in fragments, but exhibited to the public. Recently P. Della Pergola, *Villa Borghese* (Rome: Istituto poligrafico dello stato, Libreria dello stato, 1964), 46, noted that she was informed by Professor Pietrangeli that the inscription may be found in the Vatican Museum. For a complete history of the creation of the villa, see C. H. Heilmann, "Die Entstehungsgeschichte der Villa Borghese in Rom," *Münchner Jahrbuch der bildenden Kunst*, ser. 3, 24 (1973), 97–158.

3. P. Della Pergola, *Villa Borghese* (Rome: Istituto poligrafico dello stato, Libreria dello stato, 1962), 13.

4. Dr. Andrea Brenzio in an introductory letter to a book dedicated to Pope Sixtus IV says it was written at Cardinal Carafa's *vigna*, where the doctor had withdrawn during the plague, which has been suggested as the plague of 1476; see [G. L. Marini], *Degli archiatri pontificj* (Rome, 1784), vol. 1, 215. For Cardinal Aragon's visit, see P. Paschini, *Il carteggio fra il Card. Marco Barbo e Giovanni Lorenzi (1481–1490)* (Vatican City, 1948), 94.

5. F. Albertini, *Opusculum de Mirabilibus Novae & Veteris Urbis Romae* (Rome, 1510).

6. L. Schrader, *Monumentorum Italiae* (Helmstedt, 1592), 218:

> Villam Perpetuae Salubritatis
> Suburbi Modo Montis Esquilini
> Oliverius Ille Cardinalis
> Doctae Clara Neapolis Propago
> Hanc Caraffa Pius Suis Amicis
> Dicat Omnibus, Hospices Venite.

The reference to the villa set on the Esquiline hill, rather than its actual location on the Quirinal hill, is evidence of the fifteenth-century date of the inscription, when the Quirinal hill was regularly misidentified as the Esquiline.

7. J. Sadoleto, *Elogio della Sapienza (De Laulibus Philosophiae)*, trans. A. Altamura (Naples: R. Pironti, 1950), 13.

8. Rome, Biblioteca Angelica, Ms. 1729, fol. 12v:

> Julij S. Ang. Diac. Car. Caes.
> Dietam hanc statuarium
> Studijs suis
> Et gentil. suor. uolup. honestae
> Dicauit suo natali die XXXIIII
> XIII kal. Junij
> Alex. VI Pont. Max. An. VIII
> Sal. MD. ab V. C. MMCCXXXIII.

See also C. Huelsen, review of P. G. Hübner, *Le statue di Roma*, in *Göttingische gelehrte Anzeigen*, no. 176 (1914), 292; and C. Huelsen, "Römische Antikengärten des XVI. Jahrhunderts," *Abhandlungen der Heidelberger Akademie der Wissenschaften: Philosophisch-historische Klasse* 4 (1917), p. VI.

Later the Cesarini family had an even more impressive garden with classical sculpture near the church of S. Pietro in Vincoli. It is Schrader (*Monumentorum Italiae* [note 6 above], p. 217v) again who preserves a record of the inscription in the garden addressed to each visitor:

> Hosce hortos anni quacunq. intraueris hora,
> Et domus haec pulcri rustica quid quid habet,
> Inspicias lustresq. oculis licet hospes, & oris
> Ista tibe in primis esse parata putes.
> Ut si quid fuerit quo tu oblectare voluptas,
> Quae nunc vna mea est iam geminetur oro.
> Sin autem nulla hic animum re pascis, abito,
> Et patiare alios his sine lite frui.

9. C. Pietrangeli, *Il Museo di Roma* (Bologna: Cappelli, 1971), 40: "Caesiorum Atque E(o)r(um) Amicorum Viridarium."

10. S. Ortolani, *S. Bernardo alle Terme* (Rome: Casa editrice "Roma," 1924), 14.

11. The inscriptions are first recorded in Fichard's account of his trip to Rome in 1536; see "Italia, Auctore Ioanne Fichardo," *Frankfurtisches Archiv für ältere deutsche Litteratur und Geschichte* 3 (1815), 69:

I. Ad collabentium [collabeatum in Fichard] statuarum instaurationem pensiliumque hortorum ornamentum.

II. Ad amicorum iucunditatem civium advenarumque delectationem.

III. Non ad voluptatem sed ad census fortunarumque favorem.

IV. Ad delicium vitae elegantiarum gratiarumque secessum.

V. Sibi et genio posterorumque [posterisque in Fichard] hilaritati.

VI. Antiquarum rerum vivario pictorum poetarumque subsidio.

VII. Honesti otii oblectamento domesticaeque commoditati.

VIII. Maiorum memoriae nepotumque imitationi.

See also C. Huelsen and H. Egger, eds., *Die römischen Skizzenbücher von Marten van Heemskerck* (Berlin, 1916), vol. 2, 56–66.

12. T. Falk, "Studien zur Topographie und Geschichte der Villa Giulia in Rom," *Römisches Jahrbuch für Kunstgeschichte* 13 (1971), 170:

Deo et Loci Dominis Volentibus

Hoc in suburbano omnium si non quot in orbis at quot in urbis sunt ambitu pulcherrimo ad honestam potissime voluptatem facto, honeste voluptuarier cunctis fas honestis esto, set ne forte quis gratis ingratus siet, iussa haecce ante omnia omnis capessunto

Quovis quisq. ambulanto, ubivis quiescunto verum hoc citra somnum circum septa illud

Passim quid libet lustranto, ast nec hilum quidem usquam attingunto

Qui secus faxint quidquamve clepserint aut rapserint non iam ut honesti moribus set ut furtis onusti in crucem pessumam arcentor

Ollis vero qui florum frondium pomorum olerum aliquid petierint, villici pro anni tempore pro rerum copia et inopia proq. merito cuiusque largiuntor.

Aquam hanc quod virgo est ne temeranto, sitimq. fistulis non flumine, poculis non osculo aut volis extinguunto

Piscium lusu oblectantor, cantu avium mulcentor, at ne quem interturbent interim cavento

Signa statuas lapides picturas et caetera totius operis miracula quamdiu lubet obtuentor dum ne nimio stupore in ea vortantur

Sicui quid tamen haud ita mirum videbitur eorum caussa quae nemo mirari sat quivit, aequo potius silentio quam sermonibus iniquis praeterito

Dehinc proxumo in templo deo ac divo Andreae gratias agunto, vitamq. et salutem Iulio III pont. max. Balduino eius fratri et eorum familiae universae plurimam et aeviternam precantor.

Huic autem suburbano speciem atq. amplitudinem pulchriorem indies maioremq. ac in eo quicquid inest felix faustum perpetuum optanto hisce actis valento et salvi abeunto.

13. G. M. Andres, *The Villa Medici in Rome* (New York and London: Garland, 1976), vol. 2, note 585:

Aditurus hortos, hospes, in summo, ut vides,
Colle Hortulorum consisto, si forte quid
Audes probare, scire debes hos hero,
Heriq. amicis esse apertos omnibus.

Ingressus, hospes, hosce quos ingentibus
Instruxit hortos sumptibus suis Medices
Fernandus, expleare visendo licet
Atq. his fruendo plura velle non decet.

14. S. Benedetti, *Giacomo Del Duca e l'architettura del Cinquecento* (Rome: Officina Edizioni, 1972–73), 308–336; and E. B. MacDougall, "The Villa Mattei and the Development of the Roman Garden Style" (Ph.D. dissertation, Harvard University, 1970).

15. R. Lanciani, *Storia degli scavi di Roma*, vol. 3 (Rome, 1908), 84.

16. Nolli's magnificent eighteenth-century plan of Rome presents diagrammatically the areas of public access then, and undoubtedly earlier. The urban palaces and buildings of private ownership are depicted as solid black blocks, and those areas freely open to the public are in white, as are the streets, the interiors of churches, and the courtyards of palaces with their accesses from the streets; see F. Ehrle, ed., *Roma al tempo di Benedetto XIV: La pianta di Roma di Giambattista Nolli del 1748* (Vatican City, 1932).

17. Some of the most notable of the sketchbooks are those of the Bolognese painter Aspertini (P. P. Bober, *Drawings after the Antique by Amico Aspertini* [London: Warburg Institute, 1957]), the Dutch painter Heemskerck (C. Huelsen and H. Egger, eds., *Die römischen Skizzenbücher von Marten van Heemskerck* [Berlin, 1913 and 1916]), the Portuguese painter Ollanda (E. Tormo, ed., *Os desenhos das antigualhas que vio Francisco d'Ollanda, pintor português* [Madrid, 1940]), the Italian sculptor-architect Dosio (C. Huelsen, ed., *Das Skizzenbuch des Giovannantonio Dosio* [Berlin, 1933]), and the French sculptor Pierre Jacques (S. Reinach, ed., *L'Album de Pierre Jacques, sculpteur de Reims, dessiné à Rome de 1572 à 1577* [Paris: E. Leroux, 1902]).

18. M. Gmelin, "Die Romreise des Salemer Conventuals and späteren Abtes, Matthäus Rot, 1554," *Zeitschrift für die Geschichte des Oberrheins* 32 (1880), 249.

19. M. de Montaigne, *The Complete Works of Montaigne*, trans. D. M. Frame (Stanford: Stanford University Press, California, 1957), 960.

20. Rome, Biblioteca Apostolica Vaticana, Ms. Urb. Lat. 1049, fol. 175r (29 April 1581).

21. S. Locatelli, *Voyage de France*, trans. A. Vautier (Paris, 1905), 157.

22. C. Perrault, *Mémoires de Ch. Perrault*, ed. P. Lacroix (Paris, 1878), 121–122.

23. J. Fennebresque, "La replantation des parcs et jardins de Versailles (1775–1776)," *Revue de l'histoire de Versailles et de Seine-et-Oise* (1900), 167–168.

24. D. Wiebenson, *The Picturesque Garden in France* (Princeton: Princeton University Press, 1978), 116.

25. E. P. Thompson, *Whigs and Hunters: The Origin of the Black Act* (New York: Pantheon Books, 1975), 241.

26. H. Walpole, *Reminiscences Written by Mr. Horace Walpole in 1788*, ed. P. Toynbee (Oxford: The Clarendon Press, 1924), 15.

27. W. H. Wilkins, *Caroline the Illustrious* (London: Longmans, Green, 1904), 446.

28. G. Lyttelton, *Memoirs and Correspondence of George, Lord Lyttelton*, ed. R. Phillimore (London, 1845), vol. 1, 306.

29. See P. Fletcher Jones, *Richmond Park: Portrait of a Royal Playground* (London and Chichester: Philimore, 1972), especially pp. 28–31. For the memorial of the neighboring residents to the princess outlining their rights of at lcast passage through the Park, see *The Gentleman's Magazine* 22 (1752), 380–381.

30. H. Walpole, *Memoires of the Last Ten Years of the Reign of George the Second* (London, 1822), vol. 2, 61–62. Another version of Walpole's comment, first published in 1779, gives the prime minister's reply as "only three CROWNS" (J. Pinkerton, ed., *Walpoliana*, 2nd ed. [London, n.d.], 9), which is presumably the source of the more embroidered version published in *The Gentleman's Magazine* 51 (1781), 75.

31. D. Green, *Gardener to Queen Anne* (London: Oxford University Press, 1956), 109.

32. [A. Young], *A Six Months Tour through the North of England*, 2nd ed. (London, 1771), vol. 3, 83.

33. T. Jefferson, *Thomas Jefferson's Garden Book, 1766–1824*, Memoirs of the American Philosophical Society 22, ed. E. M. Betts (Philadelphia, 1944), passim: for example, Chiswick, 4/6, Hampton Court, 4/6, Pope's garden at Twickenham, 2/- (p. 111), Esher Place, 6/-, Painshill, 7/-, Woburn, 6/6, Caversham, 3/6 (p. 112).

34. C. H. C. Baker and M. I. Baker, *The Life and Circumstances of James Brydges, First Duke of Chandos* (Oxford: The Clarendon Press, 1949), 182.

35. [H. L. H. von Pückler-Muskau], *Briefe eines Verstorbenen*, vol. 1 (Munich, 1830), 42, which is not included in the English translation; for some of the frustrating incidents noted in the English version, see [H. L. H. von Pückler-Muskau], *Tour in England, Ireland, and France in the Years 1826, 1827, 1828, and 1829* (Philadelphia, 1833), 175–176, 182, 239–240, 338–339, 464, 466, and 473.

36. J. J. Volkmann, *Historisch-kritische Nachrichten von Italien*, 2nd ed. (Leipzig, 1777), vol. 2, 764–765.

37. A. R. Miller, *Letters from Italy* (London, 1776), vol. 3, 79 and 152–155.

38. J. Forsyth, *Remarks on Antiquities, Arts, and Letters During an Excursion in Italy in the Years 1802 and 1803*, 4th ed. (London, 1835), 230–231.

39. Ibid., 219–220.

40. L. B. Alberti, *Opere volgari*, ed. C. Grayson, vol. 1 (Bari: G. Laterza, 1960), 359.

41. For Caesar, see Suetonius, *Caesar*, LXXXIII; Cicero, *The Philippic Orations*, II.109; and Dio Cassius, XLIV.35; and for Agrippa, Dio Cassius, LIV.29.4, and P. Grimal, *Les jardins romains*, 2nd ed. (Paris: Presses Universitaires de France, 1969), 179–180.

42. *Epistolae Senecae ad Paulum et Pauli ad Senecam*, Papers and Monographs of the American Academy in Rome 10, ed. C. W. Barlow (Rome, 1938), 139–140; and [Oratores Panegyrici], *Panégyriques latins*, ed. E. Galletier (Paris: Belles Lettres, 1952), vol. 2, 135.

43. M. Mercati, *De gli obelischi di Roma* (Rome, 1589), 255.

44. G. Pontano, *I trattati delle virtù sociali*, ed. F. Tateo (Rome: Edizioni dell Ateneo, 1965), 101.

45. Ibid., 126.

46. Ibid., 136–137.

47. Ibid., 131–132.

48. The building activity of Alfonso II at Naples in the late fifteenth century has been related to Pontano's writings in G. L. Hersey, *Alfonso II and the Artistic Renewal of Naples, 1485–1495* (New Haven and London: Yale University Press, 1965).

49. The Botanical Garden at Padua had inscribed in Latin on its entrance gate rules for the use of the garden by the public (see T. Coryate, *Coryat's Crudities* [Glasgow and New York: Macmillan, 1905], vol. 1, 292–293), but these differ from the *Lex Hortorum* in disciplining the public in its use of a public area.

50. L. de la Ville sur-Yllon, "Il Palazzo degli Spiriti," *Napoli nobilissima* 13 (1904), 97–100; and B. Croce, *Galéas Caracciolo, Marquis de Vico* (Geneva: Droz, 1965), 6–11:

> Nic. Ant. Caracciolus Vici Marchio
> Et Caesaris a Latere Consiliarius Has
> Genio Aedes, Gratiis Hortos, Nymphis
> Fontes, Nemus Faunis, Et Totius
> Loci Venustatem
> Sebeto Et Syrenibus Dedicavit
> Ad Vitae Oblectamentum Atque
> Secessum Et Perpetuam Amicorum
> Jucunditatem. M.D.XXXXIII.

51. G. Masson, *Italian Gardens* (New York: Abrams, 1961), 71–73 and fig. 29.

52. I. Hyman, *Fifteenth Century Florentine Studies: The Palazzo Medici and a Ledger for the Church of San Lorenzo* (New York and London: Garland, 1977), 186.

53. F. Ehrle and H. Egger, *Der vaticanische Palast in seiner Entwicklung bis zur Mitte des XV. Jahrhunderts*, Studi e documenti per la storia del Palazzo Apostolico Vaticano 2 (Vatican City, 1935), 76.

54. A. S. Piccolomini, *Memoirs of a Renaissance Pope: The Commentaries of Pius II*, trans. F. A. Gragg (New York: Putnam, 1959), 324.

55. D. R. Coffin, *The Villa in the Life of Renaissance Rome* (Princeton: Princeton University Press, 1979), 219–232.

56. Modena, Archivio di Stato, Camera Ducale, Amministrazione dei Principi, Registro 958, fol. 15 (4 February 1561).

57. G. B. da Vignola, *Li cinque ordini di architettura . . .* (Venice, 1603 and 1648).

58. L. von Pastor, *The History of the Popes*, vol. 16 (London: Routledge & Kegan Paul, 1928), 465, no. 11.

59. The Farnese gardens on the Palatine, dating from the 1570s and early 1580s, had only a public entrance, but this is understandable as there was no residential villa requiring privacy. On the other hand, the gardens of Cardinal du Bellay at the Baths of Diocletian, which had likewise only one major entrance, did have a small summer residence, where, in fact, the cardinal died in 1560, but the creation of the garden in 1554–1555 predates the development of the Via Pia entrances.

60. For a detailed analysis with bibliography, see D. R. Coffin, *Villa in the Life of Renaissance Rome* (note 55 above), 311–340.

61. D. R. Coffin, *The Villa d'Este at Tivoli* (Princeton: Princeton University Press, 1960), 141–150.

62. C. Lazzaro Bruno, "The Villa Lante at Bagnaia: An Allegory of Art and Nature," *Art Bulletin* 59 (1977), 553–560; and Coffin, *Villa in the Life of Renaissance Rome* (note 55 above), 340–362.

63. See D. R. Coffin, "Some Aspects of the Villa Lante at Bagnaia," in *Arte in Europa: Scritti di storia dell'arte in onore di Edoardo Arslan* (Milan: Tipogr. Artipo, 1966), 569–575 [reprinted on pages 156–163 of this volume], for the probable influence of garden ideas and garden features from the Villa d'Este at Tivoli.

11

The Study of the History of the Italian Garden until the First Dumbarton Oaks Colloquium

The first significant study of Italian gardens in their own right was that of W. P. Tuckermann, *Die Gartenkunst der italienischen Renaissance-Zeit*, published at Berlin in 1884. Certainly there had been earlier considerations of Italian gardens in relation to Italian villas, most notably Charles Percier's and Pierre Fontaine's *Choix des plus célèbres maisons de plaisance de Rome et de ses environs*, first published at Paris in 1809. Percier and Fontaine as architects wished to adapt antiquity to their own time, thus creating the Empire style appropriate to the reign of the emperor Napoleon. As they noted in the introduction to their book, their purpose was "to offer useful material to the progress of the art which we profess."

Tuckermann was also an architect connected with the Technische Hochschule at Berlin, but was interested in the history of Italian gardening as a discipline in its own right. Thus the late nineteenth century presented a dichotomy in the historiography of Italian gardens between a concern for design principles and historical values that would continue through much of the twentieth century.

Earlier, in 1868, Tuckermann had published a reconstruction of the Odeon of Herodes Atticus in Athens and later, in 1879, a study of the literary output of the German architect Karl Friedrich Schinkel. In contrast to the later flood of publication on the Italian garden, Tuckermann's work was a very thorough investigation of the subject using a variety of sources. Unlike the later writers, he considered the geography and climate of Italy and their effect on the

horticulture of the Italian garden. He accordingly identified four different Italian landscapes determined by the climate: first, the landscape of the northern lake country; second, that of the northern seacoast; third, the area around Rome; and, finally, that of Naples. He was equally interested in the historical aspect of Italian gardening, unlike many of his successors. In a chapter on gardening before the Italian Renaissance, he considered Pliny the Younger's villa complexes and illustrated Schinkel's reconstructions of the two layouts, thus renewing his earlier interest in the reconstruction of ancient monuments and the ideas of Schinkel. Tuckermann also studied the medieval monastic gardens and the Moorish gardens in Spain. His longest chapter, of course, is devoted to the descriptions and history of Italian gardens from the sixteenth century to the beginning of the nineteenth, when English gardening overwhelmed the classic style. He illustrated the principal gardens with engraved *vedute* and some twenty-one plans.

Tuckermann's study, for all its thoroughness, seems to have had very little influence outside Germany. From the end of the nineteenth century until 1931 the study of the Italian garden was dominated by Anglo-American publications. In July and August 1893, the artist Charles Platt, soon to be an outstanding designer of Italianate villas and gardens in the United States, published two articles on Italian gardens in *Harper's New Monthly Magazine*. He explained his articles by claiming that there is "no existing

work of any great latitude treating of the subject of gardens, the only one of importance being that of Percier and Fontaine." At the same time he signed a contract with *Harper's* to publish a book on the subject with one thousand new words supplementing the two thousand words of his articles.[1] Platt illustrated his book with some thirty-one of his own photographs of Italian gardens as his main sources, emphasizing that his descriptions were purely supplementary to the illustrations. Thus the emphasis of his work is almost solely on the design of the gardens. Their history is not considered at all. The only possible historical reference is a vague acknowledgment of an eighteenth-century date for the Villa Albani in Rome.

Although Platt's book was soon a popular and influential one, it was rather severely criticized by Charles Eliot in *The Nation* of December 28, 1893, noting among other things that "Evidently our author is not acquainted with W. P. Tuckermann's 'Die Gartenkunst der Italienischen Renaissance-Zeit,' published in Berlin in 1884, and containing, besides twenty-one plates and numerous other cuts, some twenty ground-plans and cross-sections of Renaissance villas." Platt's principal audience was primarily American architects.

The popular architectural periodical *American Architect and Building News* ran in the 1890s a series of photographs titled "Accessories of Landscape Architecture," and by at least 1897 began to include views of Italian gardens, although the factual information of the captions was occasionally inaccurate, in one case locating the Farnese villa at Caprarola in Sicily. These were followed in February and March of 1900 by the article "The Italian Garden," by James S. Pray. This study, like Platt's, was basically on the design of the gardens, although at the end he incorporated a slight history, noting that the Renaissance garden was inaugurated by Bramante's Belvedere Court at the Vatican. He also observed that there was a growing popularity of the use of the Italian garden in he United States, which was, of course, in part due to Platt's work. In the following year the elder Professor Alfred Dwight Foster Hamlin at Columbia published in the February issue of the *American Architect and Building News* a three-page paper, "The Italian Formal Garden," which he had read at the convention of the American Institute of Architects. His dates were often quite inaccurate, claiming that the Villa Lante at Bagnaia was first built in 1477 by Cardinal Riario and then remodeled about 1550 by Giacomo Vignola, or that the Villa d'Este at Tivoli was designed about 1540 by Pirro Ligorio.

A broader audience was addressed by the appearance in 1904 of Edith Wharton's *Italian Villas and Their Gardens.*

She too observed that the "cult of the Italian garden has spread from England to America." Although she remarked on "the deeper harmony of design" in the Italian villa and its garden, her study was much more historical than those of her American predecessors. By examining the monuments in chapters devoted to different regions she suggested that there was both a geographical and chronological development of the villa and garden. Her descriptions of the individual sites are charming but limited in their consideration of any possible meaning, so she characterizes the animals in the grotto of the garden at Castello as merely a "curious delight." She was so sensitive, however, to aesthetic values that she would designate the architect Francesco Borromini as a "brilliant artist" long before his acceptance by most Anglo-American historians. An additional factor in the popularization of her book were the illustrations by the artist Maxfield Parrish, who would soon be the most famous American illustrator. The intense blues and greens of Parrish's watercolors and their rather hard edge almost seem to foreshadow color photography.

There appeared about this time two delightful essays on the restoration of Italian gardens. Frederick Eden, the landscape painter and brother-in-law of the English gardener Gertrude Jekyll, published in 1903 *A Garden in Venice*, which is an account of the restoration of a garden on the Giudecca that he had bought in 1884. In his essay he considered in detail every aspect of the restoration: different types of pergolas, paths of seashells bordered with box or old brick, the construction of wells and reservoirs, and even the difficulties an owner may suffer with Italian gardeners, although he notes that his head gardener at age 25 was paid 100 francs a month, which he claimed was a good salary in the region. A few years later, in 1909, appeared the essay by Sir George Sitwell, father of the famous Sitwell siblings, titled *An Essay on the Making of Gardens.* Later his son Osbert would assert that his father hoped that his work would rank with Sir Francis Bacon's famous essay on gardens. Certainly the extended first part of Sitwell's essay is successful in that regard, but the last part, with its detailed consideration of the psychology of the beauty of a garden (with frequent references to William James's *Principles of Psychology* and the ideas of Herbert Spencer and Archibald Alison), diminishes its literary quality. Repelled by French gardening and the English landscape style, Sir George claims that "no place is so full of poetry as the Villa d'Este," which in company with the Villa Lante at Bagnaia and the Giusti gardens in Verona he identified as the three greatest gardens of Italy from which he could educe the

principles of good gardening. He also, however, examined many little-publicized gardens, such as those of the Canossa Palace in Verona, of the Quirini Palace in Vicenza, and gardens in Bergamo, Cremona, Piacenza, and Brescia. He believed that through such study art could be used to perfect the beauty of nature.

Commencing in 1910 and continuing for the next quarter century, the English architect Cecil Pinsent designed and built Tuscan villas and their gardens for the well-to-do Anglo-American community in Tuscany.[2] This activity encouraged a mutual relationship with writings on the Italian gardens.

In 1906 the architect H. Inigo Triggs followed his study of formal gardening in England and Scotland with *The Art of Garden Design in Italy*. Although other English and American works have often achieved more popularity and fame, I would judge that Triggs's book was at that time by far the most important historical account. His work commenced with an excellent long historical introduction. Engravings of Pompeian garden frescoes and a drawing attributed to Pinturicchio, and now identified as by Baldassare Peruzzi, of the plan of a town garden were even incorporated among the illustrations of the introduction. This section was then followed by some thirty-one chapters devoted to individual gardens or regions. In the introduction Triggs noted that Percier and Fontaine's collection of garden plans was limited to Rome and its environs; this was his explanation for his study, which contains some twenty-seven plans. Some of the plans were created by Triggs himself, while others, such as those of the Villa d'Este or the Villa Borghese, were redrawn after Percier and Fontaine. Several plans were derived from historical documents: the plan of the garden parterre intended for Caserta is from Luigi Vanvitelli's original drawing; that of the Villa Pamphili is based on a seventeenth-century plan in the collection of Prince Doria.

Soon the English historian Julia Cartwright contributed to the subject her *Italian Gardens of the Renaissance and Other Studies* (1914). Limited to Renaissance gardens of the fifteenth and sixteenth centuries, most of which have disappeared, Cartwright's book concentrated on the history associated with the gardens and has no consideration of garden design. In fact, her book is really a collection of historical studies of the owners of individual villas.

Although there has been avoided any mention of general histories of gardens in which there is incorporated some treatment of the Italian garden, one must not omit consideration of Marie Luise Gothein's *Geschichte der Gartenkunst*, which first appeared in 1914, with a second edition

in 1926 and an English edition in 1928. Although occasionally dated in its historical information, it nevertheless remains an important standard work today. The only treatise in the field of gardening contemporary with it that can rival it is Amelia Amherst's *A History of Gardening in England*, which first appeared in 1895, followed by a second edition in 1896, and a third and enlarged edition in 1910. Gothein, pointing out in her introduction that even art historians have shown only a perfunctory interest in the subject of gardens, relied on early prints of gardens, such as those of G. B. Falda, as well as photographs to illustrate her section on Italian gardens, indicating a historical orientation rather than the design concentration offered only by photographs.

A series of important articles on individual sixteenth-century Roman gardens by archaeologists and topographical historians commenced with Domenico Gnoli's article in the *Römische Mitteilungen* in 1905 on the garden of the Cesi family in Rome. Thomas Ashby in *Archaeologia* of 1908 reconstructed the collection of ancient sculpture in the gardens of the Villa d'Este at Tivoli. Christian Hülsen enlarged the subject in 1917 with an exhaustive, fundamental study of several sixteenth-century antique sculpture gardens in Rome in the *Abhandlungen* of the Heidelberg Academy, followed by Luigi Dami's account of the Quirinal garden at Rome in the *Bollettino d'arte* of 1919. Much later, in 1930, a delightful two-part article by Gnoli on the literary gardens in the Rome of Pope Leo X appeared posthumously in *Nuova antologia*.

Contemporary with Gnoli's first article, Edgar Williams, a young American landscape architect at the American Academy in Rome from 1910 to 1912, made drawings of the plan, elevations, and section of the famous gardens of the Isola Bella on Lake Maggiore which were published in the periodical *Landscape Architecture* in July 1914. This was one of the numerous sets of plans and drawings of Italian gardens produced by fellows of the American Academy between the two world wars. The academy, founded in the late nineteenth century on the model of the French Academy at Rome, was to introduce young American artists to the great examples of classical and Renaissance art and architecture in Italy, thus promoting the classical style in America already represented by the architects McKim, Mead, and White, and their artistic associates, several of whom were founders of the American Academy.

To offset the strong predilection to emphasize Tuscan and Roman gardens in previous publications, Charlotte Pauly concentrated on Venetian pleasure gardens in her *Der*

venezianische Lustgarten of 1916. She claimed that because of what she described as the architect Andrea Palladio's antagonism to the "Baroque" mode, the Venetian garden would remain that of the early Renaissance until the seventeenth century. With frequent references to Gothein's history of gardening and Pompeo Molmenti's social history of Venice, Pauly devotes her last chapter to an interesting examination of the place of the garden in Venetian culture. She identifies three specific qualities of gardens with respect to Venetian life. First is the hygienic aspect caused by the climate, for which she discusses the role of summer *villeggiatura* from June 12 to the end of July and autumn *villeggiatura* from October 4 to mid-November. Second, she emphasizes the oligarchic and aristocratic quality of the Venetian garden. Finally, she describes how it fulfills the traditional Venetian concept of an art of luxurious living.

In the 1920s publication on Italian gardens became more international with the French publications of Georges Gromort from 1922 to 1931 and Gabriel Faure in 1923, the American Harold Eberlein in 1922 with his emphasis on the lesser-known Tuscan villas and gardens, and the Italian Luigi Dami in 1924 with some 351 plates, including paintings and prints of gardens as well as photographs. In 1928 the English author Rose Nichols published a very full survey of Italian gardens from Pompeian peristyle gardens to those of the twentieth century. She even printed two pages of description of the Orsini garden at Bomarzo with an illustration of the elephant group. This appeared a quarter of a century before the international fanfare celebrating Mario Praz's "discovery" of Bomarzo.

The book that achieved the most popularity and acclaim was *Italian Gardens of the Renaissance*, the work of two young British fifth-year students at the Architectural Association in London, Jock Shepherd and Geoffrey Jellicoe. Their "year-master" had suggested in 1923 that they explore Italian gardens, since he claimed that "no surveys had been made since the somewhat crude drawings of the French architects Percier and Fontaine a hundred years previously."[3] Jellicoe did the ground work, while Shepherd photographed and then drew up the plans and sections, basing his technique on the drawing style of the Frenchman Gromort. Their published work included twenty-eight villas, the illustrations accompanied by brief descriptions in three languages. Jellicoe later admitted that at first they omitted the Villa d'Este at Tivoli "as being vulgar" and the Isola Bella "as being decadent." Tivoli was copied later in England from an "inaccurate plan." Regarding accuracy, it might be noted that Jellicoe later explained that, although they had

been taught the orthodox method of surveying with precision instruments, in their hurry the measurements of their drawings were made by Jellicoe pacing off the dimensions, claiming that any errors should not exceed 5 percent. *Italian Gardens of the Renaissance* has run through at least six editions, the latest in 1993.

The climax of this interest in Italian gardens came in 1931 with the great exhibition on the Italian garden held at Florence in the Palazzo Vecchio. The exhibition, comprising prints, drawings, models, paintings, and photographs, occupied three floors of the palace in some fifty-three rooms. The exhibition was undoubtedly a political move to further the Fascist goal of propagating the glory of the nation. Ugo Ojetti, in the preface to the catalogue of the exhibition *Mostra del giardino italiano*, claimed that the art of gardening is "singularly ours" but has been obscured by other modes. He noted with particular pleasure that the Italian garden was being revived outside Italy and "especially in North America." No longer are Italian gardeners exported to foreign countries, but foreign designers come to study Italian gardens. He points out that the most accurate drawings and plans of Italian villas and gardens on exhibit in the show were by American artists, that is, fellows of the American Academy in Rome.

For almost the next quarter century the study of the Italian garden lost all interest. This was, of course, in part caused by World War II, which dispersed the Anglo-American communities in Tuscany and Rome. In America this lack of interest may also have been furthered by the neglect of the history of their fields by architects and landscape architects under the influence of the teaching of Walter Gropius at Harvard from 1937 to at least 1952. There seem to have been practically no publications on Italian gardens until the "discovery" of Bomarzo announced by Mario Praz in a 1953 issue of *Illustrazione italiana*. In 1955 appeared an entire issue of the *Quaderni dell'Istituto di Storia dell'Architettura*, with articles by five Italian scholars, devoted to Bomarzo. This opened the floodgates of publication on Bomarzo, although much of the resulting material in fact obfuscated our comprehension of the garden. Meanwhile, in 1954 James Ackerman's magisterial study of the Belvedere Court at the Vatican was published, demonstrating its innovative role in the development of landscape architecture and site planning.

Soon two general works on Italian gardens were published by Camillo Fiorani in 1960 and Barbara Johnson under the pseudonym Georgina Masson in 1961. The outstanding scholarship of the latter was obscured by its popular

presentation and lack of scholarly apparatus. A series of monographs and articles on individual gardens revived scholarship in the field, including my work on the Villa d'Este at Tivoli in 1960, Angelo Cantoni and his colleagues' on the Villa Lante at Bagnaia in 1961, Webster Smith's article on Pratolino in 1961, Eugenio Battisti's *L'Antirinascimento* of 1962, and Elisabeth MacDougall's Harvard dissertation on the Villa Mattei and Roman gardening in 1970. Much later, in 1979, Sir Roy Strong in the preface to *The Renaissance Garden in England* identified these studies as marking a new development in the subject, noting that "as an area of academic study, garden history is a relatively new one" and acknowledging his debt "to the pioneers in the field of Italian Renaissance studies, in particular the exemplary work by David Coffin and Eugenio Battisti."

The first Dumbarton Oaks Colloquium, "The Italian Garden," was held on 24 April 1971, and the resulting papers were published in 1972. The participants in the conference were concerned with the meeting as an attempt to revive interest in the discipline. Lionello Puppi, at the beginning of his paper on Venetian gardens, remarked that in the study of gardens there is "almost [a] total absence of the best qualified scholars." The quantity of negative replies that I received from my numerous letters and telephone calls to invite colleagues to participate confirms his observations. In the end I had to invite three foreign scholars to join one American for a minimum panel. At the meeting, however, one member of the audience was very aware, and probably disturbed, that the conference marked a new approach to the discipline. Angelo Cantoni, restorer of the gardens at Bagnaia, and Sir Geoffrey Jellicoe, coauthor of the 1925 collection of plans and drawings of Italian Renaissance gardens, were invited by Dumbarton Oaks to attend the colloquium as guests. Cantoni was taken ill on his trip to the States and had to return home, but Sir Geoffrey came. After the papers had been presented, Sir Geoffrey was invited to comment on the conference. Unfortunately there was no tape recorder to register his remarks, so we have to rely on my fading memory. After politely commending the participants for their papers, he added an admonition to the effect that we should always remember that the essence of the Italian garden was its design. Although the four papers at the colloquium often referred to elements of design, it was obvious that their major thrust was the meaning, the iconography, and the social context of the gardens. This, however, was not so much a generational difference as a difference in training and interests. Of the five partici-

pants in the colloquium, four of us were trained as art historians who approached the gardens as we would any work of art. Sir Geoffrey and many of his contemporaries were architects or landscape architects who looked to the Italian gardens primarily for what they might contribute to their own work, hence their concentration on design.

In the quarter century since the first colloquium there have again been many new developments in the subject, but I shall leave it to a member of the generation that has participated in those elaborations to survey them for you.

Bibliography

1884 Tuckermann, W. P. *Die Gartenkunst der italienischen Renaissance-Zeit.* Berlin.

1893 Platt, C. A. "Italian Gardens." *Harper's New Monthly Magazine* 87, 518 (July), pp. 165–180, and 519 (August), pp. 393–406.

1894 Platt, C. A. *Italian Gardens.* New York.

1897, "Accessories of Landscape Architecture." *The
1899 American Architect and Building News* 55 and 64, illustrations.

1900 Pray, J. S. "The Italian Garden." *The American Architect and Building News* 67 (Feburary 10), pp. 43–45; (February 17), pp. 51–52; (March 17), pp. 83–85; (March 24), pp. 91–92.

1901 Hamlin, A. D. F. "The Italian Formal Garden." *The American Architect and Building News* 71, pp. 43–45.

1902 Forbes, A. H. *Architectural Gardens of Italy.* New York.

1903 Eden, F. *A Garden in Venice.* London.

1904 Wharton, E. *Italian Villas and Their Gardens.* New York.

1905 Gnoli, D. "Il giardino e l'antiquario del Cardinal Cesi." *Mitteilungen des kaiserlich deutschen archäologischen Instituts: Römische Abteilung* 20, pp. 267–276.

1905 Latham, C. *The Gardens of Italy.* With descriptions by E. M. Phillips. 2 vols., London.

1906 Triggs, H. I. *The Art of Garden Design in Italy.* London, New York, and Bombay.

1907 Elgood, G. S. *Italian Gardens.* London, New York, Bombay, and Calcutta.

1908 Ashby, T. "The Villa d'Este at Tivoli and the Collection of Classical Sculptures Which It Contained." *Archaeologia* 61, pt. 1, pp. 219–256.

1909 Sitwell, G. *An Essay on the Making of Gardens.* London.

1912 Le Blond, A. *The Old Gardens of Italy: How to Visit Them.* London and New York.

1914 Cartwright, J. *Italian Gardens of the Renaissance and Other Studies.* London.

1914 Gothein, M. L. *Geschichte der Gartenkunst.* 2 vols., Jena; 2nd ed., 1926; English ed., London, Toronto, and New York, 1928.

1914 Williams, E. I. "Isola Bella." *Landscape Architecture* (July), pp. 167–170.

1915 Ponti, M. P. *Il giardino italiano.* Rome.

1916 Pauly, C. E. *Der venezianische Lustgarten: seine Entwicklung und seine Beziehungen zur venezianischen Malerei.* Strassburg.

1917 Hülsen, C. "Römische Antikengärten des XVI. Jahrhunderts." *Abhandlungen der Heidelberger Akademie der Wissenschaften, Philosophisch-Historische Klasse* 4.

1919 Dami, L. "Il giardino Quirinale ai primi del '600." *Bollettino d'arte* 13, pp. 113–116.

1922 Eberlein, H. D. *Villas of Florence and Tuscany.* Philadelphia and London.

1922–31 Gromort, G. *Jardins d'Italie.* 3 vols., Paris.

1923 Faure, G. *Les jardins de Rome.* Grenoble.

1924 Dami, L. *Il giardino italiano.* Milan.

[1925] Shepherd, J. C., and G. A. Jellicoe. *Italian Gardens of the Renaissance.* London and New York.

[1927] Damerini, G. *Giardini sulla laguna.* Bologna.

1928 Nichols, R. S. *Italian Pleasure Gardens.* New York.

1930 Gnoli, D. "Orti letterari nella Roma di Leon X." *Nuova antologia* 347, pp. 1–19, 137–148.

1931 Damerini, G. *Giardini di Venezia.* Bologna.

1931 *Mostra del giardino italiano: Catalogo, Palazzo Vecchio.* Florence.

1942 Bafile, M. *Il giardino di Villa Madama.* Rome.

1953 Praz, M. "I mostri di Bomarzo." *Illustrazione italiana* 8, pp. 48–51, 86.

1954 Ackerman, J. S. *The Cortile del Belvedere.* Vatican City.

1955 *Quaderni dell'Istituto di Storia dell'Architettura* 7–9 (July), pp. 3–76.

1956 Calvesi, M. "Il Sacro Bosco di Bomarzo." *Scritti di storia dell'arte in onore di Lionello Venturi*, vol. 1. Rome, 369–402.

1957 Lang, S. "Bomarzo." *The Architectural Review* 121 (January–June), 427–430.

1960 Coffin, D. R. *The Villa d'Este at Tivoli.* Princeton, N.J.

1960 Fiorani, C. *Giardini d'Italia: Arte, carattere e storia del giardino italiano.* Rome.

1960 Romanelli, P. "Horti Palatini Farnesiorum." *Studi romani* 8, pp. 661–672.

[1961] Cantoni, A., et al. *La Villa Lante di Bagnaia.* Milan.

[1961] Masson, G. *Italian Gardens.* London.

1961 Smith, W. "Pratolino." *Journal of the Society of Architectural Historians* 20, pp. 155–168.

1962 Battisti, E. *L'Antirinascimento.* Milan.

1964 McGuire, F. M. *Gardens of Italy.* New York.

1966 Lamb, C. *Die Villa d'Este in Tivoli: Ein Beitrag zur Geschichte der Gartenkunst.* Munich.

1967 Von Henneberg, J. "Bomarzo: The Extravagant Garden of Pier Francesco Orsini." *Italian Quarterly* 11, no. 42 (fall), pp. 3–19.

1969 Benedetti, S. "Sul giardino grande di Caprarola ed altre note." *Quaderni dell'Istituto di Storia dell'Architettura* 91–96, pp. 3–46.

1970 MacDougall, E. B. "The Villa Mattei and the Development of the Roman Garden Style." Ph.D. diss., Harvard.

1972 Coffin, D. R., ed. *The Italian Garden.* First Dumbarton Oaks Colloquium on the History of Landscape Architecture. Washington, D.C.

Notes

1. For Platt's book, see Keith Morgan, "Overview," in C. A. Platt, *Italian Gardens* (Portland, Ore., 1993), 97–117.

2. For the most recent information on Cecil Pinsent and his work, see the several essays in *Cecil Pinsent and His Gardens in Tuscany*, ed. M. Fantoni, H. Flores, and J. Pfordresher (Florence, 1996).

3. For an account of the preparation of the book, see G. Jellicoe, "An Italian Study, Being an Analysis of *Italian Gardens of the Renaissance* Published in 1925," in *Geoffrey Jellicoe: The Studies of a Landscape Designer over 80 Years* (Woodbridge, Suffolk, 1993), 61–157.

12

The Gardens of Venice

The gardens of Venice were hidden away, removed from the view of casual visitors, so that a French tourist in 1480 could assert that the city "is more inhabited than one has ever seen, for one does not see gardens and empty squares, and all the streets are very narrow."[1] Yet the Milanese canon Pietro Casola, visiting the island of Murano in 1494, remarked that "many more things could be said of this place and of its beauty and charm of being on water and having so many lovely gardens, still I shall leave it to someone else to say. Except that I cannot contain myself from repeating that there is nothing that has aroused in me more admiration in this city built upon water, than the fact of seeing how many beautiful gardens there are."[2] The densely inhabited urban areas around the Rialto Bridge or St. Mark's square left scant room for gardens other than roof terraces or small, walled-in enclosures hidden behind the tall walls that protected the palaces and houses from the narrow, bustling alleys. But as one wandered out to the edges of the city, to the Cannaregio toward the north or to the islands of Murano at the north and the Giudecca at the south, the gardens increased in size and number.

The garden of the Priuli family on Murano was renowned not only for its horticultural beauty, but as a location for an extraordinary variety of meetings.[3] A Latin epigram of 1494 commends the academy which assembled in the garden of Nicolò Priuli, while entries in Sanudo's diary—especially from 1513 to 1515, but even as late as 1526—record banquets held in the garden, often with performances of comedies and the company of gay courtesans. A Latin poem by Castaldi of 1502 offers an evocative picture of the garden centered around a fountain decorated with tigers from which rose a jet of water.[4] The garden beds were colorful with narcissi, violets, and roses, while other flowers lightened the dark groves, and golden apples hung from the swaying branches, hinting at the mythical garden of the Hesperides. Other garden features were a labyrinth of cypress and an aviary. Another resident of Murano, Trifone Gabriele, in his autobiography published in 1543, passionately reaffirmed that desire revived by Petrarch in the fourteenth century to find relief from the noise and conflicts of the city in the solitude of a garden: "Commotion is not agreeable to me, but rather solitude, not the Rialto, Saint Marks, and the piazzas."[5] So his humanist friends, such as Trissino, Manutius, and Stampa, would come to visit him at his garden, several of whom comment especially on the beauty of his pergola of white jasmine.

A visual image of some of the gardens on the island of the Giudecca is preserved in the magnificent woodcut map of Venice in 1500 by Jacopo de' Barbari (Fig. 1). Like the palaces in the densely inhabited center of the city, the building lots are long rectangles with the palace at one end, facing the canal, here at the north end of the premises, followed by a court and a garden stretching back

to the outer edge of the island. A good example is the Trevisan palace, Ca' Trevisan, left of center next to the long wooden bridge, the Ponte Lungo.[6] The facade of the palace faces the canal and toward the city at the north. At the rear of the palace, the ground floor is completely open, with an arcaded loggia giving onto an independent court and with a glimpse in the loggia of an external staircase to the *piano nobile*. The court, paved with terra-cotta and stone, has a wellhead at its center and is completely surrounded by a tall wall, converting it into an open room of the palace. A raised bank of plants runs about the interior of the walls, and a grill in the back wall offered glimpses into the garden behind. Down the center of the garden ran a long, vine-covered pergola flanked by horizontally cultivated beds, like in a kitchen garden. A tall, vertical wooden palisade surrounded all the gardens at the rear, cutting them off from the uncultivated edge of the island and the outer waters. Trees planted on the inner edge of the palisade mask it in the Trevisan garden. Sanudo, in his diary, again records the comedies performed by the company of the Ortolani, or Gardeners, in the Trevisan garden in 1515. Other noble families had similar gardens on the Giudecca: the Dandolo at the end of the island opposite San Giorgio Maggiore, where Sanudo reports feasts and entertainment in 1512 and in 1520; or the gardens of Doge Andrea Gritti; or those of the Mocenighi or of the Vendramini.[7] Pietro Aretino, the writer and blackmailer of princes, in 1549 praised "the garden which blooms" around the residence of Benedetto Cornaro and was especially admiring of the garden of his friend, the printer Francesco Marcolini, "since the breath of its air, the shade of its greenery, the fragrance of its flowers, and the song of its Petrarchan birds refresh, restore, delight, and lull one to sleep."[8]

The life and activities of one gentleman, Andrea Navagero, delineates how proud the Venetians were of their gardens and how involved some of them were in their

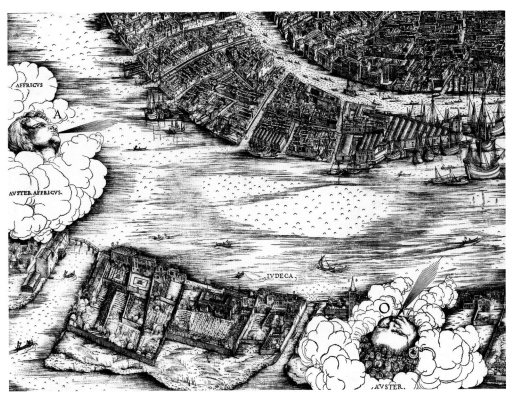

upkeep.[9] A close friend of many of the humanists in the Veneto, including Gianfrancesco Priuli and the poet Fracastoro, Navagero possessed two gardens, one at his permanent residence on the island of Murano and the other at Selva on the mainland. In 1516, at the age of thirty-three, he was appointed by the senate to be the official historian of the republic and librarian of the state library of St. Mark's. In May of the same year, he went to Rome to visit Bembo, then a secretary in the Vatican, and was taken by Bembo along with Agostino Beazzano, Castiglione, and the painter Raphael to visit Hadrian's Villa at Tivoli. During this Roman sojourn, Raphael painted a double portrait of Navagero and Beazzano, which Bembo once had at Padua. Although there is no evidence as to when and how Navagero came to own his residence on Murano, there is a letter of 1520 from the youthful Flemish humanist Christophe Longueil to Bembo describing the garden and Navagero's activities there. Longueil remarks that the garden "is planned and precisely ordered so that all the trees in the orchard and in the nursery are laid out in ranks in the form of a quincunx, and along the sides of his alley is most exquisite topiary." The quincunx was a

pattern for planting trees recommended in antiquity, using as its module five trees, four of which formed a square with the fifth in the center so that straight rows of trees were not only set at right angles to one another, but also on the diagonal. Longueil went on to say: "Truly the many apples exceeded my every expectation, arranged at discrete intervals and in a certain order, which I understand Navagero himself planted a few months previously." Longueil praised Navagero for devoting as much attention to his horticultural interests as to his humanistic pursuits. Further proof of this occurs three years later, when Navagero was sent with Lorenzo Priuli by the senate as their ambassadors to Charles V of Spain.

In the years 1525 and 1526, while Navagero was in Spain, he sent five extensive letters to his son-in-law, Giambattista Ramusio, who had been left in charge of the gardens at Murano and Selva, with detailed instructions for their maintenance. It was Navagero's descriptions of the water effects of the Moorish gardens at Granada, which were first printed in 1556, that would influence some of the waterworks at the later Villa d'Este at Tivoli. In May 1525, he bade Ramusio to thicken up all the trees so as to provide a dense wood (*bosco foltissimo*). On one wall, additional laurels were to be planted so that in time an espalier could be made. The same was to be done on another wall where roses grew. In order to ensure the growth of the new planting, cypress trees were also to be planted densely, since then an espalier could be formed by them. Later from Seville, homesickness for his beloved gardens bursts through his letter:

> Sweetest Ramusio, I care more for my gardens at Murano and Selva than for anything else in the world. You will wonder that I have time to think of them in the midst of all my labors, but I am a true Epicurean and should like to spend my whole life in a garden. Therefore, as you love me, dear Ramusio, take care of these beloved groves while I am absent from home, for this is the truest service that you can render me.

Part of the pleasure of being in Spain, however, was the discovery of new plants to be sent home to try in his gardens. From Barcelona, he forwarded specimens of the caronba tree for Murano. At Seville, he wrote that "the seeds which I have sent you with those of sweet oranges are of *Ladano*. The ones that were sent from Candia to our Frate of San Francesco were not true *Ladano*." The orange trees that were grown in Italy in the past and that continued to be popular much later were the bitter orange (*melangoli*), also known as the Seville orange, so that Navagero's importation of sweet oranges was quite early. The friar from San Francesco is mentioned several times. Once Navagero ordered the friar to plant as many rosebushes at Selva as possible, "so that all should be roses." The friar, who apparently served as gardener at Navagero's two gardens, was presumably a reformed Franciscan brother, Franceso Zorzi, of the monastery of San Francesco della Vigna.

Not only did the Venetian patricians have lovely gardens for the entertainment of their friends, but so did notable *nouveaux riches* like the painter Titian.[10] In 1531 he rented a house on the northeast of Venice behind the church of Santi Giovanni e Paolo, overlooking the lagoon. Sometime before 1540, a group of notable artists and literary men, mainly of Tuscan origin, assembled in Titian's garden, as described in a letter of Francesco Priscianese, the writer on Roman grammar:

> I was invited on the Calends of August to celebrate that type of Bacchanal which (I don't really know why) is called Ferragosto, even if much of the evening it was disputed, in a delightful garden of the Venetian Messer Tiziano Vecellio, a most excellent painter (as everyone knows) and truly a noble person in conducting with his pleasantries any splendid banquet.

In addition to Priscianese, there were three other guests: the writer Pietro Aretino, the sculptor Jacopo Sansovino, and Jacopo Nardi. After viewing the painting in the house, they went to the garden,

> which is placed in the extreme part of Venice on the seashore whence is seen the beautiful little island of Murano and other most lovely places. That part of the lagoon, as soon as the sun had gone down, was filled with thousands of small gondolas decorated with most lovely ladies and resounding with diverse harmonies both vocal and instrumental which accompanied our delightful supper until midnight. But returning to the garden, it was so well ordered and so beautiful, and consequently so praised, that the resemblance which it offered my mind to the most pleasant gardens of Sant'Agata [at Rome] of the

Most Reverend Monsignore Ridolfi, our patron (in so much as small things can compare with large ones), caused me to refresh our memory of his Most Reverend Lordship.

Priscianese thereupon began to describe the site and arrangement of the Roman garden, while others praised Ridolfi.

In the midst of this came time for dinner, which was no less beautiful and well arranged as copious and furnished (in addition to the most delicate food and most precious wines) with all those pleasures and amusements that suited the time and the people and the feast. And having already reached the fruit course, when behold your most delightful letter arrived. . . .

The letter, however, which asserted the superiority of the Latin language over the vernacular (*la lingua toscana*), infuriated Aretino, who demanded paper and ink to reply but was soon mollified. "Finally the dinner ended gaily."

Venice, by its location at the top of the Adriatic Sea and oriented toward the Near East, acted as a fulcrum between Europe and the East. Many unusual plants from the eastern Mediterranean and the Near East would be introduced into western Europe by way of Venice. Guillaume Pellicier, bishop of Montpellier and French ambassador of King Francis I to Venice from 1539 to 1541, had a garden at Venice where he acclimatized new horticultural imports before sending them on to France, particularly to the king at Fontainebleau.[11] In July 1540, Pellicier wrote the bishop of Tulle:

Since I know that His Majesty has pleasure in seeing and learning of all new and rare things, likewise of trees and herbs found useful, I have not failed to charge some merchants who go to Candia, Syria, and Alexandria in Egypt, who are my friends, begging them to send me any sorts that are found in those countries, of which for the most part they have remembered to send. And in order to experiment if they can come into this country from there, I have several herbs planted in my little garden, like *Colocasia* and others, which by being irrigated and cultivated not only have taken but are doing very well, and also some plants of Malvoisie and other unusual types of vines.

Later, in October, he wrote Rabelais, the French writer, that he was awaiting roots of "Nardus Celtica" (*Valeriana celtica*) and of the ranunculus he calls "Anthora" (*Aconitum anthora*), which should arrive in their native soil in small boxes to be transplanted into his garden. In 1541 he informed Rabelais that he would send on some plants from Candia when they arrived. Soon the ambassador wrote the king that he had heard from Sieur Polin of the king's pleasure in his services, and he informed the king that he wished his Venetian garden "to serve as the nursery for your very beautiful, incomparable Fontainebleau."

Notes

1. Quoted in L. Puppi, "Venezia: Architettura, città e territorio tra la fine del '400 e l'avvio del '500," in *Florence and Venice: Comparisons and Relations*, 2 vols. (Florence, 1980), vol. 2, 342.

2. See P. Casola, *Canon Pietro Casola's Pilgrimage to Jerusalem in the Year 1494*, ed. M. M. Newett (Manchester, 1907), 142.

3. M. Cermenati, "Un diplomatico naturalista del Rinascimento: Andrea Navagero," *Nuovo archivio veneto*, n.s., 24 (1912), 183–185; and L. Puppi, "I giardini veneziani del Rinascimento," *Il Veltro* 22 (1978), 284.

4. C. Castaldi, *La vita e le poesie italiane e latine edite e inedite di Cornelio Castaldi*, ed. G. B. Ferracina, 2 vols. (Feltre, 1899–1904), vol. 2, 147.

5. Puppi, "I giardini veneziani" (note 3 above), 282.

6. V. Fontana, "Giardini alla Giudecca," in *Il giardino veneto: Dal tardo Medioevo al Novecento*, ed. M. Azzi Visentini (Milan, 1988), 83.

7. For gardens on the Giudecca, see Puppi, "I giardini veneziani" (note 3 above), 286–287.

8. A. Quondam, "Nel giardino del Marcolini: Un editore tra Aretino e Doni," *Giornale storico della letteratura italiana* 157 (1980), 75–76.

9. Cermenati, "Un diplomatico naturalista" (note 3 above), 164–205; J. Cartwright, *Italian Gardens of the Renaissance* (New York, 1914), 115–122; and A. Navagero, *Opera Omnia*, ed. G. A. Volpi and G. C. Volpi (Padua, 1718), passim. Navagero's letters from Spain were first published in *Raccolta delle lettere di XIII huomini illustri*, ed. T. Porcacchi (Venice, 1556).

10. G. Padoan, *Momenti del Rinascimento veneto* (Padua, 1978), 379–381; and J. Schulz, "The Houses of Titian, Aretino, and Sansovino," in *Titian: His World and His Legacy*, ed. D. Rosand (New York, 1982), 78–82.

11. J. Zeller, *La diplomatie française vers le milieu du XVIe siècle d'après la correspondance de Guillaume Pellicier* (Paris, 1881), 135–138.

13

Repton's "Red Book" for Beaudesert

The winter of 1813–1814 in England was so severe that contributors to *The Gentleman's Magazine* vied with one another to recall similar circumstances. Under such miserable conditions Humphry Repton, the landscape gardener, as he described himself on his trade card,[1] prepared "during a Month's confinement by the severest winter & deepest Snow remembered" one of his famous Red Books, in this case for improving the grounds of the estate of Beaudesert in Staffordshire. On folio six of the manuscript, Repton comments on the foggy atmosphere that pervaded Beaudesert during the ten days early in December 1813 when he surveyed the lands in preparation for the Red Book, which, as he noted on the first folio, was completed at his home at Harestreet near Romford, Essex, on January 7, 1814. This Red Book is now preserved in the Robert H. Taylor Collection of manuscripts and rare books recently bequeathed to the Princeton University Library.[2]

As Repton's Red Book would not be considered a work of literature, Mr. Taylor's excuse for its purchase as one of his last notable acquisitions was that Jane Austen had referred to Repton as an "estate improver" in her novel *Mansfield Park*. Probably because of his training as an architect, Mr. Taylor was always particularly sensitive to any relationship between literature and the visual arts, as demonstrated by his outstanding collection of the work of Max Beerbohm or his albums of Thackeray's drawings.[3] In Jane Austen's *Mansfield Park*, first published in 1814, Mr. Rushworth, visiting the estate of Sir Thomas and Lady Bertram in Northamptonshire, has just left his friend Smith, whose grounds at Compton had recently been "improved" by Humphry Repton. As a result Rushworth can only talk about the possibility of improving his nearby estate at Sotherton Court, and his future wife, Miss Bertram, urges him also to employ Repton. Although Rushworth notes that Repton's "terms are five guineas a day," he later resolves to have Repton.[4]

Not only is the 1814 date of the Repton Red Book appropriate for *Mansfield Park*, but Repton's commission was to improve the grounds of an Elizabethan house like Mr. Rushworth's Sotherton Court. Even the scandal which closes the novel, when Mrs. Rushworth runs off with Henry Crawford, "intimate friend and associate of Mr. R.," had its parallel in the notorious scandal that had arisen about Lord Uxbridge, owner of Beaudesert, and which may have inspired the incident in Jane Austen's novel.

Throughout his career Humphry Repton normally prepared a book of his drawings accompanied by a handwritten explanatory text for any commission he was seeking or awarded. Attached to most of the drawings depicting actual topographical scenes were small flaps, called "slides" by Repton, which when lifted revealed the scene in the transformed condition Repton proposed. These oblong folios, usually about 8¾ inches by 11¾ inches,

were then bound in red morocco and presented to the owner, who often exhibited his Red Book in the library or on the card table at the entrance of his house to ensure that visitors were aware of the "fashionable improvements" he had undertaken. The Red Book for Beaudesert, however, is physically very different from most of the others. The pages, larger than usual, are vertical in format, 15 inches by $10^{1/2}$ inches, and are bound in brown leather tooled in gold.[5]

The estate of Beaudesert near Rugeley in Staffordshire had been an ecclesiastical holding seized during the Reformation and eventually owned by Sir William Paget, created Baron Paget de Beaudesert by Edward VI in 1549. During the reign of Queen Elizabeth his son, Thomas Paget, built the large mansion whose grounds Repton proposed to refashion in 1814. Henry William Paget (1768–1854), who, as second Earl of Uxbridge, called upon Repton's advice, had a career touched with both heroics and scandal. Married in 1798 to Lady Caroline Elizabeth Villiers,[6] Paget had already begun a military career which would bring him fame as probably the most skillful cavalry commander in Europe. In 1809, however, he eloped with Charlotte Wellesley, wife of the younger brother of the future Duke of Wellington. A year later, the couple married, having been divorced by their respective spouses, but for the next five years they had to withdraw from society because of the scandal they had occasioned. It was during this retirement that Paget succeeded his father as the second Earl of Uxbridge (1812) and soon after requested Repton's ideas for improving his estate at Beaudesert.

Paget's father had consulted Repton in 1798 about Plas Newydd, an estate in Wales standing on the Menai Straits.[7] The Reverend Stebbing Shaw, in his history of Staffordshire (1798), notes that the first Earl of Uxbridge had made extensive improvements at Beaudesert, including the stables and coach houses of white stone in the form of a crescent, and the kitchen garden beyond the stables "at a considerable distance," but that other improvements were "in contemplation (after he has finished his new house in Anglesea)."[8] This suggests that the second Earl, in calling in Repton later to survey Beaudesert, was following the example or even the plan of his father. Shaw praises the landscape of Beaudesert, noting that it "wants nothing but water to render it exquisitely grand and perfect." Repton will later agree, and will suggest several projects to create lakes and cascades. Shaw also informs us that the rather mysterious landscapist

William Emes or Eames earlier laid out the walks and pleasure grounds of Beaudesert, inspired by the nearby Needwood Forest.

Before turning to landscape design in 1788, Repton had literary expectations which encouraged his correspondence from at least 1786 with the poetess Anna Seward, known as the Swan of Lichfield. She informed him as early as 1789 that "Emes laid out Beaudesert, which is on the edge of Needwood, very finely; and is thus complimented upon the subject by Mundy, in his beautiful poem which celebrates and bears the name of our forest."[9] Francis Mundy's poem "Needwood Forest," which honors Emes's improvements of Beaudesert, was first made public in 1776, offering a date *ante quem* for this work.[10] Very little is known about William Emes (1729–1803), who is usually described as a follower of the famous landscapist Capability Brown. It may be that Emes's earlier work in Wales at Chirk Castle (from 1764) and Erddig (from 1767) and in Staffordshire itself at Oak Edge (1771) caused his employment at Beaudesert.

A series of letters written in 1773 by Lord Paget and his agents and preserved in the Staffordshire Public Record Office is concerned with the building and planting of the kitchen garden which the Reverend Shaw singled out for praise. It is probable, therefore, that Emes was commissioned about 1773 to oversee the landscaping at Beaudesert. On September 1, 1773, Paget's agent, William Edlington, reported that "the Walls [of the kitchen garden] are built," and he hopes that a suitable gardener has been hired.[11] Later letters indicate, however, that the search for a gardener was unsuccessful and would be quite protracted. In the meantime, John Beecroft, gardener of Warwick Castle, oversaw the purchase and did the actual planting of the fruit trees and vines. On September 20, the nurserymen William and John Perfect at Pontefract informed Beecroft that they had failed in a search in "the Country" to find suitable "pine plants," but that if he would forward them a plan of the kitchen garden they would select appropriate fruit trees for "the different Situations."[12]

The Pontefract nursery of the Perfects was active at least from the beginning of the eighteenth century, having furnished trees for John Aislabie's extravagant garden park at Studley Royal in 1717 and 1718; it survived under the family's ownership until 1810.[13] On October 4, the nursery acknowledged the reception of a plan with a list of the trees, seeds, and tools necessary for the new garden, and at the end of the month Beecroft sent Lord Paget a plan of the garden and an account of what was undertaken.[14]

| *Repton's "Red Book" for Beaudesert*

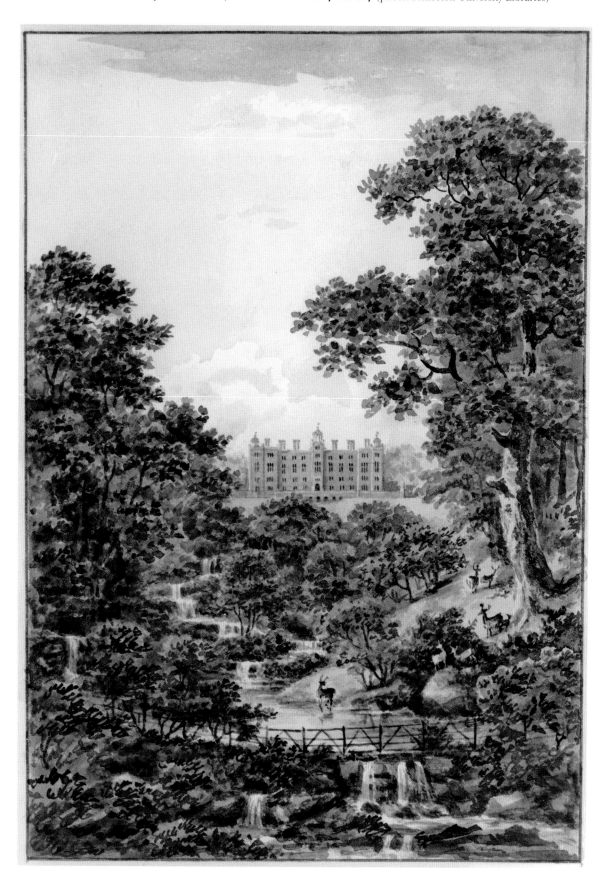

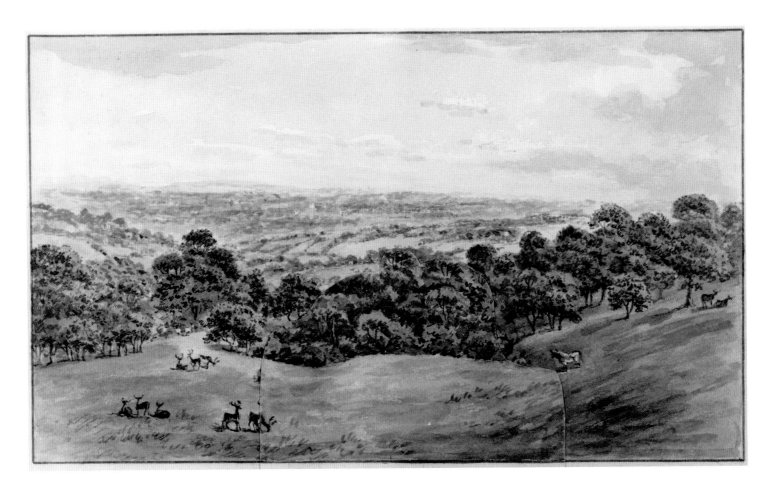

Fig. 2a. "View towards the East from the Library . . ."

Finally, on November 1 the nursery informed Beecroft that the planting material, comprising "thirteen matted bundles, three hampers and small sack" had been dispatched, and that they had returned the plan of the garden with notes regarding the planting.[15] The Perfects also proposed as a possible gardener one Alexander Robinson, aged about fifty, who had once worked at Duncombe Park and after that at Wentworth House for five or six years, but was now unemployed. Some forty years later, Humphry Repton's plan of 1813–1814 was to suggest a complete relocation of the kitchen garden created in 1773 and to revise the park laid out by Emes, which may have suffered neglect because of the first Earl's concern at the turn of the century for his Welsh estate of Plas Newydd.

Apparently very little was accomplished of Repton's ideas for Beaudesert. The major activity advocated by Repton in the wooded park was the removal of trees, unlike most of his commissions. He will recommend planting Castle Hill at Beaudesert, but comments that he has "seldom seen a place where [planting] is less absolutely nec-

essary" (fol. 5 recto). He notes in the Red Book that "many of these trees [have] been taken away during my first visit" (fol. 4 recto) and, in his discussion of the view from the mansion to the west, that some tall trees are already removed (fol. 7 recto). Very soon the second Earl of Uxbridge will resume his military career, which may explain why Repton's proposals were not pursued. In April 1815 Paget was appointed cavalry commander of the allied forces under Wellington, thus being the second in command at Waterloo on June 18, where Paget, while conferring with Wellington, was struck by grape shot, necessitating the amputation of his right leg. Elevated to be Marquess of Anglesey, Paget was promoted to full general in 1819, but the active military career of "One-leg" ended with Waterloo. Soon he would become involved in political affairs with Wellington, and in 1828 was made Lord Lieutenant of Ireland.

In 1935 the Tudor mansion at Beaudesert was largely destroyed, and Plas Newydd in Wales remained the principal estate of the Marquess of Anglesey. Beaudesert became a scout camp, and further ruin ensued. The luxurious oak forest is logged by the Forestry Service. But the

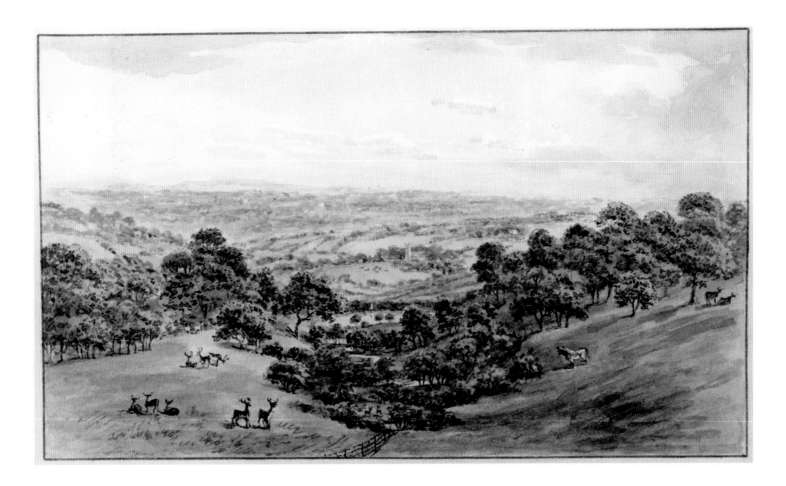

Lichfield gatehouse and the crescent-shaped stable block still exist.[16] Remains of the kitchen garden are preserved where the original garden was built and planted in 1773 north of the location of the house.

*

Repton's dedication of the Red Book to the second Earl of Uxbridge remarks on his military career and hopes that his improved estate "may furnish many future years of Enjoyment to you—when the fields of battle shall be superceded by the Gardens of Peace, & when the necessity of defending the country may give place to the Satisfaction of improving it" (fol. 1 recto). Thus, Repton evokes the old theme so popular in England of retirement to the country and the pleasures of gardening, following the examples of General Fairfax at Nun Appleton, Sir William Temple at Moor Park, and Lord Cobham at Stowe.

The first section of the Red Book, entitled "Character and Situation," and section two, "The Situation," are standard in Repton's Red Books. The remaining sections will then vary according to the particular problems involved,

although there will almost always be sections devoted to "The Approaches," "Plantations," and "Water."[17] Repton, in his first treatise on landscaping in 1795, insisted that there must be "due attention to the Character and Situation of the place to be improved; the *former* teaches what is advisable, the *latter* what is *possible* to be done."[18] Alexander Pope's "Genius of the Place" has thus become prosaically a basic principle of Repton's landscaping. He notes at Beaudesert that the mansion of Tudor style, Elizabethan in date, although Repton refers it to Henry VIII, stands as a "massy pile" at the edge of the royal forest, but that, as its name indicates, it was not to be in a desert or haunt only of wild beasts. It was, of course, to be a beautified desert, a Beaudesert, appropriate to man's enjoyment. The courtyards and terraces of the past are to be preserved and restored so that there will be a clear demarkation between the

Fig. 3a. "Under these lower Slides, is shewn the effect of restoring the original Style of Geometrical Gardens. . . ."

gardens or pleasure grounds where man dwells and the "Forest or Desert which belong to the Denizens of the Chace." Constant throughout Repton's career has been a concern for the relationship between man's habitation of regular forms and the irregularity of the natural setting. His famous predecessor, Capability Brown, banished any formal features from his designs, whether terraces or parterres, allowing his naturalistic landscaping to run unhindered up to the foundations of the mansion. Later in the Red Book (fol. 8 recto), Repton speaks of creating a terrace and privy garden as a transition between the worlds of man and of nature. He claims that he "discovered thro' old Labourers on the premises, that in the line of the Terrace & other parts of the artificial Garden proposed, we are restoring the place to what they remember it to have been in the beginning of the last century."

Because of his concern for the character of the old mansions whose grounds he is improving, Repton's ideas in his late work, such as at Beaudesert, are dominated by historicism. He even acknowledges (fol. 2 verso) that John Shaw (1776–1832), architect and antiquarian, Fellow of the Society of Antiquaries, has assisted on the architectural features proposed for Beaudesert. In fact, in 1814 Shaw exhibited at the Royal Academy a drawing for the Lichfield gatehouse at Beaudesert.[19]

Under "The Situation," Repton asserts that all the beauties of the estate of Beaudesert are concealed. For

him beauty in landscaping depends upon four features: Inequality of Ground, Rocks, Water, and Wood, all characteristic of the Picturesque attitude toward landscaping first enunciated by William Gilpin. At Beaudesert only the wood prevails because the abundance of trees hides the other features. In a brief sketch on folio three, Repton illustrates how trees grow taller in the valleys than on the hills, thus leveling visually the inequalities of the ground which are so essential to Picturesque beauty.

The only solution is to remove some trees, allowing the other features of water, rocks, and irregular ground to be visible. In his watercolor entitled "Scene in the Dell," Repton illustrates how effective this thinning of the woods may be. The watercolor, with its covering slide illustrating the scene as it was before improvement (Fig. 1a), presents only a rather dense forest of large trees with a few small figures hidden in it. Repton apparently suggests that the wild nature of that forest brings out in man his animal passions, for at the lower right two small figures seem to be in combat. The scene "improved," with the slide raised (Fig. 1b), reveals dramatically the Tudor mansion at the top of the hill framed by large trees. An irregular stream flows along the base of the valley, broken by small cascades which will be created by stopping the current with large stone ledges wherever the natural stream is narrowest, thus making the water more visible. This watercolor illustrates the east facade of the house, with the stream plunging down the hillside into the water-meadows below, which Repton intended to convert into a broad lake, on

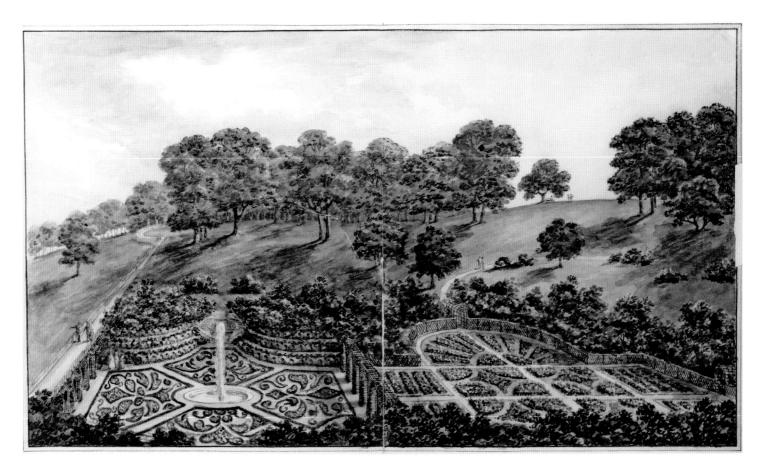

the bank of which was to be located a new kitchen garden.

The Red Book for Beaudesert is particularly concerned with the vistas from the old mansion, for there are four sections, each devoted to the view toward one of the four geographical points of orientation. In Repton's watercolor of the "View towards the North from the Music Room," trees are again removed to reveal the main access road spanning a deep ravine on a bridge or viaduct. It is here that he indicates, as noted above, that "many of these trees [have] been taken away during my first visit." He is conscious of possible objections to the destruction of the old trees, the same accusations of willful destruction that his predecessor Capability Brown often suffered, but Repton points out that one tree may hide forty others.

Perhaps because of Repton's concern for the possible objections raised against his destruction of old trees, the next section of the Red Book, entitled "Of Plantations," does discuss a location at Beaudesert where some planting is desirable, although he notes that he has seldom seen a site where it was less absolutely necessary. His watercolor following folio five depicts Castle Hill southwest of the mansion as "a naked hill" which is to be planted with trees. He carefully enumerates the types of trees that are suitable

Fig. 3b. "Under the upper Slide, is shewn the effect of taking away some trees to admit the light of a Southern Sun & an indefinite extent of Lawn." Humphry Repton, Red Book for Beaudesert, Staffordshire. Robert H. Taylor Collection, Princeton University Library (photo: Princeton University Libraries)

to the landscape, for ever since his first Red Books and their adaptation in his first treatise, *Sketches and Hints of Landscape Gardening* (1795), Repton has insisted on the appropriateness of certain trees, particularly in their shape, to certain modes of architecture or other plantations. Thus, "conic" trees, that is, firs, are unsuitable with the Gothic style of architecture, where only "round-headed" trees should be planted. Here at Beaudesert, oak and Spanish chestnut should be the major types used, never "conic shaped trees which belong rather to the Scenery of Norway or of Scotland." Hornbeam and hazel may be blended in the copses, and the nurse trees should be birch to the east and sycamore to the west. "Thorns, Crabs and Holleys" should be planted in the proportion of five or six for every tree. Juniper may be added in dry locations, and alder in moist with some Scotch firs; "but as to Poplars,

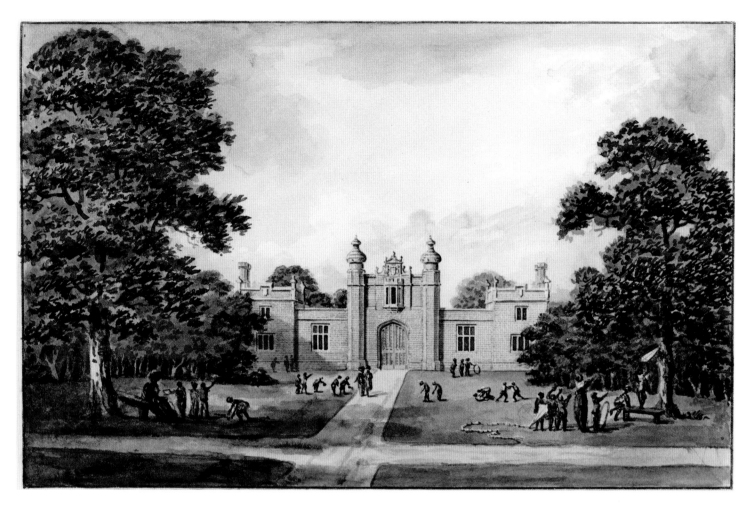

Larch & Spruce Procul oh procul! este prophani" (Away, away, you who are common). Added, probably later, is a consideration of winter greens: "In winter, great advantage may be taken of native Evergreens, Holly, Yew, Box & Ivy." Certainly added later in a lighter ink: "Ivy is not the Enemy of trees—I hope I have proved it to be Decus et Tutamen [ornament and defence]—vide Linnean Transactions." This is a reference to a paper prepared by Repton and read on April 17, 1810, to the Linnean Society of London in which he claimed that ivy growing on trees was not necessarily injurious, but even beneficial to them, quoting examples at some eight sites, including Blickling, Wimpole, and Woburn Abbey.[20]

The section and its accompanying watercolor, entitled the "View towards the East . . . ," is concerned with the vista away from the house, in contrast to that toward the house discussed above. Seen from the library (Figs. 2a and b), the dell below the house is excavated and thinned out, permitting a glimpse of the expanse of water planned for the Water Meadows below, and beyond the latter a church, presumably that of St. James in the little village of Longdon.

Repton claims that the woods in the valley not only hides the land in the bottom, but foreshortens the distance between the house and the village, noting that modern improvers mistakenly and selfishly limit views to the land belonging to the estate.

The view toward the west from the end window of the Great Hall of the mansion is also improved by thinning the woods to permit a glimpse of a cascading stream. Since the southern vista is diminished by painted glass in the lower panels of the windows, the lower panels of the great window in the Great Hall must be clear plate glass to permit the broad view. On the south side, however, will be several new features, particularly a "Lofty Terrace & secluded Privy Garden" as well as the more "modern Luxuries of hot house & Conservatory." It is here, as noted

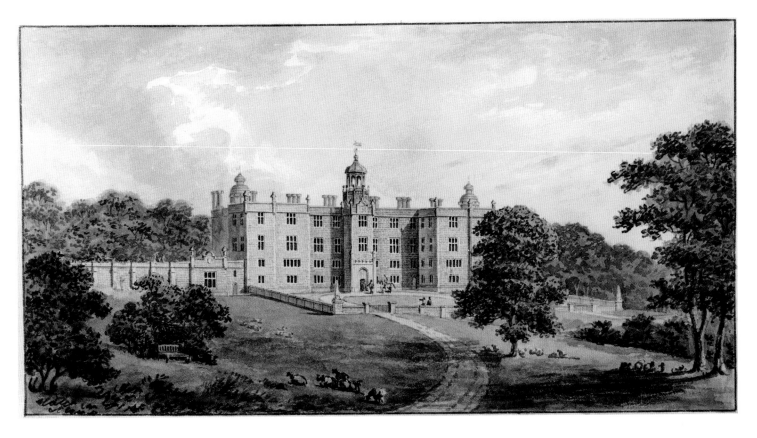

Fig. 5. "The East Front, with the proposed additions, or restored parts. . . ." Humphry Repton, Red Book for Beaudesert, Staffordshire. Robert H. Taylor Collection, Princeton University Library (photo: Princeton University Libraries)

before, that Repton was pleased to discover from some of the old laborers of the estate that his terrace and private garden would restore the layout as they claimed to recall it almost a century previous. As the gardens are to be private, he wishes to mask them by adding shutter-blinds or stained glass to the lower panels of the windows of the Billiard Room, thus admitting only the upper part of the landscape. This he depicts in a double-page watercolor with three superimposed slides (Fig. 3a).

After the turn of the century, formal gardens or parterres become an important element in Repton's late mode of "improving." Such formal gardening also accompanied the growing historicism apparent in Repton's late designs. As early as 1804, when the Duke of Bedford commissioned Repton and his son, the architect John Adey Repton, to build and landscape a lodge at Aspley Wood (Bedfordshire) in the "style and date of buildings prior to the reign of Henry VIII," he designed an old-fashioned

Tudor garden with topiary, labyrinths, and a selection of flowers suggested by the Tudor portraits in the duke's great house at Woburn Abbey. At Ashridge Park (Hertfordshire) in 1813, just prior to his work at Beaudesert, he planned several rather formal flower gardens, including a very decorative Rosary and a Monk's Garden around a Gothic-style water fountain appropriate to that house, which had been fashioned out of the remains of a medieval abbey.

The two formal and private gardens Repton proposed to plant on the south side of Beaudesert have recently been labelled the "apotheosis of the Repton parterre," and their prophetic spirit has been evoked by likening them to the gardens of the Victorian landscapist William Nesfield (1793–1881).[21] In the "improved" picture (Fig. 3b) a straight, terraced walkway at the left marches determinedly into the distance, separating the formal gardens from the park. The left parterre is slightly sunken, with a tall jet of water rising from a central pool surrounded by floral compartments planted in the form of fleurs-de-lis. At the rear, curved stairs flanked by sweeping, curved, floral terraces exit into the park. Separated from this parterre by a trellis is another formal garden of a rectangular shape with a semicircular exedra at the rear. This garden on the right, which is at ground level, is fenced

Fig. 6a. "View from the Water Meadow . . ."

and has an arched trellis exit at the rear. These formal gardens are Repton's attempt to emphasize the Tudor quality of the site, although the left garden with its tall jet of water and curvilinear floral decoration seems more in the spirit of French seventeenth-century gardening. In his commentary Repton notes: "Under the upper Slide, is shewn the effect of taking away some trees to admit the light of a Southern Sun & an indefinite extent of Lawn. These lofty trees being on ground steeply sloping to the house, project such long Shadows that the whole surface is dark & the gardens would be to[o] much Shaded."

In the section on "The Approaches," Repton condemns the idea of Capability Brown and his followers that

> the Importance of [the mansion] is supposed to be increased by the length of the approach. Therefore according to the best receipt for *Modern gardening*

or Improvement (all Gardens being exploded as being unnatural) a Serpentine road is led twisting & writhing about till it reaches one corner of a house placed on a Naked Lawn, like a Cottage on a Common; but without even the fence which protects the Latter from the Common Cattle; how different from the Antient Palace! surrounded and defended by Courts & Iron gates, which separated their gardens from the forest, & kept not the distinction betwixt Man & beast!

Appropriate to the Tudor mansion, he proposes to restore the "quadrangle or Basse Court in front" and to move the Porter's Gate to the entrance of the park instead of the entrance to the court. Rather than the "modern practice of a pair of Lodges," which is condemned elsewhere for its symmetry and for the lack of habitable space in each lodge, Repton wishes a large gatehouse to which the Countess's School might be moved. The watercolor of the

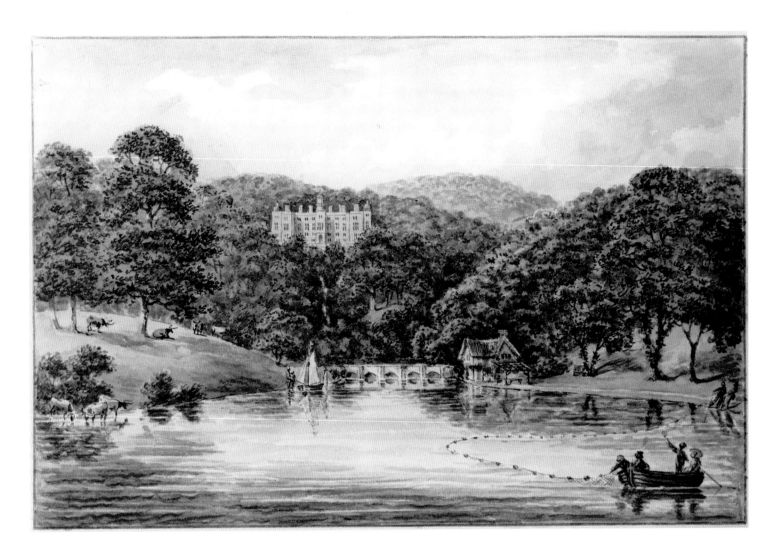

Fig. 6b. ". . . & also the Effect of the Lakes proposed."
Humphry Repton, Red Book for Beaudesert, Staffordshire.
Robert H. Taylor Collection, Princeton University Library
(photo: Princeton University Libraries)

gatehouse (Fig. 4) illustrates this function with an idyllic scene of children flying a kite at the right, and in the center boys doffing their caps politely to a pair of adults, perhaps the earl and his countess.

A watercolor of the east facade of the house depicts the forecourt Repton plans to restore, enclosed with a low wall and decorated with obelisks at the corners (Fig. 5). At the left is the new terrace that protects the formal gardens behind it from cattle in the park, pictured in the foreground. The comment on the illustration points out that "a Turret" is to be added "to the Clock Tower."

The Reverend Shaw in 1798, as noted previously, lamented the lack of water at Beaudesert. Throughout the eighteenth century, water in the form of lakes, streams, and cascades was a prime feature for landscaping. So, early in the century, the site of Houghton Hall (Norfolk), residence of Sir Robert Walpole, the domineering Prime Minister, was regularly condemned for its lack of water for ornamental purposes, although the architect Sir Thomas

Robinson considered the site otherwise so agreeable that he thought only envy could arouse criticism.[22] Even the estate at Hagley (Worcestershire), praised by the poet Thomson in his *Seasons*, was nevertheless criticized by later more Picturesque-minded visitors for its want of water.[23] Repton points out that water attracts the eye; it is the first feature perceived and the last to keep the spectator's attention. On the east side, where there were several small houses in the Water Meadows (Fig. 6a), he planned to dam up the small stream so as to flood the meadows. The watercolor of the "improved" site is a delightful scene (Fig. 6b). In the foreground a wide expanse of water is enlivened by fishermen and a sailing boat, while the mansion, now visible through the thinned woods, towers

| *Repton's "Red Book" for Beaudesert*

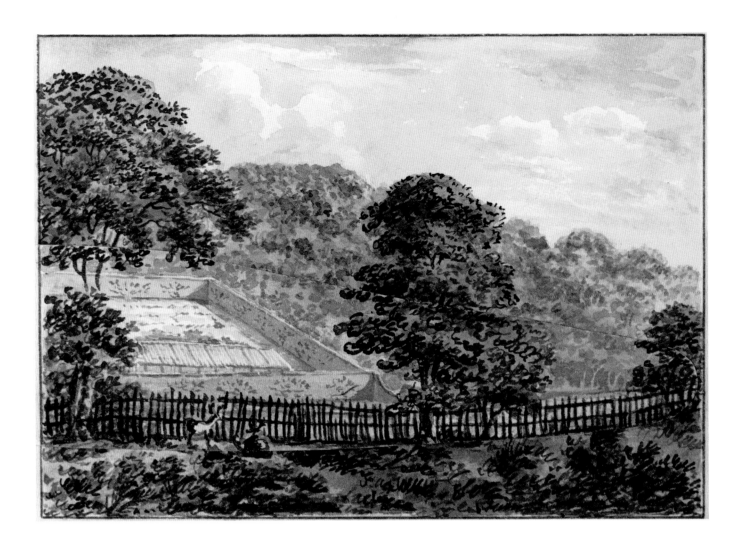

Fig. 7a. "Fruit and Kitchen Garden. In former times . . . the views from a house were little considered . . ."

above the access bridge over the river.

Of all his proposals, perhaps the most important change Repton planned was to remove the kitchen garden, created by the previous earl in 1773 on the north beyond the stables, to the banks of the new lake at the east. The original walled-in garden is depicted set into the hillside with a long hothouse crossing it (Fig. 7a). Since the Shropshire Brook flowed through the garden, Repton took advantage of it to replace the garden with another lake (Fig. 7b). He warns in his commentary that this removal of the kitchen garden will require much time and cost and "will deserve very serious deliberation." This warning and the Earl's return to military activity undoubtedly prevented the realization of Repton's plans for the kitchen garden, which remained at its original location.

To move the kitchen garden from its distant and rather hidden site, to visual prominence on the north bank of the new lake in front of the mansion, reflects Repton's wish to improve and renew the setting in a mode appropriate to the "Style & Antiquity of Beaudesert." He points out that in the earlier days it was desirable and convenient to have the kitchen garden near the house, with little consideration given to the views from the building. During the Tudor period the orchard and the kitchen garden were at least of equal importance with the flower garden, and all three were situated somewhat haphazardly next to the residence as, for example, at the royal palace at Hampton Court. During the eighteenth century, with its interest in a broad landscape sweeping up to the mansion, the kitchen garden was often banished to a hidden corner, as here at Beaudesert when it was located beyond the stables to the north.

Repton includes on a fold-out page a watercolor plan of the new kitchen garden accompanied by a section of the garden on which are apposed lines of sight and of

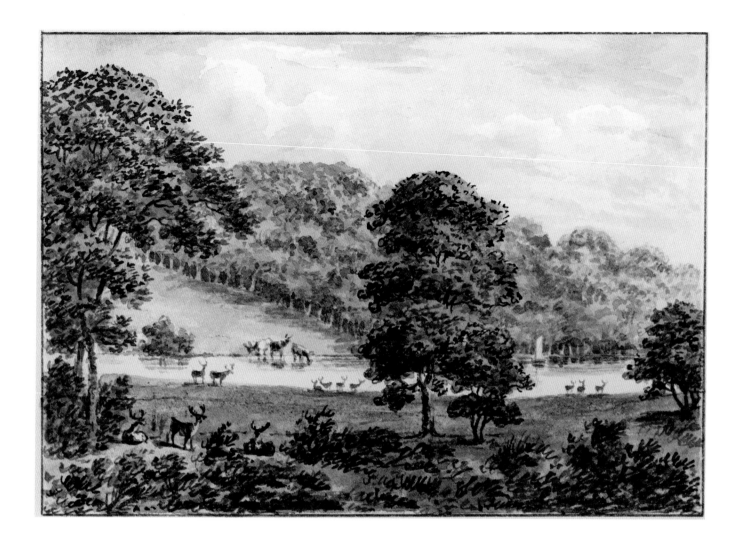

sunshine. In his discussion of the new garden, Repton points out that he wishes to feature it visually, and ends the Red Book with a watercolor view of the garden from "the opposite high bank [of the lake] near the Approach" (Fig. 8). The walled-in garden is terraced into the steep bank, with "the corners to be marked with Turrets or Pavillons, which Mr Shaw will of course make to correspond with the date of the House." The upper wall was to have recessed arches which Repton notes are copied from those of Oxnead Hall in Norfolk, dating from the time of Queen Elizabeth. Oxnead Hall had been the principal Tudor residence of the famous Paston family, whose archive of letters has been of inestimable value to the social and economic history of fifteenth-century England. With the death in 1732 of the last member of the family, the second Earl of Yarmouth, Oxnead Hall was abandoned. As reported in 1744 by the antiquarian Tom Martin: "The Hall, now in the utmost Ruins, is a deplorable sight."[24] Repton, before becoming a landscape

gardener, had lived for some eight years in Norfolk at Sustead, and his younger brother John was a farmer dwelling in a wing left from the ruins of Oxnead Hall. Therefore, Humphry Repton was personally cognizant of the remains of the Tudor hall. In 1809 his elder son, the architect and antiquarian John Adey Repton, drew a reconstruction of the mansion for John Britton's *The Architectural Antiquities of Great Britain*. The reconstruction depicts a garden in front of the house rather similar to his father's project for the kitchen garden at Beaudesert (Fig. 9).[25]

During Repton's active years as a landscape designer, two major ideas dominated his thinking and differentiate

| *Repton's "Red Book" for Beaudesert*

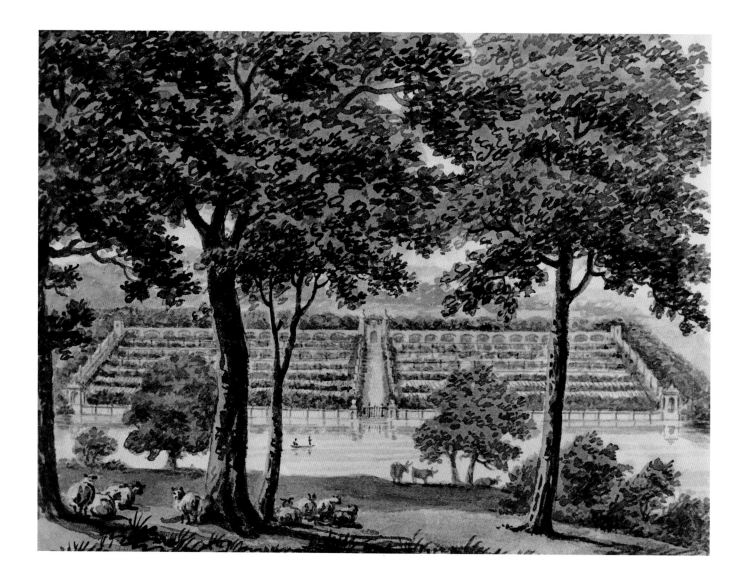

Fig. 8. "Of the New Garden. Instead of endeavoring to conceal the Garden, I think it might be made a feature of the Place in character with the Style of Antiquity of Beaudesert. . . ." Humphry Repton, Red Book for Beaudesert, Staffordshire. Robert H. Taylor Collection, Princeton University Library (photo: Princeton University Libraries)

his early style of landscaping from his later mode. In the late eighteenth century, Repton was involved in the "Picturesque controversy" with his friend Richard Payne Knight and with Uvedale Price, both of whom had published in 1794 accounts of the Picturesque which attacked the landscaping of Capability Brown and by implication of Repton, as he believed. He in turn added an appendix to his treatise of 1795 condemning particularly their idea that landscape design should be modelled on landscape painting. Repton will repeat his opposition in several of his Red Books of the period, such as that for Attingham Park in Shropshire.[26] It was Repton's credo that landscape design must adhere to principles derived from nature, its proper sphere of concern, and not from other arts. Much of this "tempest in a teapot" was occasioned by the fact that Knight and Price were primarily theorists, thinking somewhat abstractly, and generally limited in practice to their own estates or to giving advice to friends, in contrast to the more pragmatic practitioner Repton, who had to appeal to a variety of patrons and work at diverse sites.

With the nineteenth century, Repton began to reject more of Capability Brown's feigned naturalism and the consequent destruction of formal elements. He began reviving terraces, parterres, and formal gardens as a gradual transition from the regularity of man's habitation to the irregularity of nature. So in his last treatise, *Fragments on the*

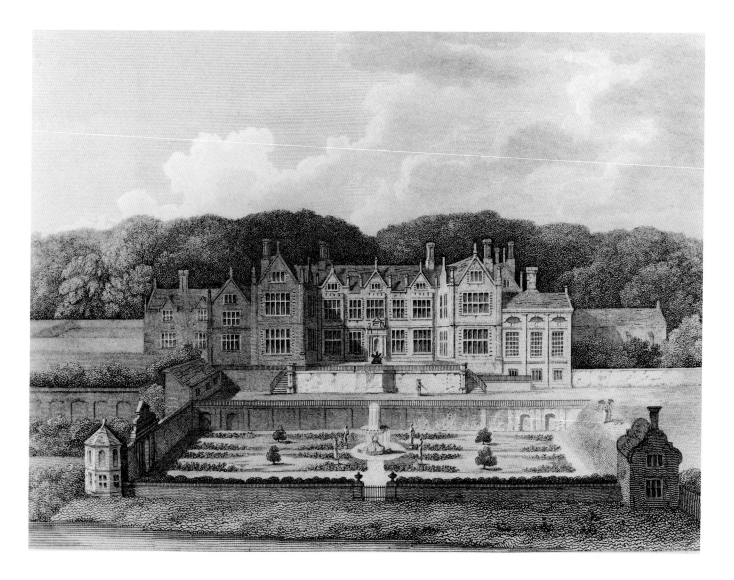

Theory and Practice of Landscape Gardening (1816), a garden will be defined as

> a piece of ground fenced off from cattle, and appropriated to the use and pleasure of man: it is, or ought to be, cultivated and enriched by art with such products as are not natural to this country, and, consequently it must be artificial in its treatment, and may, without impropriety, be so in its appearance; yet there is so much of littleness in Art, when compared with Nature, that they cannot well be blended: it were therefore to be wished, that the exterior of a garden should be made to assimilate with Park Scenery, or the Landscape of Nature; the interior may then be laid out with all the variety, contrast, and even whim, that can produce pleasing objects to the eye, however ill adapted as studies for a picture.[27]

Fig. 9. Oxnead Hall, Norfolk. Restoration by J. A. Repton, from J. Britton, *The Architectural Antiquities of Great Britain*, vol. 2 (London, 1809), following p. 98

This concern for the relationship between art and nature has haunted almost every generation, which has often allowed one of the two elements to dominate the other. Hence the reaction in the mid-eighteenth century of the generation of Capability Brown to the formal gardening to which Henry Wise subjected England in the early eighteenth century. Today, as landscape architects and architects have parted company, the same problem arises. The Red Book of Beaudesert offers one of Repton's more attractive presentations of how man's world of habitation, the world of art, may be related to nature, and restores the formal garden to its traditional role of mediator between man and nature.

Notes

1. G. Carter, P. Goode, and K. Laurie, *Humphry Repton, Landscape Gardener, 1752–1818* ([Norwich], 1982), 13, pl. 9.

2. Purchased in 1984. Twenty-four folios (six blank folios, title page, twelve text folios, and eleven drawings) 15" × 10½". Pasted on the back of the front cover is an engraving of Beaudesert from S. Shaw, *The History and Antiquities of Staffordshire* (London, 1798), vol. 1, pl. XVII opposite p. 221, which in turn reproduces plate VIII of R. Plot, *The Natural History of Stafford-Shire* (Oxford, 1686).

Long selections from the Red Book of Beaudesert, but completely revised, are published by Repton in his last treatise, *Fragments on the Theory and Practice of Landscape Gardening* (London, 1816), fragment XI, and these in turn were later reproduced by J. C. Loudon, *The Landscape Gardening and Landscape Architecture of the Late Humphry Repton, Esq.*, new ed. (London, 1840), 445–452.

3. E. D. H. Johnson, "Romantic, Victorian, and Edwardian," *The Princeton University Library Chronicle* 38 (1977), 222–224.

4. The artist Joseph Farington records in his diary on June 8, 1794, that Repton "charges 5 guineas a day to those who employ him besides his expenses," and Farington repeats this on June 20, 1799 (J. Farington, *The Diary of Joseph Farington*, ed. K. Garlick and A. MacIntyre, vol. 1 [New Haven and London, 1978], 198, and vol. 4 [1979], 1242).

5. Regarding the physical size of Red Books, see Carter, Goode, and Laurie, *Humphry Repton* (note 1 above), 21.

6. For the life of Uxbridge, see the Marquess of Anglesey, *One-Leg: The Life and Letters of Henry William Paget, First Marquess of Anglesey, K. G. (1768–1854)* (London, 1961). H. Colvin's architectural history, "Beaudesert, Staffordshire," in *Transactions of the Ancient Monument Society*, n.s., 29 (1985), 107–123, became available too late to be used for this study.

7. Carter, Goode, and Laurie, *Humphry Repton* (note 1 above), 164. A letter dated Nov. 4, 1798, in the Staffordshire Public Record Office (D 603/K/16/5), addressed by Repton from his home in Essex to Paget at Plas Newydd, reports that Repton and his son expect to be there by Nov. 13 or 14 after stopping at Lord Berwick's estate of Attingham Park in Shropshire.

8. Shaw, *History and Antiquities* (note 2 above), 221.

9. A. Seward, *Letters of Anna Seward* (Edinburgh, 1811), vol. 2, 309–314.

10. F. N. C. Mundy, *Needwood Forest, and the Fall of Needwood, with Other Poems* (Derby, 1830), pp. vi–vii.

11. Stafford, Staffordshire PRO, D 603/K/9/5, fol. 70. Mr. Dudley Fowkes of the Public Record Office permitted me to see his manuscript inventory of estate maps and aided my search for material on Beaudesert. Colvin, "Beaudesert, Staffordshire" (note 6 above), 116, records a letter by Emes of May 10, 1771, regarding the landscaping.

12. Stafford, Staffordshire PRO, D 603/K/9/5, fol. 77.

13. J. Harvey, *Early Nurserymen* (London and Chicester, 1974), 66.

14. Staffordshire PRO, D 603/K/9/5, fols. 85 and 91. Three late-eighteenth-century plans of the garden and its planting preserved in the Staffordshire Public Record Office (D 603/H/1/7, 8, and 9) may be related to this work. In Lord Paget's correspondence (D 603/K/12/2) there are many other letters regarding gardening, gardeners' salaries, etc.

15. Staffordshire PRO, D 603/K/9/5, fol. 96.

16. Mr. Mel Newman of nearby Rugeley, who may be the most knowledgeable scholar of the topography and remains of the site of Beaudesert, very generously reviewed with me the present site.

17. The sections in the Beaudesert Red Book are titled:
1. Character and Situation (fol. 2)
2. The Situation (fol. 3)
3. View to the North (fol. 4)
4. Of Plantations (fol. 5)
5. View towards the East (fol. 6)
6. View to the West (fol. 7)
7. View to the South (fol. 8)
8. The Approaches (fol. 9)
9. Of Water (fol. 10)
10. Fruit & Kitchen Garden (fol. 11)
11. Of the New Garden (fol. 12)

18. H. Repton, *Sketches and Hints of Landscape Gardening* (London, [1795]), 1.

19. H. Colvin, *A Biographical Dictionary of British Architects, 1600–1840* (London, 1978), 728–729; and A. Graves, *The Royal Academy of Arts: A Complete Dictionary of Contributors . . . 1769 to 1904* (London, 1906), vol. 7, 94.

20. H. Repton, "Observations on the Supposed Effects of Ivy upon Trees, in a Letter to the President," *Transactions of the Linnean Society of London*, 1815, 27–34.

21. Kedrun Laurie on "The Pleasure Ground" in Carter, Goode, and Laurie, *Humphry Repton* (note 1 above), 58.

22. Historical Manuscripts Commission, *The Manuscripts of the Earl of Carlisle* (London, 1897), 85, letter of Dec. 9, 1731; other less qualified condemnations are offered by Lord Hervey in 1727 (John Lord Hervey, *Lord Hervey and His Friends, 1726–38*, ed. Earl of Ilchester [London, 1950], 70–71) and Lady Beauchamp Proctor in 1771 (E. Moir, *The Discovery of Britain* [London, 1964], 80).

23. John Parnell in his 1770 diary (J. Sambrook, "Parnell's Garden Tours: Hagley and The Leasowes," *Eighteenth-Century Life* 8, n.s., 2 [January 1983], 57); W. Gilpin, *Observations, Relative Chiefly to Picturesque Beauty, Made in the Year 1772, . . . of Cumberland and Westermoreland* (London,

1786), vol. 1, 60; and Viscount Torrington in 1781 (J. Byng, Viscount Torrington, *The Torrington Diaries*, ed. C. B. Andrews [London, 1934], vol. 1, 48).

24. R. W. Ketton-Cremer, *Norfolk Assembly* (London, 1957), 214.

25. In 1844 John Adey Repton published a revised reconstruction with a partial inventory of the house in *The Gentleman's Magazine*, n.s., 21, pt. 1 (1844), 21–24 and 150–153. In the article he mentions his previous reconstruction of 1809 and notes that his uncle, John Repton, dwelt there until his death in 1809.

26. E. Malins, ed., *The Red Books of Humphry Repton* (London, 1976), vol. 3, fol. 1r.

27. H. Repton, *Fragments on the Theory and Practice of Landscape Gardening* (London, 1816), 141–142.

14

The Elysian Fields of Rousham

During the Middle Ages gardens were associated naturally with those biblical themes devoted to gardens or landscape, such as the Garden of Eden, or terrestrial paradise, and the Heavenly Paradise.[1] Similarly, Solomon's *Song of Songs*, with its celebration of the *hortus conclusus* and its symbolism of the virginity of Mary, gave meaning to the cloister gardens of the monasteries and the walled-in gardens of the castles. With the advent of the Renaissance, gardens shared with all the other facets of Italian culture in their reformation on the model of ancient culture, although the transformation of gardening was rather late, coming only in the sixteenth century. Classical *topoi*, often derived from ancient mythology, such as Mount Parnassus or Hercules and Antaeus, dominated the decoration of Italian gardens, and the classical myths of the Garden of the Hesperides or the Golden Age, parallels of the biblical Garden of Eden, became the themes of some Italian gardens.[2] In England, however, Francis Bacon as late as about 1625 could still commence his charming essay *Of Gardens* with the statement that "God *Almightie* first Planted a *Garden*" and devote his extended first paragraph to identifying those plants which irrespective of the English seasons would guarantee a *ver perpetuum* (a perpetual spring) like that of the Garden of Eden.

Gradually, although very late, classical themes began to appear in English gardening, and one of the more interesting ones is that of the Elysian Fields. The Greek poet

Homer in Book 4 of the *Odyssey* promised Menelaus, king of Sparta, that he would not die in Argos but would be transported to the Elysian Fields at the western, outermost edge of the earth where there are no storms, nor snow, nor rain. Later the poet Vergil in the *Aeneid* (VI.539ff.) has his hero descend to the Elysian Fields to seek his father Anchises, who is among those chosen to live peacefully in the shady groves and verdant meadows. The Elysian Fields are, therefore, the paradise of classical antiquity set aside for those of virtue or valor.

As one might expect, it would seem to be John Evelyn, the seventeenth-century horticulturist and great garden enthusiast, who appropriated the concept of Elysium or the Elysian Fields from the poets and applied it to actual gardening. From about 1653 Evelyn began to write what he undoubtedly expected to be his magnum opus on horticulture, which was to consider every aspect of gardening, including the history of gardens.[3] For more than forty years Evelyn accumulated material until toward the end of his life he abandoned the project and began to pillage some of the material for other publications. His book *Acetaria*, published in 1699, was actually the third chapter of Book II of the projected work. By the end there must have been about a thousand pages of text or notes that overwhelmed him, as he hints in a letter of 1703: "What I gathered of this nature . . . would astonish you, did you see the bundles and packets amongst other things in my

chartaphylacia here promiscuously ranged among multitudes of papers, letters and other matters."[4] About three hundred leaves of the ill-fated treatise are still preserved in the Christ Church Library at Oxford.

In 1659 Evelyn printed a synopsis of this projected treatise, presumably to arouse the expectations of readers, and in November 1669 he announced in the *Philosophical Transactions* of the Royal Society its imminent publication. Both announcements gave the title of the work as the "Elysium Britannicum." Picking up the classical association of the Elysian Fields with virtue, Evelyn wrote Sir Thomas Browne in 1660: "Our drift is a noble, princely, and universall Elysium, capable of all the amoenities that can naturally be introduced into Gardens of pleasure. . . . We will endeavour to shew how the aire and genious of Gardens operat upon humane spirits towards virtue and sanctitie."[5] In the same letter Evelyn lists all the gardens throughout the world that he will discuss, starting with Paradise and followed directly by the Elysian Fields and the Garden of the Hesperides.

At least some of Evelyn's friends were still perturbed by his insistence on using the classical, pagan reference, for in a letter of February 1660 Jeremy Taylor, later bishop of Dublin, objected: "But that which I promise to myself as an excellent entertainment, is your 'Elysium Britannicum.' But, Sir, seeing you intend it to the purposes of piety as well as pleasure, why do you not rather call it Paradisus than Elysium." And in a later letter of November 1661 Taylor insisted on referring to Evelyn's work as "your 'Terrestrial Paradise.'"[6] Although Evelyn's "Elysium" would never be published, knowledge of it was widespread during the second half of the seventeenth century and early eighteenth century among English intellectuals and gardening enthusiasts, who are often the same men.

It was in the eighteenth century that the classical theme of the Elysian Fields was realized in England in horticultural form at one of the most famous of eighteenth-century gardens, that of Richard Temple, first Viscount Cobham, at Stowe Manor in Buckinghamshire.[7] The gardens at Stowe had been gradually evolving over a long period, commencing about 1715 with the earliest garden design by Charles Bridgeman in a formal manner inspired by French seventeenth-century gardening. In the early 1730s the English painter William Kent, who had then earned more fame in architecture and would soon do so in landscape design, began to introduce some garden architecture at Stowe accompanied by a more naturalistic landscape setting. The formal gardening of Bridgeman had been generally confined to the southwestern side of the manor, as the access road came up from the south through open fields to attain the house on its eastern side behind the church of the manor.[8] Previous to Kent's engagement the access road was moved to the west to follow the outer edge of Bridgeman's formal gardens, reaching the house from the north. In the farmland freed toward the east Kent fashioned a small artificial stream running down a valley in a series of elongated pools between small artificial hills. On one hill Kent erected a circular structure called the Temple of Ancient Virtue.

All the guidebooks to Stowe gardens—and it is here that the idea of a garden guidebook printed for public visitors evolved—describe the area designed by Kent as the Elysian Fields with its river, the Styx.[9] The Temple of Ancient Virtue, based on a reconstruction of the ancient Roman temple of Vesta by the Italian Renaissance architect Palladio, contained the statues of four ancient Greeks renowned for their virtuous acts. Their pedestals inscribed in Latin with their accomplishments, there were the lawyer Lycurgus, the philosopher Socrates, the poet Homer, and the general Epaminondas. Near the Temple of Ancient Virtue Kent built a Temple of Modern Virtue in ruins, now lost, beside which stood a headless statue in contemporary clothes. Set in the valley across the river Styx is the Temple of British Worthies, an exedra or curved wall in which are the busts of sixteen British notables—eight men of intellectual accomplishment, such as Shakespeare, Locke, Francis Bacon, and Newton, and eight men and women of action, including Drake, Raleigh, Queen Elizabeth I, and King William III.

The area known as the Elysian Fields, therefore, expressed a personal theme for Temple, a leader of the wing of the Whig party that was particularly opposed to the Excise Bill of 1733 of the Whig prime minister, Robert Walpole. Temple was punished by dismissal from command of his regiment and, in a typical English gesture, retired to his garden just at the moment Kent took over the garden design. So, responding to the classical association of virtue with the natural enchantment of the Elysian Fields, Temple declared modern virtue to be in ruins, and presumably the headless statue was Walpole.

Temple was also pointing out that British men and women of action and thought should turn to antiquity. They must look up to antiquity just as the Worthies at Stowe down in the valley across the Styx look up to the Greek home of virtue for their moral example. Each of the busts of the English leaders also has a Latin inscription describing

Fig. 1. Plan of Rousham estate, Rousham (photo: Country Life)

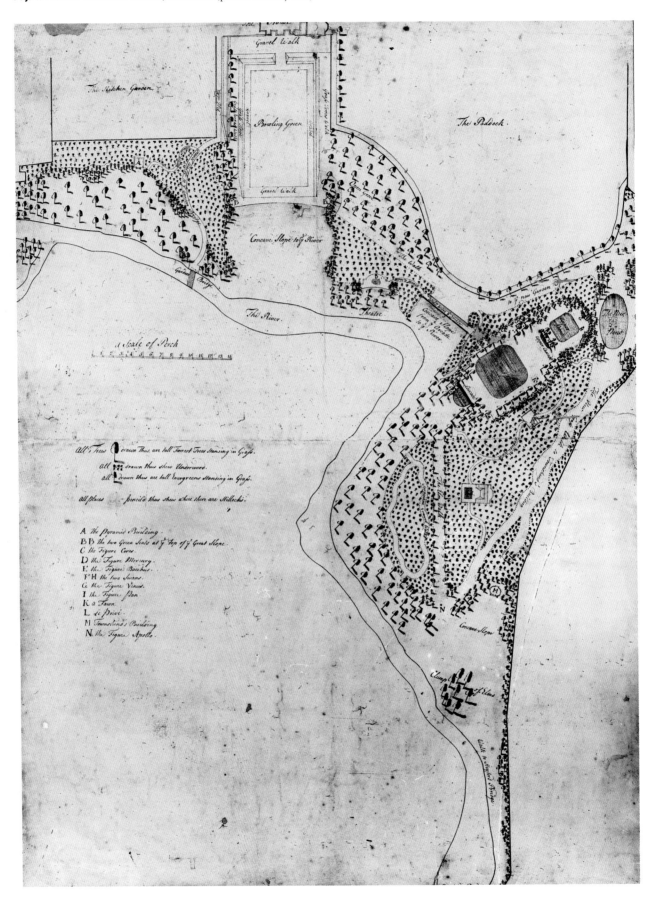

his or her accomplishments. In the oval niche set above in the central pyramid of the Temple of British Worthies was once a head of the classical deity Mercury, guide to the Elysian Fields, with the inscription: "Campos Ducit ad Elysios." On the rear of the exedra was an inscription, often unnoticed but recorded in 1735, honoring a favorite dog of the family, an Italian greyhound named Fido.[10] The eulogy of his inscription, as well as his name suggesting fidelity as the principal virtue of a dog, defines his right to be memorialized here along with the virtuous Englishmen.

The garden theorist Thomas Whately, discussing the character of gardens in his treatise *Observations on Modern Gardening*, published in 1770 but written about 1765, identified a mode he labeled "emblematic," which he obviously disliked and felt was being replaced in his own time by an "expressive" character.[11] The combination at Stowe of inscriptions with images to express the meaning of the garden belongs to such an "emblematic" mode, recalling sixteenth-century Renaissance emblems. The inscriptions are important, however, in permitting the visitor to comprehend very readily the meaning of the area of the Elysian Fields at Stowe, which is not true of a later garden design of William Kent.

In 1737 General James Dormer, a former officer with the Duke of Marlborough and later special ambassador to Portugal, inherited the estate of Rousham near Oxford. The manor house at Rousham faces the small river Cherwell flowing between Banbury and Oxford (Fig. 1). The kitchen garden was located to the east of the house, and an enclosed paddock was on the west. Just previous to Dormer's inheritance the so-called New Garden had been laid out west of the house on the slope running down from the paddock to the river. This New Garden had been designed by Charles Bridgeman, the first garden designer at Stowe, in a formal manner with geometrically designed water basins and straight paths in the woods. With the possession of Rousham by General Dormer, William Kent, having just established his fame at Stowe as a garden designer, was called in by at least 1738 to revise the New Garden park in his more naturalistic mode of gardening and to add some classical sculpture within the garden.

In front of the house at the edge of the greensward or bowling green, just before the

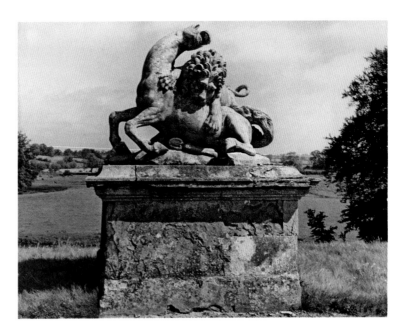

Fig. 2. Peter Scheemakers, *Lion and Horse*, Rousham (photo: Country Life)

terrain dropped off into a bowl at the edge of the river, Kent erected by 1743 a statuary group of a lion attacking a horse carved by Peter Scheemakers (Fig. 2).[12] The group was derived from an ancient piece of sculpture that once stood on the Capitoline Hill at Rome and is now in the Capitoline Museums. Interestingly, for some reason, the group at Rousham is not a direct copy of the ancient

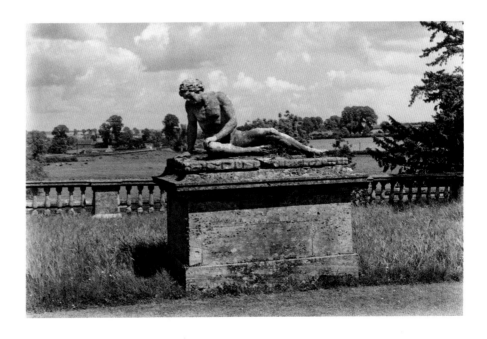

Fig. 3. Peter Scheemakers, *Dying Gladiator*, Rousham (photo: Country Life)

| *The Elysian Fields of Rousham*

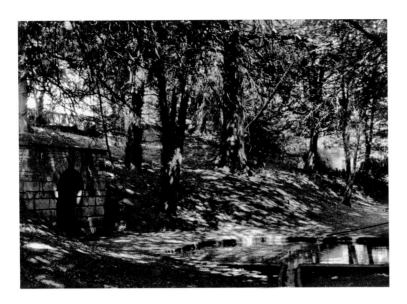

Fig. 4. Proserpina's Grotto and Rill, Rousham (photo: author)

sculpture, as seen in the position of the head of the horse, but is a copy of a version made in the early seventeenth century to decorate the Fountain of the Rometta in the Villa d'Este at Tivoli in Italy. There the group was meant to symbolize the struggle between Tivoli and Rome and the domination of Rome, the lion, over Tivoli, the horse,[13] but presumably not so at Rousham.

Just beyond the bowling green of the house toward the west, the river Cherwell makes an acute angle toward the north. William Kent's major work was then devoted to developing the woodland of the so-called New Garden along the south side of the river just west of the house. Kent's garden was arranged with a circuitous walk running through the edge of the woods. A letter of 1750 of the gardener John MacClary, better known as Clary, defines the itinerary a visitor might take, and we should follow his instructions, starting into the wood at the northwestern corner of the bowling green.[14] The walk through the upper part of the woods is protected by a ha-ha or ditch along the south side of the garden which restrains the livestock in the paddock from invading the garden. Suddenly the visitor comes upon an opening closed on its north side by a long stone balustrade from which there are magnificent vistas out over the surrounding countryside on the north similar to the views from the bowling green in front of the house. Within this opening in the woods is another copy by Scheemakers of an ancient statue, then called the Dying Gladiator, also in the Capitoline Museums (Fig. 3).[15]

The existence at Rousham of the two copies by Scheemakers of ancient statues in Rome has apparently puzzled most garden historians, who have merely identified the figures without attempting to offer a reason for the choice of their subjects. A drawing by Kent indicates that he once planned to set the figure of the Dying Gladiator on a pedestal in the form of an ancient sarcophagus, which was never executed. It has been suggested, therefore, that "the strong mortuary associations" of the two statues were to offer an appropriate memorial to General Dormer, who was mortally ill in 1741.[16]

Some distance beyond the opening with the statue of the Dying Gladiator, the path turns right toward the north and descends rather steeply down to the Cherwell below, this peripheral path being labeled on the plan of probably 1739 as "the new Grass Walk to Townshend's building" (Fig. 1). Clary's letter of 1750 and the plan both indicate that there was an alternate route, the "little Serpentine Gravil Walk" of Clary, which ran roughly parallel to the "new Grass Walk," but within the woods down to the so-called Cold Bath (Fig. 4). The latter is an octagonal water basin in front of a low cave or grotto set into the hillside and with a serpentine rill, one arm of which flows toward Venus's Vale within the center of the woods, and the other out to the "new Grass Walk" near Townesend's Building. No explanation has ever been offered for the existence of the so-called Cold Bath, but Clary's letter of 1750 gives a clue to this feature and, in fact, to the meaning of the entire garden-park.

In 1750 Clary noted that along the serpentine gravel walk just above the Cold Bath was at that time "a pretty little Gothick Building, (which I designed for Proserpines Cave, and placed in it five Figures in Bass Relife, done by the best Hand in England, the two princeable figures, was pluto and proserpine, the other three, was proserpines Chaplain, Doctor, and her Apothecary, but my Master not likeing the Doctor, I chopt them all down)."[17] Clary's account is a rather incomprehensible description probably garbled by his attempt to be amusing. Later he will claim to have seen twenty-five trout swimming in the serpentine rill, which at least today is only a very shallow rill about one foot in width, adequate only for miniature goldfish. The listing of a chaplain, doctor, and apothecary for Proserpina likewise sounds like an attempt at levity probably inspired by Kent's Cave of Merlin at Richmond for Queen Caroline. What is important in Clary's letter is the association of this area with the ancient goddess Proserpina, for this explains the existence of the so-called Cold Bath.

A rather obscure legend regarding the Greek goddess Persephone, or Proserpina in Latin, is preserved by the ancient Greek topographer Pausanias in his description of the region of Boeotia (IX.39.2).[18] Pausanias recounts that the young Persephone was playing one day with a friend, Hercyna, who had a pet goose which escaped them and hid in a nearby cave. Persephone entered the cave to recapture the goose, and, as she lifted a rock under which the goose lurked, water spouted forth to form a river. It was not necessary for Kent to know the legend in Pausanias, for one of the most popular artists' handbooks on mythology, Vincenzo Cartari's *Imagini de gli dei delli antichi*, contained the tale.[19] Published first in Venice in 1556, it had numerous later editions. The sale catalogue of Kent's library after his death in 1748 lists a copy of the 1626 Paduan edition of the handbook among his effects.[20]

Proserpina, the daughter of Ceres, was, of course, a fertility goddess fated to spend half the year in the Underworld with her husband Pluto, ruler of the Underworld, and half the year above ground with her mother Ceres. Significantly, therefore, Proserpina's cave and rill at Rousham are part way down the slope of the hillside below the upper level of the garden and of the house and above the lower level of the river. Hence there is the suggestion that the actual river Cherwell below the garden symbolizes the river Styx which bounded the classical underworld of the Elysian Fields. Here at Rousham, then, in contrast to Stowe, Kent did not have to manufacture a new river Styx.

At the end of the descent near the river, a visitor, according to Clary, would turn right and follow a path into the woods. Eventually one could glimpse at the end of the path the large arched niches of the great arcade known as Praeneste, actually the retaining wall for the terrace on which is the statue of the Dying Gladiator (Fig. 5). Before reaching the arcade, however, there opens out at the right a lovely glade mounting the hill within a grove of trees (Fig. 6). Originally a series of small cascades flowing out of rustic arches enlivened the center of the quiet valley. At this lower level the classic statuary of the Lion and the Horse and of the Dying Gladiator is no longer visible, for they are to recall the existence of conflict and strife and of death pervading the upper world. The statues, planned earlier but finally set up in 1743 after the death of General Dormer, indicate that he has escaped the tribulations of this world and is in the home of the virtuous and valorous, the Elysian Fields, visible here in the peaceful valley within the woods.

Unlike at Stowe, there are no inscriptions to define or identify the scene. The one exception at Rousham is a modest inscription, ignored by most visitors, set into the rustic arch of the middle cascade to commemorate the burial there of a pet otterhound, Ringwood (Fig. 7). This inscription recalls the one in the Elysian Fields at Stowe celebrating their pet dog, so that it may be presumed that whoever authorized the dog's burial at Rousham was aware of the association of this valley with the concept of the Elysian Fields.

Other statues in the valley, however, suggest that this area is to recall more than the Elysian Fields. Standing above the uppermost cascade was a copy of the ancient statue known as the Medici Venus, from which the valley has usually been called Venus's Vale. Below, at the edge of the woods on each side of the middle cascade, were statues of Pan and of a faun. Farther along the walk paralleling the river was a spurting fountain, behind which stood a figure of Mercury flanked by Bacchus and Ceres.[21] None of these statues seems appropriate to the Elysian Fields except the Mercury, who is, of course, the guide to Elysium as seen also at Stowe. The rustic deity Pan in Venus's Vale may, however, clarify the reason for the other statues. Pan, of course, was particularly associated with the area of Arcadia in ancient Greece, which the Roman poet Vergil depicted as a lovely rustic home of shepherds. Cartari's book on classical mythology, which furnished Kent with the legend regarding the young Proserpina, also claimed that the deities Venus, Ceres, and Proserpina, as well as

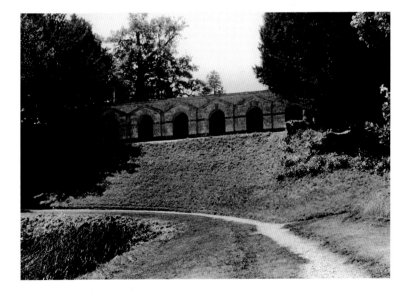

Fig. 5. Praeneste Arcade, Rousham (photo: author)

| The Elysian Fields of Rousham

Pan, were worshipped in Arcadia.[22] The valley with its statues is, therefore, also to recall the famous theme *Et in Arcadia Ego* developed in the seventeenth century, particularly in paintings by the French artist Poussin and continuing in popularity into eighteenth-century England.[23] The Latin inscription *Et in Arcadia Ego* can be translated "And I (that is, Death) too am in Arcadia," suggesting that Death also resides in the lovely countryside of Arcadia, coming inevitably to the peaceful shepherds there. Soon this same theme will appear in at least two other English gardens. In 1759 the poet William Shenstone, who owned and personally laid out his famous garden-park at The Leasowes, wrote his friend, the Reverend Richard Graves:

> . . . pray, did you ever see a print or drawing of Poussin's Arcadia? The *idea* of it is so very pleasing to me, that I had no peace till I had used the inscription on one side of Miss Dolman's urn, "Et in Arcadia Ego." Mr. Anson has the two shepherds with the monument and inscription in alto relievo at Shugborough. Mr. Dodsley will borrow me a drawing of it from Mr. Spence. See it described, vol. I, page 53, of the Abbe du Bos, "sur la poesie et la peinture."[24]

The relief in the park of Shugborough mentioned by Shenstone was carved by Peter Scheemakers for Thomas Anson, older brother of Admiral Lord George Anson.[25]

The suggestion that Venus's Vale at Rousham also reflected the Arcadian theme associates at least two somewhat different meanings with the same area. Both, however, endow a lovely landscape setting with mortuary overtones. This conflation of ideas is possible as there are no inscriptions involved which might define the meaning more specifically. The mode of expression at Rousham is obviously quite different from that at Stowe. The "emblematic" character identified later by Whately was waning at Rousham, which was inclining more toward his "expressive" mode or what will later be called associationism.[26] The importance of the garden at Rousham as a late work of Kent is that already about 1740 he is offering hints of shifting from the early-eighteenth-century mode of expression to that of a later period. So at Rousham the meaning is not only conveyed by the various pieces of statuary, but by the topography or physical condition of the site, with the slope down to the river involved in the meaning. It may be presumptuous to point out that the garden is also set west of the house, recalling in Homer

that the Elysian Fields were west of the known, inhabited, living world. The garden at Rousham was, of course, located there previous to Kent's involvement, but the geographical orientation along with the topography of the site might have suggested to Kent or to the general or to some of his friends the concept of the Elysian Fields, which later became so appropriate as a commemoration of the owner.

Clary in the letter of 1750 identifies numerous other statues, busts, and bas-reliefs scattered through the garden and the several garden houses. Many of these were undoubtedly antique pieces no longer extant at Rousham and probably were only included in the decoration to give an authentic antique air to the garden, as well as to satisfy the general's passion for collecting sculpture. Some, however, may have related to the garden themes. As noted above, there was a fountain of Mercury, flanked by Ceres and Bacchus, the Mercury and Ceres participating severally in the two major themes of the Elysian Fields and Arcadia. Bacchus, however, from the Renaissance on is regularly paired with Ceres as the rustic fertility gods proper to the decoration of a country residence. So in the center of the ceiling of General Dormer's parlor in the house at Rousham, Kent painted a large oval panel depicting a semireclining Venus with her son Cupid in the center. Venus holds out with her left hand a bowl being filled with wine by Bacchus, while Ceres reclines behind Venus at the left.[27] These are all fertility gods of nature—Venus, goddess of the garden, Ceres, goddess of grain, and Bacchus, god of wine—but here at Rousham with Proserpina, goddess of the renewal of nature, and in the context of the Elysian Fields and the theme of *Et in Arcadia Ego* with their mortuary associations, the meaning must center on rebirth and resurrection.

Another copy of an ancient statue, which should in some way relate to the iconography of the garden, stands near the river at the foot of the walkway described on the plan of 1739 as "the new Grass Walk." For some reason Clary, the gardener, who seems to identify in his letter every, even very minor, piece of sculpture in the garden, does not mention this figure, although its location had been discussed previously in a letter of June 1739 by the steward William White.[28] There is, therefore, some doubt about the identification of the figure, called by White the "Colossus," and consequently uncertainty about its role in the iconography of the garden (Fig. 8). The present statue, still standing at the location discussed by White, is a copy of a well-known antique figure in the Belvedere

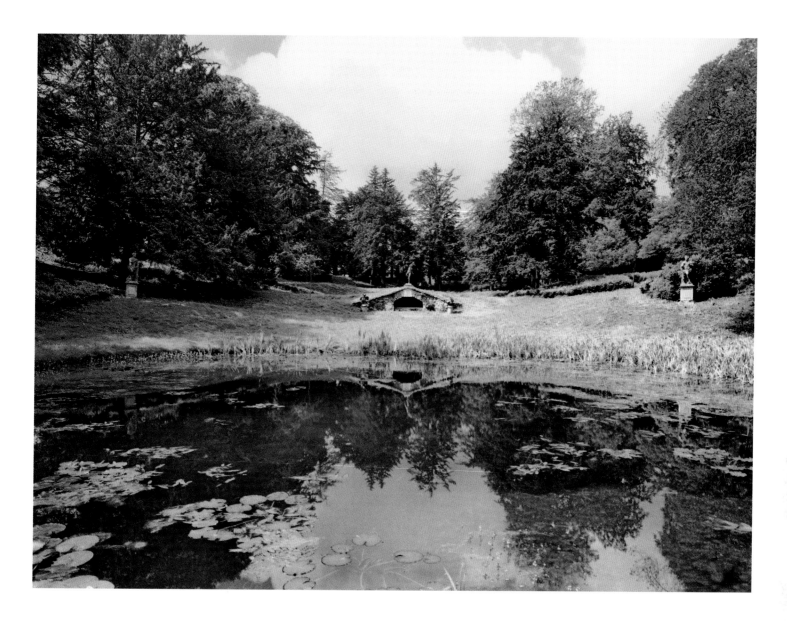

Fig. 6. Venus's Vale or the Elysian Fields, Rousham (photo: Country Life)

Statue Court of the papal Vatican Palace in Rome. The statue was identified during the Renaissance as Antinous, the youth beloved by the Roman emperor Hadrian. Such an identification, however, was rather meaningless, since during the Renaissance a statue of a handsome youth without any particular identifying characteristics was often called Antinous. The copy at Rousham is only a late version of several copies in England. Already in 1631 King Charles I had commissioned the sculptor Hubert Le Sueur to make a bronze copy of the Antinous in the Vatican along with several other bronze copies of ancient statues which were created to decorate the garden of St. James's Palace.[29] At that time the figure was still identified as Antinous, and Charles I in having such copies of famous antique statues made to decorate his garden was probably

only emulating the French King Francis I, who had in the sixteenth century such a group of copies, including the Antinous, in his garden at Fontainebleau. As Antinous the statue might relate to the theme of the Elysian Fields and resurrection. The youth Antinous had drowned in the river Nile, and the statue at Rousham stood close to the river Cherwell just before the visitor turned to go up to Venus's Vale or the Elysian Fields. After the disappearance of Antinous the emperor had proclaimed that the youth had been transformed into a deity.

In contrast, the 1739 plan of Rousham (Fig. 1) depicts a statue at the present location of the figure, but identifies it as an Apollo. As Apollo the statue is even more appropriate for Rousham, but for the theme of Arcadia. As deities particularly associated with music, Pan with the shepherd's pipe and Apollo with the cithara were, according to Cartari's handbook, the principal gods of Arcadia.[30] It is puzzling, however, that the copy was not made

| The Elysian Fields of Rousham

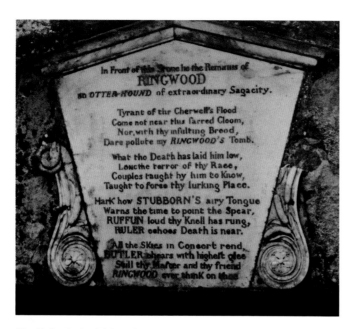

Fig. 7. Dog's burial inscription, Rousham (photo: author)

of a more readily identifiable Apollo, for example, with a lyre or cithara.

A third possible identification of the Antinous, as Mercury, is much more dubious but would be appropriate to Rousham, since Mercury was the guide to the Elysian Fields, as was clearly indicated in Kent's Elysian Fields at Stowe. It was the Richardsons in their account of ancient sculpture, published shortly before the work at Rousham, who related the Belvedere Antinous to a figure of Mercury in the Farnese collection.[31] This identification, while often accepted today, seems not to have been convincing in the eighteenth century. Mercury was also already represented at Rousham in a more clearly identifiable form at the fountain farther along the river.

The sculptural figures introduced as decoration in the niches on the exterior of the wings of the house added by Kent might help in the problem of identification, since one might expect those statues to relate to the iconography of the garden, as does Kent's ceiling painting in the library. The letters, however, indicate that there was an almost constant change and relocation of pieces of statuary between the house and the garden, so that at different times there have been figures of Venus, Apollo, Antinous, and a dancing faun identified in the niches of the house.[32] The reference to an Antinous is made by the steward White in November 1739, while in 1750 Clary notes an Apollo but no Antinous there. The two men, therefore, may be using two different identifications for the same statue. Today the statues agree with Clary's identification

and include an Apollo. From all the confusing evidence, one can only conclude that it is more likely that the statue in the garden is probably meant to be Apollo, as the contemporary evidence of the 1739 plan of the garden claims.

There are also several works of architecture either incorporated within the garden or standing outside the actual grounds of the garden but visually related to it. Some of the buildings are garden houses offering protected seats where one may rest and enjoy the lovely vistas beyond the garden. Two of the most interesting structures are far to the north beyond the garden in the neighboring countryside, created obviously as visual accents or focal points for vistas from the garden. One, described by Clary in 1750 as the "very pretty Corn Mill, Built in the Gothick manner"[33] and now generally called the "Temple of the Mill" (Fig. 9), was an old mill which presumably Kent had emphasized as a visual attraction by adding a Gothicized

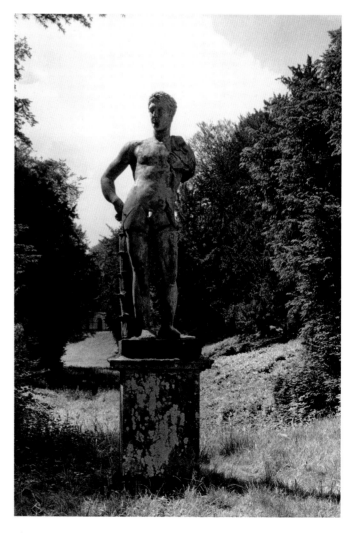

Fig. 8. Apollo, Rousham (photo: Country Life)

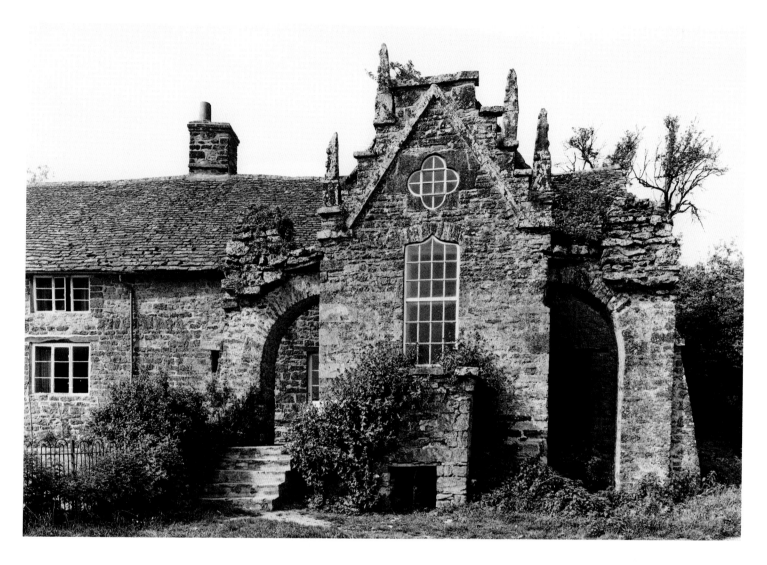

Fig. 9. Cuttle's Mill or the "Temple of the Mill," Rousham (photo: Country Life)

front with large buttresses, pinnacles, and Gothic windows. Much farther on, and in fact on the horizon, Kent erected a rather two-dimensional structure of three great arches with buttresses and pinnacles, whose function is apparent in its present title "the Eye-Catcher" (Fig. 10). It is identified by Clary as "the Grant Triumphant Arch in Aston Field,"[34] but an anonymous poem, entitled "To General Dormer on His Building in Aston Fields," suggests that the arch was built to commemorate the general's role in the Spanish War.[35] The most intriguing aspect of both these buildings toward the north of the garden is that Kent has used the Gothic architectural style for them, as one might at least expect a triumphal arch to be classical. With that in mind, the architectural style of the other garden buildings may become significant. The little house

sheltering a seat at the east side of the garden, called by Clary "a Egyptian pyrimade,"[36] has a tall pyramidal roof. Along the south side of the garden is the Praeneste arcade consisting of seven large arched niches, each containing a garden seat where a tired or contemplative visitor could sit to admire the magnificent vista over the English countryside (Fig. 5). The name Praeneste was given the arcade during Kent's activity and is the Latin name for the Italian hill town of Palestrina where the ancient Romans had built on the hillside the awesome sanctuary dedicated to Fortuna. During the Renaissance and eighteenth century, tourists faithfully visited the site not only to study the Roman ruins, but to enjoy the broad vista out over the Roman *campagna* analogous to the view from Kent's arcade.

The architecture of these garden buildings seems to be determined by their geographical orientation: Gothic toward the north, Egyptian at the east, and ancient Roman at the south. There is, moreover, one garden house on the

| *The Elysian Fields of Rousham*

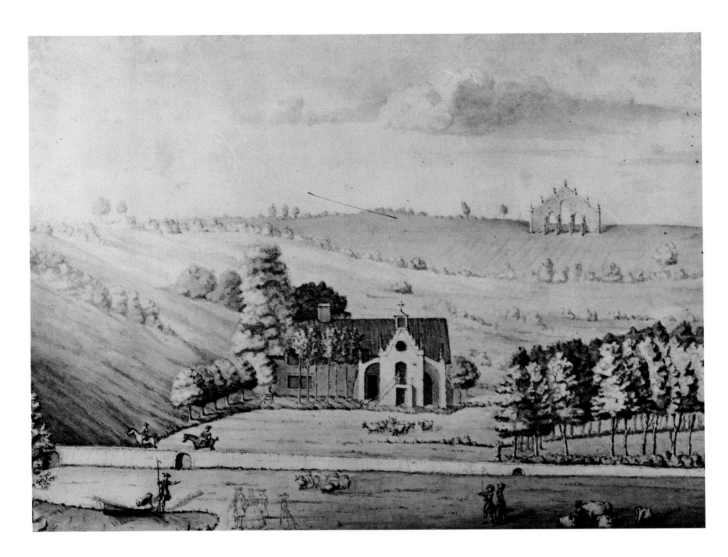

Fig. 10. Drawing, the "Temple of the Mill" and the "Eye-Catcher," Rousham (photo: Country Life)

west side of the garden; although its architectural style does not readily suggest a geographical direction, it should seem to do so in the context of the others. This is the structure that was called Townesend's Building and stands at the foot of "the new Grass Walk" almost opposite the statue of Apollo. A drawing attributed to Kent presumably illustrates an earlier design for the garden house, which would have been somewhat larger, with prominent four column porticoes projecting from three sides of it.[37] The present building is more modest, omitting the projecting porticoes and having only a portico of two Tuscan columns *in antis* (Fig. 11). The change in design is presumably Kent's, for John Vardy in his 1744 publication of the work of Inigo Jones and Kent depicts the present building as one by Kent.[38] The architectural style is typically

classical, but rather severe with strong, almost primitive entasis in the Tuscan columns. The most unusual feature, however, is the decoration of the frieze, which has been described by Hussey as "rusticated"[39] but also resembles pseudo-runes. One can, therefore, only conclude that Kent identified the geographical west with a classical style that was, however, less polished, perhaps even more primitive, than the mature Roman style of architecture. On the plan of Rousham of about 1739 the garden house is labeled Townesend's Building. In December 1738 William Townesend, a prominent mason and builder in Oxford, had agreed to construct the little house, but work on it had not yet begun in March 1739.[40] Townesend having died in September 1739, while the building was being erected, William White, the steward, probably used Townesend's name merely to identify the building.

The idea of different architectural styles as an expression of geographical orientation had previously been used by Alexander Pope in his allegorical poem of 1711

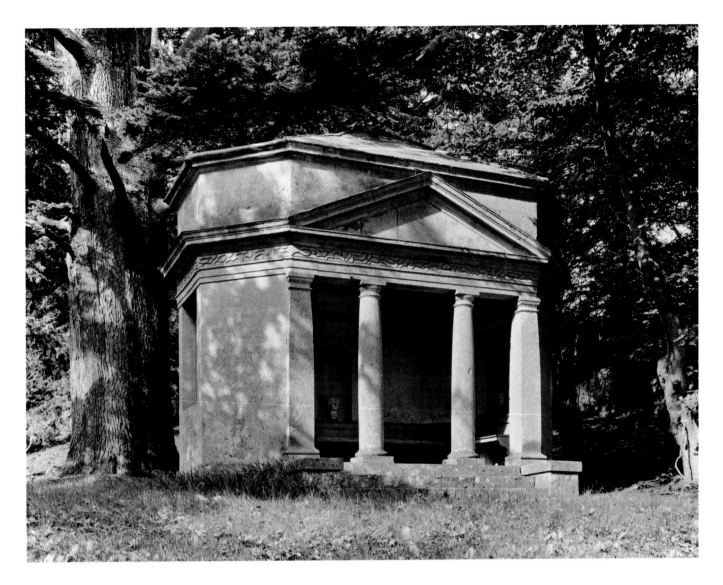

Fig. 11. Townesend's Building, Rousham (photo: Country Life)

entitled *The Temple of Fame*. Pope commences his poem with an evocative description of nature that could be appropriate to the garden of Rousham and its broad vistas:

In that soft Season when descending Showers
Call forth the Greens, and wake the rising Flowers;
When opening Buds salute the welcome Day,
And Earth relenting feels the Genial Ray;
.
I stood, methought, betwixt Earth, Seas, and Skies;
The whole Creation open to my eyes.

Suddenly he encounters the great Temple of Fame whose four facades, "facing the different Quarters of the World," are of four different styles."[41] So in a note to the poem Pope explains: "The Western Front is of *Grecian* Architecture: the Dorick Order was peculiarly sacred to Heroes and Worthies." The eastern facade refers to Persia, Assyria, and China, and the southern front Egyptian. Finally, "Of *Gothic* Structure was the Northern Side."

Pope was a friend of both the Dormers and had visited the manor at least three times: in 1728 and 1734, when it was owned by Robert Dormer, brother of the general, and in 1738.[42] Pope's ideas, therefore, would be very familiar at Rousham, although his concept was applied not to the four sides of one building, but to the four sides of the garden, with two different styles for two of the geographical directions. This change of styles may be occasioned by the desire at the Praeneste on the south to have a monument associative of a broad, wonderful vista which could not be expressed in the Egyptian style. If Pope's concept is

| *The Elysian Fields of Rousham*

being applied to the garden at Rousham, it is to suggest that the entire garden is a home, a temple, of fame. This, of course, is appropriate to the Elysian Fields which provide the final home for the famous.

The application of a theme expressed by Alexander Pope in the garden of his acquaintances raises the question of who might be the author of the program. Although we know that Pope was involved in the creation of several notable gardens in the third and fourth decades of the eighteenth century, there is no patent evidence of Pope's involvement at Rousham. Likewise, the deviations in the architectural styles from his poem *The Temple of Fame* lessen the possibility of his personal contribution. The fantasy of the architecture, the dependence of the iconography on a painter's handbook owned by William Kent, and the choice of important works of sculpture in Rome and Florence known to Kent during his extended stay in Italy all suggest that at least many details of the program are due to the artist. The choice of the principal themes, however, may come from General Dormer himself. Letters show that he was a passionate collector of sculpture so essential to the meaning of his garden. Moreover, he was apparently well learned, as in 1718 crusty Thomas Hearne said of the general, a graduate of Merton College, Oxford: "Besides his being a Souldier, he is, withall, a curious gentleman, and well skill'd in Books."[43]

The word Elysian became in the eighteenth century almost the inevitable descriptive adjective for any lovely landscape or garden.[44] Hence, it is not surprising that the garden historian Horace Walpole described William Kent in his biography printed in 1771, but not published until 1780, as "a painter, an architect, and the father of modern gardening. In the first character, he was below mediocrity; in the second, he was a restorer of the science; in the last, an original, and the inventor of an art that realizes painting, and improves nature. Mahomet imagined an Elysium, but Kent created many."[45] Walpole, of course, is using Elysium as a metaphor, but, if Rousham, as well as Stowe, was meant to recreate the Elysian Fields, Walpole was more correct than he realized. Both gardens demonstrate, however, that Kent, identified by Walpole as "the father of modern gardening," is nevertheless working fully in the classical ambience of Augustan England.

Notes

1. T. McLean, *Medieval English Gardens* (New York, 1980), 120–131.

2. E. B. MacDougall, "Ars Hortulorum: Sixteenth-Century Garden Iconography and Literary Theory in Italy," in *The Italian Garden*, First Dumbarton Oaks Colloquium on the History of Landscape Architecture, ed. D. R. Coffin (Washington, D.C., 1972), 39–59; and D. R. Coffin, *The Villa in the Life of Renaissance Rome* (Princeton, 1979), 319–338, 347–361.

3. W. G. Hiscock, *John Evelyn and His Family Circle* (London, 1955), 32–33; and G. Keynes, *John Evelyn: A Study in Bibliophily with a Bibliography of His Writings* (Oxford, 1968), 236.

4. W. Bray, ed., *Diary and Correspondence of John Evelyn, F.R.S.*, new ed. (London, 1859), vol. 3, 392.

5. G. Keynes, ed., *The Works of Sir Thomas Browne* (Chicago, 1964), vol. 4, 273–278.

6. *Diary and Correspondence of John Evelyn*, ed. Bray (note 4 above), 128, 134.

7. The Champs-Élysées of Paris were not so named when the long avenue of trees was laid out by Le Nôtre about 1670 as a continuation of the Tuileries garden. The avenue was originally known as *le Grand-Cours*: J. A. Dulaure, *Histoire physique, civile et morale de Paris*, 4th ed. (Paris, 1829), vol. 6, 452. The name Champs-Élysées, which was attached to it about a decade later, was presumably suggested by the location of the avenue across the fields just west of the old city wall of Paris.

8. In the extensive bibliography on Stowe, see particularly the articles by George Clarke: "The Gardens of Stowe" and "Grecian Taste and Gothic Virtue: Lord Cobham's Gardening Programme and Its Iconography," *Apollo* 97 (1973), 558–565 and 566–571; and "William Kent: Heresy in Stowe's Elysium," in *Furor Hortensis: Essays on the History of the English Landscape Garden in Memory of H. F. Clark*, ed. P. Willis (Edinburgh, 1974), 49–56.

9. J. Harris, "English Country House Guides, 1740–1840," in *Concerning Architecture: Essays on Architectural Writers and Writing Presented to Nikolas Pevsner*, ed. J. Summerson (London, 1968), 63–67.

10. T. Hearne, *Remarks and Collections of Thomas Hearne*, vol. 11, Oxford Historical Society, vol. 72, ed. H. E. Salter (Oxford, 1921), 438–439.

11. [T. Whately], *Observations on Modern Gardening* (London, 1770), 150–151.

12. R. Gunnis, *Dictionary of British Sculptors, 1660–1851*, new ed. (London, 1968), 342; and F. Haskell and N. Penny, *Taste and the Antique* (New Haven and London, 1981), 250–251.

13. D. R. Coffin, *The Villa d'Este at Tivoli* (Princeton, 1960), 27, 105–106.

14. M. Batey, "The Way to View Rousham by Kent's Gardener," *Garden History* 11 (1983), 125–132.

15. Gunnis, *Dictionary* (note 12 above), 342; and Haskell and Penny, *Taste and the Antique* (note 12 above), 224.

16. K. Woodbridge, "William Kent's Gardening: The Rousham Letters," *Apollo* 100 (1974), 286 and fig. 9.

17. Batey, "Way to View Rousham" (note 14 above), 129.

18. Pausanias, *Description of Greece* (Loeb Classical Library), trans. W. H. S. Jones (Cambridge, Mass., and London, 1935), vol. 4, 346–347.

19. V. Cartari, *Imagini de gli dei delli antichi* (Padua, 1626), 200–201. Ron Hill, a graduate student, identified the legend and its source in a paper in 1979.

20. Oxford, Bodleian Library, Bibl. III 8º 20(2), p. 2.

21. Batey, "Way to View Rousham" (note 14 above), 130.

22. Cartari, *Imagini de gli dei* (note 19 above), 116, 191, 443.

23. E. Panofsky, "Et in Arcadia Ego," in *Philosophy and History: Essays Presented to Ernst Cassirer*, ed. R. Klibansky and H. J. Paton (Oxford, 1936), 295–320.

24. W. Shenstone, *The Letters of William Shenstone*, ed. M. Williams (Oxford, 1939), 524–525.

25. Sir T. Clifford and A. Clifford, *A Topographical and Historical Description of the Parish of Tixall* (Paris, 1817), 65; and D. Watkin, *Athenian Stuart* (London, 1982), 27–28.

26. J. D. Hunt, "Emblem and Expressionism in the Eighteenth-Century Landscape Garden," *Eighteenth-Century Studies* 4 (1970–71), 294–317; J. D. Hunt, *The Figure in the Landscape: Poetry, Painting, and Gardening during the Eighteenth Century* (Baltimore and London, 1976), 190–191; and J. Archer, "The Real Beginnings of Association in British Architectural Esthetics," *Eighteenth-Century Studies* 16 (1983), 241–264.

27. M. Jourdain, *The Work of William Kent* (London and New York, 1948), fig. 89. The theme of the three deities Venus, Ceres, and Bacchus, together may ultimately go back to a line in Terence's Latin play *Eunuchus* (line 732): "sine Cerere et Libero friget Venus." The Renaissance humanist, Erasmus, discussed the line in his book of proverbs included in the publication of all his works that appeared in 1703; D. Erasmus, *Opera Omnia*, vol. 2, *Complectens Adagia* (Leiden, 1703), cols. 521–522: *Adagiorum*, chil. II, cent. III, prov. XCVII.

28. C. Hussey, "A Georgian Arcady II: The Gardens at Rousham, Oxfordshire," *Country Life* 99 (21 June 1946), 1133.

29. C. Avery, "Hubert Le Sueur, the 'Unworthy Praxiteles' of King Charles I," *Walpole Society* 48 (1980–82), 135–209. The Antinous and some of the other copies are now in the East Terrace Garden at Windsor Castle.

30. Cartari, *Imagini de gli dei* (note 19 above), 192.

31. Haskell and Penny, *Taste and the Antique* (note 12 above), 142.

32. C. Hussey, "Rousham, Oxfordshire II," *Country Life* 99 (24 May 946), 946; and Clary's letter of 1750 in Batey, "Way to View Rousham" (note 14 above), 128. Now the statues in the niches of the wings are a dancing faun, Bacchus, Venus, and Apollo, as reported by Clary.

33. Batey, "Way to View Rousham" (note 14 above), 128.

34. Ibid.

35. T. Cottrell-Dormer, "Kent's Eye-Catcher," *Country Life* 100 (6 September 1946), 448.

36. Batey, "Way to View Rousham" (note 14 above), 130.

37. Hussey, "Georgian Arcady" (note 28 above), 1132, fig. 9.

38. J. Vardy, *Some Designs of Mr. Inigo Jones and Mr. Wm. Kent* ([London], 1744), pl. 39.

39. Hussey, "Georgian Arcady" (note 28 above), 1132.

40. Ibid.

41. The quotations from Pope's poem and his own notes to the poem regarding the modes of architecture are from A. Pope, *The Rape of the Lock and Other Poems*, ed. G. Tillotson (London, 1940), 245–246, 248, 249, and 252. The suggestion that the garden architecture at Rousham might be inspired by Pope's poem was proposed in the senior thesis of Alexander Ward on the gardening of Kent submitted to the Department of Art and Archaeology of Princeton University in 1975, but with a slightly different interpretation than here.

42. A. Pope, *The Correspondence of Alexander Pope*, ed. G. Sherburn (Oxford, 1956), vol. 2, 513; vol. 3, 410; vol. 4, 150.

43. T. Hearne, *Remarks and Collections of Thomas Hearne*, vol. 6, Oxford Historical Society, vol. 43 (Oxford, 1902), 241.

44. H. F. Clark, *The English Landscape Garden* (Gloucester, 1980), 13–14.

45. H. Walpole, *Anecdotes of Painting in England*, rev. ed., ed. R. N. Wornum (London, 1876), vol. 3, 57.

15

Venus in the Eighteenth-Century English Garden

The favorite decorative figure of the eighteenth-century English garden was Venus, the classical deity of the garden as well as of love and beauty. The changing meaning associated with the goddess is traced through the eighteenth century from the allegorical figure of love both at Stowe in Buckinghamshire and at Rousham in Oxfordshire to the coy representative of modest taste at William Shenstone's The Leasowes in Salop, Worcestershire, and the exuberant enunciator of eroticism at West Wycombe Park in Buckinghamshire.

The importance of Venus, the ancient Roman deity, in the decoration of the English garden was occasioned in part by her double role with respect to gardens. She was, of course, the traditional goddess of love and beauty. Less known, however, was her identification by ancient Romans as the guardian or goddess of the garden.[1] During the Stuart period the likeness of Venus used in garden decoration was a generic type derived from literary descriptions of the goddess. Gradually in the seventeenth century one particular ancient statue of Venus began to be identified as an especially notable and beautiful representation of the goddess of love and beauty. This was the so-called Venus de' Medici, which came into the possession of the Medici at Rome in the late sixteenth or early seventeenth century and was put on exhibition in the Villa Medici on the Pincian Hill at Rome.[2]

Already in the early seventeenth century, Thomas Howard, second Earl of Arundel, owned a version of the Medici Venus in his gallery of ancient sculpture at Arundel House in London, as depicted in a portrait of the earl attributed to Daniel Mytens of ca. 1618 (Fig. 1).[3] By 1638, François Perrier in his *Segmenta Nobilium Signorum et Statuarum*, illustrating the most celebrated ancient statues in Rome, had included three views of the Venus (Fig. 2).[4] The statue had a very distinctive pose. Slightly bent, Venus held her right hand before her breasts and veiled her loins with her left, suggesting an expression of coy shame. By November 1644, the English tourist John Evelyn, visiting the Villa Medici, noted in his diary,

> In the great chamber [of the villa] is the naked *Gladiator*, whetting a knife; but the *Venus* is without parallel, being the masterpiece of *Apelles* [name deleted], whose name you see graven under it in old Greeke characters, certainly nothing in sculpture ever aproched this miracle of art.[5]

The popularity of the Venus de' Medici at Rome came to a climax during the reign of Innocent XI (1676–89). The critic F. Baldinucci noted that the Medici were induced to move the statue from Rome to Florence because of the improper and lewd remarks offered by young art

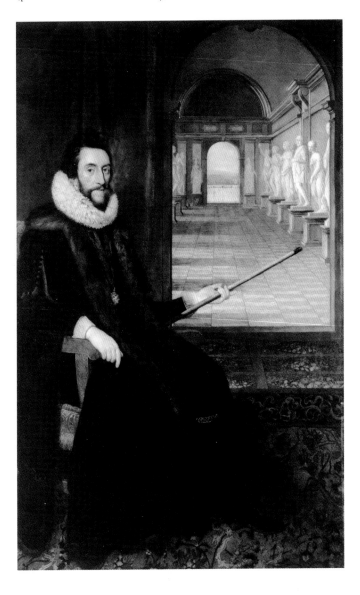

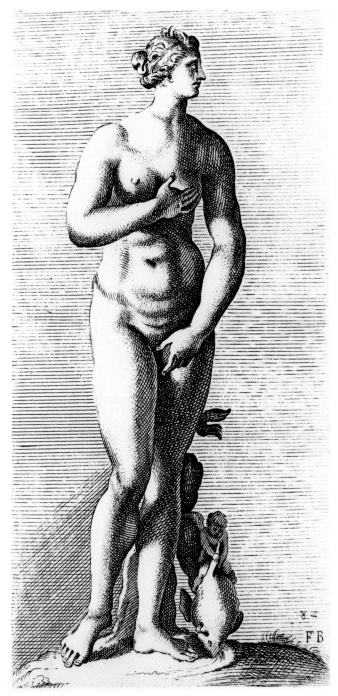

students when studying the figure.[6] Previous popes had been very reluctant to permit ancient sculpture to be removed from Rome, and strict laws had been promulgated to limit such action. Innocent, however, was particularly devout and ascetic, having attempted to control feminine dress at Rome and to forbid the excesses of the theater and carnival. He was likewise unhappy at the notoriety associated with the Medici statue and was apparently very willing to authorize its transfer. In fact, it is possible that word had been quietly forwarded to Florence of the pope's displeasure so as to prompt the request for the removal of the statue. By 1680, the Venus was on display in the octagonal Tribuna of the Uffizi at Florence (where it still remains), and its popularity never lessened, as seen in

Venus in the English Garden

François Mission's *A New Voyage to Italy* (1691), Joseph Addison's *Remarks on Several Parts of Italy, &c.* (1705), James Thomson's poems "The Seasons" (1730) and "Liberty" (1736), or the Richardsons' account of the arts of Italy and France, *An Account of the Statues, Bas-Reliefs, Drawings and Pictures in Italy, France, &c.* (1722), among others.[7]

Even the historian Edward Gibbon enthusiastically rhapsodized in French in 1764 in his travel journal on seeing the Medici Venus. He claims, in translation:

> It is the most voluptuous sensation that my eye has ever experienced. The most soft, the most elegant contours, a soft and full roundness, the softness of flesh imparted to marble and the firmness one still desires in this flesh expressed without hardness.[8]

As late as 1821, Mrs. A. B. Jameson, the famous writer on religious art, after praising the statue, recounts how the English poet Samuel Rogers

> may be seen every day about eleven or twelve in the Tribune, seated opposite to the Venus, which appears to be the exclusive object of his adoration; and gazing, as if he hoped, like another Pygmalion, to animate the statue or rather perhaps, that the statue might animate him.[9]

Toward the mid-eighteenth century, a rage for casts and carved copies of antiquities, particularly in the Medici collection at Florence, prevailed in England.[10] In April 1745, Horace Walpole wrote to his friend Sir Thomas Mann at Florence seeking plaster casts of five statues in the Medici collection, including the Medici Venus. Almost a decade later, in March 1756, Walpole again requested Mann's aid in obtaining "gesses of the Venus, the dancing faun, the Apollo Medicis, (I think there is a cast of it) the Mercury, and some other female statue, at your choice" for the Chancellor of the Exchequer, Sir George Lyttelton, for the hall of his new country house at Hagley Park in Worcestershire.[11] In the end, four *scaglione* (plaster) copies of the Medici antiques were exhibited in the hall at Hagley. It was the English sculptor Joseph Wilton, in Rome in 1747–51 and then at Florence in 1751–53, who furnished copies for the English collections, including versions of the Medici Venus for Lord Charlemont, one for Lord Pembroke at Wilton House, Wiltshire, and another for Wentworth Woodhouse in Yorkshire.[12]

About the same time the artist William Hogarth satirized the fad for copies of antiquities in an engraving illustrating a sculptor's workshop where, as one writer suggested, the copy of Venus is "complacently ogling her fellow pin-up, *Apollo Belvedere*" (Fig. 3).[13] Hogarth depicts her in profile thus revealing "her right hand's failure to achieve the modesty it was conventional to attribute to her."

Needless to say, the Medici Venus was the image that prevailed throughout the eighteenth century as the central figure in gardens of England almost irrespective of the meaning involved. Only one other type of Venus occasionally appeared, the so-called Crouching Venus, or Venus Anadyomene, usually placed by a pool or in a grotto as if bathing.[14]

Stowe Gardens, Buckinghamshire

It was undoubtedly the landscape improvements undertaken at Stowe in Buckinghamshire that popularized the image of the Medici Venus as a central garden ornament. About 1718, Richard Temple, 1st Viscount Cobham, commissioned the landscape gardener, later Royal Gardener, Charles Bridgeman to improve the area known as Home Park west of the original access avenue to the house.[15] (The old access road was re-routed west of Home Park to make a new entrance to the mansion from the north.) Soon the architect Sir John Vanbrugh was called in not only to make additions to the house, perhaps including the north portico, but also to design garden buildings within the new landscape. One of the earliest structures of 1721 was the so-called Rotondo or Tempietto of Venus, erected on a low mount or bastion southwest of the house on the eastern edge of Home Park (Fig. 4). It was an open, round pavilion with a bulbous dome and ball finial supported on ten Ionic columns. Under the dome stood an over life-sized gilded copy of the Venus de' Medici on a round Roman altar. The open pavilion corresponds to Pliny's description of the original shrine on the island of Cnidus: "The shrine in which it [Venus] stands is entirely open as to allow the image of the goddess to be viewed from every side, and it is believed to have been made in this way with the blessing of the goddess herself."[16] Thus, Vanbrugh's Rotondo was probably an attempt to reconstruct the ancient shrine.

Another significance of the existence of Venus at Stowe, however, has not been noted in contemporary guidebooks. In Jacques Rigaud and Bernard Barons' engraving

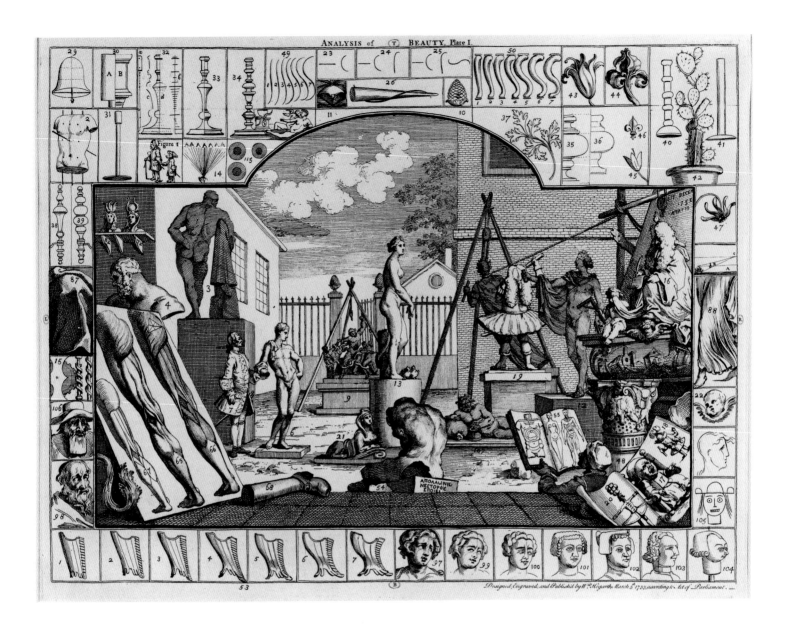

Stowe: View of the Queen's Theater from the Rotunda (1739) (Fig. 4), the Rotondo and the Venus are at one end of a water canal, at the other end of which is a large quadripartite triumphal column surmounted by a portrait statue of Caroline, Princess of Wales, consort of the future George II. The princess looks directly down the canal toward the statue of Venus, as Venus returns the look, thus obviously creating a relationship between the two, equating the princess to the goddess of beauty.[17] Already in 1715, in the poem "Claremont," celebrating the Surrey estate of the Earl of Claremont, later Duke of Newcastle, Dr. Samuel Garth likened the princess to Venus. Garth proclaimed that the safety of Britain was secure under the rule of the future George II and his Caroline:

> Like him, shall his Augustus shine in arms,
> Though captive to his Caroline's charms.
> Ages with future heroes she shall bless;
> And Venus once more found an Alban race.[18]

Later in the eighteenth century, the canal at Stowe was filled in, transforming it into a grassed sward, and in 1754 the triumphal column with the statue of the princess was dismantled and re-erected elsewhere on the estate, thus destroying the affinity between the two statues. In 1752 the Rotondo itself was changed. The Italian architect

| *Venus in the English Garden*

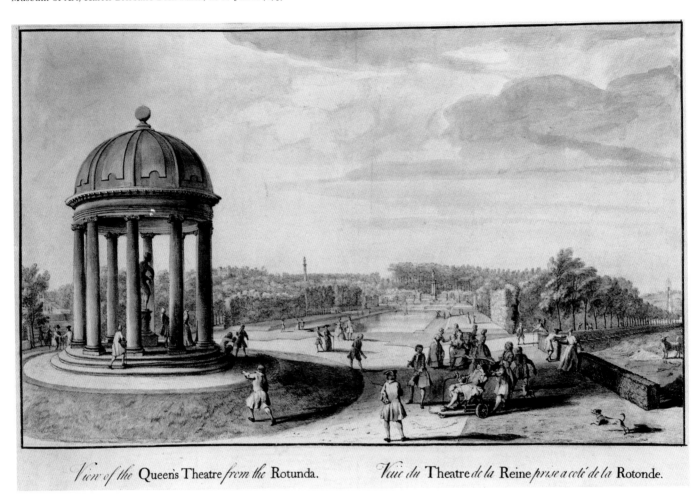

View of the Queen's Theatre *from the* Rotunda. *Vue du* Theatre *de la* Reine *prise a coté de la* Rotonde.

Giovanni Battista Borra removed Vanbrugh's rather Baroque dome and substituted a more classic saucerlike dome like that of the Pantheon in Rome. The statue of Venus, along with other statuary in the landscape, was apparently sold at auction in the 1920s and disappeared.

After Vanbrugh's death in 1726, William Kent began to design some garden architecture and soon undertook to landscape new areas, especially the so-called Elysian Fields east of the central axial greensward. Kent first built ca. 1731 a temple dedicated to Venus in the southwest bastion of Home Park across the lake from the Rotondo (Fig. 5). The Latin inscription on the building, "Veneri Hortensi," indicated that the temple was dedicated to Venus as goddess of the garden, but the ceiling painted with a naked Venus and the walls decorated by Francesco Sleter with scenes from Edmund Spenser's *Faerie Queene* (written in 1590) imparted an erotic ambience. So Spenser's Hellemore

was seen revelling with satyrs as her cuckolded husband, Malbecco, watched. Inscribed on the frieze were two lines from the *Pervigilium Veneris*, which read in translation: "Let him love now, who never lov'd before; / Let him who always lov'd, now love the more." This inspired George Bickham to comment in 1750: "'Tis true, the Stories are a little loose, the luxurious Couches or Sopha's, and the Embellishment round the Walls, give the Piece quite a *Cyprian* Air, and make it a very proper Retreat for its incontinent Inhabitant."[19]

Kent's Temple of Venus focused on the erotic imagery that prevailed around Venus in Home Park and in other garden structures, most from Vanbrugh's period.[20] The several structures are best described in Bickham's *The Beauties of Stow* (1750). St Augustine's Cave (built by 1742, dem.) was concerned with the carnal temptation of a religious hermit, who in one case fashioned a maiden of

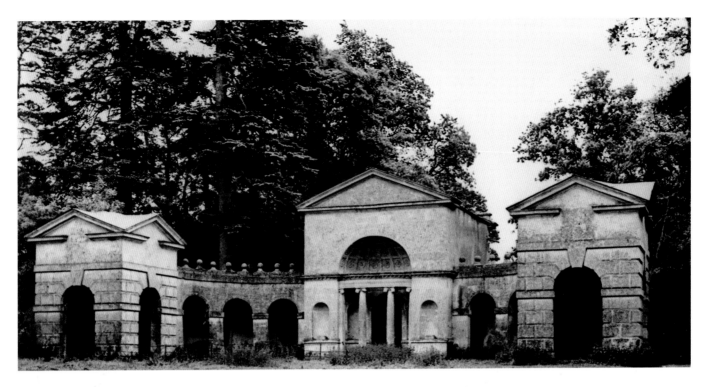

Fig. 5. William Kent, Temple of Venus (before 1731) at Stowe, Buckinghamshire (photo: J. H. Gough/Stowe School of Photographic Archives)

snow with whom he lay to quench his lust. Dido's Cave (perhaps by Vanbrugh, 1720s) was a dark stone building hidden in the woods where Aeneas could make love to Dido, Queen of Carthage, and where Dido would bewail her abandonment by Aeneas. The Temple of Bacchus (by Vanbrugh, ca. 1718, dem. 1926) was decorated with the "Triumphs of Drunkenness and Jollity." The association of Bacchus with Venus evokes the adage of the ancient Roman playwright Terence that "sine Cerere et Libero friget Venus,"[21] a saying which Kent soon illustrated at Rousham in Oxfordshire. Finally, there was the Sleeping Parlour (perhaps by Vanbrugh, 1725, dem. 1760) with its motto, "Since all things are uncertain, indulge thyself."[22]

This realm of Venus revolving around the Medici Venus in the Rotondo exploits the erotic tone of the statue and creates a very private world for the enjoyment of Lord Cobham and his close friends. Soon, however, Kent developed to the east the so-called Elysian Fields, which proclaimed loudly Cobham's concern for public and political morality. Here, Venus played a very modest role, and it is not the alluring Medici Venus. At the head of the Elysian Fields Kent built a rustic grotto from which water gushed forth to form the so-called River Styx with his Temple of Ancient Virtue (ca. 1735–37) and ruined Temple of Modern Virtue (ca. 1737) on the west bank, and below on the east bank the Temple of British Worthies (ca. 1735).[23] Set within the grotto was a statue of the Crouching Venus carved by Peter Scheemakers as if she were bathing in the stream of water.

In general, Cobham's artistic efforts were highly praised, but in 1743 an anonymous poet lamented the paganism exhibited in the garden. He was undoubtedly particularly disturbed that pagan temples engulfed the estate's old parish church and graveyard. The author especially wished that the motto on the Sleeping Parlour be erased:

> While stately temples numberless arise,
> Temples devote to heathen deities:
> On which is spar'd no cost, no grace, no art,
> (Such their importance) genius could impart;
> and thy sweet numbers unrestrained flow,
> Their pomp and proud magnificence to shew;
> One single line is all thou canst afford
> To decorate the temple of the lord.
>> Shall greater honour be to *Bacchus* given,
> And strumpet *Venus* than the God of heav'n?
> Are banish'd *Thor* and *Woden* then restor'd,
> And more than *Christ*, our present God, ador'd?
> In christian land, gods *Pagan* to prefer!
> Christian! is this in taste or character?

Venus in the English Garden

Our country God eclips'd by foreign! hence
To boasted patriot virtue vain pretence.
　　　Oh *C-b-m*! deign God's house to beautifie,
Nor let this only place neglected lye.
Where decency and order so much divine,
Sure decency is due to things divine.
Let this be paid—*Morpheus*'s motto* raze,
And *Stowe* will be allow'd to want no *Grace*.

　　Cum omnia sunt in incerto, fave tibi.[24]

The Influence of Stowe

The influence of the Rotondo of Venus at Stowe was soon apparent in other English gardens. Probably after 1724, the architect Colen Campbell designed a Temple of Venus at Hall Barn in Buckinghamshire for Harry Waller, grandson of the poet Edmund Waller, or for Harry's stepfather, John Aislabie, who at about the same time was creating a wonderful garden at Studley Royal in North Yorkshire.[25] The Temple of Venus at Hall Barn is an open, Ionic (but with eight columns, not ten as at Stowe), domed rotunda set at the center of alleys radiating through the surrounding grove of trees. At Studley Royal, the open Doric rotunda was placed opposite the Orangery, which was built at one end of a bowling green from 1727 to 1730, probably after Campbell's designs. In the 1740s the Orangery was converted into the Banqueting House, the interior being wood-panelled and a bronze copy of the Medici Venus set in a recess at one end.[26]

By at least 1748, Sir Francis Dashwood had built a Temple of Venus at West Wycombe Park in Buckinghamshire in the form of an open, domed rotunda housing a statue of the Venus de' Medici obviously modelled on the Rotondo at Stowe.[27]

Certainly the Temple of Venus at Oatlands in Surrey, designed by Stephen Wright, once an assistant to Kent, was derived from the Temple of Venus at Stowe.[28] The Oatlands structure, however, was apparently primarily of wood when it was first erected in 1757–58 by a carpenter, who then dismantled it in 1758 to reinstall it at another location.

Fig. 6. Peter Scheemakers, *Lion and Horse* (1740) at Rousham, Oxfordshire (photo: author)

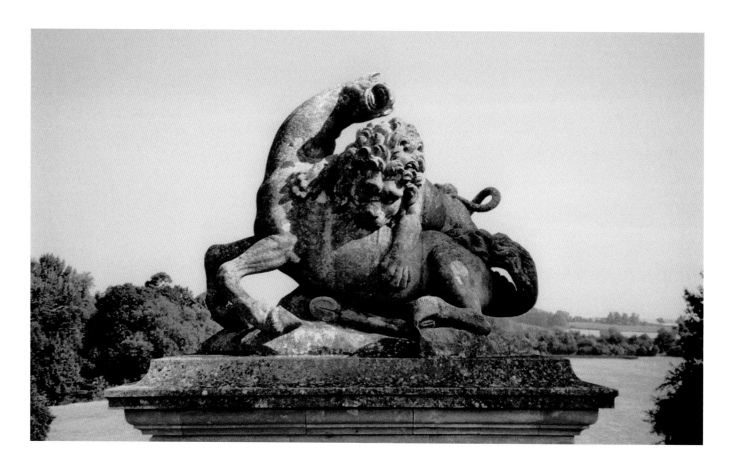

The cult of Venus was furthered later at Oatlands in its famous grotto first built from 1760 to 1767 by Wright and then refashioned a decade later by Joseph Lane and his son. The grotto was in two stories with a bathing room in the lower story where once stood a copy of the Venus de' Medici, which, when the grotto was destroyed in 1948, was moved to the local public library.

After Vanbrugh's death in 1726, Nicholas Hawksmoor continued the work at Castle Howard in North Yorkshire for the Earl of Carlisle. By December 1731 there was considered the idea of building another garden temple in the northeast corner of Ray Wood, just north of Vanbrugh's Temple of the Four Winds (1724–26).[29] The dedication of the temple was still uncertain a few years later when Hawksmoor wrote to Carlisle that the temple might have a "handsom statue of Diana, or any Godess you please, Gilded." Finally by July 1735 the idea of a dedication to Venus is mentioned presumably under the influence of the rotunda at Stowe, since Hawksmoor quotes Vitruvius, identifying the temple as monopteral and suggesting that a gilded statue of the Venus de' Medici, like that at Stowe, should decorate the temple:

I have sent you downe by this post, what your Lordship Mentiond in Your Last vizt the Sketch of the Cieling of ye Octogon; the pavement of the floor, and the pedestall or ara upon which a figure may be placed, I think the Greek Venus Gilt, woud do very well, but that I Leave to your Lordships great wisdom, and the Tast of the fam'd vertuosi. but cannot help mentioning, that the proposition is according to what Vitruvius mentions & directs in this Sort of Temple which he calls monopter.[30]

In time, the Temple of Venus fell into ruins, and now only its foundation and crumbling bastion remain.

Rousham, Oxfordshire

Probably in 1737, when Gen. James Dormer inherited from his brother the country house at Rousham, he called on Kent, who had become the most innovative landscape gardener as well as architect at that time, to enlarge and refashion the house as well as to improve the landscape.[31] The house was an early-seventeenth-century mansion to which Kent added wings and gothicized with battlements, ogee-arched niches and mullioned windows. In the 1720s Bridgeman, whose first fame was established at Stowe, had created a new garden park northwest of the house. Kent "improved" Bridgeman's landscaping by leveling terraces, widening the nearby Cherwell River, and by replanting the grounds with Scotch and spruce firs as well as flowering trees. Kent also opened up vistas beyond the estate, including the erection of the so-called Eyecatcher about a mile distant in the adjacent village of Steeple Aston. Dormer had a passionate devotion to sculpture that Kent satisfied with the introduction of copies of antique sculpture in the landscape and smaller lead figures in the niches decorating the exterior of the house.

By 1739 most of the sites for the garden sculpture were determined, although much of the sculpture took longer to be completed. By July 1741, Scheemakers was still working on the group of A Lion Attacking a Horse, which now stands some distance from the garden side of the house (Fig. 6). Within the small grove of trees northwest of the house on a small terrace opened above the Cherwell, which flows past the house at a lower level, Kent erected a copy of the ancient sculpture known as the Dying Gladiator (Fig. 7). There is a drawing by Kent, now at Chatsworth House in Derbyshire, illustrating a Roman sarcophagus that he apparently planned to create as a base for the statue, but never used. A little farther beyond the Dying Gladiator a visitor plunged down the hillside to the river below.[32]

Walking along the river bank one comes upon a delightful valley cut into the hillside. It was entitled the Vale of Venus, for a copy of the Venus de' Medici stood on a rustic arch from which a cascade originally flowed into basin below (Fig. 8). Statues of Pan and a faun were partially withdrawn into the groves on either side of Venus. These figures were to convey the idea of ancient Arcadia in Greece celebrated by the Roman poet Vergil. It is a lovely retreat away from the upper level of the garden where statuary suggests the strife and death common to mortal existence. Venus, however, as the goddess of the garden is a fertility goddess, a goddess of rebirth, just as her gardens die in the autumn and are revived in spring. During his visit to Rousham in June 1748, Kent probably set up on the ceiling of the parlor of the house a large oval painting depicting Venus reclining between Bacchus, the god of the vine, and Ceres, god of grain. The painting is a visualization of the adage by Terence mentioned above. Again, however, all three deities are fertility gods that offer the hope of rebirth in correspondence with the garden sculpture. The reference to bread and wine also recalls the sacramental elements of the mass.

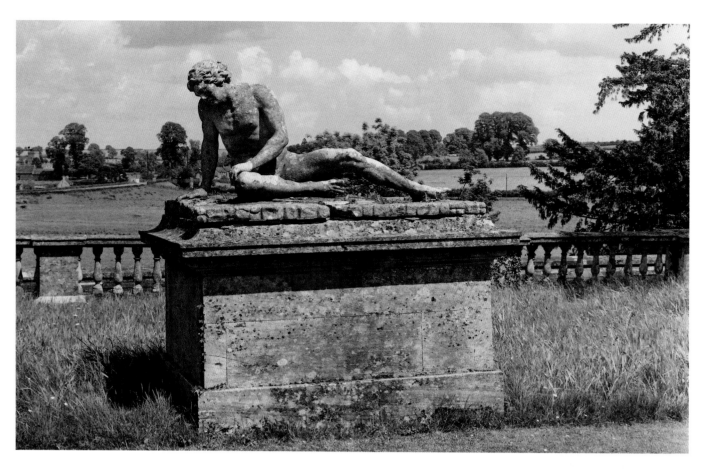

Fig. 7. Peter Scheemakers, *Dying Gladiator* (ca. 1743) at Rousham, Oxfordshire (photo: Country Life)

Kent carried the theme even further in the garden when in a small amphitheater by the riverside beyond the Vale of Venus and the so-called Praeneste Arcade on which the *Dying Gladiator* is located he placed a statue of Mercury flanked by figures of Bacchus and Ceres. One of the roles of Mercury in antiquity was to guide heroes to the Elysian Fields, a beautiful landscape for the enjoyment of the dead. Kent had just recently illustrated that theme with a bust of Mercury in the Temple of the British Worthies in the Elysian Fields at Stowe.

Later Gardens

As the eighteenth century proceeded, almost every garden had to have a shrine to Venus or at least a statue of the Medici Venus. In 1735 Henrietta St. John, Lady Luxborough, was exiled by her husband to a neglected country estate at Barrells in Warwickshire.[33] Soon under the influence of her good friend the poet William Shenstone, who lived some sixteen miles away at The Leasowes, Lady

Luxborough began to "improve" her estate. Letters between the two friends were constantly filled with questions about landscaping and gardening on her part and with his advice in response. Late in 1748 Lady Luxborough wrote that a garden pavilion she was building had been in part pulled down to permit the addition of a shrine to Venus. In April of the following year, Shenstone wrote extensively on the planting of shrubbery walks. He noted that he had heard that she was putting up her pavilion again and included advice on how to site it. In August he requested details of how the shrine to Venus was to be introduced into the pavilion, asking whether it was "a Semicircle in ye Middle of ye Back-wall." In September, Lady Luxborough informed Shenstone that she had the inscription "O Venus Regina Gnidi" put "in the New Pavillion over Venus's Shrine, opposite my house, instead of over the Summer-house door, where it was." By February 1750 she advised Shenstone that Mr. Smith, an artist,

is also against my painting the niche where Venus is: for he says she is supposed to have been bathing, and to crouch herself in that manner, upon the approach of somebody, by way of hiding herself: and he would have the niche adorned

with moss, &c. like some bathing place in a remote corner; and (he says) some bits of looking-glass among it to reflect what is to be seen, and also to give a watery look at a distance, will have a good effect from the Hall-door.

Work on the shrine continued off and on with constant consultation with Shenstone about the gardens at Barrells until July 1754, when the poet even suggested the possibility of destroying the pavilion and its shrine for a "more elegant" object, a wooden Gothick screen, which he sketched in his letter.

Even the Revd. William Stukeley, who would be a devotee of the Druids, wrote to his brother-in-law, Samuel Gale, in June 1747 that he was building for his wife in their garden at Stamford in Lancashire a Gothic temple of Flora.[34] In addition to sheltering a marble statue of Flora given him by the Duke of Montagu, there would be "a nich with a gilt statue of Venus de Medicis, 2 foot high."

At the same time, at least from 1747, George Lord Lyttelton, a close neighbor of Shenstone, was improving the wonderful park behind his house at Hagley Park in Worcestershire. Many of his improvements irritated Shenstone because he claimed that they incorporated his ideas which Lyttelton could realize more readily because of his wealth. By 1751, when Richard Pococke described the park, there was

a grotto where the water runs, and there is a statue of a Venus of Medici as coming up out of a fountain, and a stream runs from it, to the right of which is a mossy seat with this inscription: *Ego laudo ruris amoeni / Rivos et musco circumtita saxa nemusque.*

Later, in 1768, Arthur Young called the locale a "paradise for contemplation" with "a sweet little watery cave of rocks in which is a small statue of Venus."[35]

Joseph Heely was less enthused, but reluctantly admitted

A medicean Venus first drew my attention, and almost reconciled me to statues; the effect is really very pretty; owing perhaps to its lucky situation, which is chosen with great judgment standing in a rustic arched nook, retired, and solitary, under an interwoven thicket of trees and shrubs.

Apparently Thomas Jefferson was seduced by the statue when he visited Hagley in 1785. He noted in his journal: "In one of these [recesses of stone] is a Venus *predique [pudique],* turned half round as if inviting you with her into the recess."[36]

For some two decades, from 1743 to 1763, Shenstone tirelessly fashioned a modest farm he had inherited at The Leasowes into a delightful landscape, a *ferme ornée* or ornamental farm, as he called it, with a circuitous walk about the house along which he developed wonderful vistas and recesses marked with benches or urns inscribed with Latin or English verse commemorating his friends, such as the poets James Thomson or William Somerville.[37] In October 1759, Shenstone visited Sherrington Davenport's garden at Warfield in Berkshire and composed a poem honoring a statue of Venus in a grotto in the garden: "Tis, you know, ye Venus of Medici; which has a more bashful attitude yn any other, & is almost hid there in a Recess." But in November Shenstone informed his friend Thomas Percy that he was changing the poem and, since Davenport had moved to Bath, Shenstone was going to make other use of the poem.[38] Soon Shenstone recomposed the poem to become an ode on taste in terms of the pose of Venus. During their correspondence Percy remarked: "I wonder that this Figure which stands in almost every garden, hath never furnished hints of the subject of taste to any Poet before." By January 1761, *The London Magazine* printed Shenstone's revised poem with a note that it stood under

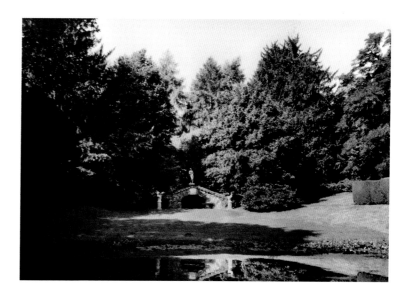

Fig. 8. William Kent, Vale of Venus (ca. 1740) at Rousham, Oxfordshire (photo: author)

| *Venus in the English Garden*

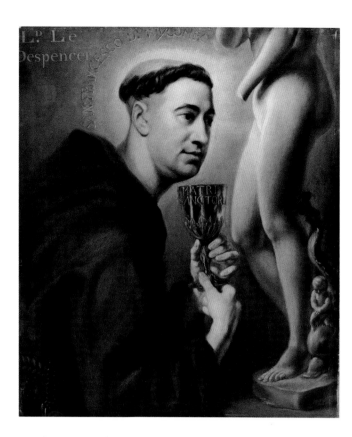

Fig. 9. George Knapton, *Sir Francis Dashwood, Bart., 15th Baron Le Despenser* (Society of Dilettanti, London, 1742) (photo: Photographic Survey, Courtauld Institute of Art, London)

a statue of Venus at The Leasowes, and Robert Dodsley's description of The Leasowes in 1764 identified a statue of "a Venus de Medicis, beside a bason of gold-fish, surrounded by shrubs and illustrated with the following inscription."[39] The inscription, with the Latin title "Semi-reducta Venus," meaning the "partially retired Venus," reads in part:

> To Venus, Venus here retir'd,
> My sober vows I pay:
> Not her on Paphian plains admir'd,
> The bold, the pert, the gay.
>
> Not her whose amorous leer prevail'd
> To bribe the Phrygian boy;
> Not her who, clad in armour, fail'd
> To save disast'rous Troy.
>
> Fresh rising from the foamy tide,
> She every bosom warms;
> While half withdrawn she seems to hide,
> And half reveals her charms.

> Learn hence, y[e] boastful sons of taste,
> Who plan the rural shade;
> Learn hence to shun the vicious waste
> Of pomp, at large display'd.
>
> Let sweet concealment's magic art
> Your mazy bounds invest,
> And while the sight unveils a part,
> Let fancy paint the rest.

The verses are undoubtedly primarily to rebuke Lord Lyttelton's expensive improvements at Hagley, which Shenstone resented. The mention later in the poem of "China's vain alcoves" may refer to Lord Cobham's Stowe, where the first Chinese garden pavilion in England was erected. Certainly the lines "and far be driven the sumptuous glare of gold, from British groves" are a criticism of the gilding of the statue of Venus at Stowe.

Later, the American Jabez Maud Fisher, in his travel journal of 1776, offers some additional information: "At the foot of this Cataract, Venus de Medici as if just rising from the Stream, is placed on a Pillar, her feet on the Surface of the Water."[40] Heely, in his descriptive letter published in 1777, notes "a Venus supposed either going to lave, or just emerged, stands in modest attitude, seemingly listening, and conscious of her exposed charms."

The garden Venus, which in the early eighteenth century at Stowe or Rousham was still an allegorical figure as she had been in the time of Charles I, by the mid-eighteenth century was a very sentimental, specific, coy creature exploiting the pose of the Medicean Venus. In fact, in some cases, as at West Wycombe Park, she existed in an erotic ambience.

Sir Francis Dashwood, owner of West Wycombe Park, was a man of extraordinarily different interests, which he pursued vigorously.[41] A member of the Royal Society and of the Society of Antiquaries, Sir Francis was one of the founders of the Society of Dilettanti in 1732–35, which supported archaeological expeditions. He himself visited Greece and went to Rome several times. (During one of the Roman trips he caused an international scandal by disrupting a religious ceremony at the Vatican.) Every member of the Dilettanti had his portrait made to hang in their meeting hall. The portrait of Sir Francis, painted by George Knapton in 1742, bore witness to Dashwood's anticlericalism as well as to his lechery (Fig. 9). In it he is depicted in the habit of a Franciscan friar, with the inscription "San: Francesco di Wycombo" written on his halo.

Kneeling before a statue of the Venus de' Medici, he holds a chalice inscribed "*Matri Sanctoru[m]*" (To the Mother of the Saints) and, as John Wilkes took pleasure in noting, "his gloating eyes fixed, as in a trance, on what the modesty of nature seems most desirous to conceal."[42] Similarly, an engraving of 1760 occasionally attributed to Hogarth again pictures Dashwood in Franciscan robes kneeling in worship before a small statue of a nude Venus, reminiscent of paintings depicting saints in adoration before a crucifix (Fig. 10).[43]

Probably in the 1740s, Sir Francis formed a group of men and women of common interest to assemble twice a year at the nearby ruined Cistercian abbey at Medmenham, also in Buckinghamshire, where they pursued secret rites often described as those of a Black Mass. Wilkes describes the garden at Medmenham and some of the sculpture decorating it:

> At the entrance of a cave was *Venus*, stooping to pull a thorn out of her foot. The statue turned from you, and just over the two nether hills of snow were these lines of Virgil:
>
> > *Hic locus est, partes ubi se via findit in ambas:*
> > *Hac iter Elyzium nobis; at laeva malorum*
> > *Exercet poenas, et ad impia Tartara mittit.*
>
> On the inside, over a mossy couch, was the following exhortation:
>
> > *Ite, agite, ô juvences, pariter fundate medullis*
> > *Omnibus inter vos; non murmura vestra columbae,*
> > *Brachia non hederae, non vincant oscula conchae.*
>
> The favourite doctrine of the Abbey, is certainly not *penitence;* for in the centre of the orchard is a very grotesque figure, *and in his hand a reed stood flaming, tipt with fire,* to use Milton's words; and you might trace out *peni tento non penitenti.*[44]

About 1739 Sir Francis began to revise his house and improve the grounds, including the erection of a temple to Venus hardly visible in an engraving of the West Wycombe landscape by William Woollett of 1757 (Fig. 11). A few building accounts in 1748–49 record masons working on "steps att the cave" and preparing "plinths for Figers to stand on att the cave mount," which apply to the new temple, and there is preserved a drawing attributed to the Italian architect Giovanni Niccolò Hieronimo Servandoni for the so-called Venus's Parlour below the Temple of Venus.[45] The engraving of 1757 gives a glimpse of the original temple to the right above the bridge. The

temple was an open, round, domed rotunda or *tempietto* housing a copy of the Medici Venus, almost identical with the Rotondo of Venus at Stowe, which undoubtedly inspired it. The rotunda at West Wycombe Park, however, stood on top of a large garden mount, particularly common in Tudor gardens. Here Dashwood had excavated a grotto within the mount, which is entered by a large oval entrance. The erotic symbolism of Dashwood's Mount of Venus must have been obvious to all eighteenth-century visitors. Again, Wilkes describes the temple:

> As to the temple I have mentioned, you find at first what is called an *error in limine;* for the entrance to it is the same entrance by which we all come into the world, and the door is what some idle wits have called the door of life. It is reported that, on a late visit to his chancellor [Dashwood was for a short while Chancellor of the Exchequer], lord Bute particularly admired this building, and advised the noble owner to lay out the 500£ bequeathed to him by lord Melcombe's will for an erection, in a Paphian column to stand at the entrance, and it is said he advised it to be made of Scottish pebbles.[46]

Later, in 1819, Sir John Dashwood-King, with a sense of greater moral rectitude, perhaps foreshadowing the Victorian era, destroyed the Temple of Venus and its statue, allowing the wall enclosing Venus's Parlour to collapse and leaving only an overgrown grotto. In 1982, however, Sir Francis Dashwood had the Temple of Venus completely rebuilt with apparently a very accurate reconstruction except for the omission of the sculpture in front of the mount and one other notable change (Fig. 12). In 1986 a copy of the Venus de Milo, discovered in 1820, was placed in the *tempietto* rather than a copy of the original Venus de' Medici. This change obviously denoted a different aesthetic taste. Rather than the coy, sentimental Venus of eighteenth-century preference, there is now a lusty, bold Venus presumably more conducive to twentieth-century taste.

The erotic aura associated with the Venus at West Wycombe Park and at Medmenham Abbey can be encountered in many writings of the second half of the eighteenth century. Edward Thompson published in 1763 a satire on the period entitled *The Temple of Venus:*

> Whores, and the Dame I sing, who first inspires
> The thrilling Virgin with unhallow'd fires.

| *Venus in the English Garden*

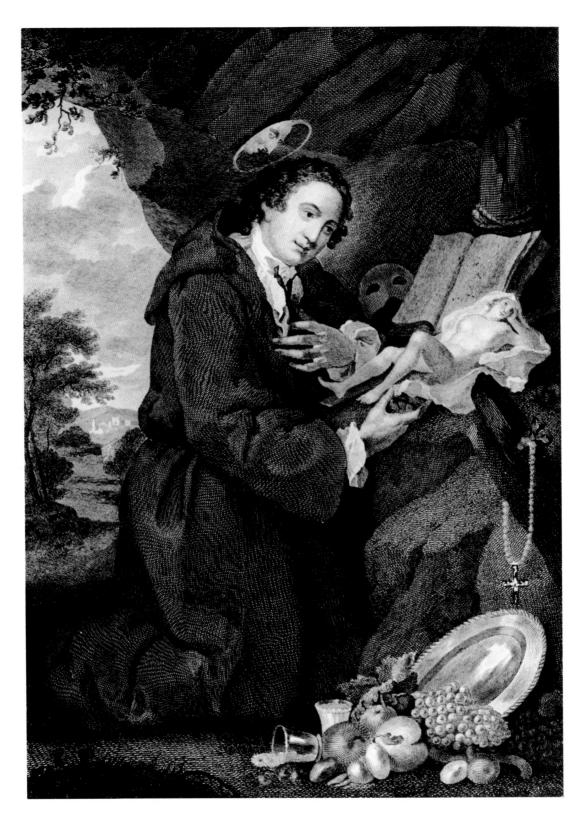

Fig. 10. William Hogarth (attributed), *Sir Francis Dashwood Worshipping Venus* **(1760)** (photo: © Copyright The Trustees of The British Museum)

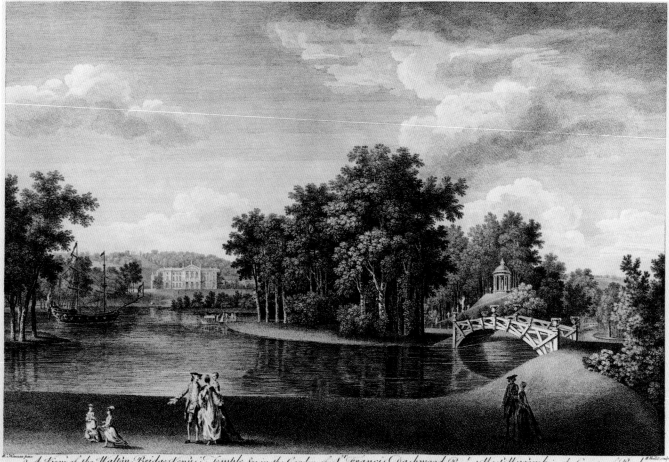

A View of the Walton Bridge, Venus's Temple, &c. in the Garden of Sr. Francis Dashwood, Bart. at West Wycomb in the County of Bucks
Veüe du Pont, du Temple de Venus &c. dans le Jardin du Chevalier Fr. Dashwood, a West Wycomb dans la Comté de Bucks

Say, lovely Goddess, why's mankind so curst,
That Cull the second, pays like Cull the first?
Venus, declare, for you alone can tell,
Why lust drives Virtue from her hallow'd cell?
. . .
Love's lovely Goddess from the Ocean sprung,
So greater fools than *Hesiod* whilom sung:
But where's no matter, she's a wanton girl.[47]

In 1766 the poet William Whitehead composed verses in Latin and English to be inscribed "on a Tablet in the Temple of Venus, in Lord Jersey's Wood at Middleton Stoney":

Whoe'er thou art, whom chance ordains to rove,
A youthful stranger to this fatal grove.
Oh! if thy breast can feel too soft a flame,
And with thee wanders some unguarded dame,

Fig. 11. William Woollett after William Hannan, *A View of the Walton Bridge, Venus's Temple, &c. in the Garden of Sir Francis Dashwood Bt. at West Wycomb in the County of Bucks*, 1757. Yale Center for British Art, Paul Mellon Collection (photo: Yale Center for British Art)

Fly, fly the place—each object thro' the shade
Persuades to love, and in this cottage laid,
What cannot, may not, will not love persuade?
. . .
Above, the boughs a pleasing darkness shed,
Beneath, a downey couch soft fleeces spread,
Or softer herbage forms a living bed.
. . .
But *Venus* self does her own rites approve
In naked state, and thro' the raptur'd grove
Breaths the sweet madness of excessive love.[48]

| *Venus in the English Garden*

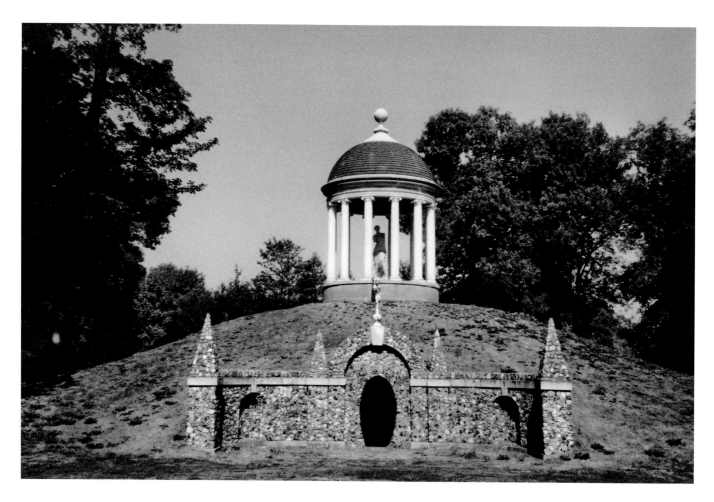

Fig. 12. Temple of Venus (built by 1748, restored 1982) at West Wycombe Park, Buckinghamshire (photo: author)

So Sir Philip Francis, visiting the Tribuna of the Uffizi in Florence in 1772, debated in his tour diary about whether he would prefer carnal relations with the Venus de' Medici or Titian's Venus, both being exhibited there. The solution for Sir Philip was offered about that time by Dr. Samuel Johnson when walking in the garden of his friend Mr. Wickins in Lichfield in Staffordshire:

> Upon the margin [of a cold bath] stood the Venus de' Medicis—
> "So stands the statue that enchants the world."
> "Throw her," said he, "into the pond to hide her nakedness, and to cool her lasciviousness."[49]

Conclusion

The changing image of Venus and her role in English gardening reflect, of course, the different ideals and values held by the varying generations of the English. The principal change during the seventeenth and eighteenth centuries was a shift from an emphasis on the allegorical and general to the specific and individual. By the Georgian period not only portraits of royalty, but also of military and cultural heroes and even genre figures, were frequent in English gardens. This change from the more generalized, universal expression to the particular and the individual may relate to the political-social ambience of England, marking the change from the absolute monarchy of the early Stuart period and its lingering traces with the later Stuarts to the more democratic, parliamentary government of the Georgian period, allowing more individual expression, at least for the upper class.

Notes

1. Pliny the Elder (Gaius Plinius Secundus), *Historia naturalis*, XIX.xix.20; Marcus Terentius Varro, *De re rustica*, I.i.6.

2. For the history of the statue, see F. Haskell and N. Penny, *Taste and the Antique* (New Haven and London: Yale University Press, 1981), 56, 325–328.

3. D. Howarth, *Lord Arundel and His Circle* (New Haven and London: Yale University Press, 1985), 57–59.

4. François Perrier, *Segmenta Nobilium Signorum et Statuarum* (Rome and Paris, 1638), pls. 81–83.

5. E. S. de Beer, ed., *The Diary of John Evelyn* (Oxford: Oxford University Press, 1955), vol. 2, 286.

6. F. Baldinucci, *Notizie dei professori del disegno* (Florence: V. Barelli, 1847), vol. 5, 383–384.

7. [François Misson], *A New Voyage to Italy*, 4th ed. (London: R. Bonwicke, 1714), vol. 2, 284–285; Joseph Addison, *Remarks on Several Parts of Italy, &c., in the Years 1701, 1702, 1703* (London: J. Tonson, 1705), in *The Miscellaneous Works of Joseph Addison*, ed. A. C. Gutketch (London: G. Bell & Sons, 1914), vol. 2, 155–156, 188–189; D. C. Tovey, ed., *The Poetical Works of James Thomson*, new ed. (London: Bell, 1897), vol. 1, 85, ll. 1344–49. Also John R. Hale, "Art and Audience: The Medici Venus c. 1750–c. 1850," *Italian Studies* 31 (1976), 40–41. For Thomson's *Liberty*, see James Thomson, *Liberty, the Castle of Indolence, and Other Poems*, ed. J. Sambrook (Oxford: Clarendon, 1986), 95, ll. 175–184. Also [J.] Richardson, Sr. and Jr., *An Account of the Statues, Bas-Reliefs, Drawings and Pictures in Italy, France, &c.*, 2nd ed. (London: D. Browne, 1754), 55–56.

8. G. A. Bonnard, ed., *Gibbon's Journey from Geneva to Rome* (London: Thomas Nelson, 1961), 179.

9. [A. B.] Jameson, *The Diary of an Ennuyée* (Boston: Ticknor, 1860), 90.

10. Hugh Honour, "English Patrons and Italian Sculptors in the First Half of the Eighteenth Century," *Connoisseur* 141 (1958), 224, 226 n. 25; Hale, "Art and Audience" (note 7 above), 37–58.

11. For the Walpole letters, see Horace Walpole, *Correspondence*, ed. W. S. Lewis (New Haven: Yale University Press, 1954), vol. 19, 34 (15 April 1745); vol. 20, 539 (18 March 1756).

12. For Joseph Wilton as copyist, see Rupert Gunnis, *Dictionary of British Sculptors, 1660–1851*, rev. ed. (London: Abbey Library, 1968), 434–437.

13. Hale, "Art and Audience" (note 7 above), 50.

14. Haskell and Penny, *Taste and the Antique* (note 2 above), 321–323.

15. For Bridgeman's bird's-eye view drawing of Home Park, see Christopher Hussey, *English Gardens and Landscapes, 1700–1750* (London: Country Life, 1967), pl. 117. Also M. Gibbon, "Stowe, Buckinghamshire: The House and Garden Buildings and Their Designers," *Architectural History* 20 (1977), 38–40; M. Bevington, "The Development of the Classical Revival at Stowe," *Architectura* 21 (1991), 136–138.

16. Pliny, *Historia naturalis*, XXXVI.iv.21.

17. For the column, see Benton Seeley, *Views of the Temples and Other Ornamental Buildings in the Gardens* (1750), pl. 4; repr. G. B. Clarke, ed., *Descriptions of Lord Cobham's Gardens at Stowe 1700–1750* (Buckingham: Buckinghamshire Record Society, 1990), 151.

18. *The British Poets* (Chiswick: Whittingham, 1822), xxvi, 101.

19. George Bickham, *The Beauties of Stow* (London: E. Owen, 1750), 7; repr. John D. Hunt, ed., *The Gardens at Stowe* (New York, 1982).

20. R. Paulson, *Emblems and Expression* (London: Thames & Hudson, 1975), 22–23; "A Cajun Chapbook," *New Arcadian Journal* 33/34 (1992), 38–41.

21. "[W]ithout grain and wine love is cold"; Terence, *Eunuchus*, IV.732.

22. For the buildings, see Seeley, *Views of the Temples* (note 17 above), pls. 3–5; repr. Clarke, *Descriptions of Lord Cobham's Gardens* (note 17 above), 150–152.

23. For the buildings, see Seeley, *Views of the Temples* (note 17 above), pls. 5, 6; repr. Clarke, *Descriptions of Lord Cobham's Gardens* (note 17 above), 152, 153.

24. *The Gentleman's Magazine* 13 (March 1743), 154.

25. For Hall Barn, see Hussey, *English Gardens and Landscapes* (note 15 above), 24–26, pl. 11; and for the temple, see George Mott and Sally S. Aall, *Follies and Pleasure Pavilions* (London: Pavilion, 1989), 70. For Studley Royal, see Hussey, *English Gardens and Landscapes*, 132–138; Richard Haslam, "Studley Royal, North Yorkshire," *Country Life* 179 (27 March 1986), 802–805; Mary Mauchline and Lydia Greeves, *Fountains Abbey & Studley Royal, North Yorkshire* (London: National Trust, 1988); and Patrick Eyres, "Rambo in the Landscape Garden: The British Hercules as Champion of the Protestant Succession," *New Arcadian Journal* 37/38 (1994), 31–36.

26. For the Banqueting House and Rotunda, see Gervase Jackson-Stops, *An English Arcadia, 1600–1990: Designs for Gardens and Garden Buildings in the Care of the National Trust* (Washington, D.C.: American Institute of Architects Press and British National Trust, 1991), 56, 57, cat. no. 30.

27. F. Dashwood, *The Dashwoods of West Wycombe* (London, 1987), 223–224.

28. J. W. L. Forge, "The Grotto, Oatlands Park, c. 1778–1948," *Surrey Archaeological Collections* 51 (1950), 134–140; Michael Symes, "New Light on

Oatlands Park in the Eighteenth Century," *Garden History* 20 (1992), 14–20.

29. Charles Saumarez Smith, *The Building of Castle Howard* (London: Faber & Faber, 1990), 146–147.

30. Ibid., 147, the original source being Castle Howard Ms. CH J8/1/631.

31. K. Woodbridge, "William Kent's Gardening: The Rousham Letters," *Apollo* 100 (1974), 287–291; David R. Coffin, "The Elysian Fields of Rousham," *Proceedings of the American Philosophical Society* 130 (1986), 406–423 [reprinted on pages 218–231 of this volume]; John D. Hunt, *William Kent, Landscape Garden Designer* (London: A. Zwemmer, 1987), 79–86.

32. There has been much debate about whether there was a given way to experience the garden, but in 1750 the gardener, John MacClary, clearly defined the route for a visitor; M. Batey, "The Way to View Rousham by Kent's Gardener," *Garden History* 11 (1983), 125–132.

33. H. Luxborough, *Letters Written by the Late Right Honourable Lady Luxborough to William Shenstone, Esq.* (Dublin: D. Jenkin, 1776), 38, letter XIII (1748); 108, XXXII (8 September 1749); 163, XLIV (25 February 1750); 274, LXXXIX (27 November 1752); M. Williams, ed., *The Letters of William Shenstone* (Oxford: Blackwell, 1939), 191 (23 April 1749), 210 (9 August 1749), 408 (17 July 1754).

34. William Stukeley, *The Family Memoirs of the Rev. William Stukeley, M.D.*, Surtees Society Publication no. 72 (Durham: Surtees Society, 1882), 391, no. CXLII (12 June 1747).

35. Richard Pococke, *The Travels through England of Dr. Richard Pococke*, ed. J. J. Cartwright, Camden Society, n.s., vol. 42 (London: Camden Society, 1888), vol. 1, 226–227. For Arthur Young, see his *A Six Months Tour through the North of England*, 2nd ed. (London: W. Strahan, 1771), vol. 3, 294–295.

36. Joseph Heely, *Letters on the Beauties of Hagley, Envil, and The Leasowes* (London: R. Baldwin, 1777), vol. 1, 144–145. Also E. M. Betts, ed., *Thomas Jefferson's Garden Book, 1766–1824*, Memoir 22 (Philadelphia: American Philosophical Society, 1944), 113. About the same time, the Italian visitor Carlo Gastone della Torre di Rezzonico noted that the statue was of lead (*piombo*) covered by gesso, which was damaged by the humidity; E. Bonora, ed., *Letterati, memorialisti e viaggiatori del Settecento* (Milan: Riccardo Ricciardi, 1951), 1010.

37. R. Dodsley, "A Description of The Leasowes, the Seat of the Late William Shenstone, Esq;," in *The Works in Verse and Prose of William Shenstone, Esq;*, 4th ed. (London: J. Dodsley, 1773), vol. 2, 285–320; Heely, *Letters* (note 36 above), vol. 2, 97–228. J. G. Turner, "The Sexual Politics of Landscapes: Images of Venus in Eighteenth-Century English Poetry

and Landscape Gardening," *Studies in Eighteenth-Century Culture* 11 (1982), 343–366, considered the use of the Venus de' Medici in eighteenth-century English gardens, primarily concentrating on the role of Venus in Alexander Pope's garden at Twickenham in Surrey and in Shenstone's The Leasowes. Shenstone's "neighbor and competitor" at Hagley, however, was not Lord Cobham but Lord Lyttelton (p. 347), and one might suggest that Graves's "China's vain alcoves" may refer to the earlier Chinese pavilion at Stowe rather than at Stourhead in Wiltshire (p. 366).

38. Williams, *Letters of William Shenstone* (note 33 above), 522, 531–534, 571, 588–592. For Percy's comment on Venus, see H. Hecht, ed., *Thomas Percy und William Shenstone*, Quellen und Forschungen 103 (Strassburg: K. J. Trübner, 1909), 33.

39. *The London Magazine* 30 (January 1761), 47. For Robert Dodsley's description of The Leasowes, see Dodsley, *Works . . . of William Shenstone* (note 37 above), vol. 2, 61–62.

40. *An American Quaker in the British Isles: The Travel Journals of Jabez Maud Fisher, 1775–1779*, ed. K. Morgan (Oxford: Oxford University Press, 1992), 259. Also Heely, *Letters* (note 36 above), vol. 2, 202, 218–219. The anonymous *A Companion to The Leasowes, Hagley, and Enville, with a Sketch of Fisherwick* (Birmingham: Swinney & Hawkins, 1789) states that the lead statue was stolen on 6 June 1785; M. Charlesworth, ed., *The English Garden: Literary Sources and Documents* (Mountfield: Helm Information, 1993), vol. 2, 222.

41. R. Fuller, *Hell-Fire Francis* (London: Chatto & Windus, 1939); B. Kemp, *Sir Francis Dashwood* (London: Macmillan, 1967); Dashwood, *Dashwoods of West Wycombe* (note 27 above).

42. John Wilkes, *The New Foundling Hospital for Wit*, 2nd ed. (London: J. Almon, 1768), vol. 1, 44.

43. For Hogarth's painted version of the engraving, see H. Mallalieu, "Northern Stars Sparkle Bright" [a review of an exhibition that brought together rarely seen works of art from private collections in the north of England], *Country Life* 194 (17 February 2000), 54.

44. The two Latin passages read, respectively: "Here is the place where the way divided into two: this on the right is our route to Heaven; but the left-hand path exacts punishment from the wicked, and sends them to pitiless Hell"; and "Go into action, you youngsters; put everything you've got into it together, both of you; let not doves outdo your cooings, nor ivy your embraces, nor oysters your kisses"; Dashwood, *Dashwoods of West Wycombe* (note 27 above), 31–32.

45. G. Jackson-Stops, "The West Wycombe Landscape I," *Country Life* 155 (20 June 1974), 1619. For Servandoni's drawing of the Parlour, see Jackson-Stops, *An English Arcadia* (note 26 above), cat. no. 66.

46. Wilkes, *New Foundling Hospital* (note 42 above), vol. 1, 44–45.

47. [Edward Thompson], *The Temple of Venus: A Gentle Satire on the Times* (London: C. Moran, 1763), 1, 4.

48. For Middleton Stoney, see *The Gentleman's Magazine* 36 (September 1766), 429.

49. G. B. Hill, ed., *Johnsonian Miscellanies* (Oxford: Clarendon, 1897), vol. 2, 428. "So stands the statue that enchants the world" is taken from Thomson's poem *Summer* (1730), l. 1346. For Sir Philip Francis, see Jeremy Black, *The British and the Grand Tour* (London: Croom Helm, 1985), 109.

16

Venus in the Garden of Wilton House

The classical deity Venus was a major subject in the decoration of English gardens in the seventeenth and eighteenth centuries since she was not only the traditional goddess of love and beauty, but was also identified by ancient Romans as the guardian or goddess of the garden.[1]

It was Philip Herbert, Earl of Pembroke, who created one of the earliest celebrations of Venus in a Stuart garden in his new, lavish layout at Wilton House in Wiltshire.[2] In 1632–1633 some £200 were expended on the "construction of the new garden" at Wilton, and by 1634–1635 over £1,000 had been spent and the garden more or less completed. Originally, a new architectural wing as wide as the garden was planned to be added to the Tudor house looking out over the garden, but, probably because of financial limitations, the new wing was reduced to half the width of the garden, with the central axis of the garden on line with the east end of the architectural addition. Unfortunately, the great garden was destroyed in the eighteenth century when more naturalistic gardening prevailed. There is, however, a series of etched views of the garden illustrating the whole complex and many details.[3]

The garden, walled in on three sides, was rectangular in form, about 1,000 feet long and 400 feet wide, according to the brief description accompanying the etchings (Fig. 1). The garden was divided into three major parts with a long, central alley tying them together in an Italianlike perspectival manner. Near the house, in the foreground of the etching, were four large flower beds, called "plats" by the English at the time—that is, plots or layouts—but soon to be identified with the French designation "parterres." The so-called embroidered parterres at Wilton, entitled thus because of elaborate floral patterns like embroidery, invented in France, are among the earliest of this type in England. In the center of each parterre was a sculptured group. The garden at Wilton, with its long central axis, the emphasis on sculptural decoration, and its rich floral parterres, was in the classical manner of Italian and French gardens, distinctly different from English Tudor centripetal designs, and, in fact, the garden at Wilton was designed by Isaac de Caus, a French Huguenot architect and hydraulic engineer, whose elder brother, Salomon, had been a garden and hydraulic designer slightly earlier in England and later at Heidelberg, Germany.

Beyond the floral parterres at Wilton, in the middle distance, was a wooded area. In the classical gardens of Italy or France, a wood or grove—*bosco* in Italian, *bosquet* in French—served as a background to the formal gardens. Here at Wilton, the grove has been moved to the midpoint, presumably to mask the small, irregular stream, the Nadder, that casually flowed across the garden. At the house level, unlike the etching, the stream would have been hidden by the woods. Set in the center of each of the two groves were large figures of traditional garden sculpture: Flora, the goddess of flowers, and Bacchus, the god

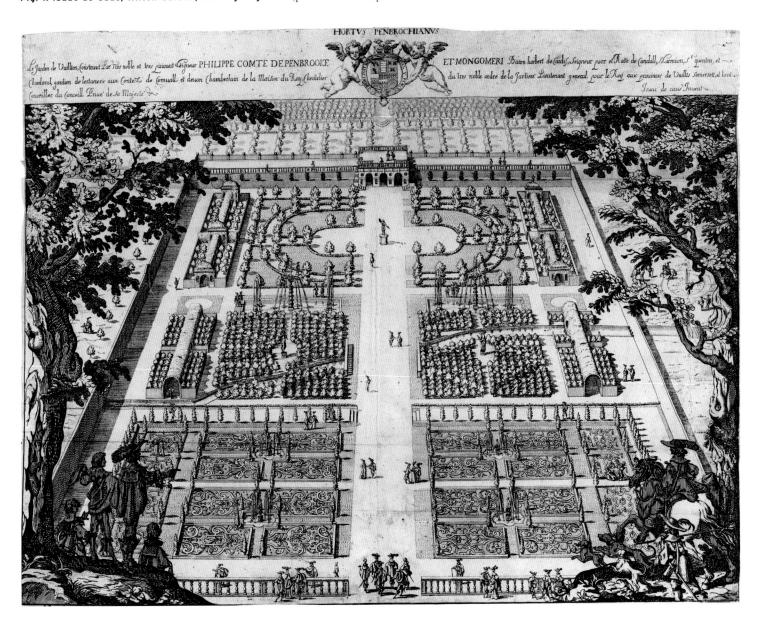

Fig. 1. Isaac de Caus, *Wilton Garden*, etching of garden (photo: The Metropolitan Museum of Art, Harris Brisbane Dick Fund, 1927 [27.66.2])

of the vine. The statues now stand on the nineteenth-century bridge east of the house.

The last third of the garden had a wide, oval alley lined with cherry trees encircling a bronze statue of a nude warrior or gladiator with shield and sword. It is a copy of the famous ancient statue the *Borghese Warrior*, then in the Villa Borghese at Rome. A copy of the ancient piece made for King Charles I was on display by 1630 in the Privy Garden at St. James's Palace in London.[4] Presumably through the kindness of the king, the Earl of Pembroke had obtained a copy. When the garden at Wilton was destroyed in the eighteenth century, the statue

was given to the prime minister, Robert Walpole, and now stands in the stair hall of his country estate at Houghton in Norfolk.

In 1635 one Lieutenant Hammond visited Wilton about the time that the garden was completed and wrote an account of what he saw. In his description, he identified the four female figures in the parterres as he knew them:

In one [of the parterres] is Venus, with her sonne Cupid in her Armes; in another Diana, with her bathing sheet; in a third is Susanna pulling a

251

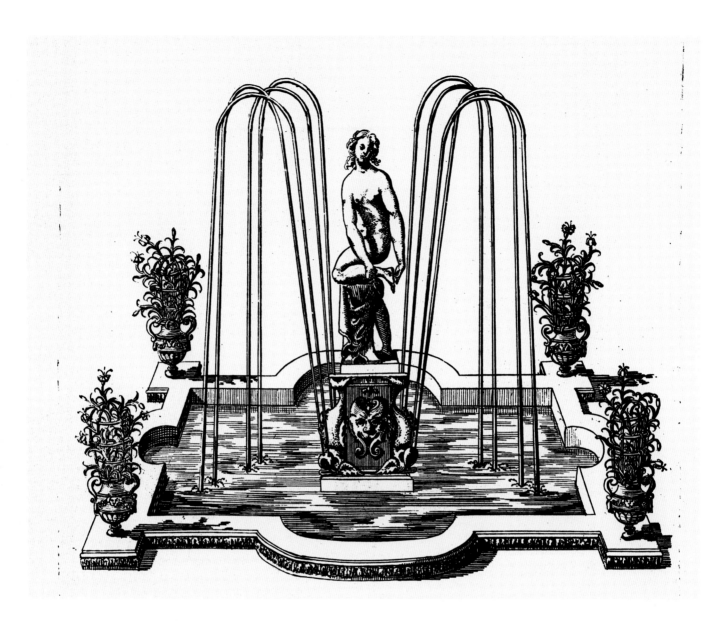

thorne out of her Foote; and in the 4th Cleopatra with the Serpent.[5]

There still exist at Wilton, set recently in a small, new garden in the forecourt of the house, four female statuary groups undoubtedly carved by the royal mason and sculptor Nicholas Stone.[6] Three of the figures agree with Hammond's description. There is a Diana, goddess of chaste love, with a crescent moon on her head. There is a group of Venus with her son Cupid begging for the return of his quiver of arrows. There is a third figure that Hammond identified as the biblical heroine Susanna plucking a thorn from her foot (Fig. 2). In place of Cleopatra, the ancient Egyptian queen who was faithful in her love of Marc Antony even unto her suicide, there is another statue of Venus—at least it is a female figure accompanied by a dolphin—which apparently, according to one of the etchings, stood in a water parterre at Wilton.

The female statue that Hammond called Susanna is misidentified by him.[7] There is nothing in the depiction of the figure to suggest the story of Susanna except that she is nude, nothing to suggest the significant moment of the story of her being spied on by two lustful, elderly men (Fig. 3). The significant gesture of the figure is that she is engrossed with the bottom of her foot. For many years, there had been a famous ancient statue of a young

boy in a similar pose on Rome's Capitoline Hill; it is called the *Spinario* since the youth is drawing a thorn out of the sole of his foot. The ancient statue was well known in England because the sculptor Le Sueur had made a copy of the figure, which was in the royal collection. This copy may have served as a model for the female figure.

The pose of the female nude at Wilton can, therefore, be explained by a myth associated with Venus, a myth not well known today, but of common knowledge during the Renaissance. The myth is an addition to Ovid's story of Venus and Adonis that recounts how Adonis spurned the love of Venus to go hunting, only to be killed by a wild boar. In the addition to Ovid's myth, Venus had a foreboding of the danger threatening Adonis and ran through the woods seeking to warn him. During her pursuit, she stepped upon the thorn of a white rose. As she plucked the thorn from her foot, blood gushed forth, dyeing the white rose red and thus explaining the origin of the red rose.

The myth of Venus and the red rose was first told by a late Greek rhetorician, Aphthonius, in the fourth century A.D. In the sixteenth century, a German scholar, Reinhard Lorich, prepared a Latin translation for the teaching of rhetoric, which ran through numerous editions.[8] At least ten editions were printed in England alone from 1572 on. In 1563 Richard Rainholde or Reynolds published *A Booke Called the Foundacion of Rhetorike* with an English translation of the myth. Aphthonius's book, therefore, became a manual for every English youth learning rhetoric. Interestingly, several of the eighteenth-century guides to the statuary at Wilton identify the figure as "Venus picking a thorn out of her foot."[9] It may seem unusual that at Wilton there were in the floral parterres two statues dedicated to Venus, but that is precisely her significance for gardening, as was noted earlier. The group of Venus and Cupid with his quiver of arrows depicts her as the goddess of love and beauty, while the figure of Venus as thorn puller corresponds to her role as the goddess of the garden and particularly of the rose.

Most historians have been content simply to list the identifications of the several garden figures at Wilton as given by Lieutenant Hammond and have not considered the significance of the whole. Recently, however, several historians have suggested that the garden honors the Earl of Pembroke and his countess, Anne Clifford, whom he married in 1630. The earl would be symbolized by the martial figure of the gladiator at one end of the garden,

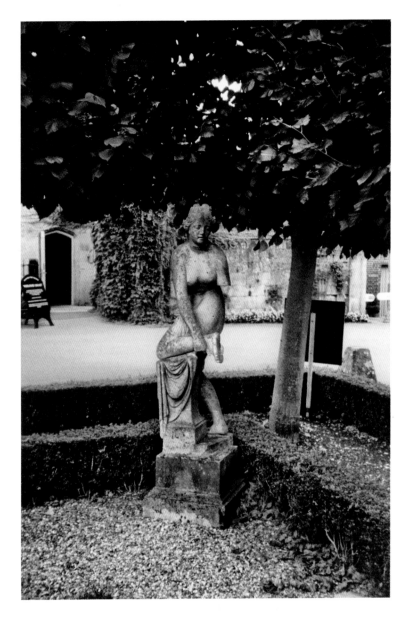

Fig. 3. *Venus Spinaria*. Wilton (Wilts) (photo: author)

and the countess by the several statuary groups expressing love and chastity at the near end.[10] The seventeenth-century chronicler John Aubrey, in his history of Wiltshire, published only in the nineteenth century, indirectly offers the answer to the significance of the garden when he writes:

> King Charles the first did love Wilton above all places, and came thither every summer. It was he that did put Philip first Earle of Pembroke upon making this magnificent garden and grotto, and

to new build that side of the house that fronts the garden, with two stately pavilions at each end, all *al Italiano*.[11]

Repeatedly contemporary poetry honors the queen and king by likening them to Venus and to either Mars or Heroic Virtue. So Sir John Denham, in his topographical poem "Coopers Hill," whose first text dates from 1642, speaks of

Windsor the next (where *Mars* with *Venus* dwells,
Beauty with strength) above the valley swels
Into my eie, . . . [12]

In the manuscript of Text A, the first line is glossed: "Kinge and Queene there." The several groups of feminine statuary at Wilton refer to the queen. The group of Venus and Cupid, of course, symbolize her as an embodiment of love and beauty. Venus with the rose must also reflect the queen. In addition to the references to her as Venus, the queen is frequently identified as the Lily-Rose Queen, the lily alluding to her French birth as daughter of the king of France and the rose to her position as queen of England. The statue of Diana connotes chaste love as that of Cleopatra speaks of the fidelity of love. Interestingly, Mary Sidney, Countess of Pembroke and mother of the creator of the garden, had published in 1590 a translation of a French tragedy entitled *Marc Antoine* in which Cleopatra asserts that she had loved Antony "more deare than Sceptre, children, Freedome, light."[13] Later, the countess will persuade Samuel Daniel to write a companion play, *Cleopatra*, first published in 1594. Finally, the statue of the nude warrior at Wilton was presumably a reference to the king in his role of Heroic Virtue.

Unlike later examples, the figure of Venus in the early Caroline garden was always an allegorical, generic figure derived from literary descriptions of her. In the eighteenth century, in contrast, one specific ancient type of Venus, the so-called Medici Venus, will unfailingly be the model for garden Venuses, which, in turn, will evoke the individual emotions of the owner and visitors, usually inspired by the pose of the figure.[14]

Notes

1. See Pliny the Elder, *Natural History*, XIX.xix.20; and Varro, *On Agriculture*, I.1.6.

2. T. Lever, *The Herberts of Wilton* (London, 1967), 100–103; R. Strong, *The Renaissance Garden in England* (London, 1979), 147–161; and J. Bold, *Wilton House and English Palladianism* (London, 1988).

3. A. Globe, *Peter Stent, London Printseller circa 1642–1665* (Vancouver, 1985), 159–160, no. 563.

4. F. Haskell and N. Penny, *Taste and the Antique* (New Haven and London, 1981), 31.

5. L. G. Wickham Legg, ed., "A Relation of a Short Survey of the Westerne Counties," *Camden Miscellany*, 3d ser., 52 (1936), 67.

6. For Stone, see W. L. Spiers, "The Notebook and Account Book of Nicholas Stone," in *Walpole Society* 7 (1919), 137. In a review of Strong's book on Renaissance gardens in England, it has been suggested that Venus and Cupid should be identified as Psyche and Cupid. This cannot be for several reasons. First, the little boy is much smaller than the female figure as proper in a mother and son, but not in the lovers Psyche and Cupid. More important, Venus holds a quiver of arrows away from Cupid, while he sits on a dolphin, the symbol of her birth from the sea. See A. A. Tait, in *Burlington Magazine* 72 (1980), 773.

7. Sir Roy Strong, in his important book *The Renaissance Garden in England* (note 2 above), originally followed Hammond's identification, as have other historians, but in Strong's recent book, *Lost Treasures of Britain* (London, 1990), 175, he correctly identifies the figure as Venus without any explanation.

8. See the introduction by F. R. Johnson to R. Rainholde [Reynolds], *The Foundacion of Rhetorike* (New York, 1945).

9. R. Cowdry, *A Description of the Pictures, Statues, Busto's, Basso-Relievo's, and Other Curiosities at the Earl of Pembroke's House at Wilton*, 2d ed. (London, 1752), 104; and Thomas Herbert, Earl of Pembroke, with James Kennedy, *A Description of the Antiquities and Curiosities in Wilton-House* (Sarum, 1781). The guidebooks also identify the statues of Venus and Cupid, Venus with her left hand on the tail of a dolphin, and Diana.

10. Strong, *Renaissance Garden* (note 2 above), 158; and V. Hart, *Art and Magic in the Court of the Stuarts* (London and New York, 1994), 103.

11. J. Aubrey, *The Natural History of Wiltshire*, ed. J. Britton (London, 1847), 83.

12. B. O'Hehir, *Expans'd Hieroglyphicks: A Critical Edition of Sir John Denham's Coopers Hill* (Berkeley and Los Angeles, 1969), 113. For contemporary poetry, see G. Parry, *The Golden Age Restor'd* (Manchester, 1981), 184–187. Among the innumerable poems and examples of

doggerel honoring the queen as Venus, see the marriage verses offered at Cambridge, *Epithalamium Illustriss. & Feliciss. Principum Caroli Regis et H. Mariae Reginae Magnae Britanniae, &c. a Musis Cantabrigiensibus Decantatum* (Cambridge, 1625), 15–17; Waller's poem "To the Queen," in E. Waller, *The Poems of Edmund Waller*, ed. G. T. Drury (London and New York, 1893), 8; or G. Sandys's preface to his translation of Ovid, G. S[andys], *Ovids Metamorphoses: Englished, Mythologiz'd, and Represented in Figures* (Oxford, 1632), unpaginated.

13. G. Bullough, ed., *Narrative and Dramatic Sources of Shakespeare*, vol. 5, *The Roman Plays: Julius Caesar, Antony and Cleopatra, Coriolanus* (New York, 1964), 228–231; and S. Daniel, *The Complete Works in Verse and Prose of Samuel Daniel*, ed. A. B. Grosart (New York, 1893), vol. 3, 2–26.

14. See my article "Venus in the Eighteenth-Century English Garden," in a forthcoming issue of *Garden History* [reprinted on pages 232–249 of this volume].

17

Tintoretto and the Medici Tombs*

It is often not difficult to analyze the effect of the influence of a great artist upon one of his minor followers. This influence is usually limited to an undigested repetition of figures, compositions, or the most striking stylistic characteristics of the greater artist. However, when the influence is being exerted from one master upon another of almost equal caliber, who will re-create the elements of influence into a totally new work of art, an analysis of the extent of this influence is often reduced to generalities. One can point to a vague similarity in the proportions of the figures or the similarity in the means of delineating forms, but such indications say little about the impact and assimilation of the influence upon the second artist and, therefore, reveal little about the relationship between the two artists.

The influence of Michelangelo upon Tintoretto at times shares this ambiguity. Tintoretto's version of *Cain and Abel*, now in the Accademia, Venice, has rightfully been described as Michelangelesque[1] on the basis of its monumentality and interest in the nude. However, these characteristics are more probably reflections of Titian's similar painting of *Cain and Abel* in Santa Maria della Salute, Venice, of a decade earlier than Tintoretto's version, rather than direct influences from Michelangelo.[2] Nevertheless, there is a series of works by Tintoretto which can be directly connected with a group of some of the most notable works by Michelangelo, namely, the Medici

Tombs in San Lorenzo, Florence. These works by Tintoretto show various levels of assimilation of the overpowering influence of Michelangelo.

The influence of Michelangelo is usually considered as commencing with Tintoretto's *Miracle of the Slave* (Fig. 1) in the Accademia, Venice, painted for the Scuola di San Marco in 1548. Pittaluga, in her book on Tintoretto, believes that he must have been in Rome before this work,[3] while von der Bercken and Mayer commence a new period in the development of Tintoretto with this painting.[4] In fact, this influence was, in part, the goal of Tintoretto, according to Ridolfi, who asserted in 1648 that Tintoretto had written on the wall of his studio the famous precept "the drawing of Michelangelo and the color of Titian."[5] Actually, as early as 1548 Paolo Pino had proposed this formula as the ideal of painting.[6] Whether Ridolfi is correct or not, the motto exemplifies the difficulty and debate of the period. The contact between the various schools and regions of Italy and their influence upon one another in the Cinquecento had usually resulted in contrasting Venetian color and Florentine-Roman design and drawing. A certain feeling had arisen, as exemplified in Pino, to resolve this contrast.

Tintoretto's attempt to acquire the Florentine-Roman *disegno* is revealed in part by the descriptions in old sources of his method of study and creation. Borghini, in *Il riposo*, written in 1584, points out that Tintoretto studied

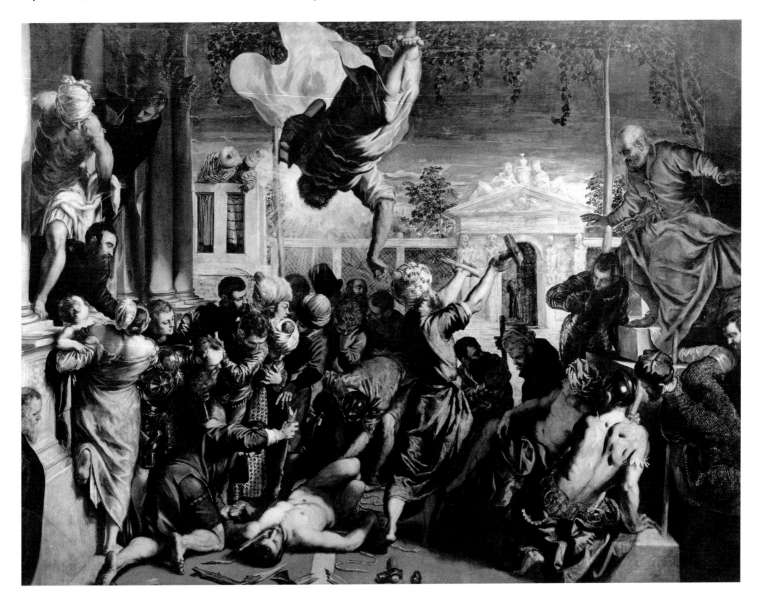

the statues of Jacopo Sansovino, particularly the *Mars* and *Neptune* in Venice, and that he had reproductions made of Michelangelo's figures in the Medici Chapel and of the best statues in Florence.[7] Ridolfi adds that the models of the Medici Chapel figures, mentioning particularly the four *Times of Day*, were made by Daniele da Volterra.[8] He says that Tintoretto was accustomed to make drawings of these models from many different angles and under varied combinations of lighting. Boschini, in his description of the atelier of Tintoretto as preserved as late as 1660, mentions the occurrence of statuettes of the *Notte* and *Crepuscolo* among antique casts and figures after Giovanni da Bologna.[9]

There is a large assortment of drawings after the sculpture of Michelangelo which will support the previously mentioned writings. However, there is an annoying problem regarding the attribution of these many varied drawings, for the models after Michelangelo served in the atelier as subjects for drawing by the pupils of Tintoretto; apparently such drawing was part of their training as well as Tintoretto's. Many of these drawings are now attributed to Tintoretto's son, Domenico,[10] and other pupils.[11] In general, we shall only consider those drawings which seem surely Tintoretto's.[12] There are preserved in this more select group of drawings views of only three of the Medici Chapel figures, the *Giorno*, the *Crepuscolo*, and *Giuliano de' Medici*.

Fig. 2. Oxford, Christ Church Library, JBS 762 recto. Tintoretto, drawing after Michelangelo's *Giorno* (photo: The Governing Body of Christ Church, Oxford)

Of the two certain drawings after Michelangelo's *Giorno*,[13] the drawing in Christ Church Library, Oxford, JBS 762 recto, is rather interesting as visual verification of the comments of Ridolfi and Borghini on Tintoretto's method of studying the *disegno* of Michelangelo (Fig. 2). In the drawing the figure is viewed from the feet at a fairly high level. The strong lighting from above reveals Tintoretto's great interest in this problem. At least two factors in the drawings themselves, as well as the unusual point of observation, suggest that the drawings were made, not after the

originals, but from models. The uncut block, so evident in Michelangelo's figure, is not indicated in the drawing; rather, the figure stands out baldly, all alone, like a clay or bronze model. Also, the treatment of the hair and beard, with their lumpy protuberances, in the drawing suggests modeling of clay rather than the cut-back, simplified, almost cubistic stone forms in the original of Michelangelo.

The drawing after the *Crepuscolo* in the Uffizi, Florence, no. 13048 (Fig. 3),[14] is taken from a point of observation behind and above the head of the figure. In this example, also, there seems to be no indication of the portions of uncut block; the shadow cast by the right foot and ankle seems cast on a flat surface, such as a table top. The rather smooth lower left arm and hand of Michelangelo's original are now more varied and less smooth.[15]

The third statue by Michelangelo from the Medici Tombs of which drawings are preserved, attributed to Tintoretto, is the figure of *Giuliano de' Medici*. There are several drawings which depict only the head of the *Giuliano* statue, such as the one in Christ Church Library, JBS 758 (Fig. 4),[16] in which the head is seen from the right and slightly above it. The draftsmanship in all these head studies is very close to the original statue and shows none of the clay modeling effects which we have observed in the other statuettes. The head and neck alone are represented and suggest that in this case a bust cast or stone copy after the original was used as a subject rather than the modeled. statuettes we have studied. One drawing alone, in Christ Church Library, JBS 761,[17] shows more than just the head and neck of *Giuliano*. There is a glimpse in front of what may be the shoulder of the figure, but the awkwardness of this apparent shoulder in relation to the head suggests that it is an addition by Tintoretto. This is further indicated by two other drawings: one, in the sketchbook in the British Museum, London, no. 1907-7-17-30 verso,[18] was once attributed to Jacopo Tintoretto but is now given to his son, Domenico;[19] the other, by Tintoretto's daughter, Marietta, is now in the Rasini collection in Milan.[20] In both of these drawings, obviously after the same model as the drawings by Tintoretto himself, there is a curved line at the right edge of the neck which indicates that the model for all the drawings was simply a bust from the *Giuliano* figure.

The drawings after the complete figure of *Giuliano* done by Tintoretto and his pupils are most instructive to us concerning the type of object depicted in these drawings. The Oxford drawing in the Christ Church Library, JBS 759 recto (Fig. 5),[21] is undoubtedly related to Michelangelo's statue of Giuliano de' Medici, but two striking changes are

significant. First, the left arm is changed; it is drawn farther across the body so that now the left hand rests on the right knee. As a result the shoulders and torso are twisted more to the left. Secondly, the figure is now completely nude, and the knotty, bumpy character of clay modeling, seen in the other drawings except the ones after the head of *Giuliano*, is emphasized, in fact exaggerated. Outside of the figure itself there is no indication of supports save for a vague curved line at the left upper leg and the more clearly indicated rock on which the right foot rests, the foot having been turned down to rest in this manner.

The statuettes from which Tintoretto studied the Medici Chapel figures, therefore, were not always exact transcriptions of the statues executed by Michelangelo. As De Tolnay indicates,[22] it seems as if the statuette of Giuliano de' Medici possessed by Tintoretto was taken from a preliminary model by Michelangelo which was nude and in stronger contrapposto.

The influence of these studies by Tintoretto after Michelangelo is revealed in various levels of assimilation in the paintings by Tintoretto himself. The most direct use of Michelangelo's figures was in the lost frescoes on the Casa Gussoni in Venice. Ridolfi states that "On the Grand Canal, on the Houses of the Gussoni, he [Tintoretto] portrayed in his youth two of the figures of Michelangelo, the Aurora and the Crepuscolo."[23] Although these frescoes no longer exist, we have their image preserved in two engravings.[24]

The fresco after the *Crepuscolo* (Fig. 6) was depicted feet foremost, in strong contrast to the Uffizi drawing no. 13048, which is seen from above and behind the head (Fig. 3), but it is simply another case of turning the model to another position, for the pose of the figure is identical with the drawings and with the original. Additions have been made, but they are of a very minor type—the drapery over the left leg on which, then, the right leg rests; also now the figure rests on clouds. The right leg seems to cross the left one higher up on the thigh than in the drawings or the original, and this right leg has a more muscular form than does Michelangelo's figure.

For the *Aurora* (Fig. 7) we have no acceptable drawing by Tintoretto, but with Ridolfi's mention of this figure and our knowledge of Tintoretto's previous handling of these statues, a similar process of creation may be suggested for this figure. Viewed again from the feet, this figure is further changed by being a mirror reversal of the original. As in the *Crepuscolo*, the main variations from the original occur in the drapery, for now he has added a garment over

Fig. 3. Florence, Gabinetto Disegni e Stampi degli Uffizi, 13048. Tintoretto, drawing after Michelangelo's *Crepuscolo* (photo: Alinari/Art Resource, NY)

the loins, the drapery under the left arm (right arm in the original) is now draped over the arm, the strip beneath the breasts is loosened. In this painting little details are changed, such as the two outstretched fingers of the right hand or the drapery of the head. The face seems to have a plumper appearance, and the breasts are not set as far apart, but these changes have little meaning, and several changes in media and example make any such conclusions doubtful.

In Zanetti's comments on these lost frescoes no attempt is made to identify the subject depicted by the figures; however, there is a slight hint to their meaning in the attributes associated with the figures. The *Crepuscolo* is seated

| *Tintoretto and the Medici Tombs*

from the figure of the *Crepuscolo*, and the *Aurora* should have been Air, but the old tradition of Earth as Cybele and a woman undoubtedly caused the change.[27]

The date of these frescoes at the Casa Gussoni is difficult to determine. Ridolfi[28] attributes them to Tintoretto's youth, as he does the studies after Michelangelo, but Ridolfi is often inaccurate in his dates.[29] The turning of the original figures in various positions, seen in these frescoes and in the drawings, suggests that they were executed after statuettes made of the Michelangelo figures. The dated record we have of statuettes made after the Medici Chapel figures is in Vasari's life of Daniele da Volterra,[30] in which he notes that Daniele made casts of most of the figures in the Medici Chapel in 1557. Ridolfi himself specifically mentions[31] that it was from statuettes of Daniele da Volterra that Tintoretto worked. If these statuettes by Daniele to which Ridolfi refers were the ones executed in 1557, the Casa Gussoni frescoes and the studies after Michelangelo could not be as early as Ridolfi seems to suggest.

However, in any discussion regarding the date of the influence of Michelangelo on Tintoretto, the latter's *Miracle of the Slave*, Accademia, Venice, dated 1548 (Fig. 1), is always important. Generally this influence is described as being apparent in the emphasis on the nude, the two reclining figures on the gateway in the background, and the flying saint.[32] The general composition of the painting resembles Michelangelo's fresco of the Conversion of Saint Paul in the Pauline Chapel of the Vatican[33]—the semicircular composition below with the figures tending to shoot out from the recumbent figure in the center and to build up at the side, also the figure of Christ above flying inward at the upper left of Michelangelo's painting while in the center of Tintoretto's design, and even the counter-movement into the center of the semicircle from the left side. In both compositions the semicircle of figures lies in the front plane against a rather light background. Tintoretto's acquaintance with this Pauline Chapel fresco might either be through an unrecorded visit by Tintoretto to Rome just before 1548, as some recent art historians propose,[34] or more likely through an engraving of this fresco.[35]

Some of the individual figures in Tintoretto's painting recall specific figures of Michelangelo. The sculptural figures

on clouds, while the *Aurora* reclines on a more substantial medium and has near her right elbow a crown. These brief attributes probably identify them as two of the four elements of Neoplatonism: Air and Earth.[25] If so, the quartet of elements may have been completed by translating the other two Michelangelo figures of the Times of Day into Fire and Water, although they are not mentioned by Ridolfi. Italian Neoplatonism often associated the four elements with the four seasons and times of day, as well as with the four humors of man,[26] but Tintoretto does not seem to follow the system in his transformation of the Michelangelo *Times of Day* into elements. If Tintoretto had followed the usual philosophical system, Earth should have been created

Fig. 5. Oxford, Christ Church Library, JBS 759 recto. Tintoretto, drawing after Michelangelo's *Giuliano* (photo: The Governing Body of Christ Church, Oxford)

reclining on the gate in the background resemble in their symmetry on a triangular base the symmetrical bronze nudes flanking the window penetrations between the Prophets and the Sibyls on the Sistine ceiling.[36] Perhaps the most crucial figure is the turbaned one seated at the right in front of the throne. The limp hand on the crossed legs can only recall the *Crepuscolo* of the Medici Chapel. The *Crepuscolo* had been foreshadowed in one of the bronze nudes of the Sistine ceiling,[37] but the *Crepuscolo*, by the crossing of the legs, is much closer to this figure of Tintoretto. In fact, the turbaned figure of Tintoretto's *Miracle of the Slave* is not parallel to the picture plane, as one would also expect if it were based on the Sistine ceiling bronze nudes, but it is rather seen from the right and slightly above the figure, reminiscent of Tintoretto's drawing studies after the statuettes based on Michelangelo's figures of the four Times of Day. Thus, Tintoretto's drawing after the *Crepuscolo* in the Uffizi, no. 13048 (Fig. 3), is viewed from the extreme right of the figure so that the observer is actually behind and above the head of the figure. This suggests very strongly that Tintoretto had statuettes based on Michelangelo's figures sometime before 1548 and that Ridolfi may not be inaccurate when he attributes the Casa Gussoni frescoes, and at least some of the studies after Michelangelo's figures, to an early date in the career of Tintoretto.

The influence of Tintoretto's consideration of Michelangelo's Medici Chapel statues is further hinted in a work difficult to date, such as the *Vulcan Surprising Venus and Mars* in the Alte Pinakothek, Munich.[38] The figure of Venus is related to Michelangelo's *Aurora*, the main changes occurring in the left arm, which is raised above the head, and the left leg, which is bent back; also, the head does not incline as far toward the right shoulder.[39] Two minor paintings attributed to Tintoretto reproduce the same motif of the Venus with its suggestion of Michelangelo's *Aurora*. So the version of *Lot and His Daughters* mentioned by von der Bercken as formerly in the Haberstock collection in Berlin[40] has the daughter at the right in the same pose as the Venus, except that she is now clothed and turns her head toward her father and, in this respect, comes closer to Michelangelo's *Aurora*. The long drapery which Venus holds over her head is now a thin veil closer to the *Aurora*. Likewise, the picture of Susanna and the Elders formerly in Munich in the Von Nemes collection[41] has Susanna as a fairly close reversal of the Munich Venus.

These reminiscences of the Medici Chapel statues go on throughout the career of Tintoretto, gradually being assimilated into his style. Thus, in Tintoretto's *Last Judgment* in the Ducal Palace, Venice,[42] dated about 1588, the figure of Saint Luke belongs to the tradition of the *Aurora*, although here he follows more closely Tintoretto's own version of Aurora or Earth on the Casa Gussoni.

About midway in the career of Tintoretto, he, or his close associates, clearly stated their dependence upon Michelangelo's statues in a group of minor works which are, however, interesting in their revelation of a change in

Fig. 6. Engraving after lost fresco by Tintoretto, *Air* (after A. M. Zanetti, *Varie pitture a fresco de' principali maestri veneziani* [Venice, 1760], pl. 8)

Fig. 7. Engraving after lost fresco by Tintoretto, *Earth* (after A. M. Zanetti, *Varie pitture a fresco de' principali maestri veneziani* [Venice, 1760], pl. 9)

Tintoretto's attitude toward his mentor, Michelangelo. In the ceiling of the Atrio Quadrato in the Ducal Palace at Venice, which has *Doge Girolamo Priuli Receiving the Sword of Justice* as its central panel, there are in the four corners of the ceiling small paintings of the Four Seasons executed between 1559 and 1567.[43] The Four Seasons are represented as single putti in various reclining poses which are surprisingly faithful to the statues of the four Times of Day in the Medici Chapel. The *Spring* (Fig. 8) is based on the *Crepuscolo*, but the legs are now uncrossed and viewed from the feet, somewhat similar in viewpoint to his fresco of the Casa Gussoni. The muscular modeling of Michelangelo's figure and Tintoretto's drawings is now changed into the soft flesh of the child. The figure of *Summer* (Fig. 9) is taken from the rear of the *Giorno* but with several alterations such as the uncrossing of the legs and the changing of the forearms. The grain and the sickle held by this putto indicate the season. For *Autumn* (Fig. 10) the *Notte* serves as the example, although the former is again a sleepy putto, whose temporal significance is suggested by the rich vines, fruit, and the vine wreath on the child's head. In viewpoint much closer to the usual view of the *Notte*, the putto is not contorted as much as the *Notte*, neither raising the left leg as high nor resting the right elbow across on the left leg.

Winter (Fig. 11) is derived, of course, from the *Aurora*, with the principal change in the legs, as the right leg is raised and the left one outstretched, in contrast to the *Aurora*. The time of year is suggested by the bleak natural growth and the slight drapery worn by the child. This drapery is developed from that of the *Aurora*—the girdle beneath the breasts of the *Aurora* has now become a wide band across the figure, and the veil is now a drape along the far side of the figure, across the back, and clutched over the breast.

In all of the Four Seasons the principal variation from the statues by Michelangelo occurs in the position of the legs, while the whole figures are generally observed from the feet or head, which was also noticed in Tintoretto's Casa Gussoni frescoes.

That Michelangelo's figures of the Times of the Day should be used by Tintoretto for the Four Seasons is completely fitting with the prevalence of Neoplatonic thought in Italy during the fifteenth and sixteenth centuries. Neoplatonism in its systematization had equated the four humors of man, the four elements of the universe, the four seasons of the year, and the four periods of the day, or four ages of man.[44] For two of his figures Tintoretto followed this system by transposing the *Giorno* into *Summer* and the *Notte* into *Autumn*.[45] However, the other two seasons,

the *Spring* based upon the *Crepuscolo* and the *Winter* taken from the *Aurora*, are reversed from the usual Neoplatonic order. An artistic explanation for this reversal would seem more in keeping with the personality of Tintoretto than a reinterpretation of the philosophical system.[46] Of Michelangelo's four statues the only one which might suggest in posture the pleasantness of spring would be the rather weary nonchalance of the *Crepuscolo;* the *Giorno* and the *Notte* are too introverted in their strong contrapposto or tormented pose to lend themselves to an artistic expression of the expansive budding of spring. On the other hand, the *Aurora* would, in pose, be the most fitting for a depiction of the chilling effect of winter, as she pulls the veil

around her neck and has the girdle about her middle, which Tintoretto enlarges. It would seem, therefore, that Tintoretto probably reversed the interpretation of two of Michelangelo's figures in order to express more fully one's feelings associated with these two seasons.

It has recently been pointed out[47] that in Venice and in the neighboring town of Bassano, Jacopo da Ponte and his son, Francesco, contemporary with Tintoretto, created series of pictures of the Four Seasons and series of the four Elements. Ridolfi claims that Jacopo Bassano made many series of the Seasons which he sent to Venice for sale.[48] In fact, in the inventory of 1592 of works left in the home of Jacopo[49] there are mentioned four different complete

Fig. 8. Venice, Ducal Palace. Tintoretto, *Spring* (photo: Musei Civici Veneziani)

Fig. 9. Venice, Ducal Palace. Tintoretto, *Summer* (photo: Musei Civici Veneziani)

Fig. 10. Venice, Ducal Palace. Tintoretto, *Autumn* (photo: Musei Civici Veneziani)

Fig. 11. Venice, Ducal Palace. Tintoretto, *Winter* (photo: Musei Civici Veneziani)

263 | *Tintoretto and the Medici Tombs*

series of the Seasons and one complete group of the Elements, the latter of which may have been complementary to one of the groups of Seasons, as the sizes of the paintings are specified in the inventory as being the same.[50] There are also listed some five paintings or groups of paintings which include one or more of the Seasons and five pictures of single Elements. According to Ridolfi's description of one series of Elements done for a German prince by Jacopo Bassano, there may even have been a reference to the equation of the Times of Day with the Elements.[51] Although these groups of the Seasons and Elements seem to be genre scenes with no relation to Tintoretto's more allegorical figures, they do indicate the popularity of these subjects in Venice.

Even a very clear-cut example of the influence of Michelangelo upon Tintoretto, represented by the Medici Chapel statues, becomes, therefore, quite complex. The lost Casa Gussoni frescoes and the reminiscence of the *Crepuscolo* in Tintoretto's *Miracle of the Slave* suggest that the Medici Chapel figures may have early influenced the career of Tintoretto. By the time of the little putti of the Four Seasons in the Ducal Palace, Tintoretto has achieved enough control and command of those elements of Michelangelo's style which were his desire that he could treat the Medici Chapel statues rather frivolously. Tintoretto's late great works in the Scuola di San Rocco and the *Paradise* of the Ducal Palace reveal that then Michelangelo had been assimilated completely and could be used very freely by Tintoretto for his own purposes.

The artistic theorists of the Renaissance had argued quite heatedly regarding the merits of painting versus sculpture. Leonardo da Vinci had, of course, presented the superior position of painting on the basis of the intellectual superiority required of the painter who must control various types of perspective, light and shade, and color.[52] Naturally the side of sculpture was sustained by Michelangelo.[53] In the first half of the sixteenth century this argument had developed into a disagreement between the two great schools of Italian art, with Florence supporting sculpture and Michelangelo as the greater of the two arts and the greatest artist, while Venice claimed that painting and its native artist Titian excelled all others. Four books issued at Venice during the period when Tintoretto was formulating his style of painting reflect this argument. Paolo Pino published a dialogue in 1548[54] which considered both points of view, having a Tuscan, Fabio, present the Florentine beliefs; but finally Fabio acknowledges the superiority of the Venetian arguments

given by one Lauro. A year later the Florentine writer Antonio Francesco Doni replied in a dialogue published in Venice,[55] in which Pino himself is introduced as the representative of painting but is defeated, as one would expect in a Florentine writer. Also during 1549 the Venetian Michelangelo Biondo again indicated the Venetian belief in the superiority of expression possible in the art of painting in his essay upon the nobility of painting.[56] Finally, in 1557 another Venetian, Lodovico Dolce, put his friend, the influential Pietro Aretino, and undoubtedly Aretino's own ideas and sentiments, into a dialogue[57] which asserts the excellence of Raphael and especially the painting of Titian over Michelangelo. Of all these four writers Pino's theory is in many ways the most advanced in relation to the course of Mannerist painting as it developed in Italy at this time. It is Pino, as we have seen, who felt that the artist who had both the *disegno* of Michelangelo and the color of Titian would be the "god of painting."[58] It is exactly in this same year of 1548 that we have seen Tintoretto realize this combination of the two great artists in his *Miracle of the Slave* (Fig. 1), in which he creates figures which partake of the dynamic plasticity of Michelangelo's figures and the rich color of Titian.

According to Ridolfi, as we have noted, the elements of Michelangelo's style which Tintoretto wished to command are summed up in the word *disegno*. To understand what is meant by *disegno*, we have the direct statement of Pino, who remarks that painting is divided into three parts: *disegno, inuentione,* and *colorire.*[59] *Disegno*, then, is composed of four parts, of which the first is "Judgment," or what we should call talent. The second factor within *disegno* is "Circumscription," which is the ability to create contours and to endow figures with light and shade. The third element is "Practice," which has to do with the ability to choose correct lighting, to recognize the beautiful, and to know and to handle the various technical media of drawing. Finally, *disegno* also includes "Composition," which deals with the position and parts of the human body, its foreshortening, drapery folds, and the plasticity of the human body created by the suggestion of the nude form under the drapery. Pino's definition of *disegno* is, therefore, quite analogous to Tintoretto's interest in Michelangelo's sculpture, which permits him to study Michelangelo's control of the nude in various foreshortenings and to translate the plasticity of actual sculpture into a pictorial plasticity by means of contours and lighting.

Tintoretto was both great enough as an artist in himself and was far enough away, both in time and geography,

from the titanic personality of Michelangelo to use the accomplishments of the latter for his own expression and never be engulfed by him, as even Raphael had been for a while. Tintoretto was consciously able to extract from two of the greatest artists of all times, Titian and Michelangelo, those factors which would express his new interests without ever falling into the danger of eclecticism. The philosophy of Michelangelo had little apparent influence upon Tintoretto; it was rather his sculptural form which, by means of light and color, Tintoretto could transform into a pictorial manner proper to a Venetian and influential on later painting.

Notes

*An article submitted for the issue in honor of Charles Rufus Morey as listed in *The Art Bulletin*, December 1950.

1. E. von der Bercken and A. L. Mayer, *Jacopo Tintoretto* (Munich, 1923), vol. 1, 56, and vol. 2, fig. 31.

2. L. Coletti, *Il Tintoretto*, 2nd ed. (Bergamo, n.d.), 16. Illustrated in H. Tietze, *Titian: Paintings and Drawings* (Vienna and London, 1937), pl. 156.

3. M. Pittaluga, *Il Tintoretto* (Bologna, 1925), 58.

4. Von der Bercken and Mayer, *Tintoretto* (note 1 above), 54.

5. C. Ridolfi, *Le maraviglie dell'arte* (Venice, 1648), vol. 2, 6: "Il disegno di Michel Angelo, e'l colorito di Titiano."

6. P. Pino, *Dialogo di pittura* (Venice, 1548), fols. 24v–25.

7. R. Borghini, *Il riposo* (Florence, 1584), 551.

8. Ridolfi, *Maraviglie dell'arte* (note 5 above), vol. 2, 6.

9. M. Boschini, *La carta del navegar pitoresco* (Venice, 1660), 140–141.

10. H. Tietze and E. Tietze-Conrat, *The Drawings of the Venetian Painters in the Fifteenth and Sixteenth Centuries* (New York, 1944), 256–268.

11. Ibid., 293–304.

12. In attribution of the drawings by Tintoretto, we are, in general, following the selection proposed by Tietze and Tietze-Conrat, *Drawings of the Venetian Painters* (note 10 above), 277–293.

13. Oxford, Christ Church Library, JBS 762 recto (formerly L.3): C. F. Bell, *Drawings by the Old Masters in the Library of Christ Church, Oxford* (Oxford, 1914), 87; D. von Hadeln, *Zeichnungen des Giacomo Tintoretto* (Berlin, 1922), 26, pl. 5; Tietze and Tietze-Conrat, *Drawings of the Venetian Painters* (note 10 above), 290, no. 1730; Coletti, *Tintoretto* (note 2 above),

24 (as *Crepuscolo*), pl. 56b: Coletti accuses von Hadeln of "an evident lapse" for labeling this drawing *Giorno*, but the "lapse" is completely on the part of Coletti. As a result, Coletti's suggestion that the Oxford drawing is preparatory for Tintoretto's lost fresco on the Casa Gussoni, discussed by us later, is completely wrong.

Paris, Louvre, no. 5384: A. L. Mayer, "Tintoretto Drawings in the Louvre," *Burlington Magazine* 43 (1923), 34 (illustrated by wrong photograph); Tietze and Tietze-Conrat, *Drawings of the Venetian Painters*, 291, no. 1739; H. Tietze, *Tintoretto: The Paintings and Drawings* (New York, 1948), 383, pl. 137.

14. Florence, Gabinetto Disegni e Stampi degli Uffizi, no. 13048 recto and verso: J. von Schlosser, "Aus der Bildnerwerkstatt der Renaissance," *Jahrbuch der kunsthistorischen Sammlungen des allerhöchsten Kaiserhauses* 31 (1913/14), 102, fig. 30 (as Uffizi no. 13042); von Hadeln, *Zeichnungen* (note 13 above), 26, pl. 6; von der Bercken and Mayer, *Tintoretto* (note 1 above), vol. 1, 21 and note 3 (as Uffizi no. 13042); A. E. Popham, *Italian Drawings Exhibited at the Royal Academy, Burlington House, London, 1930* (London, 1931), 76, no. 277, pl. CCXXXIII; *La mostra del Tintoretto* (Venice, 1937), 213; Tietze and Tietze-Conrat, *Drawings of the Venetian Painters* (note 10 above), 284, no. 1643, pl. CXII, fig. 2; Coletti, *Tintoretto* (note 2 above), 24 (as Uffizi no. 13078).

15. While it is rather characteristic of Tintoretto's style of drawing to give a lumpy effect to his figures, a drawing in the Fenwick collection, Cheltenham (Tietze and Tietze-Conrat, *Drawings of the Venetian Painters* [note 10 above], 298, no. 1774), after the *Crepuscolo* reveals similar lumpy effects in the modeling at the same points in the statue, particularly noticeable in the left arm and hand and the right forearm. The fact that the attribution of the English drawing to Tintoretto is very doubtful would strengthen these observations that the changes are in the model and not the draughtsmanship, while the different point of observation for the Cheltenham drawing, seen from in front but from a rather high level, indicates that it is not dependent upon the Uffizi drawing no. 13048. The Cheltenham drawing is illustrated in A. E. Popham, *Catalogue of Drawings . . . of . . . T. Fitzroy Phillips Fenwick, Cheltenham* (n.p., 1935), 104, pl. XLIX.

16. Oxford, Christ Church Library, JBS 758 (formerly L.4): E. Steinmann, *Das Geheimnis der Medicigräber Michel Angelos*, Kunstgeschichtliche Monographien 4 (Leipzig, 1907), 115 n. 1, fig. 30; S. Colvin, *Selected Drawings from Old Masters in the University Galleries and in the Library at Christ Church, Oxford* (Oxford, 1907), vol. 3, pl. 14; H. Thode, *Michelangelo* (Berlin, 1908), vol. 1, 481; Bell, *Drawings by the Old Masters* (note 13 above), 87, pl. CXII; von Hadeln, *Zeichnungen* (note 13 above), 27, pl. 9; Popham, *Italian Drawings* (note 14 above), no. 279, pl. CCXXXV; Tietze and Tietze-Conrat, *Drawings of the Venetian Painters* (note 10 above), 290, no. 1731.

17. Oxford, Christ Church Library, JBS 761 (formerly L.5): Bell, *Drawings by the Old Masters* (note 13 above), pl. CXIII.

18. Illustrated by K. T. Parker, in *Old Master Drawings* 2 (1927), pl. 5.

19. Tietze and Tietze-Conrat, *Drawings of the Venetian Painters* (note 10 above), 263, no. 1526.

20. A. Morassi, *Disegni antichi dalla collezione Rasini in Milano* (Milan, 1937), 341, pl. XXIX.

Tintoretto and the Medici Tombs

21. Oxford, Christ Church Library, JBS 759 (formerly L.2): Colvin, *Selected Drawings* (note 16 above), vol. 3, pl. 17; Bell, *Drawings by the Old Masters* (note 13 above), 87, pl. CXI; von Hadeln, *Zeichnungen* (note 13 above), 26, pl. 7; Popham, *Italian Drawings* (note 14 above), no. 278, pl. CCXXXIV; W. Paesler, "Die Münchner Greco-Zeichnung and Michelangelos Modell zur Gestalt des 'Tages' in der Medici-Kapelle," *Münchner Jahrbuch der bildenden Kunst*, n.s., 10 (1933), p. xxix; Tietze and Tietze-Conrat, *Drawings of the Venetian Painters* (note 10 above), 290, no. 1729.

22. C. de Tolnay, *Michelangelo*, vol. 3, *The Medici Chapel* (Princeton, 1948), 142.

23. Ridolfi, *Maraviglie dell'arte* (note 5 above), vol. 2, 34: "Sopra il gran canale dunque, nelle case de' Gussoni, ritrasse in sua giouentù due delle figure di Michel 'Angelo, l'Aurora, e'l Crepuscolo; . . ." Ridolfi also notes (p. 206) that the painter Santo Zago had decorated another building facade with a painting after the *Crepuscolo* of Michelangelo ("Sopra il Campo di San Fantino colorì il crepusculo di Michel Angelo, & altre figure, . . ."). Zago, who died before 1568, was an older contemporary of Tintoretto, but unfortunately we have no indication when Zago did his figure of the *Crepuscolo*, which might otherwise be important in connection with the vexing problem of when Tintoretto began to work from copies of the sculpture of Michelangelo.

24. A. M. Zanetti, *Varie pitture a fresco de' principali maestri veneziani* (Venice, 1760), pls. 8 and 9.

25. The identification of the figure based on the *Aurora* as Earth was suggested by Dr. Erwin Panofsky, Institute for Advanced Study, Princeton, since Hrabanus Maurus, among others, equates Cybele and Earth and specifies that Earth is a woman with a turreted crown (Hrabanus Maurus, *De universo*, XV, chap. vi, in J. P. Migne, *Patrologiae cursus completus, Series latina*, cxi [Paris, 1864], col. 431). See also H. Liebeschütz, *Fulgentius Metaforalis*, Studien der Bibliothek Warburg 4 (Leipzig and Berlin, 1926), 54 and 62–63.

26. E. Panofsky, *Studies in Iconology* (New York, 1939), 206–207.

27. See note 25.

28. Ridolfi, *Maraviglie dell'arte* (note 5 above), vol. 2, 34.

29. Ridolfi claims that Tintoretto was born in 1512 (ibid., vol. 2, 5), but as von Hadeln indicates (C. Ridolfi, *Le maraviglie dell'arte*, ed. D. von Hadeln [Berlin, 1924], vol. 2, 13 n. 1), other sources such as the death records show that he must have been born as late as 1518.

30. G. Vasari, *Le vite de' più eccellenti pittori, scultori ed architettori*, ed. G. Milanesi, vol. 7 (Florence, 1881), 63.

31. Ridolfi, *Maraviglie dell'arte* (note 5 above), vol. 2, 6.

32. Von der Bercken and Mayer, *Tintoretto* (note 1 above), vol. 1, 54–55.

33. M. Dvořák, *Geschichte der italienischen Kunst im Zeitalter der Renaissance* (Munich, 1928), vol. 2, 145.

34. Pittaluga, *Tintoretto* (note 3 above), 58.

35. There is an undated engraving after the *Conversion of Saint Paul* by Nicolaus Beatrizet, who engraved many of the works of Michelangelo (W. von Seidlitz, in *Allgemeines Künstler-Lexikon*, ed. J. Meyer, H. Lücke, and H. von Tschudi, vol. 3 [Leipzig, 1885], s.v. "Beatrizet"). Three of Beatrizet's engravings after Michelangelo are dated: the *Jeremiah* from the Sistine Ceiling (1547), the *Pietà* at Rome (1547), and the *Last Judgment* (1562). Beatrizet did many of the works of Michelangelo but not the complementary Pauline Chapel fresco of the *Crucifixion of Saint Peter*, which was engraved only later by De Cavalieri. Since two of the dated engravings after Michelangelo were done in 1547, one wonders whether the undated engraving of the *Conversion of Saint Paul* was not done at this time, which would find the fresco of the Conversion completed already for the visit of Pope Paul III to the chapel on July 12, 1545 (F. Baumgart and B. Biagetti, *Die Fresken des Michelangelo, L. Sabbatini und F. Zuccari in der Cappella Paolina im Vatikan* [Vatican City, 1934], 16–17), but not the other fresco of the crucifixion of Saint Peter, which was only completed by 1550, and which would explain why Beatrizet did not also engrave this latter work.

36. C. de Tolnay, *Michelangelo*, vol. 2, *The Sistine Ceiling* (Princeton, 1945), 70–71, particularly the pair illustrated in figs. 206 and 207.

37. Ibid.

38. Von der Bercken and Mayer, *Tintoretto* (note 1 above), vol. 1, 83, and vol. 2, fig. 2; von Hadeln, *Zeichnungen* (note 13 above), 31; and E. von der Bercken, *Die Gemälde des Jacopo Tintoretto* (Munich, 1942), 41–42, date it very early in Tintoretto's oeuvre, while Pittaluga, *Tintoretto* (note 3 above), 262, and the catalogue of the Tintoretto show at Venice in 1937 (*Mostra di Tintoretto* [note 14 above], 183, no. 66) date it late, about 1580. Tietze and Tietze-Conrat, *Drawings of the Venetian Painters* (note 10 above), 274 and 278, no. 1561, and H. Tietze, *Tintoretto* (note 13 above), 43, take a middle course and date the painting and its preparatory drawing in the Kupferstichkabinett, Berlin (no. 4193), in the 1550s. If the early date of this work could be substantiated, it would lend more surety to the suggestion that Tintoretto had statuettes of the Medici Chapel figures from an early date. Actually, the Venus of the preparatory drawing at Berlin is further from Michelangelo's *Aurora* than the Venus of the completed painting.

R. Pallucchini, in his book analyzing the formative years of Tintoretto (*La giovinezza del Tintoretto* [Milan, 1950]), which became available after this article had gone to print, also dates the Munich painting in the sixth decade of the sixteenth century (pp. 132–133). The other material in his very comprehensive study does not affect the arguments of this paper, although Pallucchini would seem to be inclined (p. 84) to date the Casa Gussoni frescoes very early except for the argument that they are based upon models by Daniele da Volterra.

39. The suggestion by Tietze, *Tintoretto* (note 13 above), 356, that the figure of Venus may be dependent upon Titian's Andromeda in his painting of Perseus and Andromeda in the Wallace collection, London, seems rather wide of the mark.

40. Von der Bercken, *Die Gemälde des Jacopo Tintoretto* (note 38 above), 105, fig. 120.

41. Ibid., p. 117, fig. 165; also accepted by D. von Hadeln, "Einige wenig bekannte Werke des Tintoretto. II," *Zeitschrift für bildende Kunst* 57 (1922), 95.

42. Tietze, *Tintoretto* (note 13 above), 54, the whole painting illustrated on folding plate opposite pl. 242.

43. M. Boschini, *Le ricche minere della pittura veneziana* (Venice, 1674), pp. 8 and 9: ". . . vi sono in varij comparti, historiette di chiari oscuri, & ne' angoli quattro Puttini coloriti; e tutto questo Salotto, è dipinto da Giacomo Tintoretto della esquisitissima maniera." Pittaluga, *Tintoretto* (note 3 above), 227, specifically denies these works as from the hand of Tintoretto. Although there may be some doubts as to the actual painting, the general conception and design of the ceiling would seem to be due to Tintoretto. A. L. Mayer ("New Documents and Attributions: From the Strasbourg Museum to the Venice Palazzo Ducale," *Gazette des beaux-arts*, 6th ser., 27 [1945], 90–91) was the first to publish illustrations of these works, which he characterized as "his [Tintoretto's] personal invention."

44. Steinmann, *Das Geheimnis der Medicigräber* (note 16 above), 74–106; corrected by Panofsky, *Studies in Iconology* (note 26 above), 206–207. For a late, but explicit, equation of the various quartets, see F. Piccolomini, *De Rerum Definitionibus* (Frankfort, 1600), 150 and 157.

45. Florentine Neoplatonism, based on Greek thought, had the phlegmatic temperament and the element water equated with winter, while the melancholic humor was related to earth and autumn. In the north, as represented by Albrecht Dürer, the associations were reversed, so that the phlegmatic equaled autumn, and the melancholic, winter, explained by Panofsky as due to the climatic difference between classic Greece and Germany (E. Panofsky, *Albrecht Dürer* [Princeton, 1943], vol. 1, 157). Therefore, it is not surprising to find a Venetian artist following the scheme also prevalent in Germany.

46. Tintoretto makes the same reversal for his lost frescoes of the two elements (see above) where the *Crepuscolo* becomes Air and the *Aurora* is Earth. According to Neoplatonism the *Aurora* should equal Spring and Air, while the *Crepuscolo* should be aligned with Winter and Earth, that is,

in accordance with the revision apparently in effect in the north (see note 45).

47. L. Baldass, "Some Remarks on Francesco Bassano and His Historical Function," *Art Quarterly* 12 (1949), 199–219.

48. Ridolfi, *Maraviglie dell'arte* (note 5 above), vol. 1, 396.

49. G. Verei, *Notizie intorno alla vita e alle opere de' pittori, scultori e intagliatori della città di Bassano* (Venice, 1775), 91–100.

50. Ibid., p. 95, inventory nos. 80 and 88.

51. Ridolfi, *Maraviglie dell'arte* (note 5 above), vol. 1, 387: "Dipinse pure per altro gran Prencipe gli Elementi facendo assistere a ciascuno una Deità. All' aere Giunone; all' Acqua Nettuno; alla Terra Cerere; al Fuoco Volcano: cō la diversità delle cose, che si comprendono sotto gli elementi, e le parti del giorno, e della notte facendovi cadere quelle operationi, che si trattano in quel tempo da mortali."

52. J. P. Richter, ed., *The Literary Works of Leonardo da Vinci*, 2nd ed., enl. and rev. by J. P. Richter and I. A. Richter (London, 1939), vol. 1, 82–101.

53. G. Bottari and S. Ticozzi, *Raccolta di lettere sulla pittura, scultura ed architettura*, vol. 1 (Milan, 1822), 9, letter no. IX.

54. P. Pino, *Dialogo di pittura* (Venice, 1548).

55. A. F. Doni, *Disegno* (Venice, 1549).

56. M. A. Biondo, *Della nobilissima pittura* (Venice, 1549).

57. L. Dolce, *Dialogo della pittura . . . , intitolato l'Aretino* (Venice, 1557).

58. Pino, *Dialogo* (note 54 above), fol. 25.

59. Ibid., fols. 15v–16.

18

A Drawing by Pietro da Cortona for His Fresco of the *Age of Iron*

In July 1637 the Italian painter and architect Pietro da Cortona stopped in Florence on his way north to study painting in Bologna and Venice. Pietro had already begun in 1633 his great project to fresco the vault in the *salone* of the Palazzo Barberini at Rome, but he interrupted this work in order to take advantage of the journey to Bologna of his patron Cardinal Giulio Sacchetti, who had just been appointed papal legate to Bologna. Cortona's training had been confined to work with artists only from Florence and Rome, so that he desired some acquaintance with the work of the painters of the Renaissance and early Baroque schools of North Italy.

The fame of Pietro da Cortona, based on his earlier paintings for the Marchese Sacchetti and the unfinished Barberini ceiling, accompanied him to Florence, where the Grand Duke of Tuscany, Ferdinando II de' Medici, immediately requested the artist to decorate one of the rooms in the Palazzo Pitti. He was commissioned to fresco the walls of the small Sala della Stufa with the four ages of history, as first related in Hesiod's *Works and Days*. However, the Renaissance and Baroque periods undoubtedly took this subject from Ovid's *Metamorphoses* (Book I, 89–150), which was one of the most popular source books for Italian artists. This is also indicated by the fact that Ovid specifies only four ages—the Age of Gold, the Age of Silver, the Age of Bronze, and the Age of Iron—while Hesiod actually had

a fifth period, the Age of Heroes, between the Ages of Bronze and Iron. The subject for these frescoes was probably suggested by Michelangelo Buonarroti the Younger, the poet grandnephew of the artist Michelangelo, at whose home Pietro stayed during this visit to Florence.[1]

In a letter of July 20, 1637, to the Cardinal Barberini[2] Cortona relates that he is "to make two pictures in fresco for His Highness, of which one is the age of gold and the other of silver, and by the end of August I will have surely finished them." Another letter to the cardinal, dated September 13, 1637,[3] states: "I have brought to an end two stories in fresco, I only need to retouch them, one of which is that of the [Age of] Gold, and the other of Silver. In this room there is missing those of Bronze and of Iron." He adds that to finish the latter would require two more months, which was the time necessary for the first two frescoes. Pietro, however, left the Sala della Stufa unfinished and continued on to North Italy. By the end of the year he had to rush back to Rome for fear that his incomplete work in the Palazzo Barberini might be taken away from him by his assistants.[4] The Barberini ceiling was then completed late in 1639. This permitted Pietro to return to Florence in the summer of 1640 where he quickly finished the two frescoes of the *Age of Bronze* and the *Age of Iron*.[5] The success of the Sala della Stufa brought to the artist the important commission to decorate the ceilings of seven of the chief rooms of the

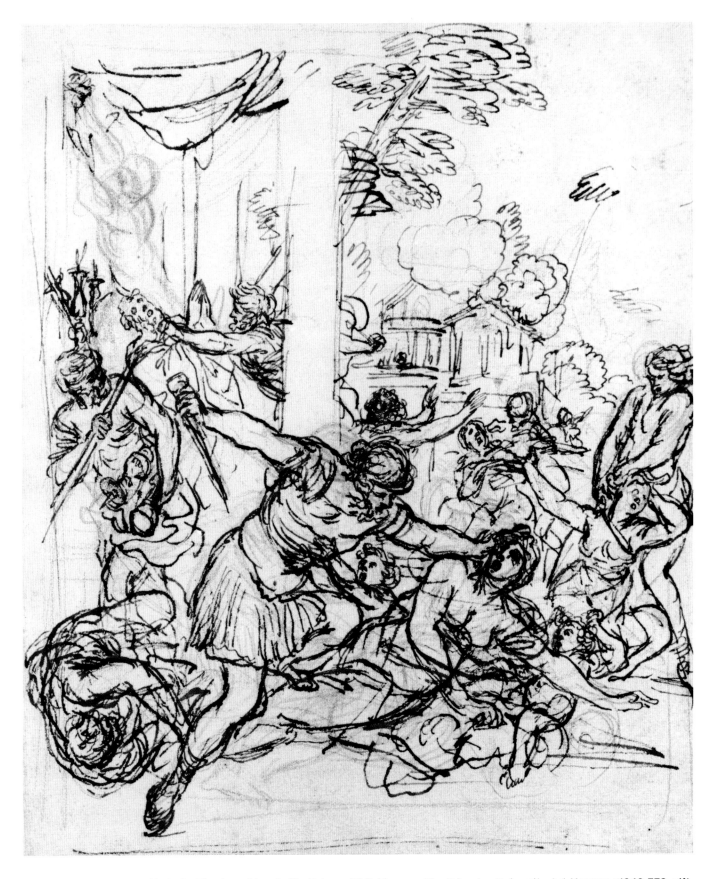

Fig. 1. Pietro da Cortona, *Study for The Age of Iron in the Palazzo Pitti, Florence.* The Princeton University Art Museum x1948-772, gift of Dan Fellows Platt, Class of 1895 (photo: Princeton University Art Museum)

| A Drawing by Pietro da Cortona

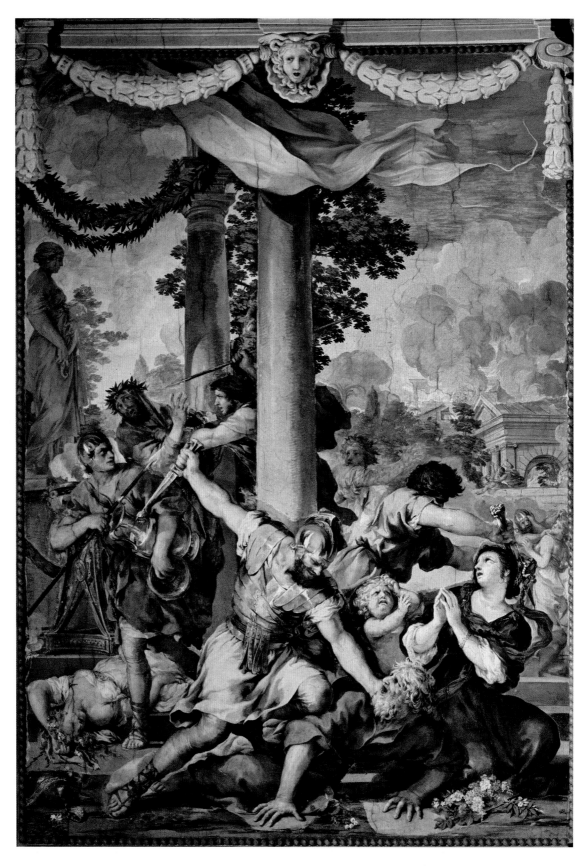

Fig. 2. Pietro da Cortona, *The Age of Iron*, **fresco in the Palazzo Pitti** (photo: Alinari/Art Resource, NY)

Magnificent Buildings, Splendid Gardens | **David R. Coffin**　　　　270

Palazzo Pitti, of which three were completed by the master from 1641 to 1647, while two others were in part or totally the work of his pupil Ciro Ferri.

In the great collection of drawings left to the Princeton University Art Museum by the late Dan Fellows Platt, Class of 1895, is one correctly attributed to Pietro da Cortona (Fig. 1) which is closely related to the fresco of the *Age of Iron* in the Sala della Stufa (Fig. 2) and must be a preliminary drawing for the painting.[6] Like a drawing in the Uffizi Gallery at Florence,[7] which is similarly related to the fresco of the *Age of Gold*, the sketch at Princeton was executed first in red crayon and then completely retouched in ink. The proportions of the two drawings are much shorter and wider in format than the proportions of the finished frescoes, which suggests that both drawings were very early sketches in the development of the paintings. This is also indicated by the many differences between the drawings and the frescoes.

It seems most probable that the Princeton drawing was created, along with the Uffizi study, during Pietro da Cortona's first visit to Florence in 1637. The drawing is much more classic in its composition than the later fresco. In the drawing the action runs parallel to the picture plane and is stopped at each side, at the left by the rolled-up body of the dead girl which carries the action back into the picture and at the right by the standing man with his back to the margin who is tearing the jewels from the hair of a woman. There is then an opening in the center of the composition, allowing the eye to go back to the sketchy representation of architecture, which is also parallel to the picture plane. The structure of the drawing is, therefore, very like the earlier paintings of the *Rape of the Sabines* and the *Triumph of Bacchus*,[8] which he made in the late twenties for the Marchese Sacchetti. In the fresco of the *Age of Iron* Cortona has, on the other hand, stressed the diagonal accents which were only intimated in the drawing. This is particularly so in the treatment of the outstretched arms of the soldier who is the central protagonist, so that the main accent goes diagonally up the arms of the soldier from the head of the old man sprawled at the right foreground to the head of the priest attacked by the youth with a spear at the foot of the statue in the left mid-distance. He also reversed the group at the right so that it paralleled the main diagonal and did not stop the action so abruptly at the right frame. He moved the vista to the edge and shifted the columns, over which a wind-blown curtain reflects the violence of the scene.

If, as has been suggested, the Princeton drawing was made during the development of Cortona's first ideas in 1637, his trip to North Italy intervened between the drawing and the fresco. During this trip north the artist was particularly impressed by the works of the painter Titian, as, according to Pascoli,[9] he brought back with him several paintings by Titian. It is possible that it is this new experience of the more dynamic compositions of Titian which appears in the later fresco of the *Age of Iron* in contrast to the more classic compositions of the Central Italian Renaissance painters Raphael and Polidoro da Caravaggio which were Pietro da Cortona's earlier inspiration.[10]

Notes

1. The eighteenth-century *Serie degli uomini i più illustri nella pittura, scultura, e architettura con i loro elogi, e ritratti*, vol. 10 (Florence, 1774), 54, claims that Buonarroti submitted the subject. Cortona's residence with Buonarroti is mentioned in one of the former's letters to the Cardinal Barberini; see G. Bottari and S. Ticozzi, *Raccolta di lettere sulla pittura, scultura ed architettura*, vol. 5 (Milan, 1822), 311–313, letter no. CXIV.

2. H. Geisenheimer, *Pietro da Cortona e gli affreschi nel Palazzo Pitti* (Florence, 1909), 17–18.

3. Bottari and Ticozzi, *Raccolta di lettere* (note 1 above), 311–312.

4. T. H. Fokker, *Roman Baroque Art* (London, 1938), vol. 1, 227.

5. Geisenheimer, *Pietro da Cortona* (note 2 above), 5 and note 1.

6. Accession number x1948-772; 31.2 × 25.7 cm; F. J. Mather, Jr., "The Platt Collection of Drawings," *Bulletin of the Department of Art and Archaeology, Princeton University* (June 1944), 4 and fig. 2. According to an inscription on the mount, the drawing was once owned by William Young Ottley, the early-nineteenth-century writer and artist who was Keeper of Prints in the British Museum.

7. O. H. Giglioli, "Disegni inediti . . . nella R. Galleria degli Uffizi," *Bollettino d'arte*, ser. 2, 2 (1922–23), 514–515 and 520–521, and A. Stix, "Barockstudien," *Belvedere* 9, no. 12 (1930), 181–182, fig. 123, who also published a more finished drawing in the Albertina at Vienna (fig. 122) for one of the female figures; for this latter drawing, see A. Stix and L. Fröhlich-Bum, *Beschreibender Katalog der Handzeichnungen in der graphischen Sammlung Albertina*, vol. 3, *Die Zeichnungen der toskanischen, umbrischen und römischen Schulen* (Vienna, 1932), 71, no. 704, and pl. 158.

8. H. Voss, *Die Malerei des Barock in Rom* (Berlin, n.d.), 240–241.

9. L. Pascoli, *Vite de' pittori, scultori, ed architetti moderni*, facsimile of ed. of Rome 1730 (Rome, 1933), 6.

10. G. B. Passeri, *Die Künstlerbiographien von Giovanni Battista Passeri*, Römische Forschungen der Bibliotheca Hertziana 10, ed. J. Hess (Leipzig and Vienna, 1934), 374.

19

Earl Baldwin Smith

Early on a Monday morning at the beginning of freshman orientation week at Princeton in September 1936, a somewhat bewildered freshman was sent from the Registrar's office in Nassau Hall to the office of Professor E. Baldwin Smith of the Department of Art and Archaeology on the third floor of the north stairway of old McCormick Hall. This was to be my first meeting with the man who would remain my mentor until his death in 1956. After knocking on his open door, I was greeted with the view of Smith perched on a tall stool poring over a drafting table. This was a position characteristic of him; it immediately put me at ease, since I had often seen my father, an architect, in the same pose. Rugged looks and a direct gaze conveyed the idea of a man who brooked no nonsense, while the receding hairline and domed forehead topping these features seemed appropriate to his nickname "Baldy," which actually referred to his name. I had been sent to Smith in his capacity as departmental representative of Art and Archaeology responsible for the academic programs of undergraduates electing the department, and as departmental representative and chairman of the recently established Divisional Program in the Humanities (later called the Special Program in the Humanities) in which I wished eventually to be enrolled. He quickly reviewed my course elections, making only one suggestion: during my first year I should be enrolled in the freshman course in architectural drawing. As his pose indicated, drafting was one of

his main interests. To the dismay of most students, he believed that anyone could draw. It was simply "a matter of applying common sense to paper."

The evening before our conference I had been invited to dine with a young Cuban instructor in the School of Architecture, Eugenio Battista, who, learning that I was to enroll in Professor Smith's course in the history of ancient architecture, noted that he was one of the most popular teachers on the campus. Each year at graduation the seniors elected him their favorite lecturer. Battista did warn me that I might at first be baffled by Smith's "Down East" accent. As one familiar with New Englanders, I was more at home with the accent than was a Cuban, but my notes of the first few lectures transcribed unfamiliar architectural terms properly ending in vowels, such as "basilica," with a final "r," reflecting his New England pronunciation.

Earl Baldwin Smith was born at Topsham, Maine, in 1888. As a youth, he studied drafting and illustration at Pratt Institute for a year, where he developed his belief in the importance of drawing. He spent endless hours at the drafting table preparing the illustrations for his books, which lent a certain uniform elegance to all his publications. After Pratt he entered Bowdoin College, where he graduated Phi Beta Kappa with an A.B. in 1911. Twenty years later Bowdoin honored him with an honorary Doctorate in Humane Letters. In the spring of 1911, in anticipation of his graduation, Smith wrote a letter to Dean Andrew Fleming West requesting

Earl Baldwin Smith (photo: Department of Art and Archaeology, Princeton University)

admission to the Princeton Graduate School in the Department of Art and Archaeology, which, after a check of his qualifications, was granted. During his first year he held a scholarship from Bowdoin, then in successive years he was awarded a Princeton Fellowship, followed by a Procter Fellowship, and finally the Jacobus Fellowship, the University's most distinguished graduate fellowship. Having completed his doctorate in 1915, Smith was appointed instructor in the department.

In March 1917 Smith enlisted as a corporal in the New Jersey National Guard. After officers' training at Plattsburg, he was commissioned a captain in the regular army and commanded Company H of the 312th Infantry of the 78th Division. He was wounded during the St. Michel offensive in September 1918 and, a month later, he was severely gassed at Grand Pres during the battle of the Argonne. Throughout the remainder of his life he suffered bouts of acute pain, but never revealed it to his students or colleagues. During World War II he taught aerial map reading and photographic interpretation at the Naval Air Combat Intelligence Officer School at Quonset, Rhode Island.

Professor Smith's war service may have contributed to his character, for he became a dominant member of the Princeton faculty. Everyone who met him was immediately struck by his strong personality. Often an undergraduate would use the image of an army first sergeant to describe him. During my first year as chairman of the department, Dean J. Douglas Brown took care to put me at my ease by recounting how nervous he had been as a novice dean of the faculty when he held his first meeting with "Baldy," then chairman of the art department. Smith's experience as a commanding officer served him well during his later years, too, when he officiated as Chief Marshal at University convocations, ordering and leading the academic processions under the authority of his baton.

To be a member and chairman of the Divisional Program in the Humanities was very appropriate for Smith, given the extraordinary breadth of his research. He read widely in anthropology, psychology, philosophy, and religion and instilled the same curiosity in his students. So, when as a senior I was writing a thesis on the Greek attitude toward nature in art and literature, he sent me to audit the course in cultural anthropology and to a fascinating public lecture on non-Euclidean geometry given by his friend, the eminent mathematician Howard Robertson; to William James's *Principles of Psychology;* and to articles by the philosopher Francis Cornford.

Smith's career in research and teaching demonstrated this interdisciplinary drive. His doctoral dissertation on the iconography of Early Christian art was written under the guidance of Princeton's Charles Rufus Morey, who would soon be recognized as the most eminent medievalist in the country, wooed unsuccessfully by Harvard. This study was published in 1917, while Smith was in the army. Soon, however, Smith turned to the history of architecture, completing and publishing a manuscript on early churches in Syria left incomplete by another of his teachers, Howard Crosby Butler. (Smith later became the Howard Crosby Butler Memorial Professor of the History of Architecture.) While the Syrian book was basically archaeological and descriptive, Smith in his own research began to be more concerned with the meaning of architecture. His next book, on ancient Egyptian architecture, was not the traditional archaeological study, but bore the title *Egyptian Architecture as Cultural Expression.* Its last chapter was a superb consideration of habits of imagery and aesthetic attitude in ancient Egypt. After World War II, Smith's last two books considered the meaning of domical architecture in antiquity and the Early Christian era and the significance of the two-towered facade in ancient gateways and medieval churches. These

books were the result of several graduate seminars. The seminars were often arduous, as the participants were obliged to view a stream of coin images, but the students learned to be thorough, and to recognize that "truth was in the details." They came to understand that moral virtue informed research. These values guided the wide-ranging research of Smith's students, whether that of Alex Soper on Japanese Buddhist architecture, Alan Gowans on nineteenth-century American and Canadian architecture, or mine on Italian Renaissance architecture and gardens.

Smith's scholarly research always reinforced an intense and constant interest in teaching. In preparation for the 1912 International Conference on the History of Art, the president and eminent Italian art historian Adolfo Venturi wrote to Professor Marquand, founder and first chairman of the Princeton department, to inquire about the state of the discipline of art history in America. Marquand immediately asked Baldwin Smith, his first-year graduate student, to research the question. Smith queried some four hundred institutions of higher education regarding their courses, their instructors, and their libraries and photographic facilities in the history of art. Of ninety-five respondents, Smith determined that only sixty-eight offered adequate programs. He undoubtedly took pride in the fact that Princeton's rivals, Harvard and Yale, offered only eighteen and seven courses respectively, while Princeton had thirty-four, of which Smith himself would participate in twenty. In 1912, *The Study of the History of Art in the Colleges and Universities of the United States*, Smith's report, was published by the Princeton University Press, ensuring him a role as an authority on this aspect of American education.

Throughout his career at Princeton, Smith was involved in almost every educational innovation the University undertook. After World War, I Smith and Sherley Morgan, an instructor in the School of Architecture and later its director, guided the School for at least the next thirty years "and succeeded in making Princeton's School of Architecture one of the foremost in the country."[1]

In 1925 Smith was a member of the faculty committee that devised the so-called Four Course Plan of Study, in which every undergraduate would undertake junior independent work and write a senior thesis, thus being actively involved in research rather than passively absorbing knowledge from lectures. Soon afterwards, Smith was chosen to be chairman of the Faculty Committee on the Library. Already Charles Rufus Morey, who succeeded Marquand as chairman, had outlined the idea for a new library, to be labeled a "Humanistic Laboratory," differing in its arrangement from the traditional library building. His idea had met opposition from the administration and from the architect, who favored the customary huge warehouse to store books and a single large reading room to accommodate all users. Morey suggested that each of eight reading departments in the humanities and social sciences should have a separate section within the structure, each with its own conference room, undergraduate and graduate reading rooms with individual desks, and some offices adjacent to the books of their discipline—in short, eight departmental libraries like the physically independent Marquand Library of Art and Archaeology. Under Smith's leadership the faculty committee and then the faculty endorsed the concept.

In 1935 the University issued a booklet entitled *The New Princeton Library* with brief essays by President Harold W. Dodds and the chairman of the Trustees' Library Committee, and a long one by Professor Smith accompanied by illustrative drawings by the architect Charles Klauder.[2] Lack of money, aggravated by World War II, delayed the project. Smith spent most of 1944 touring the country, speaking to alumni on the need for the library and the concept for its arrangement. From 1945 on there is extensive correspondence between Smith and the new architect, Robert O'Connor, on almost every detail of the library, including the location and wording of memorial plaques, lighting, and the crenellations along the roof line. During the bicentennial of the University in 1946, the cornerstone of the new Firestone Library was laid.

Smith was no stranger to controversy. In 1930 he had persuaded the University to invite architect Frank Lloyd Wright to offer the six Kahn lectures on architecture. Wright's career was at its nadir. Architects favoring traditional styles of architecture controlled the media of architectural criticism, condemning most of Wright's ideas. At the same time Wright's domestic life was featured in all the newspapers, occasioned by quarrels in court with his wife, the birth of a child by his mistress Olgivanna, later to be his third wife, and by his brief imprisonment under the Mann Act. Smith much later recalled with amusement the scandalized reaction of some Princetonians on seeing Wright and Olgivanna, then his wife, drive down Nassau Street in his open sedan.

Wright's Kahn lectures were published in 1931 as *Modern Architecture*, with a preface by Smith. Identifying Wright as a "prophet without honor in his own country," Smith indicated that the lectures were primarily to inspire young architectural students. Admitting that Wright was belligerent in his attitude, Smith noted that the lectures "are not didactic

rules—rather are they sermons of an engaging, self-confident and enthusiastic artist fired with a faith, not in the machine itself, but in the power of man to master his creation, the machine, and to make it fashion new manifestations of beauty." Accompanying Wright's lectures at Princeton was the first showing of a large exhibition of photographs, drawings, and models of Wright's architecture. The exhibition then toured many institutions, although Wright later claimed that it was rejected by Cornell, Harvard, MIT, and Yale. The Kahn lectures and exhibition, combined with the appearance of Wright's autobiography in 1932, began his rehabilitation as the greatest architect produced in America.

From 1936 to 1941, Professor Smith was the art department's representative to the Divisional Program in the Humanities, and its first chairman. A student in the program would satisfy departmental requirements a year earlier than usual, so that his senior year could be devoted to a larger, broadly oriented senior thesis synthesizing work in several of the humanities. In the mid-1950s, with increasing student interest in specialization, Smith would often come back from meetings of the committee disgusted that some of the theses were merely departmental theses, with no attempt at bridging the humanities. The Program soon died a natural death from lack of student interest.

In 1945, when Charles Rufus Morey retired, Smith was appointed chairman of the Department of Art and Archaeology. Despite his new responsibilities, he continued to teach at least seven or eight hours each week, including lectures in the spring on modern painting, which was one of the most popular courses on campus. It was during his chairmanship that the Creative Arts Program began to teach painting, and with his support the department accepted Bill Seitz's doctoral dissertation on Abstract Expresionism, recognized as the first dissertation on contemporary art accepted by an American university. Although the faculty taught undergraduate courses in the entire history of art, their research was limited to ancient, medieval, and Chinese art. The new appointments under Smith were of faculty interested in scholarship in the additional fields of Northern Renaissance and Baroque art, Renaissance architecture, and modern painting.

Like many New Englanders who experienced the Depression, Baldwin Smith was rather frugal in terms of money and time. His younger colleague Donald Drew Egbert once complained that Smith would buy the least expensive chairs on the market, which would collapse the first time one sat in them, while their colleague Albert M. Friend would insist on

antique Louis XV chairs that no one dared sit in. Egbert lamented that he just wanted simple, solid chairs.

To the dismay of some of the students, Smith always scheduled his preceptorials at 8:30 A.M., so that some of the morning and many afternoons were free for administration and research. He expected the same intensive teaching schedule from his faculty as he himself pursued. During my first year on the faculty, I taught twelve preceptorial hours in two courses each term.

With all his academic activities, Professor Smith had a strong domestic life. His first wife died prematurely, leaving him with two young children. His second wife, who bore him two more children, had as dominant a personality as he did. An influential citizen of the town, she was a leader in the planning and building of a new public library.

Smith devoted his entire adult life to furthering the study of architectural history, to teaching the profession of architecture at Princeton, and to developing and refining educational methods and facilities at the University. Hospitalized during his last term of teaching, he died in March 1956, just a few months short of his scheduled retirement in June 1956.

Reading List

With Howard Crosby Butler: *Early Churches in Syria.* Princeton: Published for the Department of Art and Archaeology of Princeton University, 1929.

Egyptian Architecture as Cultural Expression. New York: Appleton, 1938.

The Dome: A Study in the History of Ideas. Princeton: Princeton University Press, 1950.

Architectural Symbolism of Imperial Rome and the Middle Ages. Princeton: Princeton University Press, 1956.

Notes

1. Alexander Leitch, *A Princeton Companion* (Princeton: Princeton University Press, 1978), p. 25.

2. See E. B. Smith, "The Idea of the New Princeton Library and Its Plan," in *The New Princeton Library* (Princeton, 1935).

20

In Memoriam: Erwin Panofsky

Last night, considering whether there is any single word which would describe Erwin Panofsky, I realized that there is one word which summed up thirty years of acquaintance of him. I should like to celebrate Erwin Panofsky as the greatest, and perhaps the last, humanist whom, I believe, I have ever known or expect to know. I use the word humanist knowing well that its definition has been a source of bitter conflict among scholars of the humanities, but this is of no importance, for Erwin Panofsky fits every definition of the word offered, from the narrowest to the broadest.

In the narrowest definition of the humanist as a grammarian, this is Pan, for he loved words. He loved their origins and their histories. No pupil can ever forget those digressions in his classroom, some brief, some long, when he would expatiate on the history of a word. They were so perfect that one sometimes questioned their spontaneity, but their genuineness was proven at other times. For in the same way, no one can ever forget those sudden interruptions at home of an evening when he darted into the nearby study to seek vindication, as he always found it, in a dictionary or in a pamphlet dragged down from the shelves as he teetered on a book-laden chair.

In the definition of a humanist as a master of classical languages, this also is Pan. This is the Pan who deflated doting parents with the dictum that no child should be seen much less heard until he could read his Latin, and he meant it. This is the Pan, who, when his paperback, *Meaning in the Visual Arts,* appeared, triumphantly noted that the quotations in Greek in the footnotes were generally printed without translation and wondered whether this was not the first such event in American paperback printing, because Pan loved "firsts."

The definition of a humanist as a scholar of classical antiquity, and especially of its literature and philosophy, needs no comment; the proof lies there for all to see and to use in those books from *Idea* to Correggio's *Camera di S. Paolo.*

Like almost every great humanist, Pan was a distinguished and indefatigable letter writer, an art which our age has lost. Everyone had the experience of receiving in the return post a thank-you note for an offprint which, at least briefly and more often at great length, revealed that every word of the article had been read. More important, in one or two sentences he would unerringly sum up the major significance of the article, a significance which, I suspect, was often unknown previously to the author.

I am convinced, however, that the definition of a humanist which best fits Pan is properly his own definition. For Pan, a humanist is one convinced of the dignity of

man—one, as he said, who rejects authority but respects tradition. He found in Erasmus the humanist par excellence, and in many ways Erwin Panofsky and Erasmus must have been similar. Like every humanist, Pan was aware of the transience of life. He did not like it, but he understood it. He knew that all man had was his dignity, and that would be preserved only as long as man questioned authority and respected tradition, which he did in his teaching and his writings.

Erwin Panofsky (photo: Lotte Jacobi)

Commentaries on David R. Coffin's Articles

ARCHITECTURE AND ARCHITECTS

1. "Pirro Ligorio and Decoration of the Late Sixteenth Century at Ferrara." *The Art Bulletin* 37 (1955), pp. 167–185

In the earlier of his two Ligorio articles, "Pirro Ligorio and Decoration of the Late Sixteenth Century at Ferrara," Coffin begins strikingly with the death of the painter Bartolomeo Faccini at the Este Castle in Ferrara in 1577. From this event Coffin develops several interconnected subjects. Moving from the surviving fragments of Faccini's paintings in the Este Castle to some thirty drawings by Ligorio, he establishes the latter's responsibility for the planning of the Ferrara project. This commission provides a context for discussion of the Este preoccupation with genealogy and explains a contemporary disagreement over the standing of the Estes, relative to the Medici, at the imperial and papal courts. Coffin concludes that Faccini's painted genealogy promoted the Estes's precedence. This discussion leads to a consideration of other decorations painted during the reign of Alfonso II and to the conclusion that Ligorio was also responsible for archaeological subjects in two rooms inside the castle. A description of the library and museum that Ligorio designed for the castle follows, and Ligorio's views on the nature of grotesque painting are analyzed in further detail. The clarity, coherence, and copiousness of this article are impressive. Notable also is the cumulative nature of the argument. From a particular incident, Coffin develops a broad and profound study encompassing Alfonso II's ambitions for the Este court at Ferrara.

Graham Smith
The University of St Andrews, Scotland

2. **"Pirro Ligorio and the Nobility of the Arts."** *Journal of the Warburg and Courtauld Institutes* 27 (1964), pp. 191–210

This article discusses Ligorio's unpublished "Trattato . . . di alcune cose appartenente alla nobiltà delle antiche arti," a manuscript preserved in the Archivio di Stato in Turin. From a focus on date and provenance, Coffin extends his field to consider the contents and significance of the treatise. First he considers the spirit of disillusionment that permeates the manuscript, explaining this by reference to Ligorio's disgrace at the end of the pontificate of Pius IV and his exclusion from the court of Pius V. Next he evaluates the contents of the manuscript, winnowing from it an understanding of Ligorio's artistic theory and explicating his characterization of the sixteenth century as "this century of lost hope." Ligorio's treatise is rambling and disorderly, according to Coffin's assessment, but his own commentary is admirably clear. Ligorio was a Classicist and an anti-Mannerist, and admired Raphael rather than Michelangelo. His treatise, in Coffin's summation, is "the last gasp of the rivalry and enmity that commenced in the early sixteenth century between the circle of Bramante and Raphael and that of Michelangelo." There is, then, something symbolic in the fact the second edition of Vasari's *Vite* appeared in 1568, the year Ligorio left Rome for Ferrara.

Graham Smith
The University of St Andrews, Scotland

Comparing these two articles to Coffin's book *Pirro Ligoro: The Renaissance Artist, Architect, and Antiquarian, with a Checklist of Drawings* (University Park, Pa., 2004), it is clear that Ligorio was a life-long interest accompanying Coffin throughout his career. So much so that Graham Smith added the following metaphor: the articles on Ligorio form the wings of a triptych in which Coffin's book *The Villa d'Este at Tivoli* (Princeton, 1960) is the central panel. Completing this metaphor, Coffin's Princeton doctoral dissertation "Pirro Ligorio and the Villa d'Este," can be viewed as the predella, while his last book, also on Pirro Ligoro, may be considered the lunette or pinnacle. Interestingly, in the preface of his Ligorio book, Coffin confirms the aptness of this metaphor himself by reviewing the life-long history of his work on Ligorio: it grew from a graduate seminar offered by Erwin Panofsky in the fall of 1945, to a Fulbright scholarship in Rome, and resulted in the writing of his doctoral dissertation, with the personal encouragement of his mentor, Baldwin Smith. Coffin writes that his interest in Ligorio was then put aside so that he could concentrate on Italian and English gardening, and that it was not until after his retirement that he had the pleasure of returning to Ligorio and producing his biography to "satisfy his commitment of more than forty years' standing."

Vanessa Bezemer Sellers
Independent Scholar, New York

3. **"Pope Innocent VIII and the Villa Belvedere."** In *Studies in Late Medieval and Renaissance Painting in Honor of Millard Meiss*, **edited by Irving Lavin and John Plummer. New York, 1978, pp. 88–97**

David Coffin's contribution to the 1978 Millard Meiss festschrift, "Pope Innocent VIII and the Villa Belvedere," beautifully complements James Ackerman's masterful book of 1954, *The Cortile del Belvedere*. Ackerman paid attention to the Villa Belvedere only as the raison d'être behind the vast Bramante courtyard begun at the Vatican in 1505. Coffin delved back into the history of the pre-existing villa produced during the reign of Innocent VIII (1484–92), the first pope in a long line to take an active interest in villas and gardens.

Coffin's scholarly contribution in this article is twofold. Firstly, he evokes the Villa Belvedere not simply as a place of vistas, as its name implies, but as a healthful, breezy retreat from the air of pestilence combined with intrigue that hung over the Vatican palace down in the valley below. Secondly, Coffin relates the general ethos of villa life to the illness of the pope, specifically alluded to in the musical themes of the painted decoration in the loggia. Music, Coffin points out, was believed to have curative powers. The Villa Belvedere's restorative, in this case palliative, properties remind us that quite apart from the fine arts, life in a villa involves good air, prospects, food, drink, conversation, and musical cadences.

<div align="right">

Pierre de la Ruffinière du Prey
Queen's University, Kingston, Ontario

</div>

4. **"Pope Marcellus II and Architecture."** *Architectura: Zeitschrift für Geschichte der Baukunst* 9 (1979), pp. 11–29

This is the most extensive study yet published on the architectural interests and patronage of Cardinal Marcello Cervini, who briefly reigned as Pope Marcellus II in 1555. Born to a noble family of Montepulciano, Cervini had a humanist education in Siena and earned a reputation for learning, wisdom, and integrity. He rose to power under Pope Paul III Farnese, who made him a cardinal, appointed him to several important offices, and used him as a diplomat and counselor to the papal nephews. Cervini's interests in architecture and archaeology are documented in correspondence occasioned by his absences from Italy on diplomatic and church business.

Coffin's article published what survives of the cardinal's correspondence about architecture, together with drawings of a project for a villa he had commissioned from Antonio da Sangallo the Younger and an analysis of the Villa Cervini as built on Monte Amiato. No further research on the architectural patronage of Marcello Cervini was undertaken until Pietro Ruschi's recent study, published in *Le dimore di Siena* (Florence, 2002), complemented Coffin's findings. Coffin's conclusions have been accepted in the recent biographies of Antonio da Sangallo and in the comprehensive publication of Sangallo's drawings by Christoph L. Frommel and Nicholas Adams, *The Architectural Drawings of Antonio da Sangallo the Younger and His Circle*, vol. 2, *Churches, Villas, the Pantheon, Tombs, and Ancient Inscriptions* (Cambridge, Mass., 2000).

<div align="right">

Richard J. Betts
University of Illinois at Urbana-Champaign, Emeritus

</div>

5. **"The Self-Image of the Roman Villa during the Renaissance."** *Architectura: Zeitschrift für Geschichte der Baukunst* 28 (1998), pp. 181–203

This short article brilliantly encapsulates David Coffin's scholarly achievement over the period of nearly forty years. The overview it provides resembles one of those Renaissance aerial prints or maps that Coffin delighted in using to illustrate his publications. We are treated to a sweeping panorama of some of the most wonderful scenes that art and nature have ever produced in unison. At the same time, the text closely focuses on the decoration of celebrated villas in and around Rome that reveal their self-referential, self-preoccupied character.

Coffin documents the curious and significant fact that quite frequently the interior decoration of villas includes a painted depiction of the house itself—the architectural equivalent, if I may say so, of a Shakespearean play within a play. One of the earliest instances of such a punning form of pictorial allusion to a villa within a villa occurs in the Farnesina's loggia, painted by Baldassare Peruzzi for his

client Agostino Chigi, a practical joker of the first order. Anecdotes of Chigi's hilarious pranks highlight the sense in which a villa is perhaps best understood as a place where life ought to be taken with a touch of humor.

<div align="right">

Pierre de la Ruffinière du Prey
Queen's University, Kingston, Ontario

</div>

6. "Some Architectural Drawings of Giovan Battista Aleotti." *Journal of the Society of Architectural Historians* 21 (1962), pp. 116–128

Coffin's succinct 1962 account of disparate and serendipitously discovered documents related to the career of Giovan Battista Aleotti remains foundational to the study of this important and versatile Emilian architect. While more recent investigations have expanded the knowledge of Aleotti's life and oeuvre, underscoring his importance, this article continues to be cited. Some of Coffin's attributions have been questioned, however. For example, in a 1987 article ("Il palazzo Bentivoglio e gli architetti ferraresi del secondo Cinquecento," in *L'impresa di Alfonso II* [Bologna, 1987]), Marcolini and Marcon reattributed the facade of the Palazzo Bentivoglio to Ligorio based on its relationship to an elaborate plan they likewise attributed to the Neapolitan architect, though they believe that Ligorio's design was completed under the direction of Aleotti. Still more recently, however, Diego Cuoghi ("La rocca di Scandiano nei progetti di Giovanni Battista Aleotti," in *Atti e memorie della deputazione di storia patria per le antiche province modenesi*, ser. 9, vol. 16 [Modena, 1994]), and Alessandra Frabetti ("Aleotti, Giovanni Battista," in *The Dictionary of Art* [London, 1996], vol. 1) have maintained Aleotti's authorship.

The strength of Coffin's formalist analysis of Aleotti's drawings goes beyond matters of attribution. His analysis unfolds a world in which palace and church facades, city gates, tombs, frontispieces, and stage sets are formed from a unified but evolving grammar of design. As Coffin concludes, this evolution shows how Aleotti's architectural career links the Renaissance with the Baroque or "a provincial version of it." In retrospect, however, we might consider whether in this study of Aleotti, Coffin has not actually shown the limitations of traditional formalist categories and thereby presaged the kind of thematic, social analysis that would later develop in his own work and throughout the discipline. The trajectory toward "the Baroque," for example, might best be understood by focusing on the theme of theatricality, a hallmark of early modern society and a leitmotif in Aleotti's oeuvre. His inventive stage sets and theater designs bear direct witness of this, but theatrical aspects can be seen in his churches and palaces as well. His masterpiece, the Teatro Farnese in Parma, celebrated for its introduction of the proscenium arch, redefined the relationship of the audience to actor and of fictive stage to reality. But, just as the interior of the Teatro Farnese, with its colossal columns and serlianas, connected the audience to a civic architectural realm, so did Aleotti's city gate designs, which, with their one-point perspectival elevations, explicitly turn the city into a civic stage.

<div align="right">

David W. Gobel
Savannah College of Art and Design

</div>

7. "Padre Guarino Guarini in Paris." *Journal of the Society of Architectural Historians* 15, no. 2 (May, 1956), pp. 3–11

This article, published in 1956, was the first major contribution by an American to scholarship on Guarino Guarini. With it Coffin also set a new standard for the Guarini studies that ensued, conducted by a long line of scholars in the United States as well as in Europe. What is particularly important about

Coffin's detailed recounting of the history of Guarini's Sainte Anne-la-Royale is how he situates it within the better-known history of Bernini's trip to Paris and his designs for the Louvre. By doing so, Coffin is able to identify the inflence of Bernini's early schemes for the Louvre on Guarini's design for a palace recorded in his treatise, *Architettura civile*, as well as on his preliminary sketches for the Palazzo Carignano in Turin. At the same time, Coffin addresses the problem of the relationship of Guarini's architecture to that of another well-known predecessor, Francesco Borromini, and, through a close study of Guarini's three designs, he characterizes the differences in their styles by explaining how each architect manipulated geometry. Finally, by relating the history of Guarini's designs to theoretical statements found in his later treatise, Coffin became one of the earliest architectural historians to appreciate and understand the importance of the link between practice and theory. This understanding extended to his teaching at Princeton University, where the history of theory and of theoretical texts played a key role in his pedagogy. As a result Coffin trained a significant number of doctoral students who specialized in this area, but he also had an impact on the education of the many students from Princeton's School of Architecture who wcrc drawn to his courses, not least of all because of their interest in theory.

<div align="right">

Lydia M. Soo
University of Michigan

</div>

GARDENS AND LANDSCAPE DESIGNERS

8. "John Evelyn at Tivoli." *Journal of the Warburg and Courtauld Institutes* **29 (1956), pp. 157–158**

In this short essay David Coffin demonstrates his exemplary use of contemporary accounts and images of gardens, treating all as valuable to reconstructing and understanding the whole, not in isolation, but in conjunction with each other. In this brief discussion of John Evelyn's account of his visit to the Villa d'Este in 1645, one can learn much about the way information was conveyed in the early modern period. First-hand observation was filtered through previous descriptions and representations, in this case a particularly popular source, François Schott's guidebook to Italy, *Itinerario d'Italia*, together with a later copy of Dupérac's famous engraving of the villa. Dupérac's engraving does not give a precise rendering of the garden as actually laid out and adds sections which were never completed. Chronologically later views and descriptions are not necessarily more accurate: instead of illustrating the existing site, items might have been added or subtracted, and certain features planned but not executed, while others might no longer survive. Coffin never dismisses anything as a mere copy or inaccurate account; instead close analysis reveals the significance in reconstructing the site as originally planned, as actually built, and as later altered.

<div align="right">

Claudia Lazzaro
Cornell University

</div>

9. "Some Aspects of the Villa Lante at Bagnaia." In *Arte in Europa: Scritti di storia dell'arte in onore di Edoardo Arslan.* **Milan, 1966, pp. 569–575**

In this article David Coffin makes a crucial archival find, which provides the only firm documentary evidence linking the architect Vignola to the Villa Lante at Bagnaia and establishes a date for its commencement. The letter that Coffin discovered, dated September 1568, was sent by Cardinal Farnese, for whom Vignola worked at his family villa at Caprarola, to Cardinal Gambara, who built the Villa Lante.

The letter indicates that the architect Vignola is with Cardinal Gambara at that moment to receive instructions regarding work for him. Coffin also pioneered the study of painted topographical views in villas, a history of which he outlines in this essay and elaborates in later studies. Here Coffin analyzes the frescoes painted at Bagnaia in about 1574–76 for their deliberate presentation of relationships among the Farnese, Este, and Gambara villas. The frescoes demonstrate not only the influence of Tivoli's topographical views on the Villa Lante's garden features, but also the clear connections with Vignola's designs at both the Farnese and Gambara estates, leading Coffin to conclude that Vignola was indeed the designer of the Villa Lante. Coffin provides a very brief but innovative, synthetic overview of the development of villa and garden design among the three villas, which he amplified considerably in subsequent books.

Claudia Lazzaro
Cornell University

10. **"The 'Lex Hortorum' and Access to Gardens of Latium during the Renaissance."** *Journal of Garden History* **2 (1982), pp. 201–232**

Coffin's "Lex Hortorum" article of 1982, published soon after his seminal volume on Roman Renaissance villas, extended his exploration of the function and use of their gardens and grounds. Coffin described a tradition of public access to privately owned gardens that appeared in the late fifteenth century, probably inspired by the writings of the Neapolitan humanist Giovanni Pontano. In his treatise *De Splendore* of 1498, Pontano recommended that villas be decorated with statues, paintings, and rich furnishings, for not only was their appearance pleasing, but they lent prestige to the owner as well. As Coffin noted, Pontano distinguished between magnificence, expressed in large permanent works such as palaces or villas, and splendor, expressed in moveable or ephemeral objects such as horticultural specimens or collections of antiquities. According to Pontano, villas and gardens should be opened to visitors, both friends and strangers, as a sign of personal splendor. For Roman courtiers, in particular cardinals, eager to assert their wealth, position, and cultural heritage, the *lex hortorum* (or "law of gardens") was motivated by a desire for display. The concept of public access had implications for garden design, necessitating the provision of prominent portals that allowed visitors to enter without intruding on the daily life of the residents. In this article Coffin touched upon issues of broad concern to art historians of the late twentieth century, including the social uses of gardens, collections, and material culture more generally; the Renaissance definition of public and private space; and the reception of works of art by varied audiences.

Tracy Ehrlich
Independent Scholar, New York

11. **"The Study of the History of the Italian Garden until the First Dumbarton Oaks Colloquium." In** *Perspectives on Garden Histories.* **Dumbarton Oaks Colloquium on the History of Landscape Architecture 21, edited by M. Conan. Washington, D.C., 1999, pp. 27–35**

In this article Coffin analyses the development of Italian garden studies up to the time of the first colloquium organized and convened by him at Dumbarton Oaks in the spring of 1971. After reviewing nineteenth-century German publications on the topic, Coffin proceeds to give the reader a succinct overview of early-twentieth-century literature on garden architecture, primarily in the English-speaking world. Coffin uses Charles Platt's photographs, Sir George Sitwell's *An Essay on the Making of Gardens,* and Edith Wharton's *Italian Villas and Their Gardens,* illustrated by Maxfield Parish, to elucidate the general unfolding

of the cult of the Italian garden in America. He highlights, among various outstanding publications, Marie Louise Gothein's *Geschichte der Gartenkunst* of 1914 and the garden surveys by Shepherd and Jellicoe, *Italian Gardens of the Renaissance*, of 1925. Coffin shows how not only books and architectural drawings, but also the actual construction of villas in Tuscany by the Anglo-American elite, stimulated the interest in Italian garden design. The true climax of interest in Italian gardens, according to Coffin, came with the exhibition in Florence in 1931, shortly before World War II put a temporary stop to the development of the topic.

In the 1950s and 1960s, innovative studies, contributing iconographic and social-historical information, were undertaken by scholars such as Mario Praz and James Ackerman. It was not until the 1970s, however, when garden history began to be recognized as a distinct academic discipline, that the first modern studies with clear illustrations and a scholarly apparatus were published. The best examples are the pioneering works by Coffin himself, as well as those by Elisabeth MacDougall, first director of the landscape history program at Dumbarton Oaks. As Mirka Beneš pointed out in her recent article "A Tribute to Two Historians of Landscape Architecture: David R. Coffin (1918–2003) and Elisabeth B. MacDougall (1925–2003)" in the *Journal of the Society of Architectural Historians* 63 (2004), 248–254, their publications remain classics in the field of architecture and garden history. This, in spite of the fact that in the quarter century since the first colloquium on Italian gardens convened, garden history has developed in many new directions, embracing new complexities of content and methodological approaches. With admirable foresight, Coffin ended his survey by leaving it to the next generation to forge ahead in these and other new directions.

Vanessa Bezemer Sellers
Independent Scholar, New York

12. "The Gardens of Venice." *Source: Notes in the History of Art* **21, no. 1 (fall, 2001), pp. 4–9**

In her *Italian Villas and Their Gardens* of 1904, Edith Wharton observed that writers on Italian architecture had paid little attention to the villa architecture of the Veneto, and she regretted the loss of most villas and gardens in that region. Wharton explained that, while a number of country houses in the area had survived, their gardens had not: "unfortunately, in not more than one or two instances have the old gardens of these houses been preserved in their characteristic form; and, by a singular perversity of fate, it happens that the villas which have kept their gardens are not typical of the Venetian style." This has been a particular problem for those interested in the humanist gardens formerly located on the islands of Venice proper, as Coffin points out. In an essay for a collection of articles on the Italian garden edited by David Coffin (1972), Lionello Puppi stated that there are not even any remains of the "zardini" of the Lagoon, and that only sketchy information, amounting to that from relief drawings and imprecise literary descriptions, survives. Puppi goes on to say that the *delizie* of the Giudecca alone merit a specific treatment, which should be undertaken. Thus Coffin's article, with its compilation of newly discovered documentary evidence on social usage, plantings, and spatial organization of Venetian gardens, fills a significant gap in the literature.

D. R. Edward Wright
University of South Florida, Emeritus

13. "Repton's 'Red Book' for Beaudesert." *Princeton University Library Chronicle* **47 (1986), pp. 121–146**

The essay on Humphry Repton's Red Book for Beaudesert accomplishes two distinct but related purposes for two different groups of readers. Some will come to this essay with little knowledge of

Humphry Repton or his Red Books, and for such readers, Coffin rehearses the minimal biographical material on Repton and clearly describes the typical format and characteristic contents of one of his Red Books, this particular volume being slightly larger in size and bound in brown instead of the usual red leather. At the same time, Coffin summarizes Repton's core design ideas and their evolution through two and a half decades. Thus the essay can serve as a good short introduction to the landscape architect and his work. On the other hand, many readers of this essay will already have a reasonable understanding of Repton and his work. However, even for such readers the essay is well worth perusing, since it addresses the ways in which the Beaudesert Red Book is a typical Repton product while giving a sense of its particular flavor. To be sure, the Red Books conform to a pattern, but each one is individualized around the specific exigencies and nuances of its unique site. As a result, Repton takes up issues and makes observations that are distinctive to each place. The inclusion in Coffin's essay of a number of illustrations from the Red Book's watercolors is especially helpful in this regard.

The secondary information Coffin includes in the essay is also very useful. This consists of detailed facts about the Paget family (owners of Beaudesert) and about previous landscaping efforts on the estate. Coffin also adds observations on the ways in which landscaping activity at Plas Newydd in Wales, another Paget property, might have had an effect on the course of work at Beaudesert. Coffin then provides an all-encompassing explanation as to why so few of Repton's design proposals were implemented. Of specific interest, finally, are Coffin's thoughts on the collector, Robert H. Taylor, and the latter's probable reasons for wanting to purchase this Red Book in particular.

<div style="text-align: right;">

Edward S. Harwood

Bates College

</div>

14. **"The Elysian Fields of Rousham."** *Proceedings of the American Philosophical Society* 130 (1986), pp. 406–423

At the outset of this essay, Coffin points out that it was the horticulturist and garden historian John Evelyn who first applied the concept of Elysium to actual gardens. In choosing the title for his article on Rousham, Coffin was also thinking of the title of Evelyn's magnum opus, "Elysium Britannicum," which, nearly completed, lay abandoned for almost three centuries in Christ Church Library, Oxford. The "ill-fated treatise," as Coffin calls it in this article, finally appeared in print as *Elysium Britannicum, or The Royal Gardens* (Philadelphia, 2001).

Coffin's essay on Rousham reflects the same scholarly interests and premises as some of his most important publications. On the one hand, his concern with linking many of the garden structures and sculptures at Rousham, including aspects of their siting, to the classical theme of the Elysian Fields ties this essay to his ground-breaking efforts at deciphering the iconographical program at the Villa d'Este in Tivoli. On the other hand, Coffin's pursuit of a unified world of elegiac associations at Rousham inevitably invokes the similar thematic concerns he presented at greater length in his book *The English Garden: Meditation and Memorial.* What is also manifested in this essay is the fundamental belief that gardens are places in which essential, culturally specific meanings and concerns are given form. This belief has been the foundation of Coffin's work and one of its enduring contributions to garden history.

Though the importance of sculpture for endowing gardens with meaning is readily acknowledged in Italian and French gardens, rarely is the same level of attention given to sculptural ensembles in English gardens. Is this appropriate? At Stowe, for example, the sculpture plays an integral role in the development of an array of political and cultural themes. Coffin argues in this essay that the sculpture at Rousham similarly needs to be seen as a unified thematic ensemble. Whether one agrees or disagrees with this argument, it seems warranted to look more closely at sculpture in the English garden and the

role it might have played in imparting meaning. In raising this and other important questions, Coffin's essay on Rousham is among his most stimulating.

Edward S. Harwood
Bates College

15. "Venus in the Eighteenth-Century English Garden." *Garden History* 28 (2000), pp. 173–193

16. "Venus in the Garden of Wilton House." *Source: Notes in the History of Art* 20, no. 2 (winter, 2001), pp. 25–31

It is appropriate to consider these two articles together, as they share several central concerns. One of these is obviously the sculpted presence of Venus in English gardens in the seventeenth and eighteenth centuries, and the varied readings those sculptures might inspire. Coffin's essays also bring into focus larger issues with regard to the integration of intellectual content into the garden experience, issues that have run through Coffin's work ever since his explication of the programs built into the journey through the garden of the Villa d'Este at Tivoli. Coffin investigates in what way gardens become sites in which culturally important ideas are represented, and how such content is embodied. In what manner is this content to be received or "read" by its audiences, and can that reception be controlled? These are difficult questions in garden history, and the imagery associated with Venus is a good lens through which to view their complexity.

The goddess of love and fertility can play a number of different roles as she is embodied in garden statuary, and they, in turn, can suggest different themes for the attentive garden visitor. Whether those themes are coequal in a given representation, or whether one takes precedence over the others, can vary considerably depending upon context. Coffin's ability to identify the probable references to Queen Henrietta Maria in the Wilton Venuses, for example, arises from his careful analysis of Greco-Roman myths involving this goddess. Coffin is also able to document the awareness of those stories within the Stuart court, and the documented presence of royal imagery in the garden at Wilton. Similarly, charting the protean Venus imagery found in eighteenth-century English gardens requires the ability to judge among and fit together a variety of context-related factors. For example, which type of Venus statue was chosen, which meanings were traditionally associated with it, and what was the nature of its siting? Furthermore, what is known of the character of the patron, and of his or her design goals? In other words, no single and simple meaning can be attributed to a statue of Venus in an eighteenth-century English garden. The interpretative process remains open and complex.

Edward S. Harwood
Bates College

DRAWINGS

17. "Tintoretto and the Medici Tombs." *The Art Bulletin* 33 (1951), pp. 119–125

The sculpture of Michelangelo, specifically the figures of *Day, Dusk*, and *Giuliano de' Medici* from the Medici Chapel, exerted a resonant influence on Tintoretto's painting, judging by drawings attributed to the Venetian artist that were made after models of the sculptures. In analyzing the ways in which Michelangelo was an artistic inspiration, Coffin offers convincing arguments in favor of Tintoretto's imaginative aesthetic judgments over simple Neoplatonic formulae, and he reconsiders the attribution and chronology of the artist's works, including the lost frescoes of the Casa Gussoni in Venice.

Coffin makes precise and illuminating connections with the famous *Miracle of the Slave* of 1548 and the ceiling decoration of the Atrio Quadrato in the Ducal Palace. He portrays Tintoretto's sensitive and ultimately liberated assimilation of Michelangelo's motifs, concluding with an incisive summary of the polemic among Paolo Pino, Antonio Francesco Doni, Michelangelo Biondo, and Lodovico Dolce about Florentine and Venetian values. Coffin redefines *disegno* so that Tintoretto emerges as Pino's most assured "god of painting," one who reinvented Michelangelo's nudes through his graphic investigation of foreshortening, and one who, in his penetration of their heightened plasticity, rendered Titian's color alive again.

Meredith J. Gill
University of Maryland, College Park

18. **"A Drawing by Pietro da Cortona for His Fresco of the *Age of Iron.*" *Record of the Princeton Art Museum* 13 (1954), pp. 33–37**

In this brief essay Coffin moves seamlessly from the panoramic to the particular. The first part of the article discusses Pietro da Cortona's residence in Florence in 1637, when he was on his way from Rome to study painting in Bologna and Venice. On this occasion he painted two frescos, representing the ancient ages of gold and of silver, in the Sala della Stufa, a room in the Palazzo Pitti. Cortona returned to Florence in 1640 to execute the two remaining frescoes—*The Age of Bronze* and *The Age of Iron*. At this point Coffin introduces a composition study for the latter painting, a drawing bequeathed to the Princeton University Art Museum by Dan Fellows Platt. By comparing the drawing with the fresco, Coffin succinctly characterizes Pietro da Cortona's shift from a classical style to one that is more dramatic, dynamic, and Baroque in nature. Finally, he suggests that this change may reflect the inspiration of Titian, whose paintings Cortona had admired in Venice between planning and executing *The Age of Iron*.

This early article is typical of David Coffin himself. It says no more than needs to be said, while including everything that is worthwhile to say.

Graham Smith
The University of St Andrews, Scotland

SCHOLARS

19. **"Earl Baldwin Smith." In *Luminaries: Princeton Faculty Remembered*, edited by Patricia H. Marks. Princeton, 1996, pp. 264–272**

Coffin's article on Earl Baldwin Smith (1888–1956) is an insightful analysis of that singularly brilliant man's personality and interdisciplinary interests, as well as an evaluation of his many contributions to teaching, research, and Princeton University programs in general. For those of us fortunate to have known Baldwin Smith when he was at the helm of the Department of Art and Archaeology, the Coffin article conjures up "Baldy" in a striking way. Commanding in appearance and of a no-nonsense demeanor, Smith was a stern taskmaster. Demanding of himself, he was equally demanding of his faculty, expecting of them dedication and achievement of the highest degree. Smith's own research was primarily dedicated to architectural history and led to the publication of *Egyptian Architecture as Cultural Expression, The Dome: A Study in the History of Ideas,* and *Architectural Symbolism of Imperial Rome and the Middle Ages*. Together with his many scholarly accomplishments, Smith was constantly active in the affairs of the University. As Coffin so aptly points out, "Smith devoted his entire adult life to furthering the study of architectural history, to teaching the profession of architecture at Princeton, and to developing and

refining educational methods and facilities at the University." David Coffin clearly followed in his mentor's footsteps.

Franklin Hamilton Hazlehurst
Vanderbilt University, Emeritus

20. "In Memoriam." In *A Commemorative Gathering for Erwin Panofsky at the Institute of Fine Arts, New York University, in Association with the Institute for Advanced Study.* **N.p., 1968, pp. 14–15**

Clearly, all former students of Erwin Panofsky (1892–1968) share Coffin's admiration for the man, an admiration duly recorded in his "in memoriam" for Erwin Panofsky. Citing this remarkable scholar as "the greatest, and perhaps last, humanist whom, I believe, I have ever known," Coffin reveals "Pan, the humanist" as a master of classical language, a scholar of classical antiquity, and, by his own definition, one "convinced of the dignity of man—one who rejects authority but respects tradition." Coffin's comments reflect his own indebtedness to the master; Panofsky's philosophy is apparent in the scholarly research of his younger colleague, as Panofsky's iconographical approach is carried over to the understanding of garden design and function during the Renaissance in Coffin's studies. In turn, Coffin's interpretive method would be applied ultimately to writings on gardens of later historical periods.

Coffin showed the extent of his scholarly respect and personal admiration for Smith and Panofsky by dedicating his book *Gardens and Gardening in Papal Rome* (Princeton, 1991) jointly to these two mentors.

Franklin Hamilton Hazlehurst
Vanderbilt University, Emeritus

Index

Argenta, church of the Celletta near, 132
Ariccia, 138
Ariosto, Ludovico, 24
 Orlando Furioso, 18
Aristotle, 53, 69
Ashby, Thomas, 192
Ashridge Park (Hertfordshire), 209
askoliasmos (dance on leather bottles), 25,
 26, 29
Aspertini, Amico, 187n.17
Aspley Woods (Bedfordshire), 209
associationism, 224
astrology, and healing, 68
astronomy, and predictions of natural
 disasters, 72
Athena, 52
Athens, Odeon of Herodes Atticus, 190
athletes, depictions of, 20, 21, 23, 24, 25,
 26, 27–29
Atius, Caius, 18, 21
Attingham Park (Shropshire), 214
Aubrey, John, 253
Augustus Caesar, Roman emperor, 18, 53, 140
Austen, Jane: Mansfield Park (1814), 200
Avicenna: Canon of Medicine (1473), 68, 69

Bacchus, depictions of, 110, 223, 224, 237,
 239, 240, 250
Bacon, Sir Francis, 191, 218, 219
 Of Gardens (1625), 218
Baglione, Giovanni: Le vite de' pittori, scultori et
 architetti (1642), 16, 156, 157
Bagnaia, Borgo of, 158
Bagnaia, Villa Lante
 architects of, 156–163, 183
 construction of, 104–108, 156, 157–158,
 161, 191
 decoration of, 110, 111, 112, 156, 157,
 158, 159, 162
 depiction of in Palazzina Gambara,
 107, 111
 English admiration of, 191
 engraving of, 107, 109, 183–184, 184
 gardens and fountains at, 108, 109, 161,
 161–162, 166, 183–185, 185
 Palazzina Gambara, 104–107, 108, 110,
 111, 112, 156, 158
 study of, 194
Balbi, Alessandro, 25
Baldinucci, Francesco, 232
Barbara of Austria, Duchess of Ferrara, 23
Barbari, Jacopo de': Bird's-Eye View of Venice,
 196–197, 197
Barberini, Cardinal Maffeo. See Urban VIII,
 Pope
Baron, Bernard. See Rigaud, Jacques, and
 Bernard Baron: View of the Queen's Theater
 from the Rotunda
Baroni, Evangelista, 29
Baroque style, of architecture, 133
Barrells (Warwickshire), gardens at, 240–241
Baruffaldi, Girolamo: Vite, 38n.34
 editor of, 26–28
Bassano, Jacopo, 263–264
Basso, Ercole, 54n.8

Bastianino. See Filippi, Sebastiano
baths, Roman, 78, 179, 180
Battista, Eugenio, 272
Battisti, Eugenio: L'Antirinascimento, 194
Baumgart, Fritz, 43n.112
Beatrizet, Nicolaus, 266n.35
Beaudesert (Staffordshire), estate
 kitchen garden for, 212, 213,
 parterre design for, 207, 209
 Picturesque principles at, 206, 211, 214
 Red Book for, 200–217, 202–214
 remains of, 204–205
 Tudor mansion at, 203, 204, 206, 210
beautiful, idealist theory of, 52, 57n.66
Beazzano, Agostino, 197
Beccadello, Ludovico, 79–80, 83
Beckford, William, 173
Bedford, Duke of, 209
Beecroft, John, 201–204
Beerbohm, Max, 200
Bellini, Giovanni, 24
Bembo, Pietro, 24, 197
Benavides, Marco, 97
Beneš, Mirka, 3, 284
Bentivoglio, Cornelio, Marchese, 121–123, 124
 tomb of, 124, 126
Bergamo, gardens in, 192
Bernini, Gian Lorenzo
 influence on Guarini, 138, 145–146, 148
 Louvre plan by, 138, 145–146, 147, 148,
 150n.48
 —works by
 Apollo and Daphne, 166
Berry, Duke de: Très riches heures, 160
Bessarion, Cardinal: country house of, 158
Betts, Richard J., 280
Bible: Song of Songs, 218
biblical gardens, 218
Bickham, George: The Beauties of Stow (1750),
 236–237
Bigio, Nanni di Baccio, 46, 75, 76, 101
Biondo, Michelangelo, 57n.69, 264
Bisignano, Princess of, 69
Blackett, Sir Walter, 173
Blado, Antonio, 74
Blenheim Palace (Woodstock), 172
Blondel, Jacques-François: Architecture française
 (1752), 143, 144, 149n.22
Boiardo, Matteo Maria, 24
 Orlando Innamorato, 18
Bologna, Apostolic Palace, 63
Bomarzo, Orsini garden at, 193
Borghese, Marcantonio, Prince, 164
Borghese, Scipio, Cardinal, 164, 166
 arms of, 120
Borghese double-headed eagle, 120
Borghese Warrior (statue), 251
Borghini, Raffaello: Il riposo (1584), 256, 258
Borgia, Lucrezia, 38n.30
Borra, Giovanni Battista, 236
Borromeo, Carlo, Cardinal, 99
Borromini, Francesco
 Edith Wharton's admiration for, 191
 influence on Guarini, 140, 141–142,
 146, 148

Boschini, Giuseppe, 28
Boschini, Marco, 257
Boyer, François, bishop of Mirepoix, 144
Bradamante, 18
Bramante, Donato, 59, 158, 176, 191
 school (circle) of, 42n.107, 53
Brasavola, Antonio Musa, 38–39n.40
Brenzio, Dr. Andrea, 186n.4
Brescia, gardens in, 192
Brice, German: Description de la ville de Paris et
 de tout ce qu'elle contient de plus remarquable
 (1713), 144
Bridgeman, Charles, 172, 219, 234, 239
Brienne, Comte de, 149n.14
Brinckmann, Albert E.: Theatrum novum
 Pedemontii, 147, 151n.50
Britton, John: The Architectural Antiquities of
 Great Britain (1809), 213
broken pediments, Pirro Ligorio's objections
 to, 49–50, 121
Brown, Capability, 201, 206, 207, 210,
 214–215
Brown, J. Douglas, 273
Browne, Sir Thomas, 219
Brugnoli, Maria Vittoria, 158
Brusata, Rondinelli villa at, 123
Burchard, Johann, 67
Butler, Howard Crosby, 273

Calcagnini, Celio, 26
Caldara, Polidoro. See Polidoro
 da Caravaggio
calendar, corrections to, 72
Caletti, Giuseppe, 35–36n.4
Campbell, Colen, 238
Canino, depiction of, 103
Cannons, Duke of Chandos's gardens at, 173
Cantoni, Angelo, 194
Caprania, Camillo, 168
Capranica family, classical antiquities sold
 by, 108
Caprarola
 depictions of, 103, 107, 108, 112
 poetic epigrams about, 104
Caprarola, Farnese barchetto at, 108
Caprarola, Farnese Palace
 construction of, 53, 156, 157, 158
 decoration of, 102–104, 106, 107, 108,
 109, 113, 161, 162
 depicted at Villa Lante, Bagnaia, 107,
 112, 158
 drawing of, 105
 gardens at, 102, 105, 158
 iconographical program of, 43n.112
Caracciolo, Colantonio, Marquis of
 Vico, 175
Carafa, Gian Pietro. See Paul IV, Pope
Carafa, Oliviero, Cardinal, 166, 175
Caravaggio, Polidoro da (Polidoro Caldara),
 16, 36n.9, 160, 271
Cariola, Antonio: Lives of the Estes by, 14
Carlisle, Earl of, 239
Caro, Annibal, 73
Caroline, Princess of Wales, 235
Caroline, queen of England, 172

Fiorani, Camillo, 193
Fiorini, Giambattista, 53
Fisher, Jabez Maud, 242
Flora, depiction of, 250
Florence
 depiction in Villa Medici, Rome, 109
Florence, Archivio di Stato
 Cervini correspondence in, 85–87
Florence, Campanile, 64
Florence, Palazzo Bartolini, 50
Florence, Palazzo Medici, 175–176
Florence, Palazzo Pitti, Sala della Stufa,
 268–271, *270*
Florence, Palazzo Vecchio: exhibition on the
 Italian garden at (1931), 193
Florence, San Lorenzo, Medici Chapel, 256–267
Florence, Uffizi
 drawing of *Leda and Her Children*, 35
 drawings of Este family, 15–16, 18, 36n.9
 Parmigianino drawing, 131, *134*
 Pietro da Cortona drawings, 271
 Sangallo's drawings of Villa Cervini, *73,
 74, 75,* 77–78
 Tintoretto drawings, 258, *259,* 261
 Venus de' Medici, 232–234, 246
Fontaine, Pierre. *See* Percier, Charles, and
 Pierre Fontaine: *Choix des plus célèbres
 maisons de plaisance de Rome et de ses environs*
foreshortening, over-use of, 49
Fornovo, battle of (1495), 18
Forsyth, James, 173
Fortitude, personification of, 121
Four Seasons, representations of,
 102, 110
Frabetti, Alessandra, 281
Fracastoro, Girolamo, 197
Francesco di Giorgio Martini, 70n.4
Francis, Sir Philip, 246
Francis I, king of France, 199, 225
Francisco d'Ollanda, 167, 187n.17
Francucci, Innocenzo. *See* Innocenzo
 da Imola
Francucci, Niccolo, 81
Francucci, Pietro Paulo, 80, 81
Frascati, Villa Vecchia, 156
French Revolution, 144
Friedländer, Walter, 36–37n.17
Friend, Albert M., 275
Frizzi, Antonio, 26, 38n.34
Frommel, Christoph, 5, 280
Frontinus, Sextius Julius, 56n.55
Fronto, Marcus, 51, 56n.55

Gabriele, Trifone, 196
Galata (Celtic princess), 19
Galatea, depiction of, 48
Galatis, son of Hercules, 19
Gale, Samuel, 241
Galen, 69
Gallo, Egidio: *De Viridario Augustini Chigii*
 (1511), 92
Gallo, Jacopo: vigna of, 166
Gambara, Giovanni Francesco, Cardinal,
 bishop of Viterbo, 104–108, 156–157, 161,
 162, 183. *See also* Bagnaia, Villa Lante

Ganelon of Mainz, 18
Ganymede, depiction of, 63
García, Pedro, Bishop, 68
Garden of Eden, 218
Garden of the Hesperides, 218, 219
gardens
 biblical, 218
 circulation patterns in, 180–185
 monastic, 190, 218
 portals for, 175–180
 public access to, 98, 112, 164–185
 study of, 190–195
 of Venice, 196–199
 *See also Lex Hortorum; names of specific villas
 and their gardens*
Garth, Dr. Samuel: "Claremont," 235
George I, king of England, 172
George II, king of England, 235
Germany, d'Este ties to, 23–24, 37n.22,
 39n.43
Giannotti, Donato, 74
giants, depiction of, 47
Gibbon, Edward, 234
Gilio da Fabriano, Giovanni Andrea: *Dialogo
 secondo . . . de gli errori, e de gli abusi de'
 pittori circa l'historie* (1564), 46–47, 48, 50,
 52, 53
Gill, Meredith J., 286–287
Gilpin, William, 206
Gionitus, son of Noah, 64
Giorgione (Giorgione da Castelfranco), 51
Giovanni (builder of Villa Cervini at Vivo
 d'Orcia), 79, 80, 81, 83, 84–85
Giovanni da Bologna, 257
Giovanni da Udine, 35, 51
Giraldi, Cinzio, 26
 "Dell'Hercole" (poem), 19, 38n.30
 Este genealogy by, 19–20, 21, 23, 26,
 38n.30
Girolamo da Sermoneta, 53
Gnoli, Domenico, 192
Gobel, David W., 5, 281
Golden Age, mythology of, 218
Gonzaga, Ludovico, Marquis of Mantua, 60
Gonzaga, Margherita, 92
Gothein, Marie Luise: *Geschichte der
 Gartenkunst* (1914), 192, 193
Gothic architecture
 in garden buildings, 226–227
 Guarini's sympathy for, 142
Granada, Moorish gardens at, 198
Grandi, Alessandro de', 29, 30, 46
Graves, Rev. Richard, 224
Greco, El (Doménikos Theotokópoulos), 50
Greek tragedy, depicted in Ligorio
 drawings, 32
Gregory XIII, Pope
 accession of, 38–39n.40
 calendar reform by, 72
 cancelling of Cardinal Gambara's stipend
 by, 107
 support of Medici by, 23
Grimani, Marino, Cardinal, 179
Gritti, Andrea, Doge, 197
Gromort, Georges, 193

Gropius, Walter, 193
grotesque style (*grotteschi*), *32,* 32–34, *33,* 35,
 41n.96, 43n.111, 51, 62, 109
Guarini, Giovanni Battista, 24
Guarini, Guarino
 critical view of, 138–139, 144
 education of, 140
 employment in Turin, 145, 146–147
 works in Paris, 138–151, *145, 146*
—works by
 Architettura civile (1737), *139, 141,* 142,
 143, 145, *145, 146,* 148
 Placita Philosophica (1665), 150n.43
Gubbio, abbey at, 77, 81

Hadrian, Roman emperor, 53, 225
Hagley (Worcestershire), Hagley Park, 211,
 234, 241, 242
Hall Barn (Buckinghamshire), Temple of
 Venus at, 238
Hamlin, Alfred Dwight Foster, 191
Hammond, Lieutenant (a garden visitor),
 251–252, 253
Hampton Court, royal palace at, 212
harmony, principle of, 52
Harper's New Monthly Magazine, 190, 191
Harwood, Edward S., 285–286
Hawksmoor, Nicholas, 239
Hazelhurst, Franklin Hamilton, 287–288
Hearne, Thomas, 230
Hector of Troy, 18
Heely, Joseph, 241, 242
Heemskerck, Marten van, 166, 187n.17
Henry III, king of France, 26, 131
Henry VIII, king of England, 205
Herbert, Philip, Earl of Pembroke, 234, 250,
 251, 253
Hercules
 as ancestor of Este family, 19–20, 38n.30,
 48, 103, 130, 131, 162, 182
 depicted at Villa d'Este, Tivoli, 38n.30,
 48, 182
 Ligorio design for fountain
 depicting, 48
 in Renaissance gardens, 218
Hero of Alexandria: *Pneumatica,* 73
Hervey, John Lord, 216n.22
Hesiod, 166
 Works and Days, 268
hieroglyphs, 34, 43n.111
historicism, in landscape design, 206
Hogarth, William
 Analysis of Beauty, 234, *235*
 Sir Francis Dashwood Worshipping Venus
 (attributed to), 243, *244*
Holy Trinity, depiction of, 47
Homer
 Iliad, 74
 Odyssey, 218, 224
 statue of, 219
 use of *ekphrasis,* 97
Horace, 55n.28
Horapollo, 34
hortus conclusus, 175, 176, 218
Houghton Hall (Norfolk), 211, 251